GW00676320

A BITTER TRUTH

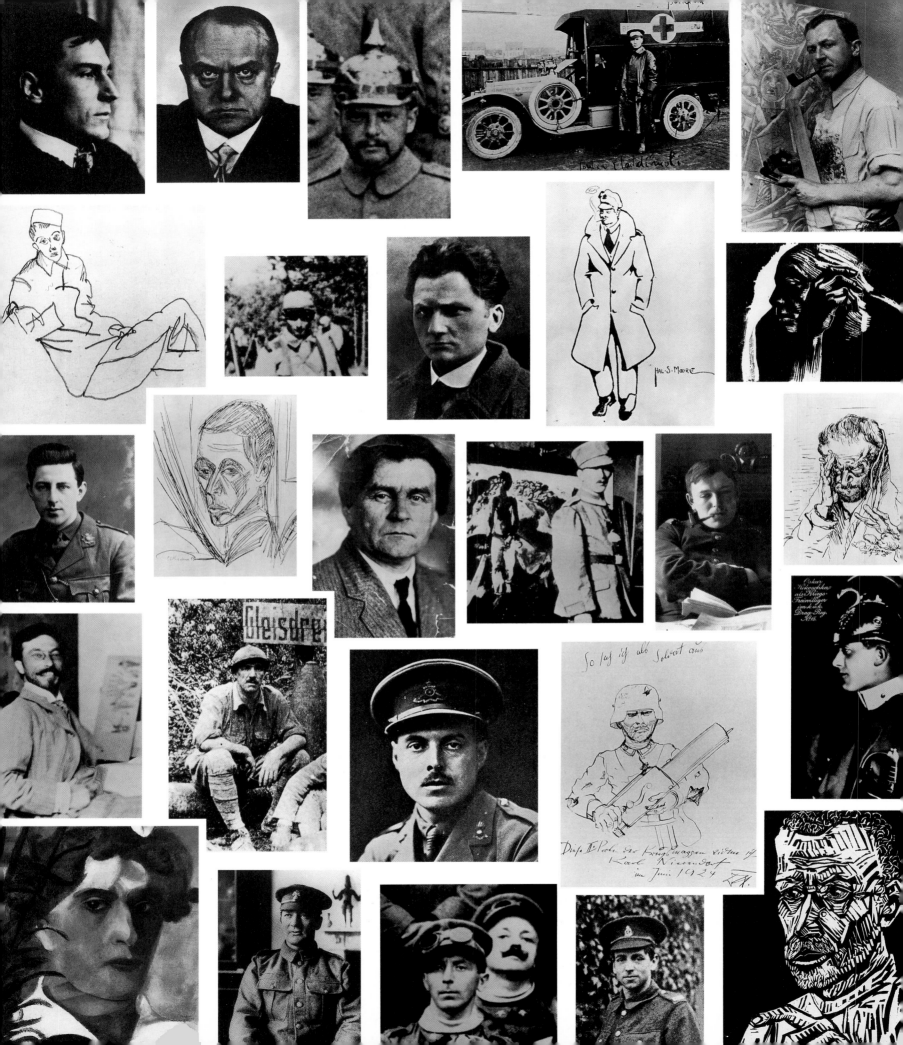

A Bitter Truth

Avant-Garde Art
and the
Great War

RICHARD CORK

YALE UNIVERSITY PRESS
NEW HAVEN AND LONDON
in association with Barbican Art Gallery
1994

In memory of my grandfather
Ernest Smale
who fought in the Great War

Copyright © 1994 by Richard Cork

All rights reserved. This book may not be reproduced in whole or in part, in any form (beyond that copying permitted by Sections 107 and 108 of the U.S. Copyright Law and except by reviewers for the public press), without written permission from the publishers.

Library of Congress Cataloging-in-Publication Data
Cork, Richard.
 A bitter truth: avant-garde art and the Great War / Richard Cork,
 p. cm.
 Includes bibliographical references and index.
 ISBN 0-300-05704-0
 1. World War—1914–1918—Art and the war. 2. Avant-garde
 (Aesthetics)—History—20th century. 3. Art, Modern—20th century.
 I. Title.
 N9150.C67 1994
 704.9′4499403—dc20 CIP 93-42951

A catalogue record for this book is available from the British Library

Edited and designed by Jane Havell

Set in Linotron Ehrhardt by Best-set Typesetter Ltd., Hong Kong
Printed in Italy by Amilcare Pizzi SpA, Milan

FRONTISPIECE Top row, left to right: Franz Marc, Max Beckmann, Paul Klee, Christopher Nevinson, George Grosz. Second row, left to right: Egon Schiele (self-portrait; courtesy of Richard Nigy, Dover Street Gallery, London), Henri Gaudier-Brzeska, Wilhelm Lehmbruck, Henry Moore (self-portrait), Käthe Kollwitz (self-portrait). Third row, left to right: Paul Nash, Ernst Ludwig Kirchner (self-portrait), Kazimir Malevich, Albert Weisgerber, August Macke, Ludwig Meidner (self-portrait; courtesy of Mr and Mrs Marvin L. Fishman, Milwaukee). Fourth row, left to right: Wassily Kandinsky, Fernand Leger, Wyndham Lewis, Otto Dix (self-portrait), Oskar Kokoschka. Bottom row, left to right: Marc Chagall (self-portrait), Jacob Epstein, Umberto Boccioni and Filippo Tommaso Marinetti, Stanley Spencer, Erich Heckel (self-portrait).

Contents

Acknowledgements 6

Introduction 8

1 Before the War 13

2 Hostilities Commence (1914–15) 37

3 Deadlock (1915) 67

4 Disillusion (1915–16) 91

5 The Great Carnage (1916) 115

6 Catastrophe and Censorship (1917) 151

7 Offensive and Defeat (1918) 181

8 Aftermath (1919) 217

9 The Memory of War 247

10 Despair and Redemption 281

Epilogue 310

Notes 315

Bibliography 324

Picture Credits 330

Index 331

ACKNOWLEDGEMENTS

I am primarily indebted to the Board of Electors to the Slade Professorship of Fine Art at Cambridge University. Their invitation, to become the Slade Professor in the academic year 1989–90, arrived at a time when I was preparing to write this book; it initially took the form of the lectures I delivered there. The experience was enormously stimulating, and I would like to thank the staff of the History of Art faculty for helping me to enjoy it. Particular thanks are due to George Henderson, Paul Joannides, Jean Michel Massing, Sylvia Stevenson and David Watkin, while Michael Foster and Daryll Wilkin showed limitless forbearance in dealing with my requests for slides. The faculty's Secretary, Annabel Dainty, ensured that even the most complicated arrangements were organised with exemplary calm and friendliness. Outside the faculty, I particularly appreciated the hospitality and interest shown by Ivan Gaskell, Richard Newbery and J. M. Winter.

While staying in Cambridge, I was fortunate enough to return as a Fellow to my old college, Trinity Hall. The welcome provided by the Master, Sir John Lyons, and the Fellows gave me great pleasure. Anyone staying at Trinity Hall benefits at once from the college's sense of intimacy. I was treated like a member of the family, and I retain especially warm memories of Jonathan Bate, Sir Roy Calne, John Collier, Charles Elliott, David Fleming, Alexander Goehr, Peter Holland, Graham Howes, Floribertus Heukensfeldt Jansen, Timothy Mathews, Sandra Raban, Jonathan Steinberg, William Stobbs, Graham Storey and Kareen Thorne. I also enjoyed the hospitality given to me by the Master of Jesus, Colin Renfrew, whose appetite for art ought in an ideal world to spread among all other Cambridge colleges as well.

During the period of research for the book, I benefited from advice and encouragement from artists, collectors, curators, dealers and historians both in Britain and abroad. They include Jan T. Ahlstrand, Francis Bacon, Wendy Baron, Yve-Alain Bois, Lilian Bomberg, Laura Brandon, Richard Calvocoressi, Ricky Cameron, Evelyn Cantor, Frances Carey, Frances Coady, Judith Collins, Susan Compton, Cécile Coutin, Tim Cross, Joseph Darracott, Dinora Davies-Rees, Pamela Diamand, Alexander Duckers, John Elderfield, Francis Farmar, Serge Faucherau, Jutta and Wolfgang Fischer, Marvin and Janet Fishman, Richard Francis, Terry Friedman, Luke Gertler, Christopher Green, Ernst-Gerhard Güse, Hugh Halliday, Mary Henderson, Sam Hynes, Audrey Isselbacher, James James-Crook, Gillian and Neville Jason, Ellen and Paul Josefowitz, Jane Lee, Michael Moody, Kjersti Sissener Munthe, M. P. Naud, Richard Nigy, Bill O'Reilly, Glenn Peck, Liv Revold, Sarah Roberts, Selma Rosen, Norman Rosenthal, Serge Sabarsky, Peyton Skipwith, Maria Tippett, Antonino Vella, Barbara Wadsworth, Angela Weight and Colin St John Wilson. Special thanks are due to Radu Varia, who made every effort to make my visit to the great Brancusi sculptural ensemble at Tirgu-Jiu as enjoyable as it was instructive.

For many years, I have been attempting to organise an exhibition on the subject explored in this book. Initially, the Hayward Gallery agreed to stage the show in London, and both Joanna Drew and Andrew Dempsey deserve thanks for supporting it. Lynne Green and, later, Greg Hilty proved immensely helpful when the detailed process of selection began. I am grateful to the Hayward for helping to finance my researches in the USA and Canada during the summer of 1988, and am only sorry that severe cutbacks by the South Bank Board forced the cancellation of the exhibition at a late stage.

The project was then taken up by John Hoole at the Barbican Art Gallery in London. His enthusiasm has proved tireless, and I was particularly delighted when the Altes Museum in Berlin agreed to stage the exhibition as well. To mount such a survey in these two cities, once so divided by the First World War, is symbolically apt. I am privileged to have collaborated with Professor Dr Christoph Stölzl, Generaldirektor of the Deutsches Historisches Museum, Professor Dr Wolf-Dieter Dube, Generaldirektor of the Staatliche Museen zu Berlin, Wulf Herzogenrath and Dr Hans Jürgen Papies. Rainer Rother and Anne-Katrin Ziesak at the Deutsches Historisches Museum and Jane Alison at the Barbican Art Gallery have also proved indispensable throughout the planning of the exhibitions.

Looking back, I realise that thanks must be extended to the kindness of two masters who taught me at Kingswood School in Bath. Soon after Benjamin Britten's *War Requiem* received its première at Coventry Cathedral in 1962, my classics teacher John Gardner invited a group of boys to hear the newly issued recording of the work. Its impact on me was electrifying. Only sixteen at the time, I had no prior knowledge of Wilfred Owen's poetry. His words, combined with Britten's music, affected me so profoundly that I have never forgotten the emotion they engendered. The quotation from Owen with which Britten prefaced his score, 'All a poet can do today is warn', remained at the forefront of my mind throughout the writing of this book.

Around the same time, serendipity allowed me to encounter another great work of art inspired by the same war. My English teacher, John Greeves, offered to take several pupils on a drive to Stanley Spencer's Memorial Chapel at Burghclere. The journey turned into a pilgrimage, for I found myself awed by the paintings installed in this surprisingly compact Giottesque interior. Although smaller than photographs had suggested, the building housed images

of such concentrated intensity that they transcended the limitations of their surroundings and ended up affirming the redemptive power of art.

Just how much these experiences contributed to my decision to write this book, over twenty years later, is impossible to tell. But the fact that they both stand out in my recollection of schooldays must be a measure of their probable significance. I discussed certain aspects of British art during the Great War in my first book, a study of the Vorticist movement. And the same upheaval played a pivotal role in a subsequent book which I wrote on the life and art of David Bomberg. Working on both these projects intensified my fascination with the transforming impact of the First World War on early twentieth-century modernism, and made me realise that a lacuna existed in the literature on the subject. So when the invitation arrived to become the Slade Professor, I had no hesitation in choosing to lecture on the full international range of images generated by the war.

Towards the end of my research, my mother boosted it by unearthing a cache of letters written by her father, Ernest Smale, from the Macedonian campaign. Apart from bringing me close to a grandfather I knew far too briefly, they offered valuable insights into the anxieties, hopes, fantasies, regrets and unrelenting everyday pressures endured by a stoical soldier during the long years of conflict. This book is dedicated to his memory.

Finally, I must once again thank John Nicoll for supporting the idea of this book with enthusiasm from the outset, and overseeing its publication with his customary skill. I have also very much enjoyed working with Jane Havell on the detailed editing of the manuscript and the design of the book. Kate Gallimore deserves my thanks for her unflagging pursuit of the pictures. As ever, my wife Vena and my children, Adam, Polly, Katy and Joe, deserve immense gratitude for everything they have done to sustain me. At times, they may well have felt that, immersed in my labours, I had become lost in the trenches. Now that armistice has at last been declared, I can appreciate even more the love they never failed to provide.

INTRODUCTION

The most public and familiar images of the First World War are found in the myriad memorials erected by nations with deaths to mourn. Everyone has encountered them, whether in a sequestered village churchyard or at the heart of a metropolis. The modest rural tributes often seem preferable to their imposing urban counterparts. Erected by small communities who lost the majority of their young men during the conflict, they focus on simple lists of names that remain moving in themselves, and testify to the sense of individual bereavement lodged at the centre of all such acts of remembrance.

Many of the grander monuments, however, are constrained by their commissioned, retrospective air. Aware of the need to console, and undoubtedly anxious to avoid offence, their very reticence is a limitation. The carved and modelled images they contain often appear merely dutiful, striving too hard for unimpeachable respectability. In most cases, they compare unfavourably with other works produced by artists who, having witnessed the war at first hand, felt impelled to define their experiences. Unlike the makers of routine memorials, they were engaged in an urgent task. Angered by the gap between the propagandist view of the struggle and the degradation of the trenches, they were driven by a determination to offer a corrective. Many were wounded themselves, or suffered severe breakdowns after exposure to the carnage at the Front. Some died, too soon to fulfil all the potential they had displayed before the war began.[1] But even when they emerged unscathed, in physical terms at least, the slaughter of so many compatriots ensured that their view of the conflict was radically removed from the enlistment posters sanctioned in their millions by governments and generals alike.

As its title indicates, this book centres above all on the work produced by avant-garde artists who, however diverse they may have been in nationality and ideological persuasion, were united by a desire to convey the rebarbative reality of war. The title comes from a phrase coined by Paul Nash, whose paintings and drawings of 1918 are definitive images of the battlefield at its most desolate. Nash had earlier been lucky to survive his spell as a second lieutenant in the trenches of St Eloi. Only three days after he was sent home with a broken rib, many of his fellow officers were decimated in a futile attack on Hill 60. His first watercolours of the Front were oddly lyrical, picturesque affairs, with names as inconsequential as *Chaos Decoratif*. After his return as an official war artist in November 1917, though, Nash's exposure to death led to a profound sense of moral disgust. Despite the comforts provided by a manservant and chauffeur-driven car, he insisted on travelling across the most devastated and dangerous areas of winter terrain where the Passchendaele campaign had just been fought. Appalled by the mud-clogged land-scape, Nash reported that 'it is unspeakable, godless, hopeless. I am no longer an artist interested and curious, I am a messenger who will bring back word from the men who are fighting to those who want the war to go on for ever. Feeble, inarticulate, will be my message, but it will have a bitter truth, and may it burn their lousy souls.'[2]

War catapulted Nash into a sudden, unexpected and formidable artistic maturity. Attempting to use oil paint for the first time in his career, he deployed this new resource to give his vision of hell a stricken conviction. But he was far from alone in transforming his work to meet the awesome challenge presented by the killing fields. More, perhaps, than any other conflict, the Great War had such a powerful effect on its participating artists that many of them produced an extraordinary range of eloquent work from the event. The primary emphasis in this book is on innovative painters, sculptors and printmakers of stature, who fought in the war and forced themselves to forge a form-language capable of conveying their response to the suffering. A considerable number of lesser-known and more academic artists are discussed as well, however. Apart from setting the avant-garde in a broader context, many of their war images prove that the negation of battle had the ability to generate within them work far more intense than anything they would go on to produce later in their careers.

Surprisingly enough, no attempt has previously been made to bring together and examine the international array of images elicited by the First World War. Studies exist of the art made in single countries, usually concentrating on official commissions; and monographic books on leading individuals inevitably take their war periods into account. There is, too, an abundance of literature which uses artists' work simply as an illustrative backdrop to discussions of historical or literary aspects of the conflict.[3] But no one has devoted a book to an assessment for its own sake of the war art produced on both sides of the Atlantic, and the present volume hopes to make a start at redressing the balance.

Why do so many of the images spawned by the Great War carry such a potent charge? One answer surely lies in the unprecedented ferocity of the struggle. The full, battering force of twentieth-century weaponry was unleashed during the conflict's protracted course, and the result forced everyone involved to revise all their preconceptions about the nature of modern warfare. Machine-age armaments produced in immense quantities by highly organised industrial nations were capable of annihilation on a hitherto inconceivable scale, and the spiralling human cost rapidly came to seem out of all proportion to the infinitesimal military gains made on either side. The obscenity of what Ezra Pound condemned as 'the war waste',[4] eventually

mounting to a tally of twelve million dead, created a deep-seated sense of incredulity, anger and revulsion. Anyone with a potent imagination was bound to be affected, and the generation which found itself embroiled in the fighting happened to contain an unusually high number of outstanding young artists.

For the outbreak of the Great War coincided with an exceptional period of ferment and innovative vitality in western painting and sculpture. The proliferation of avant-garde movements in the pre-war years had testified to a quickening pace, with vociferous and often highly competitive groups committing themselves to the principle of extreme renewal. Although the energy with which they pursued their insurrectionary goals was bound to be partially swallowed up in the sombre process of military enlistment, training and active service, an impressive range of artists refused to let the war prevent them from working altogether.

Even when ensnared in Front-line engagements, they often showed great resourcefulness in using whatever materials came most readily to hand. While Léger executed a collaged painting on a fragment of wooden shell-crate, and Beckmann carried out a mural in a soldiers' delousing house, Gaudier-Brzeska stole an enemy's Mauser rifle and countered its 'powerful IMAGE of brutality' by breaking the butt off and carving in it a design which 'tried to express a gentler order of feeling'.[5] Derain was equally adaptable, using discarded shell cases to make a series of mask-like metal sculptures, and Heckel painted a devotional image for Christmas 1915 on the side of an army tent. As for Klee, he regularly used his scissors to cut off the linen covering crashed planes and paint on it in his limited amount of spare time.

All the same, this ingenious harnessing of military materials could not solve the pressing problem of finding an adequate language. Seasoned academic artists like the redoubtable Lady Butler tried to produce images of the new war by bringing to the task all the conventions they had relied on when producing nineteenth-century battle-pieces. The outcome bore no relation to the barbarities of the campaign on the Western Front, and the wounding of her son at Ypres prompted Butler to admit that 'the gallant plumage, the glinting gold and silver' in her canvases 'have given way to universal grimness'.[6] She failed to carry this insight over into her own work, but how could such 'grimness' be conveyed by other artists bent on responding to 'the biggest war the world has ever been stricken with'?[7] As Samuel Hynes pointed out when discussing writers confronted with the same task, 'to represent the war in the traditional ways was necessarily to *mis*represent it, to give it meaning, dignity, order, greatness . . . But there was as yet no other way to represent it.'[8]

Advanced modernist abstraction soon proved an inadequate starting-point for developing a viable approach to the conflict. Mondrian avoided the problem by refusing to disrupt his increasingly purist work with any references to the war. At the same time, Malevich quickly abandoned any thought of reconciling the austerity of newly fledged Suprematism with allusions to battle. Instead, he spent the first few months of hostilities producing anti-German propaganda based on the knockabout conventions of the popular *lubok* print. Dufy took a similar course of action in France, relying for his patriotic designs on the home-grown *image d'Epinal* tradition. Neither artist could sustain this enthusiasm for long, however. Malevich soon returned to austere experimentation, purged of all figurative belligerence. And even the buoyant Dufy could not pretend indefinitely that the war was a light-hearted adventure after producing a print in 1915 entitled, with risible optimism, *The End of the Great War*. Such callow triumphalism compared poorly with the contem-poraneous work of Chagall, stranded in Vitebsk when hostilities broke out and convinced, from the outset, that the struggle would bring nothing but privation and bereavement.

Unpredictably enough, Chagall's admirable determination to view the onset of war with foreboding had been preceded well before battle commenced. When Meidner produced his extraordinary series of apocalyptic paintings in 1912, he was in no position to predict the advent of world conflict with any accuracy. But the disquieting fact remains that his visions, which dominated everything he produced for the next two years, all arise from a conviction that the world was threatened by a disaster of engulfing proportions. Meidner's seeming foresight should not obscure the fact that his paintings spring from a specific historical moment, when Germany was conscious of the threat of a major struggle. During the months of uneasy peace between the end of the first Balkan War in November 1912, and the commencement of its successor in June the following year, the most bellicose voices in the German press declared themselves in favour of war as 'the saviour, the physician'.[9] Placing Meidner in this context does not, however, detract from his pre-war achievement. Without diluting his allegiance to Expressionism, he showed in these unnerving images how an avant-garde artist's work might be directed towards an awareness of the calamity ahead.

Expressionism's ability to lend itself to the subject of war, without any significant compromise, also helped Kandinsky to make a powerful sequence of pre-war apocalyptic paintings. Hence the readiness of so many German artists, when the war came, to make forceful images from their experience of the conflict. Although Beckmann, Grosz and Kirchner suffered nervous collapses during their army service, they still managed to base fierce and outspoken work on their suffering. So did Heckel, but his preparedness to rely on Runge's inspiration in his tent painting shows that even the Expressionists started modifying their innovatory zeal when confronted by the mounting devastation. Beckmann, whose early war pictures owed a great deal to the fervent harshness of Meidner, decided as the struggle wore on to draw strength from early German and Flemish masters like van der Weyden, Grünewald and van Orley.

Artists in other countries, whose work owed far more to Cubism than Expressionism, likewise underpinned their war images with precedents from the distant past. Both Man Ray in America and Lentulov in Russia declared a debt to Uccello's San Romano battle-pieces when they produced monumental paintings of fighting soldiers in 1914. Even Picasso, after incorporating newspaper reports of the Balkan struggles in Cubist collages, and then excluding overt war references from his subsequent work, suddenly began to echo Dufy's interest in the *image d'Epinal*. The change, announced in a spirited little drawing of Apollinaire at the Front, invaded his Cubist painting soon afterwards in the form of a patriotic faïence goblet. It looks incongruous among all the other, less representational forms in the picture, and may well reflect Picasso's ambivalent attitude towards the conflict. He certainly shunned the whole notion of producing war images over the next few years, but that initial flirtation with the *image d'Epinal* tradition did inaugurate a partial withdrawal in his work from modernist extremism. By the latter years of the war he was executing frankly Ingres-like portraits of friends in military uniforms, implicitly allying their valour with his own espousal of classicism.

Picasso's startling transformation was symptomatic of a general 'return to order' as the struggle against Germany intensified. Kenneth Silver's incisive book on French art in the First World War revealed just how widespread the reaction became, and how it was accompanied by a xenophobic tendency to equate avant-garde experiment with

'Boche' decadence.[10] But the desire to renew nourishing connections with the past affected artists beyond France's borders as well. Nevinson, anticipating his friend Severini's flirtation with a more traditional alternative to Futurism in 1916, had moved towards a representational vocabulary the previous year. Unlike Severini, who retreated from war subjects altogether, Nevinson developed his revised style in order to deal more effectively with the scenes he had witnessed near the battlefield. First-hand exposure to the suffering persuaded him that Marinettian bravado was not equipped to convey the tragedy. Nor did a highly abstract language seem appropriate, now that he realised the importance of offering a comprehensible, hard-hitting alternative to the rhetoric of heroism pumped out by the propaganda system.

Throughout Europe, in fact, artists who had earlier been identified in differing ways with the innovative cause found themselves adopting less hermetic approaches. Goncharova, an enthusiastic pre-war apostle of Cubo-Futurism, relied extensively on traditional Russian precedents when she produced her *Mystical Images of War*. Temporarily abandoning his involvement with Expressionism at its most tortured and confessional, Kokoschka carried out a series of surprisingly objective studies at the Izonzo Front. Even Léger, whose active service did not prompt him to repudiate his previous affiliations, began to evolve a more plain-spoken, figurative idiom shorn of arcane pre-war complexities.

With the advent of 1916, a year of grotesque losses at Verdun and the Somme, artists began to develop an understandable obsession with what Beckmann described as 'this endless desolation'.[11] Their anguish was laced with a gathering compassion, leading a formerly self-absorbed artist like Schiele to view enemy prisoners-of-war with remarkable sympathy. By the autumn German casualties alone had amounted to a crushing total of 3,500,000, helping to explain why Lehmbruck deployed an elegiac approach to his *Fallen Man*, the forlorn antithesis of an invulnerable warrior. Barlach, who had greeted the conflict's outbreak in 1914 with a vengeful lithograph called *The Holy War*, now gave a pleading image the title *Dona Nobis Pacem*; and even the martial Balla became punch-drunk enough to produce a mournful painting entitled *Battleship + Widow + Wind*. Machine-age optimism, which had charged the Futurists with so much energy before 1914, gave way to a mortified awareness of mechanical weaponry's capacity for unlimited slaughter. Despair ran hand in hand with passionate indignation, and some artists now openly allied themselves with the pacifist cause. Grosz, invalided out from the army but living with the continual fear of military recall, contributed anti-war drawings to pacifist publications like *Die Aktion* and Wieland Herzfelde's outspoken *Die Neue Jugend*. The equally polemical Masereel, having removed himself to neutral Switzerland, executed a forceful series of woodcuts where the death-agonies of young combatants in barbed-wire entanglements are scored harshly into the blocks.

There was little sign, among these increasingly uninhibited artists, of abstractionist loyalties. The persevering Albert-Birot, whose painting of *War* reduced the struggle to an almost diagrammatic essence, persisted in arguing against a figurative revival. Although Valensi did likewise in his *Expression of the Dardanelles*, the painting itself indicated that a high degree of abstraction militated against any attempt to convey a tragic vision of the war. Wyndham Lewis may have declared, in 1915, that 'there is no room, in praising the soldiers, for anything but an abstract hymn'.[12] But the latter stages of the conflict proved so repugnant that more and more artists turned to representational imagery fired by a protesting vehemence. Senior painters with no personal experience of the conditions at the Front now felt driven to express their revulsion. Corinth's *Cain* is charged with such a wild, fervent anguish that it deserves to be ranked among the most powerful of all his later works. And Klimt, the artist least likely to make a direct painting about the war, subjected his earlier allegory of *Death and Life* to alterations drastic enough to convey his accelerating sense of gloom.

When governments started dispensing official war-artist commissions on a substantial scale, therefore, even the most avant-garde recipients were prepared to accept their patrons' inevitable demand for a more figurative idiom. Bomberg was virtually alone in finding his preliminary version of a memorial painting rejected on the grounds of obscurity. The tensions which arose were far more likely to focus on the artists' attitude towards the horror of war. Nevinson ran up against government censorship when he produced a painting of dead British soldiers, while the still more defiant Slevogt incurred disapproval on the other side when the German government banned his commissioned sequence of prints called *Visions*.

By no means all these officially sponsored images put forward an oppositional view of the conflict. Many of them were harmlessly topographical, and the first British war artist later confessed that his appointment 'resulted in rather prosaic work'.[13] Even so, there was a notable absence of triumphal afflatus in most of the large-scale canvases executed for proposed memorial buildings in both London and Ottawa. Too many young men had died; and Sargent's *Gassed*, intended as the focal point of the London scheme, summed up the prevailing mood of elegiac stoicism. The jubilation which greeted the Armistice throughout the allied nations was short-lived. In its place, a sense of relieved exhaustion soon prevailed.

On the defeated side, no such quietism could be found. In humiliated Germany paintings of crippled servicemen proliferated. Dix, who had begun the war ablaze with a Nietzschean belief in the need for purgative destruction, now consented to exhibit with the Dadaists. In the early 1920s he concentrated on painting savagely deformed victims of war, playing cards, crouching on pavements and staring enviously at the prostitutes who parade past them with open contempt. Grosz continued to vilify militarism in his elaborate and unbridled canvases, which take a Hogarthian relish in anathematizing the evils of the Weimar Republic and, a little later, the rise of Fascism. But Dix produced some of the greatest images of the war itself in an extended cycle of prints. They constitute the culmination of the ambitious print sequences which German artists like Jaeckel, Pechstein, Schubert, Slevogt, Uzarski and Kollwitz had published in previous years. Impressive though they all were, Dix's tersely entitled *War* outstrips them in its ability to probe the darkest and most disturbing recesses of a conflict he had witnessed at close quarters for several gruelling years.

Only in retrospect, then, could Dix arrive at a definitive summation of all his complex emotions about the struggle. Relying as much on his admiration for Urs Graf, Grünewald, Callot and Goya as it does on Expressionism, *War* brilliantly exemplifies the peculiar fusion of modernity and tradition which he, more than any other artist, required in order to expose the bestiality of the battle terrain. He paid the price for his temerity, however. Only one set of *War* found a buyer when it was published in 1924, and a few years later his equally unrestrained painting of *The Trench* was destroyed by Nazis bent on expunging all such admissions of misery, decay and extinction.

Other German artists, including Gies, Barlach and Scharl, also found that their war images were despised for supposed defeatism. Since the militarism resurgent in Hitler's Germany branded such

work as degenerate, formidable courage was required for Dix to persist in producing his excoriating *War Triptych* under the threat of dismissal from his teaching post. Banned from exhibiting altogether in 1934, he nevertheless located one more major painting in the Western Front. *Flanders* continues to present an image of demoralization, even though Dix must have guessed that within a year of its completion hundreds of his works would be confiscated by the Fascists. In his art, the whole notion of 'a bitter truth' takes its most unsparing form. Ultimately, though, Dix's stubborn insistence on confronting even the most repugnant aspects of the war has a cathartic effect. As Julian Barnes wrote of Géricault's *The Raft of the Medusa*: 'Catastrophe has become art; but this is no reducing process. It is freeing, enlarging, explaining.'[14]

Artists from the allied nations, by contrast, finally succeeded in arriving at a redemptive state of peace. Spencer, having refused the government's invitation in 1919 to produce more than one painting based on his memories of the Macedonian campaign, subsequently found himself able to conceive and execute an entire cycle of murals in the Sandham Memorial Chapel. Here, in a building designed for the purpose, violence and death give way to affirmations of soldierly brotherhood and the culminating prospect of resurrection above the altar. Like Dix, Spencer had needed time to meditate on his war experience before summoning up the physical and imaginative stamina which his sustained achievement in the Burghclere chapel demanded.

Just as any study of art and the Great War ought to begin well before hostilities were declared, so it should terminate with work executed long after the Armistice. The ultimate resolution of the tragedy was attained as late as 1938, when Brancusi's memorial to Tirgu-Jiu's repulsion of the German invaders received its formal unveiling in an elaborate ceremony of dedication and remembrance. Although another world war was about to commence, its outbreak does not invalidate Brancusi's great sculptural ensemble. In a monumental assertion of love's healing power, the *Table of Silence*, the *Gate of the Kiss* and the *Endless Column* are crowned, at last, by an image of resilience and fortitude stretching defiantly into the Rumanian sky.

CHAPTER ONE
BEFORE THE WAR

With one arm flung out perilously near the flames of his camp-fire, the sprawling man seems in thrall to a turbulent vision (Pl. 1). Oblivious of his immediate surroundings, where rocks and scrub provide no comfort for his exposed flesh, he succumbs to a dream which seems bound up with the apocalypse beyond. Although he might already have attempted to escape from the destruction engulfing the world, the effort appears to have exhausted him. Now, overcome by physical fatigue and spiritual turmoil alike, he submits himself to fate. So possessed has he become by the vision in his mind that there is no longer any clear distinction between fantasy and reality. Indeed, the catastrophe beyond could even be an extension of his own feverish imaginings, a backdrop onto which he has projected his most macabre anxieties about imminent annihilation.

Ludwig Meidner, the Berlin Expressionist who painted this seeming presentiment of Armageddon two years before the First World War commenced, was not alone in sensing disaster. Throughout Europe, some of the most alert artists of the emergent generation found themselves perturbed by similar intimations. Although no one could have predicted when such a war would break out, let alone foreseen the prolonged and harrowing course it took, painters of very different persuasions were united in a growing conviction that the world might soon be threatened by awesome devastation. The extent of the threat varied enormously, depending on the individual sensibilities of the artists concerned; but they all shared the sense of a cataclysm to come. None more than the 28-year-old Meidner, whose entire work was given up to a sustained series of equally tumultuous images between 1912 and the following year.

Apocalyptic Landscape is among the least exclamatory of these disquieting visions. A large part of the picture-surface is occupied by the recumbent man, and his supine stance has provoked speculation about the possible masochistic leanings of the artist who painted him. Meidner once admitted that 'I feared such visions, yet the final results gave me an especially warm feeling of satisfaction, a slightly Satanic joy.'[1] Such a confession led Donald E. Gordon to connect Meidner's 'passive open-legged figure' with the 'fantasies linking bisexuality, suicide, and the end of the world'[2] in Dr Daniel Schreber's *Memoirs of My Nervous Illness*, published in 1903. It is certainly intriguing to find resemblances between Meidner's dreams and Schreber's account of his delusions in the sanatorium, where 'there predominated in recurrent nightly visions the notion of an approaching *end of the world*, as a consequence of the indissoluble connection between God and myself.'[3] But theories about the

possible 'unmanning' of the naked figure in Meidner's *Apocalyptic Landscape* should not be allowed to dominate interpretations of his complex painting. The horror with which he views the extinction sweeping across the distant stretches of this terrain is, if anything, more trenchantly conveyed than any gratification he may have felt. Meidner's crisp yet agitated brushmarks re-enact, in their restless rhythms, the impact of the storm as it unleashes primal fury from a blackened sky on the dwellings below. Their inhabitants could never hope to survive such an onslaught, and the minuscule figures crowding the centre of the composition will find no protection in the tempestuous sea awaiting them.

Besides, the perverse strain of satisfaction plays a diminishing role in the apocalyptic canvases Meidner went on to produce during the two extraordinarily heightened years which mark the climax of his entire career. No passive observers can be found in the *Apocalyptic Landscape* in Saarbrücken, where the canvas is dominated by the splintering forms of buildings caught in a terminal convulsion. The few figures still discernible within the maelstrom are diminutive now, and they run from the fragmentation around them with scant hope of survival. Desperation rather than relish is the prevailing emotion here, and the source of destruction has taken on a more mechanized identity. Instead of storms or seismic upheavals, the cataclysm begins to resemble explosions created by titanic weaponry. In *The Burning City*, the glowing houses reel and totter in the face of fires that might well have been induced by a ferocious bombardment. This time, the foreground figures hide their faces from the conflagration, or turn back to confront its glare as they raise their hands in disbelieving protest.

The scale of the disaster is terrifying in its magnitude, and Meidner's own writings testify to the direct corporeal assault it launches against him. As 'the city nears', he declared in his prose poem *Im Nacken das Sternemeer*, 'My body crackles ... I hear eruptions at the base of my skull. The houses near. Their catastrophes explode from their windows, stairways silently collapse.'[4] The devastation seems to arise here from some discharge caused by the frenetic energy of city life in the early years of the new century. Gerhart Hauptmann would have agreed with this diagnosis, for he complained in 1908 that the rapidly expanding Berlin 'is terrible – loved by few of those who are forced to live here. The sound of endless hollow thunder ... If one could only call this mad orgy to a halt.'[5] But Meidner knew that a cessation of urban frenzy was impossible – indeed, the commotion could only grow more vehement and unbearable until, at last, all the accumulated violence burst the streets asunder.

Left: Ludwig Meidner *Apocalyptic Landscape* c. 1913 (detail). See Pl. 1.

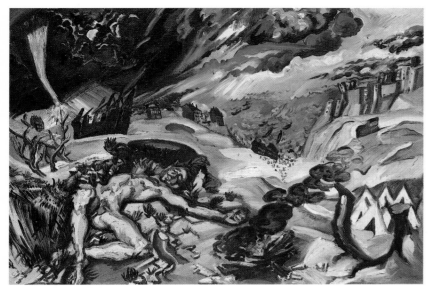

1 Ludwig Meidner *Apocalyptic Landscape* c. 1913. Oil on canvas, 80 × 116 cm. Staatliche Museen zu Berlin – Preussischer Kulturbesitz, Nationalgalerie.

The compassionate aspect of Meidner's vision was emphasized in November 1912 when he exhibited his new work, along with fellow-painters Richard Janthur and Jakob Steinhardt, in a group exhibition at the Galerie der Sturm called *Die Pathetiker* – The Pathetic Ones. Their name derived from Stefan Zweig's notion of the 'new pathos', which he believed the poet should adopt in the modern era to become 'the tamer and arouser of its passions, the rhapsodist, the challenger, the inspirer, the igniter of the sacred flame – in short, to become energy'.[6] Meidner owed a great deal to the stimulus of Expressionist poetry, declaimed with due vehemence at meetings held by the Zweig-inspired Neopathetic Cabaret. In 1911 Georg Heym, whom Meidner singled out admiringly in *Im Nacken das Sternemeer*, wrote a celebrated poem called 'The War', where an annihilating demon arises to destroy the world with a ferocity that directly anticipates Meidner's apocalyptic paintings:

A great city sank down in yellow smoke,
Threw itself without a sound into the belly of the abyss . . .[7]

Heym's use of a comet to signify the approach of conflagration in a poem entitled 'Umbra Vitae' proved particularly inspiring to Meidner, whose *Apocalyptic Landscape* in Münster (Pl. 2) could almost serve as an illustration of Heym's lines:

The people on the streets draw up and stare,
While overhead huge portents cross the sky;
Round fanglike towers threatening comets flare,
Death-bearing, fiery snouted where they fly.[8]

Ultimately, though, Meidner's visions stem more from his own charged and feverish imagination than from literary stimuli. Alone in his attic studio at Friedenau, which Thomas Grochowiak described as 'a hole of a garret, dark as a cavern, dominated by a pile of ashes and refuse',[9] this nervous, haunted and yet immensely vigorous young painter worked in a mounting frenzy of inventiveness on canvas after canvas. 'That angry, vicious summer began in the spring of 1912', he recalled; 'it was a strange and doom-laden time for me as none other ever was . . . By the end of May the heat was getting hard to bear. But I was going to hold out. I was damned stub-born . . . Bathed in sweat, I felt like a heavy-jowled hound careering along in a wild chase, mile after mile, to find his master – represented, in my case, by a finished oil painting, replete with apocalyptic doom.' The realisation that all these visions were at last being released from his overburdened psyche was cathartic enough to sustain Meidner as he pursued his single-minded course. 'So it went on', he remembered, 'day by day, every one of them sunny and scorching hot, all through June until the July moon eventually waned, still boiling hot, all through the hottest weeks of all, sweaty, unspeakably oppressive, devastating, arduous. But I never wavered: I consecrated myself to the service of the unfathomable and the arduous, and did not weaken.'[10]

Although Meidner must often have imagined that the blistering studio beneath its scorched slate roof might explode, it would be wrong to conclude that all his apocalyptic pictures were based on the notion of spontaneous combustion taken to a horrific extreme. The power unleashed in some of his visions does indeed seem to come, as Wieland Schmied argued, 'from within the picture itself'.[11] But it issues in other works from a source which relates far more to the world beyond the studio. The agents of destruction in Meidner's painting *Revolution* are human, embodied above all in the figure who, like a male equivalent of the heroic woman dominating Delacroix's *Liberty Leading the People*, rises so defiantly from the barricades and yells his insurrectionary rallying-cry (Pl. 3). The men around him are embroiled in the battle, which this time appears solely responsible for the damage sustained by the blazing buildings. Meidner has included his own face here, half cut off by the base of the canvas as he cowers beneath the bullets. But his eyes are vigilant as well as apprehensive, impelled by a determination to witness the conflict with all the clarity he can muster. He even drew *Bombing a City* where everything, from the fires in the street to the immense explosions tearing through the sky, are caused unequivocally by heavy artillery (Pl. 4). Uniformed soldiers cluster near the gun-barrels, thereby identifying the barrage as a full-blown military engagement at last.

Since Meidner carried out these images in day-and-night bouts of activity well before the Great War was declared, their prescience may seem almost uncanny. Haunted by intimations of disaster unparalleled in its destructive capability, he took on the mantle of a prophet as one picture of shuddering calamity followed another in gruesome succession. In 1918, Meidner drew a portrait of himself clairvoyant in a prayer-shawl, ruminating perhaps on the mysterious imperative which had forced him to herald the long years of bloodshed with such vehemence (see frontispiece). His visions of 1912–13 remain a signal achievement, apparently an astounding example of an artist's ability to foreshadow and warn. But their troubled acuity should not blind anyone to the fact that they arose from a specific historical moment, when Germany was alive to the threat, at least, of a major conflict. During the months of uneasy peace which elapsed between the end of the first Balkan War in November 1912 and the onset of its successor in June the following year, the most belligerent voices of the German press declared themselves in favour of war as 'the saviour, the physician' rather than 'our destroyer'.[12] Re-examining the prospect of an armed struggle with Britain, which had first seemed possible during the short-lived 'Moroccan crisis' in 1911, *Das Neue Deutschland* went so far as to proclaim that 'England it can destroy . . . Germany would become what England is now, the world power'.[13]

Viewed in this ominous light, Meidner's preoccupation with visions of wholesale devastation no longer appear quite so intuitive. He later explained that, while his apocalyptic obsession was at its height, 'the

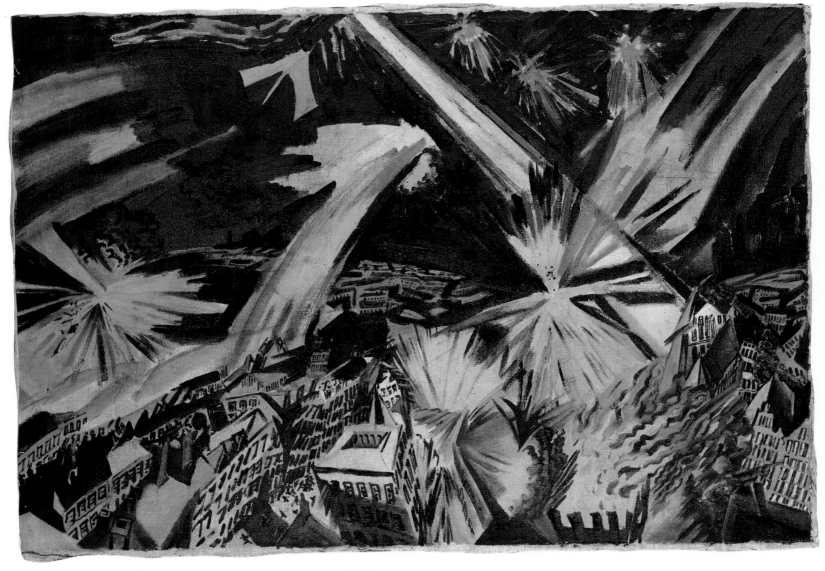

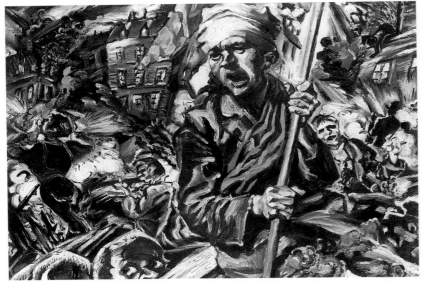

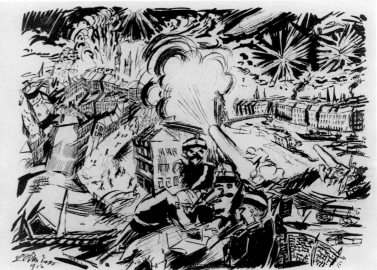

4 Ludwig Meidner *Bombing a City* 1913. Indian ink, pencil and gouache on paper, 45 × 56 cm. Berlinische Galerie, Berlin.

2 Ludwig Meidner *Apocalyptic Landscape* 1913. Oil on canvas, 81.3 × 115.5 cm. Westfälisches Landesmuseum, Münster.

3 Ludwig Meidner *Revolution* 1913. Oil on canvas, 80 × 116 cm. Staatliche Museen zu Berlin – Preussischer Kulturbesitz, Nationalgalerie.

great upheaval ahead was already showing its teeth and casting its harsh shadow over my wailing brush.'[14] Stefan Zweig agreed, when he looked back on pre-war Berlin many years afterwards and recalled that 'it was not yet panic, but there was a constantly swelling unrest; we sensed a slight discomfort whenever a rattle of shots came from the Balkans. Would war really come upon us without our knowing why and wherefore?' It is impossible to discount the role of hindsight in any retrospective account of a period, and Zweig may be indulging himself a little here. All the same, his description of the accelerating tension in Europe carries fundamental conviction. 'The French industrialists with their big profits agitated against the Germans, who were fattening no less fast, because both of them, Krupp and Schneider-Creusot, wanted to produce more cannon', he wrote. 'The Hamburg shipping interests with their huge dividends worked against those of Southampton, the Hungarian agriculturalists against the Serbians, one corporation against another. The critical juncture everywhere evident had made them frantic for more and more.' Surveying pre-1914 Europe from the vantage of 1943, Zweig was obviously able to comprehend the precise workings of this 'critical juncture' with greater clarity than he could ever have commanded at the time. But that does not invalidate his account of a period when a 'wave of power . . . beat against our hearts from all the shores of Europe . . . In Germany a war tax was introduced in the midst of peace, in France the period of military service was prolonged. The surplus energy had finally to discharge itself and the vanes showed the direction from which the clouds were already approaching Europe.'[15]

Alongside this emergent national aggression, Meidner found himself exposed to an unprecedented blast of militarist zeal from avant-garde artists as well. Marinetti's 'Initial Manifesto of Futurism', first published by *Le Figaro* in 1909, appeared in Meidner's Berlin when *Der Sturm* printed a German translation three years later. 'We wish to glorify War – the only health giver of the world', cried one of the manifesto's most notorious passages, extolling 'militarism, patriotism,

the destructive arm of the Anarchist, the beautiful Ideas that kill.'[16] Meidner is bound to have been aware of such an inflammatory outburst, published in March 1912 only weeks before he commenced his apocalyptic paintings. They may even have been precipitated by Marinetti's stimulus, and Meidner would have been among the most attentive visitors to the Futurist exhibition held at the Galerie Der Sturm in the spring of 1912. Although he described the Futurists' paintings as 'shabby goods',[17] Meidner benefited from their stylistic innovations and openly admired the panache of their manifestoes. There are, moreover, clear areas of concern uniting his scenes of revolution or bombardment with one of the largest and most vehement paintings in the Futurist exhibition: Russolo's *Revolt* (Pl. 5).

All the same, very significant differences remain. Russolo, in common with most of his Futurist friends, could easily have imagined himself in the vanguard of the scarlet figures who charge across the city, impelled by the unstoppable 'lines of force' carving through its nocturnal streets. Meidner, on the other hand, depicts himself in *Revolution* as a fearful observer rather than a heroic participant, and his vision of revolt lacks Russolo's triumphant certitude. The Futurists were dedicated to destroying the past, in the belief that an unshackled modernity would thrive once the inhibiting shadow of tradition had been ousted for ever. In 'Kill the Moonlight!', Marinetti's second Futurist manifesto published by *Der Sturm* in May 1912, war is alarmingly and naïvely described as 'our only hope, our justification for existence, our will. Yes, war! Against you, those of you who die too slowly, and against all the dead who bar the way! . . . We shall show all armed soldiers on earth how to spill blood.'[18] In view of the enthusiasm with which Marinetti voiced these belligerent convictions, it is surprising to discover how few pre-1914 Futurist paintings deal with the subject of war. Russolo's *Revolt* is almost alone in its readiness to tackle such a theme, and the official Futurist interpretation of this immense canvas saw it as a spontaneous popular uprising rather than a militaristic clash between opposed nations. 'The revolutionary element made up of enthusiasm and red lyricism', declared the

5 Luigi Russolo *Revolt* 1911. Oil on canvas, 150 × 230 cm. Gemeentemuseum, The Hague.

6 Wassily Kandinsky *Composition VI* 1913. Oil on canvas, 195 × 300 cm. The Hermitage, St Petersburg.

explanation, is shown in 'collision' with 'the force of inertia and reactionary resistance of tradition.'[19] There is no hint, here, of the gruesome hallucinations which transfixed Meidner's imagination during this period.

Other artists beyond Marinetti's charismatic sphere of influence did, nevertheless, become preoccupied with the prospect of a *dies irae*. Even August Macke, whose disposition as an artist was fundamentally genial and pacific, painted in the same year as Russolo's *Revolt* a pessimistic vision of a *Storm*. It was the most important canvas he displayed at the historic first exhibition of the *Blaue Reiter*, and departed drastically from his characteristic lyricism. The entire landscape is caught up in a convulsion which threatens to destroy everything in its path. Trees tilt at alarming angles as the cataclysm reaches them, and the geological structure of the earth seems to be undergoing a seismic upheaval. Even the land at the base of the composition, as yet relatively unaffected by the disturbance, appears blighted.

When Macke painted this picture, he was heavily influenced by Kandinsky's apocalyptic thinking. In the latter's case it carries a powerful biblical charge, and many of his greatest pre-war paintings take as their springboard a whole cluster of notions about the last judgement, a deluge or apocalyptic riders. Behind their ostensibly innocuous titles, many of Kandinsky's *Compositions* and *Improvisations* are obsessed by images of engulfment on a global scale. The formidable *Composition VI*, for example (Pl. 6), was inspired initially by his earlier painting on glass called *The Deluge*,[20] and the sense of a cataclysmic drama gives the final canvas much of its exceptional vitality. Kandinsky seems to have approached the execution of the picture in a suitably martial spirit, for he described afterwards how 'the big battle, the great conquest of the canvas had taken place.'[21] But he was at pains to ensure that the finished painting defied any attempt to saddle it with a literal meaning, apocalyptic or otherwise. 'The initial motif of the painting has been dissolved and transformed into an independent, purely artistic inner being with its own objectivity', he emphasized, adding that 'nothing could be more wrong than to consider this painting to be the representation of an event.'[22]

Although his intentions deserve respect, it is impossible to avoid thinking of a primordial disruption when surveying *Composition VI*. Kandinsky's tumbling, dithyrambic rhythms are redolent of the chaos that once attended the origins of the world and now, in the early twentieth century, threatened to do so again. Even though nudes can be detected in the previous *Deluge* painting on glass, riding the tidal waves along with an assortment of frolicsome animals and fish, human life seems untenable in *Composition VI*. But its overall mood is far from unrelieved pessimism. Kandinsky balances its darker elements against a surprising amount of exuberance, especially in the

light and buoyant colours he deploys. Seeking to account for the painting's deliberate ambiguity, he wrote that 'a great objective disaster in its independent meaning is as much of a eulogy as a hymn about the new birth that arises from it.'[23] For Kandinsky was motivated, essentially, by a faith in the imminence of a world-wide spiritual awakening. However vigorously he concentrated on images of a universe in flux, his contemporaneous writings insist that the artist will be able to hear the voice of 'the invisible Moses' and spearhead a resurgence in divine values. His fervent book, *Concerning the Spiritual in Art* (1912), is pervaded by the mystical certainty that a religious rebirth is at hand, and the extent of Kandinsky's belief in the eventual victory of the 'sacred' over the 'sinful' should never be underestimated.

Nevertheless, during the course of 1913 he found himself drawn into an ever more overt engagement with visions of conflict. As its title declares, *Improvisation Deluge* marks the moment when Kandinsky admits that the seeming abstraction of this tumultuous canvas is inspired by visions of an immense inundation. It remains generalized rather than specific, of course, but his readiness to reveal the full extent of the upheaval grew as the year proceeded. Whether he realised it or not, his work became increasingly caught up with the military tensions of his own time.

Collectors who supported him were quick to notice the new development. Michael Sadler, Kandinsky's first English patron, received the gift of a large painting from the artist for Christmas 1913. It was, apparently, a non-representational work, 'a free pattern of coloured arabesques, explosive and ballistic in its design.'[24] But Sadler, whose early enthusiasm for Kandinsky's art was far in advance of anyone else in Britain, decided to name it *War in the Air*. A few months before receiving the present, he had told the Conference of the National Union of Women Workers in Hull that 'in their present mood the arts of painting and of music were like "voices prophesying war".'[25] Kandinsky's gift confirmed him in this belief, for 'the design, strong in structure and balance, suggested hurtling masses in impending collision. The dominant colours were vermilion, black, purple, sulphur yellow, and blood red. Some of the lines of the picture called up the thought of swift arrows, aircraft and exploding shells.'[26] It impelled Sadler to find out if the artist had himself intended a prophecy. 'A year later', he recalled, 'by which time we were only too familiar with bombs and fighting planes, I wrote to Kandinsky in Sweden to ask whether, when he painted the picture, he had foreboded war. "Not this war", he replied, "but I knew that a terrible struggle was going on in the spiritual sphere, and that made me paint the picture I sent to you."' Kandinsky's remarks prompted Sadler to become 'aware of the sensibility of an artist of genius, shown at times in a flair of anticipation of what's coming.'[27]

When Kandinsky completed *Improvisation 30*, the bracketed word *Cannons* was added to the title as if to concede that its representational elements had now assumed a new significance (Pl. 7). Not only are the cannons themselves frankly depicted in one corner of the canvas; the smoke issuing from their barrels billows across the picture and affects many of its other elements as well. The vertiginous diagonals deployed elsewhere in the painting, evoking a mountainous terrain leaning at an angle close to collapse, suggest that the cannons threaten to undermine the landscape's stability. As they roar, everything around them reacts by reeling away from their impact. Kandinsky himself felt ambivalent about the pictorial significance of the weaponry he had included here. 'The designation *Cannons*, selected by me *for my own use*,' he told Arthur Jerome Eddy, the Chicago collector who bought the painting, 'is not to be conceived as indicating the "contents" of the picture. These contents are indeed what the spectator *lives*, or *feels* while under the effect of the *form and colour combinations* of the picture.' All the same, he went on to reveal that 'the presence of the cannons in the picture could probably be explained by the constant war talk that had been going on throughout the year.' Kandinsky was anxious to stress that 'I did not intend to give a representation of war; to do so would have required different pictorial means.' But he had no desire to underestimate the powerful psychological forces which had driven him, probably against his prior expectations, to paint this prophetic canvas. He explained to Eddy that *Improvisation 30 (Cannons)* was a 'picture which I have painted rather subconsciously in a state of strong inner tension. So intensively did I feel the necessity of some of the forms that I remember having given loud-voiced directions to myself, as for instance, "But the corners must be heavy!"'[28]

Compared with Meidner's visions, with their wholesale commitment to *Götterdämmerung*, Kandinsky's paintings still seem lyrical. Even the *Improvisation* he went on to execute, and then subtitle *Sea Battle*, is a strangely exuberant affair. It seems to view the struggle with rapture, as a necessary prelude to the great awakening he hoped for; and without the titles to guide us, we could be forgiven for failing to notice the military strain in his work of this period. When Roger Fry saw the *Cannons* canvas with two other Kandinskys in 1913, he ignored their representational elements completely. 'They are pure visual music', he argued, concluding that 'I cannot any longer doubt the possibility of emotional expression by such abstract visual signs.'[29] Fry, however, was in no position to understand how insecure Kandinsky became as the 'constant war talk' steadily gathered momentum. The cannons and fighting ships had invaded his art because he feared, as a Russian living in Germany, that his whole life might be disrupted by the onset of hostilities. His misgivings proved only too wellfounded: Kandinsky felt obliged to escape from Germany immediately the war arrived in August 1914.

Artists' awareness of militarism was not confined to Berlin visionaries and Russian *émigrés*. In Russia itself, two leading young proponents of the emergent avant-garde became preoccupied with army images at an early stage in their careers. Mikhail Larionov's interest arose directly from his own period of military service, which began in 1908 when he was called up at the Moscow College of Painting, Sculpture and Architecture. His first soldier paintings date from that period, and convey the easy-going tempo of life during the summer at a camp just outside the capital. The insouciance of these smoking, cardplaying figures is matched by the informal style Larionov adopts, drawing freely on folk-art traditions and even inscribing bawdy words on the second version of *The Soldiers* with the slangy bravado of a boy scrawling graffiti on a street corner. The carefree life hailed in these engagingly relaxed canvases is far removed from the reality of battle. When Larionov painted *Soldier on a Horse*, the uniformed figure on a rearing mount looked as playful as a dressed-up marionette astride a rocking-horse (Pl. 8). A holiday mood prevails, albeit laced with an irreverence which flouts the whole sacrosanct notion of a dignified army in thrall to the Tsar's unquestioned authority.

Larionov's contemporary Chagall relished an even more satirical approach to military life in several of his pre-war works. Without any enlistment experience of his own, he relied on memories of the Russo-Japanese war in 1904–5. Russian soldiers were billeted on his family in provincial Vitebsk, and *The Soldier Drinks* may derive from Chagall's recollection of a garrulous lodger who regaled him with stories by the dripping samovar. While holding one finger under the ornamental tap, the soldier lets his cap fly off to float, with typical

7 Wassily Kandinsky *Improvisation 30 (Cannons)* 1913. Oil on canvas, 109.2 × 109.9 cm. The Art Institute of Chicago. Arthur Jerome Eddy Memorial Collection.

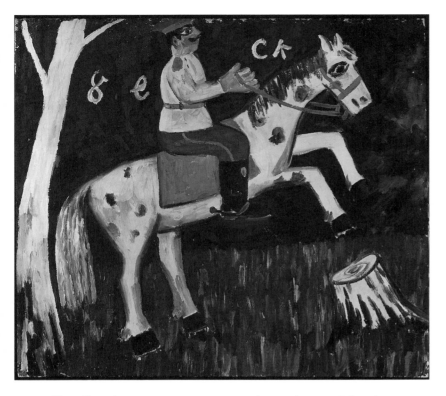

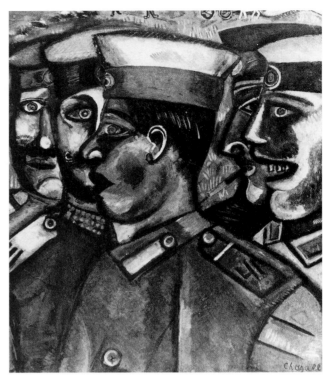

8 Mikhail Larionov *Soldier on a Horse* c. 1912. Oil on canvas, 87 × 99.1 cm. Tate Gallery, London.

9 Marc Chagall *Soldiers* 1912. Gouache on board, 38 × 32.5 cm. Private collection.

Chagallian buoyancy, at a tipsy angle in the air. The diminutive couple dancing on the table-top indicates that his memories are predominantly happy, but his other hand gestures towards a window where a more disturbing scene is disclosed. The house beyond appears to be threatened by a fiery glow irradiating the night sky, as if to suggest that the boisterous soldier is neglecting the very real menace about to destabilize Russian life. Soon after the war commenced, Chagall would become one of the first artists to define its essential tragedy, and in these pre-war images an incipient alarm is already detectable. A small but violent gouache from the same period shows an enraged Cain assailing his brother in a field serrated with saw-tooth patterns. Chagall's rasping urgency makes the picture a worthy forerunner of Corinth's far more lacerating version of the same biblical theme, executed during the darkest days of the conflict (see Pl. 239). Although Chagall shared Larionov's levity when depicting the pre-war Russian military, the smiles on the faces of his *Soldiers* are markedly more vicious (Pl. 9). Even then, when the war itself was still years away, Chagall could not help seeing this cluster of grinning, wild-eyed recruits as a potential source of brutality.

His misgivings were not shared by the Parisian Cubist Roger de La Fresnaye, who in 1910 became preoccupied with images of soldiering. Working on the illustrations for Claudel's drama *Tête d'Or* gave him the original impetus to develop an interest in the subject, and his large canvas of *The Cuirassier* stems from an involvement with the past rather than the present. Its starting-point is Géricault's celebrated *Wounded Cuirassier* in the Louvre – even if La Fresnaye transforms this apprehensive figure into a yelling semi-Cubist warrior, with his sharp-beaked helmet and commanding stance. But by the time he painted *Artillery* a few months later, the march of a modern army had replaced Géricault's inspiration altogether (Pl. 10). Executed at a moment when, as Germain Seligman pointed out, 'Europe was already tense with political conflict and the Agadir incident had even brought open talk of war',[30] it employs a simple, classicizing idiom which has grown more rigidly schematic since La

Fresnaye painted *The Cuirassier*. The bodies of the cavalry officers, with their elegant epaulets and shakos, are confined inside the same angular straitjacket as the helmeted artillery-men. All the figures seem to have taken on the machine-like impersonality of the weapons they accompany. The protruding gun-barrel is forcefully registered, and establishes the thrusting diagonal interplay which gives the entire composition its taut energy. There is, nevertheless, a brittle feeling about the picture which prevents it from becoming ominous or awesome. Robert Rosenblum perceptively argued that the structures in *Artillery* 'have a fragile, disjointed quality that belies ironically their ostensible firmness and obedience to gravity.'[31] As a result, La Fresnaye's depiction of an armed convoy lacks any sense of an inflexible progress towards the battlefield. There is an almost balletic lightness about the trumpeting, drum-banging soldiers in the distance, and even the wheels bearing the gun are wittily summarized in a sequence of playful arcs.

Soon after *Artillery* was completed the spirit of patriotic fervency increased rapidly in France, prompting the newly elected Prime Minister Poincaré to adopt a more belligerent attitude towards Germany. He supported Russia's clandestine founding of a 'Balkan League' with Bulgaria and Serbia in March 1912, the month when the *Daily Telegraph* detected a startling new mood in the annual review of the Paris garrison's reserves. It was, declared the newspaper's correspondent, 'the most remarkable demonstration of patriotism I ever remember having seen here...For a couple of hours this evening I have been hearing at frequent intervals the tramp of boots, the crashing and rolling of regimental bands, and roars of cheers along the boulevards beneath my windows.' The sound served to convince the reporter that 'the change in the French national temper is one of the most remarkable events in Europe today',[32] and Poincaré continued to build up his country's military strength as the year proceeded. In October 1912 Serbia and Bulgaria, along with Montenegro and Greece, finally declared war on Turkey. A month later, having expelled the Turks, Serbia claimed most of Albania

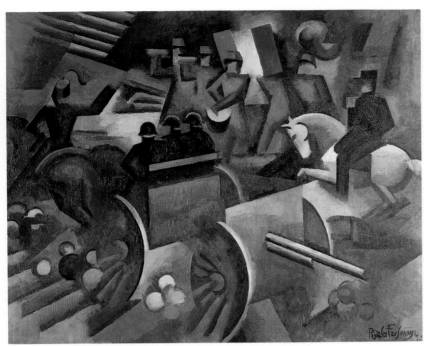

10 Roger de La Fresnaye *Artillery* 1911. Oil on canvas, 130.2 × 159.4 cm. The Metropolitan Museum of Art, New York. Anonymous gift, 1991.

from the Austro-Hungarian Empire. In predictable response, Austria mobilized its forces; but Russia, as yet unprepared for war, decided against siding openly with Serbia and escalating the conflict. Although the Tsar's vacillation enabled treaty negotiations to commence in London, they were only concluded in May the following year with an agreement so fragile that it led, soon afterwards, to the eruption of the Second Balkan War.

When Picasso started experimenting with the revolutionary possibilities of collage in October 1912, therefore, the French newspapers were devoting a substantial amount of space to reports and often excitable speculation about the progress of the First Balkan War. Over half the journalistic cuttings used in his *papiers collés* during the closing months of 1912 are concerned with that war and its effect on the political and economic condition of Europe. But how deliberate was Picasso's decision to include material dealing with the conflict? In recent years some historians have claimed a considerable amount of significance for these political reports: Patricia Leighten maintained that they 'had special resonance for an artist deeply tied to the anarcho-Symbolist, antimilitarist traditions of Barcelona and who was daily immersed in the raging arguments over the pan-European war universally acknowledged to be threatening.'[33] More cautiously, David Cottington decided that Leighten's willingness to regard Picasso's war references as antimilitarist 'is attractive but ultimately unsatisfactory, for it ignores the questions of how the cuttings signify in relation to each work as a whole, and of the *terms* on which Picasso incorporated such extraneous material into his art.'[34] Cottington is surely right to warn against the rashness involved in attaching concrete political meanings to the collages of 1912, but their inclusion of so much war-related material still deserves to be analysed.

In *Guitar, Sheet-Music and Glass*, probably one of Picasso's earliest *papiers collés* and the first to include a newspaper fragment,[35] a headline from a November 1912 edition of *Le Journal* announces that 'The Battle is Joined'. It originally introduced a report from Constantinople about the First Balkan War, and Picasso ensured that the four dramatic words were preserved intact when he removed them

from their front-page context. He might, however, have intended them as a metaphorical reference to his friendly rivalry with Braque, who had produced the first *papier collé* in September 1912. Picasso thrived on their competitive relationship at this stage in the development of Cubism, and 'The Battle is Joined' could also convey his excitement at embarking on a formal strategy certain to provoke antagonism in Paris art circles. As its title indicates, however, this important picture contains elements more important by far than the fragment from *Le Journal*. The other six pieces of paper pasted on to the ground of lozenge-patterned wallpaper are concerned with a still life unaccompanied by any belligerent associations. They occupy most of the available space, implying that music-making and wine-drinking were of greater interest to Picasso than the Balkan conflict.

A similarly subservient position is occupied by the cutting in *Violin*, where segments dealing with a musical instrument predominate once again. This time, however, the newspaper report has moved nearer to the violin itself, suggesting perhaps that the world of military affairs is encroaching on Picasso's life in the studios and café tables of Montmartre. The cutting deals with the Montenegran army's occupation of St-Jean-de-Medua and the Turkish resistance, but it is briefer and less vivid than the extensive war report incorporated in *Glass and Bottle of Suze* (Pl. 11). Here, in a diagonal position to the right of the still life placed on a blue oval table, lies an

11 Pablo Picasso *Glass and Bottle of Suze* 1912. Pasted papers, gouache and charcoal, 65.4 × 50 cm. Washington University Gallery of Art, St Louis, University Purchase, Kende Sale Fund, 1946.

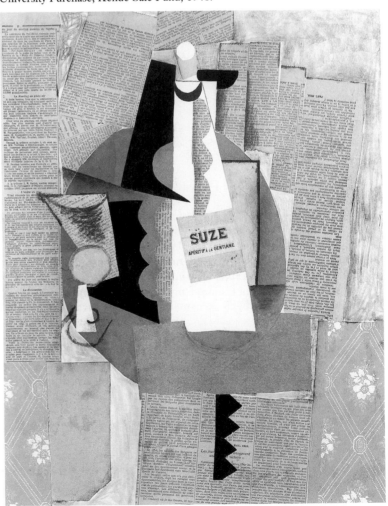

often harrowing account of the Serbian army's advance towards Monastir in Macedonia. Although its writer wonders about the effect of famine on Adrianople, the subject of Marinetti's celebrated siege-poem, Picasso's priorities are radically removed from the Futurist leader's lust for destruction. Instead of lauding violence, the report in *Glass and Bottle of Suze* stresses the suffering of Turks who had fallen victim to a cholera outbreak. 'Before long I saw the first corpse still grimacing with suffering and whose face was nearly black', wrote the reporter. 'Then I saw two, four, ten, twenty; then I saw a hundred corpses. They were stretched out there where they had fallen during the march of the left convoy, in the ditches or across the road, and the files of cars loaded with the almost dead everywhere stretched themselves out on the devastated route.' The reporter goes on to describe the thousands of bodies strewn across 'the cursed route where a wind of death blows', before adding, ominously, that 'I had seen nothing yet.'[36]

Picasso's decision to include such a gruesome document indicates that he wanted to present a view of war deliberately at odds with nationalistic accounts of the triumphant Serbian invasion. Compassion is aroused here for the enemies of France's allies, and on the left side of *Glass and Bottle of Suze* he places a cutting about a mass protest meeting of left-wingers and anarchists whose speeches unite them in a condemnation of the war. Since Picasso is likely to have been broadly in sympathy with their position, the inclusion of this report was probably meant to reinforce the revulsion expressed in the account of the cholera epidemic on the right side of the collage. All the same, the significance of both these cuttings can easily be over-stressed. For one thing, the report from Macedonia is positioned upside-down. Even though Picasso may have wanted the inversion to convey his belief that the Turks' anguish reflected the topsy-turvy values of a world gone mad, the report would have been illegible to all but the most diligent onlooker. Moreover, both sets of cuttings are subordinate to the principal aim of the collage – a sophisticated Cubist play on methods of depicting a bottle and glass with cunning ambiguity and wit. This is the true focus of Picasso's concerns, and neither the Balkan conflict nor pacifist polemic is allowed to distract much attention from this central obsession with the ordinary objects of everyday life.

It is important, then, not to be carried away by the proliferation of war references in Picasso's *papier collés* during the autumn and winter of 1912. Another collage, *Table with Bottle*, certainly makes striking use of an inverted page from *Le Journal*'s financial section discussing the effect of the Balkan truce on the European economy. But the bottle retains its dominant position in the collage, just as it does in a related picture called *Table with Bottle, Wineglass and Newspaper* where the cutting is reduced to a far smaller role again. Here Picasso makes clear just how detached he feels from the reality of the conflict. Even if the cutting refers very clearly to Bulgaria, Serbia and Montenegro, their true significance is undermined by the playful way in which the headline above is shorn of its original meaning. 'UN COUP DE THÉATRE' becomes, with the aid of Picasso's scissors, 'UN COUP DE THÉ'. War news is turned, adroitly, into a Cubist joke for the amuse-ment of the artist reading his paper at a café table. And when Picasso came across news of the peace negotiations in London, he inserted a segment from *Le Journal* which juxtaposes a report on the armistice talks with an item about a peacetime Parisian 'drama'. Once the First Balkan War looked as if it would eventually be resolved, his interest receded and turned instead to other aspects of current events. *Table with Bottle and Wineglass* in the Menil Collection is concerned, above all, with an elegant, thorough-going demonstration of Cubism at its

most formally economical. The charcoal lines are now allowed to impose their magisterial order unchallenged, for the most part, by journalistic material of any kind.

A related unwillingness to allow militarism a substantial reality prevented Jacques Villon, a year later, from making his *Marching Soldiers* wholeheartedly aggressive (Pl. 12). Villon himself coined the phrase 'Impressionistic Cubism'[37] for the style he employed here, and it helps to explain the curiously insubstantial character of the figures in this subtle painting. Their forms are difficult to pin down as they dart through the scaffolding of directional lines Villon has erected to articulate their hurried movement. The vigour and ef-ficiency of a crisply regimented column is conveyed with admirable economy, and Villon's stabbing structure hints at the slender yet deadly bayonets jutting out from the soldiers' equipment. All the same, the sheer refinement of *Marching Soldiers*' formal organization and bleached colours ensures that a robust view of the army is avoided here. Fragile rather than boisterous, these figures lose much of their solidity in the 'synthesis of movement through continuity'[38] which Villon wanted to achieve at this early stage in his career.

A parallel sense of impending dematerialization affects Malevich's painting *The Guardsman*, produced in the same year (Pl. 13). Among the radically fragmented forms that refer to the figure himself, re-ferences as specific as the stars on his cap are included. The buttons emblazoning his uniform are discernible, too, rendered as a sequence of simple discs, but the guardsman has in the main become a de-humanized assembly of signs. They exemplify Malevich's growing commitment to irrationality, an art of 'non-sense realism' which, taking the formal discoveries of Synthetic Cubism as its starting-point, here subverts the conventional depiction of military life as thoroughly as possible. This undermining process, which Camilla Gray described as 'a pictorial interpretation of the contemporary ideas in poetry put forward by Khlebnikov and Kruchenikh',[39] reaches its climax in the mysterious yellow quadrilateral which makes such a presumptuous appearance over on the right half of *The Guardsman*. It cancels out any further attempt on Malevich's part to refer to the figure who, according to the picture's title, forms the 'subject' of this deeply questioning picture. Although John Golding decided that the movement of the quadrilateral is ambiguous,[40] it does in the end seem more in favour of leading our eyes to the canvas's right edge. Confirmed in that direction by the arrow in-scribed in the pigment, the quadrilateral asserts a geometrical clarity quite at odds with the planar complexity elsewhere in the composition. It seems to propose a more unruffled and lucid order of seeing, strik-ingly prophetic of the great 1917 *Suprematist Painting* where another yellow quadrilateral is permitted to inhabit the picture-space in potent isolation.[41] Although Malevich would reveal an instinctive patriotism and readiness to fight the enemy once war had been declared (see Pls. 47–8), he uses incipient Suprematism at this stage to threaten the guardsman with pictorial dissolution.

In Berlin, the young American painter Marsden Hartley likewise became fascinated by the challenge of dealing with army themes in a near-abstract language. But he approached the task in a spirit far removed from Malevich's attempt to challenge the dominance of the ostensible subject. 'I like Deutschland', Hartley wrote to Gertrude Stein several months after he arrived there in January 1913, adding that 'I think I shall like it for long...there is a wholesome hum here.'[42] A large part of his enthusiasm stemmed from the stimulus of meeting Kandinsky and other artists associated with the *Blaue Reiter*. Since they urged him to participate in their exhibitions, he experi-enced none of the alienation which an American expatriate might

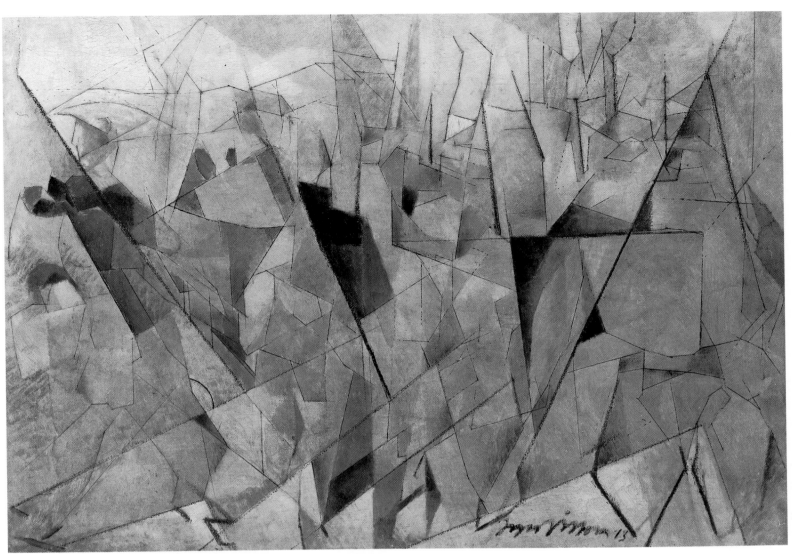

12 Jacques Villon *Marching Soldiers* 1913. Oil on canvas, 64.8 × 92 cm. Musée National d'Art Moderne, Centre Pompidou, Paris.

easily have suffered. 'I have no sense of *heimweh* here on German soil',[43] Hartley wrote, and in a painting called *Military* he celebrated his new-found involvement with the armed forces.

Far from viewing German soldiers sceptically, as members of an increasingly powerful and confident fighting unit, he reduced them to a complex of triangles and circles handled with romantic ardency. Subsequent paintings would disclose his homoerotic passion for a particular officer (see Pl. 110), and *Military* can be seen as a preliminary declaration of Hartley's infatuation with the symbolism and paraphernalia of the *junker* élite corps. Although Kandinsky's influence can be detected in the near-abstract language Hartley employs, thereby placing him among the most audacious American painters of his generation, *Military* carries no presentiment of an apocalypse. Instead, the numbers on this painting reflect his almost mystical commitment to numerology. 'I was told before I came to Berlin to look for 8-pointed stars', he explained, and this willingness to discover occult significance in mathematical combinations focused on the insignia of the German army at its most glamorous.

Hartley was particularly captivated by a military review he observed in May 1913, celebrating the cavalcade of uniformed riders in a painting of *The Warriors* where their pageantry assumes an ecstatic

significance. 'I am seeing eight-pointed stars here by the thousands', he wrote excitedly to Stieglitz, explaining that 'a symbolist friend says it is a fine star for me – on the Kaiser's breast it is always – on the helmets of the thousands of soldiers.'[44] In *Portrait of Berlin* the image which dominated *The Warriors* is confined to a single circle, resting like a medallion on the painting's bottom edge. Around this tribute to the virile cavalryman Hartley now felt free to inscribe his favourite number within a thickly framed triangle, while further up the composition an eight-pointed star bursts like a manifestation of divine guidance in the sky. The respect Hartley received from the *Blaue Reiter* artists and Herwarth Walden, who displayed five of his paintings alongside Kandinsky and Rousseau in the progressive Herbstsalon of 1913, further emboldened the young American. He ceased to rely on figurative references altogether, filling his *Painting No. 48, Berlin* with enlarged and radiant affirmations of the star and the mystical eight alike (Pl. 15). Enclosed in mandala-like contours, they blaze out Hartley's belief in cosmic transcendence triumphing over the material world.

Without first-hand experience of war, few artists in the pre-1914 period could be expected to appreciate the darker implications of

13 Kasimir Malevich *The Guardsman* 1913. Oil on canvas, 57 × 66.5 cm. Stedelijk Museum, Amsterdam.

mounting militarism. The Czech painter Bohumil Kubišta did, however, undergo active service on the Adriatic coast in 1913, and the work he executed there conveys a far harsher vision than Villon, Malevich or Hartley would have deemed appropriate. Before his enlistment, Kubišta had displayed an encyclopaedic engagement with different aspects of the European avant-garde. The Expressionism which led to his membership of the *Die Brücke* group in 1911 was followed by Cubist affiliations, and they in turn gave way to the impact of Futurism when self-styled Kubišta saw the Italian movement's exhibition at Berlin in the spring of 1912. By the time the 29-year-old painter was sent to the Adriatic coast, these Futurist leanings had gained dominance over his work. While Marinetti and his allies talked about the importance of war but avoided depicting it, Kubišta witnessed real battles and made them central to his art.

Heavy Artillery in Action brings the spectator into the thick of a bombardment (Pl. 14). Raised gun-barrels blast off missiles in thunderous unison, and the outcome of their salvoes is dramatized by the explosions lower down the canvas. Futurist simultaneity enabled Kubišta to fuse disparate times and places in a single image of assault. But the impact of the massive machine-age weaponry is not presented with wholehearted Marinettian ebullience. Although the figure silhouetted in one corner of the painting may be responsible for firing a gun, he is a furtive presence who ducks away from the shattering outcome of his actions. Wholly overshadowed by the machinery of war, he seems diminished in stature as the shells scream through the air and detonate around him.

Kubišta's appropriately fragmented vision of war, which includes a gunner's circular view of a destroyer in the upper section of the painting, is more murderous by far than Marinetti's rendering of 'The Siege of Adrianople', his notorious *parole in libertà* poem which he zestfully performed 'with various kinds of onomatopoeic noises and crashes'[45] to intensify the verbal assault. It became the centrepiece of his boisterous volume of poetry *Zang Tumb Tuuum*, which rejoiced in pounding attack without a hint of combat's tragic dimensions: 'hurrrrrrrah tatatatatata hurrrrrraaah tatatatata PUUM PAMPAM PLUFF.'[46]

It is easy to see the extent of Marinetti's debt to Nietzsche, who had urged readers of his enormously influential *Thus Spoke Zarathustra*, in a section chillingly entitled 'Of War and Warriors': 'You should seek your enemy, you should wage your war – a war for your opinions... You should love peace as a means to new wars. And the short peace more than the long. I do not exhort you to work but to battle... You say it is the good cause that hallows even war? I tell you: it is the good war that hallows every cause.'[47] But Nietzsche's mesmeric hold over artists was by no means confined to the Futurist camp. His greatest following was in his native Germany, where Zarathustra's sharply original odyssey through the contemporary world exerted a seminal hold on German artists of the Expressionist generation.

When Ernst Ludwig Kirchner first met Erich Heckel in 1904, the latter entered his Dresden lodgings declaiming passages from *Zarathustra* at full volume. They may well have come from the book's prologue, which supplied the emergent *Brücke* group with its name by declaring that 'what is great in man is that he is a bridge and not a goal; what can be loved in man is that he is a *going-across* and a down-going.'[48] Danger was of the essence in Zarathustra's view of man as 'a rope, fastened between animal and Superman – a rope over an abyss. A dangerous going-across, a dangerous wayfaring, a dangerous looking-back, a dangerous shuddering and staying-still.'[49] Sacrifice was admirable if it carried a purgative force, and Zarathustra claimed that 'I love him who justifies the men of the future and redeems the men of the past: for he wants to perish by the men of the present.'[50]

By 1913 this sense of danger and sacrifice had begun to be expressed with unprecedented forcefulness by many artists in the Nietzschean orbit. Heckel's *Landscape in Thunderstorm* appears at first no more than a climatic phenomenon, powerfully observed. After a while, though, it assumes a preternatural dimension. The colossal bulbous clouds expanding in the sky seem on the point of unleashing an onslaught too great for the countryside to withstand. Moreover, this looming monstrosity bears a resemblance to a gigantic head, bending over the defenceless earth like an agent of wholesale destruction. Half-obscured by shadows, his cheeks are pregnant with the swollen, accumulated weight of the whirlwind he is about to blow across the land. In this respect, he could be regarded as an embodiment of those who earned Nietzsche's highest praise in Zarathustra's

14 Bohumil Kubišta *Heavy Artillery in Action* 1913. Oil on canvas, 37 × 49.5 cm. Národní Galerí, Prague.

15 Marsden Hartley *Painting No. 48, Berlin* 1913. Oil on canvas, 120 × 120 cm.
The Brooklyn Museum, New York; Dick S. Ramsay Fund.

16 Otto Dix *Sunrise* 1913. Oil on millboard, 50.8 × 66 cm. Private collection, Germany.

Prologue: 'I love all those who are like heavy drops falling singly from the dark cloud that hangs over mankind: they prophesy the coming of the lightning and as prophets they perish. Behold, I am a prophet of the lightning and a heavy drop from the cloud: but this lightning is called *Superman*.'[51]

In other words, Nietzsche did not view this 'dark cloud that hangs over mankind' as a baleful threat. The storm which generated the lightning would be an emetic, purging Europe of its pervasive rottenness and heralding the vitalistic new order he cherished. If the entire continent were engulfed by the impending cataclysm, so much the better: the renovation of society would be still more widespread and effective. Whether the artists who venerated Nietzsche entirely shared his ideas about war remains debatable. There is considerable foreboding in Heckel's *Landscape in Thunderstorm*, and a similar complexity informs the dramatic *Sunrise* painted by Otto Dix in the same year (Pl. 16). The precocious Dix, still a student at the Dresden School of Arts and Crafts when he executed this picture, admired Nietzsche to the point of hero-worship at the time. He had already modelled a green-painted, life-size plaster bust of the philosopher, and the cataclysmic quality of *Sunrise* owes a great deal to Nietzschean ideas. The vigorous manipulation of impasto, no less than the presence of black crows flapping across the land, also testify to the direct inspiration of Van Gogh. But the extraordinary vehemence with which this sun appears above the horizon is impelled by a rasping power that belongs to Dix alone. The great disc of white and gold bursts like a bomb, exploding outwards in black splinters aggressive enough to drive away the thick mass of cloud which accumulated during the night. Although snow smothers the frozen winter fields, this fiery apparition emanates such a brazen amount of light and heat that everything will surely melt before it. The crows, shocked out of their nocturnal sloth, have already decided to flee from the angry intrusion. But its violence is as extreme as a Meidner eruption, and their wings may yet be caught by the inferno. Indeed, as the sun ascends its ferocity will grow, so that the entire landscape might eventually be consumed in a conflagration of epic proportions.

The rough energy with which Dix painted his visionary sun, boiling in the sky as forcefully as the flames of the foundry where his mould-maker father worked, conveys exhilaration and disquiet in equal measure. For Dix, even as he shuddered at the prospect of a catastrophe overwhelming nature, was sufficiently Nietzschian to be excited by the idea of creation through destruction. During the course of 1913, this notion also took hold of Franz Marc's imagination. Until then, he had been the painter least likely to align himself with such a disturbing notion. Convinced that great art needed a strong religious dimension, the former theology student had devoted himself to the development of a pacific and idyllic world. Turning away from 'impious' humanity, he preferred to concentrate on images of animals inhabiting a primal landscape. Graceful, compassionate and athletic, these idealized horses, does and tigers rejoiced in an unblemished moral unity which contrasted with the decadence of urban society. But the paradise Marc constructed from his simple Alpine existence, where he pursued 'the animalization of art' by studying his subjects in all their apparent purity, could not last. In 1913 his mood suddenly darkened, and Eden became a place haunted by hitherto unimagined dangers. *The Unfortunate Land of Tyrol* reveals a blighted terrain, eerie and forlorn. The bird perched on a bare, stunted branch extends his wings in a helpless gesture, as if to deplore the barren locale surrounding him. But nothing can be done to alleviate the bleakness of this impoverished place. Paradise has turned into a wasteland disconcertingly akin to the battlefields of Belgium and France during the war, and Marc's once-masterful horses are reduced to picking their disconsolate way through a terrain where nothing seems capable of growth.

Worse was to come. Expanding the size of his work in order to accommodate the calamitious events which seized his imagination, Marc embarked on a painting clearly intended as a youthful masterpiece (Pl. 17). 'The Trees Show Their Rings, the Animals Their Veins'[52] was the biblical title he originally gave this turbulent panorama. For the world which had earlier appeared so unsullied and intact now became an exposed and vulnerable domain, riven by devastation of terrifying potency. The whirlwind courses through the forest, bent on subjugating trees and animals alike. Its onslaught is so severe that trees shed drops of scarlet blood, and the green horses struggle to retain their balance as the hurricane distorts their bodies with brutish velocity. On the back of the canvas Marc's subtitle, apparently derived from the Hindu Vedas, stresses the overriding importance of nature's agony as his principle theme: 'And All Being Is Flaming Suffering.' As if to bear out this declaration, the severed tree-trunk below the horses exposes its white pulp so openly that it glistens in the darkness of the wood. But the annihilating forces have not yet completed their mission. Jagged missiles penetrate the upper corner of the picture, piercing the shadows with incandescent shafts. The surviving animals' only resort is to seek shelter beneath the tree, which leans in a noble yet beleaguered diagonal across the surface of the canvas. If it withstands the rest of the attack, with roots still firmly embedded in the ground, then at least some remnants of life might be sustainable after the fury subsides.

When Marc's prodigious painting was itself seriously damaged by fire, it must have seemed as if the warning he conveyed here was about to reach fulfilment in the most literal manner imaginable. But enough of the canvas was rescued to convince his friend Klee that a restoration should be undertaken. If Klee's retouching is all too evident today, he did succeed in remaining faithful to Marc's initial intentions. He also renamed the picture *The Fate of the Animals*, the concise title by which it has been known ever since. By choosing the determinist word *Schicksale*, Klee emphasized the Nietzschean strain in Marc's thinking as well. For he seems to have reached the con-

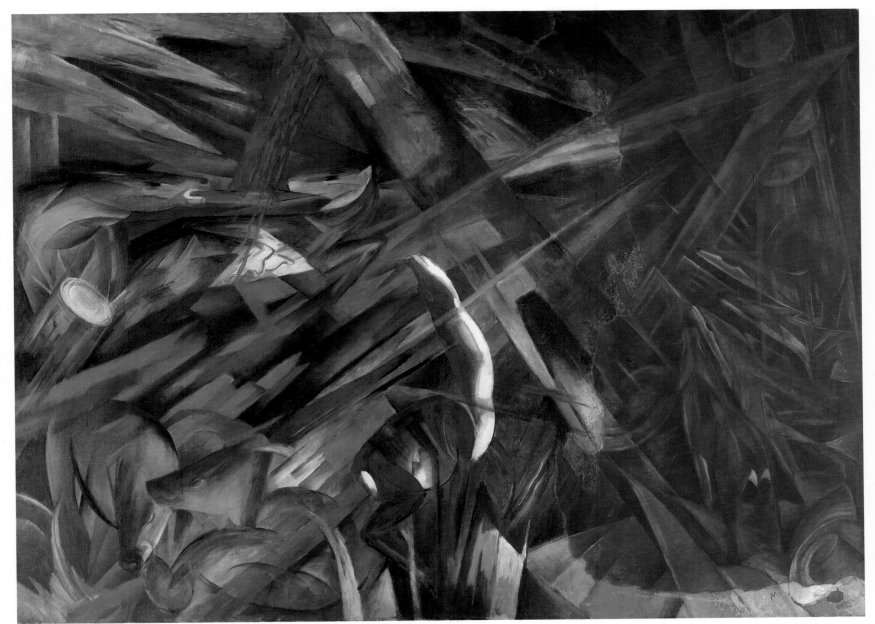

17 Franz Marc *The Fate of the Animals* 1913. Oil on canvas, 195 × 263.5 cm.
Oeffentliche Kunstsammlung, Kunstmuseum, Basel.

clusion, during 1913, that the renewal promised in his earlier animal idylls would never be achieved by a peaceful transition. Only by submitting to wholesale assault would the new order eventually emerge, and in *The Fate of the Animals* there is more than a hint that such a catharsis will come to pass. The trunk bending at such a vertiginous angle across the centre of the composition is an evergreen ash, the tree which North German mythology regards as indestructible. By stretching his neck upwards to echo the direction of the ash, therefore, the blue deer is not simply hiding from the tempest. He is attempting to identify with the tree as closely as possible, in the expectation that he will take on the ash's power of survival. Marc holds out a similar hope for the pair of pink animals clustered together in the lower reaches of the forest. Their chances of withstanding the apocalypse seem high, and the affection with which they nuzzle each other implies a readiness to propagate the new race of

pure beings in the future.

When Marc was sent a postcard reproduction of *The Fate of the Animals* at the Front in 1915, he recognised with a shock that 'it is like a premonition of this war, at once horrible and stirring. I can hardly believe that I painted it. Yet it is artistically rational to paint such a picture before the war, and not simply as a dumb memory after it is all over. That is the time to be painting formative pictures symbolic of the future.'[53] The territory in his art may not have been inhabited by humans, but their actions were echoed and interpreted throughout the metaphoric world which Marc created. The last major painting he produced before the war made this ambition more evident than before. *Fighting Forms* seems, at first glance, a wholly abstract work (Pl. 18). The two eruptive areas of red and black dominating the composition cannot easily be related to any of the landscape or animal images which enlivened his earlier pictures.

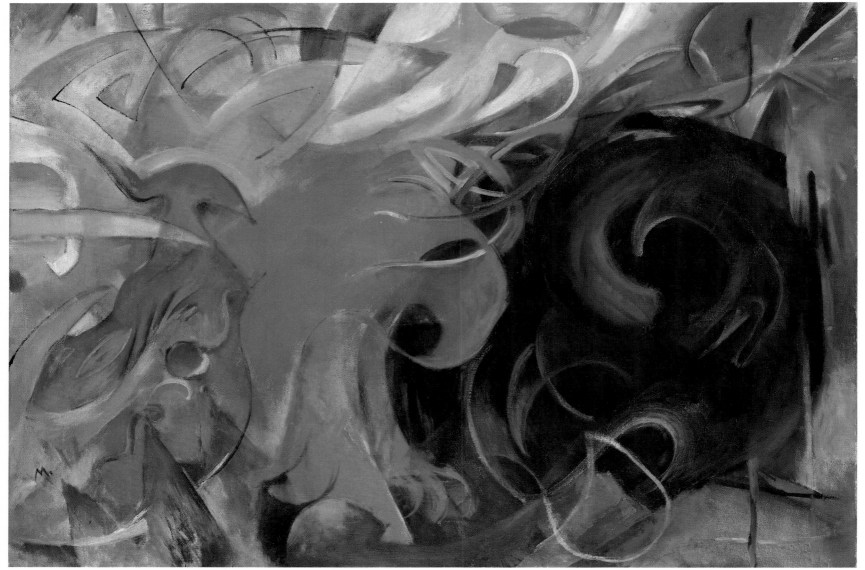

18 Franz Marc *Fighting Forms* 1914. Oil on canvas, 91 × 131.5 cm. Staatsgalerie Moderner Kunst, Munich.

They appear to be embroiled in a struggle so apocalyptic that it threatens to spread outwards and fill the entire canvas with strife. Only after a while does the volcanic red area disclose the suggestion of a bird, which immediately gives the painting an airborne dimension and suggests that the black mass is whirling through the air like a typhoon.

One historian has argued that *Fighting Forms* dramatizes 'the power of Mind contending with the forces of the material world',[54] but such a reading diminishes the baleful implications of Marc's vision. Painted in the early summer of 1914, its convulsive violence seems to be riddled with an unsettling presage of the war. A few months before, Marc had tempered the pessimism of a large canvas called *The Unhappy Tyrol* by adding a haloed Madonna, who holds her child as she shines out ameliorating shafts of hope into the chaos around her. The tragedy of the Balkan Wars, to which the painting clearly refers, is here redeemed by the healing presence of Mary the comforter. But by the time Marc produced *Fighting Forms*, his imagination was possessed by a premonition which no amount of re-ligious faith could dispel or even lighten. Despite his belief in the affirmative consequences of destruction, this strangely feverish picture indicates that Marc felt overwhelmed by a sense of havoc ahead.

In Britain, the forebodings were far less anguished. But if no artists shared Marc's Teutonic willingness to expose his most fearful visions of disaster, some did feel impelled to prefigure the hostilities ahead. Douglas Goldring, a young publisher who admired the avant-garde circle preparing to launch the Vorticist movement, afterwards described how 'the Season of 1914 was a positive frenzy of gaiety'. The mood of raucous hysteria seemed to him inherently self-destructive, and 'long before there was any shadow of war, I remember feeling that it couldn't go on, that something *had* to happen.'[55] However much Goldring benefited from retrospective wisdom when he wrote those words in later life, the truth is that a considerable amount of the experimental art produced in London during these pre-war months was powered by an overwhelming urge to attack and destroy.

Wyndham Lewis, the editor of the aggressively titled *Blast* magazine, was the Vorticist most keenly prepared to place this belligerence at the heart of his current work. In an exclamatory tirade written to announce the publication of *Blast* in July 1914, he cried:

> Well then! This is what it is time to do.
> We must kill John Bull.
> We must kill John Bull with art![56]

Lewis's fury was directed primarily at all those forces in British culture – philistinism, nostalgia, an unwillingness to engage in radical transformation – which he considered inimical to the development of a vital new art. Images and words were his weapons, and none of the Vorticists looked forward to a real war with the enthusiasm displayed by Marinetti. All the same, their boisterous and often volcanic behaviour in the first half of 1914 anticipated the war fever which gripped the entire country once hostilities against Germany were declared. Lewis later described how, within his highly combative milieu, 'all the artists and men of letters had gone into action before the bank-clerks were clapped into khaki and despatched to the land of Flanders Poppies to do their bit. Life was one big bloodless brawl, prior to the Great Bloodletting.'[57]

Although the Vorticists were concerned with aesthetic revolution rather than a real military offensive, Lewis still found himself painting images of war which heralded political events in Europe with chilling accuracy. The most monumental was a tall canvas called *Plan of War*, which he remembered executing 'six months before the Great War "broke out", as we say.'[58] (Pl. 19). Clearly intended as a major manifestation of his new-found Vorticist style, this tautly organized picture was reproduced in *Blast* to prove that Lewis's work implemented his theoretical preference for an art of bareness and austerity, calmly inhabiting the concentrated centre of modern life's metaphorical whirlpool. 'The Vorticist is at his maximum point of energy when stillest',[59] he asserted in a manifesto entitled 'Our Vortex', and *Plan of War* exemplifies this paradoxical state by enclosing its militant blocks of diagonally orientated form in rigid, schematic outlines. Since only a monochrome photograph of the painting now survives, it is impossible to tell how important a role colour played in the original work. But Lewis's contemporaneous pictures often deployed venomous, high-keyed colour oppositions, and when *Plan of War* was exhibited in June 1914 one reviewer remarked that 'the severe emphasis on geometrical forms seems to enhance the intensity of the colour.'[60] Even in reproduction it seems a very lucid design: the directional thrust of the blocks is clarified by juxtaposing them with ample areas of bareness. The ascending structures are thereby enabled to assume an awesome authority as they dispose themselves on the picture-surface, preparing for battle.

For all its willingness to use a remarkable degree of abstraction, almost as extreme as work of the same period by Kupka, *Plan of War*'s references to a martial engagement remain inescapable. Indeed, Frank Rutter, a critic who was broadly in sympathy with Lewis's art, claimed in retrospect that the painting amounted to a literal transcription of army manoeuvres. *Plan of War* was, he argued, 'no more "abstract" than the blocks of wood used in the War Game. What Lewis had done was to take for his point of departure the familiar diagram of a battle that we see in history books, with rectangles for infantry divisions, little squares for cavalry, white for the British, shaded for the enemy, and so on.'[61] But even if Rutter had been told about this starting-point by the artist himself, it would be wrong to conclude that Lewis relied too heavily on such a source. More of a metaphor than a transcription, *Plan of War* coolly evokes

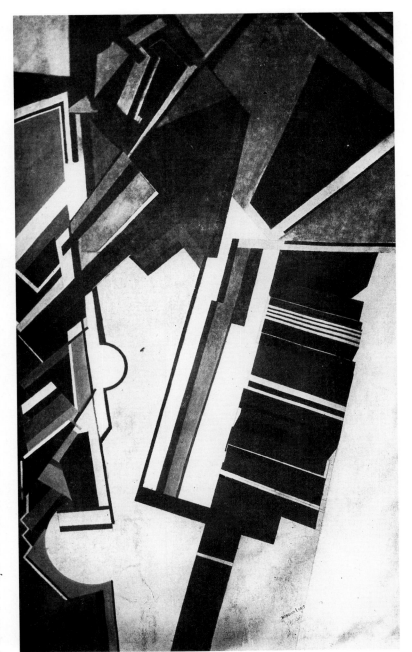

19 Wyndham Lewis *Plan of War* 1914. Oil on canvas, 255 × 143 cm. Lost.

the power-politics of a period when restless European nations aired their armies in practice displays of muscle-flexing menace. It is as if Lewis had divined what A.J.P. Taylor described as the 'factor of high strategy' which had such a 'decisive and disastrous effect' on the build-up to world war. 'All military authorities in Europe believed that attack was the only effective means of modern war,' Taylor wrote, 'essential even for defence. They were quite wrong about this. They could have learned from the Russo-Japanese War of 1904–5, and from the Balkan Wars of 1912–13 ... that defence was getting stronger and attack more difficult. None of them learnt this. Every chief of staff had offensive plans, and only offensive plans.'[62]

Plan of War seems to mirror this fatal priority, and other Lewis paintings share this preoccupation with titles like *Signalling* and *Slow*

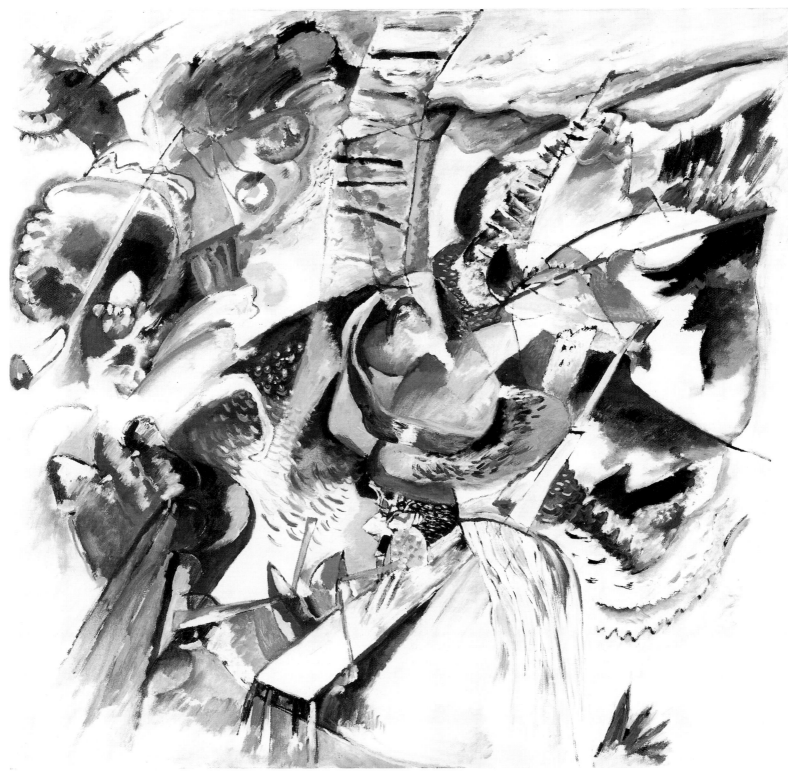

20 Wassily Kandinsky *Improvisation Gorge* 1914. Oil on canvas, 110 × 110 cm.
Städtische Galerie im Lenbachhaus, Munich. Gabriele Münter Bequest.

Attack.[63] In the latter canvas, the assembled ranks which dominated *Plan of War* have begun to assail each other and merge in unruly combat. One piston-like form manages to break free from the mêlée and stretch upwards, terminating in a claw that clutches at an enemy flank above. On the whole, though, the opposing armies appear to be locked in a struggle unlikely to yield a decisive outcome. In this respect, too, Lewis was strangely prophetic of the war's inconclusive conduct. Rutter stressed 'the mental alertness of the artist', marvelling at Lewis's ability 'to feel early in 1914 that there was "war in the air", and to begin a series of these strange designs all with titles taken from a military text book, and all based on the tactical dispositions of *Kriegspiel*.'[64] But Lewis himself, writing only two years before the

Second World War, maintained that 'it is somewhat depressing to consider how as an artist one is always holding the mirror up to politics without knowing it.' So far as he was concerned, *Plan of War* demonstrated that 'with me war and art have been mixed up from the start. It is still. I wish I could get away from war.'[65]

In 1914, however, neither Lewis nor the other European artists aware of the impending crisis had any alternative open to them. War seemed to be an inescapable prospect, and it even affected Kandinsky's response to the majestic countryside he saw on an excursion to the Bavarian Alps in July 1914 (Pl. 20). *Improvisation Gorge*, the painting which takes its title from that trip, refers to memories of an area explored by Kandinsky during his visit: the Höllentalklamm, or Devil's Gorge. It may have contributed to the sense of unbounded exaltation that constitutes part, at least, of this painting's complex meaning. But the vertiginous sensation induced by looking into the mouth of the gorge plays a still more potent part in Kandinsky's tumultuous image. Wondering at the 'heterogeneous patterns, with no relationship to each other, [which] seem to have been let loose on the canvas', Hans K. Roethel concluded that 'there appears to be no visible underlying principle for the composition as a whole.'[66] It is, perhaps, the most deliberately discordant of all Kandinsky's early works, and a preparatory pencil drawing discloses the full extent of his intentions. For the two figures in Bavarian clothes who stand on a jetty in this drawing are overshadowed by the cataclysm above them. Its agent appears to be the helmeted rider who charges in from the left side of the pencil study. Brandishing a pair of scales like a weapon above him, he is surely the horseman of the Apocalypse described by the Revelation of St John as the rider on a black mount with 'a pair of balances in his hand.' In the final painting, however, the rider bestrides a white charger, alarmingly reminiscent of the fourth rider on 'a pale horse'. He is named, in one of the New Testament's most disturbing passages, as 'Death, and Hell followed him. And power was given unto them over the fourth part of the earth, to kill with sword, and with hunger, and with death, and with the beasts of the earth.'[67]

In *Improvisation Gorge* his progress seems unstoppable, as he urges his eager mount to traverse the landscape before them. The Bavarian couple, in all their pre-war innocence, cannot prevent the advance of a rider who will destroy them as readily as he lays waste to the rest of the world. Everything in this hectic, alarmingly destabilized canvas seems doomed to be cast down into the depths of the Höllentalklamm which impressed Kandinsky so profoundly on his Alpine expedition. There, only weeks before the outbreak of war, he must have instinctively felt that an apocalypse was imminent. The blood-red sun boiling near the top of his painting seems about to set, spreading a lurid stain across the land. As if to acknowledge its terrible finality, Kandinsky wrote on his drawing a Russian word translatable either as 'setting' or 'downfall'. *Improvisation Gorge* is turbulent enough to suggest that the latter meaning was foremost in his mind when he painted this wild, cacophonous warning.

Since Kandinsky had been expecting the onset of such a calamity for some years, his frenzied canvas comes as no surprise. But during 1914 the sense of an unavoidable conflict even began to preoccupy artists who had shown no previous interest in the theme. Overt aggression never disrupts the eerie placidity of de Chirico's pre-war paintings. Most of them are uninhabited, so that statuary is free to cast long, melancholy shadows past arcades which refuse to disclose their penumbral mysteries. When people do appear in the otherwise empty piazzas, they are little more than minuscule silhouettes stand-ing immobile in the afternoon sunlight. The only sign of movement is provided, from time to time, by a train emitting smoke in soft clouds. But it is usually relegated to a distant area of the composition, and does nothing to break the paralysis afflicting everything in sight. Gradually, however, the mood pervading de Chirico's 1914 canvases undergoes a subtle change. Lassitude and silence give way to a sense of greater uncertainty, and his choice of picture titles reflects an emerging obsession with expectancy and loss. One painting is called *The Anguish of Departure*, another *The Enigma of Fatality*. The trains seem to play a more active part in taking these anonymous bystanders away from the stage settings which de Chirico favours. Although he provides no hint of their destination, they might be leaving because of a threatened war.

His imagination certainly started brooding on military concerns, for he made a specific reference to them in an important painting called *The Philosopher's Conquest* (Pl. 21). All the familiar elements are there; but this time the arcade has grown to monstrous proportions, and it casts an implacable iron-grey shadow across the middle of the composition. Within the arcade, an unexpected glimpse of a white tower festooned with flags introduces a martial note, albeit medieval rather than modern. And this mood is reinforced by the intrusive cannon-barrel, thrusting itself into the picture-space from a white plinth where the cannon-balls rest in readiness. Ever-elusive, de Chirico goes some way towards deflating the sinister impact of the weapon by likening barrel and balls to the male genitalia in a state of arousal. He fortifies the absurdity by juxtaposing the virile member with two artichokes. The contrast is bathetic, and yet the artichokes' leaves are turned into sharp-edged segments capable of pricking anyone rash enough to touch their tips. In this respect, they confirm the menace of the cannon's open mouth, raised so expectantly in the air. De Chirico distorts the perspectival handling of the mouth so that its gaping aperture is exposed with greater prominence. It looks hungry for ammunition, and everything else in the painting appears to be held in suspense. Sailing-ship, train, factory chimney and figures lurking behind the arcade all wait for something to happen. Even the outside clock seems arrested, unable to move on towards half-past one. The sense of paralysis suddenly becomes intolerable, and the most likely way to end it must be the firing of the gun.

Why did de Chirico elect to deploy the image of a cannon and its ammunition, in a painting completed several months before the outbreak of war?[68] It may simply be a reference to the kind of nineteenth-century military monuments which had already appeared in his work, casting their shadows across the otherwise deserted squares. He could also have been drawing on boyhood experiences, for de Chirico recalled that 'while my father was away the cook Nicola kept a strange revolver under the pillow on his bed. It consisted simply of a cylinder attached to the stock . . . Later, in Italy, I saw revolvers of this type, but fitted with a barrel, on monuments representing soldiers and heroes of the Risorgimento. I was deeply impressed when I saw this strange mysterious weapon.'[69] He was equally excited when, gazing out from the balcony of his family home in the Thessalian port of Volos, he noticed an old ship called *Vesuvio* 'whose principal ornament consisted of an enormous cannon which had to be loaded from the breach, not with a single, compact shell, but with separate explosive, missiles and percussion cap.'[70]

These potent childhood memories do not altogether explain why de Chirico should give a cannon such a prominent position in one of the largest and most considered paintings he produced in the first half of 1914. He shied away from any attempt to pin down the motives behind his work or the meanings they harboured, arguing

21 Giorgio de Chirico *The Philosopher's Conquest* 1914. Oil on canvas, 125.1 × 99.1 cm. The Art Institute of Chicago. Joseph Winterbotham Collection.

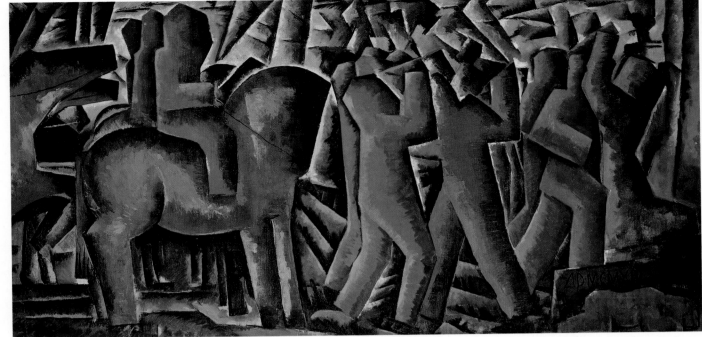

22 Man Ray *AD MCMXIV* 1914. Oil on canvas, 94 × 176.5 cm. Philadelphia Museum of Art.

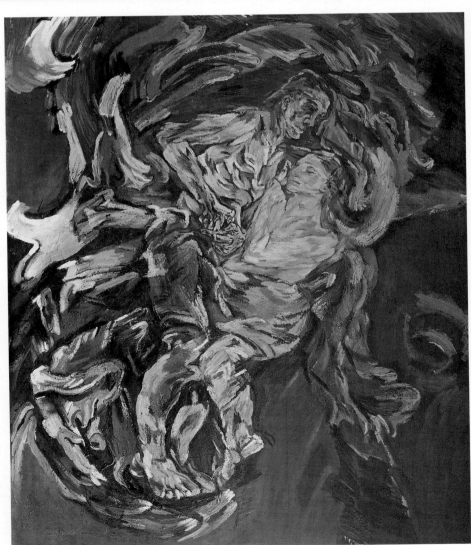

23 Oskar Kokoschka *The Tempest* 1914. Oil on canvas, 181 × 221 cm. Oeffentliche Kunstsammlung, Kunstmuseum, Basel.

that 'the revelation we have of a work of art, the conception of a picture *must* represent something which has no sense in itself, has no subject, which from the point of view of human logic *means nothing at all.*' But he also explained that he was driven to paint 'by a force greater than the force which impels a starving man to bite like a wild beast into the piece of bread he happens to find.'[71] An anxious, unaccountable premonition of war would amount to just such a 'force', and de Chirico may well have used his early recollection of a revolver and a cannon to give this urgent intuition pictorial expression.

A similar compulsion, to deal with warlike subject-matter by referring to the past rather than the present, is detectable in a grand frieze-like canvas which Man Ray started painting during the summer of 1914 (Pl. 22). In America, artists had every excuse to remain oblivious of the rising militarist tide threatening European stability. Man Ray, sequestered in the rural fastness of Ridgefield in the hills on the far side of the Hudson River, could easily have concentrated all his energies on landscapes and portraits of his lover the Belgian poet Donna Lacroix. When he began work on this ambitious picture, however, the subject turned out to be centrally concerned with combat. He recalled later that it was executed 'on a specially prepared canvas to make it look like a fresco painting, which was first to fill a space in our living room.'[72] Reading about Uccello's perspectival researches had prompted the desire to make the image, and its dimensions seem to have been conceived as a homage to the San Romano battle-pieces. Other artists would be inspired by the same source after the war had commenced (see Pls. 45, 305), but Man Ray set out to ignore the spatial recession for which Uccello had striven. Having recently been impressed by the spirit of renewal in the Armory Show, he was anxious to honour the integrity of the flat canvas by working in a two-dimensional manner. Although the figures in his picture possess an almost sculptural solidity, he did not allow them to penetrate far behind the surface of the design. They remain gathered at the forefront, struggling with each other in a space clotted with the mass of their bodies, deep blue pitted against a rust-coloured ground reminiscent of dried blood. Simplified into their most elementary compoments, these gesticulating forms are devoid of individuality. Hostilities have, it seems, transformed them into featureless fighting machines dedicated to violence alone. The men seated on their mounts nearby are equally dehumanized; and although Man Ray thought of 'the Trojan horse'[73] while painting them, they are not limited to a particular moment in history. Rather does he strive for universality in this sombre, remorseless picture, inspired by the belief that war is a continually recurring urge.

Man Ray would have been astonished and dismayed to learn, when he began this painting, that a world war would break out before its completion. But in August 1914 his obsession with conflict was borne out by the news from Europe. 'I was finishing my large canvas', Man Ray remembered; 'Donna said it was prophetic, that I should call it War. I simply added the Roman numerals in a corner: MCMXIV.' By prefixing them with the letters 'AD', he made clear his own awareness of the picture's unlooked-for topicality. The decision to employ Roman numbering demonstrated, nevertheless, that he viewed the onset of a fresh war in the context of all its gruesome predecessors. Ridgefield itself remained unaffected by the news, and when Man Ray visited New York he found the city in a repugnant state of elation. 'It was a field day for the newspapers with their accounts of battles and atrocities', he recalled, describing how 'Wall Street was booming; speculators were reaping fortunes in a day. During my lunch hour when in town I walked around the streets near

the stock market, filled with gesticulating employees shouting to men in the open windows of the offices, transmitting orders to buy and sell. It was like a great holiday, all the profits of war with none of its miseries.' Returning to Ridgefield, he realised that the grimmest forebodings expressed in *A.D. MCMXIV* had been confirmed. 'Walking home in the evening through the silent wood, I felt depressed', he wrote, 'and at the same time glad that we had not yet been able to get to Europe. There must be a way, I thought, of avoiding the calamities that human beings brought upon themselves. Wasn't it enough to wage the slow battle against nature and sickness?'[74]

Man Ray must have known, however, that events in Europe had gone too far to be halted now. When Donna wrote a pacifist poem for a portfolio published some months later, he illustrated it with a drawing of his big war picture.[75] But such protests could not affect the course of events in Europe, which had assumed an unstoppable momentum ever since the first fateful decisions were taken. In Vienna, at the heart of the Hapsburg Empire, Kokoschka heard the newsvendors calling through a hot July morning that Austria had declared war on Serbia. Although the Austro-Hungarian army did not cross the Danube to invade Serbia for several weeks, the declaration of hostilities set in chain a sequence of similar decisions which swept up the rest of Europe in the conflict. It was as if the elemental disturbance dramatized in Kokoschka's recent painting, *The Tempest*, had widened to encompass an entire continent (Pl. 23).

The picture was principally concerned with the relationship between the artist and Alma Mahler, whose mutual infatuation began to wane in 1914. Despite their physical proximity, in a painting which seems initially to celebrate the union they once enjoyed, Kokoschka has awoken and stares mournfully beyond the sleeping Alma. Conscious of his isolation, he digs his anguished fingers into each other and surveys the impermanence of a love about to be destroyed by the force of the storm encircling them. Kokoschka was sufficiently influenced by Vienna's proccupation with the power of the unconscious to appreciate that the tempest was the result, not of a climatic crisis, but of their own inner tensions. Sleep gave him access, through dreams, to the source of his anxieties, and he used the tempest as a metaphor for the forces which threaten to sunder their intimacy. They already appear to be adrift, floating in an ice-blue region where

24 Dorothy Shakespear *War Scare, July 1914* 1914. Watercolour on paper, 25.5 × 35.5 cm. Collection of Omar S. Pound, Princeton.

angry waves fuse with equally turbulent clouds beneath an elegiac moon. Kokoschka depicts himself as an emaciated figure who seems to be confronting the prospect of death. He made sketches for a crematorium mural around this time, and *The Tempest* echoes these funereal concerns by giving him the blanched aspect of a corpse. Kokoschka had no means of telling, at this stage in 1914, that he would eventually be close to death on the battlefield. But *The Tempest* seems, with hindsight, to be haunted by a premonition of his near-fatal wounding, just as the storm itself anticipates the commotion which afflicted Europe soon after he completed the painting. It seems wholly appropriate that Kokoschka should have decided, soon after completing *The Tempest*, to sell it in order to raise money for the uniform he needed to join the cavalry and fight in the war.

When Dorothy Shakespear executed a watercolour in London entitled *War Scare, July 1914*, she hardly needed prophetic powers to divine the import of the event which inspired her (Pl. 24). Inscribed on the back of the paper is a brief explanation, testifying that the watercolour was executed 'when the Stock Exchange shut, before war was declared'. Although Shakespear refrained from revealing the reason why the picture was made, it shows how disturbed she felt by the end of that uneasy month. The language employed is virtually abstract, but most of the forms seem to be aimed at the large architectural mass in the uppermost area of the design. Evoking gun-barrels, missiles and shafts of lightning, they converge on their target like an invading force determined to eliminate the opposition as quickly and efficiently as possible. The prospect of war pushed Shakespear into making an image far more belligerent than anything she had earlier produced. Before marrying Ezra Pound in April 1914

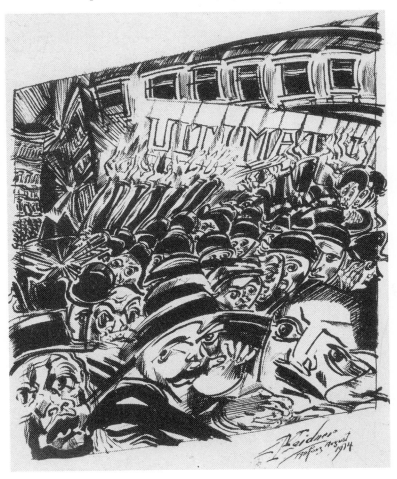

and frequenting Vorticist gatherings at the Rebel Art Centre, she had been devoted to landscape painting of a decidedly lyrical kind. Meeting the emergent Vorticists transformed her art, and she was especially impressed by Wyndham Lewis's role in the group, 'I watched it all with deep interest', she remembered, adding that 'I certainly never had any "lessons" from him but the movement came just as I needed a shove out of the Victorian.'[76] *War Scare, July 1914* shows just how much of a 'shove' she was prepared to accept. Jolted both by Lewis's provocative example and the mounting rumours of war in London, Shakespear here pushed her work towards a non-representational extreme, deploying a range of outspoken colours which accentuate the picture's strident impact. She may subsequently have concluded that it was too radical, for the inscription on the back of the watercolour declares that it ought 'NOT *to be shown* to any body.' But *War Scare, July 1914* now looks like a wholly appropriate response to the historical moment which inspired it. The abstraction developed by Shakespear helps to emphasize the looming, destructive and above all impersonal character of the conflict ahead.

Only an artist of Meidner's visionary fire was, however, capable of defining the anguish of a nation about to be engulfed by war. At the very beginning of August 1914, Germany waited for Russia to respond to an ultimatum demanding demobilization within twelve hours. If Meidner's inscription on the drawing is correct, he produced *On the Eve of War* during that period of acute tension (Pl. 25). Berlin crowds jostle beneath a banner bearing the word ULTIMATUM in forceful capitals, bigger and more exclamatory than any hoarding. A cluster of arms rise up before it, as though to salute the spirit of apparent resolve behind the German government's demand. But as they become visible, the faces in Meidner's agitated drawing bear expressions very far from gleeful. The bowler-hatted men look apprehensive, even appalled. The women share their concern, and in the foreground one of them widens her eyes to the point of outright hysteria as she contemplates the prospect ahead. As for the old man on the left, he opens his mouth in an involuntary cry. His anguish is intensified by a sense of impotence, for the crowd knows that the ultimatum can only have one outcome. On 1 August, after the request to demobilize was rejected, Germany declared war on Russia. Listening to the proclamation on that decisive day, Meidner would have realised that the Armageddon forecast two years before in his apocalypse paintings was about to be unleashed. All the same, not even he could have guessed at the full, protracted extent of the horrors inflicted on Europe during the struggle to come.

25 Ludwig Meidner *On the Eve of War* 1914. Pen, pencil and ink on paper, 83 × 66.5 cm. Städtische Kunsthalle, Recklinghausen.

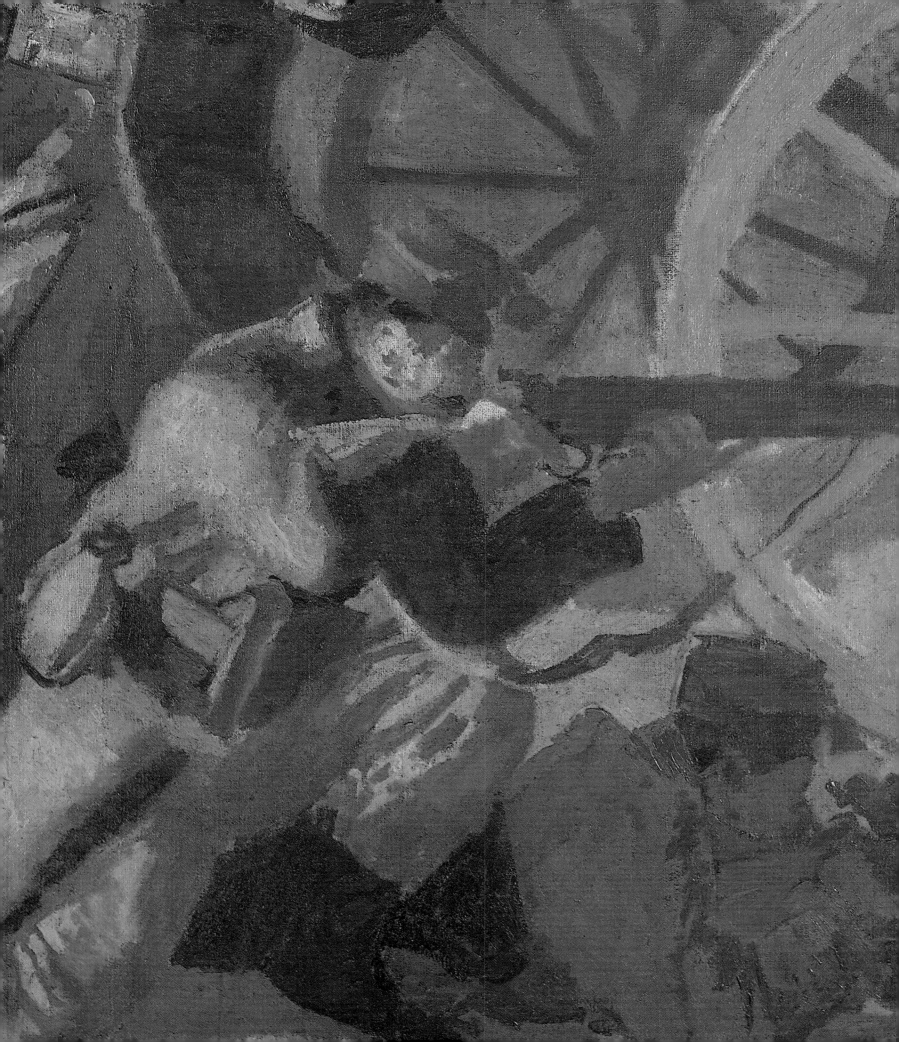

CHAPTER TWO
HOSTILITIES COMMENCE
(1914–15)

Soon after war was officially declared in Germany, Max Beckmann produced a powerful etching of a *Weeping Woman* (Pl. 26). Although her elaborate hat implies that she is out of doors, and possibly part of a Meidner-like crowd reacting to the fateful news, Beckmann presents this woman as an isolated being. Oblivious of the other face frowning behind her shoulder, she seems enclosed within an entirely private grief. Perhaps the announcement has reminded this mournful figure of a bereavement she suffered during a previous war: the excited reactions of the other people in the street would, in such a melancholy context, sound grotesquely misplaced. But Beckmann invests her ageing features, which bear the marks of past adversity clearly enough, with a chorus-like significance as well. Her eyes, almost lost in the deep shadows created by the drypoint, possess a mesmeric authority. They gaze out from the recesses of her misfortune as if to imply that a similar mournfulness will soon assail everyone around her. The wing forms stretching into the air from the rim of her hat accentuate this oracular quality, and her downturned mouth rules out any possibility of a favourable outcome to the hostilities. No amount of dabbing with a handkerchief will stem the tears once the killing commences.

In one sense, Beckmann's readiness to greet the advent of war with a tragic image coincides with his pre-war interest in topical disasters. *Scene from the Destruction of Messina* and *The Sinking of the 'Titanic'* were among the most deeply considered of his previous paintings, and in the '*Titanic*' canvas he concentrated on the plight of survivors either crammed into lifeboats or struggling for life in the icy waters nearby. But Beckmann did not view their suffering with pessimism. Although manifestly indebted to Géricault, this enormous canvas lacks the strain of macabre agony to be found among the figures on *The Raft of the Medusa*. Beckmann may have been impressed by the sight of the apocalyptic canvases in Meidner's studio (see Pls. 1, 2), which he visited in 1912 after securing Meidner a monthly stipend of a hundred marks from an anonymous benefactor. But the '*Titanic*' painting still stops well short of frenzied despair. Even if Beckmann afterwards declared that the sight of Meidner's paintings 'powerfully stimulated him and gave him fresh impulses',[1] the liner's passengers endure their affliction with stoicism and resilience. 'Struggle is the element from which a new and vital humanity will emerge', Matthias Eberle wrote of this painting, arguing that Beckmann is dealing here with 'the incipient gods and heroes of the modern age'.[2] In other words, Beckmann favoured a Nietzschean view of the vessel's demise, following other German artists in his readiness to

discover hope in the spectacle of destruction. As early as February 1909 he had expressed a similar belief about war during a discussion with his brother-in-law, Martin Tube. Writing in his diary, Beckmann recorded that 'Martin thinks there will be a war. Russia France England against Germany. We agreed that it really would not be so bad for our present quite demoralized society if the instincts and drives were all to be focused again by a single interest.'[3]

Is it possible, therefore, to see behind the evident grief of *Weeping Woman* a lingering conviction, on the artist's part, that the onset of world war should be welcomed? Along with her genuine sorrow, does this suffering witness also display a dignity and fortitude which Beckmann imagined would emerge in a purified, strengthened state from the conflict? It is difficult to tell. The *Weeping Woman* does indeed demonstrate considerable poise despite her distress, and an innate resolve can be detected beneath the crumpled features. But Beckmann himself reacted to the outbreak of war by describing it as the 'greatest national catastrophe',[4] and his Nietzschean theories underwent a gradual erosion during the closing months of 1914. A significant change is already noticeable in two different states of another etching he produced after the *Weeping Woman*. Continuing with the theme of the crowd's response to the news, and yet widening his viewpoint to encompass a cluster of heads, Beckmann entitled this new drypoint *Declaration of War* (Pl. 27). Although none of the figures greets the announcement with delight, the range of reactions is wide. The two central men in the foreground appear relatively undisturbed as they direct their attention, frowning a little, at the newspaper reports in front of them. The faces peering on either side are aghast, however, as they ponder the full implications of the news. Their wide-eyed perturbation runs like a tremor through the heads behind, all jostling for space in the press of agitated bystanders. Over on the right, a boy frees himself from the group and opens his mouth in a Munch-like cry. But the dominant person in *Declaration of War* is once again a woman, who stares over the hats with a steady, grim-featured thoughtfulness. She conveys foreboding and resolution in equal measure. As Beckmann worked on the print, though, his mood grew more harsh. A later state of the etching is significantly darker, above all in the area behind the screaming boy. Blackness has descended there like a harbinger of the devastation to come, and it gives the entire crowd a more apprehensive air.

While Beckmann acknowledged the full horror of war only after he had volunteered for ambulance service on the Eastern Front in September 1914, Chagall viewed it with wholehearted consternation from the outset. In his case, Germany's decision to declare war on Russia forced him to remain in his native country for the duration of

Left: Walter Richard Sickert *The Soldiers of King Albert the Ready* 1914 (detail). See Pl. 50.

the conflict. He had originally intended to stay for less than three months after travelling, in June 1914, from Berlin to his family in Vitebsk. But within a week of the war's announcement, Chagall found that his return to Paris was impossible. The realisation that provincial Vitebsk had now become his prison added, no doubt, to his condemnation of the hostilities. Russia had decided on a general mobilization at the end of August, and in his autobiography Chagall described his emotions when confronted with the prospect of enlistment:

'Why don't they call me up?
I must wait my turn . . .
It looked as if they didn't even want me. I'm not reliable. I'm good for nothing. I haven't even any flesh on me. And colours – pink in the cheeks, blue in the eyes – colours don't make a soldier.'[5]

Chagall soon found himself reflecting the war atmosphere in his work. He even managed to invest the image of a newspaper seller with a disconsolate air. A powerful pencil drawing on grey paper concentrates on the bearded head, rearing gloomily above papers where the Russian word for 'war' is emblazoned. The vendor takes on the role of a sorrowful Cassandra, and Chagall subsequently decided that the figure he had created here deserved to be granted a still more prophetic status in an oil painting. *The Newspaper Vendor*

27 Max Beckmann *Declaration of War* 1914. Drypoint on paper, 19.8 × 24.8 cm. Private collection.

26 Max Beckmann *Weeping Woman* 1914. Drypoint on paper, 24.3 × 19 cm. Private collection.

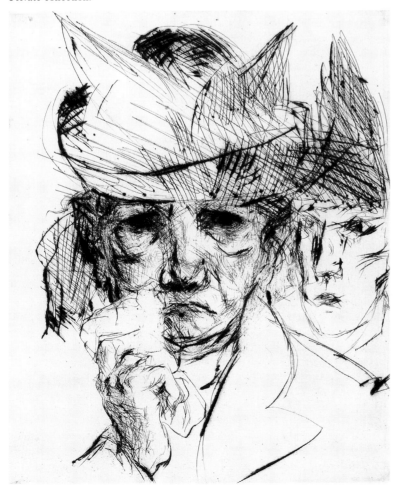

expands him into a half-length presence, wearing a grey cap and uniform which reinforce the depressing nature of the tidings he offers for sale (Pl. 28). None of the newspapers slung from his drooping shoulders contains the word 'war' this time, but its menace dominates the entire picture. The ample expanse of sky above him is filled with a red evocative of both blood and fire. Its vehemence is intensified in juxtaposition with the black spreading across both ground and buildings, which already appear to have been scorched by a bombardment. The austere planes of the newspapers refer, as Susan Compton observed,[6] to the language of Cubism, and one of the sheets bears the title of a St Petersburg journal where reviews of avant-garde exhibitions were regularly published.[7] But Chagall makes clear, in the rest of this haunting image, that he is now committed to a depiction of daily life in Vitebsk far more figurative than anything so far favoured by his most innovative contemporaries. The vendor inhabits a recognisable context, based on surroundings Chagall had known since childhood, and the liberties he takes with form and colour are all dedicated to heightening the significance of a fateful moment in Russia's history. The tiny orange flicker in the lamp-post cannot dispel the funereal atmosphere enveloping the town. A figure staring out of a penumbral window seems to be oppressed by the vendor's sadness, and the white flowers symbolizing death in the neighbouring window are almost extinguished by the encircling gloom.

During these early stages of the war, Chagall pursued its profound effect on the Russian people like a novelist unfolding an inexorable narrative. In *The Smolensk Newspaper*, the grim headline has been purchased from the vendor and brought indoors for lengthier perusal. There it lies on the rudimentary wooden table, with the word 'war' once again revealed in all its starkness underneath the title 'Smolensk News'. Although the presence of the word seems to transfix both the men who sit contemplating its implications, they react in very different

28 Marc Chagall *The Newspaper Vendor* 1914. Oil on canvas, 98 × 78.5 cm. Musée National d'Art Moderne, Centre Pompidou, Paris.

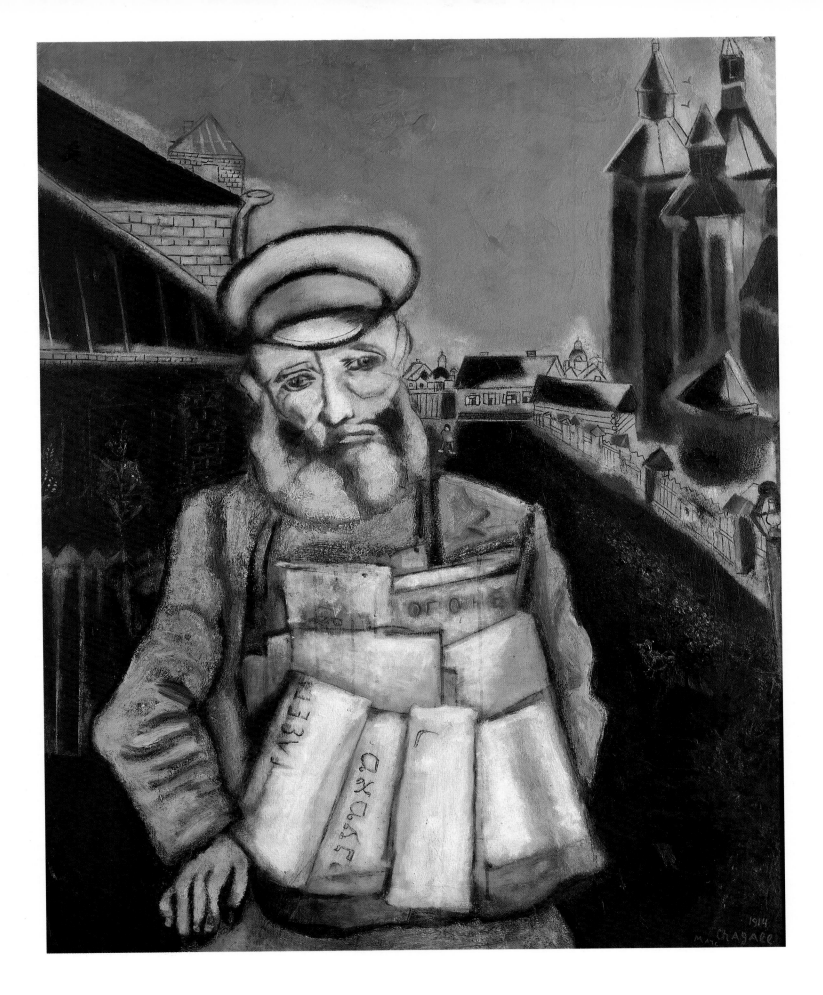

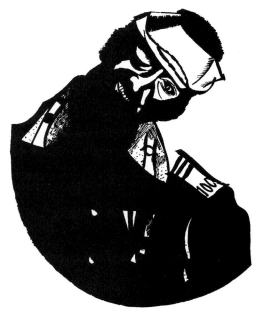

29 Marc Chagall *Wounded Soldier* 1914. Indian ink and pen on paper, 22.3 × 17.2 cm. Tretyakov Gallery, Moscow.

ways. The old man recoils from the paper, clutching his beard in a defensive gesture which indicates that the news reawakens memories of older wars fought during his youth. But his companion is more animated, gesturing with one hand while the other taps his hat at an angle giddy enough to signify displacement. Just as his hat no longer sits securely on his head, so his whole life now appears in jeopardy. He exclaims, while the old man withdraws into a hunched stance suggesting helpless resignation and the futility of protest. The mysterious pale green orb surrounding the gas lamp encompasses them both, however. It suggests that they are caught up in a shared dilemma – one which is bound to transform their future.

The next stage in the narrative is dramatized by an ink drawing, restricted to harsh monochrome as Chagall depicts the soldiers' moment of departure from home (Pl. 30). The young woman on the right of this design smiles as she lays her head on the shoulder of a man who could be her lover, fiancé or newly-wed husband. Her closed eyes imply an unwillingness to confront the likely outcome of his leave-taking. She is, no doubt mercifully, absorbed in love, and her display of devotion may be intensified by the pride she takes in his smart uniform and militant ardour. Only her hand, grasping his coat with splayed fingers, demonstrates a more agitated reluctance to see him go, but Chagall ensures that the moment of departure takes on a more woeful dimension in the rest of the drawing. The child in the centre parts his lips to utter a cry. Although more restrained than the yelling boy in Beckmann's *Declaration of War* (Pl. 27), he sounds a note of warning in the shadows of the room. His concern turns into anguish for the haggard woman in a scarf, who appears to be beseeching her husband. He inclines a sympathetic ear towards his wife's entreaties, and considerable sadness dominates the expression he wears in order to confront the prospect ahead. There is, nevertheless, an air of weary submission about him. He cannot escape enlistment, and no amount of pleading from his wife will affect the future he is obliged to endure.

In another drawing, bearing the terse title *War*, Chagall again combines in a single image the departing soldiers and the relatives

they leave behind. Now, however, the separation is irrevocable. A young recruit embraces his girl beyond one window, but the words curling into the sky like smoke after an explosion emphasize how far he might have to travel once they have parted: 'War – 1914 – Russia – Serbia – Belgium – Japan – France – England.' So the infantrymen marching outside the other window are exchanging the womb-like security of Vitebsk for distant, wholly unknown territories, and the bearded old man left inside the room seems possessed by terrible misgivings. Seen in near-silhouette against the cruciform structure of the window bars, his dark body sags under the weight of sadness. Although his hands reach down through the shadows as if to support his legs, they buckle at the knees. He knows, from long experience, that war can only bring tragedy to those involved, and Chagall is clear-sighted enough to insist on an anti-heroic view of the conflict even in its early, most militant phase.

Judging by a little painting called *The Salute*, Chagall had little time for the absolute obedience demanded by the armed forces. The aloof officer arrayed in his crisp green uniform stiffens as a pink-faced soldier salutes and utters an automatic response to the issued command. With hindsight, it is tempting to see in the gulf between these faces a hint of the deep social divisions which would later widen into national revolution. Apart from the ritual they both enact, no real contact or understanding unites the figures in a shared view of the struggle to come. Not that Chagall automatically sided with the ordinary infantryman against the officer class. Trapped in Vitebsk, he viewed everyone involved in the war with repugnance. 'Soldiers, moujiks in woollen caps, with laptis on their feet, pass in front of me', he recalled later, describing how 'they eat, they stink. The smell of the front, the stench of herrings, tobacco, fleas.' Their presence brought home the horror of war: 'I hear, I feel the battles, the gunfire, the soldiers buried in the trenches.' When the injured began to arrive, however, all this revulsion gave way to guilty compassion. 'Another wounded man looks at me with an air of reproach,' Chagall wrote. 'He is pale, he is old and thin, like my bearded grandfather.'[8]

In the work he produced as a response to the war, Chagall insists that its victims are always left to suffer their misfortune alone. Nobody alleviates the agony of the *Wounded Soldier* (Pl. 29), surely the same bearded man who had said farewell to his wife in *Leave-taking Soldiers*

30 Marc Chagall *Leave-taking Soldiers* 1914. Pencil and ink on card, 22.6 × 36.2 cm. Kunstmuseum, Basel.

(Pl. 30). His cap is replaced now by a bandage stemming a head wound, and he tilts his neck at an angle alarming enough to suggest acute mental disorientation. He exposes his teeth in a snarl of bitterness, but nothing can ease the pain or enable him to raise the lid flapping loose over his right eye. The other pupil stares out fixedly, condemned to relive the trauma of battle rather than welcome the chance of recuperation. He seems possessed by rage, not only at his own fate but also, perhaps, at the conduct of a campaign that had already resulted in a severe defeat for Russia at the disastrous battle of Tannenberg, where an entire army was broken by the German forces and 90,000 soldiers became prisoners of war.

The excoriating mood of Chagall's drawing of the wounded soldier could hardly be further removed from the pre-war innocence displayed by the men in Larionov's series of soldier paintings (see Pl. 8). They had been essentially playful, presenting the artist's experience in military service as a time of conviviality, games and an almost arcadian preoccupation with comradeship. Larionov may have influenced Chagall in stylistic terms, but this blissful gambolling played no part in the 1914 images of soldiering produced by the young artist stranded in Vitebsk. One deft watercolour shows Chagall in a relatively light mood, defining the comic glumness of the soldiers walking home with heavy loaves jammed under each arm. But the majority of these wartime images concentrate on the conflict's more harrowing aspects. Vitebsk played an important part in Russia's eastern defences, and Chagall would not have needed to wait very long before returning combatants bore witness to the reality of war. His story-telling bent is more evident than ever in a watercolour and gouache study of *The Wounded Soldier*. Tottering on legs scarcely able to support him, the blanched figure holds out his left hand like a blind man seeking to anticipate any obstacles in his path. With his right arm swathed in a sling as white as his face, this forlorn invalid is the very antithesis of

the heroic, impregnable soldiers portrayed in propaganda posters of the period.

The fact that Chagall produced a series of similar images, all concentrating on the human cost of war, suggests that he felt impelled to counter the prevalent view that fighting Germany was an irresistible and wholly glorious adventure. He was one of the first artists anywhere to offer a sustained alternative to the militarist ideal of 1914, and his own early tribulations as a Jew from the provinces must have made him predisposed to sympathize with the plight of war's victims. *The Wounded Soldier* is not confined to a depiction of unrelieved suffering. It is a more tender work than the harshly scored pen drawings, and the man's outstretched left arm also seems to be summoning and acknowledging a grateful memory of assistance on the battlefield. Lurching under the impact of his wound, the soldier was led carefully away by two friends. The recollection of their help sustains him now as he staggers along the streets of Vitebsk, wondering no doubt whether they will ever return from the war to greet him again.

The affirmative side of *The Wounded Soldier* accords with John Russell's observation that the youthful Chagall's 'first purpose was to heal the hurt of living in a society which denied him certain fundamental human rights.'[9] His remarkable sequence of 1914 war pictures shows how instinctively he was drawn, without first-hand experience of the fighting, to the 'hurt' inflicted on people engaged in the conflict. All the same, *Man on Stretcher* deals with nothing except bitter experience of a battle which reduced the subject to helpless pain, probably centred on the wound he covers with his hand. He seems resigned to the knowledge that no one will help him, and in another drawing Chagall shows a woman weeping over the inert form of a man who is now beyond assistance of all kinds (Pl. 31). Confronted with the finality of death, there was no point in holding out hope for the amelioration of tragedy any more.

31 Marc Chagall *Woman Crying* 1914–15. Indian ink and gouache on paper, 16.2 × 32 cm. State Russian Museum, St Petersburg.

32　August Macke *Farewell* 1914. Oil on canvas, 100.5 × 130.5 cm. Ludwig
Museum, Cologne.

If August Macke had survived the first stage of the war, he might
well have arrived at a similar understanding. Although his large
painting *Farewell* was only entitled retrospectively, it reveals how
deeply he sympathized with the people involved in the countless
departures enacted throughout Germany during August 1914 (Pl.
32). His own mobilization for the infantry brought about an extra-
ordinary change of mood in his work. Only a few months before,
Macke had undertaken a spring trip to Tunisia with Klee and Louis
Moilliet which generated the most radiant of all his works. Always the
most luminous and equable of the Expressionists, he discovered
during the visit a heightened enjoyment of colour which can only be
called ecstatic. Previous works had shown how blithely he was attracted
to brilliant spectacle, whether the tempting display in a grocer's
window, the Red Indians in Buffalo Bill shows or the orchidaceous
plumage irradiating parrots at the Cologne zoological gardens.
Tunisia, though, brought out a new spirit of exaltation in him. Inspired
by the overwhelming heat and light of his new surroundings, Macke
reached a luminous pitch of refinement which makes his death in the
autumn seem particularly abhorrent.

Like so many of his contemporaries, he greeted the declaration of

war with an initial enthusiasm that led him to anticipate 'walloping'
the French in August. Max Ernst, who remembered that 'nobody in
our circle of friends was in any great hurry to lay down his life,' could
not understand such bravado. 'Macke's attitude disconcerted us,'
Ernst recalled. 'Influenced by Futurism, he accepted war not only as
the most grandiose manifestation of the modern age but also as a
philosophical necessity (war being necessary for the realisation of the
idea of humanity!). His belligerence, however, had not the slightest
trace of patriotism.'[10] Macke's jauntiness is conveyed in a small
version of the *Farewell* theme, where a blithe young man theatrically
tips his hat to a devoted woman before taking his leave. Although
there is a hint of wistfulness in the woman's stance as she leans for-
ward on her balcony, no sorrow is permitted to disrupt the prevailing
mood of gallantry and romance.

In the large *Farewell*, by contrast, every hint of joie-de-vivre has
been expunged. To compare the austerity of this painting with the
smaller version is to comprehend just how drastic a change Macke
had suddenly undergone in his perception of war. The children
inhabiting the centre of the canvas are as motionless as their mothers,
and they entirely lack the animation which Chagall gave his women in

the drawing of *Leave-taking Soldiers* (Pl. 30). Drained even of the urge to protest, these heavily shawled wives stand mute while their husbands lean to one side in dejection. The backs they present to the Munch-like women signify their withdrawal from family life, but it is unaccompanied by any sense of release on their part. These men appear bowed down by the urge to fight for their country, and the male figure who walks away from them looks prematurely fatigued as he contemplates the finality of his commitment to war. The most ominous of all the people in this dour, autumnal canvas are, however, the two women standing together in the distance. Their pale faces are devoid of features, as if veils hung down over them, and their black coats sound an inescapably funereal note. Like Beckmann's *Weeping Woman* (Pl. 26), they may have experienced bereavement during some earlier conflict. Their silhouettes cast a pall over everything else in sight, and their jagged contours are echoed in the fragmented structure of the ground sloping so steeply towards the paralysed figures who congest the foreground with their melancholy bulk.

Soon afterwards, Macke was sent with his Rhineland Regiment to France on 8 August. Whatever Nietzschean illusions he may still have harboured about the purgative value of war were quickly destroyed. 'It is all so ghastly that I don't want to tell you about it,'[11] he wrote to his wife Elisabeth a month later, anxious to shield her from his experiences. Within a couple of days he tried, in another letter, to reassure her by declaring that 'I'm healthy and in a good state of mind.' But the fact remained that, as he went on to reveal, 'up to now I've fought at the battles in Porcheresse, Bièvre, Montgou, Lissy, Luxémont, Vitry.' Macke could hardly expect to continue enduring such a succession of engagements without harm to mind and body alike. The strain must have been immense, and he was unable to prevent himself from protesting in the same letter that 'the people in Germany, drunk with ideas of victory, don't suspect how terrible war is.'[12]

A few weeks afterwards, on 12 October 1914, Macke went missing in yet another battle at Perthes-les-Hurlus. He was a young man, still at the beginning of an exceptionally promising career, and the loss to

33 Ernst Ludwig Kirchner *Sailor Saying Goodbye* 1914. Crayon, brush and ink, 42.7 × 50.7 cm. The Museum of Modern Art, New York. Gift of Mr and Mrs Eugene Victor Thaw.

modern German painting was considerable. His close friend Marc certainly thought so. Appalled by this early news of an outstanding artist's death, he began to question his own earlier belief in the positive aspects of destruction. Writing an impassioned tribute to Macke, he wondered at the senselessness of chance's insistence 'that among a thousand brave men a bullet should hit one who is irreplaceable. With his death a hand has been severed from the arm of the people; an eye blinded. How many terrible mutilations must our future culture suffer in this gruesome war? How many a young spirit will be murdered whom we never knew and who bore our future within him?'[13]

The oppressive sadness of Macke's large version of *Farewell* had been borne out far sooner and more brutally than the artist himself could have expected in August 1914. But he was not the only German artist to produce an image of departure which predicted the anguish ahead. Kirchner, who had already spent much of that year painting prostitutes strutting on the Berlin streets like armed warriors ready for the nocturnal fray, reacted to the advent of war with greater emotional violence than Macke. The hectic drawing of a *Sailor Saying Goodbye* (Pl. 33) has no time for the subdued, almost acquiescent sorrow conveyed in Macke's *Farewell*. Kirchner's embracing pair is closer in spirit to the principal couple in Chagall's *Leave-taking Soldiers* (Pl. 30), but the bodily contact between sailor and woman is far more disturbingly presented. She hurls herself against the man with shocking vehemence. Departure for war is seen here as the agent of trauma, generating within the woman an hysterical determination to prevent the severance from taking place. Whether impelled by a desire to remain in close physical union with the sailor, or a wish to protect him from the dangers of military engagement, she acts with the impulsiveness of someone momentarily deranged by panic. He reacts by clasping her shoulder in an urgent, claw-like gesture, and the flailing lines reinforce the feeling that departure has been transformed into an outright struggle against an event which tears men and women from each other's grasp. But the hull of the sailor's ship rears behind him, like an inexorable reminder that military imperatives will prevail in the end.

Kirchner himself acknowledged those imperatives, after war was declared, by volunteering for service as a driver in an artillery regiment. He would have realised, soon enough, that the embrace defined with such whiplash force in *Sailor Saying Goodbye* was almost indistinguishable from the spectacle of soldiers locked in strife. Wyndham Lewis, while delaying his enlistment until 1916, nevertheless became preoccupied with images of implacable physical engagement in 1914. His *Combat No. 2* relies on a steely command of line to give three clusters of combatants a dehumanized conviction (Pl. 34). The militant manifesto in *Blast* magazine had earlier described the Vorticist artists as 'Primitive Mercenaries in the Modern World',[14] and in *Combat No. 2* aesthetic insurgency gives way to the altogether more sinister reality of a struggle to the death. Each pair of soldiers appears to have merged, so that it is no longer possible to distinguish one fighting form from the other. They fuse in an eerie dance, and the only resolution of their mechanistic writhings lies in a killing. Lewis had anticipated this macabre choreography in an essay on 'The New Egos' some months prior to the war, where he argued that for 'the modern town-dweller of our civilization ... impersonality becomes a disease.' In a passage directly prophetic of the vision he would define in *Combat No. 2*, Lewis described how 'the frontiers interpenetrate, individual demarcations are confused and interests dispersed. According to the most approved contemporary methods in boxing, two men burrow into each other, and after an infinitude of

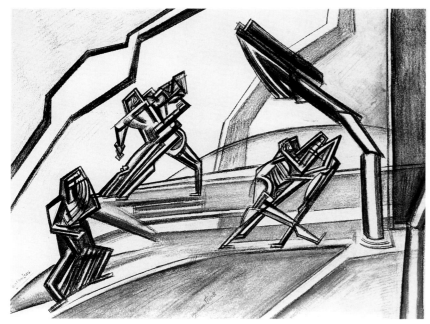

34 Wyndham Lewis *Combat No. 2* 1914. Pen, ink and chalk on paper, 27.5 × 35 cm. Courtesy of the Board of Trustees of the Victoria and Albert Museum, London.

little intimate pommels [*sic*], one collapses. In the old style, two distinct, heroic figures were confronted, and one ninepin tried to knock the other ninepin over. We all today (possibly with a coldness reminiscent of the insect-world) are in each other's vitals – overlap, intersect, and are Siamese to any extent.'[15]

The three armoured couples cranking their piston-like limbs across the bare, stage-set arena in *Combat No. 2* suggest that Lewis's theories found their sinister fulfilment in war. He presents the struggle with bleak objectivity here, obeying his own earlier insistence that 'in a Vorticist Universe we don't get excited at what we have invented.'[16] But the closely related *Combat No. 3* offers a rather more anguished interpretation of the same theme. Using a warm orange chalk, which lends a softer quality to the scene, Lewis replaces the angular props of *Combat No. 2* with more rounded alternatives. They bulge in an organic manner behind the two struggling figures, indicating that a landscape rather than an urban context is now depicted. The centre of the drawing is dominated, unequivocally, by the fierce and brutal aggregate of forms in strife. Their harsh interlocking is, however, juxtaposed with the figure of a woman seated under a nearby tree. She sets her face in a mask of weary resignation, and the hands clasped in front of her suggest that she is praying like a mother for the safety of an endangered son.

Her anxiety was fully shared in the Berkshire village of Cookham, where Stanley Spencer's parents confronted the prospect of losing at least five of their seven sons in the conflict. Even Stanley, small in height and slight in build, insisted with his brother Gilbert on joining the Maidenhead branch of the Civic Guard and a local brigade of the St John's Ambulance Corps as well. Their parents had declared that they would only allow the two brothers to become medical orderlies. But making this stipulation did not lessen Mr and Mrs Spencer's inevitable alarm, and Gilbert dramatized their concern in a large, arresting painting of *The Crucifixion*. The bearded figure nailed to the wood bears an unmistakeable resemblance to his father, helpless in patriarchal martyrdom as five young men help to push the cross up-right. Although the painting implies that the Spencer sons' willingness

to volunteer for Front-line duties is causing their father unimaginable suffering, Gilbert had no intention of abandoning his army plans. Nor did Stanley, and yet an openly disturbed painting of *The Centurion's Servant* indicates some, at least, of the apprehensiveness which war generated within him (Pl. 35).

He intended the picture as half of a projected diptych, which would in the companion canvas have shown the centurion's messenger appealing to Christ. The latter image was never painted, probably because the advent of war upset all Stanley's plans. But *The Centurion's Servant* seems complete enough in itself, and its overt anguish introduces a new mood to Spencer's work. Until August 1914, his entire output as a painter had been bound up with the need to celebrate. Now, however, the outbreak of hostilities burst in on the visionary paradise he had constructed in Cookham. Although *The Centurion's Servant* takes as its setting the servant's attic bedroom in his family home, which he associated with an aura of religious wonder, it takes on here an air of unease. The dark walls, as bare and uninviting as the floorboards beneath the iron bed, appear to press in on the figures ranged like a tragic chorus beyond the mattress. One of them looks back at the wall as if conscious of its oppressive presence, while another raises clenched hands in front of her face and parts her lips in a cry. Spencer later revealed that he had drawn on memories of an elder brother's illness, which led the rest of the family to pray around the bed. In the painting, however, he personalizes the scene by portraying himself, not only as the central attendant gazing down at the pillow, but as the servant, too.

In the picture's biblical source, Christ heals the stricken youth from a distance, and Spencer intended the painting to have a redemptive significance. Nevertheless, his misgivings about the war give *The Centurion's Servant* an even greater feeling of disquiet. His biographer Kenneth Pople argued that it should be seen as an allegory comparable with Gilbert's *The Crucifixion*, and detected within it 'the visual equivalent of a personal nightmare or sleepwalk.'[17] He was right to do so, for the painting derives much of its power from a mood of almost unbearable expectancy. The servant may be undergoing a miraculous recovery, but he still appears to suffer from a lingering sense of dread. While one hand is raised defensively against his mouth, the other pushes out beyond the safety of the bed with diffidence, doubtless reflecting Spencer's own nervousness at the thought of leaving his family home for the uncertainties and dangers of army service.

De Chirico, whose awareness of the same threat made him reluctant to leave Paris and involve himself in the war at all, now began painting images like *The Sailors' Barracks* which refer indirectly to the conflict (Pl. 36).[18] The title of the picture transforms the arcades familiar from his previous work into a military setting; and the absence of humanity – apart from the two familiar silhouettes in the distance – implies that the barracks have recently been vacated. The sailors are, perhaps, on full alert at sea, leaving behind them a strange assortment of metaphysical objects on the tilted foreground plane. Suggestive of the games played by sailors in their recreational hours, the chequerboard, balls and pipe look as if they might at any moment slide off this sloping surface altogether. The feeling of impermanence is quietly persuasive, implying that games will henceforward be replaced by a more unsettling alternative. Although de Chirico is too much in love with enigma ever to specify what this alternative might be, he was certainly distressed by the advent of hostilities. He remembered later how 'hot and sultry' it was when 'the terrible calamitous war'[19] arrived, and 'everything became confused and uncertain . . . We remained in Paris amidst the great tension of the

35 Stanley Spencer *The Centurion's Servant* 1914. Oil on canvas, 114.3 ×
114.3 cm. Tate Gallery, London.

first days of fighting; the Germans were advancing on the capital. Every evening, towards sunset, isolated German aeroplanes flew over Paris, scattering manifestoes and streamers inciting people to surrender. But as I was going back home one morning about 11 o'clock I heard a shot. At first, I thought it was the cannon fired at midday and took out my watch to see the time; but then I saw many people running to a place nearby; I joined the crowd. An aeroplane had dropped a small bomb which had fallen on the pavement, killing an old gentleman and fracturing a girl's leg. An ambulance arrived at high speed; I heard people in the crowd cursing the *Boches*; there were bloodstains on the ground.'[20]

In *The Evil Genius of a King*, probably completed soon after *The Sailors' Barracks*, the sense of abandonment and vertigo is still more pronounced. This time the foreground plane tilts at an alarmingly steep angle, so that the objects lying there seem in imminent danger of careering downwards to oblivion. They are as brightly coloured as children's toys, implying that their owner has discarded them after a tantrum. But he is a king rather than an angry boy, and his displeasure means that the whole of Europe is threatened by the upheaval. Although the distant arcade occupies a position similar to its predecessor in *The Sailors' Barracks*, its shadowy arches are now about to be obliterated by the slope rearing so ominously in front. With deceptive quietism, de Chirico manages in *The Evil Genius of a King* to view monarchical rage as the agent of chaos.

Plenty of artists were ready, nevertheless, to greet the onset of war

36 Giorgio de Chirico *The Sailors' Barracks* 1914. Oil on canvas, 81.2 × 64.8 cm. Norton Gallery and School of Art, West Palm Beach, Florida.

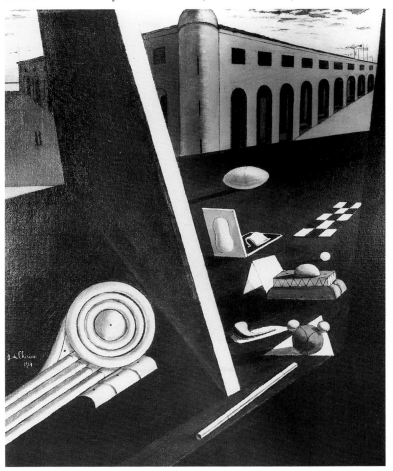

37 Peter August Böckstiegel *Departure of the Youngsters for War, Study* 1914. Oil on canvas, 96 × 170 cm. Peter August Böckstiegel-Haus, Werther über Bielefeld.

with unashamedly patriotic and belligerent images. The hapless Macke had been right to hit out against his fellow-Germans' willingness to become 'drunk with ideas of victory',[21] for the initial wave of militant fervour proved difficult to resist. Within weeks of the war's declaration, the avant-garde dealer and publisher Paul Cassirer began a weekly paper entitled *Kriegszeit*. It was profusely illustrated with patriotic prints by a whole range of artists (see Pl. 61), in tune with the rousing call-to-arms written by Julius Meier-Graefe as an opening editorial. Fired by the opportunity which the outbreak of hostilities had apparently bestowed, he urged artists of all persuasions to acknowledge that 'the war bestows on us a gift. Since yesterday we are different. The fight over words and programmes is over. We were tilting at windmills. Art was for many but an amusement . . . What we were missing was meaning – and that, brothers, the times now give us . . . The war has given us unity. All parties are agreed on the goal. May art follow!'[22]

As if in response to the rallying-cry, Peter August Böckstiegel produced an elaborate study for a painting entitled *Departure of the Youngsters for War* (Pl. 37). It shares none of the apprehensions disclosed by Chagall, Macke and Kirchner when they dealt with the same subject. Instead of family grief and fear for the future, Böckstiegel offers a noble and heroic nude youth unshackled by any sentiment other than awakening love of the fatherland. He arises from his peacetime sloth like a man charged with a sacred mission, ready to do battle with the enemy forces who, according to Rupert Brooke's inappropriately named 1914 sonnet 'Peace', were likewise supported by divine authority:

> Now, God be thanked Who has matched us with His hour,
> And caught our youth, and wakened us from sleeping,
> With hand made sure, clear eye, and sharpened power,
> To turn, as swimmers into cleanness leaping,
> Glad from a world grown old and cold and weary,
> Leave the sick hearts that honour could not move,
> And half-men, and their dirty songs and dreary,
> And all the little emptiness of love![23]

Although both sides in the conflict claimed sacred support for their causes, this religious ardour becomes unusually explicit in a lithograph produced by Ernst Barlach for *Kriegszeit* (Pl. 38).[24] He called it *The Holy War*, thereby dignifying the conflict with a mystical significance which outweighed all its more worldly aspects. The

robed figure advancing towards the spectator in Barlach's thunderous print is reminiscent of the Gothic statuary which inspired so much of his sculpture. As a result, it lends the weight of history and tradition to the warrior, striding across a bare plain with his mighty sword prepared for a decisive blow.

Barlach himself was by no means unequivocally in favour of the war. As early as August 1914, he revealed in his diary how moved he had been by the sight of women at the railway station saying goodbye to their enlisted husbands. 'They carry the heaviest burden', he wrote, before noting that the spectacle had made him see his newly completed carving of *Hunger* in a different light. 'My wood sculpture, even though it was done before all this happened, is a picture of the future: they wander across fields and steal turnips to stave off their hunger.'[25] All the same, Barlach was able in another mood to imagine that the German armed forces had embarked on an exalted crusade. The blade wielded with such muscular conviction by the protagonist in *The Holy War* would cut through Europe like an instrument of purification, and the ease with which this bulky figure fills the picture-space implies that he is unstoppable. The sculpture Barlach modelled of the same warrior accentuates his headlong conviction (Pl. 39). Seen from the side, he bends at a more horizontal angle than his counterpart in the lithograph, and Barlach emphasized the zeal of his advance by naming him *The Avenger*.[26] Once he had begun modelling 'my storming *Berserker*', Barlach asked: 'Could it be possible that a war is being waged and I forget it over a hundred-pound image of clay? To me this *Berserker* is the crystallized essence of War, the assault of each and every obstacle, rendered credible. I began it once before but cast it aside because the composition seemed to burst apart. Now the unbearable is necessary to me.'[27] Despite his modest dimensions, the hurtling swordsman takes on an awesome power. Unlike the figure in the lithograph, he raises one leg well above the ground and thrusts it back in an attempt to propel himself with greater force towards his foes. He resembles an anguished yet vengeful angel about to take flight, and this hint of divine intervention adds spiritual sanction to his singleminded authority.

The Munich-based painter Albert Weisgerber took the whole notion of a biblically authorised struggle to a victorious conclusion in his large-scale painting of *David and Goliath* (Pl. 40). Part of a sequence of religious images drawn from the Old and New Testaments,[28] it marks a high point in Weisgerber's development from conventional Impressionism to a more independent and expressive style. Simply because it was painted in 1914, *David and Goliath* should not automatically be seen as a statement about the war. But Weisgerber had already displayed a pronounced tendency to invest subjects derived from religious sources with a very personal meaning. His obsession with the theme of St Sebastian, which resulted in twenty images painted between 1910 and 1913, derived its peculiar intensity from his own intimations of a premature, violent death. So it is reasonable to speculate about the underlying import of *David and Goliath*, one of the last and most monumental canvases Weisgerber completed before his departure for the Front in 1915.

His earlier preoccupation with the martyrdom of St Sebastian does not mean that he now identified in some way with the stricken figure of Goliath. Although the giant's ungainly body occupies two-thirds of the painting, and his upflung legs provide the composition with its most arresting forms, the artist's sympathy is reserved for the slender figure of David. This poised and tousled hero, who seems to have strayed from the romantic images of Amazonian camps which Weisgerber produced during the pre-war period, stands fearlessly beside his felled opponent. Graceful in victory, and disdaining to indulge in any boastful celebration of his unlikely triumph, the youth nevertheless seizes Goliath's weapon without delay. The act of grasping the outsize sword is clearly meant to announce a warrior-like resolve, casting aside his former innocence and assuming a new, formidable invincibility. Weisgerber's readiness to associate himself with David is confirmed by a photograph taken in his studio before leaving with his infantry regiment for the war (see frontispiece). The uniformed painter, his lieutenant's cap tipped at an insouciant angle, places himself directly in front of Goliath's stricken form. David is therefore the only figure clearly visible, and he now appears to be looking

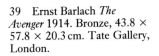

38 Ernst Barlach *The Holy War* 1914. Lithograph, 41.3 × 25.4 cm. Kunsthalle, Bremen.

39 Ernst Barlach *The Avenger* 1914. Bronze, 43.8 × 57.8 × 20.3 cm. Tate Gallery, London.

40 Albert Weisgerber *David and Goliath* 1914. Oil on canvas, 104 × 122 cm.
Saarland Museum, Saarbrücken.

across at the artist himself – as though exhorting him to show the
same resolution in his forthcoming battles at the Front. Lieutenant
Weisgerber looked determined enough when he rested on a tree-
trunk with his troops before an engagement in the Fromelles sector at
Ypres in May 1915. But he was killed soon after the photograph was
taken, prompting Beckmann to record in his diary how 'devastated'
he felt by the tragic news.

　　While Barlach and Weisgerber sought to justify the German cause
with resounding biblical references, the same authority was claimed
on the Russian side as well. Natalia Goncharova, obliged by the war
to return to her native country after holidaying with her companion
Larionov in Brittany, turned her attention to the hostilities in a major
sequence of lithographs. Before the war began, she had been princi-
pally occupied with the Russian Ballet's triumphant season in Paris.
Her exuberant designs for the Diaghilev production of Rimsky-
Korsakov's *Le Coq d'Or* were widely praised; and the creator of these
richly decorative images might seem unlikely to address herself, only
a few months later, to the subject of war. Alongside her gift for

fantasy in set and costume designing, however, Goncharova also harboured an alert interest in contemporary life. True to her involvement with Futurist ideas, she had painted many easel pictures devoted to the most electrifying aspects of the modern industrial age[29] – among them an explosive Rayonist canvas entitled *Dynamo Machine* which was probably included in her joint Paris exhibition with Larionov at the Galerie Paul Guillaume in June 1914. So she was well equipped to deal with the mechanisms of war in her lithographs, and even one of her designs for *Le Coq d'Or* contained an unexpected foreshadowing of the struggle ahead. For the opera's second act, she painted a backdrop which could hardly be more removed from the exhilaration of the gaudy palace scenes in the other acts. Gaunt and overcast, this uninhabited landscape represents the battlefield where King Dodon's two sons have recently been killed. The grieving monarch visits the scene, and Goncharova provided him with a setting so desolate that it seems eerily akin to the locations where soldiers on both sides of the conflict would meet their end later in the year.

Soon after returning to Russia, Larionov was conscripted and despatched to the war. His experience at the Front was very different to the relaxed, holiday mood which had dominated his earlier period in the army (see Pl. 8), and he sustained serious wounds during the retreat from East Prussia.[30] Goncharova was inevitably affected, not only by his suffering but by the series of defeats inflicted on the Russian troops. The optimism and pride which had initially swept the country gave way to a growing sense of doubt. Errors in strategy, combined with an acute shortage of weaponry and armaments, meant that the limitless supplies of manpower counted for little against the Germans. Towards the end of 1914 the Russian commander, Grand Duke Nicholas, admitted to his allies that the forces under his control could not be relied on to undertake any further offensive campaigns. Hence the ambivalence of Goncharova's fourteen lithographs, published around that time in Moscow by V.N. Kashin. They disclose considerable misgivings about the conduct of the war even as she tries to present it as a divinely protected, triumphant endeavour.

The title of the series, *Mystical Images of War*, proudly highlights the religious conviction which inspired them. It appears to sustain a confident view of the struggle in the first half of the sequence, prefaced on the yellow cover by a stern image of an angel armed with a sword. Goncharova commences the sequence with three prints based on saintly and heraldic sources, and no glimpse of the First World War can be found within them. The first, *St George Victorious*, claims outright victory already: the dragon offers no resistance as the youthful, haloed saint inserts his spear into its mouth. Succeeding lithographs continue the theme of symbolic triumph in *The White Eagle*, filling the sky with its multiple, diagonally thrusting wings, and *The English Lion*, a frieze-like image of an animal whose bared teeth cannot disguise his fundamental amiability.

Only with the fourth print, *The French Cock*, does the war begin to penetrate this mythological world of unchallenged prowess. The crowing bird, prophetic of the cock which Dufy would soon place at the centre of an equally patriotic image (see Pl. 55), is perched this time on a titanic gun-barrel, and fiery missiles hurl themselves through the air like black, flaring suns. They are, however, more like cannon-balls than modern shells, and the next lithograph reverts to a more fabulous region where a virgin, simultaneously smiling and frowning, bestrides a phantasmagoric horned beast. Triple-headed and equipped with a tail that grows into a serpent's head, the monster tramples on dead and wounded soldiers without discrimination. Both he and the goblet-bearing virgin seem remote indeed from the realities of the struggle against Germany. Fearing for Larionov's life, Goncharova

may well have tried to comfort herself by dwelling on a removed realm of activity, and the sixth image confirms her preoccupation with the past rather than the present. Its title is derived from the story of Peresvyet and Oslyabaya, a pair of Russian soldiers who, after taking monastic orders, joined the war against the Tartars at the Battle of the Don. Goncharova depicts them as two darkly hooded figures, galloping across an overcast sky with spiked clubs resting on their shoulders.

The solace to be gained from history and religion alike reaches its most ecstatic expression halfway through the sequence, where the Archangel Michael suddenly erupts into flamboyant life on a leaping steed (Pl. 41). How could any hostile army withstand such an irrepressible figure, blowing a trumpet and clasping a book while a censer swings from his right wrist? A rainbow arches over him, linking the two outstretched hands with geometric certitude. Goncharova was here reviving a victorious symbol widely deployed in earlier times of Russian crisis, during the Polish invasion and civil wars. St Michael was, in fact, a favourite with her. He had appeared four years before, on the earliest extant example of her graphic art. Published on the cover of the *Knave of Diamonds Album* in 1910, it proclaimed her debt to icon painting and the popular print tradition. Both these sources of inspiration continued to feed her work, and they lend the entire *Mystical Images of War* series a clear, outspoken finality. But Goncharova's St Michael is much livelier than his predecessor. He

41 Natalia Goncharova *The Archangel Michael Vision* 1914. Lithograph on paper, 33 × 25 cm. The British Library, London.

makes his mount leap over the flames in an arresting diagonal, and this soaring motion contrasts with the more earthbound progress of the six cavalrymen who ride across the eighth lithograph, *Vision*. Seen mostly from behind, so that they remain anonymous, the horsemen are sustained by the colossal Virgin and the Child who raises his hand to bless them. A similar beneficence hovers over the marching infantry in *The Christ Loving Host*, where airborne angels appear to guide the soldiers and the slanting bayonets they brandish above their heads.

These angels assume a more active role in the two succeeding prints. Seizing on the notion that they would be particularly capable of controlling the outcome of combat in the sky, Goncharova portrays their omnipotent manipulation of an aeroplane flight (Pl. 42). Their wings, haloes and youthful faces contrast strongly with the schematic, impersonal forms of the warring machines. But the pilot in the principal plane is subservient to their manoeuvres, and in *The Doomed City* the angels become aggressive agents of destruction (Pl. 43). Goncharova takes her cue this time from an apocalytic passage in Revelation, where St John the Divine describes how 'a mighty angel took up a stone like a great millstone, and cast it into the sea, saying, Thus with violence shall that great city Babylon be thrown down and shall be found no more at all.'[31] She had already used the theme in one of her nine compositions for *The Harvest* three years earlier,[32]

but here the hurled stones take on the force of bombs as they are flung down on to the quiet nocturnal city. All the houses seem defenceless, wholly unprepared for this heavenly onslaught. The outcome of the raid is beyond doubt, confirming the insistence on victory which pervades the first eleven lithographs in the sequence.

For the twelfth print, though, Goncharova permitted herself to convey a more troubled vision of the conflict. Perhaps her gathering realisation of Russia's early and disastrous defeats affected the mood of the lithographs as they approached completion. For *The Pale Horse* is a melancholy work, offering no sign of hope to ameliorate the funereal impact of the cowled, winged figure who rides over the heaped skulls and bones. The scythe he carries beside him leaves no doubt about the identity of this gruesome presence, and the black sun in the sky adds to the feeling that life throughout the planet is confronted with extinction. Goncharova attempts to provide a measure of reassurance in the penultimate print, *A Common Grave*, where skeletons are at least replaced by recognisable soldiers and an angel presides over them (Pl. 44). But most of the men appear to be corpses, at the mercy of the predatory birds diving down towards their bodies. Despite the angel's protective wings, there is no suggestion of an imminent resurrection within this ignominious burial ground.

Byzantine mysticism reasserts itself in the final lithograph, which relies once more on the comfort offered by history. The spirit of *St*

42 Natalia Goncharova *Angels and Aeroplanes* 1914. Lithograph on paper, 33 × 25 cm. The British Library, London.

43 Natalia Goncharova *The Doomed City* 1914. Lithograph on paper, 33 × 25 cm. The British Library, London.

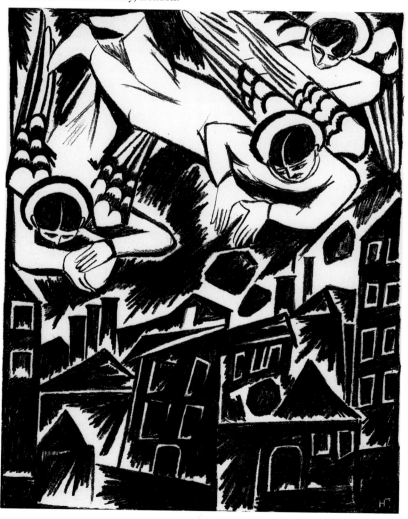

Alexander Nevsky is summoned, doubtless because Goncharova hoped that Russia would still be able to repeat his success in trouncing the German Knights of the Teutonic Order on the ice of Lake Peipus in 1242. For all the stiff, icon-like strength of this national hero, holding up his ever-vigilant sword as he rides past the capital city of St Petersburg, there is something unconvincing about him. Dutiful rather than wholly persuasive, he may well reflect Goncharova's inability to convince herself that the Germans would again meet with defeat.

The prevailing mysticism and obsession with history in Goncharova's lithographic sequence are a measure of the Russian Futurists' opposition to Marinettian ideas about war. Most of them preferred to avoid dealing with it as a subject in their work; and on the rare occasions when they overcame this resistance, the result had little to do with the harshness of violent struggle. By 1914, Aristarkh Lentulov had lived in Paris long enough to acquaint himself with many of the city's outstanding avant-garde painters. After working in the *atelier* of Le Fauconnier, he met Metzinger, Gleizes, Léger and Delaunay. Although Lentulov became known among his French friends as the 'cubiste à la russe',[33] he had a great deal in common with Futurist ideas as well. They duly predisposed him to the notion of painting a large canvas entitled *A Victorious Battle*, just as Marinetti might have wished (Pl. 45). But none of the Futurist leader's belligerence can be detected in this curiously childlike canvas. Although a cavalry charge is in progress, and the enemy soldiers collapse under its impact, the entire painting resembles a glorious charade. The Germans are like puppets whose strings have been cut, and the only hint of an explosion is reserved for the discreet scarlet flash on the right edge of the composition. As for the cavalry officers, they merely wave imperiously and ensure that their medal-strewn uniforms are displayed with aplomb.

Sartorial magnificence is, apparently, enough in itself to demoralise the foe. The commander occupying the central position in this nursery-rhyme view of war seems to be protected by a glowing circle of rosy light, which makes the image sweeter still. Its innocence is almost laughable, for the Russian steeds are nothing more than prancing rocking-horses borrowed from a fairground carnival. Two years later, the metaphor of a merry-go-round would be employed by another artist to produce a nightmarish indictment of the war (see Pl. 175). Here, by contrast, it adds to the playful charm of a painting which

44 Natalia Goncharova *A Common Grave* 1914. Lithograph on paper, 25 × 33 cm. The British Library, London.

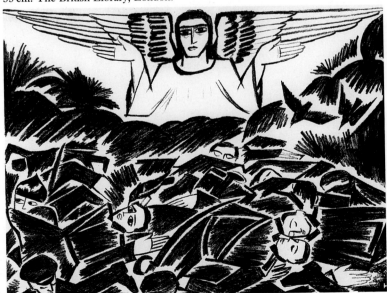

surely owes a debt to Uccello's *The Battle of San Romano*. Lentulov was doubtless familiar with this celebrated quattrocento battle-piece from visits to the Louvre, and his charging commander is virtually a reversed image of Micheletto da Cotignalo who leads the Florentine squadron's counter-attack in the Louvre panel.[34] Lentulov's picture is, nevertheless, even more harmless than Uccello's fairy-tale vision of conflict – and far less persuasive than the prophetic painting which Man Ray had already executed under the influence of the San Romano series (Pl. 22). Despite the mounting evidence of Russia's incompetence in the field, Lentulov persists in seeing the war as a beguiling pageant where real aggression and bloodshed need play no part in securing a swift, painless victory.

Lentulov's nationalistic fervour, equally evident in his kaleidoscopic *Allegory of the Patriotic War of 1812*, led him to participate with other avant-garde artists like David Burliuk and Larionov in an official commission to design popular woodcuts (*lubki*) and postcards as anti-German propaganda. Their enthusiasm did not survive the first few months of war, but while it lasted even the uncompromising Malevich was caught up in this martial mood. His painting, *1914 – Private of the First Division*, shows how removed he really was from the raucous rhetoric of the *lubki* (Pl. 46). The private himself can only be glimpsed in fragments, many of which betoken a wittily subversive attitude towards the armed forces. Although a spirited moustache curls from the edge of the pale blue rectangle hovering in the upper portion of the canvas, and a profile view of an ear is included below, the man's other facial features are hard to pin down. They have been replaced by a military cross, the number 8 and other devices which suggest that his individuality has become subsumed in the regimental machine. The thermometer placed so unexpectedly near the enormous capital C is a cunning device, reflecting Malevich's delight in setting up what Larissa Zhadova described as ' "a-logical" clashes between the elements of a composition. Their intention is less a matter of plastic treatment than a deliberate attempt to shock and protest.'[35]

However unsettling these devices may be in pictorial terms, though, Malevich also uses them to convey his own response to the country's mobilization. The thermometer immediately introduces the idea, not only of temperature but of illness: war fever could easily lead to an overheated mentality, and the coolly analytic organization of *1914 – Private of the First Division* indicates how far he distanced himself from patriotic hysteria. The steady blocks of pale colour dominating this picture imply a calculated attempt to offer a critical alternative to rabble-rousing. Indeed, the post-marked stamp placed at the heart of the painting suggests a questioning, even irreverent attitude towards Tsar Nicholas II, who in wartime automatically expected his loyal subjects to volunteer for the defence of the nation.

How, therefore, to account for Malevich's willingness to put aside his views about abstraction and the absurdity of war to make several boisterous coloured lithographs, as an offical commission? Mayakovsky, who argued elsewhere that 'one may not write about war, but one must write with war',[36] was likewise prepared to produce captions for these propaganda images. He produced several designs himself, most notably a vigorous fantasy involving cannons, aerial bombardment and a full-blooded cavalry charge against the German citadel. 'Come Germans, come, come', cries the taunting caption. 'You will never reach Paris. And, my friend, as you go to Paris, we go to Berlin.' Both Mayakovsky and Malevich probably found government demands difficult to resist once the Russian war-machine became fully active. The most sceptical avant-gardists found themselves caught up in the endeavour to beat off the German threat. While Chagall retained his independence and expressed eloquent misgivings in Vitebsk (see Pls.

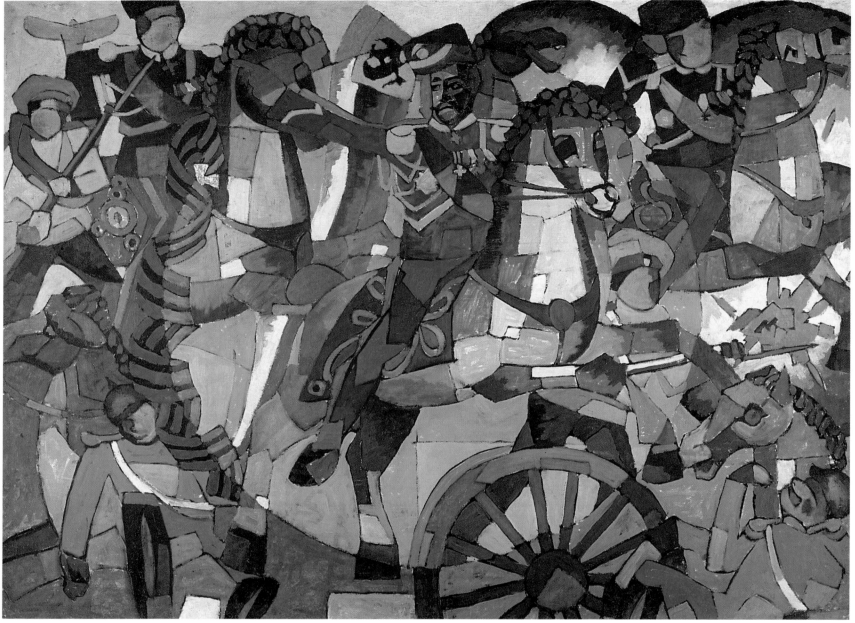

45 Aristarkh Vasilyevitch Lentulov *A Victorious Battle* 1914. Oil and collage on canvas, 137.5 × 183 cm. Collection of M.A. Lentulova, Moscow.

28–31), the arch-innovatory Malevich carried out with considerable bravado a series of blatantly drum-thumping designs. Deploying the idiom of the peasant woodcut, with its insistent flatness, emotive distortions and exclamatory colours, he set aside his experimental painter's language and produced images with an immediate appeal to a broad public.

Writing to his friend Mikhail Matyushin in December 1914, he tried to justify the deliberate crudeness of these full-blooded prints. 'I have pondered over the woodcuts', he declared, before arguing that 'they are straight from the people, and if the words are on the coarse side, no need to worry, because that's how the people are – they have a different aesthetic sense.'[37] Malevich certainly did his best to ridicule the enemy with a satirical verve which would entertain the audience he aimed at. '*A Butcher came along to Lodz...*', the only

two-framed propaganda print he produced, has the cheekiness of a children's book illustration. The lithograph presents the Russian defence as a sturdy, full-bearded countryman who greets the invading Germans with a devil-may-care 'Good day, sir.' Having waved his hat with mock civility, the Russian trounces his aggressors so severely that he is able, in the second frame of this comic-strip story, to turn his back on them and stride proudly back to the undefeated city on the hill.

The landscape he inhabits is an innocent region, with pantomime flowers and clouds hovering like loaves of rudimentary bread over the terrain. Malevich lets similar countryside run through all his prints,

46 Kasimir Malevich *1914 – Private of the First Division* 1914. Oil and collage on canvas, 53.7 × 44.8 cm. The Museum of Modern Art, New York.

but in 'The French Allies have a Wagon full of defeated Germans' burly figures dominate the scene (Pl. 47). Expanding the size of the striding soldier to colossal proportions, Malevich lets him carry the basketful of helmeted enemies with swaggering ease. Although they have shrunk to a diminutive size, these toy Germans retain a risible variety of expressions. By turn aghast, resigned and apoplectic, they are treated with no more dignity than would be accorded to a heap of potatoes in a cart. As for the imbecilic figure who dominates another print, 'Look, Oh Look. Near the Vistula...', his obesity is matched by craven trepidation. The enemy's distended stomach seems to be expanding still further with fear at the thought of the task ahead, for the caption concludes: 'the German bellies are swelling up, so they don't feel so good.' The fatuous figure whose loosening braces threaten to let his trousers down is defined with knockabout relish, implying that Malevich refused to view the German invaders as a serious threat at all.

The Russians, his prints insisted, had nothing to fear from such pathetic antagonists. In *The Carousel of Wilhelm*, where the title is printed above the image like a triumphant newspaper headline, German ambitions to subjugate the French capital are mocked. 'Under the walls of Paris they beat my army up,' runs the caption: 'I'm just running around and can't do a thing.' Like Mayakovsky's *Come Germans, come...*, this image makes rumbustious play with cannons in action, marauding aeroplanes and geometric shell-bursts among the panic-stricken enemy forces. Malevich's lithograph predicts that Germany will suffer a decisive defeat in front of the French capital's ramparts. Although his prophecy was not borne out in reality, the carousel motif gives the print an infectious whirling conviction.

In the most ebullient print from Malevich's series, a gigantic farm-worker belabours all his opponents with a simple agricultural implement (Pl. 48). '*What a Boom! What a Blast!*' roars the caption, rejoicing in the strength of this bearded Hercules as he scatters the forces who had been ranged against him. The print seeks to minimize the gravity of the problem arising from the Russians' chronic shortage of military equipment. German rifles and bayonets lie broken on the hillside, of no avail against the muscular superiority displayed by the defender of his nation. The enemy forces either sprawl like marionettes or break into a retreat, and Malevich savours their humiliation. In reality, however, the pitiful performance of the Russian troops engendered widespread despair by the end of the year. It is significant that the work he carried out on this sequence, for the 'Sovremennyi lubok' publishing firm, came to an abrupt end only a few months after war was declared. Malevich subsequently reverted to the far from 'popular' preoccupations which had produced *Private of the First Division* (Pl. 46). The development of Suprematism was now his principal goal, and he came to regard the possibility of an army call-up as a threat to his pictorial ambitions. This apprehensiveness is evident in a small, wildly handled drawing called *Death of the Cavalry General*, where Malevich employs his avant-garde form-language to convey a vision of war utterly removed from the gung-ho propaganda of his patriotic prints. Everything here is in a state of turmoil; and the only outcome of this hurtling, stabbing mêlée is the slaughter of a commanding officer who, like his complacent counterpart in Lentulov's *A Victorious Battle* (Pl. 45), probably imagined that a cavalry charge was still as formidable as it had been in nineteenth-century campaigns. Malevich knew better, and he was fortunate enough to be left alone until the summer of 1916, when a posting to a rear defence unit guaranteed his safety for the duration of hostilities.

Sickert, who had abominated war ever since acquiring a childhood

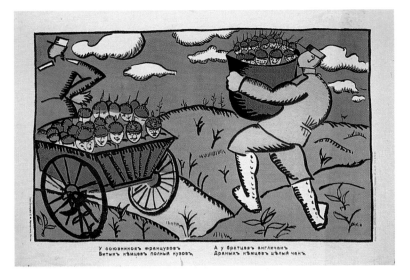

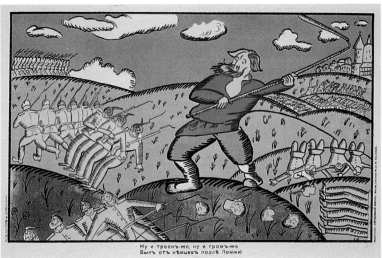

47 Kasimir Malevich '*The French Allies...*' 1914. Lithograph in five colours, 33 × 51 cm. The British Library, London.

48 Kasimir Malevich '*What a Boom! What a Blast!*' 1914. Lithograph in five colours, 33.2 × 51.1 cm. State Russian Museum, St Petersburg.

hatred of fireworks and other explosives, likewise committed himself only to a short-lived involvement with the conflict. But for a time, during the final months of 1914, he threw himself into a vigorous engagement with the images it generated in his mind. Having returned with intense difficulty from Dieppe when war was declared, the Munich-born painter found himself summoned by the police. The experience did not, however, dampen his growing interest in battle themes. He even expressed a wish to become a war artist, and soon started work on a painting which reflected the renewed popularity of army marching songs in London (Pl. 49). Although based on his model Chicken, posing at the grand piano in his Red Lion Square studio where she played 'the contes d'Hoffman'[38] while he worked, *Tipperary* successfully evokes the atmosphere of a pub where rousing renditions could be heard every evening. As a devotee of the music hall, and a man who had once been a professional actor under the pseudonym Mr Nemo, Sickert was instinctively attracted to these raucous manifestations of home-front emotion. The viewpoint he adopts, looking down on the pianist, implies the vantage of a volunteer

soldier who has leapt to his feet and joined in the singing with gusto. The player seems restrained, her face almost obscured by an elaborately feathered hat. But her reticence may be explained by Sickert's desire to paint similar piano pictures, like *Chopin*, where war has given way to more pacific alternatives. Even the preparatory drawing for *Tipperary* is called *The Baby Grand*, and only one of the piano paintings makes the military link overt by juxtaposing the player with a listening soldier. A 'capital fellow' in khaki posed for the purpose, and seemed to Sickert the 'ideal noble and somewhat beefy young Briton – enfin John Bull young.'[39]

The outbreak of war also persuaded him to regret his previous lack of involvement with military matters. Soon after hostilities were declared, he revealed that 'it is a lesson to me that every man should be – as well as his own business – a soldier as well. If I had been in the Volunteers and the Territorial all my life I should now have been eligible for service.'[40] Since Sickert was 54 when he voiced those sentiments, his sudden enthusiasm for army commitment seems even more astonishing. But perhaps the police's investigation into his German birth had made him anxious to prove his own patriotism. He certainly accepted John Lavery's invitation to lend his services to a project in aid of the Artists' Benevolent Fund, agreeing to paint a portrait of a soldier or nurse for a fee which the Fund would receive. The private soldier who posed for Sickert gave him 'excellent positions and tips and I bought his kit for ninety five shillings so I am well set up as a military painter.'[41]

By October, though, he had embarked on a far grander project which made his support for anti-German resistance monumentally apparent. His choice of theme reflected the powerful feeling aroused throughout Britain by the invasion of Belgium: Robert Graves recalled that, when he enlisted in 1914 with the belief that it would all be 'over by Christmas', he was 'outraged to read of the Germans' cynical violation of Belgian neutrality.'[42] For Sickert to paint a battle picture was, nevertheless, a highly unusual step. *Tipperary* accorded well with his long-held convictions about studying the workaday urban life he relished, but *The Soldiers of King Albert the Ready* constituted a bold departure from his accustomed procedures (Pl. 50).

It was, for one thing, based on an event he had not witnessed – the Belgian defence of Liège, which Ludendorff captured with the aid of massive shelling by Austrian howitzers. Sickert may have taken as his starting-point a press photograph of an incident in the battle, and he undoubtedly had plenty to choose from in the war-filled pages of the newspapers. But he also decided to work from posed models in the studio, and wrote for assistance to his friend Lady Hamilton, patron of the avant-garde and wife of the general who later led the disastrous Dardenelles campaign. Sickert asked her to get him 'a note to the Belgian authorities so that I can borrow some uniforms from Belgians in hospital. One has a kind of distaste for using misfortunes to further one's own ends, but pictures of Belgian incidents so far as they have any effect can be useful. Besides if military painters had always been too bloody delicate they would never have got anything done at all.'[43]

Fired now by the belief that 'military paintings have a definite patriotic and recruiting value',[44] he began work as soon as the uniforms arrived. Many detailed ink and charcoal drawings testify to the care Sickert took in making his figures as authentic as possible. He delighted in studying the uniforms, announcing that 'the artilleryman's forage cap with a little gold tassel is the sauciest thing in the world.'[45] And he planned at first to paint 'a really Daumieresque scheme of an artilleryman who has seized a gun and is standing on mattresses on a piano firing through a loophole above a door.'[46] But once he had

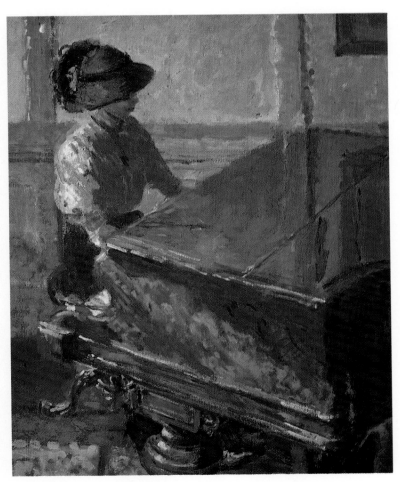

49 Walter Richard Sickert *Tipperary* 1914. Oil on canvas, 50.8 × 40.6 cm. Tate Gallery, London.

settled on the final composition, showing three soldiers firing behind a waggon, his debt to Daumier vanished. Instead, other connections with the art of the past are now impossible to overlook.

The emphasis on a row of soldiers, caught with their rifles raised to fire, is immediately reminiscent of similar figures in Goya's *The Shooting of The Third of May 1808* and the other great painting it inspired half a century later: Manet's *The Execution of the Emperor Maximilian*. Goya's image is more impassioned than anything produced by Manet, who virtually eradicated protesting emotion from his several versions of the scene.[47] But even his final canvas[48] implicitly condemned Napoleon III, who had forsaken Maximilian by withdrawing all French troops from Mexico. Ignoring historical accuracy, Manet replaced the guerilla executioners with a group of French soldiers, thereby demonstrating in a cool yet provocative manner Napoleon's ultimate responsibility for the murderous deed.

Sickert would have been able to study the dismembered version of the *Execution* painting when he called on his old friend Degas, who had purchased the fragments from Vollard and lovingly reassembled them on a single canvas. But in *The Soldiers of King Albert the Ready*, he favoured a leaning stance more reminiscent of Goya's executioners, and the inclusion of a corpse likewise recalls the bodies sprawled across the blood-smeared ground in *The Shooting of The Third of May 1808*. The presence of the dead Belgian also suggests that Sickert knew the images Manet subsequently produced in response to the tragic events of the Paris Commune. For Manet transposed Maximilian's executioners to the streets of Paris in one watercolour

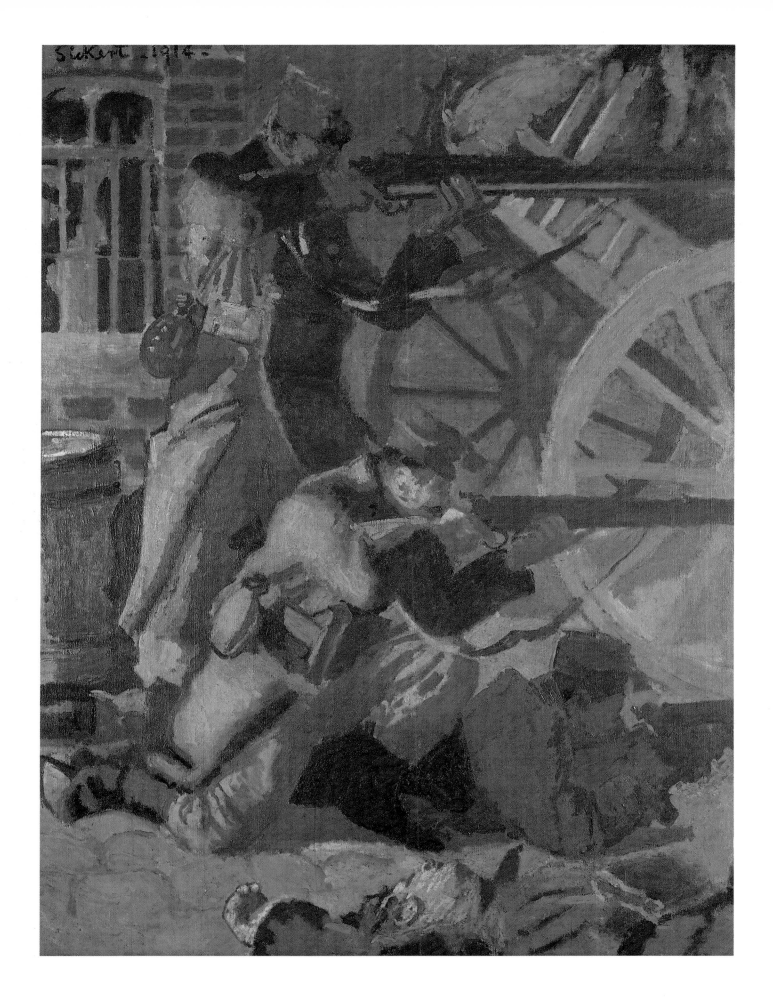

and then, in an elegiac lithograph, filled most of the foreground with a soldier's inert body.

In other respects, though, *The Soldiers of King Albert the Ready* departs from its distinguished precedents. Rather than copying either Goya or Manet, Sickert took enormous pains over scrutinizing the men's positions for himself. 'The model takes up his very strenuous and tense pose', he wrote, describing how 'I draw for a few minutes till he cant hold it and breaks out in a sweat poor man. Then in the next room, instantly, I paint on little separate studies the detail passage I have just drawn and observed.'[49] The effort he expended on these poses reflected Sickert's determination to make his shooting soldiers actively heroic rather than treacherous. Both Goya and Manet had portrayed them as cold-blooded executioners carrying out orders, whereas Sickert's figures wage a courageous fight against the invaders.

Moreover, the extraordinary speed with which he completed his picture could hardly be more removed from the protracted and continually revised gestation of Manet's painting. Although *The Soldiers of King Albert the Ready* was one of the largest canvases Sickert ever executed, he tried hard to complete it in time for the New English Art Club exhibition of November 1914. Setting the price at what he described as 'five hundred bloody guineas', in aid of the Belgian Relief Fund, he told a friend that 'I very much want to make sure of getting the big Belgian canvas done for the New English as it is topical and I shall run a better chance of selling it before the new enthusiasm for the Belgians has cooled. I want to do something for them and it will probably be all I can do.'[50]

In order to meet his exacting deadline, Sickert revolutionized his whole painting method. Determined to eradicate every vestige of an Impressionist approach from his handling, he deposited an initial layer of white with cobalt for the highlights, and white with three strengths of red for the shadows. When the large, pattern-like colour patches had been applied, the outcome possessed a thick flatness which he joyfully described as 'the best way on earth to do a picture.'[51] It set the course for the technical development of his innovative late work, as well as giving *The Soldiers of King Albert the Ready* a freedom and attack which escapes entirely from the preoccupation with reportorial detail in the preliminary drawings. The patches of colour, deftly applied to a *camaieu* preparation which had dried with great swiftness, stress the urgency of the figures' efforts by presenting them in broad, summarizing masses. They indicate that Sickert had seized the essence of an instantaneous scene and, without any delay, set down the Belgians' resistance at white heat on the surface of his coarse-grained canvas. But even as he defined the strain of fighting in a hot and dusty Liège street, his picture invests the dogged soldiers with a timeless quality as well. Sickert himself thought the painting was 'like some 1830 classic frieze',[52] and it does attain a rough grandeur of which the arch-classicist Degas would surely have approved. 'It is only suitable for a public gallery',[53] Sickert wrote, and so his disappointment at failing to find such a home for the picture must have been intense. It was sold instead to a private collector, and only entered the collection of Sheffield's Graves Art Gallery in 1969.

Working with such brio on an unaccustomed scale seems to have temporarily invigorated Sickert, leading him to paint another military picture called *The Integrity of Belgium* (Pl. 51). Displayed at the Royal Academy 'War Relief' Exhibition in January 1915 and later lost, it attested to his continuing involvement with the Belgian cause. He must have started it soon after completing the *Albert the Ready* canvas,

50 Walter Richard Sickert *The Soldiers of King Albert the Ready* 1914. Oil on canvas, 196.2 × 152.4 cm. Graves Art Gallery, Sheffield.

for in December 1914 he reported that 'I have laid in my R.A. picture in *camaieu*. I have got a magnificent platform 7 foot by 7 to get Veronese-like foreshortenings.'[54] When the swiftly completed picture was placed on exhibition, the *Sunday Times* observed that 'here again the resistance of Belgium is his theme. He shows the land far stretched to the horizon, the mists rising from the ground; in the foreground is a soldier leading the attack; to the left are faintly discerned the ranks of the resolute Belgians.'[55]

However much Sickert admired the soldiers' courage, though, he could not help acknowledging the hopelessness of their cause. The painting, recently unearthed after decades of obscurity, reveals this tragic dimension with considerable subtlety. It possesses even more of a snapshot quality than the *Albert the Ready* canvas, with a boldly summarized dark blue silhouette of the soldier himself dominating the foreground. Although he is crouching, his right leg seems ready at any instant to change position and propel him back to cover. For this is a man exposed to great danger, as he scans the countryside for signs of enemy movement. While his comrades stay in the shelter of a trench, he moves out and risks becoming a target for sniper fire.

His face is obscured by the binoculars, but the tension he feels still remains palpable. Both he and the riflemen beyond seem condemned to watch and wait, expecting an attack from the invader and yet unable to predict its timing. Sickert underlines the apprehensive mood by placing the trench in raw sunlight, accentuating the acid green of the soldiers' coats against a mustard yellow ground. The bitterness of the colours conveys Sickert's awareness of their plight, and the vigour of his handling lends additional urgency to the scene. Along a distant river-bank the splashes of ochre pigment are surprisingly thick, and the crimson piping which runs down the centre of the principal soldier's uniform is brushed in with conspicuous fluency and speed.

The verve of the mark-making also promotes a sense of transience. Despite their preparedness and vigilance, all the men in this picture must realise that they have scant chance of maintaining their resistance for long. Military superiority is not on their side, and they will soon be overwhelmed by the German advance. That is why the soldier with the binoculars looks doomed as well as defiant. Sickert places his entire body in shadow, thereby endowing him with a funereal air. However keenly he gazes ahead and hopes to anticipate the inevitable assault, this overcast observer appears, in the end, as vulnerable as the nation he is attempting to defend.

The intensity of Sickert's preoccupation with the Belgian theme suggests that he may have felt indignant, not simply about the German invasion, but the British army's tactics. Having declared war on Germany specifically in support of 'little' Belgium's neutrality and independence, Asquith's Council of War balked at sending troops directly to assist either Liège or Antwerp, where the small Belgium army fortified itself against the enemy's advance. No direct assistance was forthcoming from France or Britain, apart from the 3,000 marines despatched in vain to Antwerp by Churchill. He could not prevent the fall of Antwerp on 10 October, and British public opinion was impressed by news of the Belgian troops' continuing gallantry when they held the German advance on the coast. Sickert shared this admiration, but after exhibiting *The Integrity of Belgium* his increasing fear of air-raids[56] prompted him to escape to the west country for much of the war.

The declaration of hostilities between France and Germany found Picasso in Avignon. Conscious of his detached position as a citizen of neutral Spain, and refusing to volunteer for the French legion like

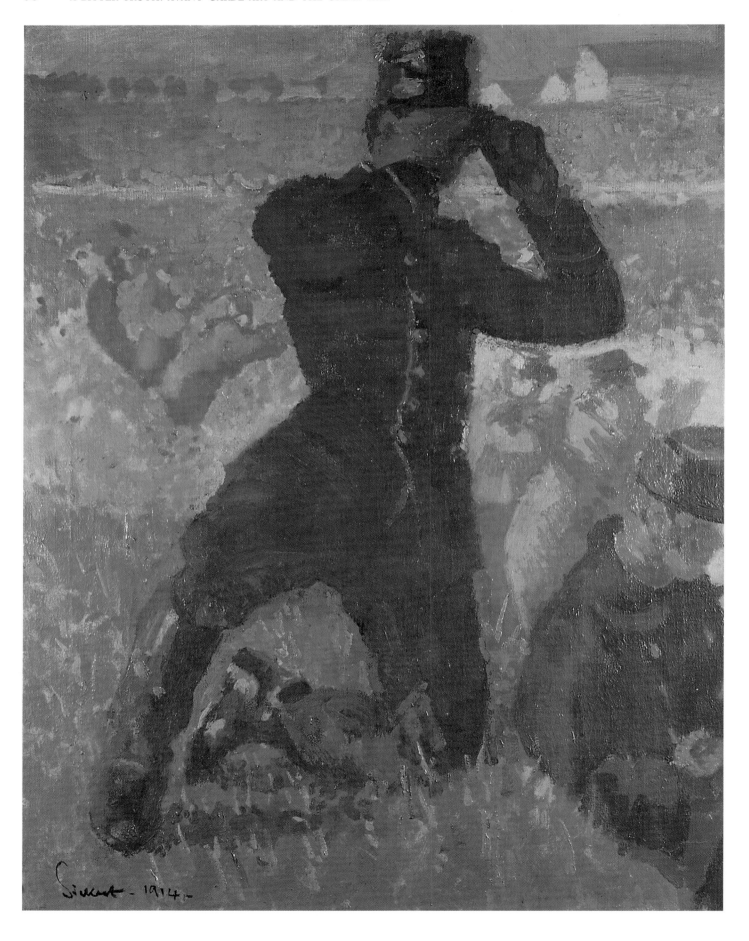

other foreigners who had made Paris their home, he was now obliged to bid his artist friends farewell. Braque and Derain, who had recently joined him at Avignon, were both mobilized with great speed in August. Picasso said goodbye to them at Avignon station and, according to Roland Penrose, returned home 'sad, worried and solitary. It was not his war.'[57] Nor did he feel constrained to deal directly with its outbreak in his work. Picasso's fellow-Spaniard Gris, who believed that 'in the nightmare through which we are passing, previous engagements are no longer valid and each of us must make his own way',[58] began incorporating newspaper references to the war in his Cubist work. It followed the example set by Picasso's collages two years before (see Pl. 11); but most of the pictures painted by the latter in Avignon now seemed impervious to the threat of war, celebrating instead a decorative delight in portraits and still-life compositions which have often been categorized as 'Rococo Cubism'.

They certainly betray no sign of the melancholy he now experienced, and only one painting contains a reference to the military challenge France was confronting. In a *Still Life with Cards, Glasses, and a Bottle of Rum*, commenced during the summer but only completed the following year, he plays sly pictorial games in a holiday mood (Pl. 52). Although the floral wallpaper behind the objects clustered on their table-top resembles a strip of *papier collé*, it is in fact a careful simulation in oil paint. Elsewhere in the picture he enjoys himself with illusionistic shadows, deceptively suggesting that parts of the composition have been glued on, and expansive areas are scattered with confetti-like showers of pointillist-inspired dots. As a contrast to all these *jeux d'esprit*, a goblet stands out in surprising whiteness among the ornamental elaboration. Bare to the point of starkness, this patriotic *faïence* bears the capital letters 'VIVE LA' above jauntily crossed French flags. Since they leap out of a picture otherwise remarkable for its witty duplicity, these clearly inscribed words must reflect a desire to highlight nationalist sentiment. Their importance is acknowledged in the picture's subtitle, but its gaiety of mood was at odds with the upheaval he found on returning to Paris around the end of October.

The pre-war circle of friends had been disrupted, and would never reassemble in the same way. His dealer Kahnweiler, a German citizen and therefore liable to internment in France, felt unable to leave Italy and spent the rest of the war in Switzerland. Other artists departed for active service, without blaming Picasso for remaining behind. Jacques Villon recalled that 'we never dreamt of holding against him that he did not go to war. We knew he was worth much more than that. And besides, it was not his country that needed defending.'[59] His close friend Apollinaire, however, the stateless son of a Polish mother and an Italian father, applied for French nationality. After strenuous attempts to enlist he finally succeeded in joining the artillery. His departure must have made Picasso realise that Paris had now been denuded of almost all his closest allies. Gertrude Stein believed that 'Apollinaire's leaving perhaps affected him the most',[60] and Picasso found himself presented with white feathers by those eager to discredit the pre-war avant-garde with insinuations of cowardice or treacherous *boche* sympathies. Within a year, as Kenneth Silver has demonstrated,[61] their attempt to tarnish experimental art by identifying it as a German malaise would have profound consequences (see Pls. 190-1).

For the moment, Picasso contented himself with drawing an affectionate portrait of Apollinaire at the Front (Pl. 53). The style employed

in this playful little study was deliberately indebted to the tradition of the *image d'Epinal*, originally a Napoleonic cult which later became a folk art extolling the virtues of the French people. During the Great War the *image d'Epinal* became a propagandist idiom (see Pls. 54-5), but Picasso uses it rather more ambiguously in his Apollinaire drawing. Standing with sword in hand beside a decidedly phallic shell upended on the ground, the poet looks somewhat puzzled as he turns away from his gun. Perhaps the 'plan' lying nearby, filled with geometric signs reminiscent of Cubism at its most calligraphic, has confounded the new recruit. Picasso's ambivalent attitude towards the war is plain in this less-than-heroic portrait, and his decision to inscribe Apollinaire's Polish surname on a *tricolore* underneath the drawing appears to convey his surprise that anyone should become French in order to fight a war.

All the same, Picasso did allow himself to wax patriotic about his adopted country in a letter written to Apollinaire just after Christmas 1914. The first page is framed in a pyramidal form, blithely festooned with French flags. He became still more expansive in a letter to André Salmon five months later, inscribing it with the slogan 'Vive La France' and setting another victorious French flag against a sun emitting red and blue rays. Further on in the letter, Picasso executed a swift and dashing watercolour of a French cavalry officer standing next to his horse and waving a sabre *à la* Géricault. Moreover, his satisfaction knew no bounds when he discovered that the new language created for art in the pre-war years even seemed to have affected military developments. 'The first year of the war', wrote Gertrude Stein in *The Autobiography of Alice B. Toklas*, 'Picasso and Eve, with whom he was living then, Gertrude Stein and myself, were walking down the boulevard Raspail a cold winter evening. There is nothing in the world colder than the Raspail on a cold winter evening, we used to call it the retreat from Moscow. All of a sudden down the street came some big cannon, the first any of us had seen painted, that is camouflaged. Pablo stopped, he was spell-bound. C'est nous qui avons fait ça, he said, it is we that have created that, he said. And he was right, he had. From Cézanne through him they had come to that.'[62]

52 Pablo Picasso *Still Life with Cards, Glasses, and Bottle of Rum ('Vive la France')* 1914-15. Oil on canvas, 52.1 × 63.5 cm. Private collection.

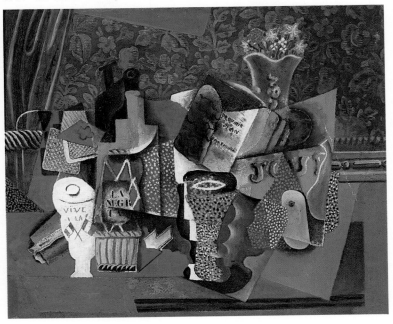

51 Walter Richard Sickert *The Integrity of Belgium* 1914. Oil on canvas, 91 × 71 cm. The Government Art Collection, UK.

53 Pablo Picasso *Guillaume Apollinaire, Artilleryman (Guillaume de Kostrowitzky, Artilleur)* 1914. Ink and watercolour, 23 × 12.5 cm. Private collection, Paris.

Whether or not Picasso and Stein were right to make such a claim, camouflage design throughout Europe continued to bear a marked resemblance to innovative art throughout the war years – culminating in the spectacular dazzle patterns devised for Allied shipping (see Pls. 312–13). Camouflage grew so sophisticated during the war, for artillery and navy alike, that it eventually inspired the formation of Les Peintres de la Guerre au Camouflage. It thereby became the subject-matter for painters whose own earlier work may have contributed to its initial development (see Pl. 102). Indeed, its boldly geometric dissonance could be seen as a vivid public manifestation of the way art had been transformed before the war. 'The spirit of

everybody is changed, of a whole people is changed,' wrote Stein in her book on Picasso, 'but mostly nobody knows it and a war forces them to recognise it because during a war the appearance of everything changes very much quicker.'[63]

One of the French artists who subsequently became involved with Les Peintres de la Guerre au Camouflage was Dufy. When war broke out, however, he busied himself at first driving a van for the military postal service. Then he found employment at the Musée de la Guerre, producing propagandist designs like *The Four Aymon Sons*, which updates a French medieval legend by turning the four brothers into the military heads of the Allied countries (Pl. 54). In another design he decided, like Picasso, to depict Apollinaire in the artillery, and all his patriotic work was similarly indebted to the *image d'Epinal* tradition. Dufy's previous experience, with textile printing for Paul Poiret and woodcuts for Apollinaire's *Bestiare*, enabled him to carry out the government propaganda bureau commissions with winning facility and dash. His innate optimism seemed unshaken by the war, and in a 1914 painting entitled *The Allies* he portrayed six of them riding together in full ceremonial fig with swords upraised. Confidently expecting victory, their assurance is reinforced by the sun's shafts as it penetrates the clouds and falls with equal force on all their shoulders. The air of jauntiness and unshakeable unity receives further confirmation on the frame Dufy has devised, garlanded with flags of the nations involved. The riders look as though they are cantering off for a day's hunting rather than preparing for the bloodiest war in human history.

Dufy's naive faith in the allies' invincibility was limitless. The sporting analogy received even more chivalric expression in his print of soldiers addressing themselves with courtly etiquette to battle in the trenches. A British officer gallantly invites his French comrades to savour the privilege of the first shot, while rabbits skip across a landscape punctuated by the comic helmets of the waiting enemy. The Germans are here presented as dismissively as in Malevich's contemporaneous prints (see Pls. 47–8). But Dufy's belief in victory surpassed even the most blatant Russian propaganda: in June 1915, Jean Cocteau's new magazine *Le Mot* published his ecstatic image of *The End of the Great War* (Pl. 55). Here a vanquished teutonic eagle writhes within the claws of the victorious French cock Chanteclaire, who sings a victory hymn to the tune of 'The Wandering Jew' as Joan of Arc's spirit rises from the ruins of Reims cathedral – set ablaze by German shelling the previous year.

This readiness to let art be invaded by martial rhetoric was not shared by Matisse, whose early attempt to enlist was rejected on grounds of age. While avoiding any direct reference to the war in his work, he soon found himself disturbed by the conflict. By the winter of 1914 all the members of Matisse's family, apart from his wife and children, were stranded behind enemy lines. When he heard that his brother was held as a civilian hostage by the Germans, Matisse decided to help by donating the proceeds of his work to the cause. He produced a series of eleven prints for sale in aid of 'civilian prisoners of Bohain-en-Vermandois', where his relatives lived. The suite consisted mostly of portrait heads, and nothing in the images themselves demonstrated an awareness of the war on Matisse's part. But he continued to be haunted by the conflict, and not only because of his family's plight. Writing later to his patron Hans Purrmann, he revealed the full extent of his frustration and guilt. 'Derain, who came back yesterday, displayed a state of mind so marvellous, so grand, that in spite of the risks I shall always regret that I could not see all these upheavals,' he confessed, adding: 'How irrelevant the mentality of the rear must appear to those who return from the front.'

Despite realising that his own current paintings 'are the most important things of my life', he went on to admit that the 'struggle' they demand 'is not the real one, I know very well, and it is with special respect that I think of the *poilus* who say deprecatingly, "we are forced to it." This war will have its rewards – what a gravity it will have given to the lives even of those who did not participate in it if they can share the feelings of the simple soldier who gives his life without knowing too well why but who has an inkling that the gift is necessary. Waste no sympathy on the idle conversation of a man who is not at the front. Painters, and I in particular, are not clever at translating their feelings into words – and besides a man not at the front feels rather good for nothing . . .'[64]

However much Matisse was impressed by Derain's attitude to the ordeal of war, the fact remained that active service prevented an artist of the latter's stature from continuing his work. Looking back later on his four years at the Front, Derain realised that he had spent his time

54 Raoul Dufy *The Four Aymon Sons* 1914. Printed paper, 33.5 × 25.5 cm. Musée d'Histoire Contemporaine – BDIC, Hôtel National des Invalides, Paris.

55 Raoul Dufy *The End of the Great War* 1915. Pen, ink and gouache on paper, 43.3 × 55 cm. Musée d'Histoire Contemporaine – BDIC, Hôtel National des Invalides, Paris.

'always under fire, the mud, the rain or the dust, nothing to eat, nowhere to sleep, and always the same, always, with no let-up.'[65] Although he planned ambitious work at the Front, and filled a number of sketchbooks with drawings, they did not lead to paintings and were subsequently lost.[66] But he managed to extemporize with the materials at hand in the trenches. Abandoned shell cases revived his pre-war interest in sculpture, and he made several mask-like heads from this sinister beaten metal. They served as a melancholy reminder of the abilities which Derain, a prolific and inventive artist before the war, was forced to neglect as long as the fighting continued.

Even a painter as reclusive as Gwen John found herself with greater opportunities to study and define the war activity which impinged on her isolated existence in Meudon. She began making occasional watercolours of the *poilus* whom Matisse admired so much, but it is typical of John that she views them with sobriety – either from behind or as figures sitting alone at café tables contemplating the ordeal ahead (Pl. 56). She was under no illusions about the degree of human suffering which hostilities would bring. While refusing to take her anxious relatives' advice and return to Britain, she knew as early as September 1914 that 'the war is heartbreaking, as you say, and the horrors don't seem to end . . . The people were frightened at Meudon and many went away, as the Germans came that way in 1870. It is very high here and we can see all Paris. We saw the chase of the aeroplanes when the enemy dropped a few bombs those afternoons. Paris is quiet now. Many of the shops are shut, and there is less traffic. One sees a crowd round a wounded now and then, and bodies of soldiers marching.'[67]

Gwen John's refusal to derive any spurious excitement from the conflict could hardly be further removed from the Futurists, whose frustration became acute when Italy retreated into neutrality once the war broke out elsewhere in Europe. This, after all, was the grand purifying struggle they had advocated for so long, the 'only health giver of the world'[68] which Marinetti first glorified in his initial manifesto of 1909. Now, to his intense chagrin, Italy was courted by both sides, each equally eager to gain a major ally. While Mussolini

preached the benefits of joining the French cause, most Italians preferred to remain outside the struggle. But the Futurists refused to accept that a country as 'virile' as their own could fail to fulfil its martial destiny. In the middle of August their magazine, *Lacerba*, proclaimed a steadfast commitment to the campaign for intervention. Then, a month later, Marinetti joined Boccioni and Russolo in a fiery demonstration at the Milan *Galleria* where they put Austrian flags to the torch. On 16 September Boccioni proudly informed his family that, 'from a box in the [Teatro] Dal Verme during a gala performance yesterday evening, I ripped up an Austrian flag and Marinetti waved the Italian. Tonight we will begin again. Perhaps they will arrest us for a few hours. It is necessary.'[69] Subsequent imprisonment, and a legal edict banning them from any more public gatherings, did not prevent them from pursuing their cause with undiminished zeal. On 20 September they signed 'The Futurist Synthesis of the War', a declaration to which Carrà and Ercole Piatti also added their names. During the final months of 1914 they implemented their statement of intent in a flurry of belligerent images, each artist seemingly determined to outdo the others in strident enthusiasm.

Marinetti exploited his love of *parole in libertà* to raucous effect, producing an extended series of ink and collage works where aggressive words were fired at the viewer like gunshot. One of them, dominated by the fierce capitals shouting 'IRREDENTISMO', fantasized about an irresistible advance over the border into Italy (Pl. 57). Another took the patriotic cry Picasso had employed, 'Vive La France', and repeated it with delirious abandon across a composition where the familiar

56 Gwen John *Soldier at a Bar* c. 1914–18. Watercolour and pencil on paper, 22 × 17.4 cm. Collection of Mellon Bank.

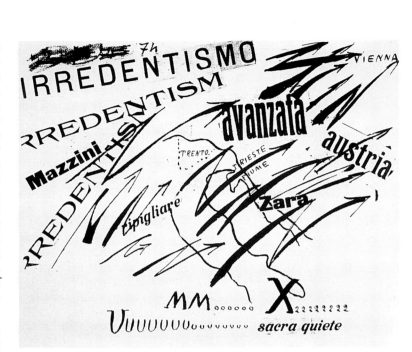

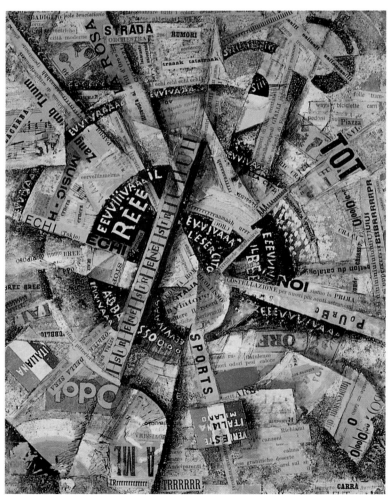

57 Filippo Tommaso Marinetti *Parole in libertà (Irredentismo)* 1914–15. Ink and collage on paper. Private collection.

58 Carlo Carrà *Interventionist Demonstration* 1914. Collage on paste-board, 38.5 × 30 cm. Laura Mattioli Collection, Milan.

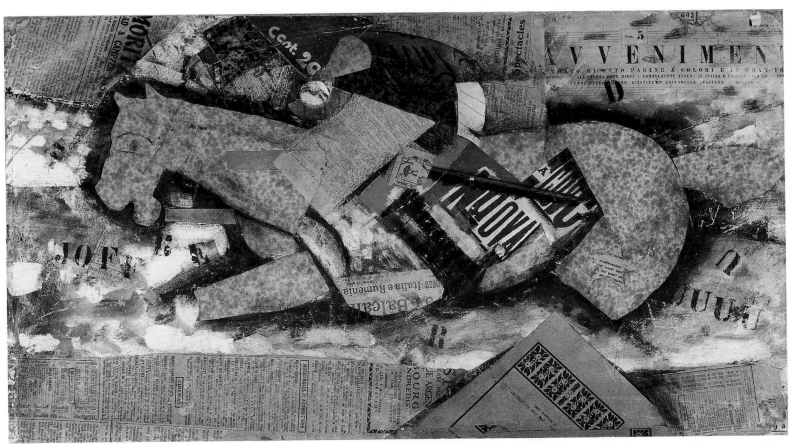

59 Carlo Carrà *The Chase* 1914. Collage on paste-board, 39 × 68 cm. Laura Mattioli Collection, Milan.

verbal punch of 'Zang Tumb Tuuum' was delivered as zestfully as possible. The prevailing note was callow in the extreme. Despite Marinetti's intriguing theories about liberating words from their conventional meanings, so that they aspired to the condition of painting and appealed to 'the wireless imagination', the pictures themselves compare poorly with the astounding impact of their maker's verbal performances. In a collage called *Parole in libertà (Bombardamento)*, Marinetti takes that belligerent word and stretches it into onomatopoeic distortion: 'Booooomboooooombaaaaardaamento'. But it seems merely playful on paper, without the essential dramatic reinforcement provided by Marinetti's bellowing exertions on the lecture platform. Audiences were dumbfounded by his frenetic renditions of poems inspired by the Balkan War, and Wyndham Lewis even went so far as to assert that 'a day of attack upon the Western Front, with all the "heavies" hammering together, right back to the horizon, was nothing' in comparison with the Futurist leader's 'unaided voice'.[70]

Carrà paid tribute to Marinetti's prodigious battle poems in *Atmospheric Swirls. A Bursting Shell*. Here the familiar incantation 'Zang Tumb Tuuum' is sliced into collaged fragments which fly out, like ricocheting bullets, from the freely brushed ink explosion. But Carrà's most successful experiment with *parole in libertà* far outstripped Marinetti's collages in its carefully orchestrated complexity. Published in *Lacerba* as promptly as 1 August, before the declaration of hostilities between France and Germany, *Interventionist Demonstration* revolves like a catherine wheel from a centre crammed with curving exhortations to honour the twin imperatives of monarchy and military might (Pl. 58). 'Eevviiivaaa il Reee' screams the most prominent slogan, commanding its readers to cry 'Long live the King!' Then, as

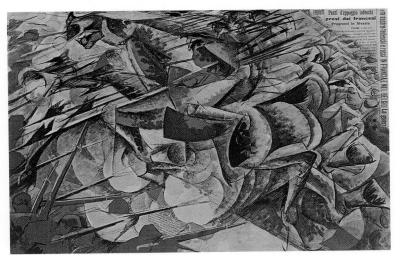

60 Umberto Boccioni *Charge of the Lancers* 1915. Tempera and collage on paste-board, 32 × 50 cm. Jucker Collection, Milan.

if in answering echo, another burst of excitable words shouts out 'Evvivaaa L'Esercito' ('Long Live the Army!'). Radiating crazily from the heart of this cacophonous image are shafts of sounds inspired by sirens, machine-guns, traffic, songs, grunts, snorts and a plethora of other aggressive noises. Carrà called this prodigious call-to-arms a *'Free-Word' Painting*, and colour plays a potent role in its pictorial effectiveness. The predominance of pink and pale blue accentuates the blitheness with which the Futurists viewed the onset of a global conflict, as though suffering had no part to play in their unbridled

61 Max Liebermann '*Now we will thresh you!*' 1914. Cover of *Kriegszeit No. 2*, 7 September 1914.

machismo fantasies.

Once Italy entered the war the following May, they discovered that real combat led to a very different outcome. But for the moment, in the first rash of enthusiasm for a struggle they had not yet experienced, the Futurists' exhilaration knew no limits. Like a boy captivated by visions of boundless adventure, Carrà pasted together a collage called *The Chase* (Pl. 59). Although it was probably inspired by Marshal Joffre's victory at the battle of Marne in September, there is little sign that Carrà views this pursuit as anything more than a lighthearted escapade. The newspapers and programme cuttings which surround the galloping rider evoke a harmless world of games, sport and other entertainments. However low the cavalryman bows, in his attempt to evade enemy fire and make his horse go faster, he is scarcely more than a marionette. The horse may appear to breathe the name 'Joffre' from his gaping mouth, but the entire conception of the picture belongs to the nursery rather than the battlefield.

As 1914 neared its end, though, even the Futurists began to sense that war might entail more than a display of puerile bravado. Late in the year, Boccioni commenced work on a tempera and collage *Charge of the Lancers*, and the difference separating it from Carrà's ostensibly similar *The Chase* is significant (Pl. 60). Boccioni had only just resumed his work as an artist after months of political agitation for the interventionist cause. 'I want to work but the anxiety that grips everybody perhaps prevents me,' he had admitted in September, adding with uncharacteristic indecisiveness that 'I should go to the country but . . . and the war?'[71] All this pent-up emotion was finally unleashed in *Charge of the Lancers*, and it gives a demonic energy to the cavalrymen as their mounts hurtle towards the enemy trenches. The newspaper report behind them refers to the progress of the war in France, but Boccioni would no doubt have preferred to use a cutting that recounted Italy's courageous exploits. By selecting a report dated 4 January, he implies a desire to see his own country heralding the new year by joining in the conflict.

Like the other Futurists, Boccioni was convinced that an Italian offensive would be irresistible. His outsize lancers seem impregnable as they gallop fearlessly towards the gunfire of the diminutive soldiers in the trenches. At any moment, the enemy will either be trampled on by the horses' hooves or skewered by the lances forming such a powerful cluster of diagonal 'lines of force'. When the picture was

62 Alfred Kubin *Torch of War* 1914. Städtische Galerie im Lenbachhaus, Munich.

published days after completion by the magazine *La Grande Illustrazione*,[72] it would have been seen as an especially spirited vision of the war's glorious capacity to bring out the heroism in its fighting men. There is, however, something more than straightforward bellicosity in Boccioni's vigorous image. The repetition of the horses' rears, stretching towards apparent infinity, has the feverish quality of a nightmare. This strain of delirium is most overt in his handling of the dominant lancers and their steeds. Oblivious of danger as they fling themselves towards the rifles in the enemy ranks, they are nevertheless dominated by a skeletal head rearing above them at the top of the composition. Its phantasmic presence is redolent of death rather than victory, suggesting that even the militant Boccioni was beginning to acknowledge the horror of war as well as its adrenalin-inducing appeal.

Italy had yet to experience the human cost of the hostilities, whereas the participating countries were already revising their initial view of the conflict. At the beginning of September,[73] the German Impressionist Max Liebermann had been sufficiently seduced by nationalist ardency to contribute a sabre-rattling cover for Cassirer's *Kriegszeit* (Pl. 61). 'Now we will thresh you!' roared the caption, using the Kaiser's war-cry to convey the ferocity of a German cavalry officer as he sets off, with sword brandished above his helmet. The charge he leads will be as singlemindedly aggressive as Boccioni's *Charge of the Lancers*, and Liebermann showed no sign of questioning his fervour a few months later. Some of his fellow-countrymen began to question the jingoist urge, however. While Liebermann continued to produce lithographs for *Kriegszeit* like *March, March, Hurrah!*, Alfred Kubin produced a drawing which presented a very different view (Pl. 62). By December 1914, when Kubin published *Torch of War* in Munich, even the most optimistic of German generals were forced to admit that the war had taken a disturbing course. Despite the loss of over 400,000 soldiers, little had been achieved and a resolution of the conflict seemed a long way off. Germany found itself fighting on two fronts, forced on to the defensive instead of pushing out of deadlock towards a decisive outcome. Far from achieving a quick victory, everything now indicated a prolonged war of attrition which might well exact an unprecedented toll on human lives.

Kubin's drawing accepts this terrible prospect, and foresees a world where even woman has transformed herself into a monstrous embodiment of evil. She bestrides the land like a marauding emissary from hell, gazing over Europe through the eye-sockets of a face already reduced to a skull. While her left hand points imperiously towards the next target, her gloved right hand holds a torch which appears to have been plucked from the inferno behind her. A wall of flame consumes the forest, and no one appears capable of opposing the conflagration. A female figure sprawls in the distance, arms outstretched as if to deplore the devastation around her. But she is entirely overshadowed by the rampaging hag, whose appetite for annihilation will not be assuaged until the whole of Europe has been consumed by the holocaust.

In the very same month, Paul Klee's lithograph *Death for an Idea* appeared in a Munich journal called *Zeit-Echo* (Pl. 63). His image of the lifeless soldier in a spiked helmet, sprawled beneath an intricate structure of ladders, windows, walls and crosses, was reproduced next to a poem by Georg Trakl about death in war. Its tragic mood received reinforcement below, where Trakl's recent death at the age of 27 was announced. He had become gravely depressed after struggling, as a lieutenant in the Austrian Medical Corps, to look after serious casualties from the battle of Grodek, most of whom were

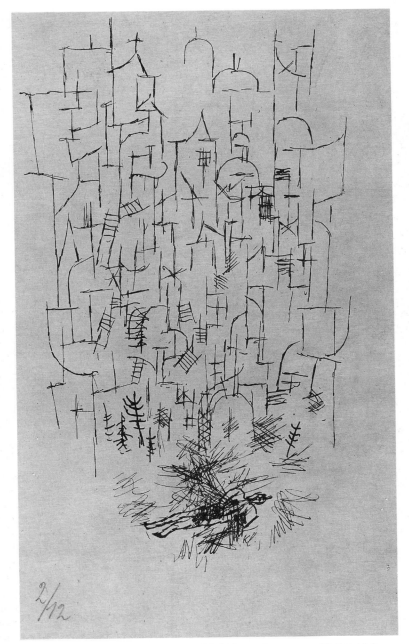

63 Paul Klee *Death for an Idea* 1914-15. Lithograph on paper, 21.5 × 12.3 cm. Staatsgalerie, Stuttgart.

beyond his assistance. A schizophrenic attack led the army to lock him in a cell, where he took an overdose of cocaine. The elegiac poem published in *Zeit-Echo* indicated the seriousness of the loss to contemporary literature, and Klee's lithograph provided a quiet yet questioning accompaniment. *Death for an Idea* refuses to find any comfort in the soldier's extinction. Instead, Klee already seems to be distancing himself from the cruel ideology that impels young men to sacrifice themselves at the beginning of their adult lives. By signing his own name near the slaughtered figure, he affirms a desire to emphasize the value of the individual at a time when casualties were habitually measured in thousands. A single loss deserves commemoration, Klee appears to insist, even as his attenuated lines define a fragile world poised on the edge of irrevocable collapse.

la terre

SZSZSZSZSZS

TREMENT

EMENT

RRE

-ANXIÈTÉ - SILENCE

ERRE

ITÉ

de l'herbe vers le canon

iiiiiii
iiiii iiiii iiiii iiiii
iiiii iiiii iiiii iiiii
iiiii iiiii iiiii iiiii
iiiii iiiii
iiiii

Artilleurchronom
PRECISISION
Tension des nerfs

Allons les gars
FEU !

Perf
Ryt

CHAPTER THREE
Deadlock
(1915)

Still untouched by first-hand experience of the war, the Italian Futurists greeted 1915 with their pugnacity intact. Ignoring the neutralist policy of their Prime Minister Giolitti, who was backed by the Catholics, liberals and socialists, they stepped up their campaign to force Italy into a direct involvement in the conflict. Balla's work was the most exhortatory of all. He turned himself into a militant crusader for the interventionist cause, hotly equating it with the honour of his native country. In *Patriotic Demonstration*, he interweaves the red, white and green of the Italian flag in a swirling abstraction (Pl. 64). It evokes the restless energy generated by the frequent rallies held in the streets of Rome, where bellicose young men roared their support for the idea of Italy entering the war. Although the outspoken colours of the flag are accompanied by sombre arcs and triangles of grey and black, the predominant mood is festive. Balla revelled in the opportunity to put Futurism's innate machismo at the service of an attempt to mobilize his country.

Courted throughout the winter of 1914–15 by both sides in the conflict, who offered Italy terrritorial prizes like frantic bidders at an auction,[1] the government continued to waver for several more months. But Balla was resolute in his desire for a show of martial ardour, nowhere more violently than in a sculpture called *Boccioni's Fist*. The image, which also appeared as a design on the Futurist movement's official letter-head, was conceived in one preparatory drawing as an assault on 'passéism'. A lunging embodiment of Futurist belligerence, outlined in a few spare strokes of the pencil, assails the cartoon-like figure of a shabby old man standing among columns symbolic of the obsolescent classical tradition. In its sculptural form, however, the original cardboard and wood version of *Boccioni's Fist*[2] assumed a more general significance (Pl. 65). Despite a high degree of abstraction, the 'lines of force' conveying the fist's action are powered by an unmistakeable desire to advocate the use of physical force in national life. The fist may belong to a particular individual, but it signifies the spirit of Italy. Balla believed that intervention in the war was now a proof of his country's nobility and pride.

As if to demonstrate the link between his vehement, red-painted sculpture and the nation at large, he transposed the great curving form at the base of *Boccioni's Fist* to a painting entitled *Flags at the Country's Altar* (Pl. 66). Its engulfing grey presence dominates the colours of the Italian flag, which flicker and dart in a fitful manner within the gleaming white structure above them. If Balla meant to imply that the flag might be sacrificed on the altar of national interests, he did not view the prospect with alarm. It was, to him, an inevitable

process, and his painting invests it with a chilling, metallic implacability. Even the boisterous Boccioni sensed how disconcerting his friend's anti-neutralist work had now become. 'All that could be considered episodic or contingent has been ruthlessly eliminated, with an iron conviction that is almost frightening,' he wrote. 'Anything that appears to him weakness is abolished. He goes on destroying. The earth becomes majolica-crystal . . . An enamelled surface seems to him warmer than blood that flows and spurts irregularly.'[3]

Not all Balla's interventionist paintings were quite so inexorable. *Volume-forms of the Cry 'Viva l'Italia'* is a more flamboyant work, joyfully transmitting the full-throated patriotic shout in a sequence of undulations which dance across the canvas like frolicsome waves. But a more sinister mood soon reasserted itself. In early May 1915, just after Italy signed a secret treaty with Britain and France in London,[4] he painted a more malignant picture where the familiar curves are accompanied by two pincer-like antagonists. One of them is shown seizing its opponent, like an aggressor bent on severing the enemy's strength in a single, decisive assault. Balla called the image *The Risks of 9 May – Risks of War*, as if to warn the Italian Chamber of Deputies that it courted disaster by continuing to vote in favour of neutrality.

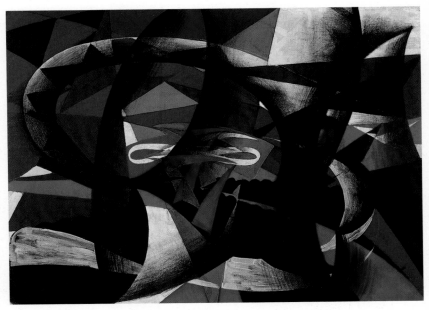

64 Giacomo Balla *Patriotic Demonstration* 1915. Oil on canvas, 100 × 136.5 cm. Thyssen Foundation, Madrid.

Left: Gino Severini *Cannon in Action* 1915 (detail). See Pl. 72.

Eventually, with the help of mob intimidation which launched an attack on Parliament House, Italy declared war on Austria-Hungary on 23 May. Among the first to celebrate the news was Cocteau, who swiftly devoted the cover of his magazine *Le Mot* to a concise and ingenious drawing of Dante wearing a Phrygian cap adorned by the antique laurel (Pl. 67). 'Dante on Our Side' declared the caption below, and elsewhere in the issue Cocteau joined Paul Iribe in saluting 'with love a people who might have chosen to sleep on palm leaves under the olive trees of Latium, and who, with a tuft of feather from our cock over their ear, marries us.'[5]

Although Italy waited over a year to come out against Germany as well, the Futurists were delighted. 'There is one man in Europe who must be in the seventh heaven: that is Marinetti,' wrote Wyndham Lewis around this time. 'From every direction come to him sounds and rumours of conflict. He must be torn in mind, as to which point of the compass to rush to and drink up the booming and banging, lap up the blood! He must be a radiant figure now!'[6] In July 1915 Boccioni, Marinetti, Russolo, Sant'Elia and several of the movement's younger associates joined the Volunteer Cyclists' Battalion. Sironi, who was already at the Front, lost little time in painting a gouache and collage image of militarism in the sky (Pl. 68). *Yellow Aeroplane with Urban Landscape*, closer in style to Cubism than Futurism, nevertheless remains faithful to the Italian movement in its emphasis on the destructive potential of the aircraft. Larger by far than the silent houses over which it hovers, the flying machine with its blurred Futurist propellor menaces the defenceless buildings like an agent of death. Within moments the solitary and anonymous pilot could easily unleash his lethal cargo, like the angels in Goncharova's *The Doomed City* who hurl colossal stones on to the roofs below (see Pl. 44). But

65 Giacomo Balla *Boccioni's Fist – Lines of Force* 1915. Cardboard and wood, painted red, 80 × 75 × 33 cm. Winston Collection, New York.

66 Giacomo Balla *Flags at the Country's Altar* 1915. Oil on canvas, 30 × 31.2 cm. Private collection.

for the moment, at least, Sironi withholds the bombs; and the atmosphere of de Chirico-like expectancy he creates instead is all the more haunting because of this pictorial restraint.

In reality, though, the exposure to combat catapulted the Futurists into a far more taxing and dangerous world than anything they had fantasized about before Italy's involvement commenced. The campaign turned out to have nothing in common with Alberto Martini's triumphalist *Avanti Italia!*, where the mother-country is transformed into a light-emitting colossus daunting enough to preside over a prematurely dejected enemy. Boccioni may have rhapsodized about Balla's patriotic paintings, declaring in a letter from the Front that 'you are great! Bravo, my very dear friend!'[7] But in the privacy of his diary, Boccioni admitted to experiences of war radically removed from the Futurists' jejune visions of martial glory. 'Reveille, cold! cold! cold? Some of us exhausted or near so,' he wrote in one demoralized entry, before noting: 'Sironi doing very badly . . . Having won a trench they [the Alpines regiment] ask what we are doing. Monticelli replies that attack for our side means a massacre.'[8] Posing for the camera with other Futurist volunteers in 1915, Boccioni and his friends looked resolute enough (see frontispiece). Sant'Elia screws his face into the fiercest frown he can muster, and Marinetti tilts his head back in an attitude of absolute defiance. All the same, their bravado could not disguise the fact that Italian troops made pathetically little progress in their advance against the Austrians. After announcing in his diary that 'we are heroic', Boccioni was forced to confess that they found themselves fighting 'without the shadow of equipment and training and without having the right physique.'[9]

Bodily infirmity prevented Severini from participating in the war at all. He settled in Paris near the end of 1914, ill and desperately short of money. But his plight did not prevent him from executing a remarkable series of paintings inspired by the conflict. Living in a French capital alive with war preparations, and rumours of the German advance, brought about a dramatic change in Severini's

work. His earlier preoccupation with the exuberance of sequin-spattered nightclub dancers, who rejoiced in their athleticism and orchidaceous costumes, gave way to a sterner vision. A canvas starkly entitled *War* shares his Futurist allies' willingness to drum up martial ardour. But the capital letters urging 'EFFORT MAXIMUM' are arranged in a more frontal, stable manner on the surface of the canvas, eschewing the excitability with which Carrà's *Interventionist Demonstration* had screamed out its frantic support for king and army (see Pl. 58).

The Francophile Severini had always been cooler and more analytic than the most eruptive of his Italian allies. *War* is dominated by the firm verticals of chimney-stacks and other industrial forms, all working to manufacture the propellor which inhabits the centre of the picture. Severini realised, quite accurately, that the war would be won or lost by machine power, and he interpreted the words 'ORDRE DE MOBILISATION GENERALE' as a signal for the stepping-up of industrial output. The same words recur on another painting, *Plastic Synthesis of the Idea 'War'*, and here they are again accompanied by images of armaments rather than soldiers (Pl. 69). Human figures are nowhere to be seen in this fusion of gun wheels, aircraft wings and related weaponry. Their predominantly grey, metallic structures fill the canvas with ominous assertions of mechanistic prowess, implying that the ordinary fighting man no longer played the central role he once fulfilled in battle.

Not all Severini's war paintings omitted humanity altogether. *Italian Lancers at a Gallop*, a rare attempt to depict his own countrymen rather than the French army, follows on from earlier attempts by both

67 Jean Cocteau *Dante On Our Side* 1915. Cover of *Le Mot*, 15 June 1915.

68 Mario Sironi *Yellow Aeroplane with Urban Landscape* 1915. Gouache and collage on paper, 71 × 53 cm. Ludwig Museum, Cologne.

Boccioni and Carrà to celebrate the dynamism and romantic dash of a cavalry charge (see Pls. 59, 60). But Severini's visored lancers look more like medieval knights than modern warriors, and he must have been aware of their anachronistic appearance in a conflict where a powerful gun battery could decimate even the most courageous cavalry division. Hence his decision to paint *Cannon in Action*, where the entire image is alive with reactions to the mighty 'BBOUMM' of the gun (Pl. 72). As flame and clouds burst out of the barrel, the surrounding landscape recoils from the impact in a series of fan-like curves inscribed with words like 'Pénétration', 'Bruit + Lumière' and 'Expansion centrifuge'. The ultimate objective is to further the cause of 'AVANCER – AVANCER – AVANCER', and Severini gives great prominence to the word 'Anéantissement' as he stresses the annihilating impact of the bursting shells. But he is equally aware of the cold, methodical expertise commanded by the gunners who activate the weapon. Words like 'PRECISISION' [*sic*], 'SYSTEMATIQUEMENT' and 'Perfection Arithmétique' cluster round the cannon, all applying to men capable of controlling their 'Tension des nerfs.' The orderly, matter-of-fact way they go about their duties in the maelstrom indicates that these soldiers have been trained to a dehumanized extent. Severini implies as much when he amalgamates the two words 'SOLDATS MACHINES'. It would be unwise, all the same, to over-emphasize the sinister aspect of his painting. Within a cloud belched

69 Gino Severini *Plastic Synthesis of the Idea 'War'* 1915. Oil on canvas, 60 × 50 cm. Bayerische Staatsgemäldesammlungen, Staatsgalerie Moderner Kunst, Munich.

70 Gino Severini *Armoured Train in Action* 1915. Oil on canvas, 115.8 × 88.5 cm. The Museum of Modern Art, New York. Gift of Richard S. Zeisler.
71 Gino Severini *The Hospital Train* 1915. Oil on canvas, 117 × 90 cm. Stedelijk Museum, Amsterdam.

from the rear of the gun-barrel, he has inscribed a series of pungent observations attesting to the risible side of mechanized warfare:

> Emanation de Gaz puants
> Pénétration désagreable
> Paunteur Acide
> oh là là! ça sent mauvais.

The more he dwelt on images of the Front line, however, the less Severini felt disposed to find humour in battle. After taking his family to Igny, in the country outside Paris, he stayed there several weeks and found himself watching day and night trains loaded with war materials, or with soldiers and wounded. He had been attracted to modern transport during the pre-war years, most notably in a painting called *Nord-Sud*[10] where disjointed views of passengers are fused with 'simultaneous' fragments of metro signs, directions and glimpses of blurred railway track. Now, seen from an aerial vantage presumably provided by the artist's window at Igny, the trains were viewed in a more distanced manner. No longer does Severini strive to place the observer at 'the centre of the picture',[11] as he and the other Futurists had announced in their 1910 manifesto. The spectator is removed from the passenger's position and invited to see *Armoured Train in Action* as a streamlined, metal-plated form passing below like a shell in motion (Pl. 70). The soldiers crouching within its bolted carapace are all faceless, their identities subsumed in the collective act of firing at the enemy. Their rifles seem far less potent than the green gun beyond them, its phallic barrel projecting from a riveted box in order to bombard the countryside. No trace of Severini's playful wit can be found in this scene of ruthless concentration, where the riflemen seem almost as metallic as the vehicle they defend. But the train is seen as a strangely pristine object, undefiled by any of the bullet-dents, scorchmarks or other blemishes which war generates in reality. Severini's view of battle is laundered of all unpleasantness, and betrays his lack of direct involvement in the human cost of the conflict.

Only in his images of medical trains did he begin to hint at a more compassionate attitude. *Red Cross Train Passing a Village* is little more than a transposition of an old Futurist motif, and the gaudiness of the fragmented countryside suggests that Severini still saw the war as an occasion for high spirits. The red cross painted on the side of the speeding carriage is reduced to the level of a decorative extra, as bright and attractive as the fresh green leaves or the orange rooftops blaring from other areas of the painting. In *The Hospital Train*, however, the cross has assumed a far greater significance within the composition (Pl. 71). Considerably larger than the French flag along-side, this Malevich-like red cruciform gives the entire picture a more pacific character. It seems actively to seek a more defensive role, attempting to shield the figures inside the train from whatever dangers may lurk behind the spiralling smoke nearby. Just as Stanley Spencer would decide to do four years later (see Pl. 307), Severini looks down on the stretchers from above. Unlike Spencer, though, he cuts off the wounded bodies above their waists. Only the shapes beneath the dun-coloured blankets are visible, along with a single hand protruding from a uniformed sleeve. The potential pathos of the scene is thereby reduced, and it is difficult at first to distinguish the patients' bodies from the equally subdued segments of train around them. But the figure of a nurse is prominently installed in the foreground, and she introduces a more humane mood. Contemplative and utterly com-posed, this purifying presence offers an alternative to the pugnacity of the Futurist vision of war. She helps to explain why Severini, after completing his sustained sequence of battle paintings, abandoned Marinettian ideas the following year and adopted a neo-classical style to depict even more serene and nurturing subjects like *Maternité*.[12]

Christopher Nevinson was to retreat from Futurism with a greater sense of revulsion. Before the war, this ambitious young painter had become a devoted disciple of Marinetti's movement soon after leaving the Slade School of Art. When the charismatic Futurist leader invaded London with his belligerent performances, Nevinson sat behind a

72 Giro Severini *Cannon in Action* 1915. Oil on canvas, 50 × 60 cm.
Städelisches Kunstinstitut, Frankfurt am Main (on loan from a private collection).

curtain and banged a drum to heighten the verbal onslaught. He was also instrumental in organizing a grand banquet in Marinetti's honour at the Florence Restaurant, where the Italian propagandist delivered an apoplectic rendering of his poem about the siege of Adrianople 'while all the time a band downstairs played "You made me love you, I didn't want to do it".'[13] Nevinson certainly came to love Marinetti, joining him in a rash attempt to convert other members of the British avant-garde to the Futurist cause.[14] Their overtures were rejected, and Nevinson remained the sole English follower of Marinetti's movement.[15] He responded to the onset of war with true Futurist determination, although a limp prevented him from enlisting as a soldier. Volunteering instead for the Red Cross, he served in France as an ambulance driver. Marinetti received a signed and dedicated photograph of Nevinson standing proudly beside his motor, a powerful symbol of the machine age among the horses and mules used for most transport at the Front (see frontispiece). As if to stress his

valour, Nevinson has arrowed and outlined the places where shrapnel pierced the ambulance. 'All this was demolished,' he wrote dramatically on the photograph, pointing to the rear wheel, and Marinetti was sufficiently impressed by his disciple's courage to preserve the picture in his scrapbooks. 'This war will be a violent incentive to Futurism,' Nevinson told the *Daily Express* in February 1915, 'for we believe that there is no beauty except in strife, and no masterpiece without aggressiveness.'

In the same interview, however, he sounded a rather different note by explaining that 'I have tried to express the emotion produced by the apparent ugliness and dullness of modern warfare.'[16] The ambivalence of this statement was duly reflected in the first war paintings Nevinson exhibited in London. The only one which presented a wholehearted Futurist vision was a pre-war painting of a red-funnelled liner which he had opportunistically retitled *My Arrival at Dunkirk* to give it a topical *frisson*. But this clamorous celebration of up-to-date

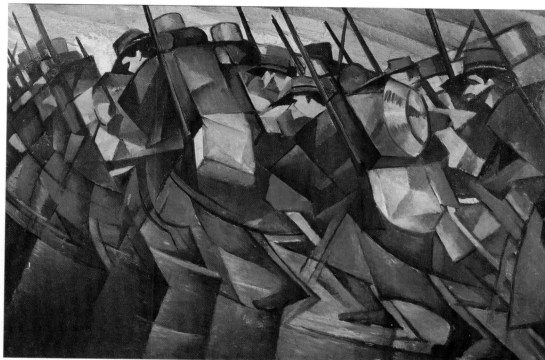

73 Recruiting poster by Johnson, Riddle and Co. Ltd., London, published by the Parliamentary Recruiting Committee, 1914. National Army Museum, London.

74 Christopher Nevinson *Returning to the Trenches* 1914–15. Oil on canvas, 51 × 76 cm. National Gallery of Canada, Ottawa.

streamlined prowess, where the clean-cut vessel carves through a 'simultaneous' mêlée of cranes, wharves, tugs and warehouses, had nothing to do with the war. It was originally entitled *The Arrival*, and took no account of the shocking conditions Nevinson had been forced to confront in France. Working as an ambulance driver, stretcher-bearer and interpreter meant that he encountered suffering from the outset. After crossing from Dover to Dunkirk, he found himself the next evening strenuously at work 'in a shed full of dead, wounded, and dying. It was a sudden transition from peaceful England, and I thought then that the people at home could never be expected to realize what war was. A few hours from London, with its theatres playing to crowded houses and a kind of mock heroism abroad . . . and here we were working in a shed that was nicknamed the "Shambles." '[17]

As the ambulance photograph sent to Marinetti indicates, the experience did not shake Nevinson's Futurist convictions overnight. Nor did he immediately paint the terrible agony he had witnessed in the 'Shambles'. But the most important of his initial war paintings, *Returning to the Trenches*, marked the beginning of a shift away from his earlier loyalties (Pl. 74). For this beleaguered image does not present a Marinettian view of battle. The Futurist style is evident enough, most of all in the 'lines of force' which split up the canvas with their lancing, schematic precision. But the motion that impels the marching soldiers does not seem to be leading them towards a Futurist victory. On the contrary: the men look huddled and burdened, grimly caught up in a grinding process over which they have no control. Although there is considerable dynamism in the picture, and it stops some way short of outright pessimism, Lewis was right to observe that Nevinson's marching soldiers 'have a hurried and harassed melancholy and chilliness that is well seen.'[18]

Whether or not he had yet fully realised it, Nevinson was starting to use his art as an antidote to the offical, propagandist depiction of the conflict. Invalided home from France, he began to feel angry about the complacent atmosphere in England. 'Back I went to London, to see life still unshaken, with bands playing, drums banging, the New Armies marching and the papers telling us nothing at all,'[19] he remembered later. In spite of its lingering attachment to Futurism, *Returning to the Trenches* can be seen as a rebuttal of the images of men on the march popularized by recruitment posters of the period (Pl. 73). These persisted in presenting the war as a patriotic adventure, whereas Nevinson had the temerity to provide a markedly less glamorous view of life at the Front. He must have known that his canvases flew in the face of the requirements voiced by jingoistic journalists, who called for paintings offering a complacent and morale-raising view of the war. 'One is already asking on the Continent who will be the first to immortalise on canvas or in marble the tremendous realities of 1914–15,' declared the *Daily News* only a month before *Returning to the Trenches* was first exhibited at the London Group. 'Defeat inspired the historical painters in the 'seventies. Victory will be the new theme . . . The campaign of last year and this! What masterpieces must be born!'[20]

Lady Butler, the doyenne of Victorian battle painters, could be relied upon to gratify such expectations. Although 67 when war broke out, she was still vigorous enough to work towards a 'Waterloo Centenary Exhibition' at the Leicester Galleries in May 1915. The knowledge that two of her sons had enlisted, as an infantry officer and a chaplain, boosted Lady Butler's involvement in the campaign. She painted a jaunty watercolour of Patrick Butler on the day he left for Belgium as aide-de-camp to General Thompson Capper (Pl. 75). The young man smiles as he salutes on horseback, and the picture's sprightliness is accentuated by the cheerful inscription added by his mother below the horse's hooves: *Patrick, Au Revoir!* Within a month, his severe wounding at the first battle of Ypres prompted Lady Butler to admit private doubts. 'Who will look at my Waterloos now?' she

wondered, acknowledging that 'the gallant plumage, the glinting gold and silver, have given way to universal grimness.'[21] But the woman who had managed in her work of the 1870s to inject a melancholy realism into some of her battle scenes remained unwilling to reflect this 'grimness' in most of her First World War pictures. Only after the Armistice did she permit herself to present a more disillusioned vision of the conflict. While the war lasted, dutiful watercolours of Victoria Cross winners alternated in her output with more animated scenes equating assault with the pleasures of sport. She commemorated the battle of Loos in 1915 by depicting the charge of the London Irish Rifles across No Man's Land, kicking a football towards the enemy line with true goal-scoring determination.

Nevinson's refusal to paint such inanities counted against him in certain quarters when *Returning to the Trenches* was exhibited, along with three other paintings devoted to war themes, in March 1915. Although they attracted a great deal of attention in the Press, Nevinson soon became aware of hostility both from diehard patriots and avant-gardists who considered the war a 'vulgar' subject for an experimental artist. 'The intellectuals made violent attacks on them,' he wrote later, 'and I remember Harold Monro saying, "What on earth are you doing journalistic clippings for?" Of course, the Clive Bell group dismissed them as being "merely melodramatic". The *Times* was horrified, and said the pictures were not a bit like cricket, an interesting comment on England in 1915, when war was still considered a sport which received the support of the clerics because it brought out the finest forms of self-sacrifice, Christian virtues, and all the other nonsense . . . To me the soldier was going to be dominated by the machine. Nobody thinks otherwise today, but because I was the first man to express this feeling on canvas I was treated as though I had committed a crime.'[22]

Undeterred by the vilification he had aroused, Nevinson went on to produce the most cogent and pessimistic of all his war paintings. By this time he was working as an orderly for the Royal Army Medical Corps at the Third London General Hospital in Wandsworth, helping once again to tend the wounded and caring in particular for soldiers suffering from severe mental disturbance. 'Some were mad, some were shell-shocked, and some were nit-wits,' he recalled.

75 Lady Butler *Patrick, Au Revoir!* 1914. Watercolour and pencil on paper, 15 × 10.2 cm. Rupert Butler Collection.

'The change of environment and breaking of routine, or a dreadful experience in "the line", or for some the proximity day and night of other men in the same plight, sent them completely into a world of hallucination and persecution, especially the latter . . . I began to have an uneasy feeling that I was catching their complaint.'[23] He did his best to comfort them, and on occasion brought the patients into direct contact with his own art. A photograph survives of Nevinson explaining to a private wounded at Mons the 'inner meaning' of a plaster sculpture called *Automobilist* or *Machine Slave*.[24] This harshly modelled head had probably been conceived before the war;[25] but as soon as he gained leave to get married, Nevinson produced two outstanding canvases based on his memories of the conflict on the Continent.

So determined was he to confront the British public with the reality of war that Nevinson did not allow a honeymoon to delay his efforts. The time he had been granted away from the RAMC was precious, and after returning from a short stay in Ramsgate he set to work with extraordinary energy. 'I still had two days' leave', he remembered, 'and I painted "La Mitrailleuse" and "The Deserted Trench on the Yser." A queer honeymoon, and it was typical of my wife that she put up with it.'[26] Private happiness did nothing to ameliorate his bleak memories of the Front, and both pictures are notable for their uncompromising gloom. The landscape in particular, which came to be known as *Flooded Trench on the Yser*, has a desolation that reveals the full extent of Nevinson's misgivings (Pl. 76). The trench itself is reduced to a jagged cleft in the waterlogged terrain, zig-zagging towards the horizon with a tensile economy which shows how much he may have owed here to the precision of the Japanese colour print. Futurism's stylistic precepts are now left behind, in favour of a more conventional and accessible landscape view. But this return to a relatively orthodox way of seeing is not accompanied by any softening of emotion. Most of the picture-surface is burdened with the cloud-heavy sky, from which rain lances down like a shower of loose bayonets to pierce the defenceless earth. Surveying the battlefield after just such a downpour, one soldier described it as 'just one big sea for miles and miles', and noticed that 'when the wind blew it made waves just like the real sea.'[27] In Nevinson's painting, however, the wind is still. Human life has been excluded from the scene, and seems impossible to sustain in this forlorn panorama. Nevinson even implies that nature herself might never be able to recover from the wounds inflicted by a war without any discernible end in view.

A similar urge to replace Futurist complexity with a more direct, abrasive alternative can be found in *La Mitrailleuse* (Pl. 77). Taking as his subject the weapon which caused so much devastation during all those futile infantry advances, Nevinson presents a terse, grim-visaged view of a French machine-gun post in the trenches. The gunner has become almost as dehumanized as the machine he wields. Hemmed in by barbed-wire fences and sharp-edged wooden blocks, he crouches over the controls and waits for the enemy to appear. But there is no suggestion of impending triumph here. One of his companions lies prone and blanched on the ground already, while another yells for assistance or fresh supplies of ammunition. Nevinson reveals a near-journalistic flair which he probably inherited from his distinguished war correspondent father. Just as H.W. Nevinson would never have allowed arcane literary experimentation to obscure the impact of his newspaper despatches, so his son now abjured his former loyalties and staked all on stark, direct communication. If the result was a loss of subtlety, Nevinson willingly paid the price. The meaning he wanted to convey seemed more important than innovative

credibility, and he decided to break completely with Marinetti. Lewis took understandable satisfaction in describing how Nevinson had written 'to the compact Milanese volcano that he no longer shares, that he REPUDIATES, all his (Marinetti's) utterances on the subject of War . . . Marinetti's solitary English disciple has discovered that War is not Magnifique, or that Marinetti's Guerre is not la Guerre. Tant mieux.'[28]

The move did not, however, alienate Nevinson from all his earlier allies. Severini, whose *Armoured Train* had found in the war a clean beauty rejected by the Englishman (Pl. 71), nevertheless sustained an amicable exchange of letters with him for several years after the rift with Marinetti.[29] Since Severini asked Nevinson to send him photographs of his recent work,[30] perhaps the Italian was responsible for alerting Apollinaire to the significance of canvases like *La Mitrailleuse*. For Apollinaire announced, in his regular column published by *L'Europe Nouvelle*, that 'people are talking a lot about an Englishman who has been painting the present war: C.R.W. Nevinson. The secret of his art, and of his success, lies in his way of rendering and making palpable the soldiers' sufferings, and of communicating to others the feelings of pity and horror which have driven him to paint. He has set down on canvas the mechanistic aspect of the present war: the way in which man and machine are fused in a single force of nature. His picture, *La Mitrailleuse*, makes this point ideally well.'[31] While his reputation spread to the continent, Nevinson also found that the war pictures gained him respect among artists in England who would never have approved of his previous work. Sickert, adamantly opposed to the Futurists, declared in *The Burlington Magazine* that *La Mitrailleuse* was 'the most authoritative and concentrated utterance on the war.'[32] Although he did not say so, Sickert may even have recognised a kinship between Nevinson's gaunt gunner and the Belgian soldiers bent over their rifles in his earlier *Soldiers of King Albert the Ready* (see Pl. 50).

Despite the rapidity and certitude with which Nevinson painted these two remarkable pictures, he felt ill on his honeymoon and soon succumbed to a bout of acute rheumatic fever. He was 'on the danger

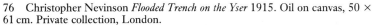

76 Christopher Nevinson *Flooded Trench on the Yser* 1915. Oil on canvas, 50 × 61 cm. Private collection, London.

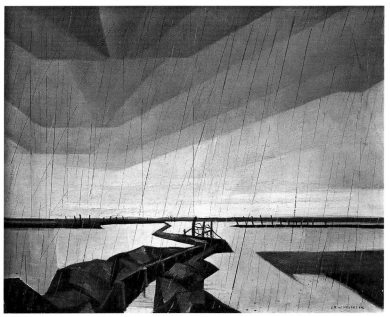

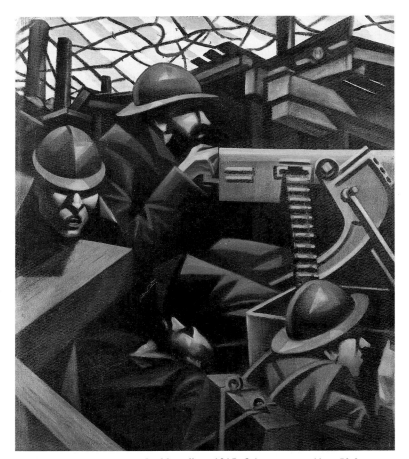

77 Christopher Nevinson *La Mitrailleuse* 1915. Oil on canvas, 61 × 50.8 cm. Tate Gallery, London.

list'[33] for weeks, and even after recovery his general debilitation eventually meant that he was declared unfit for further service. His nightmarish experiences with the Red Cross probably contributed to the undermining of his health, leading him to depict the war with increasing gloom as 1915 progressed. One of his most apocalyptic canvases was entitled *A Bursting Shell*, and it constitutes Nevinson's last dalliance with the language he had favoured as a Futurist (Pl. 78). Taking as his theme the explosion of a shell within a confined urban setting, he selects an extreme aerial viewpoint so that the directional force of the event can be exploited as a diagrammatic pattern. Five dark triangles erupt from the centre towards the outer perimeters of the canvas, providing it with an instantaneously dramatic structure. These huge splinters of form give the composition such aggressive clarity that Nevinson can afford to court ambiguity elsewhere, deploying brick walls, window-frames and rafters in a welter of disjointed fragments. Everything flies out from the flash, driven away not only by the power of the shell-burst itself but also by the harsh light that so spectacularly illuminates the surroundings. It is a mordant vision of destruction, and Nevinson clearly felt that his armoury of Futurist techniques could in this instance be justifiably deployed to heighten the impact. *The Observer*'s critic pinpointed the picture's stylistic ancestry when it was exhibited at the Third London Group show, declaring it to be 'Futurism pure and simple, without a remnant of realistic tendencies. An extraordinary sense of irresistible, destructive force is conveyed by that revolving rainbow-coloured spiral from which radiate black, orange bordered shafts.'[34]

By this time, Nevinson had lived in London long enough to realise

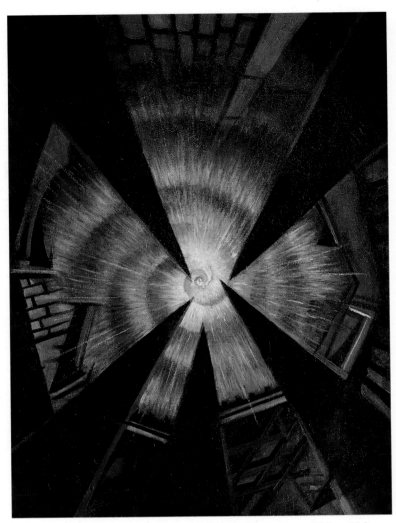

78 Christopher Nevinson *A Bursting Shell* 1915. Oil on canvas, 76.2 × 55.9 cm. Tate Gallery, London.

Now that the war had become so unavoidable in London, other British artists followed Nevinson's lead by reflecting the conflict in their work. William Roberts, a student contemporary of Nevinson's at the Slade only three years before, seems to have been converted to war subjects by a commission from the *Evening News*. He later asserted that, 'despite Lord Kitchener's image with its commanding finger pointing down from the hoardings, during most of 1915 I paid more attention to matters of art and picture-making (as did most of the artists with whom I associated) than to the war.'[37] But when the *Evening News*, through his friend Bernard Meninsky, invited him to produce a drawing for the St George's Day issue in April, he produced an uncompromising Vorticist design of the saint's fight with the dragon (Pl. 79). The newspaper had doubtless been expecting a celebratory picture, rousingly in tune with the nation's hope that its favourite saint would lead Britain to victory against the enemy. In Roberts's drawing, though, St George is enmeshed within the structure of a machine-age locale, and there is nothing especially heroic about the way his body merges with the forms of an urban environment. How could the *Evening News*'s readers rejoice in the saint's martial prowess when he was almost impossible to discern? Only those acquainted with the Vorticist language would have been able to distinguish his diagonal figure, and the inverted dragon beneath him, from the elements defining a modern, industrialized city. Meninsky's version of the theme, with its lunging saint piercing the monster at the end of a spear-thrust, was rather more accessible, and the news-

79 William Roberts *St George and the Dragon* 1915. Reproduced in the *Evening News*, 23 April 1915. Lost.

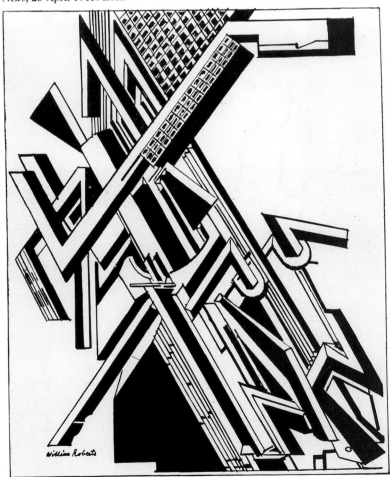

that the metropolis offered wartime subjects of its own. *Searchlights* was originally called *The First Searchlights at Charing Cross*,[35] and it reveals how the Thames bridge at night was transformed into a series of watchtowers. Each one projects brilliant beams through a sky where arcs of light swell upwards like ripples from an unseen source by the river's edge. In the face of the Zeppelin attacks of 1915 and 1916, when the nation was blacked out for the first time, the city itself had become defensive, even beleaguered. No one inhabiting it could have remained unaware of this eerie metamorphosis. Everybody knew that the searchlights might one night pick out the form of an aeroplane heavy with bombs, just as Bohumil Kubišta revealed in his contemporaneous painting of the *Bombing of Pulju*. Although extensive damage is clearly being inflicted by the raid, and Kubišta employs an almost Expressionist language to dramatize the subject, he makes an unexpectedly festive spectacle out of the orchestration of light-beams, anti-aircraft explosions and falling bombs. Wartime defence against air raids could manifest itself in strangely compelling ways, as the young Francis Bacon discovered when he moved with his family to London at the beginning of the war. 'When there was a blackout they used to spray [Hyde] Park with something phosphorescent out of watering cans', he remembered, 'thinking that the Zeppelins would suppose it was the lights of London and drop the bombs on the Park; it didn't work at all.'[36]

paper declared that 'with care and patience this drawing may be understood of the Philistine.' But the caption beneath Roberts's robot-like depiction of the hallowed national figurehead merely warned that, to the uninitiated, 'this drawing will appear rather like a distorted jig-saw puzzle.'[38]

The disapproval was overt, for the *Evening News* would far rather have received a picture as exalted as John Hassall's contemporaneous *The Vision of St George over the Battlefield* (Pl. 80). Here, although carnage prevails on the distant plain, the saint appears in full medieval regalia to inspire the soldiers behind their makeshift fortifications. It is a transparently propagandist exercise, calculated to inspire the increasing number of those who were becoming sickened by the loss of young men's lives for no apparent purpose. Roberts, however, provided a more accurate image of the struggle when he accepted Lewis's invitation to make two drawings for the 'War Number' of *Blast*. In *Machine Gunners*,[39] the figure hurling himself in the bullets' direction seems to have taken on the hard, brutal character of the ammunition itself. *Combat* is still more disquieting, for it proposes that the soldiers from both sides have become locked, willy-nilly, in a struggle from which they cannot be disentangled (Pl. 81). The stalemate of war is conveyed here without any belief, on the artist's part, that a successful resolution will be achieved by the British forces. Moreover, the figures are becoming fused with the weapons they wield, thereby stressing Roberts's belief that humanity is being affected by the harsh depersonalization of the machine-world.

His fellow-Vorticist Edward Wadsworth went one stage further in his contribution to *Blast*'s 'War Number'. The *War-Engine* he drew for the magazine has no room for figures in its cold, schematic structure (Pl. 82). It seems self-sufficient, capable of wreaking destruction without the assistance of soldiers. If they had been included in the rigid chambers of Wadsworth's invention, its sheer immensity would doubtless have dwarfed them altogether. For this is a vision of modern conflict overshadowed by the superhuman growth of industrialized armaments, generating a machine power which made the efforts of the individual combatant appear puny indeed. In 1914, some months before the war was declared, Lewis had proclaimed in the first issue of *Blast* that 'we hunt machines, they are our favourite game. We invent them and then hunt them down.'[40] But even he could not have predicted just how terrible the arsenal amassed by twentieth-century armies would prove. By the summer of 1915, when *Blast*'s 'War Number' was published, soldiers and civilians alike were beginning to grasp the full horror of the devastation inflicted by mechanized weaponry, and Wadsworth's hard, merciless drawing replaces the bravado of pre-war Vorticist utterances with an altogether more ominous alternative.

Elsewhere in the magazine Jacob Kramer reinstated the human presence of combatants in his crudely drawn *Types of the Russian Army*, and Lewis himself was reluctant to oust the soldiers from his drawing for the cover of the 'War Number' (Pl. 83). He called it *Before Antwerp*, and followed Sickert's example by including a defiant cluster of Belgian soldiers pointing their rifles towards the assailant forces. The men's determination is manifest, and made more unyielding by the tensile stiffness of bodies as dehumanized as automata. But forms belonging to the same implacable world as Wadsworth's *War-Engine* rear around them, conveying Lewis's awareness of the forces massed against the besieged Belgian city. Despite the soldiers' courage, Antwerp had fallen; and even the stubborn infantry in Lewis's drawing seem dominated by the inflexible might of their surroundings. As if to acknowledge the impossibility of producing heroic war images based on nineteenth-century models, he confessed

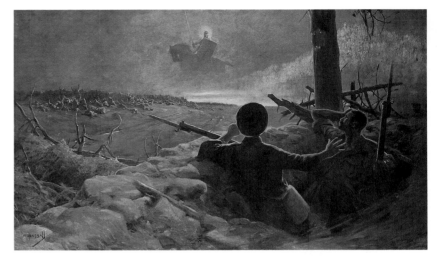

80 John Hassall *The Vision of St George over the Battlefield* 1915. Oil on canvas, 76.2 × 130.2 cm. Imperial War Museum, London.

in *Blast No. 2* that 'the quality of uniqueness is absent from the present rambling and universal campaign. There are so many actions every day, necessarily of brilliant daring, that they become impersonal. Like the multitudes of drab and colourless uniforms – these in their turn covered with still more characterless mud – there is no room, in praising the soldiers, for anything but an abstract hymn.'[41]

Perhaps that is why he had already produced, in his illustrations for Ford Madox Ford's poem *Antwerp*, images which progressively departed from a figurative representation of the fighting man's role. On the cover of the pamphlet, published by Harold Monro's Poetry Bookshop in January 1915, the solitary Belgian infantryman brandishes his bayoneted weapon with obstinate energy (Pl. 84). But this maroon-coloured figure, surely based on Ford's reference to the 'Belgian man in his ugly tunic ... shooting on, in a sort of obsession', is subservient to the diagonal dynamism of the jagged forms above him. They propel him towards his own inevitable death, as Ford went on to reveal:

> Doom!
> He finds that in a sudden scrimmage,
> And lies, an unsightly lump on the sodden grass ...
> An image that shall take long to pass!

The certainty of extinction pervades the entire threnody, giving it an elegiac force that helps to explain why T.S. Eliot, in 1917, described *Antwerp* as the 'only good poem I have met with on the subject of the war.'[42] Ford devoted most of it to a despairing evocation of the funereal atmosphere in a railway station, peopled by relatives awaiting the return of wounded and dying soldiers:

> This is Charing Cross;
> It is midnight;
> There is a great crowd
> And no light.
> A great crowd, all black that hardly whispers aloud.[43]

Lewis responded to Ford's terse lines by giving his other two illustrations a skeletal, near-abstract rigour. If traces of grieving, mask-like faces can still be discerned within the black scaffolding Lewis has erected here, they are imprisoned by lines which show how helplessly enmeshed humanity has now become in the war's machinations.

For all his outspoken belligerence, Lewis flatly opposed the Futurist glorification of combat. 'As to Desirability,' he declared with conviction in *Blast No. 2*, 'nobody but Marinetti, the Kaiser, and professional soldiers WANT War.'[44] His condemnation was given melancholy reinforcement by the announcement, in the same magazine, of Gaudier-Brzeska's death at the Front. 'MORT POUR LA PATRIE' was the headline Lewis gave his friend's obituary notice, which explained inside a black border that the 23-year-old sculptor, 'after months of fighting and two promotions for gallantry . . . was killed in a charge at Neuville St Vaast, on June 5th, 1915.'[45] The loss of this precocious, prodigiously inventive young man cast a pall over the entire magazine, lending great poignancy to the irrepressible 'short essay on sculpture'[46] he had sent to *Blast* before his death. Defiantly called 'VORTEX GAUDIER-BRZESKA (Written from the Trenches)', it insisted that the incessant fighting and carnage had done nothing to diminish his singular vitality. 'WITH ALL THE DESTRUCTION that works around us NOTHING IS CHANGED, EVEN SUPERFICIALLY', he wrote, emphasizing that 'LIFE IS THE SAME STRENGTH, THE MOVING AGENT THAT PERMITS THE SMALL INDIVIDUAL TO ASSERT HIMSELF.'

But this sturdy affirmation of Gaudier's own resilience was set against his disturbing belief that the struggle should be welcomed for its purgative force. 'THIS WAR IS A GREAT REMEDY', the capitals announced, arguing with rebarbative conviction that 'IT TAKES AWAY FROM THE MASSES NUMBERS UPON NUMBERS OF UNIMPORTANT UNITS, WHOSE ECONOMIC ACTIVITIES HAVE BECOME NOXIOUS AS THE RECENT TRADE CRISES HAVE SHOWN US.'[47] Gaudier's view of war was not so far removed from the Nietzschean belief favoured, during the initial stages of the conflict at least, by many other European artists. If he had lived longer, his opinion could well have altered as drastically as his contemporaries' attitude did towards the waste of death. He had already displayed an awareness of the war's tragic dimension in an unusual pen drawing, *The Martyrdom of St Sebastian*, where the victim making a pitiful attempt to shield his face from the executioners' bullets could well be a portrait of Gaudier himself (Pl. 85). Most of his letters from the Front are filled with instinctive optimism, and he looks ebullient enough in a photograph with fellow-soldiers (see frontispiece). But on one occasion he admitted to his friend

81 William Roberts *Combat* c. 1915. Size and whereabouts unknown.

Wadsworth that 'now it's the third circle of Dante's Inferno. We have to stand in ditches with a foot of fluid mud at the bottom for four days at a time with only a few hours sleep in holes dug into the trench side – these holes are muddy too, cold and damp.'[48]

In this hellish environment there was no possibility of devoting his energies to a sustained bout of modelling or carving, and he was left dreaming about the sculpture he might have been able to produce. After a particularly ferocious battle, he concluded that 'the only thing I can prey on for my own work of sculptor are putrefying corpses of dead Germans which give fine ideas to sculpt war demons in black stone once the fight's over.'[49] In his *Blast* essay, however, he went a long way towards countering this apparent callousness by describing how he carried out a final, affirmative carving with typical ingenuity. 'I have made an experiment,' he reported. 'Two days ago I pinched from an enemy a mauser rifle. Its heavy unwieldy shape swamped me with a powerful IMAGE of brutality. I was in doubt for a long time whether it pleased or displeased me. I found that I did not like it. I

82 Edward Wadsworth *War-Engine* c. 1915. Size and whereabouts unknown.

83 Wyndham Lewis *Before Antwerp: Cover of Blast No. 2* 1915. Original drawing lost.

84 Wyndham Lewis. Cover of *Antwerp* 1915. Printed paper, 21.5 × 17 cm. Anthony d'Offay Gallery, London.

85 Henri Gaudier-Brzeska *The Martyrdom of St Sebastian* 1914. Ink on paper, 25.5 × 36.8 cm. Imperial War Museum, London.

86 Henri Gaudier-Brzeska *A Mitrailleuse in Action* 1915. Pencil on paper, 28 × 22 cm. Musée National d'Art Moderne, Centre Pompidou, Paris.

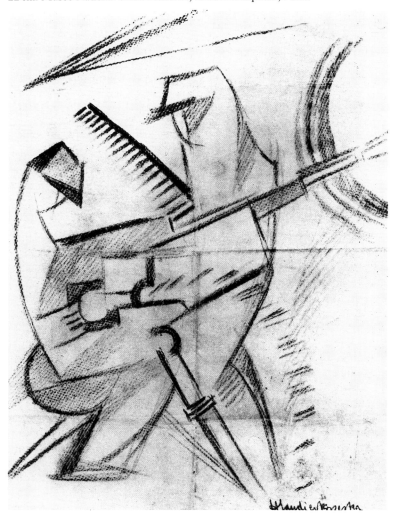

broke the butt off and with my knife I carved in it a design, through which I tried to express a gentler order of feeling, which I preferred.'[50] Although he had struggled for a while with the side of his temperament which warmed to the Mauser rifle's 'brutality', Gaudier's innate tenderness won in the end. His pre-war work proves that he was not, fundamentally, an artist in thrall to violence; and his decision to snap off the butt, replacing its aggression with a kinder image of his own, constituted a symbolic victory for pacific values.

The carving he made on that memorable day has not survived, but the meaning of his gesture still reverberates powerfully today. The only certain war works which now exist are a pair of swift pencil drawings he posted back from Craonne. They were both shown in the London Group exhibition of March 1915, where one of the sketches, *A Mitrailleuse in Action* (Pl. 86), may have inspired Nevinson to tackle the same theme later that year (see Pl. 77). Gaudier's drawing lacks the strain of pessimism in *La Mitrailleuse*. But there is a similar urge to depict the gunner as a metallic extension of the weapon he fires with such concentrated certitude. As anonymous as the companion who feeds the bullets into the stuttering machine, the mitrailleuse seems oblivious of the devastation he inflicts. The stripped-down formal language Gaudier employs here shows how faithful he remained to his pre-war beliefs. 'MY VIEWS ON SCULPTURE REMAIN ABSOLUTELY THE SAME', he insisted in his *Blast* essay, claiming that 'IT IS THE VORTEX OF WILL, OF DECISION, THAT BEGINS.'[51]

His other war drawing, *One of our Shells Exploding*, exemplifies his ability to produce a detached, analytical study of an eruptive event (Pl. 87). The perceptual confusion of the shell-burst has been reduced to a few essential contours, and Gaudier was under no illusions about the explosion's ability to affect its surroundings for more than a moment. 'THE BURSTING SHELLS, the volleys, wire entanglements, projectors, motors, the chaos of battle DO NOT ALTER IN THE LEAST, the outlines of the hill we are besieging,'[52] he wrote in his 'VORTEX' credo. The fundamental 'lines and planes' made up, as before, the basis of his vision, and Lewis was particularly impressed by the sang-froid with which Gaudier had been able to define the shell's impact. Writing before the news of his friend's death arrived in London, he maintained that Gaudier's 'beautiful drawing from the trenches of a

87 Henri Gaudier-Brzeska *One of our Shells Exploding* 1915. Pencil on paper, 22 × 28.5 cm. Musée National d'Art Moderne, Centre Pompidou, Paris.

bursting shell is not only a fine design, but a curiosity. It is surely a pretty satisfactory answer to those who would kill us with Prussian bullets: who say, in short, that Germany, in attacking Europe, has killed spiritually all the Cubists, Vorticists and Futurists in the world. Here is one, a great artist, who makes drawings of those shells as they come towards him, and which, thank God, have not killed him or changed him yet.'[53]

Within weeks of Lewis writing those words, Gaudier lay dead in France – 'gone out', as Ford Madox Ford wrote in a lamentation, 'through a little hole in the high forehead.'[54] Nearly three years later, Lewis wrote to Ezra Pound from France describing how 'with a dismal & angry feeling I passed the place, through the fields, anyway, where Gaudier was killed. The ground was covered with snow, nobody about, and my god, it did look a cheerless place to die in.'[55] His shockingly premature end caused widespread dismay among the artists and writers who had cherished him in London, contributing in no small measure to their realisation that the war was an obscenity. 'We have lost the best of the young sculptors, and the most promising,' Ezra Pound wrote to Felix Schelling soon after the tragedy, adding: 'The arts will incur no worse loss from the war than this is.'[56] Even Lewis, who was never given to displays of sentiment, admitted a gnawing sense of regret when he recalled, over twenty years later, Gaudier's final departure from the railway station in London. 'I remember him in the carriage window of the boat-train, with his excited eyes,' Lewis wrote. 'We left the platform, a depressed, almost a guilty, group. It is easy to laugh at the exaggerated estimate "the artist" puts upon his precious life. But when it is *really* an artist – and there are very few – it is at the death of something terribly alive that you are assisting. And this little figure was so preternaturally *alive*.'[57]

Vorticist artists were not alone in experiencing a sudden sense of loss. In the rival Bloomsbury camp, Duncan Grant was sufficiently affected by Rupert Brooke's death from blood-poisoning in April 1915 to set about producing a memorial to the young poet. Grant's close friend Vanessa Bell had no time for the myth-making mourners who arose from every side to bestow on Brooke the status of a national martyr. 'I think it's queer how all these people who couldn't stand him alive are driven to talking about the waste and meaninglessness of life by Rupert's death,' she wrote to Clive Bell in April, confessing her inability to 'see a great deal beyond his looks to regret.'[58] But Grant, who abhorred violence so much that he became a conscientious objector the following year, thought otherwise, starting work on a small panel entitled *In Memoriam: Rupert Brooke* (Pl. 88). Eschewing any attempt to portray the handsome writer, he devotes much of this oil and collage to a severe arrangement of vertical, abstract forms. Reminiscent of certain paintings by Kupka, their severity testifies to Grant's sombre emotions when he contemplated Brooke's loss. A suggestion of religious transcendence can be detected in the steeple-like contours which stretch towards the top of the picture. The harshness of these black lines is countered, however, by the two grey borders undulating at either side. Grant's innate decorative bent could not remain satisfied with extreme austerity or absolute abstraction, and near the base of the painting an atmospheric hint appears of the English countryside which inspired some of Brooke's most celebrated poems.

Grant's influential mentor Roger Fry was likewise moved to exhibit war images in his one-man show at the Alpine Club Gallery in November 1915. Alongside familiar Cézannesque landscapes and a trio of exercises in what he described as 'abstract design',[59] Fry surprised his audience by including a large oil and *papier collé* composition called *German General Staff* (Pl. 89). Deliberately brusque in

88 Duncan Grant *In Memoriam: Rupert Brooke* 1915. Oil and collage on panel, 55.2 × 30.5 cm. Yale Center for British Art, Paul Mellon Collection, New Haven.

execution, and making extensive use of torn and cut newspaper strips, this dour picture sets the Kaiser and two of his generals against what one viewer regarded as a 'melodramatic sky'.[60] It is virtually a caricature, and Fry must have intended to debunk the three figures as they brood over the battlefield in their military cloaks.[61] Two other paintings in his one-man show were listed as *Bulldog* and *Queen Victoria*, suggesting that *German General Staff* was not alone in striving to make aggressive comic propaganda out of the war. Fry's daughter recalled that his starting-point for the Kaiser picture 'was a newspaper illustration which caught his attention', so he may have been attempting to vie with Sickert's earlier Belgian pictures derived from similar

89 Roger Fry *German General Staff* 1915. Oil and *papier collé* on canvas, 182.9 × 152.4 cm. Lost.

90 Photograph of the Kaiser with General-oberst Helmuth von Moltke and General Staff officers, 1914.

sources (see Pl. 50). But his intentions were more subversive than Sickert's: Fry's daughter also described how, 'when someone pointed out that the German generals had no feet, Fry explained that he couldn't put them in: "They're men without feet, you see." That was how he felt about them, they hadn't got their feet on their ground – they were detached from reality.'[62] Now that it is possible to identify the photograph on which Fry based the painting, his determination to strip the three figures of everything except their gaunt and menacing bulk becomes clearer still (Pl. 90).

Fry's picture, which survives only in an old photographic reproduction, appears subsequently to have been used in a bid to secure his appointment as an official war artist.[63] But it was returned to him by the Ministry of Information, and the print-maker John Copley met with no more success when he produced a large lithograph of *Recruits* around the same time. The youths and men who people his sombre image are not impelled by any discernible enthusiasm for either the army or the war. Unlike the volunteers who so blithely went off to battle the previous summer, these civilians form into their ranks with sombre expressions. They look more like condemned figures than would-be soldiers eager to defeat the enemy. Copley's heavy use of shadows implies that the only expectation shared by everyone in this procession is the likelihood of death, and they move forward with the downcast deliberation of mourners at a funeral.

A similar melancholy hangs over the densely worked picture exhibited at the New English Art Club's spring show by David Bomberg, who intended his drawing 'to meet war time conditions.'[64] His first wife Alice, who modelled for the drawing with strenuous zeal, related that it 'was to depict the new volunteers as they had first arrived at their new Billet, to find themselves with one bedstead between them,

showing their attempts to find places for themselves.'[65] Although Bomberg himself had not yet enlisted, he uses his semi-abstract forms with great vividness to convey the jolting confusion of the scene (Pl. 91). Far from echoing the heroic rhetoric of government propaganda, *Billet* presents the recruits as tired and despondent figures already beaten down by the grimness of army life. The unsightly mêlée of limbs, struggling for space on the hard iron bed, is the antithesis of the soldiering images put forward by enlistment posters (see Pl. 74). Their swagger and optimism is replaced, here, by a subdued wariness. Bomberg's heavy ink cross-hatching stresses the air of confinement, trussing up the soldiers' bodies in a linear mesh which reduces them to the level of prisoners. Trapped by the military system which would soon send so many of them to their deaths in France, the recruits wearily submit to an existence shut in by the bars stamping the drawing with authoritarian rigidity.

No one was prepared to purchase such a stifling view of army life in 1915, and the drawing was duly returned to Bomberg after the New English Art Club exhibition closed. Later in the year, Eric Kennington provoked governmental displeasure when he produced a large and elaborate painting of *The Kensingtons at Laventie* (Pl. 92). Having himself been invalided out of the Kensingtons' Regiment in the summer of 1915, he decided to produce an ambitious image summarizing his six months' experience at the Front. Possibly fired by Nevinson's first war paintings, Kennington shunned all thought of bellicose patriotism. But the style he employed bore no trace of Nevinson's influence. Painting on glass, which intensifies the hard, piercing light of a January day in the Laventie district, the 27-year-old Kennington displays formidable skill as a realist. Instead of selecting a moment from the battle, which might have excited his spectators with notions of valour, he opts like Bomberg for a more disconcerting lull in army activities.

The Kensingtons are assembling in order to go back to their billets, after enduring arduous winter conditions in the trenches where, as one eye-witness recorded, 'the men had no shelters at all. They dug themselves cubby-holes in the sides of the trench and crept in to rest with knees doubled up to their chins. The cold was so intense that, after lying in these cubby-holes for a time they were unable to move and had to be pulled out and massaged back to life again.'[66] Many soldiers were evacuated to hospital suffering from trench foot and exposure, so the men in Kennington's painting must

have been relieved when they retired to the severely shelled village of Laventie. But they betray no sign of pleasure at the prospect of resting in the old barn; rather, they appear stunned by their experiences at the Front. Although one soldier carries a richly ornamented German helmet and rifles on his back, like trophies slung from the equipment of a returning victor, he is viewed from behind and leans rather unsteadily towards the smaller soldier next to him. There is nothing triumphant about his stance, and the other faces peering out of their protective hoods seem paralysed by the hardship they have undergone. Kennington has included himself here, staring out dazedly from his blue balaclava. No one talks, or looks at anybody else. Their eyes are directed towards some indeterminate point, as if the memory of the trenches still held them in its thrall. The shattered debris around their boots, testifying to the fierce fighting which once raged here, adds to the desolation. So does the white brick wall behind them, as frozen as the snow-covered ground where a young man sprawls. Too exhausted even to lean on his rifle, he has collapsed on a charred door-frame. His blanched features protrude from the balaclava like the head of a corpse, defeated by the frost-bitten tribulations of trench life.

With commendable honesty, Kennington does not shirk from revealing the true extent of the soldiers' fatigue. Nor is he prepared to offer any reassuring signs of revived spirits elsewhere in this chilled, forlorn painting. It is an uncompromising image of the soldiers' ordeal, and *The Times*'s critic recognised that 'they are ordinary men, very tired and dirty; there is none of the romance of war as it is commonly painted.' The only sign of hope in the painting resides in the soldiers' stoicism, as *The Times* concluded: 'all these soldiers are at one in their common sense of duty and determination to endure; and it is this sense, made visible, that imparts beauty to the picture.'[67] Kennington, who had stayed with relatives in Russia during the winter of 1904, also invested his picture with an icon-like refulgence. As Angela Weight has pointed out, the liberal use of gold paint gives the khaki uniforms 'a resplendent...glow'.[68] It was not enough to mollify the picture's critics, however. When Kennington displayed his painting at the Goupil Gallery to collect money for the Star and Garter Fund, it earned the disapproval of those who, like John

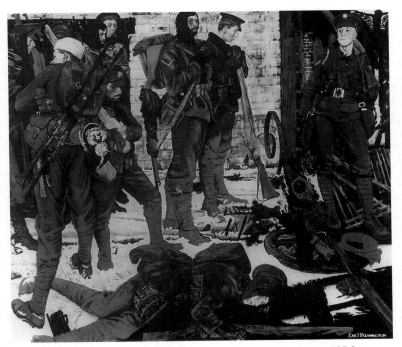

92 Eric Kennington *The Kensingtons at Laventie* 1915. Oil on glass, 137.2 × 160 cm. Imperial War Museum, London.

Buchan, afterwards tried to prevent Kennington becoming an official war artist.[69]

To produce a picture as perturbing as *The Kensingtons at Laventie*, and exhibit it in a London gallery, was to stand out against every cherished myth to which the public still clung regarding the war. During 1915, as A.J.P. Taylor observed, 'none of the generals except Falkenhayn had any great success to boast of; yet in every country the military leaders, except paradoxically Falkenhayn, increased their reputation. Kitchener, Joffre, and Hindenburg personified the will to victory of their respective countries. Public opinion, whipped up by the newspapers and by sensational writers, turned them into demi-gods. Every local citizen was expected to have unquestioning faith in these great military leaders. Nearly all did so. There was, as yet, hardly a flicker of discontent or discouragement in any belligerent country.'[70] Nothing less than national honour was at stake, and any artist who suggested that total victory might not be the outcome could expect condemnation.

The truth, however, was that little except appalling losses had been achieved. The Russian artist Maria Sinjakowa acknowledged this bleak reality in her studies for a *War* cycle, thematically related to a poem by Chebnikov, where the slaughter takes on the character of a barbarous orgy (Pl. 93). Although an orderly row of marching infantry can be glimpsed in the distance, most of the composition is given over to a frenzied massacre. A naked man has been skewered by a grinning soldier, who holds his victim aloft as triumphant proof of his prowess. Other decapitated remains litter the ground, while the severed head of a horse spurts blood from its resting-place in a tree. Sinjakowa makes the killing even more horrible by setting it in a flower-spattered landscape, presided over by a sun as innocent as a daisy. The brutality seems doubly unacceptable in such a context, and the naked woman who strides through the scene with her arms stretched up in protest surely embodies the artist's own response to the carnage.

The war had gone badly for Russia since the optimism of its

91 David Bomberg *Billet* 1915. Black ink on paper, 39.5 × 51 cm. Courtesy of the Board of Trustees of the Victoria and Albert Museum, London.

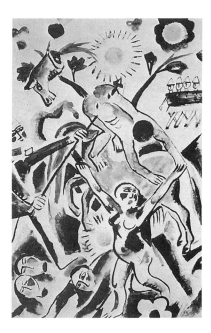

93 Maria Sinjakowa *Study for the 'War' Cycle* 1914–15. Pencil and watercolour on paper, 35 × 22 cm. Parnis Collection, Moscow.

earliest months, when Malevich and other artists collaborated with the government on the production of propaganda prints against Germany (see Pls. 47, 48). Although its army achieved a notable success in the spring of 1915 by capturing the fortress of Przemysl, victory in Galicia soon gave way to ignominious defeat. In May, German forces joined the Austro-Hungarian soldiers to attack Russia at Gorlice, and the outcome was so disastrous for the Tsar's forces that they were forced to abandon both Galicia and Poland. The victors claimed 750,000 Russian prisoners, driving the defeated army back in humiliating disarray. To make matters worse, Tsar Nicholas decided to relieve the Commander-in-Chief of his post and assume control of the war himself. Deprived of any coherent leadership, the Russian forces became even less effective than before.

No wonder Pavel Filonov saw the conflict as such a fragmented, oppressive affair in his large painting of *War with Germany* (Pl. 94). He produced this disorientating image in the year which witnessed the publication of his epic poem *A Sermon-Chant about Universal Sprouting*, based on a folk song about Ivan the Steward and incidents in the war itself. The disjointed language of the poem matches the illustrations Filonov himself provided, and a similar quality predominates in the painting. The overwhelming impression is of a shattered mosaic, whose broken tesserae have been reassembled in a peculiarly tantalizing manner. Filonov, who had travelled to France three years before and was vigorously involved in Russian Futurism, seems to have been affected by the interpenetrating, rhythmic dynamism of Léger's work around 1911 and 1912. But *War with Germany* goes further in its obsession with broken and multiplied movement than Léger's *Study for Three Portraits* or *The Wedding*. The whole of Filonov's picture-surface has become choked with an accumulation of volumes, in which fragments of heads and limbs seem to be embedded. One of the most clearly identifiable belongs to a young woman, whose pale face is represented from a variety of angles at the top of the composition. But she remains, in the end, subservient to the darker male figures below her. A titanic struggle is in progress, and one combatant appears to be prevailing over the inverted body of his opponent. Filonov's deliberately obscure, allusive style prevents a confident representational reading of the picture, however. It teems with activity, and yet fulfils his belief that art 'is a

mental process arrested'[71] by freezing this motion in a painting so heavily impacted that it conveys an overwhelming sense of *horror vacui*. Wherever we look, in this minutely organized image, toes, fingers and other anatomical fragments loom out of the compressed accumulation of faceted forms. They all seem to be caught, even buried, in a dense pictorial mesh surely signifying Filonov's view of the war as a treacherous event which imprisons all its participants. They cannot escape, any more than the poor members of Russian society whom he painted elsewhere with a melancholy compassion,[72] bearing out his belief that 'the truth of art is the truth of analysis ... the beauty of the merciless truth.'[73]

Filonov himself did not experience active service until 1916, when he was sent to the Rumanian Front for two years. He was fortunate enough to survive the ordeal without serious injury, unlike so many of the young men embroiled in the struggle between the Russian and Austro-Hungarian forces. Kokoschka, having gone to considerable trouble and expense to secure himself a position in an élite division of the Austro-Hungarian cavalry, nearly died of wounds sustained in 1915 during the campaign against Russia. His attitude towards the war was, at first, ambivalent. In September 1914 he told his publisher Kurt Wolff that 'if I were to get some money to keep my relatives' heads above water, I should like to volunteer for the army, because it will have been an eternal scandal to have sat around at home.'[74] But in another, more anguished mood, he revealed to Alma Mahler his inability to join in the general Viennese enthusiasm for the conflict: 'I have a bad conscience, as though I shared responsibility for everything because of my search for enjoyment ... and if nothing but victories come, then that would be the greatest sin of all.'[75]

The peculiar strain of guilt detectable in this letter may help to

94 Pavel Filonov *War with Germany* 1915. Oil on canvas, 176 × 156.3 cm. State Russian Museum, St Petersburg.

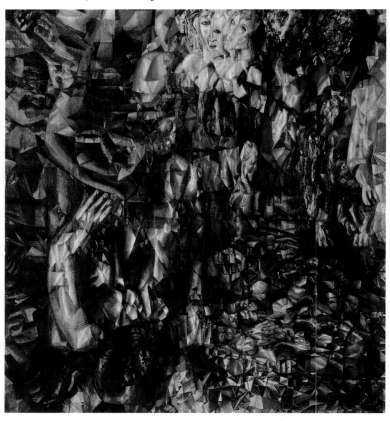

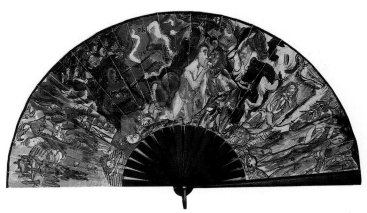

95 Oskar Kokoschka *Fan for Alma Mahler* 1914. Gouache and ink on parchment, radius 21.5 cm. Museum für Kunst und Gewerbe, Hamburg.

account for Kokoschka's mysterious ability, like a clairvoyant, to foresee his own grave injury on the Russian Front. Several works done before the war depict him with a wound in the chest, almost where he would receive the near-fatal thrust of a bayonet in 1915. The most remarkable of them is the self-portrait on a poster for Herwarth Walden's influential avant-garde magazine *Der Sturm*. Here he points a finger at the gash in his body with a certainty reminiscent of Christ revealing a similar wound to St Thomas. Then, after hostilities were declared, Kokoschka's prophecies became still more specific. In the sixth of seven fans he painted for Alma, images of battle appear on the left of the turbulent composition (Pl. 95). While a gunner fires a cannon, and sailors rush past into the smoke where Kokoschka's initials hang in the air, the artist himself is seen on the ground with a lance piercing his chest.[76] He reappears, naked and perhaps even resurrected, in the centre of the fan. Pale and bloodstained, but oblivious of the cavalry officer brandishing a sword above him, he confronts a bearded Russian adversary whose hand clasps the offending lance. The two men stare at each other as if mesmerised by the encounter, and the strangeness of this confrontation again anticipates the way Kokoschka met his real assailant on the battlefield the following year.

The most compelling of all these prophetic images was, however, *Knight Errant*, the last painting he produced before joining up (Pl. 96). In 1915 Kokoschka himself described the picture as 'a Knight in a magical landscape',[77] and the mythical realm evoked here bears no direct relation to the First World War. It is a region of fantasy, closely related to the world of *The Tempest* where Kokoschka's apocalyptic leanings had previously been revealed (see Pl. 23). The nude woman who reclines some distance from the knight immediately suggests that the painting is once more concerned with Alma. Since their relationship was about to end, the intense sadness pervading the canvas must partly be attributable to the termination of their affair. But the armour in which the prostrate and bereft Kokoschka is arrayed also refers to the battle ahead. Whether he is lying on the desolate seashore or hovering over it, the knight seems to be suffering from an affliction. Since the wound is not specified this time, he may simply have been felled by the withdrawal of Alma's love. Kokoschka nevertheless makes clear that his malaise is likely to prove fatal, for the bird with a man's head riding on a branch in the sky bears an ominous resemblance to the Grim Reaper. The entire painting is suffused with a mournful expectation of death, and the knight is

incapable of defending himself against it. All he can do is gesticulate helplessly beneath overcast clouds where the initials 'ES' are scrawled, probably as an abbreviation of the cry uttered by the dying Christ on the cross: '*Eli, Eli, lama Sabachthani* [My God, my God, why hast thou forsaken me?]'[78]

Kokoschka would have been quite justified in repeating these agonized words when he received his own wounds. But before that desperate day in August 1915, he enjoyed a remarkable amount of success in the Austro-Hungarian cavalry. Promotion came quickly, and his close friend Adolf Loos celebrated by making a postcard from a photograph of the artist in a dashing dragoon's uniform (see frontispiece). Much to Kokoschka's displeasure, Loos ensured that the postcard went on sale all over Vienna, promoting an unashamedly romantic idea not only of the artist but also of the war's supposed glamour. The reality was very different. The gleaming brass helmet, starched wing collar and brilliant blue tunic which transformed Kokoschka into a beguiling young warrior on the postcard conspired, in fact, to make him an easy target. So did the whole outdated notion of charging on horses, with a trumpet fanfare and brandished banners, towards an enemy ensconced in trenches. Traditional tactics had become obsolescent in this mechanized war, but Kokoschka's commanders insisted on adhering to a proud, unthinking reliance on hallowed precedent. It led him into danger on a number of occasions, most unnervingly in Galicia where, as he reported to Loos, 'I was really lucky to escape with my life yesterday, because the Cossacks show no mercy if they catch you! I and a patrol were ambushed in the endless forest and swamp hereabouts. We lost more than half our men. Hand-to-hand fighting, with all of us thinking our last hour had come. It was pure chance that two or three of us got away, me last because my horse is weak and, to crown it all, went lame!!! Then a life-or-death chase, with the first of the brutes only ten paces behind me, firing all the time and shrieking "Urrah-Urrah". I kept feeling his lance in my liver. I used my sabre to flog my horse to its limits and just made it back to my unit.'[79]

He always managed to escape until, at Lutsk on 29 August, a Russian machine-gun bullet passed through his head and out the back of his neck. His horse was killed beneath him, and the grievously injured Kokoschka found himself sprawled on the ground like an immobile replica of the figure in *Knight Errant*. Then the Cossacks began bayoneting all the enemy soldiers who were too badly wounded to move, and he lay there listening to the screams of his dying comrades around him. 'Now I knew it was my turn,' Kokoschka

96 Oskar Kokoschka *Knight Errant* 1915. Oil on canvas, 89.5 × 180 cm. Solomon R. Guggenheim Museum, New York.

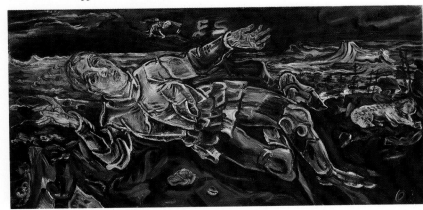

recalled later. 'In my hand, the one that was not paralysed, I felt my revolver which was pointing directly at the man's chest. He could not see the danger because I was in his shadow. He bent over me. I cocked the revolver, my finger squeezed the trigger. The bullet was in the chamber. Then his bayonet entered my jacket and I thought I could not bear the pain but knew that it was only the jacket. There was still time for me to save myself. But I could not shoot the enemy soldier because my mind was not so confused as to permit me to murder the Russian who was only carrying out an order. Now I felt the weapon very slowly penetrating the skin, the fat on my ribs and then going into the ribs. The pain was terrible, truly not to be endured and I nevertheless told myself: "Just a second more! Just endure!" And then suddenly it ceased as the weapon entered my lung. Then the pain ceased. My head felt light. I was happy as I was never happy again. I floated on air. Blood flowed from my nose, ears and mouth and blinded my eyes. Dying was so simple and easy that I suddenly had to laugh in the soldier's face. But now suddenly his eyes were so shocked, his face was a grimace . . . His hands shook, he let go of the rifle with the bayonet which stayed lodged in my body and then fell over under its own weight. The soldier disappeared from my field of vision.'[80]

By a miracle, Kokoschka survived this assault long enough to be rescued by his own division and taken to a field hospital. Then, after a long, arduous journey by open train across the steppes and through Poland, he began slowly to respond to medical care. Although the damage to his inner ear kept him in hospital for many months, Kokoschka was lucky not to have been left on the battlefield or numbered among the 70,000 Austrians who became Russian captives by September 1915. As Egon Schiele discovered when he was called up in June, only four days after his wedding, prisoners-of-war led a tedious existence. Unlike Kokoschka, who had been something of a rival in pre-war Vienna, Schiele tried to secure a post as an official 'war and battle painter'. But his claim that 'I could create the most important work about our war'[81] went unheeded, and at the end of 1915 he found himself assigned to a detachment escorting Russian prisoners in and out of Vienna. Compared with Kokoschka's harrowing ordeal, Schiele's task was easy. He obtained permission to spend the nights at home with his wife, and during the day had sufficient time to execute several studies of his Russian charges. Modest though they are, and far removed from the 'most important' war images he had boasted about making before, these penetrating portraits succeed in announcing a new sense of maturity in Schiele's work.

98 Egon Schiele *Russian Officer* 1915. Pencil and gouache on paper, 44.9 × 31.4 cm. Graphische Sammlung Albertina, Vienna.

97 Egon Schiele, poster for Arnot Gallery Exhibition, 1914. Printed paper, 67 × 50 cm. Historisches Museum der Stadt, Vienna.

Only a year before, the most theatrical and self-conscious side of his personality was revealed in the image Schiele produced for a one-man show at the Arnot Gallery (Pl. 97). Like Gaudier and Weisgerber before him (see Pls. 85, 40), he chose to portray himself as St Sebastian. But the vehemence of the martyrdom is far more gruesome here. In a pencil and gouache study of the same subject, only two spears are specified and the defiantly raised left hand is unscathed. No such restraint can be found in the poster itself, where Schiele shows himself assailed by a battery of weapons, one of which has penetrated the entire width of his body. Even the once-resilient left hand is now pierced at the wrist, and more spears are about to reach their target. Schiele set no limits on the cruelty of the forces ranged against him, whether they derived from critics' venom or the government's determination to enlist his services in the war.[82] But the image of boundless suffering on the poster courts melodrama, not to mention a curious strain of masochism. Schiele appears to be overstating his own persecution, and the reticence of the prisoner-of-war studies is far more persuasive.

These restrained, quietly compassionate drawings indicate that Schiele admired the Russians' stoicism in the face of captivity. One

99 Egon Schiele *Sick Russian Soldier* 1915. Pencil and tempera on paper,
43.8 × 29.2 cm. Private collection.

100 Egon Schiele *Austrian Soldier with Pipe* 1916. Crayon, watercolour and
gouache on paper, 44.7 × 31.4 cm. Serge Sabarsky, New York.

officer, hat pushed down on his head and coat round his shoulders,
even manages to display a hint of humour as he sits for a portrait (Pl.
98). But his heavily smeared cheeks and shadowed eyes betray an
underlying exhaustion. The ordeal of combat has left its mark, and in
Sick Russian Soldier Schiele suggests that recovery will be slow (Pl.
99). Wearing his greatcoat for warmth in winter, the bearded invalid
reclines with an expression of infinite weariness. He is unable to
prevent his eyelids drooping as Schiele defines the contours of his
slumped body. There is no sign, in these candid yet unostentatious
studies, that the artist regards his models as representations of 'the
enemy'. Patiently enduring the tedium of captivity without any end in
sight, they are vulnerable individuals cut off from the military context
which once obliged them to cultivate a collective aggression. Schiele
understood this vulnerability more keenly than he did the relative
well-being of his fellow-Austrians, one of whom he drew puffing
calmly on a long-stemmed pipe (Pl. 100). The full extent of Schiele's
readiness to befriend and admire the prisoners is revealed in his
surprising declaration that he tended, during the war years, 'much
more to sympathize with the other side, with our enemies, therefore –
their countries are much more interesting than ours – there true

freedom exists – and there are more thinking people than here.'[83]
Despite the manifest shortcomings of life under Tsarist rule in
Russia, Schiele's imprisoned sitters revealed themselves to him as
independent men, whose capacity for prolonged contemplation was
doubtless intensified by their enforced idleness.

The misery of interminable waiting was not confined to prisoners.
Soldiers in the most dangerous areas of the battle also found that
their daily routine involved an inordinate amount of monotony, on the
Western Front as much as its Eastern counterparts. Albert Gleizes,
still adhering to the Cubist language he had developed before serving
at the Front, used its stark emphasis on summarized mass to define
the weariness of combat's aftermath in an image called *Return* (Pl.
101).[84] But he refused to become as downcast as the figures in his
drawing. Writing in the short-lived magazine *Le Mot*, he paid tribute
to 'the audaciously creative French spirit', and declared that 'the
writers and artists with whom you will some day claim the honour of
belonging to the same race are almost all in the line of fire. None-
theless, nothing blinds their conscience and their love. The past is
finished. It was great. Let us have the wisdom not to make it seem

odious as we leave it behind. We remain faithful to it in going, with courage, as far as we can.'[85] By equating his pre-war radicalism with the valour needed to defeat France's enemy, Gleizes echoed the opinions expressed by Ozenfant in his new magazine, the buoyantly entitled *L'Élan*. The design he produced for the cover of his first issue, *Brow and Necklace of Victory*, was relatively traditional in its elegant depiction of a smiling woman whose jewels merge with the Allied lines on a deftly outlined map. But Ozenfant, cleverly playing on the double meaning of the French word *front* ('brow' and 'military front'), makes clear in the rest of the magazine that he intends to pursue a policy of supporting the avant-garde: 'Those who are fighting, our friends, write to us how much more strongly the war has attached them to their art: they would like some pages in which to show it.'[86]

Although he had only brief opportunities to continue his work, Léger would have concurred with these sentiments. Serving throughout most of 1915 as a sapper in the forest of Argonne, he witnessed some of the heaviest fighting anywhere in Europe. During the summer in particular, German shelling claimed a great number of French lives, and Léger's duties as a sapper would have put him at risk on many occasions. Even when he returned to the village of Le Neufour, a name inscribed on several of his drawings, the danger remained. Enemy artillery was fully capable of reaching the village and wounding or killing soldiers while they rested after the debilitating rigours and stress of the Front line. So Léger never really escaped the prospect of sudden injury or death, except when he returned on occasional leave to Paris. He showed no sign of resenting this perilous existence, however. When the opportunity arose to be transferred to a mobile team of army camouflage painters at Noyon, he turned down the invitation. Léger would have found himself in the company of fellow-artists there, among them Dunoyer de Segonzac, André Mare and Jacques Villon. In addition to camouflaging airfields and establishing dummy observation posts, they all found time to make their own images of the military life around them (Pl. 102). Léger, however, had no wish to join a specialized circle of painters removed from the ordinary soldiers of the French army. In a photograph taken at the Argonne in 1915, he looks thoroughly at ease with his sleeves rolled

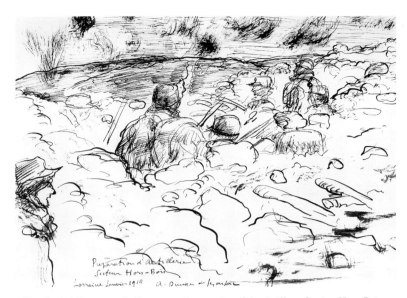

102 André Dunoyer de Segonzac *Preparation of the Artillery, Section Hors-Bois, Lorraine, January 1915* 1915. Pen and ink on paper, 21.5 × 30 cm. Musée d'Histoire Contemporaine – BDIC, Hôtel des Invalides, Paris.

up among the wicker shell containers (see frontispiece). Sitting nonchalantly on a shell, he pauses from his labours with one of the men whose company he savoured.

For the war had taken Léger away from his intellectual friendships in Paris, confronting him instead with a new social reality. He later explained that 'I found myself on an equal footing with the whole French people',[87] and he relished the experience. Although Léger had never before shared his life with 'peasants, labourers, miners and bargemen', he discovered to his satisfaction that 'I was built as they were, and as strong. I wanted my work as a painter and the imagery which would emerge from that work to be as tough as their slang, to have the same direct precision, to be as healthy.'[88] That is why Léger's war images of 1915 are notable for their robust, matter-of-fact and positive attitude towards the activities they depict. Preferring at this stage to avoid scenes of direct military engagement and the suffering it entailed, he concentrates on subjects like the *Mobile Kitchen* as it moves up to the Front with supplies for the troops (Pl. 103). The four-square forms of the men riding on the waggons are as sturdy as the metal containers beside them. Léger's repetition of the same seated pose emphasizes their steady progression, enlivened by the diagonal twist of the waggon as it negotiates a bend in the road. Everything, from the thick wheel-rims to the cylindrical bodies of the horses, is perceived in all its incontrovertible solidity.

The emphasis on volumetric substance echoes the preoccupations of Léger's pre-war work, and in that sense aesthetic continuity was affirmed in these 1915 images. But compared with the wholly impersonal, robot-like figures who inhabited his paintings of 1913–14, the Argonne pictures announce a new determination to anchor the soldiers in the landscape he inhabited with his comrades. 'I made dozens and dozens of drawings,' Léger recalled later. 'I felt the body of metal in my hands, and allowed my eye to stroll in and around the geometry of its sections. It was in the trenches that I really seized the reality of objects. I thought back on my first abstract studies, and a quite different idea concerning the means, the use and the application of abstract art took root in my mind.'[89] The ink drawing, *Soldiers in a Shelter*, is quite specific about the setting occupied by the soldiers.

101 Albert Gleizes *Return* 1915. Illustrated in *Le Mot* no. 20, July 1915.

Tree-trunks are ranged around them like pillars, and the chunky circular table is palpably represented. So are the canisters on the ground, their tubular forms prompting Léger to invest the figures' limbs with a similar cylindrical bulk. But he does not allow the machine-like aspects of the soldiers' bodies to make him omit their identifying features: the buttoned uniforms and peaked caps are represented clearly enough to ally the drawing with the war zone Léger knew so well.

In the collage and painted version of the subject, *The Card Players*, a great deal of this pictorial information drops away (Pl. 104). Strips of red, yellow and blue paper replace the hatched and cross-hatched shading in several important areas, and the brusque use of white pigment obliterates much of the former specificity. All the same, the outcome is quite distinct from the dehumanization of Léger's pre-war figure paintings. The soldiers are still recognisably grouped around the table, and their involvement with the card game stresses the communal aspect of army life. No attempt has been made to hide the fact that the picture is executed on a fragment of wooden shell crate. Although Léger's unconventional choice of material was dictated by necessity rather than preference, he turns it to expressive account: the wood's conspicuous rawness plays a vital part in conveying an authentic sense of military existence. Just as the soldiers were forced to improvise, constructing a card table and shelter from the most

rudimentary surroundings, so Léger himself overcame the absence of canvas by commandeering the lid of an ammunition box. Like Gaudier-Brzeska, who had earlier carved into a broken German rifle-butt, he refused to be defeated by circumstances. Moreover, Léger emphasized the new importance of locale in his work by inscribing on *The Card Players* the name of the place where it was painted. Before the war, that kind of information had no part in his paintings' generalized vision. But now, stimulated by a new-found fascination with 'the reality of objects', he wanted to remind viewers of *The Card Players* and his other shell-crate picture, *Horses in the Cantonment*, of their starting-point in the Argonne.

Léger became so involved with the men he fondly described as 'my new comrades' that, like the card players grouped around their absorbing game, he made no attempt to deal with enemy subjects. Away from the Front, however, other French artists felt impelled to

103 Fernand Léger *Mobile Kitchen* 1915. Pen and ink on paper, 20.3 × 15.9 cm. Musée National Fernand Léger, Biot.

104 Fernand Léger *The Card Players* 1915. Oil and *papier collé* on wooden fragment of crate, 99 × 66 cm. Rosen Collection, Baltimore.

consider the Germans and the destruction they were causing. Even the reclusive Rouault, whose work took an increasingly inward direction during the war years, felt the need to satirize the enemy. Profoundly affected by the outbreak of hostilities, he revealed his patriotism by insisting in August 1914 that 'our France, in this black and barbaric world, is still and in spite of everything a rare work of art. I am in anguish these days. It is not fear – for a long time I have held life cheap, though I should have liked to do my poor best as an artist – it is quite a different feeling, a feeling from somewhere high above me, that something *very beautiful* was going to, or could, disappear.'[90] A passionate urge to defend the civilized values he cherished therefore lay behind his decision, a year later, to produce a gouache portrait of the kind of man who threatened to destroy France (Pl. 105). Rouault gave his picture the anonymous title *Von X*, thereby signifying his intention to portray a military type rather than an individual. But that did not prevent him from delineating the German's features with waspish plausibility. Von X's air of supercilious complacency is conveyed through his arched eyebrows, unseeing eyes and self-satisfied smile. The high collar enclosing his neck emphasizes the rigidity of his views. Nothing will persuade this chubby, arrogant exemplar of the military caste to change his mind about the importance of waging war, whatever the cost. Closed off from any thought other than the automatic urge to carry out his orders, he contemplates the continued decimation of Europe with callous smugness.

Unlike Rouault, Félix Vallotton only took French citizenship fourteen years before the outbreak of war. But he swiftly proved himself even more patriotic than French-born artists during the conflict. After the 49-year-old painter had volunteered unsuccessfully for the French army in 1914, he threw his considerable energies into the publication of a magazine entitled *The Great War by Artists*. Vallotton became allied with Masereel, Steinlen and other like-minded contemporaries who committed themselves to the same venture. They produced images as ecstatic as Steinlen's *Souvenir of Mobilization*, where the triumphant figure of 'la Marseillaise' from Rude's Arc de Triomphe relief exhorts the cheering Paris crowd to achieve victory. All the same, Vallotton's concern about the mounting destruction is clear in the war landscape he painted in 1915 (Pl. 106). It marks a dramatic departure from the serene and pellucid style of his pre-war

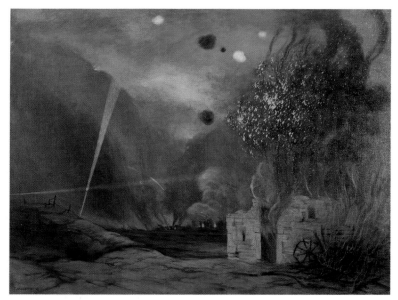

106 Félix Vallotton *1914... Landscape with Scorched Ruins* 1915. Oil on canvas, 115 × 147 cm. Kunstmuseum, Bern.

landscapes. Nothing disrupts their assertion of equanimity, whereas this ravaged locale is consumed by an inferno. In the distant village flames have engulfed every visible building, and the smoke rising from this conflagration threatens to choke the sky. Although the inhabitants are nowhere to be seen, they could not survive either in the village or the isolated ruin enveloped by a particularly vicious blaze in the foreground. Only on the left of the composition is a human presence indicated, as a stream of blood emerges from the tangle of barbed-wire fencing. Vallotton's involvement with the totality of nature *in extremis* means, however, that the entire landscape seems to be bleeding. The sense of defilement is all-pervasive, and the beleaguered searchlights serve to accentuate the impossibility of throwing any coherent illumination on the scene.

As might be expected from a master of graphic economy, Vallotton's most elaborate meditation on the early stages of the war appears in a series of woodcuts called *This Is War*. It commences with a shell-burst, tearing into the blackened air and making the soldiers in their thin foreground trench appear cowed and insignificant. Vallotton outlines their helmets and projecting bayonets with a few sparing lines, thereby emphasizing the vulnerability of men who could at any instant be blown apart by the force of the enemy bombardment. The crouching infantry are powerless to stop it, just as the stabbed woman in the second print was unable to prevent her assailants from rape and butchery. She lies there, with a dagger plunged in her breast, while the murderers cavort in the underwear they have ripped off her corpse. Several figures sprawl nearby, vomiting and stunned by drink. But they are all cosseted in the candlelit warmth of a shelter, whereas the corpses spreadeagled in the third woodcut have been exposed to the night sky (Pl. 107). Vallotton establishes a poignant correspondence between one soldier's upturned hand, frozen in death, and the stakes punctuating the bare white earth around him. They resemble a crowd of arms rising from bodies buried below ground, all beseeching help and finding instead that they are enmeshed in wire.

The killing continues, with a doggedness that appals the young man witnessing it in the fourth print (Pl. 108). He starts back, aghast as the two opponents grapple with each other in the blackness. Both their blades pierce the dark, implying that neither of them will escape

105 Georges Rouault *Von X* 1915. Gouache, pencil and ink, 28.9 × 18.4 cm. Musée National d'Art Moderne de la Ville de Paris.

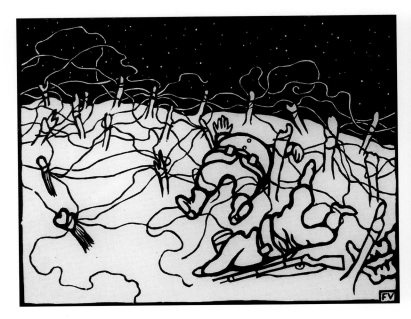

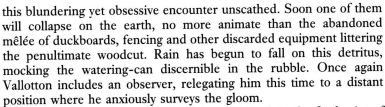

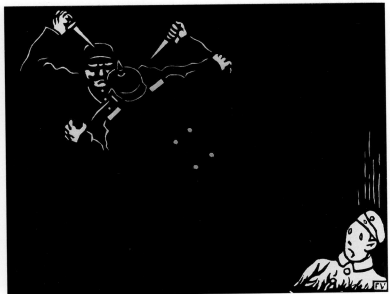

this blundering yet obsessive encounter unscathed. Soon one of them will collapse on the earth, no more animate than the abandoned mêlée of duckboards, fencing and other discarded equipment littering the penultimate woodcut. Rain has begun to fall on this detritus, mocking the watering-can discernible in the rubble. Once again Vallotton includes an observer, relegating him this time to a distant position where he anxiously surveys the gloom.

This outdoor military desolation is exchanged, in the final print of the series, for a well-lit civilian interior. But Vallotton insists that the horror of war is just as likely to prevail here. Two figures lie inert on the floor, cut down by marauding soldiers no doubt intent on raiding the ample barrels behind. While a dog whines in distress, one stricken boy clings to an older girl who, in her turn, stretches out imploring hands towards some motionless yet equally bereft adults. Their gaunt faces, emerging from shroud-like garments, are reminiscent of the mourning relatives in Munch's most funereal prints. Later in the war, Vallotton executed a number of ambitious large-scale paintings based on visits to the French Front (see Pls. 198–200). None of them, however, deals so directly with the plight of people caught up in the conflict, and his refusal to understate their suffering in *This Is War* surely helps to explain why these woodcuts were not a financial success.

French artists nevertheless persisted in exposing the horror of the conflict. In Maximilien Luce's ironically entitled *Field of Honour*, the wasteland of corpses, abandoned guns and battered buildings is unalleviated by any sign of hope (Pl. 109). Its utter desolation recalls the lithographs of Daumier, who in 1871 had marked the outcome of the Franco-German War by depicting a hooded woman grieving over a body-strewn terrain. She hides her eyes from the spectacle, whereas the two travellers contemplating the carnage in Luce's picture gaze at the scene as if transfixed. True honour is impossible to find within this landscape of abomination, a spectacle even more terrible than the tragedy Daumier had deplored over forty years earlier. However hard they scrutinize the battlefield, Luce's witnesses know that they will remain unable to halt the remorseless acceleration of killing in the years to come.

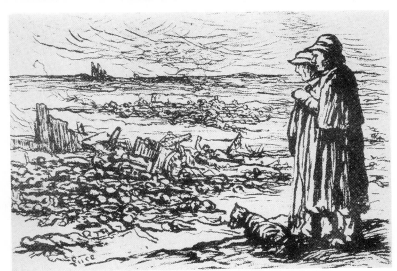

107 Félix Vallotton *Barbed Wire* 1916. Woodcut on paper, 25.2 × 33.5 cm. Kunstmuseum, Bern.

108 Félix Vallotton *In the Darkness* 1916. Woodcut on paper, 17.7 × 22.5 cm. Imperial War Museum, London.

109 Maximilien Luce *Field of Honour* 1915. Musée d'Histoire Contemporaine – BDIC, Hôtel National des Invalides, Paris.

CHAPTER FOUR
DISILLUSION

(1915–16)

As the war butchered more and more of the young men who had so blithely enlisted at the outset, even the most optimistic artists found that they could no longer ignore the reality of death in their work. Marsden Hartley, infatuated with the romance and pageantry of Berlin military life before the war (Pl. 14), was now forced to confront the loss of a cherished friend among the German officers he idolized. After returning to Berlin for a second stay in 1914, he heard from the Western Front that the 24-year-old Lieutenant Karl von Freyburg had been killed in action on 7 October. Profoundly affected by the news, Hartley was incapable of painting for nearly a month. He described his friendship with von Freyburg and his sculptor cousin Arnold Rönnebeck as a 'beautiful triangle',[1] eventually setting to work on a series of paintings in memory of the man he had loved and regarded as an epitome of handsome masculinity.

Grief did not prompt Hartley to attempt a representational likeness of the dead lieutenant. Still loyal to his earlier involvement with the *Blaue Reiter* group, synthetic Cubism and the Delaunays, as well as a more recent interest in American Indian culture, he attempted to portray von Freyburg with a semi-abstract assembly of flags, uniforms, medals and other insignia associated with his friend. One of the earliest paintings in the sequence, *Portrait of a German Officer*, shows just how readily this aim lent itself to the heraldic language Hartley favoured (Pl. 110). It suggests, as John Russell argued, 'to what an extent the uniform was the man',[2] but there is nothing negative about the equation. Despite von Freyburg's tragic loss, Hartley continued to glory in the trappings of the martial machine. The lieutenant was, after all, a hero: he had been awarded the Iron Cross shortly before his death. So the medal rides in triumph over a composition replete with allusions to the radiant identity of a man whom Hartley later described as 'the one idol of my imaginative life'.[3] Numbers, which had already played such a mystical part in his work, now honour the age of the young lieutenant. His initials are inscribed on a festive red ground, and Hartley interweaves the undulating forms of flags with references to the tassels and spurs which once bedecked von Freyburg's resplendent figure.

The only elegiac note is sounded by the blackness which runs round the painting like the borders of an official death announcement. It fails to subdue the exuberance with which Hartley's coarse, vigorous brushwork proclaims the paraphernalia of Junker militarism, for he warmed instinctively to the ritualistic aspects of army life. In a 1916 essay, 'Tribal Esthetics', he extolled the even more flamboyant ceremonial attire of the American Indian, declaring that 'we owe the

Left: Félix Vallotton *1914... Landscape with Scorched Ruins* 1915 (detail). See Pl. 106.

presence of these forms in our midst, centuries old, to the divine idea of the necessity for survival ... It is a life of eminently splendid ritual, and we of this time have lost the gift of ritual.'[4] Von Freyburg had offered a splendid embodiment of that gift as he left for the Front, filled with the fervent idealism of a man eager to fight for his country's honour. Far from questioning the wisdom of an ardour which terminated in premature extinction, Hartley sought to glorify the heroism of sacrifice. His most overt attempt to seek transcendental significance in the lieutenant's death can be found in *Painting No. 47, Berlin*, where the recurrence of dark borders makes the flags and insignia within even more festive. On a ground enlivened by the undulating stripes of the red, white and black imperial flag, Hartley gives the greatest prominence this time to von Freyburg's plumed helmet. The number nine has been attached to it like a badge, to signify the artist's passionate belief in his friend's regeneration. Religious confirmation of this hope is provided by the great yellow halo encircling the plumes like an ascendant sun. Even the iron cross, positioned now at the bottom of the canvas, seems to assume an ecclesiastical dimension, as if Hartley equated his idol's death with Christ's crucifixion.

Hartley believed that he was now 'expressing myself truly – I have perfected what I believe to be pure vision and that is sufficient.'[5] His confidence found growing support in Germany, where he sold four paintings in April 1915 and held a substantial Berlin exhibition which received extensive critical coverage later in the year. Although his admiration for the European avant-garde was shared by a number of American artists, he remained virtually alone among his compatriots in continuing to laud German military values. Most American artists regarded German culture as 'alien',[6] a prejudice which would intensify as the war proceeded (see Pls. 252–5). They chose to disregard the fact that plenty of Germans enlisted without any 'Hunnish' belligerence or enthusiasm for the conflict. When Lovis Corinth painted a portrait of the painter Hermann Struck dressed as a soldier, he found sadness rather than aggression in his sitter's face (Pl. 111). The insignia and colours of Struck's regiment are depicted with panache, most spiritedly in the flecks of scarlet applied to his epaulettes, collar and jacket edge. Rather than stressing militarism, however, they act as a foil to the dreaminess and hint of apprehensiveness detectable in Struck's gentle face. He seems temperamentally reluctant to become excited about the prospect of the fight ahead, and the wariness in his glinting eyes discloses the vulnerability of the man beneath the army uniform.

This quietly sympathetic portrait was painted by an artist in his mid-fifties, whose own military experience had ended as long ago as

110 Marsden Hartley *Portrait of a German Officer* 1914. Oil on canvas, 173 × 105 cm. The Metropolitan Museum of Art, New York; The Alfred Stieglitz Collection, 1949.

the early 1880s. Corinth's middle-aged refusal to become excited about the war is perceptible in the Struck canvas, and it could hardly be further removed from the youthful frankness with which Otto Dix revealed his own pugnacity in *Self-Portrait as a Soldier* (Pl. 112). Painted soon after he enlisted as an artilleryman in August 1914, and brushed in with a speed that implies how little time the war left for art, this bull-necked presence offers a brusque image of Dix as a prize-fighter. He strains his shaven head forward like a man eager to be let loose on the enemy, and the scarlet coat swathing his shoulders intensifies the bloodthirstiness of his stance. The bone-structure in his brutish, almost neanderthal features is heightened by a fire as fierce as in the foundry where Dix's father worked as a mould-maker. Even the surname inscribed so prominently on a white space beneath the painting's date has the aggression of graffiti scrawled on a street wall. This is a portrait of a man hungry for conflict, his belligerence backed up by a firm Nietzschean belief in the rebirth which the destruction of decadence can foster. *Self-Portrait as a Soldier* has the same jutting obstinacy as Dix's earlier bust of Nietzsche, and even in old age he was willing to admit the extent of his initial excitement in 1914. 'The war was a horrible thing', he declared, 'but there was something tremendous about it, too. I didn't want to miss it at any

112 Otto Dix *Self-Portrait as a Soldier* 1914. Recto. Oil on paper, 68 × 53.5 cm. Galerie der Stadt, Stuttgart.

111 Lovis Corinth *Portrait of Makabäus – Hermann Struck* 1915. Oil on canvas, 80.5 × 59.5 cm. Städtische Galerie im Lenbachhaus, Munich.

price. You have to have seen human beings in this unleashed state to know what human nature is.' Later in the same interview, Dix explained that he volunteered for the artillery out of an urgent 'need to experience all the depths of life for myself',[7] and in *Self-Portrait as a Soldier* he looks tough enough to withstand all the most degrading experiences which the war might hurl at him.

On the other side of the paper, however, he is already prepared to present a more cautious and ambivalent viewpoint (Pl. 113). Instead of rushing like an enraged dog towards the fray, without any apparent means of protecting himself, the soldier depicted here scrutinizes the world from the shelter of an elaborate artillery helmet. Its gleaming star emblazons the painting as ostentatiously as the insignia in Hartley's memorials to von Freyburg, and Dix specifies braid, epaulettes and buttons with a similar respect for military trappings. But compared with the swaggering *élan* which Hartley deploys in his celebration of the dead lieutenant's accoutrements, Dix's mood now seems restrained. His narrowed eyes look defensive as they stare sideways, shielded by the helmet's peak. Rather than immersing himself in the war with unqualified zeal, like his *alter ego* on the reverse of the painting, Dix appears withdrawn. His tightly buttoned uniform has a constricting effect, preventing him from making any rash commitment to an action he may later regret. As for the signature positioned above his

helmet, it no longer possesses the bravado of the capital letters spelling his name on the other self-portrait. This time it hovers uncertainly in space, and Dix has allowed the pigment to dribble down the picture like a presentiment of wounds he might soon be obliged to suffer.

At this early stage in the conflict, Dix's Nietzschean convictions were more powerful than any doubts he may already have entertained. A painting carrying the stark title *War* shows how energetically he could summarize the inferno of a full artillery barrage. Furious red zig-zags issue from the mouth of the great gun, which bristles with cogs and other mechanisms. The splintering effect of the explosions that tear their jagged paths through the air owe a formal debt to the Futurists, whose work had impressed Dix at a pre-war exhibition in the Galerie Arnold, Dresden. His cannon, however, is far more violent than its serio-comic counterpart in Severini's *Cannon in Action* (see Pl. 70). The playfulness of the Italian's word-spattered painting contrasts utterly with the singleminded ferocity of Dix's vision in *War*. He only permits himself a single terse word, 'Spandau', inscribed around the rim of the gun's mighty wheel. Moreover, Severini's artillerymen carry out their duties quite calmly – whereas Dix's soldiers are reduced to a cluster of blanched and scarlet masks, wide-eyed as they shelter from the maelstrom around them.

Dix had a firmer and more tenacious grasp of war's capacity for

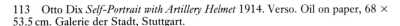

113 Otto Dix *Self-Portrait with Artillery Helmet* 1914. Verso. Oil on paper, 68 × 53.5 cm. Galerie der Stadt, Stuttgart.

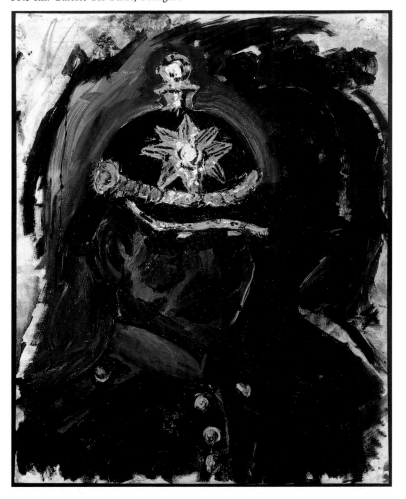

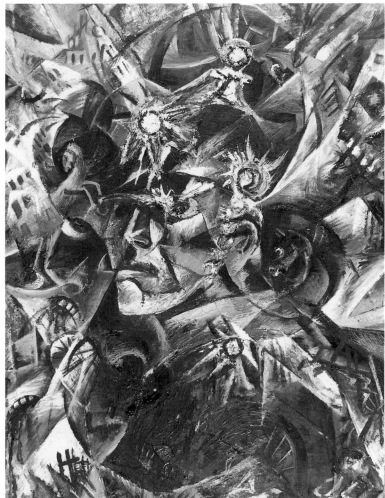

114 Otto Dix *Self-Portrait as Mars* 1915. Oil on canvas, 81 × 66 cm. Haus der Heimat, Freital (Dresden).

destruction than the Futurists. After he witnessed the battlefield at first hand, his attitude grew grimmer still. *Self-Portrait as Mars* looks, at first, like a relatively straightforward attempt to identify the artist with the god of war (Pl. 114). The artillery helmet which had appeared so defensive in his earlier self-portrait now sprouts an antique crest, as if to confirm Dix's new mythological status; and he occupies a focal position in the midst of the chaos whirling around him. The star on his helmet has lifted itself from a quiescent position and become a dancing star, just as Nietzsche recommended in *Zarathustra*. Dix alone seems to retain his composure while everything else in this wild, murderous universe is torn apart. Below his clenched head a gaggle of other faces can be discerned, their eyes sightless and mouths gushing blood. Horses rear and twist, wide-eyed with terror at the danger threatening their flame-reflecting bodies. And just below the upper right corner of the painting, a collapsing building metamorphoses into a skull with white teeth exposed.

But is Dix as immune from the havoc as he initially appeared? Despite his evident determination to ride the storm, in the Nietzschean belief that a purified world will emerge from the catharsis, his own future is by no means assured. For Dix's eyes have enlarged as much as the horses', and he is invaded at every turn by the conflict. The Futurist-inspired 'lines of force' that cause the buildings to totter behind him slice through his head, while wheels and faces like death-masks penetrate his uniform. The god of war is himself battered by the forces he has unleashed, and Dix must have been aware of the

irony involved. He was certainly prepared to admit the self-destructive absurdity of his life in the army by the time he painted *Self-Portrait as Shooting Target* (Pl. 115). Proud Mars has now deteriorated into a helpless dummy, stripped of his helmet and fit only for remaining rigid while enemy bullets seek him out. It is a nihilistic image, where despair is countered by an obstinate ability to mock the mortal danger he confronts.

If Dix was torn between seeing himself as aggressor and victim, Max Beckmann possessed a clearer idea of his role in the war. As his *Weeping Woman* indicated (see Pl. 26), he knew from an early stage how much human tragedy the conflict would cause. Unwilling to be responsible for any killing, Beckmann volunteered in autumn 1914 for the German army's medical corps. Soon he was despatched to the ambulance service on the Russian Front, but his earliest letters voice an enthralled admiration for the spectacle he is witnessing. Describing the 'incredibly grand noise of battle out there', he reported excitedly in October that 'it's like the gates of eternity bursting open when a great salvo like this sounds across the fields. Everything evokes space, distance, infinity. I wish I could paint that sound. Oh, this expanse and uncannily beautiful depth!'[8]

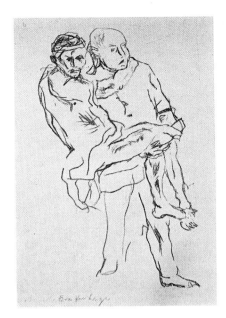

116 Max Beckmann *Carrying the Wounded* 1914. Drypoint on paper, 15.9 × 12 cm. Private collection.

115 Otto Dix *Self-Portrait as Shooting Target* 1915. Oil on paper, 72 × 51 cm. Otto Dix Foundation, Vaduz.

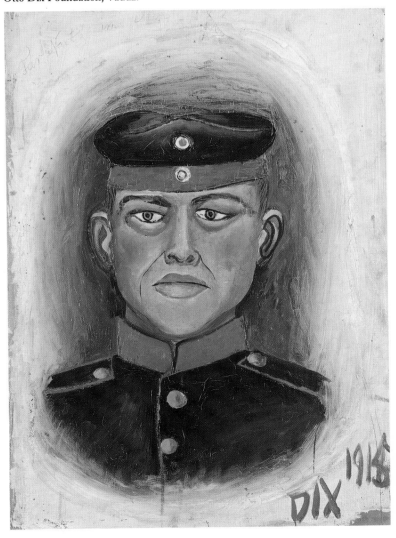

His rapturous response to the distant battle did not survive a closer confrontation with suffering. Like Nevinson, whose duties as an ambulance driver exposed him to the worst consequences of injury and death, Beckmann was forced to scrutinise the most pathetic victims of war. Among the first images he produced from his experience at the Front is *Fallen Soldiers*, which insists on presenting the conflict solely in terms of the men it mowed down. They were the people whose bodies Beckmann and his colleagues handled, and in *Carrying the Wounded* he centres on the abject dependence of the soldier cradled in the medical orderly's arms (Pl. 116). The stunned and disabled man clings to his helper's neck, so that their heads almost touch. But there is no psychological contact between them. The orderly looks to his left, possibly seeking assistance in the task of bearing his ungainly load; and the soldier's eyes are cast downwards, in bitter contemplation of the childlike state he endures.

Beckmann's sympathy for the injured was intensified when his brother-in-law Martin Tube sustained a serious head-wound on the Eastern Front. He produced a compassionate lithograph of the bandaged young man, who had predicted the war six years before and agreed with Beckmann that 'it really would not be so bad.'[9] The chastened soldier in *Portrait of my Wounded Brother-in-law Martin Tube* had doubtless altered his views by the winter of 1914, and Beckmann followed suit. For Tube died soon after the portrait was executed, and the tragedy affected Beckmann's work very dramatically. Enraged by the loss of his friend, and by the mounting evidence of pain among patients in the base hospital, he drew a protesting image of a cripple with the savagely ironic title *Théâtre du Monde – Grand Spectacle de la Vie*. The nervous, scrawling style of the drawing reveals the extremity of Beckmann's feelings. Here, only four days before Christmas 1914, he finds no demonstration of Christ's love for the world in this abused figure. As if the appalling wound on his face and paralysed legs were not enough, the man also has to endure mental torment. That much is clear from his dishevelled hair writhing above eyes which still relive the shock and terror of the battlefield. He has been reduced to the level of a traumatized animal, and Beckmann recognises the analogy by drawing the patient's exposed feet like a pair of claws.

The horror intensified when, in February 1915, Beckmann was transferred to a field hospital at Courtray in Flanders. For a moment,

he found himself tempted to use his art as a form of escapism when invited to paint a fresco on the wall of a large delousing bath. Beckmann's letters disclose that he originally planned to depict an oasis festooned with palm trees in an Oriental desert.[10] But he quickly realised that the reality of war claimed priority now, and instead of depicting 'an Oriental bath' he decided to 'paint what is around me.'[11] The outcome of his efforts did not last long: it was painted in a temporary building. But his graphic work of 1915 is motivated by a consistent desire to deal with 'what is around me', and he did not flinch from concentrating on the most harrowing scenes imaginable.

A few months before, on the Eastern Front, he had witnessed an operation at the base hospital (Pl. 117). The surgeon and nurses attending to the body on the table are disturbed by the arrival, in the foreground, of an orderly bearing the next patients on a stretcher: the harassed nurse in the centre seems divided between the rival demands of the two patients. But at least there is a prospect of tending the wounded, and the medical staff reassuringly outnumber the soldiers in their care. When Beckmann returned to the subject in 1915, however, he studied the dead rather than the injured. *The Morgue* is dominated by three corpses, and no comforting nurse bustles through the room to offset the finality of their stillness (Pl. 118). Although a blanket still swathes one of the bodies, the dead man no longer benefits from its warmth. Members of the medical team gather round the corpse on the right, but the stiffness of the limbs proves that *rigor mortis* has set in. The destination awaiting all three figures is outlined on the floor beyond, where a makeshift open coffin has already been filled. The dignity of funereal custom cannot be observed in this bleak chamber, for another coffin is pushed awkwardly away by the only man available to carry it off to the grave.

As well as studying the corpses in the field hospital at Courtray, Beckmann was probably influenced by a visit he made to the Brussels Musée des Beaux Arts in April 1915. For he told his wife that he had admired some 'wonderful' paintings by Rogier van der Weyden, 'whom I like best of all the Belgian primitives.'[12] Matthias Eberle speculated[13] that van der Weyden's *Lamentation of Christ* may have provided Beckmann with specific inspiration for the bodies in *The Morgue*. But the difference between Christ and the rigid corpses on their hospital tables is as great as any similarities they may possess. The limp figure stretched across the surface of van der Weyden's picture is graceful in death, for all his etiolation and the gashes puncturing his skin. Moreover, he is clasped with tenderness by both the people who support him, and the sorrow he arouses in the viewer is ameliorated by the knowledge that resurrection will ensue. Beckmann's bodies enjoy no such hope. With feet grotesquely upturned and flesh disfigured by calamitous wounds, they await burial without ceremony in a foreign land. Instead of relatives and disciples, they are attended by officials anxious merely to finish a disagreeable job. If the *Lamentation* was indeed in Beckmann's mind when he etched the two orderlies bending over the corpse on the right, he can only have intended a sardonic contrast with the impassioned gestures of Christ's supporters. For the body's bandaged head precludes any possibility of sympathetic contact between the dead man and his attendants. In their eyes, he is simply one more cadaver requiring summary dispatch, and they peer at his figure with the workaday detachment of refuse collectors clearing away litter.

Beckmann's work was haunted for years to come by the memory of those corpses, culminating in the bandaged tormentor who squats on an operating table in the centre of *The Night* (see Pl. 323). The artist's quarters were positioned directly above the morgue, and he

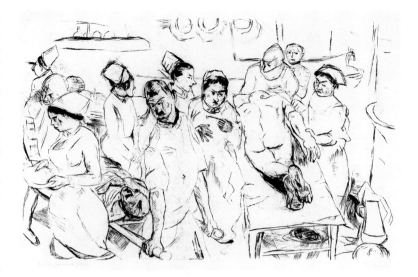

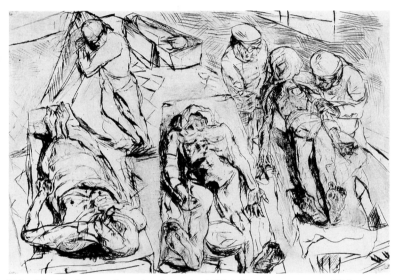

117 Max Beckmann *Operation (large plate)* 1914. Drypoint on paper, 29.8 × 43.4 cm. British Museum, London.
118 Max Beckmann *The Morgue* 1915. Drypoint on paper, 25.7 × 35.7 cm. The Museum of Modern Art, New York. Purchase.

imagined once that dead bodies had invaded his room during the night. Nor were the wounded bodies any less troubling. In the summer of 1915 he described how 'night-watch' had obliged him to look after 'two stomach wounds and a severe brain contusion with delirium. Wrestled all night with the unconscious man. The room dimly lit, by night-lights and sheet lightning, and reeking of decay.'[14] The cumulative effect of these duties took their toll on his mind and constitution alike. He succumbed to a nihilistic despair, asking in one anguished letter: 'What would we poor mortals do if we didn't continually equip ourselves with ideas about God and country, love and art, in an attempt to hide that sinister black hole. This endless desolation in eternity. This loneliness.'[15] Meeting Erich Heckel and Ludwig Meidner in Flanders did little to assuage his sense of isolation. An etching of *Two Officers of the Motor Corps* suggests how alienated Beckmann felt from the men with whom he came into contact in the army. Nothing in those cold and sullen faces indicates that Beckmann found in military service the gratifying sense of comradeship which warmed Léger's wartime life.

His accelerating agony received its most violent expression in *The Grenade*, a large etching which Beckmann worried at and transformed in a sequence of five states (Pl. 119). From the outset the grenade itself whirls in the air like a portent of cosmic catastrophe, and might well have been intended as a manifestation of the 'sinister black hole'. But he anchored the image in his experience of gas attacks at Ypres as well, for the commotion revolves around the soldiers' frantic attempts to escape the poisonous vapours. Some of the figures, even in the early states of the print, are incapable of fleeing. They lie in the foreground, felled by injuries which have gashed a hole in one man's cheek and exposed his teeth. But other infantrymen raise their rifles in a futile bid to fend off the threat, and the space directly below the bursting grenade is alive with the frantic gesticulations of a Meidner-like man whose arms are flung outwards in an unconscious echo of the crucifixion.

Subsequent states of the plate bear the mark of additional drypoint work, resulting in a general darkening of the mood. The sky, previously in a state of turmoil with strange fragments of dazed faces suspended in space, now becomes overcast. The pointing soldier on the right turns into a near-silhouette, and the disparity in scale between him and the wounded figures nearby becomes still more disquieting. Agitation permeates the entire composition, reflecting not only the men's fear but Beckmann's own nervous condition as well. The

119 Max Beckmann *The Grenade* 1915. Drypoint on paper, 38 × 28.8 cm. British Museum, London.

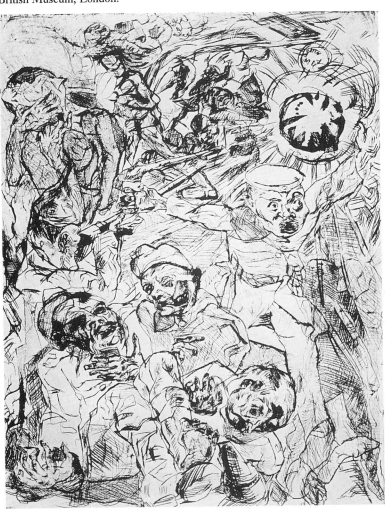

disposition of forms may owe a debt to the falling bodies in Bernard van Orley's *Altarpiece of the Visions of Job*, which Beckmann probably saw on a visit to the Brussels museum. But the sense of vertiginous disorder in *The Grenade* is an authentic reflection of his gathering inner panic, and in the final state of the print he accentuates the soldiers' hysteria more than ever. The silhouetted figures on the right have been deleted, enabling the man with outflung arms to thrust a leg into the vacated space. His rushing, yelling form thereby plays a more important part in the image as a whole, giving it a greater degree of urgency. The grenade gains in prominence too, for Beckmann has by now sliced off the top of the design and minimized the sky's former turbulence. A large figure appears in the upper left area of the composition, turning away and trying to shield his eyes from the blinding effects of the gas. But there is no escaping its evil vapours, just as Beckmann knew that the 'sinister black hole' could never be evaded in the end.

He was certainly unable to prevent himself from being overwhelmed by the destruction surrounding him. 'I suffer with every shot and have the wildest visions', he wrote during his time in the trenches, before implying that thoughts of art saved him from collapsing under the strain: 'My plans for plates that I want to make swell like a victory in Galicia.'[16] But during the summer of 1915 his health was finally undermined by a nervous and physical breakdown. Although Beckmann never referred to the collapse later, it was severe enough to persuade the army that he should be allowed to convalesce at Strasbourg. From there he moved to Frankfurt and tried to regain a semblance of his earlier strength. For the time being, however, his hopes of recovery proved elusive. 'Every day is a battle for me', he confessed in September. 'A battle with myself and with the bad dreams that buzz around my head like mosquitoes. Singing: We'll be back again, we'll be back again. Work always helps me to get over my various attacks of persecution mania.'[17]

Here, at least, Beckmann was able to take up the brush and palette he had longed to use in Flanders. 'If I only think of grey, green, and purple, or of black-yellow, sulphur yellow, and purple', he had written in June, 'I am overcome by a voluptuous shiver. I wish the war were over and I could paint again.'[18] In Frankfurt his wish was at last realised, and the recuperating artist presented himself as a medical orderly in a small yet candid self-portrait (Pl. 120).[19] Depicted in the act of applying pigment to canvas, Beckmann turns away as if startled by an unwelcome thought. His eyes have the strained, staring quality of a man transfixed by some painful memory. The presence of the red cross on his collar is surely intended to signify that army experiences have not gone away. They plague his waking hours as much as his dreams, and Beckmann's downturned mouth conveys the defensive grimness of a man condemned to struggle with recurrent nightmares.

Heckel, who had got to know Beckmann in Flanders, also served as a Red Cross orderly. That he did not succumb to the kind of collapse Beckmann suffered may partly be due to the enlightened understanding of his unit commander, the art historian Walter Kaesbach, who allowed artists in his charge to have every alternate day free for their own work. He enabled Heckel to contact other artists in the unit, and would certainly have encouraged him to execute woodcuts based on his experience at the Front. Like Beckmann, Heckel turned for subject-matter to the injured people in his care. The commanding woodcut of *Two Wounded Soldiers* does not disclose the gashed flesh Beckmann defined in his excoriating etchings. But Heckel's compassion is evident at once. Obliged to remain inactive, two men sit hunched and forlorn as they contemplate their disable-

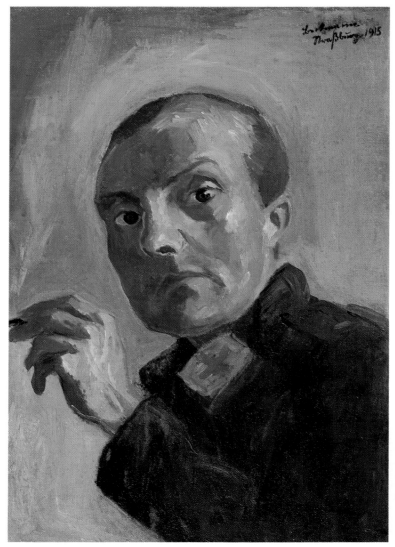

120 Max Beckmann *Self-Portrait as Medical Orderly* 1915. Oil on canvas, 55.5 × 38.5 cm. Von der Heyt Museum, Wuppertal.

Wyndham Lewis's remark that German Expressionist woodcuts, 'disciplined, thick and brutal', achieved nothing less than a 'surgery of the senses.'[20] Indeed, this prostrate man with his upturned feet exposed at the bottom of the bed is eerily reminiscent of the corpses laid out for the last time in Beckmann's *The Morgue* (Pl. 118).

Through the good offices of Walter Kaesbach, Heckel was also able to visit Ensor at Ostend and befriend him. There Heckel may well have seen the large and disturbing painting *The Banquet of the Starved*, which the Belgian artist produced in 1915 as an indirect comment on the war (Pl. 122). The feast is dominated by a medal-bedecked national leader, who clasps his knife and fork like a soldier presenting arms at a military parade. He eyes the fish and vegetables scattered so casually across the tabletop with calculating relish, and the two figures behind his shoulders appear to be urging him to assault the food forthwith. The leering and yelling grotesques who people the rest of the banquet, arranged like a blasphemous reconstruction of the Last Supper, are uniformly repellent. Their idiocy is confirmed by the *dramatis personae* in the foreground of Ensor's tableau, struggling and cackling as boisterously as characters from a knockabout puppet show. The suspicion grows that a satire is intended here, aimed at the generals, bureaucrats and profiteers who thrive on the war at a comfortable distance from the Front. For their grinning antics are juxtaposed with images of macabre activity above, where skeletons gesticulate in a bleak terrain and two death's heads fight for possession of an intestinal morsel with their teeth.

However much Heckel may have privately acknowledged the truth

121 Erich Heckel *Two Wounded Soldiers* 1915. Woodcut on paper. Private collection.

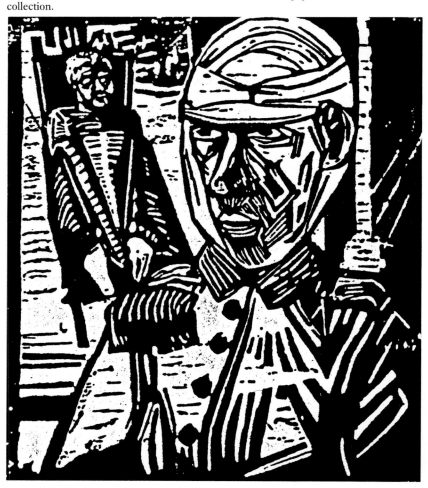

ment. The figure with his arm in a sling looks particularly dejected, and neither soldier displays the swaggering insouciance with which he had probably marched off to war only a few months before. Heckel's absolute refusal, in 1914, to display any hope or confidence in the future course of the war is uncompromising. The powerful woodcut self-portrait he executed soon afterwards has a furrowed intensity worthy of Van Gogh (see frontispiece). Indeed, the index finger extended by the frowning artist seems to be insisting that we follow his gaze, and study with him the victims of the battlefields.

The convictions which had led him to volunteer for medical duties inform all his war images, and in 1915 a second woodcut of *Two Wounded Soldiers* shows a deepening pessimism (Pl. 121). This time the picture-surface is presided over by a man with an extensively bandaged head. Heckel's roughly scored treatment of his face makes him appear emaciated and weary, gazing forwards with a sense of resignation about his chances of recovery. But at least he is not confined to a bed like the man behind him. Here Heckel's cutting knife achieves a macabre quality, so that the blanket covering the patient appears to contain an X-ray of the skeleton beneath. It recalls

122 James Ensor *The Banquet of the Starved* 1915. Oil on canvas, 114.6 ×
145.7 cm. The Metropolitan Museum of Art, New York.

in Ensor's allegory, the painting he executed on two strips of an army
tent for Christmas 1915 was far more optimistic (Pl. 123).[21] The
minuscule boat in the lowest area of the picture is threatened by
dauntingly high waves, and to that extent Heckel acknowledges the
reality of danger in his canvas. But any sense of alarm is outweighed
by the figure who rises from the sea and gives the painting its name.
For the *Ostend Madonna* is a colossus, and she is presumably meant
to help the beleaguered boatmen find a safe passage between the
rocks. The haloes irradiating both her and the child Jesus are far
brighter and more explicit than the disc behind von Freyburg's
plumed helmet in Hartley's *Painting No. 47, Berlin*. Heckel's religiosity
could hardly be expressed with greater devotion, and the angels and
flowers festooning the picture's borders vie with each other in their
determination to laud the holy pair. Donald E. Gordon convincingly
proposed that *Ostend Madonna* contains a self-conscious tribute to
Philipp Otto Runge's *Morning*,[22] and the tent painting proves how

ardently Heckel wanted to believe in the imminence of a peaceful
dawn breaking over Europe with the new year. Judging by the response
which greeted his *Madonna*, its sentiments were widely shared in the
German army. 'How glad I was to paint that for the soldiers,' Heckel
wrote at the time. 'It was fine to see how much respect and even love
for artistic things there is in people, in spite of everything. Who
would have thought that my style, which seemed so modern and
incomprehensible to the critics and urban public, would now speak
and appeal to the men to whom I have freely given it.'[23] All the same,
the hope conveyed in his tent painting was confounded by events, and
seems far less convincing now than the disillusioned work he went on
to produce in the later stages of the war (see Pls. 180, 235).

In this respect, George Grosz's images of 1915 turned out to be
informed by a greater accuracy about the true nature of the conflict.
For Grosz viewed the onset of hostilities with misgivings from the

123 Erich Heckel *Ostend Madonna* 1915. Oil on tent canvas. Size and whereabouts unknown.

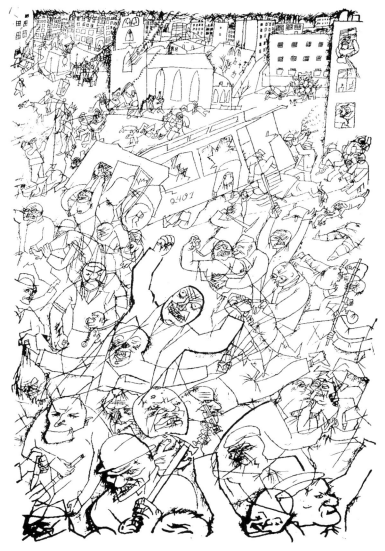

124 George Grosz *The Shell* 1915. Pen and ink on paper, 24.8 × 19.9 cm. Formerly Grosz Estate, Princeton.

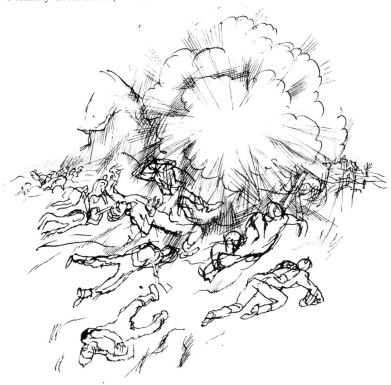

125 George Grosz *Pandemonium* 1914. Pen and ink on paper, 47 × 30.5 cm. Mr and Mrs Bernard Reis, New York.

start. 'The outbreak of war made it clear to me that the masses marching wildly cheering through the streets were without a will under the influence of the press and military pomp,' he remembered later. 'The will of the statesmen and generals dominated them. I also sensed that will above my head, but I was not cheering because I saw the threat to the individual freedom in which I had lived hitherto.'[24] All these forebodings had been ferociously conveyed in *Pandemonium*, a hectic drawing executed soon after war was declared (Pl. 125). Crazed by an aggressive fever, civilians are caught up in an orgy of greed, lust and random violence all over the city. At the top of the drawing, where the commotion is least frenzied, religious authority is snubbed as the church burns. Further down the sheet, disorder accelerates. A tram is smashed and its passengers slaughtered indiscriminately, while nearby a pedestrian is hanged on a lamp-post with a mocking paper crown on his head. Exultation of the most depraved kind breaks out below, where a bare-breasted whore brandishing a skull is carried triumphantly along the road. She relishes the mayhem

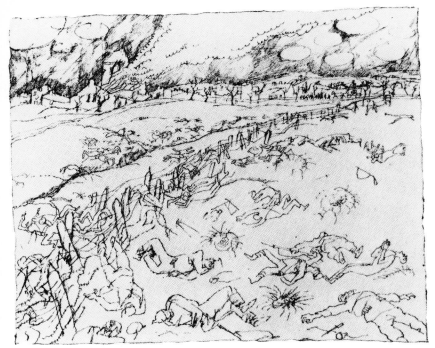

126 George Grosz *Battlefield with Dead Soldiers* 1915. Lithograph on paper, 24.5 × 31.7 cm. Private collection.

around her, while bloated and deranged figures go on the rampage with guns, knives and pickaxes. It is a vision of hell even more vicious than the drawing of civil chaos made in the same hysterical summer by Meidner, whose work influenced Grosz considerably at this time (see Pl. 25).

The hatred of the world 'in all its ugliness, sickness and lies'[25] gave way, during his short-lived military career, to a more sombre vision. Realising that he would soon be called up, Grosz volunteered in November 1914 for the Second Kaiser Franz Grenadier Guards Ist Company in Berlin. The images he made from his army experience lack the manic, overheated intensity of *Pandemonium*. Like Beckmann's *The Grenade*, Grosz's drawing of *The Shell* closes on the moment when destruction erupts in the sky (Pls. 119, 124). But none of the figures affected by the blast in Grosz's picture shares the mobility of Beckmann's running soldier as he attempts to escape. Most of them are felled by the explosion, and the man who crawls across the foreground lacks the energy to make a quick retreat. He might well collapse and expire at any moment, to end up like the corpses whose contorted forms lie beside their abandoned weapons in *Shell Crater*. Grosz draws a parallel here between the soldier's twisted limbs and the convoluted branches of the bare trees above them. Stripped of leaves and yet still obstinately upright, they are the only survivors of a conflict which has left all its human participants strewn over the gouged terrain.

Grosz's drawings and lithographs of 1915 are obsessed by corpses. Where *Pandemonium* had continued his pre-war preoccupation with frenetic decadence in the city, *Battlefield with Dead Soldiers* surveys an entire silent panorama of mangled bodies (Pl. 126). Grosz's thin, precise contours define the attitudes of the fallen with consummate economy. One figure on the right seems to have died while praying: his clasped hands still point towards heaven, even though his thrown-back head has the inertness of a doll whose neck is broken. Elsewhere, soldiers lie entangled in the barbed wire which proved such a lethal obstacle during infantry offensives. Grosz revealed in a letter that he was close enough to corpses trapped by the wire to smell their rotting flesh,[26] and *Battlefield with Dead Soldiers* fulfils the visions conveyed

by Meidner in his apocalyptic canvases three years before. The posts holding up the wire lead back in a straggling diagonal towards the horizon, where blackened trees are ranged beside ruined buildings consumed by fire. Thick smoke fills the sky to an asphyxiating extent – a metaphor, perhaps, of the nausea Grosz experienced as he grew more and more unnerved by the wholesale slaughter.

Looking back on his period in the army, where he was moved to the First Reserve Battalion in January 1915, Grosz described how 'the time I spent in the stranglehold of militarism was a period of constant resistance – and I know there was not one thing I did which did not utterly disgust me.'[27] The knowledge that he was implicated in the killing, either directly or indirectly, gives his graphic work of 1915 a terrible sense of desolation. Stillness pervades his charcoal drawing *Landscape with Dead Bodies*, broken only by the birds hanging with predatory curiosity over the horse and soldiers stretched out on the white ground. Death is inescapable here, and the building nearest the corpses assumes the shape of a coffin. Whether Grosz realised it or not, he now saw extinction in everything. The trees punctuating the distant hill like crosses on Calvary are scorched beyond recall, while the large nearby warehouse seems little more than a battered façade hiding a burned-out void behind. On the rare occasions when Grosz did depict live soldiers, most notably in a spiky lithograph called *Captured*, the figures' movements seem furtive, almost apologetic (Pl. 127). The pipe-smoking German walking behind the prisoners

127 George Grosz *Captured* 1915. Lithograph on paper, 31.5 × 24.2 cm. Private collection.

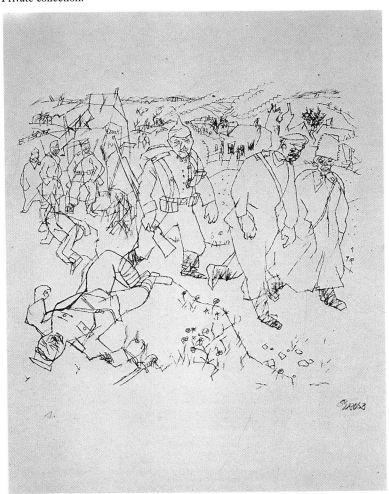

128 George Grosz *Air Attack* 1915. Pen and ink on paper, 19.9 × 26.8 cm. The Museum of Modern Art, New York. John S. Newberry Fund.

displays no trace of satisfaction, let alone triumph. He seems as weary as the men in his charge, and looks away from them towards the true focus of the picture: the corpse thrown back on a hillside. Beside the body wild flowers have sprung up, the only sign of nature's resilience in a landscape otherwise scarred by ruins leaning at precipitous angles on the slopes beyond.

By May 1915 Grosz had become sufficiently ill to be discharged as unfit for military service, albeit with the prospect of a recall in the future. He later explained that a very serious sinus condition had developed on his way to the Front. The mental strain which took its most severe toll in 1917, when Grosz was called up again, might well have contributed to his earlier ailment. But the army considered that his conduct had been good, and he reserved his jubilation for a letter to his friend Robert Bell. While rejoicing in the knowledge that he had become 'a civilian again', Grosz couched his emotion in irony. 'If it were not a sin against the prevailing sacred custom in patriotic matters, I would allow myself a feeling of happiness,' he wrote, before finally making the gleeful admission that, 'in short, I am free, free from the Prussian military.'[28]

Although he enjoyed an exceptionally productive period of work after settling into his Berlin Südende studio in July 1915, Grosz showed no sign in his art of euphoria or complacency. As a drawing called *Air Attack* discloses, he was unable to find in city life a feeling of security after the perils of active service (Pl. 128). The explosion which had caused such devastation in his earlier drawing of *The Shell* reappears now in an urban context, and the result is still more terrifying. Bursting within a confined space, the bomb causes buildings to crack and totter. As for passers-by, the ravening lawlessness which Grosz had pilloried in *Pandemonium* has now been replaced by panic. While the figures nearest the blast are thrown upwards and backwards by its impact, the rest of the crowd scatter with terror distorting their features. The clarity Grosz deploys to expose the citizens' hysteria has a merciless edge, reflecting his scornful belief that 'to be a German means invariably to be crude, stupid, ugly, fat and inflexible.'[29] But the horror in *Air Attack* could only have been

expressed by an artist who was himself living in dread. For Grosz continually feared the threat of recall, and he described how 'the sword of Damocles hangs over my head. Heavens, when shall we be strong enough to resist?'[30]

Grosz's answer, commencing in the latter months of 1915, was to involve himself with great bravery in the dangers of the anti-war movement. He distributed among his friends postcards published by *Die Aktion*, a courageous literary journal which took an almost isolated but sturdy stand against the continuation of hostilities. He also recorded[31] that *Die Aktion* had accepted several of his drawings and a poem, while conceding that the attempt to resist German militarism was still a long way from practical realisation. He had to content himself with writing about 'a dream of mine: revolts will happen and one day spineless international socialism may gain the strength for open rebellion, and then W.II and the Crown Prince will be no more. They still post the call-up papers on the hoarding. To the slaughterhouse!'[32] The only weapon Grosz possessed was his draughtsmanship, and during 1915 the self-taught artist honed it to a new sharpness. In *Stick It Out!* his handling of pen and ink takes on a raw, scratchy brutality it had never exhibited before (Pl. 129). A familiar war slogan is here turned on its head and exposed as an empty cry. The rapacious, furtive and putrefying Berlin crowd is dominated by the spectre of a hearse moving through the street, accompanied by a downcast line of top-hatted mourners.

Within a year or so, Grosz began to gain wide notoriety through the publication of such drawings in Wieland Herzfelde's radical new periodical *Die Neue Jugend*[33] (see Chapter Five). But in 1915 other, far less well-known German artists were also giving vent to their rage against war with remarkable authority and eloquence. In a sustained

129 George Grosz *Stick It Out!* c. 1915. Pen and ink on paper, reproduced in *Die Neue Jugend*, July 1916.

suite of ten lithographs entitled *Memento*, the Breslau-born artist Willy Jaeckel produced one of the earliest and most impressive of all the print sequences devoted to the conflict. Ten years before Otto Dix was finally ready to produce his great series *War* (see Pls. 367–375), Jaeckel wasted little time in showing his fellow-artists how the struggle could be depicted with a passionate indignation reminiscent of Goya. Several of the prints in *Memento* pay homage to the Spanish master's *Disasters of War* cycle, and all of them share Goya's abhorrence of the slaughter. Their condemnatory stance earned official disapproval: the entire suite was banned immediately after it appeared in 1915.

The most Goyaesque of the prints are found at the beginning of the sequence, where Jaeckel's priorities are announced with uncompromising vigour. The very first print, which isolates a man among a heap of executed bodies, refers to *The Third of May 1808* rather than the *Disasters* series (Pl. 130).[34] There is a similar emphasis on the plight of the white-shirted figure confronting his imminent death, and Jaeckel's decision to omit the firing squad does not lessen the horror of the man's predicament. Although a woman kneels in front of him pleading for her life, she already seems to belong to the corpses and does not detract from the drama of his stance. He is still agonisingly alive. The energy implicit in his bent, straining legs is a measure of his unwillingness to accept death's inevitability, and he stares out at his executioners with an expression of terror so extreme that it takes on an accusatory power.

Throughout *Memento*, in fact, Jaeckel denounces the atrocity of war with the fiery indignation which Goya manifests. Women as well as men are seen in all their martyred degradation. The second print

130 Willy Jaeckel *Memento* (1), 1914–15. Lithograph on paper. Bröhan Museum, Berlin.

131 Willy Jaeckel *Memento* (3), 1914–15. Lithograph on paper. Bröhan
Museum, Berlin.

in the sequence concentrates on the brutal assault of a woman by
soldiers who grab her leg and arms under the cold, appraising eye of
an officer. She resists far more vigorously than her counterpart in the
thirteenth plate of the *Disasters* cycle, who pleads desperately with her
assailants. But Jaeckel's debt to Goya is evident enough, and even
extends to the round-arched setting where the assault takes place.
Despite the strength of the woman's struggle, Jaeckel holds out no
more hope for her survival than Goya. Her exposed right breast
suggests that multiple rape is about to be committed, and its victim
must subsequently meet a fate as abject as the death presented in
Memento's third print (Pl. 131).

Here the image is dominated by the body of a woman who has
been raped, killed and then dumped ignominiously over the side of a
fallen chair. Her pushed-up dress, which testifies to the depravity of

her murderers, does not disguise the victim's blanched, blood-smeared
face. Nor does it prevent Jaeckel from depicting the plight of the baby
lying beside her, abandoned by the soldiers after they butchered its
mother. The child is, at least, alive. But in every other respect
Jaeckel's scene remains as grim as Goya's *Ravages of War*, a celebrated
print from the *Disasters* cycle which likewise focuses on violated
women civilians and even includes a similar chair within the ruins. A
decade later, *Ravages of War* would also inspire Dix to pay an overt
tribute in one of his *War* series, where inverted bodies are strewn
across the ruins of a bombed house in Tournai (see Pl. 372).

The rest of Jaeckel's suite deals mainly with the writhings of those
who have not yet succumbed to death. Even within the charnel house
of the fourth print, where some of the figures have already been
slaughtered in the most horrible way, the butchery is still proceeding

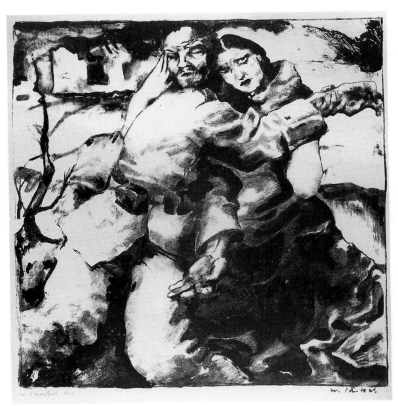

132 Willy Jaeckel *Memento* (10), 1914–15. Lithograph on paper. Bröhan Museum, Berlin.

on top of the corpses. One wounded man cowers on the floor, protecting head with hands and gazing wildly around in search of his assailants. There remains, however, no sign that the carnage above him will abate. Its inevitability is relentless, and in the next three lithographs *Memento* reveals just how destructive the battlefield can be. Threatened by colossal eruptions nearby, the two soldiers dominating the foreground in the fifth print struggle to carry the weight of a slaughtered comrade. The next lithograph brings the explosion closer, and shows how it devastates the man standing near its annihilating impact. But hand-to-hand combat can still be just as ugly. In the seventh print Jaeckel settles on the moment when a bayonet thrust enters the target's body. It is administered with all the formidable strength at the disposal of the heavily built assailant, and the ambiguity of the dying man's upraised arms makes the image even more disturbing. Did he lift his hands as a gesture of surrender before the fatal penetration, or are they clawing the air as a result of the wound? Even though Jaeckel leaves the question open, he certainly does not discount the possibility that the victim was defenceless when the bayonet skewered his chest.

In *Memento*'s final prints, attention is concentrated each time on a single soldier meeting a tragic destiny. The eighth lithograph is dominated by a figure who bestrides the corpse-strewn ground, where arms are still rising in search of help. The protagonist may have survived so far, but he is in no condition to provide that support. His swaying legs seem on the point of buckling, and he stares up at the sky as if to ask God why humanity has been deprived of heavenly protection. In order to supply the most despairing answer imaginable, Jaeckel devotes the penultimate print to a study of a man trapped in a shell-crater. He places both elbows on the side and strives to heave himself out of the pit. But barbed wire ensnares his body like the

coiled serpents in the *Laocoon*, preventing him from making the decisive move. The man's haunted eyes betray exhaustion, too, and along with it the tacit acknowledgement that he is on the verge of sinking back in the earth for the last time.

Memento ends as it began, with an accusing stare (Pl. 132). Now, however, a woman's eyes look out from the field of war, and they are even more fierce and direct than their predecessors in the first print. They belong to the grieving wife of a dead man, who remains upright only because of her efforts to hold him there. Clutching his wrist with one hand and stroking his cheek with the other, she seems at first to be pretending that her husband is still alive. After a while, though, her true motive becomes clear. She props him up in order to remain close to him, and also to display the reality of his corpse in front of us. 'Here', she could well be saying, 'is the pitiful outcome of all the elevated yet empty rhetoric which drives men to fight one another.'

Jaeckel's bull-terrier refusal to be deflected from the fundamental obscenity of war helps to ensure that *Memento* retains its angry force today. As well as suffering an offical ban, it earned him severe censure from critics who claimed, from the safety of civilian life, that it had more to do with the artist's overheated imagination than the 'real events' of the conflict.[35] But Jaeckel, who served as a trench cartographer and later as an aerial photographer on the Eastern Front, had witnessed the tragedy for himself. It prompted him, in 1915, to produce another protesting lithograph called *Battlefield*, where a trapped horse and a cavalryman shot in the chest both raise their heads to scream a collective cry of anguish towards the sky (Pl. 133). This image of human and animal helplessness is in marked contrast

133 Willy Jaeckel *Battlefield* 1915. Lithograph on paper, 26 × 22 cm. Bröhan Museum, Berlin.

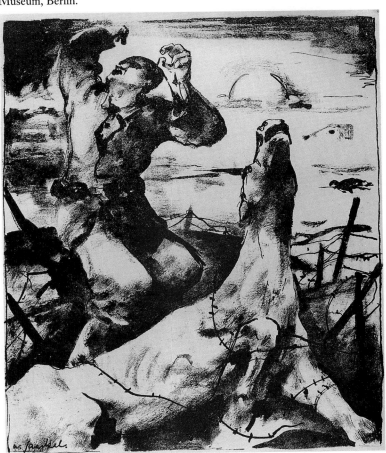

to the sabre-waving jingoism of Max Liebermann's cavalryman shouting *Now we will thresh you!*, published in *Kriegszeit* during the initial surge of enthusiasm for the conflict (see Pl. 61).

The plight of women in war, which Jaeckel highlighted at several points in *Memento*, was not often attended to by male artists. But Christian Rohlfs placed it at the emotional centre of his work when, around 1915, he decided to devote a large painting to the conflict (Pl. 134). In his mid-sixties when the hostilities broke out, Rohlfs belonged to a generation of German artists who refrained, on the whole, from dealing with the war in their work. He had developed late in his career, after meeting Nolde in 1905 and turning away from Impressionism towards a more innovative style which paralleled the Expressionism of *Die Brücke*. Working now with oil and tempera on canvas or paper, he evolved a loose and emotionally heightened style during the latter decades of his long life. Although violent subjects played little part in Rohlfs' pacific vision, he felt impelled to tackle the theme of *War* once the death-toll began to mount. Rather than dealing with the subject in a literal way, which took account of conditions at the Front,

134 Christian Rohlfs *War* c. 1915. Oil and tempera on canvas, 110 × 75 cm. Kunsthalle, Rostock.

he took a more symbolic path. It was a sensible decision. Lacking any first-hand knowledge of modern military life, Rohlfs capitalized on his removal from the struggle by painting a summation of war's essential bestiality.

The lowering, full-lipped brute who emerges in earth colours from the deep purple shadows could belong to any age. He is the archetypal monster of aggression, lumbering towards the fray as his heavily muscled thigh crashes against a woman already trapped in his grasp. The club in his left hand confirms the primordial nature of this marauder, and Rohlfs' brusque handling of tempera and oil accentuates the roughness he seeks to condemn. *War* is a forthright indictment of the barbaric impulse, and it eventually proved too outspoken for the Germans who sought to rebuild their country's military supremacy during the post-war period. In 1937 the painting was confiscated as 'degenerate' by the Nazis, who excluded Rohlfs from the Prussian Academy of Arts at the same time. Their persecution hastened his death a year later.

Ernst Ludwig Kirchner, who also died in 1938 after an even more savage hounding by the Nazis, underwent perhaps the most traumatic and protracted suffering of any artist during the war. The fact that he volunteered for service as a driver in an artillery regiment, soon after hostilities broke out, should not be taken as a demonstration of Kirchner's enthusiasm. The field artillery, where he was transferred in the spring of 1915, turned out to be intensely unnerving. Even *In the Barracks Yard: Two Artillerymen Riding*, a relatively straightforward and buoyant lithograph, carries a disturbing undertow. Kirchner finds a violence in the animals' lunging movements which suggests that they, as much as the men who ride them, are agents of annihilation. He would have been mindful that horses have traditionally played an important part in images of the apocalyptic riders, and the ostensibly harmless exercise conducted in the barracks could easily metamorphose into a full-blown scene of devastation.

Kirchner was quick to recognise that soldiers, once they leave their official duties, are far more vulnerable than they would care to realise. A large lithograph of his friend Hugo Biallowons, probably produced during a short break from artillery training in Halle when the two men returned to Berlin for the night,[36] explores the weariness and despondency engendered by military existence. Before the war Biallowons had been an irrepressible companion, who was photographed naked in Kirchner's studio and appeared in many of his most uninhibited prints. Here, by contrast, the once-brazen exhibitionist seems subdued as he reclines in his uniform, meditating on the difference between pre-war abandon and the constraints of a life spent preparing for a combat which would kill him the following year.

In his most ambitious painting of army life Kirchner went a great deal further, presenting the soldiers shorn of all the accoutrements which define and dignify their roles as fighting men (Pl. 135). He shows, in a canvas grand enough for a history picture of the most heroic kind, naked figures crammed together on a steeply inclined floor for a communal shower. The room is almost as forbidding as the chamber where Beckmann drew the hospital morgue (see Pl. 118), and water spurts from the ceiling in short, stabbing shafts. Some of the men shy away from the shower's impact as if they were threatened by falling bayonets. Their yellow flesh looks jaundiced, and none of them possesses a physique sturdy enough to withstand prolonged exposure to the rigours of the Front. With considerable temerity, Kirchner paints the ordinary members of the Kaiser's invincible army as he thought they really were: undernourished, gawky and lacking any of the camaraderie which soldiers are supposed to enjoy. The brushstrokes slashing their attenuated bodies reinforce

135 Ernst Ludwig Kirchner *Artillerymen in the Shower* 1915. Oil on canvas,
140 × 153 cm. Solomon R. Guggenheim Museum, New York. By exchange,
1988.

the sense of assault, and the figure on the left jerks his head back-
wards as he shields himself from the jets. Sprayed water here becomes
a metaphor for the gunfire which will soon decimate so many of these
wan young men. No amount of uniforms and weaponry can save
them, and their pale, forked nakedness signifies an underlying inability
to protect themselves from the savagery of modern warfare.

 A year earlier Beckmann had explored a similar mood in a prophetic
print called *Mustering*, where the new recruits shiver with embarrass-
ment as they strip for inspection (Pl. 136). One man covers his
genitals and stares awkwardly away from the officer surveying his
body, while another volunteer looks risible as he reveals his overweight
buttocks to the rest of the room. Beckmann already implies that
'soldiers' are, in the flesh, no less frail and uncertain than their
civilian counterparts. He sees the volunteers divested of all illusions,
as they confront the daunting reality of the system which now makes
them feel so ashamed. But *Mustering* seems almost lighthearted in

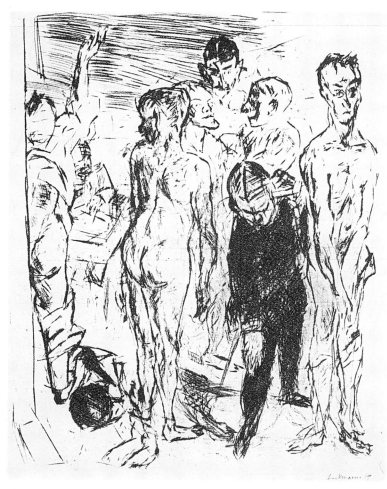

136 Max Beckmann *Mustering* 1914. Etching on paper. Private collection.

comparison with Kirchner's painting, where the men lose their identity altogether while merging in an anonymous herd. The regimentation which dominates army life even extends to the shower-room, for their ablutions are scrutinized by an officer who retains cap, uniform and boots. His cool, undemonstrative formality makes the gesticulating nudity of the other men seem still more defenceless. Indeed, the sinister aspect of the scene is accentuated by the soldier crouching beside the boiler. As he shovels coal, his face takes on a demonic aspect in front of the consuming flames.

Kirchner was unable to withstand such an environment for long. In October 1915 he obtained sick leave because of a lung infection and general debility, but his self-portraits reveal that he was afflicted by a profound malaise of the spirit as well as the body. A terse drawing reflects this inner tension (see frontispiece). The sallow artist stares at his reflection with utter fatigue, scarcely capable of raising his eyelids to perform the task. He looks drugged and demoralized, and his close-cropped hair bears witness to the military requirements which have brought him so low. The act of portraying himself was clearly important in the struggle to recover his sense of individuality after the deadening standardization he had experienced in the army. But the paradox is that the more he laboured at these portraits, the less able he became to claim that selfhood had been restored. *The Drinker*, painted in his Berlin studio 'while day and night the military

trains screeched past my window',[37] amounts to a confession of despair (Pl. 137). The aerial vantage chosen for the portrait imparts a feeling of disorientation to the scene, tilting up the table-top to an alarming extent as Kirchner clutches its edge for support. His other hand extends towards us, as if beseeching our help. But since the artist's eyes have narrowed into slits by this time, the gesture appears rhetorical rather than hopeful. A strange lilac tinge is beginning to spread across his withdrawn face, doubtless precipitated by the content of the green goblet beside him. Its magnified dimensions reflect the importance which alcohol has assumed in Kirchner's dazed existence. Since the picture was initially entitled *The Absinthe Drinker*, it is reasonable to assume that he identified with the addicts depicted in late nineteenth-century French paintings like Degas's *L'Absinthe*. Kirchner's bizarre decision to array himself in a brilliant striped scarf and pointed high-heeled shoes, possibly loaned from his dancer-mistress Erna Schilling, also indicates that he felt part of his masculinity had been impaired in the war.

The Drinker does not, however, convey the absolute horror and disgust which he injected into *Self-Portrait as a Soldier* (Pl. 138). Now the mesmeric goblet has disappeared, and Kirchner asserts the prime importance of his art by framing himself between an unfinished canvas and a nude model waiting to pose in his studio. The scene should be set for creative resurgence, but the figure who occupies so

137 Ernst Ludwig Kirchner *The Drinker, Self-Portrait* 1915. Oil on canvas, 118.5 × 88.5 cm. Germanisches Nationalmuseum, Nuremberg.

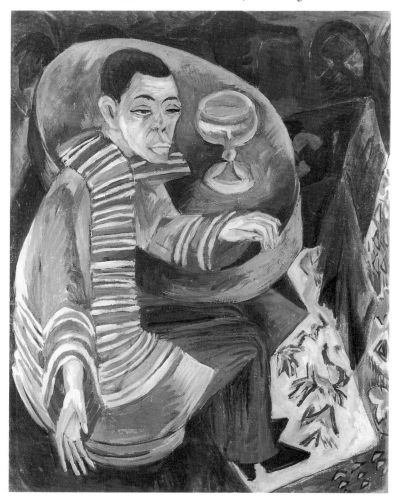

138 Ernst Ludwig Kirchner *Self-Portrait as a Soldier* 1915. Oil on canvas, 69.2 × 61 cm. Allen Memorial Art Museum, Oberlin College, Ohio. Charles F. Olney Fund, 1950.

much of the foreground does not resemble a newly invigorated painter. Obsessed by the trauma of his military experience, he is clothed in his old uniform: the numbers specified with unusual care on his red epaulets confirm that it does indeed belong to the 75th Artillery Regiment, and Kirchner even wears the cap with its target-like badge in the centre. The deep blue of the uniform is the dominant colour in the painting. It suggests, ominously, that the depressed artist has donned his army regalia in a last-ditch attempt to restore morale.

If that was the motive, however, the venture has failed. Reverting to uniform does nothing to give Kirchner's parchment-dry skin an infusion of vigour. He looks more sickly than before, and his pupils are no longer visible in eyes now entirely filled with the same shade of military blue. Is Kirchner indicating that his memories of the war have scarred him so permanently that he cannot see anything except the colour of his uniform? He clearly feels that the army has maimed him beyond reparation. Rather than trusting in his capacity to build a new life, he dwells on his former existence and protests against the damage it has inflicted. Kirchner raises his right arm as though to begin painting again, but all he manages to display is a greenish-yellow stump severed at the wrist. This macabre amputation fantasy serves as a brutal symbol of his impotence now that illness has brought his military service to an end. Unable either to paint or fight, he brandishes the raw and useless limb like an accusation. 'I feel half dead with mental and physical torment,'[38] he confessed to his patron Karl Ernst Osthaus, and in this picture the feeling of injustice festers as an exposed wound.

Apart from signifying his loss of creativity as an artist, the bloody stump also announces the more general nervous disorder of a man who would be plagued by breakdown and psychically related paralysis for the rest of the war. It could be argued, in fact, that Kirchner never fully recovered from his military ordeal. He became haunted by the suspicion that his central identity had been lost at the Front, and shared Grosz's perpetual fear of the effect that a recall to the army might have on his work. 'New draft calls of the reserves stay close at my heels and who knows when they will stick me in again,' he wrote in December 1915, 'and then one can't work any more; one is more afraid of that than any prostitute.'[39] Kirchner's growing awareness of sexual ambivalence brought him closer, in his own feverish mind, to the condition of the whores he had painted with such strident assurance in the pre-war period.

He turned this faltering grasp of selfhood to brilliant account in a cycle of seven woodcuts for *The Amazing Story of Peter Schlemihl*. Written in 1813 by the Romantic author Adelbert von Chamisso, the story concerns a Faust-like man who, after selling his shadow, came into conflict with his soul and then struggled fruitlessly to regain the shadow he had lost. Kirchner realised that von Chamisso's archetypal *doppelgänger* parable could directly reflect his suffering in the war. 'The story of Schlemihl, stripped of all romantic trimming, is strictly speaking the life story of the victim of persecution complex,' he explained later, 'that is, of the human being who through some fortuitous circumstance becomes conscious with a shock of his infinitesimal insignificance.'[40] Fired by this insight, Kirchner produced a *tour de force* of the woodcutter's art. The head dominating the title sheet has the same withdrawn appearance as the artist's own self-portraits, and he seems to be assailed by a jarring multiplicity of eyes. In the third sheet from the cycle, *Conflict*, a murderous mood is explored. The Schlemihl/Kirchner figure is juxtaposed with a naked woman who, clutching a wound with one hand, dangles the other in front of him. The scarlet blood staining her body and fingers is smeared across his lips, making him resemble a gruesomely painted whore. The feeling of persecution mania, powerfully dramatized in this woodcut, sums up Kirchner's siege mentality during the later months of 1915.

Paranoia turns to outright panic in *Schlemihl's Encounter with the Shadow* (Pl. 139), where the colours flare into a vehemence reminiscent of Van Gogh's *The Painter on his Way to Work*. In his description of this incandescent image, Kirchner admitted that self-representation had become his main motive for tackling the scene: 'Schlemihl sits sadly in the fields when, suddenly, his shadow approaches across the sunlit land. He tries to place his feet in the footprints of the shadow, under the delusion that he can thereby become himself again. An analogue is the mental process of one discharged from the military.'[41] Kirchner's wild and flaring interpretation of Schlemihl's struggle offers an unsettling insight into the hysteria which threatened to overwhelm the artist in the aftermath of his military service.

Despite the outstanding quality of the Schlemihl cycle, Kirchner remained aware that it was a precarious achievement. He became obsessed by the prospect of failing powers, even after Nolde's friend Hans Fehr finally obtained his discharge from the army in December 1915. Three spells in a sanatorium at Königstein followed over the next seven months, but he could not oust the continual suspicion that a crisis – both personal and political – was about to destroy everything. 'More oppressive than anything else', he wrote in 1916, 'is the strain of war and the prevailing shallowness. It is like a murderous carnival. One feels that a decision is in the air, and everything is topsy-turvy. One is so jaded and faltering, one hesitates to work, when all work is fruitless and the onslaught of mediocrity carries all before it. We

139 Ernst Ludwig Kirchner *Schlemihl's Encounter with the Shadow* 1915. Sheet from the *Peter Schlemihl* cycle. Coloured woodcut on paper, 31 × 28.9 cm. Städelisches Kunstinstitut, Frankfurt.

ourselves are now like the tarts I'm painting. Done with, and on the next occasion heard of no more. In spite of everything I keep trying to get my thoughts in order and out of the muddle to paint a picture of the times, which is what I am here for.'[42]

The urge to continue working, even in the face of fierce fighting at the Front, remained strong in many German artists. Marc, whose initial enthusiasm for the war had prompted him to volunteer for the cavalry in September 1914, never stopped planning the images he hoped to paint on his return to active service. At first he saw the conflict as nothing less than a Nietzschean 'cleansing of Europe', but when his great friend Macke was killed only a month later he wrote a tribute filled with sadness and indignation about the 'accident of the individual death which, with every fatal bullet, inexorably determines and alters the destiny of a race.'[43] At the same time he admitted to Kandinsky that the war had created a virulent new nationalism, threatening all the hopes about a spirit of 'Europeanism' entertained by the *Blaue Reiter* artists before the conflict began. By Christmas Marc had come to see that 'the most important lesson and irony of the Great War is certainly this: that precisely the great triumph of our "technical warfare" has forced us back into the most primitive age of the cavemen.'[44]

During the course of 1915, when he carried out an extended and incisive series of drawings in his 'Sketchbook from the Battlefield', Marc's view of the war continued to fluctuate. He found release in these thirty-six pencil studies, executed on small sheets of paper at spare moments between March and June. 'They lighten my load and help me to relax,' he revealed, describing how 'I'm drawing from time to time fragments for paintings, ideas for bible illustrations which I'm

keen to do again, small compositions and the like.'[45] The most biblical studies in the book are drawings such as *Arsenal for a Creation*, where Marc obstinately continues to associate the accumulation of armaments with the idea of primal renewal (Pl. 140). A horse's head and body can be discerned in the upper area of the composition, recalling his pre-war paintings of animals caught up in an apocalyptic storm (see Pl. 17). A related disturbance undulates through this drawing as well, but it lacks any sense of overwhelming devastation. Indeed, regeneration seems about to emerge from the maelstrom, and in 1915 Marc reiterated his hope that the conflict would turn out to be a boon. 'For several years we have been saying that many things in art and life were rotten and done for,' he wrote, 'and we pointed to new and better possibilities. No one wanted to know. What we couldn't know was that the great war would come with such terrible swiftness, pushing words aside, sweeping away death and decay to give us the future today.'[46] These sentiments help

140 Franz Marc *Arsenal for a Creation* 1915. Pencil on paper, 15.7 × 10.2 cm (from 'Sketchbook from the Battlefield'). Staatliche Graphische Sammlung, Munich.

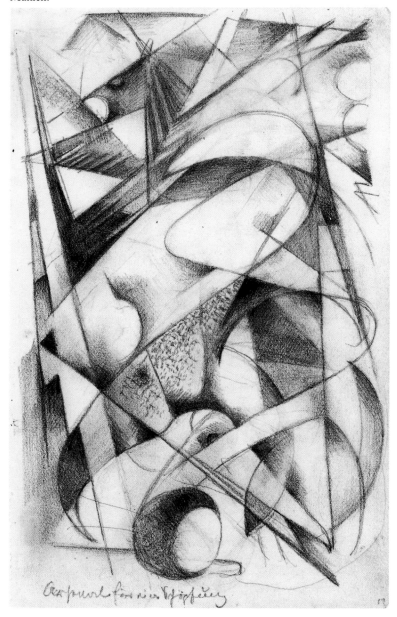

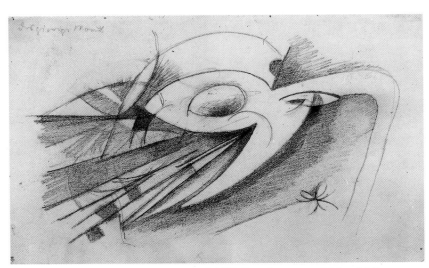

141 Franz Marc *The Greedy Mouth* 1915. Pencil on paper, 10.2 × 15.7 cm (from 'Sketchbook from the Battlefield'). Staatliche Graphische Sammlung, Munich.

to explain the optimism of a sketchbook drawing called *The Peaceful Horse*, where the animal grazes quietly in a wood after cosmic strife has almost come to an end.

By no means all the 'battlefield' drawings explore such a beneficent mood. Some of the six deer who pause before a mountain pass in a graceful untitled study raise their slender necks cautiously, and sniff the air for danger. They are reminiscent of the central deer in *The Fate of the Animals* (see Pl. 17), and below the looming crescent moon signs of imminent disturbance are beginning to manifest themselves. On the following page the promised eruption arrives, breaking out in a cataclysm which tears through the entire drawing. The sun and other planetary forms are threatened with eclipse by this turmoil, which explodes with the force of the shell-bursts Marc must often have witnessed at the Front. Even here, though, the outcome may be far from disastrous. Without any consciousness of irony he called the drawing *Magical Moment*, in the stubborn conviction that a purged and healing regeneration would result from 'the ancient rite of sacrificial blood'. Marc was still sufficiently under the influence of Nietzsche to write a hundred aphorisms inspired by the example of Zarathustra's creator. He wanted to believe in a better future, and most of the 'battlefield' studies lack a fully tragic awareness.

Marc did, however, acknowledge the devouring and grotesque aspects of the war. In a drawing entitled *The Greedy Mouth*, a predatory yet oddly impish creature gorges itself on an abundance of prey (Pl. 141). But the image is ambiguous: the shafts entering its mouth could just as easily be thrusting outwards, like diagonal tongues of fire issuing from a flame-thrower. Part gigantic insect and part diabolic instrument of war, the creature simultaneously devours and belches with a gleeful zeal that precludes all consciousness of responsibility for its actions. Around the period Marc drew this apparition, he confessed in a letter that there was a time when 'animals seemed more beautiful, more pure. But then I discovered in them too, so much that was ugly and unfeeling...until now, suddenly I have become fully conscious of nature's ugliness and impurity.'[47]

Marc's naive faith in the emetic function of war was wavering again, and the later drawings in the sketchbook show a darkening mood. One of the most violent is given the bleak title *Conflict*, and defines a world wholly consumed by the clash of opposing forces.

As well as looking back to the deluge paintings of his old friend Kandinsky, the drawing displays an increased awareness of the lancing, penetrating potential of the forces at work in this tumultuous universe. Nothing now counters their engulfing power as they travel towards the centre, burst, and then roll back in order to prepare for a fresh assault. There is no sign here of the renewal Marc had once envisaged. The annihilation appears to be caught up in a repetitive cycle, and death rather than rebirth seems the outcome in one of the final 'battlefield' studies (Pl. 142). An untitled drawing, it depicts a shattered world where everything droops in mournful attitudes of extinction. A few disconsolate birds can be glimpsed among the broken plants, but they are waiting for the end rather than embodying a more resilient alternative. It is an elegiac image, sadly prophetic of Marc's own fate only nine months later. In a moment of exhaustion he wrote from the Front, at the time when this drawing was executed, that 'there is only one blessing and release: Death; the destruction of form in order to release the soul.'[48]

Marc did not remain in this resigned and melancholy state for long. He was soon yearning for the opportunity to enjoy a sustained period of work, declaring impatiently that 'it's clear to me that I'll only be able to work properly again when I get home to Ried, with all my materials, my wooden stick and above all heavenly peace and quiet.'[49] But his ambition was never fulfilled, and as the year wore on he became strangely detached from the world of suffering and carnage. Even the loss of Macke, which had earlier forced him to reconsider his Nietzschean view of the war, receded with the passage of time and the ceaseless deaths among his fellow soldiers. More than a year after he first heard about the slaughter of Macke, Marc received a photograph of his friend cheerfully riding a donkey in Tunis. 'Admittedly this posthumous reminder of his *joie de vivre* fills me with twice as much grief,' he wrote, 'but his sad departure at the hand of a foe's bullet – one is almost tempted to say friend's – it was after all a French one – seems no more absurd than the death of Moillet's wife or some other "natural" accident. Even the war is natural; it isn't valid to say, like you always do, that the war is a totally unnatural phenomenon. The epidemic that it has perforce become is just as much a result of nature as the tsetsefly or the plague bacillus. *My attention has long since been deflected from the war.*'[50]

Perhaps Marc was forced to cultivate detachment in order to survive the military ordeal. He did not, after all, succumb to illness or breakdown like other artists, and in February 1916 he sounded a remarkably buoyant note when telling his wife about a congenial duty he had been asked to carry out. 'Dearest, had you seen me today, you would surely have had to despair of "reality" or of my reason in no time,' he wrote. 'I was standing in a massive barn (charming atelier!) and painting nine of what Walterchen [Macke's young son] calls "Kandinskys" on military tarpaulins!' Like the team of French army camouflage painters who included Villon and Segonzac (see Pl. 102), Marc had been given a task more suited to his abilities than fighting. 'The business has a totally practical purpose,' his letter continued, 'to hide artillery emplacements from airborne spotters and photography by covering them with tarpaulins painted in roughly pointillistic designs in the manner of bright natural camouflage. The distances which one has to reckon with are enormous – from an average height of 2,000 metres – your enemy aircraft never flies much lower than that...I am curious what effect the "Kandinskys" will have at 2,000 metres. The nine tarpaulins chart a development "from Manet to Kandinsky!"'[51]

If Marc had been allowed to continue with such welcome work for the rest of the war, he might well have survived. But his duties in the

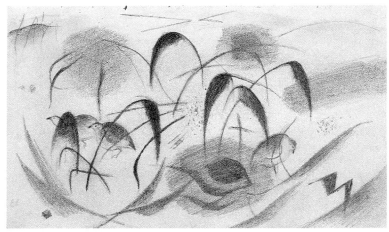

142 Franz Marc *Untitled* 1915. Pencil on paper, 10.2 × 15.7 cm (from 'Sketchbook from the Battlefield'). Staatliche Graphische Sammlung, Munich.

cavalry ensured that he was exposed to heavy bombardment only a month after describing his interlude as a camouflage painter. Full of optimism about the art he looked forward to making when the war was over – 'I was *never precocious* & am sure that I will achieve more lively things at 40 & 50 than I did at 20 & 30'[52] – Marc was killed at Gussainville Castle, Verdun, on 4 March 1916. He had just celebrated his 36th birthday, and written a letter to his mother explaining his attitude towards death and the work he still wanted to produce as a painter. 'It has never occurred to me to seek out danger and death as I had done so often in earlier years,' he wrote, remembering how 'at that time death avoided me, not I it; but that is long past. Today I would greet it very sadly and very bitterly, not out of fear and anxiety about it – nothing is more soothing than the prospect of the *stillness of death* – but because I have half-finished work to be done that, when completed, will convey the entirety of my feeling. The *whole purpose of my life* lies hidden in my unpainted pictures.'[53] The cutting-short of Marc's life only a fortnight after he wrote this letter was cruel indeed, and his commanding officer subsequently gave an account of the tragedy. 'It was a radiant early-spring afternoon, as we got ourselves ready,' he wrote. 'At the foot of a hill Marc mounted his horse, a tall chestnut bay, and as long-legged as he himself. We rode together for some length along a path that the day before had been subject to some very severe fire, but on this day the fire was relatively light. In Braquis (20 kilometres east of Verdun) we separated. Marc was supposed to reconnoitre the woods for a path for a munitions convoy. Barely twenty minutes later his horse-attendant, H., returned, covered with blood and slightly wounded. His eyes filled with tears, he pointed toward the woods where, just a few minutes earlier, his superior had been struck by a grenade fragment and had died in his arms. Whether it was an unfortunate accident or whether it was the French . . . will forever remain a mystery. Franz Marc was dead!'[54]

The news profoundly affected his close friend Klee, who had visited Marc's house at Ried on several occasions when the latter was on leave. Klee was critical of Marc's attitude towards the conflict, noting in his diary that 'he should hate the war game more than he does or, better still, be totally indifferent to it.'[55] But Klee liked the 'Sketchbook from the Battlefield', declaring that Marc 'should paint again, then his quiet smile, that is so much a part of him would appear, at once simple and simplifying.'[56] Marc was never given the chance to resume his painting, and Klee expressed his sense of the loss to modern German art in a foreword to the catalogue of Marc's Memorial Exhibition. By an irony of fate, he was himself called up only seven days after his friend's death. Commencing a diary at the recruiting depot in Landshut, he revealed that 'the name Marc frequently comes to my mind, and then I am moved, for I seem to see something collapsing.'[57]

An increasing number of German artists shared this dizzying sensation. The disastrous emphasis on offensives had been maintained throughout 1915; and although the outcome was stagnation and entrenchment, the slaughter had reached murderous proportions. Images of graveyards became more and more common, in an attempt to convey the otherwise unimaginable extent of the killings. *Peace* is the title of Friedrich August von Kaulbach's etching, where a military cemetery marks the scene of a costly battle. To the extent that the soldiers buried beneath the rows of crookedly installed crosses have been 'laid to rest', as the euphemistic phrase insists, peace of a kind has indeed been attained. But von Kaulbach knew, as well as anyone, that the deaths had achieved nothing. The soldier playing the pipe of peace on the most prominent crucifix is the very opposite of an idyllic, beneficent figure. His hands are skeletal as they dance along the instrument, and the helmet cannot disguise the fact that it encloses a skull. True peace seemed far more elusive at the end of 1915 than it had done a year before. Von Kaulbach's decision to portray death as the messenger of peace acknowledges the grim fact that the slaughter would continue indefinitely, like the lines of crosses extending in his print to the horizon and beyond.

All the same, *Peace* did not convey the full horror of the death-toll. It had now reached such intolerable proportions that soldiers' corpses had to be thrown, indiscriminately and without coffins, into hastily dug pits. Von Kaulbach's etching implies that each body was at least accorded the dignity of its own grave and marker. But Barlach recognised the utter wretchedness of war burial in an image called *Mass Grave* (Pl. 143). Only a year earlier he had envisioned the conflict as *The Holy War*, in which a cloaked figure with an awesome sword strides towards victory (see Pl. 38). Since then, Barlach's views had undergone drastic modification. News of the ceaseless massacring, coupled with his own call-up for war service in 1915, made him appreciate that the reality was totally removed from the exalted crusade he had once defined with such religious fervour. The firm ground over which his avenging agent had previously advanced was now strewn with the dying and dead. Rather than pursuing an unstoppable, all-conquering advance, progress had to be halted while vast, anonymous holes were dug in the earth. There the corpses were deposited, to share the ignominy of a collective burial. Barlach's line becomes brusque and cursory as he defines the grey, abandoned and often unidentifiable forms occupying the pit to the point of congestion. Although it should already have been filled in, the grave-digger is so exhausted that he is forced to abandon his shovel for a moment and sit on the ground. Bowed with fatigue, he acts as an unofficial mourner for all these unregarded bodies. Soon the hole will be covered over; but the diminutive figures in the distance, carrying yet another victim from the battlefield, prove that the demand for further makeshift graves shows no sign of abating.

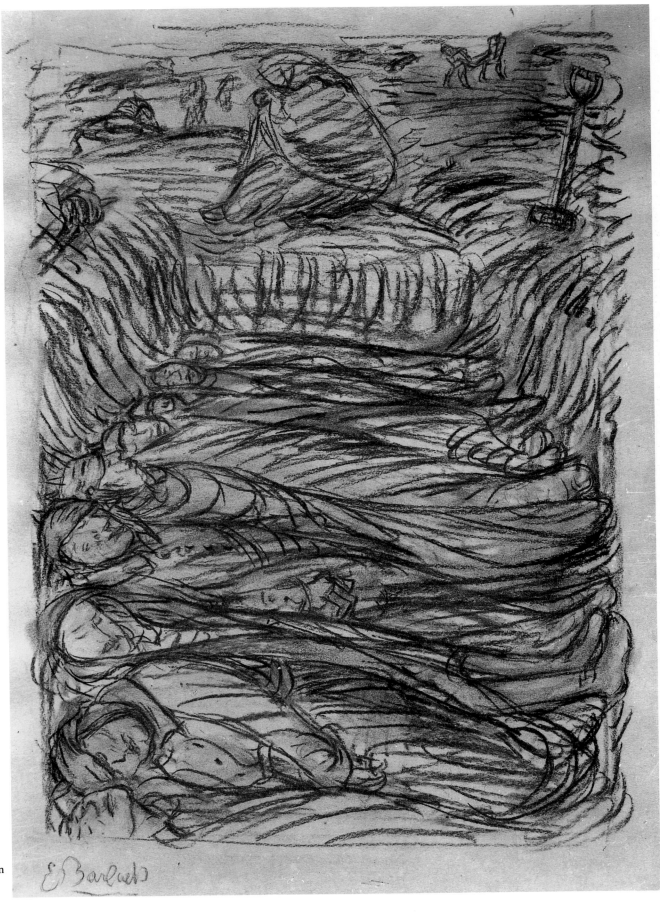

143 Ernst Barlach *Mass Grave* 1915. Lithograph on paper, 39 × 28 cm. Ernst Barlach Haus, Hamburg.

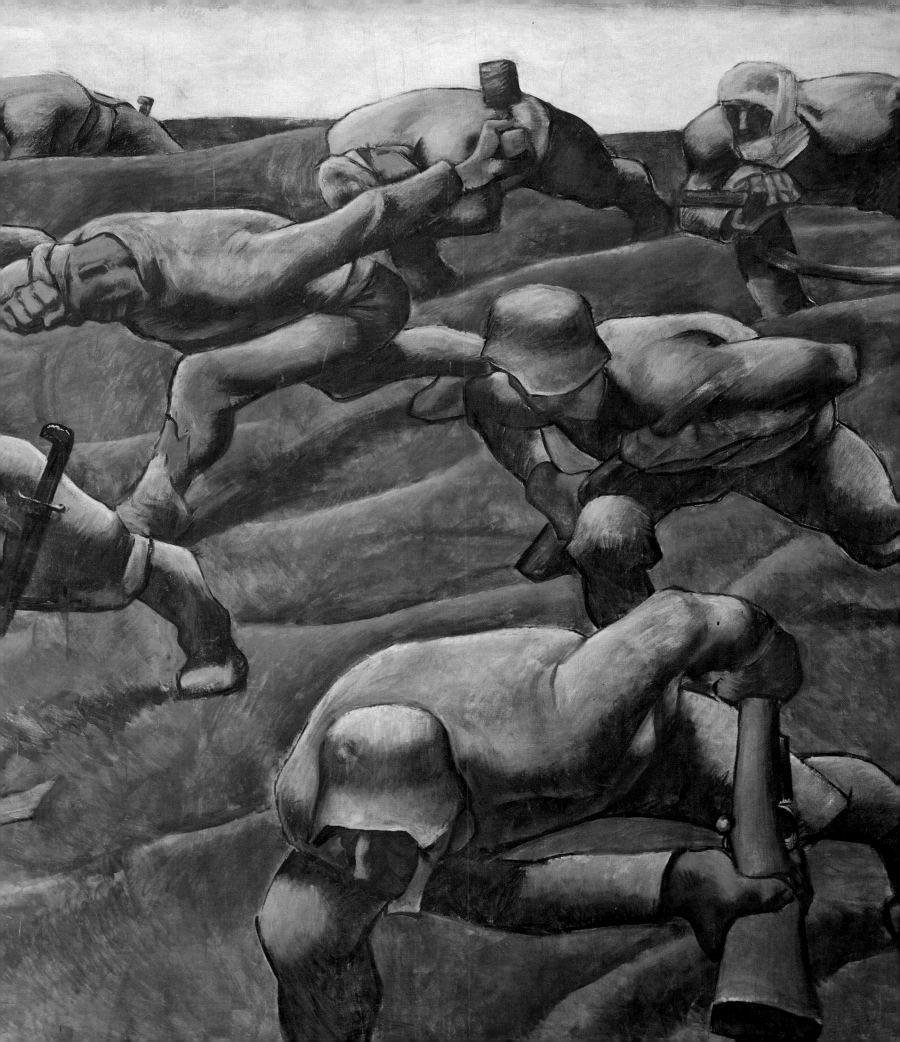

CHAPTER FIVE

THE GREAT CARNAGE

(1916)

Grievous though they had already been, the losses sustained on both sides escalated to new heights of barbarity during 1916. In February the Germans launched their offensive against the French salient at Verdun, and by the end of the year the protracted battle of attrition had claimed over half a million lives. The tally was grotesque enough to justify Othon Friesz's chaotic yet heartfelt painting *The Horrors of War*, where slaughter, rape and pillage riddle a symbolic landscape presided over by the helpless, crucified Christ (Pl. 144). Then, in the summer, the Allies retaliated with a ferocious attack on the German forces near the River Somme. Despite unleashing the biggest initial bombardment ever carried out in a war, the allied assault was cruelly misconceived. On the first day alone the British army lost 19,000 men, and the final tally for both sides at the Somme rose to well over one million casualties – all for the sake of a paltry eight kilometres gained from the German forces. No wonder the soldiers called it the Great Fuck-Up.[1] The Somme débâcle was, as Jacques Darras pointed out, 'a mutual massacre of awesome scale', ultimately engendering a 'certain communal amnesia' which contributed to 'the total lack of preparedness in France to face war again in 1939 and 1940.'[2]

But the extent of the tragedy did not prevent some clear-sighted artists from responding to it almost at once. In *The Abandoned City*, Alfred Kubin imagined the loss of so many lives resulting in a deserted urban centre, where Death is now the only figure to stride through the empty streets. As for the redoubtable Meidner, who had anticipated the calamitous nature of this war in his apocalyptic canvases four years earlier (see Pl. 1), he now reacted to events by painting *The Last Day* (Pl. 145). Meidner, who was finally called up to serve in the German infantry in 1916, did not this time include the explosions which had given so many of his previous images their hallucinatory force. But his vision here is no less desolate. Instead of running wildly away from disaster, the men and women in their funereal clothes huddle together on the battered terrain. All they are able to do is wait, without any discernible means of protecting themselves against the menace implicit in the darkened sky.

The shifting perception of war between 1915 and 1916 is nowhere more arrestingly revealed than in the work of Albin Egger-Lienz. Twenty years older than his fellow-countrymen Kokoschka and Schiele, he stood apart from the avant-garde ferment which enlivened so much Austrian art during the pre-war period. But his independence led him to take a robust, forthright attitude towards the conflict, and he devoted his best energies during the war years

to painting monumental images of the struggle. Two canvases in particular pinpoint the changing vision as hostilities entered the period of worst decimation. In 1915 Egger-Lienz started a large picture entitled *War* (Pl. 146). It is an austere work, wholly given over to the advance of infantrymen across bare, inhospitable land. The repetition of stance in their striding legs gives them a purposeful air. Monitored by the figure at the front, who turns his head to survey the progress of the troops, they seem formidable enough. Hands grip rifles in readiness for the fighting ahead, and their gaunt faces express an implacable determination to reach the objective. The only ominous aspect of this picture lies in the fallen bodies who threaten to impede the soldiers' steady marching rhythm. Several corpses must be stepped over, a man at the rear has just been hit, and the presence of a body in the foreground suggests that the enemy fire will become more lethal as the advance proceeds. After a while, therefore, the troops begin to appear more vulnerable. The military pride which keeps them so erect also makes them an easy target, and some of the soldiers already wear bandages around their heads. This proud and resolute force is not as invincible as it might initially have appeared. Without undermining the men's will to win, Egger-Lienz prompts the viewer of his canvas to wonder how many of these sturdy figures will eventually arrive at the enemy lines.

In 1916, when *War* was completed and he commenced another painting over twice the width of its predecessor, Egger-Lienz went much further in his questioning of the war. Now, on an epic scale suitable for a battle picture at its most heroic, he produced an image of *The Nameless Ones, 1914* (Pl. 147). Rather than retaining a noble, upright position like the troops in the previous canvas, these anonymous figures crouch as low as they can. With one exception, their leg positions are again repeated throughout the composition, so that the feeling of constriction is everywhere rammed home. Even the man who breaks the pattern, and thrusts a leg forward instead, keeps his head down and shields it with a fist. Although his other hand brandishes a stick-bomb, he seems in no position to hurl it with any accuracy. Like most of his comrades, he stares at the furrowed earth. They blunder forward like blind men impelled to move without any glimpse of a destination, and Egger-Lienz's use of reiteration emphasizes their loss of individuality in the slow, standardized advance. One man blows a bugle, as though to stir the bowed ranks into more militant action. But the sound has no effect. Everyone is by this time so conscious of the danger involved in moving over open ground that they keep down. Even the central figure, who has no helmet and dares to raise his face, wears an expression of pained resignation. He gazes forward with haunted eyes, ready at any moment to be

Left: Albin Egger-Lienz *The Nameless Ones* 1916 (detail). See Pl. 147.

144 Othon Friesz *The Horrors of War* 1915–16. Oil on canvas, 150 × 100 cm. Musée de Grenoble.

struck by a bullet and left dying in the bleak, exposed plain.

Egger-Lienz's fellow-countryman Carry Hauser depicted this fateful moment of wounding in a small, urgently executed water-colour polemically entitled *Against the War* (Pl. 148).[3] Having joined the army full of enthusiasm in 1914, this gentle artist was disillusioned and then disgusted by his experience of the conflict. He remained convinced of war's barbarity to the end of his life, and in 1916 found time to express his condemnation. The picture, executed in Zvitomir, doubtless records an incident Hauser witnessed. While one soldier remains at his post among the tree-lined trenches, the wounded man is carried away by two comrades. The figure whose powerful arms encircle his waist looks sturdy enough to support him as far as the medical station, but the injured infantryman seems grievously afflicted. His blanched face, devoid of animation, is dominated by a tacit realisation that death is near. And Hauser reinforces that likelihood by silhouetting the cross of a grave against the distant sky.

Kokoschka, another Austrian artist who knew what it was like to be confronted by death on a battlefield at the Russian Front (see Chapter Three), was fortunate indeed to find himself rescued and sent to hospital in Vienna. The injury to his inner ear caused by a severe head wound took a long time to heal, and left him with a permanently impaired sense of balance. At the Palffy Spital he was examined by the ear specialist Heinrich von Neumann, who sat for a portrait in the early months of 1916 (Pl. 149). Unlike most of

145 Ludwig Meidner *The Last Day* 1916. Oil on canvas, 100 × 150 cm. Berlinische Galerie, Berlin.

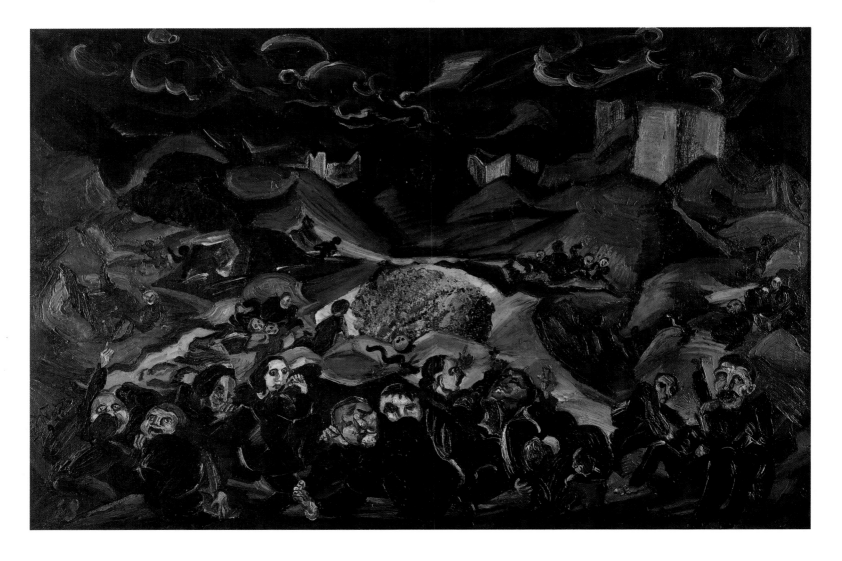

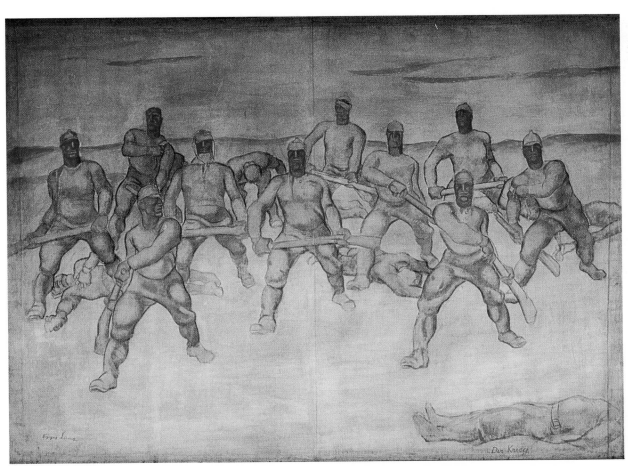

146 Albin Egger-Lienz *War* 1915–16. Oil on canvas, 172 × 232 cm. Museum Schloss Bruck, Lienz.

147 Albin Egger-Lienz *The Nameless Ones, 1914* 1916. Oil on canvas, 243 × 475 cm. Heeresgeschichtliches Museum, Vienna.

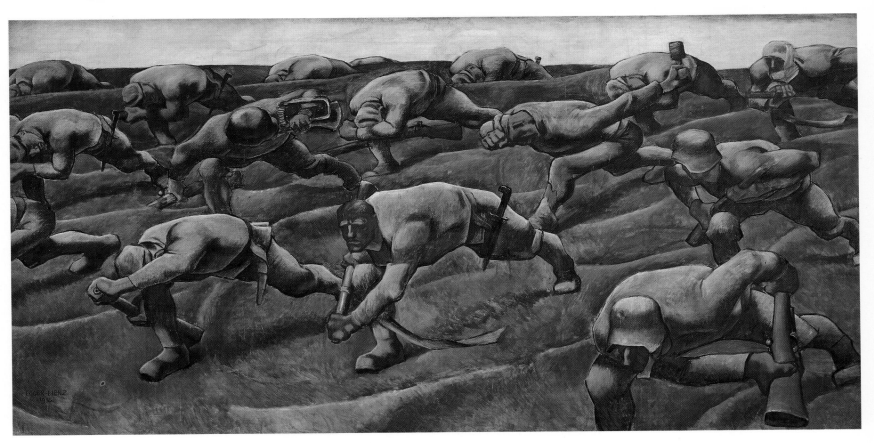

the men and women painted by Kokoschka before the war, von Neumann is seen in his working clothes. He sits in the consulting room with instruments around him, and a book which might well be a medical text in his hand. He is not, however, reading its pages. His eyes have wandered to some indeterminate point in space, and he ruminates on private thoughts while his patient works at the portrait. Ostensibly robust, with a body bulky enough to be bursting out of his consultant's coat, von Neumann has little in common with the attenuated and often neurasthenic people who sat for Kokoschka in the pre-1914 period. All the same, he looks tired and even a little despondent. He must have found himself tending more and more young soldiers with serious head injuries, and the experience seems to have left its mark. Kokoschka's heavily loaded brush and rough handling emphasize the rumpled state of the doctor's coat, as he takes a rest before returning to his duties. But the most disquieting aspect of the portrait lies in his face, discoloured by a strange purplish hue reminiscent of bruising. Perhaps Kokoschka wanted to suggest that von Neumann, like the wounded man who painted him, has been pummelled by his experience of war.

In common with Grosz and Kirchner, whose leaves of absence from the Front were tormented by the perpetual fear of recall,

148 Carry Hauser *Against the War* 1916. Pencil and watercolour on paper, 40 × 29 cm. Jenö Eisenberger Collection, Vienna.

Kokoschka dreaded returning to active service. He still remembered, many years later, that an unwelcome presence at the Palffy Spital was a 'dashing general still in the prime of life, whose nickname was "the hyena of the homeland hospitals."' Three times a month he 'would come on a morale-boosting visit. He would play a few rippling arpeggi on the hospital piano and then ask the patients in turn: "Well . . . are you feeling nearly ready to get back to the front?"'[4] The answer, so far as Kokoschka was concerned, took the form of postponement. After convalescing until May, he found that his precarious state of health led to his appointment as an inspector of military hospitals before working as a military press officer. Then, in July, he was ordered to serve as a press liaison officer on the Izonzo Front, where Austria-Hungary had recently attacked Italy. Although Kokoschka had himself asked to be posted to the Front, his request was tantamount to a death-wish. Frank Whitford speculated that 'he may even have wanted to die',[5] for his prolonged illness had coincided with the end of any lingering hopes he harboured about Alma Mahler. At all events, he reported to a friend that 'on the 14th I have to start the journey with some war artists, which I am dreading and which I am sure will very soon cost me my life . . . I'm already sick to death of life, and I'm waiting for the end of the world, when I hope I'll be able to find a cleft in the ground where I can rest.'[6]

However ambivalent he felt about the prospect of death, Kokoschka deprecated the way in which war artists like the prominent Hungarian painter József Rippl-Rónai were 'being handled with kid gloves' by army command at Ljubljana, 'where everything is comfortable and in a civilized state.'[7] Nothing could be learned there about the harshest realities of war, as Rippl-Rónai's work testified, whereas Kokoschka soon found his fears about the danger of the Izonzo Front borne out in full measure. At Selo, where he executed rapid crayon and pastel studies of the Front line and the church, he was nearly caught by a direct hit from the Italian artillery. 'Today I received my second baptism of fire in a village through which the trenches run,' he told Adolf Loos. 'Once it was very beautiful but today it is totally destroyed. I had climbed out of the trench and begun to draw the church, had taken from it only a tall votive candle for superstitious reasons although more beautiful things were lying around there, was observed as I was drawing and caught in a cloud of shrapnel which destroyed a house five paces away. Then I had to wait for a second bombardment, then escaped through the ruins.'[8]

Kokoschka was in no condition to undergo such ordeals for long. A few days later he revealed to Herwarth Walden that he was 'coughing like an old gentleman and weak as a baby',[9] and most of the drawings made at the Italian Front reflect this disability. *Tom di Tolmino*, for instance, is little more than a quick, matter-of-fact study of a battery position (Pl. 150). The soldiers crouching behind the gun look curiously toy-like, as if they were involved in a game rather than a fierce territorial struggle. The camouflaged shelter enclosing them adds to the sense of unreality, and only when Kokoschka cast aside topographical concerns did his turbulent imagination convey a grimmer vision of war. A wildly brushed ink study called *The Battle* was not, self-evidently, drawn from life (Pl. 151). The kind of image he might have produced in the evening, when his greatest misgivings about the conflict finally came to the surface of his mind, it presents the jostling group as a barbaric horde. Unruly and dishevelled, they bear no relation to the ideal of clean-cut orderliness which the troops were supposed to embody. Just as Maria Sinjakowa had shown soldiers taking an almost orgiastic pleasure in slaughter (see Pl. 93), so Kokoschka gives his combatants a gleeful animation. Are they fighting, or indulging in a bacchic riot? The ambiguity is left un-

149 Oskar Kokoschka *Heinrich von Neumann* 1916. Oil on canvas, 90.1 × 59.9 cm. Harvard University Art Museums. Association Fund.

150 Oskar Kokoschka *Tom di Tolmino* 1916. Crayon and pastel on paper, 29.2 × 41.6 cm. Marlborough Fine Art (London) Ltd.

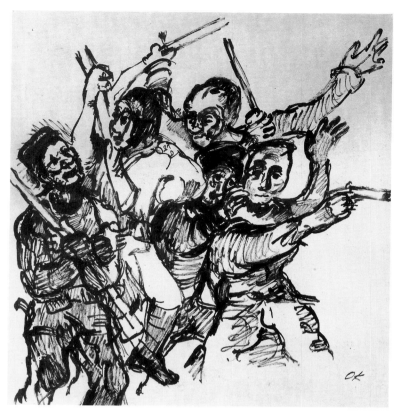

resolved: the artist must have felt disturbed by the relish with which these leering and bloodthirsty figures enter the struggle.

Weakened by such alarming presentiments, as well as his continuous ill-health, Kokoschka was further disorientated in August 1916 by a grenade explosion in No Man's Land. The shell-shock proved so severe that the unnerved artist was once again consigned to military hospital in Vienna. The crisis led him to rejoin the Catholic Church and work on six lithographs for *The Passion*, which the art dealer Paul Cassirer published in the yearbook *Der Bildermann*. In view of the experiences he had undergone during his army service, it is not surprising that a strong personal note enters Kokoschka's prints. His crayon study for *The Agony in the Garden*, which differs from the lithograph, clearly shows that he intended Christ's face as a self-portrait. The anguished question he had already emblazoned on the sky in *Knight Errant*, 'My God, my God, why hast thou forsaken me?' (see Pl. 96), now returned to haunt him once more. He was determined never again to be called up, and in November 1916 even dismissed the idea of working 'as a war artist out in the open, which I'd find far too dangerous and monotonous. After I've come through so much safe and sound, I don't want to get killed now the War's nearly over.'[10]

In order to guarantee his immunity, he planned to 'go to a sanatorium in Dresden on 1 December where I have friends among the doctors who will protect me there for as long as possible.'[11] Although evidence conflicts at this stage in Kokoschka's life, he probably did stay at Dr Teuscher's parkland sanatorium rather than a guest-house nearby. But it was in the latter building, the Felsenburg Inn, that he formed his most important relationships then. Kokoschka became friendly with a remarkable group of writers and theatre people, including the Czech actor Ernst Deutsch, the poet Paul Kornfeld, the actress Käthe Richter and the Expressionist playwright Walter Hasenclever. Richter, with whom he had an affair, proved particularly indispensable by preserving Kokoschka's frail morale during his treatment at the sanatorium. 'Katja, thank God, is still here,' he told Herwarth Walden in December, 'otherwise I should have died from hypochondria; she protects me from people; the examination is over for today, but at night I got a cardiac spasm from weeping.'[12] The friends he made in Dresden, all of whom were trying to forget the insanity of war, sustained Kokoschka in his exile.

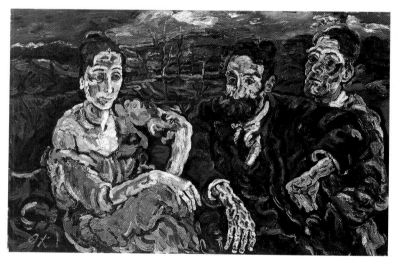

151 Oskar Kokoschka *The Battle* 1916. Brush and ink on paper, 32.8 × 31 cm. Trustees of the Cecil Higgins Art Gallery, Bedford.
152 Oskar Kokoschka *The Exiles* 1916–17. Oil on canvas, 95.25 × 146 cm. Staatsgalerie Moderner Kunst, Munich.

They were given support by Dr Fritz Neuberger, who had already come to the conclusion that the war would be lost. He worked for its termination, looked forward eagerly to the new society which could then ensue, and might even have been instrumental in helping Lenin to enter Russia and bring about a truce with Germany.

Neuberger's optimism had a tonic effect on the *déraciné* group as they struggled to continue their work. But when Kokoschka painted a group portrait of Richter, Neuberger and himself, he called it *The Exiles* and made no attempt to disguise the feeling of uprootedness (Pl. 152). Executed with nervous brushmarks which convey the artist's apprehensiveness, the picture is dominated by the seated figures of

the actress and the doctor. Their physical bulk, accentuated by the palpability of Kokoschka's thick pigment, does not however promote stability. Although the two figures rest their right arms on their knees, they fail to express repose. Neuberger's hand resembles a macabre X-ray with its tracery of white lines, and Kokoschka reinforces the sense of strain by making them both thrust out their left elbows at an ungainly angle. This repeated pose emphasizes an underlying obstinacy, as they attempt to withstand the bleakness of the world revealed in the overcast landscape beyond. Here Kokoschka evokes the field of battle, with its stripped, broken trees and furrowed ground. He confirms the mood of tense expectancy not only in the gravely preoccupied expressions of Neuberger and Richter, but in his own face as well. Half-sheltering behind his friend's outflung arm, the invalid stares from the picture with eyes widened by a consciousness of the precarious existence he leads under the continuing shadow of war.

By this time, even the Austrian artists least likely to make any overt references to the conflict found themselves impelled to take pictorial account of its menace. Klimt, who could never be imagined turning away from his landscapes, portraits and obsessive allegories in order to paint a specific war picture, reworked a large canvas called *Death and Life* between 1915 and 1916. He had commenced it several years before the outbreak of hostilities, and placed the figures it contained on a gold background. Now, however, the pervasiveness of death prompted him to replace that former sumptuousness with a far less reassuring alternative (Pl. 153). Warmth and brightness give way to a tenebrous blue chill as dark and deliberately broken colours obliterate the earlier gold. In *Death and Life*'s initial state,[13] the figures embedded in a rich, billowing tangle of flowers and embroidered draperies dominated the composition, and seemed to be sustained by the shimmering flatness of the ground behind. But Klimt's wartime revision offers them no such support. Although they occupy a more

154 Jacek Malczewski *Portrait of Jan Lissy* 1916. Oil on cardboard, 80 × 65 cm. Miroslaw Gardecki, Warsaw.

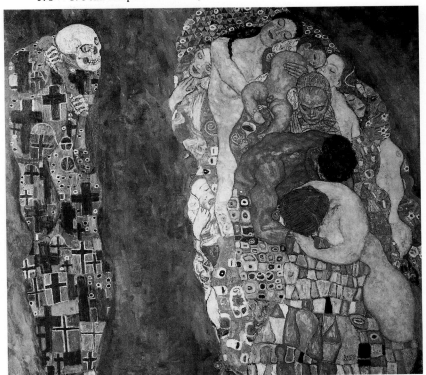

153 Gustav Klimt *Death and Life* 1908–11, revised 1915–16. Oil on canvas, 178 × 198 cm. Leopold Collection, Vienna.

substantial part of the composition, the addition of two women on the left edge of the group only brings the ensemble of doomed humanity nearer to the figure of Death. Moreover, the tumbling luxuriance of the hair belonging to the woman in the foreground of the first version has now been cut short. Both she and the other entwined bodies suddenly appear frail and adrift when pitched against the shadowy void beyond. Its darkness gives the area between life and death a more potent role, helping the skeletal predator to assume a greater degree of forcefulness within the painting. Instead of looking downwards, and half-burying his head within a cloak like a diffident reminder of mortality, he turns his head towards his victims, discloses clenched hands and threatens the entire familial chain with swift, wholesale extinction.

The depth of Klimt's pessimism can be gauged by comparing the final state of *Death and Life* with Jacek Malczewski's contemporaneous portrait of Jan Lissy, who was appointed by the Austrian government to maintain the flow of food supplies to the inhabitants of Galicia (Pl. 154). As a Polish painter, Malczewski was fully alive to the dangers threatening civilians in this Austrian sector of his partitioned homeland. Although Lissy himself is depicted as a poised politician, presiding with resolutely folded arms over the Galician countryside, his manicured urbanity contrasts with the burning village behind him. A pall of smoke fills much of the sky, and the landscape below is punctuated by the hunched forms of the dispossessed fleeing from their homes. Malczewski focuses on a particular tragedy in the middle

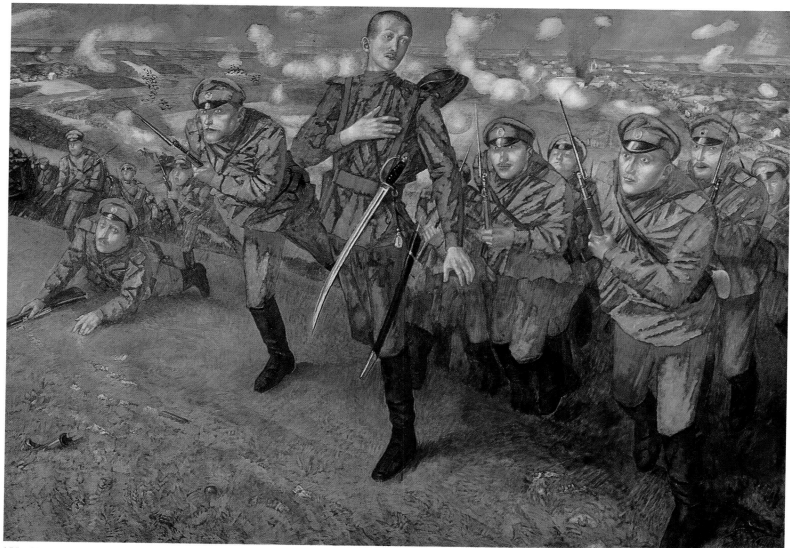

155 Kuzma Petrov-Vodkin *On the Firing Line* 1915–16. Oil on canvas, 196 × 275 cm. State Russian Museum, St Petersburg.

of the field, where an old woman crouches over the inert form of a figure who may be her daughter. Salvation is, however, offered at the head of the homeless procession. Prominent in a red robe, Christ carries the cross for all of them. As Agnieszka Ławniczakowa pointed out, he symbolizes 'the coming redemption of sin through martyrdom and of the consequent resurrection.'[14] But he may also embody Malczewski's passionate hope that the possible break-up of the Austro-Hungarian Empire would lead to independence for Poland – a freedom eventually granted in 1917 by Petrograd's new revolutionary government.

In the dying years of Tsarist Russia, when the nation was beleaguered and demoralized by successive military defeats, the notion of human vulnerability was placed at the centre of a remarkable painting by Kuzma Petrov-Vodkin. Depicting an event from the war was a departure for him, although his celebrated 1912 canvas *Bathing the Red Horse* had been retrospectively linked with the conflict. The symbolism of the determined nude youth cleansing his majestic mount in the water was left deliberately open when Petrov-Vodkin painted it, and he later recalled how, on the outbreak of hostilities,

'our learned art critics proclaimed: "Here is what *Bathing the Red Horse* means."[15] But he scorned such an interpretation, and only in 1915–16 did he overtly engage himself with the war by painting the elaborate *On the Firing Line* (Pl. 155).

Since it was his largest easel picture of the period, he clearly intended this ambitious, carefully worked composition as a major statement on the struggle. Instinctive patriotism led Petrov-Vodkin to concentrate on an image of Russian troops at their most resolute. Determined to protect the nation stretching behind them in the form of a luxuriant yet explosion-filled landscape, the platoon charges up the slope with bayonets at the ready. Most of the men look uncannily similar, with their repeated poses and cold, staring eyes. Military training has turned them, at the moment of attack, into dehumanized embodiments of the urge to kill. The brutishness implicit in their standardized movements and almost maniacal gazes is far removed from conventional ideas about courage in battle. Petrov-Vodkin is under no illusions about the murderous urges which come to the fore when soldiers are ordered to charge at and skewer the enemy with their bayonets. As well as conveying the power of the army, he expresses his repugnance at the programmed bestiality of slaughter.

By the time he completed this disquieting picture, though, Petrov-Vodkin must also have become increasingly conscious of his country's failure to withstand the German onslaught. Hence his decision to include, not just the soldier who falls wounded on the ground beside the principal group, but the dominant figure of a young ensign receiving a fatal wound. The sinister onrush of the troops behind is subverted by this startling personification of martyrdom. Brave enough to be at the very forefront of the offensive, his supposedly triumphant martial impetus is arrested by the bullet lodged in his body. Dropping the sword which once led the charge and suddenly seems so archaic and ineffectual among the hostile gunfire, he turns his face away from the enemy as if to acknowledge that he will never reach them now.

In a preliminary study of the dying officer, Petrov-Vodkin gave his head a downward direction and placed both feet on the ground. In the painting, however, his raised boot and uplifted face both promote a feeling of imminent levitation. He seems to float slightly above the earth, and one Russian writer went so far as to declare in 1917 that 'he is up in the air, unsupported, like a ray of light.'[16] A distinct strain of mysticism affects this strange, heightened, almost dream-like depiction of a mortally wounded man caught in a transitional state between life and death. The statuesque poise he displays, in the second immediately preceding his final collapse, carries a poetic significance. It suggests that Petrov-Vodkin might have regarded him as a symbol of Russia's fate, doomed to be sacrificed by a German army which had no compunction in slaughtering the anachronistic ensign with his useless sword. Two recent Russian historians decided that, 'despite its definite psychological truth', the painting was 'not much of a success. The figures of the soldiers bathed in the orange glow of the setting sun, the green scenery, and the bluish puffs of the explosions blend to produce an unpleasant colour scheme.'[17] But Petrov-Vodkin surely intended a harsh, jarring assault on the viewer's senses. For his complex painting is above all concerned with the ultimate estrangement of death, and the staring eyes of the ensign's companions contain within their fixed ferocity a fearful awareness that they, in their turn, are likely to be mown down by the enemy's firing-power before the charge is over.

No one in Russia could now pretend to be untouched by the conflict. Even the Futurists, who preferred to avoid the subject of war because of its contaminating links with Marinetti's martial enthusiasm, found themselves addressing the strife in publications and pictorial images alike. Aleksey Kruchenykh, the leading poet and proponent of 'transrational' language, issued a publication on *The War* in 1915, where his text is accompanied by two collages and ten linocuts by his wife Olga Rozanova (Pl. 156). Her contribution combines drawings and lithographs inspired by reports of cavalry and infantry battles at the Front with the far more allusive language of abstraction. Like Goncharova, whose *Mystical Images of War* provided a stimulating precedent (see Pls. 42–44), Rozanova allowed the tradition of the Russian popular print to play a part in her approach – especially when she incorporated blocks of boldly incised text in her images. *The War*, however, is far less traditional in its reliance on the *lubok* than Goncharova's sequence. Nor does Rozanova provide any reassurance with the kind of religious references which run through *Mystical Images of War*. Time and again in *The War*'s woodcuts, soldier hurl themselves at each other without any intervention from heavenly agents. One of the most complex illustrations pitches the spectator into the maelstrom of mechanized combat with a disorientating, Futurist-inspired zeal which implies that humanity is overwhelmed by the size and ferocity of twentieth-century armaments.

'They are not only technically stronger than anything I have done before,' Rozanova declared, 'but also have more content and are more original.'[18]

Unlike *The Mystical Images of War*, which had been governed by the desire to opt for stylistic accessibility, Rozanova and Kruchenykh's work became ever more extreme as they searched for a fully emancipated language. The cover of *The War* was uncompromising in its reliance on a few minimally defined abstract forms, and Rozanova claimed that the war had reinforced the need to purge their work of all archaisms and superfluity. 'In everything that was then done, in all our works and searching there was severity,' she wrote, describing how 'for a long time we had been aware of an oncoming crisis and we lived on, either blindly or hungrily, or unwillingly or impatiently. We reset the pages, the days, the months with the same sequence with which the life of the town or the fate of the war went on outside our windows ... The war did its business with us: it tore away the pieces of the past from us, which should have belonged to us, it shortened one thing, it lengthened another ... and, changing the world to a new speed, it gave a malignant background to our lives, against which everything seemed tragic or insignificant.'[19] Her painted paper cut-out forms in *The War* imply, in their universality, that the hostilities have by this time spread everywhere. Rozanova's rough-hewn lino images of aerial attack could just as easily be taking place over a nation's heartland as at the Front. Indeed, the figure who flees from the assault in one of her collages looks more like a defenceless civilian than a soldier.

The following year Kruchenykh confirmed this line of thinking in a still more memorable book entitled *The Universal War*. His text prophesies that 'a universal war will occur in 1985', echoing Khlebnikov's earlier *Battles of 1915–17: A New Teaching about War* where mathematics was employed to predict the cyclical course of history.[20] Kruchenykh's introduction also puts forward claims about the significance of Rozanova's abstractionist innovations, which she appears to have achieved independently of Malevich and Suprematism. The twelve collages she produced for *Universal War*, each 'illustrating' one of the twelve scenes devised by Kruchenykh, are certainly quite distinct from Malevich's non-objective language (Pl. 157). Using cut paper and fabric on blue paper, she deploys her carefully chosen elements with a refinement and rigour worthy of Matisse's late *gouaches découpées*. Since each copy of the publication was hand-made, the sets of collages differ in their formal distribution.[21] Kruchenykh contributed to several of the images and Rozanova 'created words'[22] for his poems, so the project was highly collaborative. But the overall sensibility remains constant throughout the edition of 100, and nowhere does Rozanova admit thoroughgoing violence into her images.

Although several forms appear to be attacking each other, and references to possible explosions occur from time to time, most of the collages seem lyrical rather than aggressive. The titles of the twelve scenes include a *Battle of Mars with Scorpio*, indicating that in some of the collages Rozanova may be dealing with the war in terms of a metaphorical struggle between cosmic forces. Other titles, like *Explosion of a Trunk*, suggest a leaning towards playfulness and the absurd. The majority nevertheless refer to a conflict, most notably in the concluding sections of the book where *Heavy Gun* and *Germany Arrogant* are followed by *Germany Lying in Dust* and *Prayer for Victory*. The final title, *Military State*, holds out no hope for the immediate future, and Kruchenykh clearly found even less comfort in his predictions about the latter years of the twentieth century. All the same, Rozanova's collages ensure that *The Universal War* is by

no means a gloomy book. Her sprightly formal variations, at times reminiscent of Jean Arp, have a balletic poise far removed from pessimism.

So have the war paintings produced in 1916 by the Norwegian artist Per Krohg, a lively Cubo-Futurist whose earlier work had been particularly indebted to Picasso. Between February and April he served as a volunteer in the Norwegian ski-patrol, helping the wounded at the Vosges Front. After returning to Norway, Krohg embarked on a sequence of paintings partially inspired by studies he had made on active service. The picture most clearly associated with Futurist ideas is the untraced *The Cannon Edith Cavell*, where his appreciative depiction of the well-polished weapon recalls Severini's earlier paintings of similarly gleaming gun-barrels (see Pls. 69–71). Krohg, who had studied at the Academie Matisse in Paris and often exhibited in the Salon d'Automne, shared Severini's Francophile sympathies. Despite his involvement with the wounded, he viewed the Vosges battlefield as an arena enlivened by high-spirited activity. In an extraordinary painting called *The Grenade*, shells fly with serenity across the sky and leave exquisitely convoluted patterns in their wake (Pl. 158). The grenade itself bursts like a flower among the swollen hills, while the troops beneath march with the sprightliness of performers in the cabaret dance shows which Krohg himself staged in Copenhagen, Kristiania and Stockholm.

Unrepentant about the excitement he derived from the conflict, Krohg recalled in the autumn that to be 'right in the line of fire . . . was simply magnificent. It is almost expected of us that we should have been horrified at what we saw. But when one has been in it and seen the unyielding humour with which these Alpine-fighters went forth – they fought like small, happy devils, and sustained their suffering like heroes – then it seems neither ugly nor good, it is simply *mighty*. So incomprehensibly mighty that one wouldn't miss seeing it for anything in the world.'[23] Only in *Wounded Horse in the Vosges* does Krohg admit destruction into his war pictures (Pl. 159). The animal's head expresses both fear and pain as the world explodes around him, and a bloodstain occupies a central position in the wild, fragmented composition. All the same, there is a lightness and choreographic elegance about this violent image, indicating that even in the year of carnage Krohg persisted in viewing war with a strange intoxication.

To judge by a feverishly excitable painting called *The Trench*, the Swedish painter Nils Dardel felt likewise (Pl. 160). A former Cubist, he developed an almost Expressionist style to deal with the maelstrom of charging infantry, battlesmoke, explosions and aeroplanes bursting out of the upper half of his painting. War is seen here with childlike enthusiasm as an adventure, and it certainly seems unable to threaten the soldier armed with an outsize bayonet who sprawls with such insouciance in front of the sandbags. By an irony, though, Dardel used as his model for this relaxed, invulnerable figure his fellow-painter Lönnberg, who would eventually be killed during the war's final stages in 1918.

However much paintings like *The Trench* or Krohg's Vosges series may have been noticed and admired in avant-garde circles, they had little effect on popular understanding of the conflict. Most people derived their visual images of the war from newspaper photographs, carefully edited to exclude anything too alarming or defeatist, and illustrations of the action. These elaborate and highly professional

156 Olga Rozanova *War* 1916. Cut and pasted papers on grey paper, 41 × 31 cm. The Museum of Modern Art, New York. Purchase.

157 Olga Rozanova *Universal War* 1916. One of twelve collages on blue paper, each 23 × 33 cm. Private collection.

drawings were intended to shape readers' views of the events they purported to record. Just how ready they were to present a sanitized version of the truth can be gauged from *The Illustrated London News*, which reproduced Albert Forestier's drawing of the Somme's 'big push' on 15 July (Pl. 161). The troops advancing in this panoramic reconstruction encounter only the most token signs of shelling, and hardly any casualties are visible. No one would guess, from this anodyne picture, that the British army suffered 60,000 casualties on the first day of the attack. Nor is there any sign of the barbed-wire entanglements which made the advance across No Man's Land so treacherous. The caption attached to Forestier's drawing claimed that only 'remnants' of the German wire had 'here and there escaped destruction by the preliminary bombardment'. But the reality was that, despite its intensity, the initial shelling had failed to clear the way for the infantry. So Forestier's illustration, like many images of its kind, seems nothing more than a reprehensible attempt to pretend that the Somme was a glorious triumph for the British.

Without seeking to minimize the extent of deliberate deception, we should also recognise that it often arose from a profound and widespread psychological need for reassurance. The nation wanted to believe in the might of the British forces, especially after the news in June of the death of Kitchener, the symbol of patriotic enlistment. The cruiser taking him on a visit to Russia struck a mine off the Orkneys; and the announcement of his drowning seemed to confirm the growing awareness that the war would last far longer, and claim many more lives, than anyone had imagined in 1914. Moreover, the mounting casualties had left bereaved relatives with a desperate wish to be convinced that the soldiers' sacrifice had not been pointless. Hence the proliferation of newspaper reports rhapsodizing over 'that first gay, impetuous and irresistible leap from the trenches',[24] and even finding cause for satisfaction in the spectacle of British corpses. 'The very attitudes of the dead, fallen eagerly forward, have a look of exuberant hope', claimed the *Daily Mail*, adding: 'You would say that they died with the light of victory in their eyes.'[25]

This kind of rhetoric, and the images which accompanied it, were bitterly denounced by the artists and poets who went on to vilify the war after 1916. They felt nothing but contempt for anyone who was prepared, in Stuart Sillars' words, to record 'the reality of war . . . not

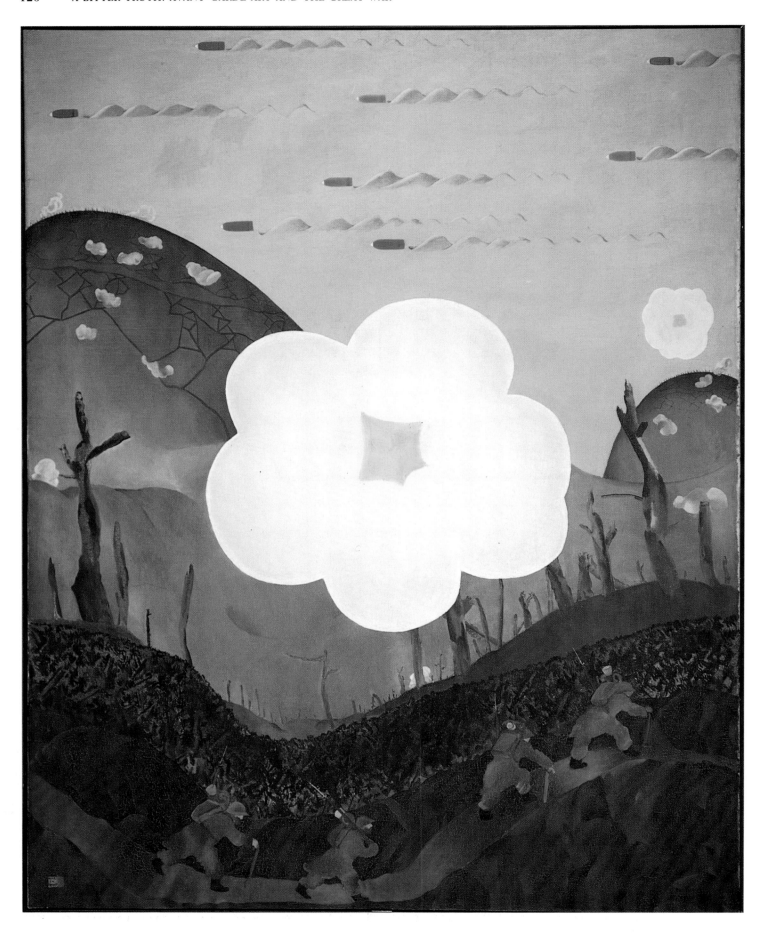

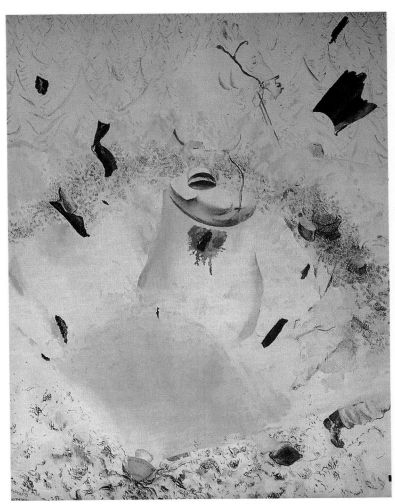

159 Per Krohg *Wounded Horse in the Vosges* 1916. Oil on canvas, 120 × 98 cm. Private collection.

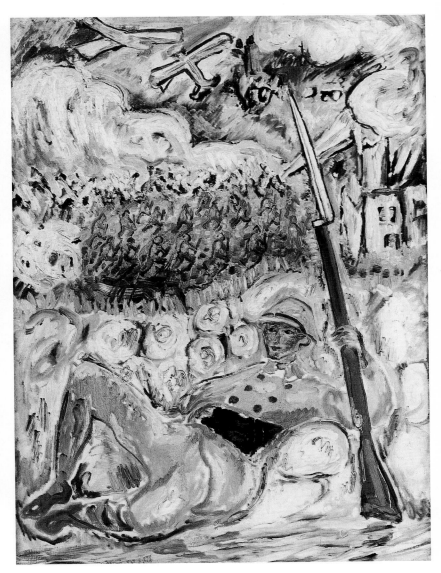

as it is, but as it was planned that it should be.'[26] Nor were they any longer willing to align themselves with the makers of popular prints and cartoons pillorying 'the Huns' as blood-crazed barbarians. Some academic painters, like the almost forgotten Charles Butler, did devote large-scale canvases to anti-German propaganda at its most virulent. His macabre painting *Blood and Iron* indulges in unashamed melodrama to portray a callous Kaiser, staring down without a flicker of sympathy at the bodies heaped below (Pl. 162). The shrouded figure of Death hovers at his shoulder, urging him on with a skeletal arm towards the sack of Louvain. Flames already rise from the Belgian town, filling the sky with an orange glow lurid enough to suit Butler's hectoring purposes. But he also provides solace in the form of Christ, lit by an up-to-date electric halo as he kneels to comfort a dying woman and child.

Other academic painters in Britain, who wanted nothing to do with such a flagrant display of sentimentality and brutality combined, nevertheless produced images intended to bolster Britain's flagging confidence in the morale of its beleaguered troops. Artists unexposed to the battlefield were still eager to stress the army's constant valour, none more pluckily than the resourceful Lucy Kemp-Welch. In 1916, capitalizing on her reputation as a virtuoso horse-painter,

160 Nils Dardel *The Trench* 1916. Oil on canvas, 78 × 58 cm. Private collection.
161 Albert Forestier, Drawing of the Somme's 'big push', reproduced in *The Illustrated London News*, 15 July 1916.

158 Per Krohg *The Grenade* 1916. Oil on canvas, 172.5 × 135 cm. Trøndelag Kunstgalleri, Trondheim.

she obtained permission to visit Bulford Camp on Salisbury Plain. Colonel Cheke, the officer in command of the Royal Field Artillery brigade training the many recruits drafted in to replace the mounting losses in France,[27] allowed Kemp-Welch to make studies there at close quarters for a monumental painting with the gung-ho title *Forward the Guns!* (Pl. 163). The vividness of the picture derives directly from her stout-hearted readiness to sit 'with her easel on Salisbury Plain while eight batteries of horse artillery were driven towards her so that she could sketch the general outline of their movement.'[28] The eruption of shells is rendered forcefully enough, but there is no suggestion that the bombardment will ultimately prevent the gallant brigade from achieving their military objective. Kemp-Welch devotes all her considerable skill to reinforcing a heroic view of war, heavily dependent on nineteenth-century prototypes. Sequestered at Bulford Camp at a reassuring remove from front-line action, she found it easy to imagine that the horse artillery still dominated the campaign. The horrors of machine-age destruction are not permitted to undermine the comforting jingoism of her *tour de force*, which met with acclaim when exhibited the following year at the Royal Academy. It was promptly purchased by the Chantrey Bequest and presented to the Tate Gallery, where visitors must have experienced difficulty in squaring this image of the new recruits' indomitable charge with the probability that most of these young men had already ended up maimed or dead on the fields of France.

Charles Sims, an even more admired Academy exhibitor, was in no mood to be taken in by the bravado of *Forward the Guns!* His *Clio and the Children*, a big canvas commenced the year before hostilities broke out, is among the most poignant of the paintings which reflected on the war uncompromised by the urge to offer the nation

162 Charles Butler *Blood and Iron* 1916. Oil on canvas, 191 × 144.5 cm. Imperial War Museum, London.
163 Lucy Kemp-Welch *Forward the Guns!* 1917. Oil on canvas, 152.4 × 306.1 cm. Tate Gallery, London.

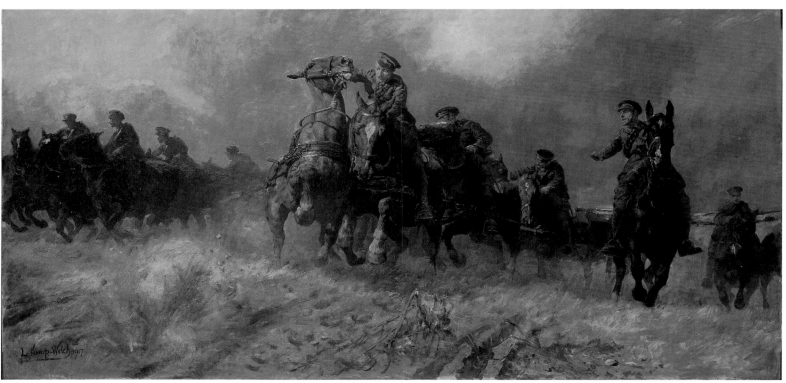

164 Charles Sims *Clio and the Children* 1913–15. Oil on canvas, 114.3 × 182.9 cm. Royal Academy of Arts, London.

any spurious comfort (Pl. 164). He had originally envisaged it as a rural idyll set in the West Sussex countryside.[29] But in 1915 Sims was stricken by the death of his eldest son at the Front, and grief prompted him to re-examine his painting. In the pre-war era, he had been able to depict the muse of history as a serene goddess declaiming her accumulated wisdom from a scroll. The children, probably based on the artist's own sons and daughters, absorbed Clio's words in a sylvan landscape. After his son's death, however, Sims was no longer able to believe in history as a beneficent force capable of inspiring the emergent generation. He radically altered the muse, transforming her into a bowed and sorrowful figure whose face is hidden from the attentive audience. Instead of reading from the scroll, she abandons the attempt and leaves the document to curve down from her lap. In a drastic gesture, which reveals how despairing Sims felt, he painted a bloodstain on the parchment to emphasize that history had now become besmirched by the young man's slaughter. This dramatic metamorphosis did not prevent the Royal Academy from accepting *Clio and the Children* as Sims's Diploma work in May 1916. But it proved too extreme for critics who had admired his once-lyrical art. While praising his depiction of the children and the unsullied English countryside, they recoiled from the melancholy Clio. *The Times* went so far as to pronounce her 'merely irrelevant',[30] and *The Connoisseur* regarded the mourning figure as a 'blemish to an otherwise fine picture'.[31] Both judgements

reveal a great deal about the reviewers' unwillingness to concede that history had indeed been defiled by the campaign in France.[32]

Sims was not the only Academician to produce a work directly affected by family bereavement. In 1916 George Clausen displayed at the Royal Academy Summer Exhibition a painting of *Youth Mourning*, where a naked woman wept on the ground near three white crosses (Pl. 165). The terrain beyond was left largely empty, which intensifies the isolation of her suffering. In the distance, however, Clausen included two clusters of crosses, and their reference to a cemetery evokes the desolation of a military graveyard. The likelihood that *Youth Mourning* sprang from the war was confirmed when Charles Aitken recorded his belief that 'it was inspired by the death in the war of his [Clausen's] daughter's fiancé.'[33] The tragedy transformed his attitude to the conflict, for he had previously painted a grand and optimistic picture in response to the destruction of Belgium. *Renaissance*, executed in the winter of 1914, placed several symbolic figures among devastated buildings and looked forward to the re-awakening of Europe. As Kenneth McConkey surmised, this lost work perhaps 'bore some of the weaknesses of a swift reaction to contemporary events.'[34] At any rate, it must quickly have seemed inappropriate as the war continued to claim so many young lives. If *Youth Mourning* was indeed produced in response to the killing of Clausen's prospective son-in-law, the starting-point for the crouching figure must have been his daughter's distress. But he was careful to

165 George Clausen *Youth Mourning* 1916 (original version). Oil on canvas, 92 × 92 cm.

166 George Clausen *Youth Mourning* 1916. Oil on canvas, 92 × 92 cm. Imperial War Museum, London.

167 James Pryde *The Monument* c. 1916–17. Oil on canvas, 137 × 127 cm. Government Art Collection, London.

avoid any trace of a likeness by hiding the woman's face in her hands. She becomes instead a universal embodiment of the grief caused by war, and her nakedness adds to the feeling that this disconsolate mourner has no defence against her anguish.

Twelve years later, possibly at the request of the painting's owner C.N. Luxmoore, Clausen altered the image to a significant extent (Pl. 166). Dispensing with all the crosses, he added in the foreground a more rudimentary alternative, less regular in form and lacking the pristine whiteness of its predecessors. Its solitary presence echoes and confirms the loneliness of the woman, who lies virtually unchanged on earth where the grass seems sparser than before. The greatest change has occurred in the background, however. For the terrain bearing the weight of the weeping figure is now turned into an eminence, and the deserted plain below has been violated by craters. Water-logged and gloomy, they bear an unmistakeable resemblance to the battlefields of Flanders and France.

So do the mysterious ruins punctuating the distant landscape in James Pryde's enigmatic painting *The Monument* (Pl. 167). Although well into middle age by the time hostilities broke out, Pryde served as a 'formidable'[35] special constable during the war years. His mood darkened, and he became obsessed by nightmares of decay and death. The dissolution of his marriage in 1914 contributed to his perturbation, but several major paintings of the period suggest that the destruction in Belgium and France haunted his mind. *The Red Ruin* merges memories of dilapidated buildings in Pryde's native Edinburgh with more recent images of shelled cities on the continent.[36] It is a desolate scene, and the stains spreading across the wall on the right of the composition are inescapably reminiscent of blood. The most disturbing of these meditations on the shattering of Pryde's pre-war world is, nevertheless, *The Monument*. Nowhere else in his work can the spectre of a broken and bleeding statue be found. The unknown colossus bestrides his plinth like a victorious general,

but no sign of triumph dissipates the grimness on his face. Deprived of a limb and smeared with blood, like so many of the soldiers who fought in the war, he presides over the battered locale as gravely as a martyred saint. On the ground below a cluster of shadowy itinerants seem to pause, as though the discovery of the suffering figure had depressed their spirits still further. No shelter is discernible in this blasted and overcast region, and Pryde might well have identified himself with these disconsolate wanderers as he brooded over the wreckage both of Europe and his own family life.[37]

For many women left at home during the war, 1916 became the year when they waited for news from the Front with even more apprehensiveness than before. Painters associated with the Camden Town Group allowed this mood of tense expectancy to enter their shabby-genteel interiors during the year. Harold Gilman, who had never previously dealt with the war as a subject, now produced a painting of *Tea in the Bed-Sitter* where unease plays a mysterious yet palpable role (Pl. 168). Ostensibly a quiet, ordered representation of a familiar afternoon ritual in the Gilmans' Maple Street flat, the picture has a melancholy mood which marks it out from his earlier interiors. Both the women seem forlorn as they sit beside the crockery, staring not at each other but into their private sadness. Although the source of this despondency is not disclosed, Gilman reinforces their loneliness by depicting two empty places at the table and an equally uninhabited chair. The possibility grows that the two women have just said farewell to their husbands, after a brief spell of leave. They might, alternatively, be oppressed by a sense of fore-boding. Not even the most optimistic news reports could hide the fact that British casualty lists grew at an appalling rate during the year of the Somme offensive. Bereavement struck more and more families as the death-toll mounted, generating an atmosphere of grief so pervasive that it was bound to affect the domestic world explored by Gilman and his friends.[38]

The subdued, shadowy mood evoked in many of these interiors characterizes Sickert's pre-1914 work as well, and caution should be exercised in any speculation about the war's possible effect on his 1916 paintings. But he had already shown a willingness, in paintings like *The Soldiers of King Albert the Ready* (see Pl. 50), openly to involve himself with the conflict. By 1916, when he began to spend long periods in Bath, the war had ceased to play an overt part in his work. One painting, however, stands out from that year by virtue of its powerful, dramatic tension. *Suspense* owes a substantial amount of its psychological force to the mystery surrounding the woman's anxiety. Although her gaze may be directed at a clock on the mantelpiece, Sickert leaves the source of her disquiet unexplained. But he could well have intended to offer an oblique reflection on the anguish experienced by so many young wives, fiancées and girlfriends in that year, wondering whether the post would soon deliver the news they had learned to fear. *Suspense* might even refer to the agony under-gone by a woman who, having already heard that the soldier she loved was reported missing, waits for clarification of the message. Desperate to find out precisely what has happened, yet dreading the finality of his probable death, she hugs her knee by the fireplace and struggles to control the hysteria within.

All the same, Sickert's painting lacks the savage, protesting edge which Nevinson gave his painting of wounded soldiers (Pl. 169). Deciding in 1916 to deal directly with his most terrible memories of Red Cross work in Dunkirk, he settled on the plight of men wounded during a retreat just before the battle of Ypres. 'They had been roughly bandaged and packed into the cattle trucks which were to carry them to hospital', Nevinson recalled. 'Here they lay, men with

168 Harold Gilman *Tea in the Bed-Sitter* 1916. Oil on canvas, 71 × 92 cm. Kirklees Metropolitan Council, Huddersfield Art Gallery.

every form of horrible wound, swelling and festering, watching their comrades die. For three weeks they lay there until only a tortured half of them were alive; and then, a staff officer happening to pass that way, there were protests because the train should have been used for other and more important things, and the men were dumped out of the way in a shed outside Dunkirk.'[39] Although their suffering remained starkly in his mind for many years, Nevinson had avoided commemorating this experience when he started his war pictures in 1915 (see Pls. 76–8). Perhaps he found it too mortifying to be contemplated so soon, when his own body was still struggling to recover from the illness which brought about his discharge from the Royal Army Medical Corps. But with the return of his strength came a determination to exorcise the sight of the soldiers in the shed. He gave the painting the bitterly ironic title *La Patrie*, and concentrated on the sight that confronted him in the dark, fetid room where the stretchers had been laid. 'There we found them,' he wrote. 'They lay on dirty straw, foul with old bandages and filth, those gaunt, bearded men, some white and still with only a faint movement of their chests to distinguish them from the dead by their side. Those who had the strength to moan wailed incessantly. "Ma mère – ma mère!" "Oh – là, là!" "Que je souffre, ma mère!" The sound of those broken men crying for their mothers is something I shall always have in my ears.'[40]

Directly reflecting the horror of that evening, *La Patrie* turned out to be the most frankly compassionate of Nevinson's war paintings. Any lingering affiliation with his old Futurist precepts has vanished, to be replaced by a gaunt emphasis on the agony of helpless men. Nothing is permitted to distract attention from the harshness of their ordeal in the penumbral building. It looks more like a charnel-house than a Red Cross shelter, and the aura of death afflicts all the stricken faces. The painting became one of the most important exhibits in Nevinson's first one-man show, held at the Leicester Galleries in September 1916. By working enormously hard through-out the preceding months, he was able to display fifty-three paintings, drawings and etchings there.[41] The titles of the exhibits ranged through the entire spectrum of modern warfare – *A Strafing*, *In the Observation Ward*, *Motor Lorries*, *Pursuing a Taube*, *Searchlights* – and

169 Christopher Nevinson *La Patrie* 1916. Oil on canvas, 60.8 × 92.5 cm. City Museum and Art Gallery, Birmingham.

Londoners reacted with the curiosity of people anxious to discover the reality behind the official propaganda. As over two years had elapsed since the war broke out, many visitors were now far more ready to accept the harshness of Nevinson's vision. Others remained adamant in their hostility, of course. 'Indignation amongst the older men was . . . intense, and the clerical opposition was voluble,' remembered Nevinson, declaring that he was 'proud to think that three canons actually preached against me and my pictures.'[42] The exhibition became a focus for animated debate about art and war alike. 'Officers of high rank came,' he recalled, 'and terrified me so much that I nearly stood at attention. Ramsay MacDonald, Philip Snowden, Balfour, Mrs Asquith, Winston Churchill, Lady Diana Manners, and Garvin were to be seen arguing before my pictures.'[43] After a sluggish start, the collectors responded with enthusiasm. Sir Michael Sadler, a leading collector of contemporary art, bought four works, Arnold Bennett purchased *La Patrie*, and eventually the entire exhibition sold out.

Nevinson's success was bolstered by the readiness of General Sir Iain Hamilton, whose view of the conflict must have darkened after he presided over the ill-fated Dardanelles expedition the previous year, to write the catalogue preface. 'The appeal made to the soldier by these works lies in their quality of truth,' Hamilton wrote. 'They bring him closer to the heart of his experiences than his own eyes could have carried him. In France, that flesh and blood column marching into the grey dawn seemed simply – a column of march. Seen on this canvas it becomes a symbol of a world tragedy – a glimpse given to us of Destiny crossing the bloodiest page in History'. Although Hamilton went on to argue that 'the Cup of War is filled not only with blood and tears, but also with the elixir of Life', his responsiveness to the grimmest aspect of Nevinson's work was symptomatic of changing perceptions in 1916. The exhibition prompted a lengthy article in *The Times Literary Supplement*, where the writer claimed that the paintings reflected Nevinson's 'sense that in war man behaves like a machine or part of a machine, that war is a process in which man is not treated as a human being but as an item in a great instrument of destruction, in which he ceases to be a person and becomes lost in a process.'[44]

If Nevinson had failed to couch this vision in an accessible style, he would never have aroused such extraordinary interest in the Press and become, as the Leicester Galleries' advertisements proudly maintained, 'the talk of London'. The visitors who walked round his show were, for the most part, undismayed by the style he employed. His pictures seemed comprehensible, and the art critic of *The Nation* spoke for all Nevinson's new admirers when he concluded that 'for

the first time in recent years, the pioneer seems to be seeking a manner which will not be merely the amusement of a coterie, but might, by its directness, its force and its simplicity, appeal to the unsophisticated perception. I can imagine that even Tolstoy might have welcomed this rude, strong style, a reaction against the art of leisure and riches.'[45] There was a protesting rigour about Nevinson's work which impressed civilians sickened by the futility of the conflict, and they were ready to accept strange stylistic devices for the sake of the pictures' powerful meaning. This crusading urgency attracted the loyalty of widely differing visitors, all of whom had come to realise that the prolonged bloodshed was nearer to tragedy than glory.

Nevinson must have seen this praise as a vindication of his increasingly populist approach. To him, the illustrative element in a picture like *Troops Resting*, one of the finest exhibits at the Leicester Galleries show, was a positive merit rather than a debasement of hard-won avant-garde precepts (Pl. 170). The insistent angularity with which he constructed this cluster of exhausted men was dedicated to accentuating the soldiers' plight. Without stressing the resignation of the troops' faces, their huddled ungainliness and fatigue, Nevinson would have been unable to ram home the degradation and misery of life at the Front. His painting could, indeed, serve as an apt illustration of Wilfred Owen's poem 'Exposure', where

> We only know war lasts, rain soaks, and clouds sag stormy.
> Dawn massing in the east her melancholy army
> Attacks once more in ranks on shivering ranks of gray,
> But nothing happens.[46]

Any vestiges of Futurism in the painting were now useful only as a form of pictorial shorthand which could be applied to a fundamentally representational image, envenoming the sense of demoralization he wanted to convey. *Troops Resting* contains brutally fragmented passages that would not look out of place in a Vorticist painting: the geometricized complex of canisters, helmets, weapons and shoulder-packs amassed in the centre has a formal austerity reminiscent of his earlier interest in more abstractionist ideas. But Nevinson's loss of faith in Marinettian priorities, which had celebrated the very

170 Christopher Nevinson *Troops Resting* 1916. Oil on canvas, 71 × 91.5 cm. Imperial War Museum, London.

machine-power responsible for the destruction at the Front, persuaded him now to espouse a more plain-spoken idiom. Stylistic consistency was, in his view, a luxury only affordable by aesthetes detached from the war. He no longer felt afraid to treat each subject according to its particular requirements, and in the catalogue of the 1916 Allied Artists' exhibition he made his new priorities plain by listing one painting as 'An Abstraction' while describing *La Mitrailleuse* as 'An Illustration' (see Pl. 77).

Whether or not Jacob Epstein thought of his own work in this way, a marked stylistic gap now separated his naturalistic portrait bronzes from the carvings which had allied him with a more innovative cause. His growing reputation as a portraitist brought a commission, from the Duchess of Hamilton, for a bust of the formidable Admiral Lord Fisher (Pl. 171). In June 1916 he was introduced to Fisher at the Duchess's West End flat, and at the Admiral's insistence sittings began at once. The week of sustained labour on the bust coincided with momentous events in the war. Kitchener's death occurred without warning, and Fisher was especially engrossed in the progress of the Battle of Jutland. The engagement, which initially promised to bring the entire British fleet into victorious conflict with its German counterpart, had ended inconclusively when Admiral Jellicoe failed to pursue his undoubted advantage over Admiral von Scheer. The news was welcome to Fisher, who had been forced out of office the previous year over the ill-fated Dardanelles campaign. Epstein noticed that his sitter 'seemed pleased at the unsatisfactory conduct of Naval affairs. One morning he came into the room where I worked, filled with sardonic satisfaction. The Battle of Jutland had just been fought. Fisher read out to me "a message from Lord Nelson" on the event which he said he had received. It did not spare the Jacks-in-Office who, he alleged, had allowed the German fleet to skedaddle back to harbour.'[47]

As the sittings proceeded, Epstein found himself torn between admiring Fisher's 'combative sturdiness' and recoiling from his approbation of aggression. 'He was the typical man of war,' Epstein remembered. 'He made no bones about it. War was terrible, and should be terrible, and some of his characteristic sayings bear out his ruthless outlook. Of an enemy he would say that "he would make his wife a widow, and his home a dunghill."'[48] Rather than softening Fisher's belligerence in the interests of a flattering portrait, the bust intensified it. Epstein transformed the medals and decorations festooning his sitter's uniform into the equivalent of an embossed breastplate, from which the old Admiral's face juts forward with implacable pugnacity.[49] The hair falling across his forehead is sliced as if by a sword, and the warlord confronts the world with an uncompromising sneer. The deeply folded lids ought to have diminished this latent violence, but in Fisher's case nothing could detract from the coldness of his gaze. 'There was a look in his eyes that was dangerous,'[50] Epstein recalled, and the bust does not shirk from conveying the full force of this seigneurial menace.

Since conscription had been introduced to Britain at the beginning of 1916, Epstein's dread of war was now heightened by the knowledge that, as a naturalized citizen, he could be called up at any moment. Hoping to exempt himself by qualifying as a war artist, he modelled a bronze head of a soldier called *The Tin Hat* (Pl. 172). For all the startling realism of the man's headgear, cast from a real trench helmet, Epstein handled his features with a sensitivity which precludes any display of bellicosity. By placing the helmet at a diagonal, a sense of fatigue is introduced; and the soldier's expression confirms this exhaustion. Dazed rather than purposeful, he embodies

171 Jacob Epstein *Admiral Lord Fisher* 1916. Bronze, 62 cm high. Imperial War Museum, London.

London Group exhibition in the summer of 1916, and this chastened fragment showed how far Epstein's views had changed since he made his first drawings for the sculpture three years before (Pl. 174).

The superhuman figure who rested triumphantly on his mighty instrument in those studies is now a forlorn, ineffective victim. Shorn of the mechanistic power he once wielded, and further enfeebled by the loss of a limb, the driller is reduced to brandishing the stump of his left arm in the air. Now that the controls of the machine have gone, his gesture serves only to emphasize impotence. He cannot protect himself against assault, let alone guard the embryonic form nestling within his metallic rib-cage. The driller's body, which previously seemed almost as schematic and impregnable as the machine itself, has been transformed into an abject shell. Where his spine should run, a deep fissure is gouged out of his back to confirm the figure's uselessness. He is almost as pathetic as the grotesquely maimed soldiers who returned in such numbers from the battlefield as the year proceeded. 'By the end of 1916 there were few families untouched by personal grief,' wrote Arthur Marwick. 'Each day at Charing Cross station a double line, mostly of women, waited patiently for disembarking troop trains; each day the newspapers carried a list of about 4,000 casualties.'[53]

Even though Epstein could not be counted among those bereaved relatives, he was inevitably affected by the return of all the blighted young men. *Torso in Metal from the 'Rock Drill'* could easily be one of these invalids, his visored head reduced to squinting fearfully out at a world where further atrocities are committed all the time. Neither he nor the unborn child growing inside him is immune from the destruction, which threatens to inflict as much damage on the embryo as the man has already sustained. The revised *Rock Drill* marked a

172 Jacob Epstein *The Tin Hat* 1916. Bronze, 35.5 cm high. Imperial War Museum, London.

the mood of 1916. Epstein's eagerness to gain official patronage did not mean that he was prepared to portray this anonymous Tommy as an archetype of heroism. As might be expected, one critic complained that 'the hat was merely an exterior object clapped on; it was not modelled *with the head*'.[51] But Epstein surely intended the disjunction between helmet and man. It signified the soldier's alienation from the violent, machine-like symbolism of the metal headgear he is obliged to wear.

Epstein had already amalgamated imagined and ready-made forms on a spectacular scale in the first version of *Rock Drill*, where the driller's white plaster figure straddled a black, phallic drill purchased second-hand for the purpose (Pl. 173). This commanding sculpture was exhibited in March 1915, and marked the high point of Epstein's involvement with Vorticist ideas about the potency of machine-age dynamism.[52] By 1916, however, his attitude towards this pre-war vision had undergone a metamorphosis. No longer capable of believing in the machine as a constructive agent, now that mechanized weaponry was proving so lethal on the western Front, he dismantled the sculpture and threw away both the drill and its tripod. Deprived of his virile mount, the plaster figure immediately took on a vulnerability he had never possessed before. But Epstein was not prepared to leave him intact. After lopping off both the driller's legs, as well as the whole of his right forearm, he cast the dismembered figure in gunmetal. The *Torso in Metal from the 'Rock Drill'* went on view at the

great turning-point in Epstein's work, for he would never again employ the analogical forms which turned his original driller into an exemplar of machine-age prowess. Looking back on the first version of the sculpture from the vantage-point of 1940, when another war had engulfed the world, he made his feeling of revulsion even more clear. 'Here is the armed, sinister figure of today and tomorrow,' he declared. 'No humanity, only the terrible Frankenstein's monster we have made ourselves into.'[54]

A related feeling of repugnance lay behind an audacious painting by another Jewish artist, Mark Gertler. He had earned a precocious reputation with images based on East End life, and nothing in his pre-1916 work prophesies the emotional vehemence which produced *Merry-Go-Round* (Pl. 175). As he worked on this unprecedentedly large canvas in the early months of 1916, Gertler was aware of its special significance. While describing it as a *'very unsaleable* picture',[55] at a time when he desperately needed to earn money from his work, Gertler was sustained by the knowledge that 'my heart is in my "Merry-Go-Round"'.[56] But this mood of assurance took its toll on the nervous state of an artist who often fell prey to extremes of elation and depression. 'I feel this last year or so much surer with my work. I have never felt quite like it before,' he confessed to William

173 Jacob Epstein *Rock Drill* (original and incomplete state), 1913–15, in the artist's studio.

174 Jacob Epstein *Torso in Metal from the 'Rock Drill'* 1913–16. Bronze, 70.5 × 58.4 × 44.5 cm. Tate Gallery, London.

Rothenstein in April, before conceding that 'I live in a constant state of over-excitement, so much do my work and conception thrill me. It is almost too much for me and I am always feeling rather ill. Sometimes after a day's work I can hardly walk! One seems to work at the expense of one's body and there is no other way, apparently, of doing it.'[57]

The severe psychic and physical strain Gertler suffered while working on *Merry-Go-Round* is matched by the ferocious impact of the painting itself. Like an earlier picture called *Swing Boats*, its origins lay in his fascination with the fair on the Heath near his new Hampstead home. At first, relishing his own move away from the

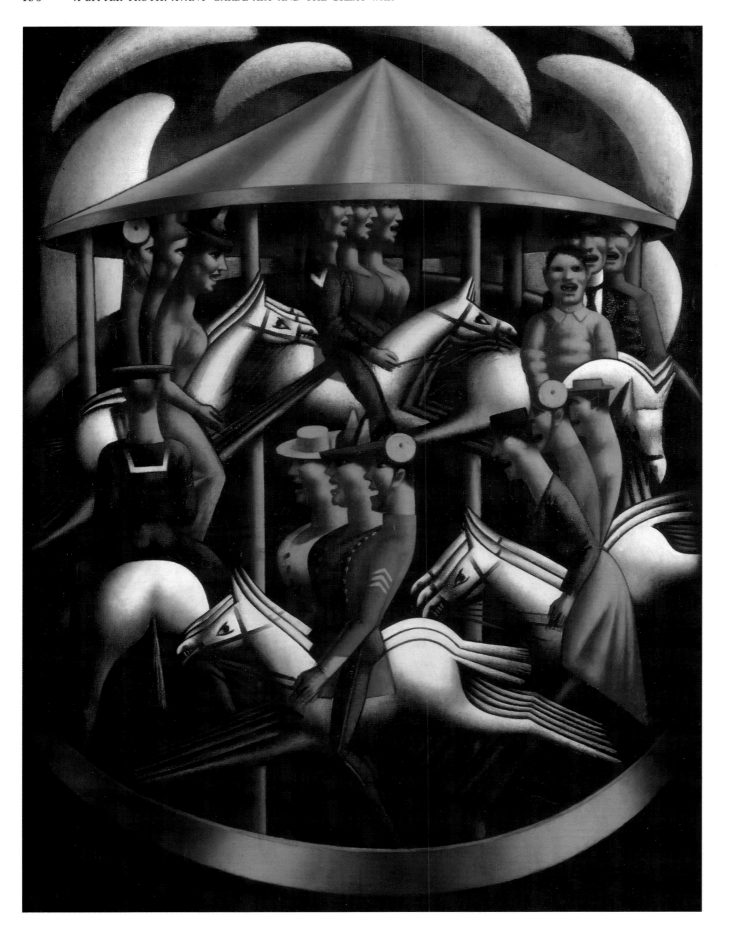

claustrophobia of East End life, he had regarded the fair as a symbol of happiness and liberation. By the time he set to work on *Merry-Go-Round*, however, all this innocent pleasure had vanished. 'Lately the whole horror of the war has come freshly upon me,'[58] Gertler admitted to Dora Carrington, whose failure to respond to the intensity of his ardour aggravated his despair and prompted him to declare: 'You are not able to return me an equal love and for that I hate life.'[59] In his macabre canvas he gave vent to a civilian's view of a world enmeshed in the insanity of a conflict with no foreseeable resolution. As a conscientious objector, Gertler had made his abhorrence of war clear from the outset. But the deepening barbarity intensified his revulsion, and he turned the harmless Hampstead carousel into a metaphor for the military machine transforming everyone caught up in its diabolic motion.

Although the soldiers on the roundabout are presumably savouring their leave from active service, Gertler insists that there can be no escape. Seated so stiffly on the wooden horses, both they and their companions remain robbed of their individual humanity. All the riders have become infected by the standardized rigidity of the mounts they straddle. As if obeying an irresistible command, they open their mouths in unison. But no cries of playful delight seem to be issuing from their lips. The yells they make are more sinister, and the uniformity of their response implies that they have been programmed to behave in an identical way. Men and women both derive a maniacal satisfaction from the gyrations of this seemingly unstoppable whirligig. If they are trapped in its infernal dynamo, they show no sign of deploring their predicament. Instead, they urge their mounts on with a collective frenzy which also affects the clouds curving like white missile-tracks through the sky.

The regimented harshness of *Merry-Go-Round* is reinforced, finally, by the structure enclosing riders and steeds alike. Just as the horses have been stripped of all the decorative features which might alleviate the sharply pointed aggression of their ears, tails and legs, so the carousel itself displays no embellishments. The flamboyant ornamentation normally found on such mechanisms, disguising and softening their geometrical rigour, gives way here to blatant exposure. The roundabout is revealed in all its starkness as a strident metal cage. The roof's surface gleams in a ferocious blend of yellow, orange and red, as if reflecting the glare of a conflagration nearby. The same blaze seems to irradiate the riders, but they glory in its glow. So far as these robot-like figures are concerned, nothing matters apart from the pursuit of endlessly repetitive movement. They dedicate themselves to the task with relish, encouraging their jerky steeds to encroach on the space inhabited by other horses. The front legs thrust out by one set of animals threaten to interlock with the hind legs of the horses in front. The most surprising act of bellicosity is carried out by the mounts occupying the upper left section of the roundabout. Their front legs are aimed like a cluster of cavalrymen's lances at the body of the rider ahead, and throughout the composition other horses convey belligerence by baring their teeth in sadistic leers.

Gertler's rasping moral allegory expresses the despair of an artist who now saw the entire population caught up in the inexorable momentum of a process over which no one had any control. His painting's garish vitality revealed the horrible attraction exerted by the war, for the riders are captivated by the carousel as well as imprisoned within its coils. The first viewers of the completed picture were

175 Mark Gertler *Merry-Go-Round* 1916. Oil on canvas, 189.2 × 142.2 cm. Tate Gallery, London.

similarly fascinated, but they felt unnerved by its virulent impact. 'Oh Lord, Oh Lord, have mercy upon us!' cried Lytton Strachey to Lady Ottoline Morrell after viewing the canvas. 'It is a devastating affair, isn't it? I felt that if I were to look at it for any length of time, I should be carried away suffering from shell shock. I admired it of course, but as for liking it, one might as well think of liking a machine-gun.'[60] Even in reproduction *Merry-Go-Round* was enough to provoke a startled response. D.H. Lawrence asked Gertler to send him 'a photograph copy' of the painting, and insisted that 'the stark truth is all that matters' at a time when newspapers were filled with reports of 'the Zeppelin wrecks, etc. How exhausted one is by all this fury of strident lies and foul death.'[61] When Gertler duly sent him the photograph, Lawrence was profoundly troubled by the image. 'Your terrible and dreadful picture has just come,' he wrote. 'This is the first picture you have ever painted: it is the best *modern* picture I have seen: I think it is great, and true. But it is horrible and terrifying. I'm not sure that I wouldn't be too frightened to come and look at the original.' Although Lawrence refrained from disclosing 'what I, as a man of words and ideas, read in the picture', he insisted that 'in this combination of blaze, and violent mechanized rotation . . . and ghastly, utterly mindless human intensity of sensational extremity, you have made a real and ultimate revelation.'[62]

Gertler's masterpiece confirmed Lawrence's own feelings, for he voiced equally vehement views about the war's catastrophic effect around that time. 'In the winter of 1915–16', he wrote, 'the spirit of the old London collapsed; the city, in some way, perished, perished from being a heart of the world, and became a vortex of broken passions, lusts, hopes, fears, and horrors. The integrity of London collapsed, and the genuine debasement began.'[63] Since *Merry-Go-Round* coincided with such a verdict, Lawrence's approbation of the picture was understandable. He even incorporated it in *Women in Love*, the novel he was revising when Gertler's photograph arrived. Towards the end of the book Loerke the sculptor tells Gudrun about 'the great granite frieze' he is carving for the exterior of a Cologne factory, and Lawrence describes it as 'a representation of a fair, with peasants and artisans in an orgy of enjoyment, drunk and absurd in their modern dress, whirling ridiculously in roundabouts, gaping at shows, kissing and staggering and rolling in knots, swinging in swing-boats, and firing down shooting-galleries, a frenzy of chaotic motion.'[64] Lawrence told Gertler that 'your whirligig' was part of the frieze, although he assured the painter that there was no resemblance between him and Loerke.[65] When Lawrence completed the revision of *Women in Love*, however, he reacted to it in the same way that he had responded to *Merry-Go-Round*, declaring that 'the book frightens me: it is so end-of-the-world.'[66]

He even feared for Gertler's survival, warning him to 'take care, or you will burn your flame so fast, it will suddenly go out . . . one cannot assist at this auto-da-fé without suffering.' Lawrence also thought that the painting should be 'bought *by the nation*',[67] presumably to ensure that Gertler's alternative to the propagandist view of war would enjoy the widest possible public exposure. Other friends counselled caution, however. The distinguished barrister St John Hutchison asked him 'whether you think you are quite wise in exhibiting the "Merry-Go-Round" at the London Group? It will of course raise a tremendous outcry; the old, the wise, the professional critic will go mad with anger and righteous indignation and what strikes me is that these symptoms may drive them to write all sorts of rubbish about German art or German artists in their papers and may raise the question acutely and publicly as to your position under conscription.'[68] The fears expressed by Hutchison were far from

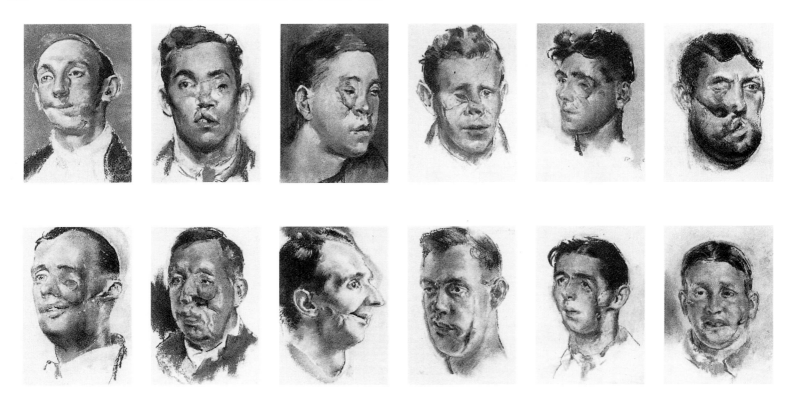

176 Henry Tonks *Studies of Facial Wounds* 1916. Pastel on paper, each 61 × 45.7 cm. Royal College of Surgeons, London (on permanent loan to the RADC Museum).

groundless. Gertler had already suffered such an attack, when he displayed his painting of *Eve* in a 1915 exhibition only to find a label stuck on her stomach by an incensed visitor with the words 'Made in Germany' scrawled across it.[69] Moreover, the owner of the gallery which held the London Group shows now announced that 'no enemy aliens, conscientious objectors or sympathisers with the enemy were permitted to exhibit in his galleries.'[70] Undismayed by this stricture, which prompted the London Group to change its exhibition premises, Gertler went ahead and displayed *Merry-Go-Round* in the group's next show at the Mansard Gallery in May 1917. He also embarked on a sculptural version, informing Carrington that 'I am now working on my carving of the "Merry-Go-Round" – if it goes well it will be a beautiful thing, but it is a greater job than I thought and will take a long time.'[71]

Henry Tonks, who had presided sternly over Gertler's student years at the Slade, harboured severe doubts about exhibiting the images he produced in 1916. A former surgeon, Tonks was quick to volunteer as a hospital orderly when war broke out. After working for the Red Cross in France, and witnessing scenes as harrowing as Nevinson had encountered at the same period, the 60-year-old painter then joined the Royal Army Medical Corps at Aldershot. In April 1916 he became preoccupied with the idea of depicting soldiers whose damaged faces qualified them for plastic surgery. He began spending his time at the Cambridge Military Hospital in Aldershot, using pastel to record the injuries which gashed and twisted their victims' features (Pl. 176). The distortions were gruesome enough to deter most artists from scrutinizing them. But Tonks, bolstered by his early medical training, suffered no squeamishness. He portrayed

even the most repellent wounds with unflinching objectivity, and the calm accuracy of his studies does not understate the gravity of these disfigurements. 'It is a chamber of horrors', he admitted to his friend D.S. MacColl, 'but I am quite content to draw them, as it is excellent practice.'[72]

He even attended the operations carried out in the theatre by the surgeon Sir Harold Gillies, who pioneered the Maxillo-facial method of covering damaged areas with skin flaps taken from intact parts of the patient's body. Gillies paid tribute to Tonks's contribution in his book of case histories *Plastic Surgery of the Face*, declaring that 'the foundation of the graphic method of recording these cases lies to the credit of Professor H. Tonks (Slade Professor), many of whose diagrams and remarkable pastel drawings adorn these pages.'[73] But the book was only published after the war, when the revelations it contained could no longer be considered detrimental to the British cause. Before then, Tonks himself felt uneasy about showing any of his sixty-nine pastel heads to people visiting Gillies' unit. He believed that the curiosity aroused by his work was morbid, even though the pastels now seem admirable in their frank yet tender depiction of the soldiers' battered faces. After continuing to collaborate with Gillies at Sidcup in a civilian capacity, he offered the Department of Information his available work and simultaneously voiced deep misgivings about making it available to the public.[74] His reservations must have been shared by the DoI, for Tonks's remarkable pastels remain in the possession of the Royal College of Surgeons and were never displayed in official exhibitions of war art.

What, therefore, *would* be regarded as acceptable war images by the government? In the summer of 1916 the propaganda department

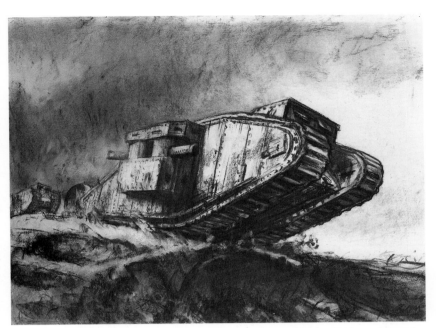

177 Muirhead Bone *Tanks* 1916. Charcoal on paper, 54.6 × 74.9 cm. Imperial War Museum, London.

run by C.F. Masterman at Wellington House finally acknowledged the need to commission an artist's view of the conflict. Propagandist techniques had developed with unprecedented alacrity during the war, as every nation realised that hitherto untapped potential lurked in the manipulation of public opinion. Masterman's team concentrated its early efforts on the printed word, but then they probably became aware of other countries' initiatives in sending artists off to the Front. Germany was the first to exploit the possibilities of official war art, setting commissioned artists to work soon after hostilities commenced. After a few months German and Austrian paintings of the war, at home as well as on the battlefield, began to penetrate American publications. Galleries in Vienna, Weimar and Berlin displayed similar pictures soon afterwards, and France lost little time in despatching artists to the Front under the auspices of the Mission des Beaux-Arts. Not to be outdone, Australia ensured that its involvement with the 1915 Gallipoli campaign was covered on the spot by officially sponsored artists, whose work was quickly displayed at the Fine Arts Society Gallery in London and published later the same year in *The Anzac Book*.

All this activity, coupled with Nevinson's success in commanding attention with his early, uncommissioned war paintings, persuaded Masterman that Britain should delay no longer. Official photographs of the battle zone, required for propaganda publications, too often turned out to be drab, monotonous and uninspiring. In search of more arresting alternatives, he responded positively to the suggestion that the Scottish etcher Muirhead Bone should become the first official British war artist. In August 1916 Bone duly toured the Front line of the Somme offensive in a chauffeur-driven car, working swiftly enough to complete around 150 elaborate drawings by the autumn. They included the widely admired charcoal study of tanks on the move, the very first drawing of these menacing yet limited inventions after they were introduced to the battlefield in the autumn of 1916 (Pl. 177). Deft, conscientious and utterly professional, Bone's images were quickly used as illustrations in patriotic publications like *The Western Front*. But they remain oddly remote in

feeling, as if the artist regarded the conflict as a distant event from which all trace of human agony had long since been expunged. Lacking any first-hand experience of active service, Bone's drawings were dismissed by the soldiers who saw them. 'Those "Somme Pictures" are the laughing stock of the army,' wrote Wilfred Owen, '– like the trenches on exhibition in Kensington.'[75]

Both Bone and the portrait specialist Francis Dodd, the other British war artist appointed in 1916, lacked the moral involvement which animates the protesting work produced by unofficial artists like Gertler or Epstein. Sufficiently anodyne to be acceptable in all government circles, Dodd reduced the obscenity of the Somme to a picturesque panorama peopled by blandly handsome officers. No wonder Field-Marshal Haig sent a telegram to congratulate Dodd on his portrait: the British Commander-in-Chief, complete with gloves and walking-stick, looks as spruce and lordly as an aristocratic land-owner surveying his estates with the aid of his binoculars. Looking back on his skilful yet disappointingly topographical war pictures, Bone later admitted that his commission had 'resulted in rather prosaic work'.[76] He may have satisfied his patrons, but his view of the Somme contained not a hint of the reality encountered there by soldiers like Edmund Blunden, who subsequently reflected on the offensive with an indignant anger barely modified by the passage of years. 'I knew a colonel whose hair had turned white in this experience,' Blunden wrote in 1929. 'I knew Thiepval, in which battalions disappeared that day. I knew Thiepval Wood, before which, in the mud of November, were withering the bodies of the British and German combatants of 1 July. The outbreak of the Somme battle may be described as a tremendous question-mark. By the end of the day both sides had seen, in a sad scrawl of broken earth and murdered men, the answer to that question. No road. No thoroughfare. Neither race had won, nor could win, the war. The war had won, and would go on winning.'[77]

If official artists like Bone and Dodd were incapable of making such judgements, Jules de Bruycker had no hesitation in producing a headlong indictment of the forces he saw at work in Europe. Having moved to London from his native Belgium, a country which had already suffered severely from the war's depradations, he conveyed his despair in a series of large, outspoken prints. In the ironically entitled *Kultur!* an immense siege gun on wheels dominates the design, while a skeleton peers into its smoking mouth. The rabble beneath playing fifes and drums, controlled by a horned conductor in silhouette, are equally symbolic of true culture's extermination. Nothing escapes the condemnation of de Bruycker's despairing vision. The finest of these prints, *The Death Knell in Flanders*, introduces the vastness of a Gothic cathedral only to insist that religious faith provides no refuge in these fearful times (Pl. 178). For the building has been taken over by Death, who straddles the roof with bony legs jutting out from a pair of military boots. Clutching the bell he has ripped from the belfry, this maniacal heretic rings out the instrument over the snow-choked countryside where ravens rest Poe-like on the branches of withered trees. A procession of mourners trudges through the fields bearing coffins, but no solace can be expected when they reach their destination. For the devil hastens towards the cathedral from the foreground of the picture, accompanied by an equally evil altar-boy swinging his incense-burner. The forces of darkness have invaded God's house, blasphemously transformed into the site of a gallows where the keepers of the faith will be hanged.

Even if de Bruycker's principal target was the country responsible for Belgium's invasion, his revulsion had come to be shared by many

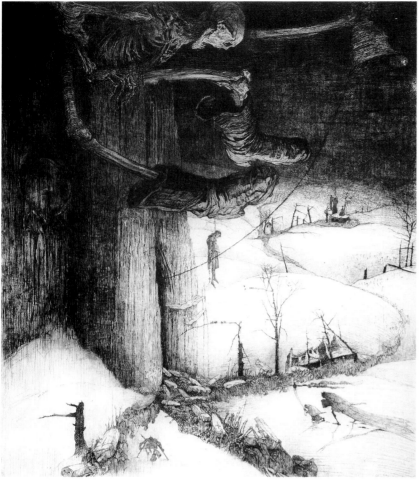

178 Jules de Bruycker *The Death Knell in Flanders* 1916. Etching on paper, 80 × 68 cm. British Museum, London.

within Germany itself. The symbolism of a cathedral was employed again in a major painting by Hubertus Maria Davringhausen, who allied himself with the group of dissenting Berlin artists and writers contributing to *Die Neue Jugend* after Wieland Herzfelde took over its editorship. As we have already seen, Grosz published anti-war drawings in this radical periodical (see Pl. 129), and Herzfelde's first edition of the magazine included a poem by J.R. Becher frankly entitled 'To Peace'. Having been nurtured on Nietzsche, the *Neue Jugend* circle was now inclined towards pacifism. Even Davringhausen, whose eye trouble had excused him from active service, felt as disgusted by the conflict as many of his contemporaries who underwent harrowing experiences at the Front. He summarized his attitude in a large and complex canvas called *The Madman*, where a deranged figure in a brilliant white suit gesticulates with alarm as he stands, disorientated, in a Gothic nave (Pl. 179). The formality of his clothes contrasts with the unfocused motion of his arms and head. His emaciated hands reach out for reassurance, but find nothing to grasp. Incapable of coordination, he swivels his face in the opposite direction like a puppet no longer under the control of its master. These incoherent gestures make the white garments look more like a costume, worn by a man who inhabits a world outside normal social limits.

Although Davringhausen himself had a reputation as a dandy and

even a *flâneur*, *The Madman* is clearly intended to be the embodiment of a state of mind rather than a self-portrait. He takes his place alongside the other representative characters who peopled Davringhausen's art at this period: *The Dreamer*, *The Sex Murderer* and *The General*. The stylish yet dislocated young man in the cathedral conveys the bewilderment of Germans who could make no sense of the destruction around them. Perhaps Davringhausen had been accused of insanity by fellow-countrymen who remained pugnaciously in favour of the war. At all events, he makes plain his disapproval of the conflict by showing how the nave's silence is now brutally disrupted by scenes of belligerence. On one side of the 'insane' figure, a French soldier is locked with his German enemy in a struggle which reduces them both to snarling animals. On the other side, regimented ranks bearing a black, white and red flag march before a mass of top-hatted war profiteers whose red flag is adorned with a victorious laurel branch. By making all these exemplars of militant zeal invade such hallowed territory, Davringhausen reveals the full extent of his condemnation. In such a context, the 'madman' appears more truly sane than his mindless, bloodthirsty compatriots. After all, artists like Beckmann, Grosz and Kirchner had suffered nervous breakdowns after confronting the horror of war, and Davringhausen may well have concluded that their mental disorder was healthier than a continuing acceptance of Germany's role in the conflict. Kirchner, whose illustration for Georg Heym's 1912 poem 'The Madman' may have influenced Davringhausen's choice of theme for this painting, was by this time receiving treatment for a psychosomatic partial paralysis in a Königswald sanatorium. But he continued to work, and his *Memorial Woodcut to Hugo Biallowons* is a powerful tribute to a close friend who had been killed at the Front in July 1916.

Davringhausen would have respected such an image far more than the work of artists who, against all available evidence, persisted in presenting the war as a valorous enterprise. His *Madman* is capped by a halo, and a red cross floats above his right hand as if to sanctify the attitude of a man justifiably at odds with the society he inhabits. The painting likewise pays homage to avant-garde art rather than the conventional, academic alternative which usually found favour with the politicians and generals responsible for masterminding the war. The stylistic handling of the architecture receding behind the figure in white is overtly indebted to the first of Robert Delaunay's paintings of Saint-Severin's interior. As Ernst-Gerhard Güse pointed out,[78] the Delaunay canvas was purchased by a German painter from a Munich exhibition, and it had also been illustrated in the *Blaue Reiter* almanac. So it was accessible to Davringhausen, who would have further relished the fact that Saint-Severin – like the Lourdes cathedral which appears in two of his other 1916 works – was a French building. By making these admiring references to Germany's enemy, he presumably wanted to subvert wartime prejudice. But he aimed as well at anticipating the regeneration that might occur after the hostilities ceased. Within the two bubbles, hovering so strangely near the madman's jacket, a ruined church is juxtaposed with a soaring alternative signifying revitalized faith in the post-war world. This small but significant note of optimism is echoed by the floor in the painting, a crystalline structure which supports the white figure and symbolizes a utopian ideal of emancipation and renewal cherished by Davringhausen and his friends.

In this respect, *The Madman* counters its bitterness and denunciation with the prospect – however slender – of a better future. A similar balancing act characterizes Heckel's *Springtime in Flanders*, an important painting which he managed to produce in the spare time

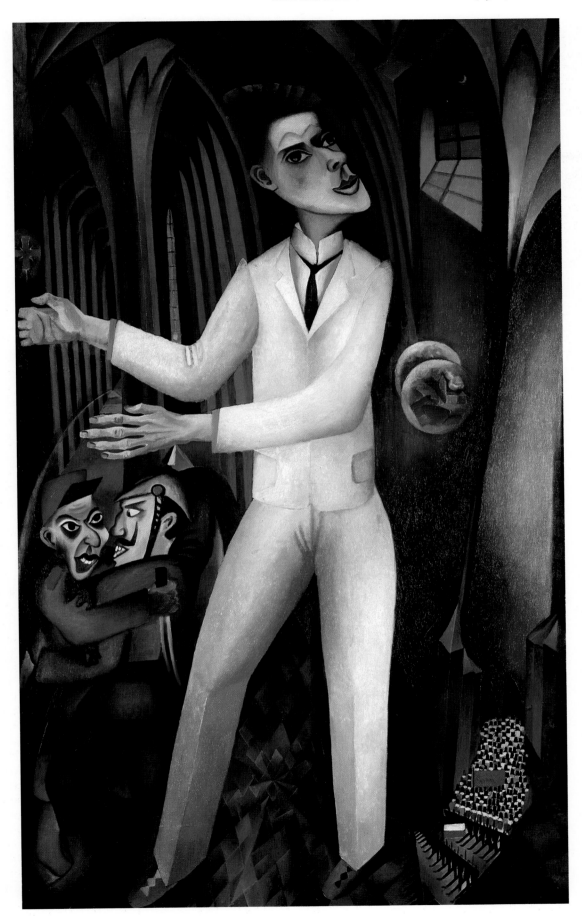

179 Hubertus Maria Davringhausen *The Madman* 1916. Oil on canvas, 198 × 120 cm. Westfälisches Landesmuseum, Münster.

180 Erich Heckel *Springtime in Flanders* 1916. Distemper on canvas, 82.7 × 96.7 cm. Karl Ernst Osthaus Museum, Hagen, Westfalen.

granted to him as a medical orderly (Pl. 180). Heckel, whose 1914 painting of *The Madman* is another possible source for Davringhausen's picture,[79] attempted to catch the landscape at a moment of dramatic transition. At the centre of the sky a pale sun manages to penetrate the menacing clouds which presage a storm. Watery light illuminates the land below, where neither the road nor the canal ameliorates the general air of desolation. The isolated figure on the path tilts to one side, as vulnerable as the forked trees to surprise attack from the volatile weather. They have already been bent and twisted by previous assaults, and Heckel implies that they were battered by combat as well as the climate. Although *Springtime in Flanders* contains no direct reference to the war, its effect is

manifested throughout the painting. For the country presented here looks beleaguered, the shell-shocked terrain of a nation desperately trying to sustain itself while opposing armies inflict terrible injuries on themselves and their surroundings. Heckel could see for himself just how ravaged Belgium had become, and his picture refuses to hold out too much hope for the regenerative power of spring. The turbulence which looked so threatening in his pre-war *Landscape in Thunderstorm* could easily regain its sway now, extinguishing the sun's pallid illumination. Although Wieland Schmied may be right in supposing that 'this is only a cleansing storm, after which the clouds will drift away and the air will be pure and clear',[80] Heckel deliberately left his picture equivocal in meaning. Since he could not predict

181 Paul Klee *Demon above the Ships* 1916. Watercolour, pen and ink on paper, 23.7 × 20.7 cm. The Museum of Modern Art, New York. Acquired through the Lillie P. Bliss Bequest.

the composition assigns prominent positions to stars – brown at the base, pale grey at the top – these symbols of hope are outweighed by the turmoil defined by Klee's scratched hieroglyphics in the rest of the print. As James Thrall Soby observed, they have 'some of the intensity of a George Grosz.'[82] The criss-cross of superimposed lines form a spiky armature, within which grim martial figures and references to whirling destruction are enclosed. Klee wields his lithographic tool like a rapier, making the lines clash and pierce each other as he builds up his image of universal strife.

By good fortune, and the string-pulling strategies of his wife,[83] the 35-year-old artist was spared direct confrontation with front-line slaughter. In November 1916 he was sent to Schleissheim as a member of an airforce reserve workshop company. 'A factory worker; how adventurous!'[84] Klee ironically declared, but he did find himself the unexpected beneficiary of materials for his art. 'At that time', recalled his son Felix, 'he began to paint on airplane linen. After a plane had crashed and the dead had been removed, my father, armed with scissors, would rush to the field and cut off pieces of the linen with which the planes were then covered.'[85] Moreover, his art reveals that painting aeroplanes and related tasks had a stimulating effect on his imagination. In *Demon above the Ships* he unleashed a phantasmic vision, utterly removed from the gentle, hedonistic images which had dominated his work in pre-war Tunisia (Pl. 181). A monster with flailing limbs appears to have burst upon the sky, menacing the vessels below with a wild, ragtime relish. It may owe something to the Zeppelin which Klee observed flying over Cologne cathedral at night, for he described it as 'a truly festive scene of evil'.[86] The demon in

182 Cover of *The Graphic*, January 1915.

Flanders's future, the signs of incipient growth in this weary land are left to the vagaries of fate.

Working as a medical orderly continually reminded Heckel about the human cost of war. His prints reveal an obsession with the wounded soldiers he helped to tend and, compared with his previous portrayals of the injured, the overall mood has darkened. In 1915 the patients Heckel depicted were stoical (see Pl. 121), but now he closes in on the stubbly face of a *Demented Soldier*. Suffering has damaged the man's mind even more than his body, and the lithograph maximizes the horror experienced by a man unable to escape from the psychic turbulence which assails him. But at least he can still see, unlike the pathetic figure nearby who lies swathed in bandages from eyes to limbs. Heckel had no desire to underestimate the plight of those condemned to a life of physical disability. Most artists only became aware of the cripples' wretchedness after the war had finished, when Dix and Grosz produced the most outstanding of many attempts to define the dilemma of these savagely deformed victims (see Pls. 340–3). But Heckel anticipated their concern by several years, in prints like *Cripple by the Ocean* where a pitiful figure pauses, as if overcome by an awareness of his isolation at the edge of the water's immensity.

Klee, who was called up in March 1916 and drafted into the German infantry reserves at Landshut, Bavaria (see frontispiece), had no more illusions than Heckel about the progress of the conflict. The news of his friend Marc's death confirmed his growing realisation that Germany was defeated,[81] and he conveyed some of this disquiet in a watercolour and lithograph called *Destruction and Hope*. Although

his watercolour is infected by a similar carnivalesque spirit, and Klee's encounter with Bosch and Bruegel The Elder in the Cologne museum doubtless encouraged him to give his most nightmarish forebodings free rein. But there is an element of absurdity in this apparition as well, matching British cartoonists' attempts to ridicule the threat posed by the airborne German terror-weapons. 'The Threat of the Zeppelin: Gas-Bag or Terror – Which?' had been the caption underneath *The Graphic*'s cover illustration in January 1915, before the air raids began (Pl. 182). Despite the caricature of the Kaiser's features on the Zeppelin it looks ominous enough, enclosed in a gigantic question-mark of smoke above the German High Seas Fleet. Its sheer size is awesome, and so is the demon gesticulating in Klee's small yet alarming watercolour.

Humanity seemed insignificant when pitched against the dimensions of such destructive inventions, and Wilhelm Lehmbruck summarized this sense of helplessness in two outstanding sculptures. Having volunteered for orderly service in a military hospital, he knew as much as Beckmann, Heckel and Nevinson about the suffering of injured or dying soldiers. Like Beckmann again, he was afflicted by severe bouts of depression because of his experiences, and as early as 1914 began a plaster *Violent Man*, later cast in cement and coloured black, filled with a tense understanding of aggression's destructive power. Then, a year later, Lehmbruck commenced work on a large figure of *The Fallen Man* which fused his own despair with a larger awareness of war's tragedy (Pl. 183). Although the figure still holds a sword in his right hand, there is no suggestion that the weapon can ever again be effectively wielded. The fingers touching it seem to have loosened their grip, and his other hand lies on the ground clutching at emptiness. This attenuated man is so weak that he cannot even rely on his arms to support him. His head has been enlisted instead, resting in a bowed position so that the arching torso can still be held in the air. While symbolizing defeat, the inversion of the head also suggests that the victim's whole world has turned topsy-turvy. Only a year before, this young fighter would have faced the enemy with as much ardent assurance as Lehmbruck's *Siegfried*, who in an earlier sculpture grasped a similar sword like a crusader ready for victory. Now, however, the warrior is stricken. Although one historian recently claimed that 'all is not over with him',[87] the figure

does appear to be accepting the inevitability of defeat.

Shorn of the uniform and military insignia which another, more conventionally heroic memorial might have insisted on, he is reduced to the ultimate vulnerability of nakedness. Nor is his body bolstered by any of the robust musculature normally associated with images of fighting men. Slender to the point of emaciation, Lehmbruck's man cannot rely on the resources of a proudly developed physique. All his ebbing strength is required to drag those exhausted legs along. While one foot still succeeds in raising itself slightly off the ground, with the aid of some stubborn toes, the other has given way to passivity. The man will soon be unable to prevent himself from complete collapse, and when Lehmbruck first displayed the sculpture in a 1916 Berlin exhibition he gave it the more pessimistic title *Dying Warrior*. No comfort could be derived from this forlorn image of impending extinction, and Paul Westheim declared in his review of the exhibition that 'something burdensome, something of the world's anxiety as it learned that the great Pan was dead, is the mood emitted by this figure . . . There are no soft lines, no melting surfaces in this body. Even in the form there is groaning and grating and oppression.'[88]

During the course of 1916, as Lehmbruck's mood darkened further in the face of imminent conscription, he produced an even more elegiac reflection on the war. Germany's losses mounted as its armies lost the ability to sustain their early momentum. By the autumn casualties on both Fronts reached a gruesome total of 3,500,000, with around one million dead. The sheer relentlessness of the carnage was overwhelming, and the *Seated Youth* Lehmbruck made in that dismal period of butchery at Galicia and Verdun is burdened with grief (Pl. 184). Unlike *The Fallen Man*, his life does not appear to be in any danger. But his spirit has been crushed by the accumulated weight of dead and wounded countrymen. Lehmbruck's subtitle for the work was 'The Friend',[89] and it was once used as a monument in the Kaiserberg War Cemetery at Duisburg. No setting could be more appropriate, for the figure certainly appears to be lost in mourning. Hunched on a bare mound reminiscent of a burial-ground, he gives way to an inconsolable sorrow. Classical, Renaissance and Rodinesque precedents for this figure lack the sense of aching melancholy which Lehmbruck distils. Although the figure's bony, elongated limbs are realised with palpable conviction, especially

183 Wilhelm Lehmbruck *The Fallen Man* 1915–16. Stone cast, 78 × 240 × 82.5 cm. Nachlass Lehmbruck.

184 Wilhelm Lehmbruck *Seated Youth* 1916. Bronze, 103 × 77 × 115 cm. Wilhelm Lehmbruck Museum der Stadt, Duisburg.

Which murder butchered horribly.
My friends lie all around me,
My brothers are no longer here,
Our faith, love, is all gone,
And Death appears on every path, on every flower.
Damn!
You, who have prepared so much death,
Have you no death
 for me?[90]

Lehmbruck himself provided the answer a year later when, having returned to Berlin, he committed suicide in his studio.

The Fallen Man and *Seated Youth* reflected the pacifist feelings of a growing number of Germans in 1916, most notably within the membership of the Socialist party. Barlach, whose *Mass Grave* had announced his own conversion to an anti-war standpoint the previous year (see Pl. 143), intensified his opposition still further. Although the timely intervention of Liebermann and Slevogt had secured his discharge from the infantry after only two months, his hatred of the conflict never lessened. 'One learns to accept the war, but only for brief spells', he wrote to Reinhard Piper in 1916; 'then it catches up with you with giant steps, more terrible than before.'[91] He conveyed this agitated mood in a wood carving called *The Ecstatic One: The Desperate One*. The anguished figure, based on a Güstrow bricklayer, barely seems capable of directing his stride as he clasps his head with both hands and points a gaping mouth towards the sky. At the same time, Barlach's lithographs became openly polemical in their denunciation of the hostilities. The horror of death conveyed by *Mass Grave* was magnified in a print entitled *The Year of the Lord 1916 A.D.*, published by Cassirer in *Der Bildermann's* October issue. The spectacle confronting Christ on his return to earth is not confined to one communal grave any more: now he gazes at a whole landscape filled with similar pits, all containing the bodies of dead soldiers. Just in case anyone might have concluded that the battles were over, Barlach also issued a lithograph of rampaging ferocity (Pl. 185). *From a Modern Dance of Death* is dominated by a robed colossus swinging an outsize sledgehammer like a man programmed to crush everything within sight. This crazed exterminator does not appear to care that he

where the right foot digs into the earth, the sculpture makes eloquent use of voids as well as solid form. By making the youth lean elbows on thighs, Lehmbruck draws attention to the space created behind by the curve of the concave chest. Into this emptiness the mourner directs his own gaze, contemplating the absence of those whose company he once cherished. His dejection is expressed above all by the left hand, which cannot even find a resting-place on his knee. Instead it hangs down forlornly, as though acknowledging the fact that it will never again be able to grasp the palms of friends annihilated on the killing-fields of Europe and Russia.

Anxious to avoid conscription, Lehmbruck took the drastic step of fleeing to Switzerland later in the year. There his wife and children joined him, but survival in Zürich did not bring relief. Early in 1918 he disclosed his permanent sense of loss in a poem called 'Who Is Still Here?', which commences by asking:

> Who stayed behind after these murders,
> Who survived this bloody sea?
> I step across this stubbled field
> And look around at the crop

185 Ernst Barlach *From a Modern Dance of Death* 1916. Lithograph on paper, 29.9 × 21 cm. Leicester Museum and Art Gallery.

186 Ernst Barlach *Dona Nobis Pacem!* 1916. Lithograph on paper, 17.8 × 23.2 cm. Leicester Museum and Art Gallery.

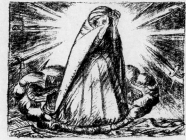

DONA NOBIS PACEM!

might end up merely cracking the bones already abandoned on the ground. Seized by an automatic desire to annihilate, he continues to aim his weapon regardless of the outcome. In the face of such severely diminished responsibility, which was no longer capable of answering to rational argument, Barlach concluded that the only hope lay with religious intercession. So he devoted the front page of *Der Bildermann*'s Christmas issue to a heartfelt image of prayer (Pl. 186). The woman whose hands are clasped in front of her head is menaced on every side by swords. But their blades are prevented from piercing her by the powerful light of faith, blazing from her body with such conviction that she is assured divine protection for as long as God ordains.

Her plea for the rest of humanity went unheeded, however. Uttering the words 'Dona Nobis Pacem' did not rescue the world from war, and even in the relative safety of Switzerland Maximilian Mopp felt threatened by news of the conflict. In 1916 he painted for the first Dada exhibition in Zürich a small but carefully wrought *trompe-l'oeil* image of *The World War*. The entire surface of the canvas is heaped with layer upon layer of reports about the struggle – whether from the European and American newspapers, or from letters and postcards sent to the artist when he lived, as Max Oppenheimer, in Bern. The accumulation of documents leads to a sense of oppression, as if the artist felt that he could not escape from the proliferating reminders of aggression. A similar emotion informs Pierre Albert-Birot's *War*, even though he employs a style wholly at odds with Mopp's meticulous illusionism (Pl. 187). This time, letters and newspapers are replaced by abstract segments redolent of assault. Thrusting triangles clash throughout the painting, and linear arcs add their own slicing rhythms to the general discord. In contrast with all this geometric severity, a dark and irregular zig-zag moves like a trail of smoke

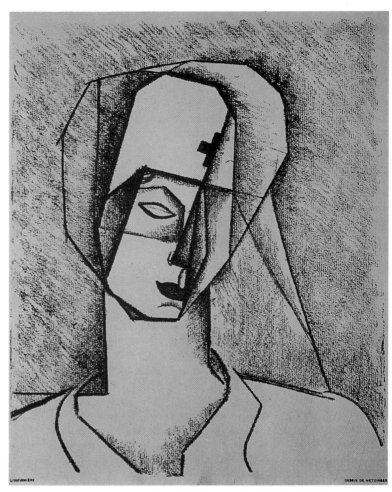

187 Pierre Albert-Birot *War* 1916. Oil on canvas, 125.5 × 118 cm. Musée National d'Art Moderne, Centre Pompidou, Paris.

188 Jean Metzinger *Nurse* c. 1914–16. Illustrated in *L'Elan*, 1 February 1916.

through the clash of opposing forces. As Albert-Birot made clear in his new avant-garde magazine *Sic*, he believed in the potential of an abstract language. The 'French tradition', he maintained in the April issue, is 'to break the shackles . . . TO NEGATE TRADITION.'[92]

Such an argument had become increasingly rare in France by 1916. Even a committed pre-war Cubist like Metzinger revealed, in his drawing of a *Nurse*, a desire to amalgamate his earlier style with a more conventional approach to the human figure (Pl. 188). As for Dufy, still employed by the government propaganda bureau and the Musée de la Guerre, he continued to plan further patriotic prints in the style of his earlier morale-boosting war images. 'Allow me to describe this idea to you', he wrote to Simon Bussy in May, referring to a proposal he had just put forward at the propaganda office: 'it is to recount in coloured pictures (like the *images d'Epinal*) the events of the war involving our native soldiers in the colonies, so that on the walls of the barracks and homes of the Blacks in Africa and the Yellow races in Asia there would be a record of their participation in the Great War, just as our own peasants once had pictures of the Napoleonic Wars in their cottages. My idea has already been very well received in various departments of the Minister of the Colonies'.[93]

Prints like *The Nations United for the Triumph of Right and Liberty* look absurdly optimistic in the light of the war's futility in 1916, but Dufy persisted with his venture in a style blatantly appealing to tradition rather than the innovation he had explored in his pre-war

work. The urge to withdraw from experimentation even affected an apostle of modernity as zealous as Duchamp-Villon, who felt unable to pursue his avant-garde interests while serving in the front line at Champagne. He was transferred there from a hospital post in Paris, where he had been assigned as a medical officer after volunteering in 1914. His pacifist convictions did not prevent him from wanting to defend France, and at Champagne he reported that 'I've been able to examine and follow all aspects of the war; marvel at her incredible genius. Because it has to be said: the grandeur of a battle-line is impressive and gives the mind a new understanding of things. Is it the idea of death, always present in the fire of cannons and falling shells which alters the mind, enlarging its boundaries? Is it the idea of life, assembled in swarming crowds which grow in size by absorbing individuals into its mass? I don't know – but our whole conception of life makes great progress here.'[94] His art, however, did not. The only sculpture he managed to complete at Champagne was a painted plaster medallion for a theatre established to entertain troops at the Front (Pl. 189). Like Dufy's *The End of the Great War* a year earlier (see Pl. 55), Duchamp-Villon's *Rooster* was intended as a rousing symbol of indomitable French valour. But the style he employed looks diluted and decorative to a fault after the audacious radicalism of his machine-age *Horse*. He admitted to his American friend Walter Pach that he felt constrained by the expectations of the soldiers, who would not have understood a more abstract sculpture. So *The Rooster* ended up compromised by the need to respect familiar represen-

189 Raymond Duchamp-Villon *Rooster (The Gallic Cock)* 1916. Polychromed plaster bas-relief on wood support, 44.8 × 37.2 cm. The Phillips Collection, Washington, D.C. Bequest of Katherine S. Dreier, 1953.

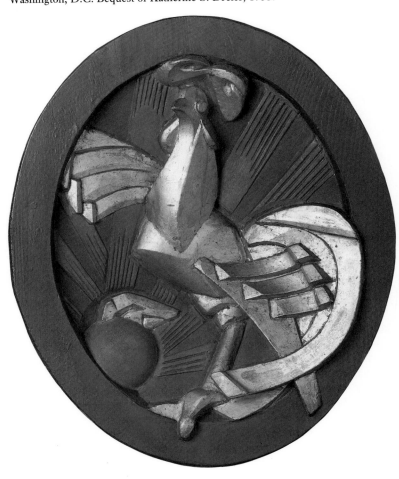

tational conventions.

War gave opponents of Cubism, and the other innovative movements which had blossomed in pre-war Paris, an opportunity to brand experimentalism as a manifestation of 'Munich' barbarism. Patriotism was now enlisted in the attempt to argue for a reassertion of lost classical values, and Rodin, who had produced a frankly mythological image of an equestrian warrior a year earlier, spoke for many when he argued that 'we will do well to abandon all the chimeras coming from a sick mind and return to the true ancient tradition, old as the centuries, instead of making things without value. For a while now the cities of Europe have been damaged by these Barbarians. We don't need German influence, but rather that of our most beautiful classic traditions.'[95] As so often, Picasso had anticipated this development by executing , as early as 1915, pencil drawings of Vollard and Max Jacob which announced a passion for Ingres. The arch-Cubist thereby revealed his preoccupation with classicism in a manner which confounded many of his supporters, but when Apollinaire sat for Picasso in 1916 the wounded poet did not object to finding himself portrayed in the same Ingresque manner (Pl. 190). For Apollinaire, the champion of the avant-garde, was himself working towards the notion of a 'new spirit' inspired by classical tradition, and he would have been gratified by Picasso's ability to invest him with the dignity of an antique statue.

Apollinaire had returned to Paris with a severe head wound, for which he was trepanned. But Picasso's pure contours betray no obvious sign of frailty or unease on his sitter's part. Dressed in his uniform, and proudly displaying the Croix de Guerre on his chest, Apollinaire exudes a formidable amount of authority. The forage cap surmounting his bandaged head gives him a hieratic air, as if Picasso wanted to imply that his friend was the high priest of modern French art. Apollinaire's assurance is fortified by the decision to depict him seated at an informal angle to the chair, and relaxed enough to let his right arm dangle from the back. All the same, Picasso is too good an artist to omit all trace of the poet's recent ordeal from the drawing. There is just a hint, around the eyes, of the strain Apollinaire must have undergone at the Front. Perhaps Picasso allowed his own anxiety about the poet's condition to affect this predominantly poised and resilient image, so far removed his light-hearted caricature of Apollinaire as a fledgling artilleryman in 1914 (see Pl. 53).

The move towards a reassessment of the classical tradition was undoubtedly hastened by the war. Picasso used the Ingres idiom to assert, among other things, the steadfastness of Apollinaire as a man who had helped to resist the German advance. Even Cocteau, whose attempts to enlist as a fighting soldier at the Front remained frustrated, found himself portrayed by his new friend as an exemplar of youthful military zeal (Pl. 191). *Portrait of Jean Cocteau in Uniform* appears to celebrate the alert, eager energy of a young soldier whose ambitions are set on victory in battle. The reality, though, was quite different. However hard Cocteau tried to become involved in active service, he was obliged to remain in Paris as an auxiliary member for the majority of the war period. The clear-sighted gaze and resolute nose, almost drawn in a teasing Cubist profile view, belong to a man whose horizons were frustratingly confined. Even the uniform, which Cocteau favoured wearing at the time, was made specially for him rather than issuing from standard military sources. Picasso's drawing can therefore be seen as a form of compensation, allowing his ardent supporter to fantasize about the heroic reputation he might have acquired as a sacrificial victim at the Front. Cocteau approved of the result, telling a friend that the '"Ingres" head of me' would be 'very suitable for portrait of young author to accompany posthumous works

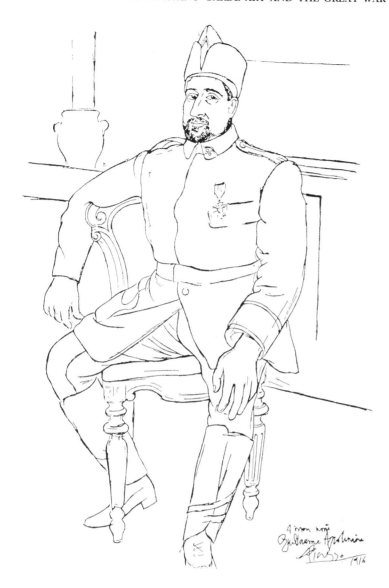

190 Pablo Picasso *The Wounded Apollinaire* 1916. Pencil on paper, 48.8 × 30.5 cm. Private collection.

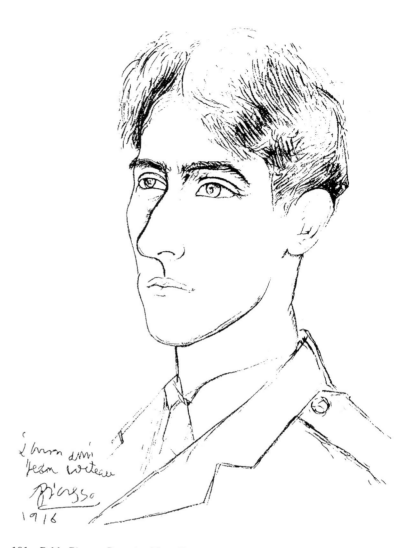

191 Pablo Picasso *Portrait of Jean Cocteau in Uniform* 1916. Pencil on paper. Private collection, France.

after premature death.'[96]

Whether by request or on his own initiative, Picasso ended up producing an array of army portraits of his friends during 1916. His future dealer, Léonce Rosenberg, was depicted standing with calm authority in the studio. His greatcoat, cap and gloves contrast with the informality of the canvases stacked behind him, and yet everything is unified by the suave assurance of Picasso's line. Rosenberg cuts an almost dandefied figure as he poses, spruce and unbesmirched by combat, with one hand casually resting in his capacious pocket. This mood of relaxation reaches its climax two years later in the even more urbane portrait of Riccioto Canudo, whose identity as the editor of the innovative magazine *Montjoie* is only partially disguised by a Zouave uniform as theatrical as a costume in a pageant.

If Picasso was the first avant-garde artist in Paris to espouse Ingresque classicism, he was soon followed by other, equally surprising converts. Severini, once so closely associated with Marinettian Futurism, wavered in his adherence to an anti-traditionalist stance.

Always the Francophile among the Futurists, and still living in Paris with his French wife, he underwent an even more unpredictable conversion. Only a few months after opening his *First Futurist Exhibition of the Plastic Art of War* at the Galerie Boutet de Monvel in January 1916, he abandoned his former involvement with dynamic simultaneity and the machine age. Not one of the sophisticated paintings included in his exhibition was sold, and Severini may himself have come to recognise that the 'hygienic' vision presented in his 1915 war pictures (see Pls. 69–72) had now been overtaken by the gathering tragedy of the carnage. At all events, his 1916 painting of *Motherhood* espouses precisely the classicizing style which Futurism had despised. Although he continued to paint cubist-influenced works for several years, no trace of mechanistic modernity can be discerned in his preference, here, for a domesticated celebration of nurturing. The artist who, just a year before, had painted 'ANTI-HUMANISME' in large capitals on a bellicose canvas called *War* now

rejoiced in the simple humanity of a mother's love for her child. *Motherhood* asserts a set of pacific values directly opposed to the Marinettian glorification of war, and Kenneth Silver was right to observe that its unqualified espousal of a neo-classical idiom makes Picasso's Ingresque drawings 'look rather tame in comparison.'[97]

Severini's apostasy was made easier, and more understandable, by his physical separation from the other Futurists. Most of them were embroiled in fighting on the Italian Front, and they demonstrated their continuing militancy by publishing, in January 1916, an unrepentant manifesto entitled *Italian Pride* which called for 'slaps, kicks and gunshots in the back of the Italian artist or intellectual who hides beneath his talent like an ostrich behind its luxuriant plumes, and who fails to align his own pride with the military pride of his race.'[98] By the end of the year, however, all this *braggadocio* had been fatally undermined. Two of the manifesto's signatories, Boccioni and Sant'Elia, died in August and October respectively. Futurism never recovered from their loss.

Boccioni, who had only just been recalled to the army and assigned to the field artillery, was knocked from a horse during a cavalry exercise and died the following day from the injuries he sustained. The most outstanding of all the Futurist artists, he lost his life at a time when most of the movement's members were re-examining their earlier convictions in the light of recent events. His own 1916 work, executed after the Cyclists' Battalion was dissolved the previous December, had begun to retreat from extreme innovation and look again at Cézanne's legacy. Moreover, he viewed his return to military service in July with less than true Futurist enthusiasm. 'You can't imagine what it means to *re-become* a soldier at 34 and in my condition', he confessed to his friend Vico Baer, 'and with what life was about to give me. Courage, but it's terrible.'[99] Such a view was startlingly removed from Marinetti's insistence in the 1909 Manifesto that 'we wish to glorify War – the only health giver of the world'.[100] The field of battle could no longer be regarded as healthy, when it inspired such dread in a Futurist artist who would now meet his death on military service. Carrà, himself soon to forsake all vestige of his Futurist beliefs, expressed the widespread grief in a heartbroken tribute written for Boccioni's memorial exhibition in Milan at the end of the year. Recalling the last time he saw his old ally in July 1916, when Boccioni left for army duties, Carrà confessed that 'we would have liked to give vent to all the tenderness that filled us with agitated emotion on that eve of departure for Verona, for war and death. I should have liked to clasp him to my breast, and for him to take with him that act of brotherly feeling, but I lacked courage to do so, and at the dawning of the day (oh how many dawns had found us together conversing about art) we exchanged a firm handshake, and I could think of nothing except a salutation: *Addio, caro! Addio.* How could I have thought that those words were the terrible salute to the brother about to die?'[101]

Even Balla, who persisted in his loyalty to the Futurist cause for many years to come, was prompted to produce an image of war markedly different from his rousing pro-interventionist paintings of 1915 (see Pls. 64, 66). He became preoccupied now with the idea of a widow's veil, fusing it with landscape forms to create an abstraction heavy with mourning. He also brought the grieving widow into conjunction with the kind of war machine so beloved of the Futurists in their belligerent heyday. *Battleship + Widow + Wind* was the title he gave one of his most complex 1916 paintings – a revealing work where the grey-green of the battleship itself seems to permeate the entire canvas with its melancholy hue (Pl. 192). The turbulence sweeping through his downcast picture, signifying both the widow's sorrow and a storm strong enough to toss the vessel on the sea, reflects Balla's own state of mind as well. Whether he intended it or not, this openly distressed painting resembles an elegy for all the hopes which war once aroused in the Futurist artists. Having devoted so much of their energy to bringing about Italy's active involvement in the conflict, they now discovered that militarism was itself responsible for the movement's downfall.

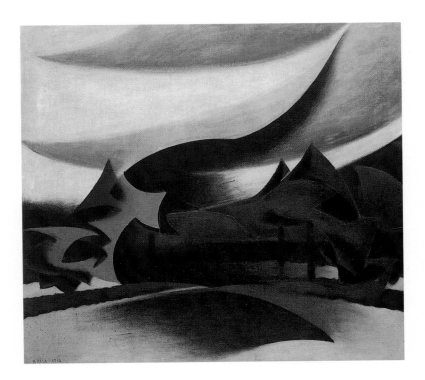

192 Giacomo Balla *Battleship + Widow + Wind* 1916. Oil on canvas, 105 × 110 cm. Ludwig Museum, Cologne.

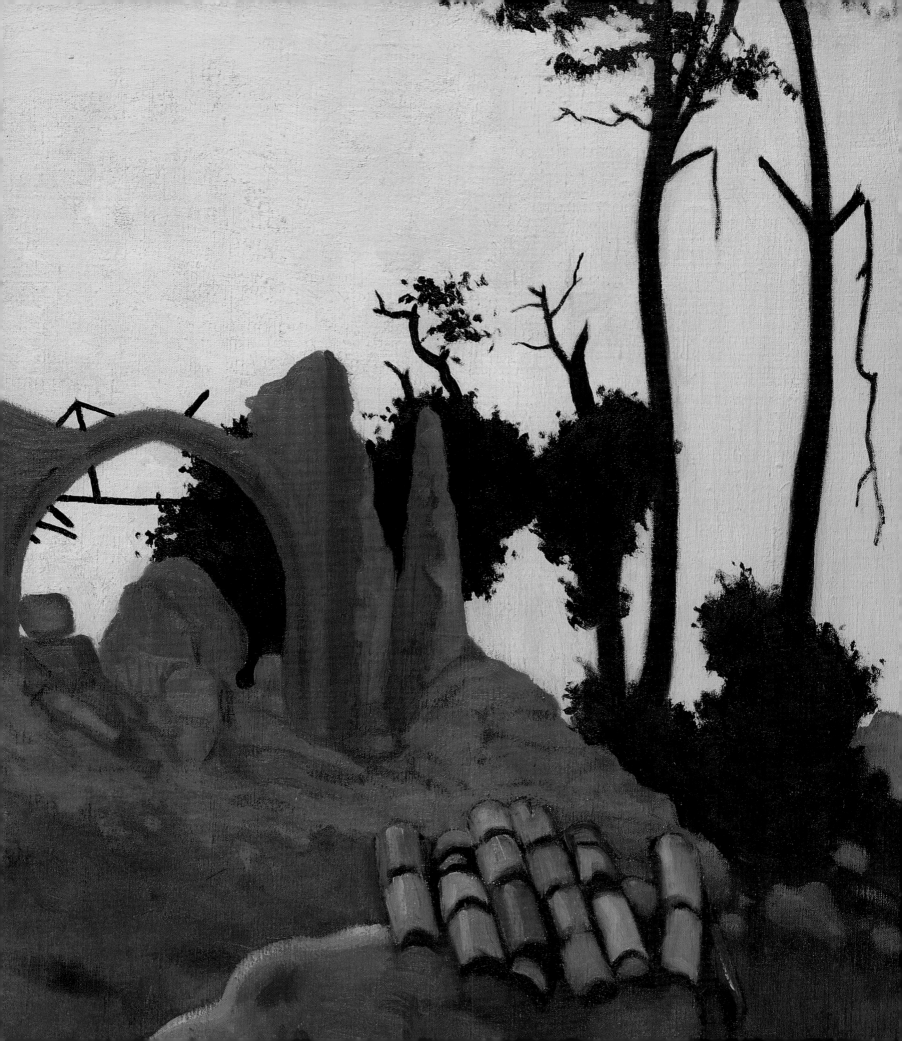

CHAPTER SIX
CATASTROPHE AND CENSORSHIP

(1917)

In one respect, 1917 brought a clear reason to hope that war might eventually reach a decisive conclusion. Provoked by the German U-Boat campaign, the United States resolved in April to enter the conflict at last. The Americans' involvement would play a crucial role in securing a victory against Germany, and Childe Hassam was quick to celebrate his country's declaration of war in a festive painting called *Allied Flags, April 1917* (Pl. 193). Taken from a vantage-point across the street at the Macbeth Gallery, the picture makes full heraldic use of the eleven flags draped over the balcony of the Union League Club, a luxurious New York men's club on the corner of Thirty-Ninth Street and Fifth Avenue. The discreet red-brown hues of the Queen Anne-style building are transformed by the colours emblazoning its façade. Although the American flag is placed above the others, its horizontal projection means that the stars and stripes are less prominent than the other designs hanging beneath. Japan, Portugal, Belgium, Italy and Britain make up the left half of the display, and the row is completed by France, Russia, Cuba, Serbia and Romania. It looks impressive, but many of the represented countries counted for little in terms of military power. Moreover, the red flag of Russia[1] was only a temporary affair, denoting the recent overthrow of the Tsar's imperial rule by the revolution. The Provisional government established in the wake of this momentous event was soon to prove miserably incapable of conducting a successful offensive against the German army then on Russian soil.

All the same, Hassam's enthusiasm for his country's entry into the war knew no bounds. He identified with the solidarity of the flag display by portraying himself, as the man holding a green portfolio, among the pedestrians on the pavement.[2] His English ancestry, coupled with an abiding love of Paris and Impressionist painting, predisposed him to support the countries ranged against Germany. He had already served on the American Artists' Committee of One Hundred, established in September 1914 by New York painters and sculptors who organized an exhibition in aid of a relief fund for the families of French soldier-artists. When the great Preparedness Day parade was held on Fifth Avenue in May 1916, he painted the first of his flag paintings to acknowledge his sympathy with a demonstration that marked the onset of America's involvement with the war.[3] Modest in itself, this initial picture inaugurated an extensive sequence of flamboyant flag compositions, all rousingly dedicated to the interventionist cause. America's entry into the conflict only quickened Hassam's interest in the subject, and when the French and British war commissioners[4] visited the United States he executed the most

famous of all his flag canvases. *Allies Day, May 1917* was painted during a month wholly given over to the official celebration of Anglo-French-American cooperation. Hassam's buoyant image places the flag clusters against the backdrop of Saint Thomas's Episcopal Church, symbolically illuminated by brilliant sunshine to confer divine authority and benediction on the Allied cause.

But it was easy to indulge in optimism about the war from the safety of a banner-festooned New York. Over in Europe, armies continued to pound each other's lines with remarkably little effect. Despite the 'turnip winter' of 1916–17, caused by a series of poor harvests which weakened the German economy, its armies continued to hold their ground. Indeed, the French soldiers looked as if they were about to succumb to widespread demoralization. The ten-month battle around Verdun, which had claimed so many casualties on both sides by the end of 1916, left the French forces in a weary and thoroughly dispirited mood. When Nivelle's Chemin des Dames offensive was launched against massively fortified German lines in Champagne, the disastrous result led to outbreaks of mutiny among the French ranks. Hundreds of ordinary infantrymen decided that they had endured too many blood-baths, and refused to return to the line. Acute exhaustion, combined with the senselessness of battles that achieved nothing, led to similar manifestations of collapse in other Allied forces. Soon after Russia's new Provisional government initiated a major offensive in Galicia, its army gave way in the face of a German counter-attack. A similar rout split up the Italian ranks when they were attacked by the Austro-Hungarian army in the Isonzo Valley. Throughout the battlefields of Europe, soldiers reached breaking-point in 1917. They began more and more to question the rationale of campaigns which, like the doomed British initiative at Passchendaele, wasted so many lives for negligible territorial gains.

On both sides, the darkening mood was inevitably reflected in artists' representations of the conflict. Some painters concentrated on the image of an explosion to sum up their vision of war's annihilating force. Nevinson had produced a characteristically vivid picture of this eruptive power in 1916 (Pl. 195). Although the triangular segments of earth retain their solidity at the base of the composition, most of the space is filled with the shafts of an explosion immense enough to obliterate everything in its path. The only light in this predominantly dour and oppressive picture derives from the flash at the point of contact between missile and ground. Its thin blades of whiteness throw out a dull orange glow beyond, but the gloom of cataclysm predominates.

Grosz's *Explosion*, by contrast, sees the moment of eruption as a fiery incandescence (Pl. 194). A bomb has gone off in the middle of a

Left: Félix Vallotton *Church at Souain* 1917 (detail). See Pl. 200.

193 Childe Hassam *Allied Flags, April 1917* 1917. Oil on canvas, 77.5 ×
124.5 cm. Kennedy Galleries, New York.

densely built-up urban area, and it irradiates the surrounding offices
and houses with a hellish red glare. One façade is completely blown
out by the blast, sending bricks hurtling pell-mell through the
scorched air. In other buildings, flames flare from windows which
reveal that whole interiors are being consumed by heat worthy of a
furnace. Unlike Nevinson, who focused on the explosion alone and
omitted to survey its effect on the vicinity, Grosz made his small yet
comprehensive panorama encompass civilians as well as the cityscape.
Aghast faces and fragments of upturned limbs can be glimpsed in the
turmoil, lit by acrid lime and lemon flashes which seem to be reflected
in the noxious edges of the explosion's cloud.

This ferocious painting must have been provoked by the sudden
return of all Grosz's fears about the war. Early in January 1917 the
army recall he had been dreading for so long obliged him to report to
the regiment. A day later the severely distressed artist was admitted
to a military hospital in Guben, and a few weeks later his nervous
disorder had become alarming enough to qualify him for entry to a
mental hospital at Görden. 'My nerves broke down', he wrote to a
friend in March, 'this time before I could even get near the front and
see rotting corpses and barbed wire – first of all they defused me,
interned me, for a special investigation of what they still think is my
fitness for active service, which is still a possibility. My nerves, every
fibre, disgust, revulsion!'[5] When a doctor pronounced him healthy
enough for the army, and a medical student ordered him out of bed,

194 George Grosz *Explosion* 1917. Oil on board, 47.8 × 68.2 cm. The Museum
of Modern Art, New York. Gift of Mr and Mrs Irving Moskovitz.

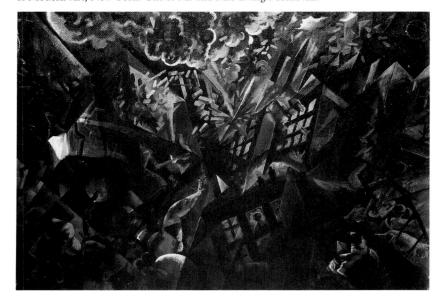

195 Christopher Nevinson *Explosion* c. 1916. Oil on canvas, 61 × 45.8 cm. Private collection, London.

Grosz attacked the latter and found himself assailed by the other inmates of the sick-room. He described later how the incident had 'burned an indelible scar in my brain – the way those normal everyday fellows beat me up, and the fun they had doing it.'[6] His venomous contempt for military doctors reaches its height in a corrosive drawing called *K.V. (Fit for active service)*, where Grosz's nightmares about a recall take the form of a macabre inspection (Pl. 196). Although the object of the medical inspector's blinkered attention is nothing more than a skeleton, he places an ear trumpet against the exposed intestines and announces a positive verdict. Complacent, gossiping officers bark their routine approval, confirming Grosz's fear that nothing would prevent them from insisting that he was fit enough to return to the Front.

'All round me is darkness, and the hours, black like bones,' he wrote from the military hospital at Guben, driven to the edge of insanity by his horror of returning to the battlefield. 'My hatred of men has grown to enormity. It seems I shall slowly approach the madness of despair . . . I am crossing bare hell – white, skull white. The ragged sky stands in the window, but I never see the stars. Above the beds hang black birds; the nameplates of the sick animals. All human features have disappeared from their faces. Often Death rattles melodiously amongst the swinish beds. Someone with evil spectacles plays the piano, penetrating the trenches and dug-outs of my brain. From the retort of my mind I extract much poison and hatred. I am still a fighter!' Although he concluded by signing the letter 'Your G. deceased',[7] Grosz finally obtained his release from the army. After being discharged from the mental hospital in April, he was declared permanently unfit for service a month later. Grosz was free to channel his obsession with Death, bones and 'skull white' into drawings which pillory the men controlling the war.

Dix was still caught up in the fighting, and the work he produced there confirmed Grosz's most despairing misgivings about life at the Front. He depicted the ubiquitous explosion in terms of an *Artillery Duel*, where shafts of battery fire from opposing sides turn the scene into an inferno. At the centre, a solitary victim is trapped. All he can do is let out a scream, but his protesting cry must be lost in the greater shriek and roar of the shells as they hurtle past him and pound the earth. Although Dix withstood the war better than Beckmann, Grosz and Kirchner, by serving as a machine-gunner in France and Russia after his initial experience in the field artillery, this relentless gouache shows that he was able to appreciate the extent of the suffering caused by a heavy and prolonged bombardment.

Henry Valensi, who had painted at the Dardanelles Front for General Gouraud, attempted to transform the moment of an explosion into a rhythmic semi-abstraction (Pl. 197). Before the war, he had been involved with Duchamp, Gleizes and Picabia in the 1912 Section d'Or exhibition, becoming fascinated with the possibilities inherent in the relationship between music and painting. Although a more documentary impulse governed the small neo-Impressionist paintings Valensi executed at the Dardanelles,[8] the large canvas which summarized his experience there returned to a musicalist idiom. *Expression of the Dardanelles* contains at its heart a bursting shell, connected by a series of thin, curving lines to gun-barrels ranged round the painting's perimeter. Pursuing his belief that various aspects of a subject could be brought together through the rhythmic division of the canvas, Valensi weaves a complex web of upright, diagonal and zig-zag strips into his composition. Within this mesh, references to destroyers, gun-batteries and the Severini-like forms of firing soldiers can be discerned. But the sweetness of his colours, combined with the decorative bent of an artist who had

argued in 1913 for the exploration of 'pure painting',[9] conspire to rob this ambitious picture of any ability to convey violence or destruction. War is transformed here into a strangely harmless exercise, by an artist who sought to distance himself from the reality of the conflict he had witnessed as an observer rather than a participant.

Vallotton also attempted to remove any trace of literalism from his art, especially after paying an official visit to the French Front in June 1917. All the same, his emotional response to the scene was so powerful that he discovered how to give his landscapes a greater impact than Valensi. Avoiding the complexity of rhythms in *Expression of the Dardanelles*, Vallotton aimed instead at a primal simplicity. In a sketch called *Verdun* he concentrates, like Nevinson, Grosz and Dix, on an explosion tearing jagged, splintering fragments through ground and sky alike. The previous year, he had reacted to the onset of the Battle of Verdun by writing in his diary that 'out of all this horror there emerges something perfectly noble; one feels truly proud to be standing on this side of humanity, and whatever happens, the notion "French" is once more young and resplendent as never before.'[10] A year later, however, his intense patriotism gave way to a sense of revulsion. Appalled by the devastation, Vallotton began to doubt whether the war's continuation could be justified. 'The virtues of the French are being exaggerated,' he wrote in May 1917, asking himself: 'why sacrifice another life if we are only going to have to obey the enemy in the end?'[11]

In a large painting of *Verdun*, he tried to give pictorial order to his growing belief that war had become a huge 'fatality' (Pl. 198). Figures are nowhere to be seen, and in their place searchlights of purple, crimson, violet and dark blue carve their way across a ravaged panorama. Rain slants down on the mud-choked foreground, but it

196 George Grosz *K.V. (Fit for active service)* 1916–17. Pen, brush and ink on paper, 50.8 × 36.5 cm. The Museum of Modern Art, New York.

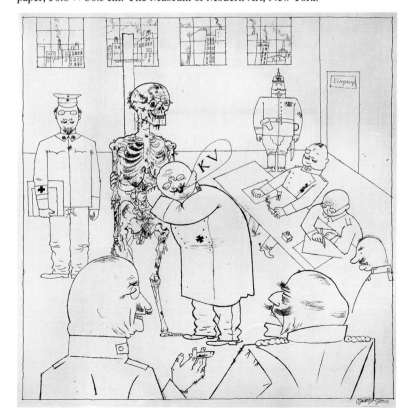

fails to prevent the emergence of a black cloud, rising so thickly beyond that it threatens, eventually, to asphyxiate the entire landscape. Nor does the rainfall extinguish the flames raging through the stripped trees of a forest where the earth itself has turned red with the heat. Modern war, which desecrates the natural world to the point of obliteration, is dominated by technological forces rather than the efforts of the soldiers trapped in this impersonal pandemonium.

No bombardment lasts for ever. But after the artillery's fury had momentarily spent itself, the consequent desolation was revealed in all its emptiness. Although Vallotton's paintings of *The Yser* and the *Plateau of Bolante* may seem mercifully calm in comparison with the mayhem of his *Verdun*, their stillness is deceptive. For it is the silence of death that prevails here. The blackened and twisted stumps punctuating the nearest slope give way to white trunks further back, and they project from the land like bleached bones. As they congregate near the horizon, these pale remnants of the once richly-foliated Argonne almost become indistinguishable from crosses. They stand as forlorn reminders of the young men who fell there, and Vallotton's awareness of butchery prompted him to paint the *Military Cemetery at Châlons-sur-Marne* as well (Pl. 199).

Left to themselves, the dense ranks of grave-markers in this quiet yet potent painting would have made an image as minimal as Mondrian's *Pier and Ocean* series two years before. Vallotton, however, insisted on including the insignia, wreaths and other individual tributes left on the crosses by mourners. Their small, discreet

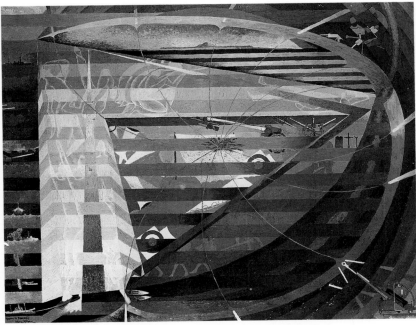

197 Henry Valensi *Expression of the Dardanelles* 1917. Oil on canvas, 123 × 161 cm. Musée d'Histoire Contemporaine – BDIC, Hôtel National des Invalides, Paris.

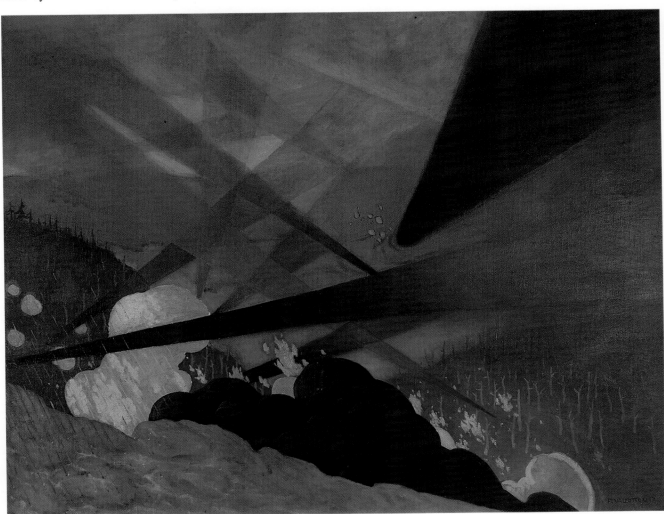

198 Félix Vallotton
Verdun, an interpreted picture of war 1917. Oil on canvas, 114 × 146 cm. Musée de l'Armée, Paris.

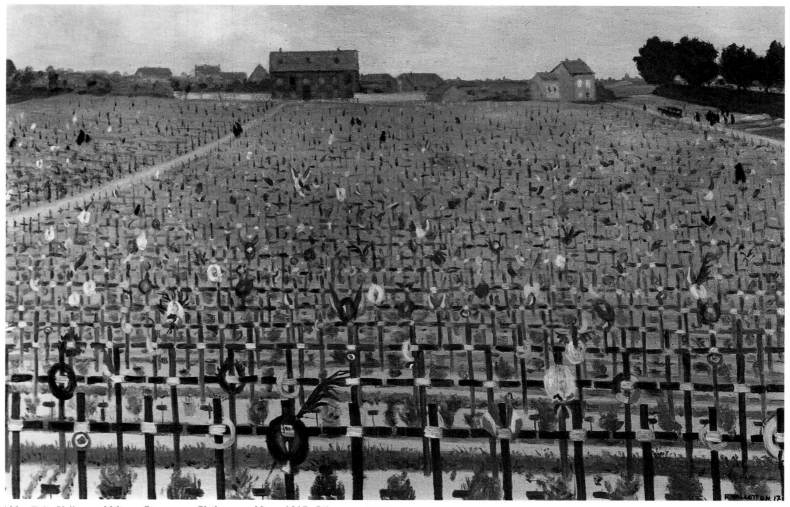

199 Félix Vallotton *Military Cemetery at Châlons-sur-Marne* 1917. Oil on canvas,
54 × 80 cm. Musée d'Histoire Contemporaine – BDIC, Hôtel National des
Invalides, Paris.

touches of colour deepen the scene's poignancy by stressing the grief
attendant on each burial; and as our eyes travel through the grey,
misty cemetery we grow conscious of occasional dark smudges, which
resolve themselves into the silhouettes of visitors searching for the
graves of sons, brothers, husbands and lovers. The isolation of these
huddled, diminutive figures sums up the pathos of a conflict which
had proved so indiscriminate in its capacity to kill. Nothing, Vallotton
realised, was safe from the exterminating power of modern warfare –
not even the church at Souain which he found, bombed and gutted,
beyond the ruins of another building (Pl. 200). By looking at the
shattered house of God through the secular rubble in the foreground,
he implied that the old consolations of religion could no longer be
relied on by anyone in search of a place to shelter and pray.

As if to provide their own solace in this wilderness, some artists
persisted in finding a melancholy beauty on the battlefields of France.
Maurice Denis painted a canvas of *Evening Calm at the Front Line*,
where the central ruin takes on an unexpected splendour in the rose
light of sunset. The waning of the day gives the entire scene a
deceptively flattering aura. A white shirt glows as its wearer aims his
axe at a block of wood, and the watery mud traversed by soldiers
takes on a pale mauve delicacy. Blasted trees can be discerned across
the river, testifying to the onslaught suffered by the countryside
around them. But Denis focuses on repose rather than violence,

finding room for the infantryman who leans against a post and, pipe
in mouth, reads a letter from home. It is a lyrical, frieze-like painting,
more concerned with finding poetry in the lull between battles than
in reflecting the realities of the French army's most hard-pressed and
demoralized year.

The despondency which spread through the *poilus*' ranks during
1917 was caught in an uncharacteristic painting by Bonnard. He was,
perhaps, the least likely artist to involve himself in painting the war.
Although his father had been the head of a department at the
Ministry of War in the previous century, Bonnard himself tried to
avoid aggressive and disturbing subjects throughout his life. During
the war years he lived for the most part at Saint Germain-en-Laye,
quietly continuing to relish the sensuous pleasures of domesticity and
the French landscape. But in 1917 the 50-year-old artist turned away
from these preoccupations for a moment and painted *Village in Ruins
near Ham* (Pl. 201). At first glance, the picture looks frankly un-
finished. The bombed buildings are handled in a perfunctory manner,
and the group of soldiers huddled together on the right are sketched
in rather than fully realised. Dealing with a scene so removed from
his favoured territory may well have depressed Bonnard, discouraging
him from bringing the canvas to completion. All the same, its very
bareness suits the desolation of the scene he depicts. A Red Cross
van has paused in the distance, possibly to pick up wounded people

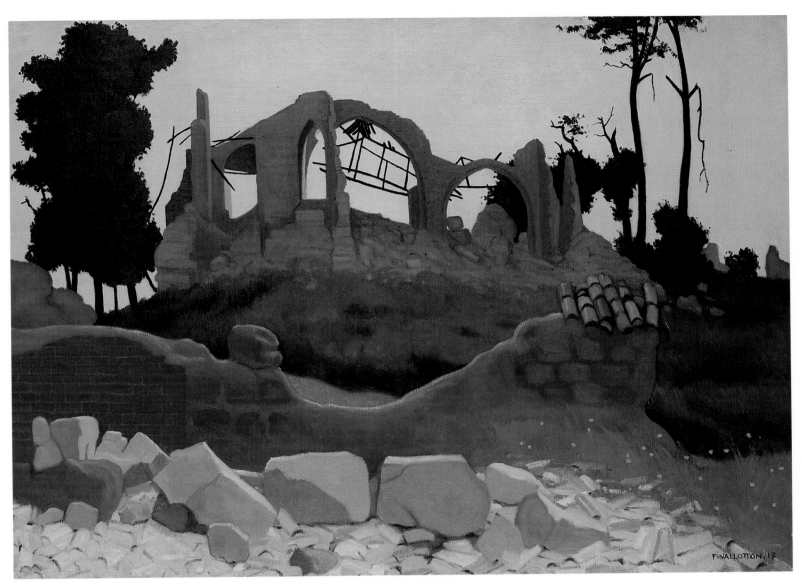

200 Félix Vallotton *Church at Souain, ruins and rubble* 1917. Oil on canvas, 97 × 130 cm. National Gallery of Art, Washington, D.C.

found in the debris. But the ruins suggest that the village has effectively been destroyed, and its passing seems to be mourned by the solitary figure who sits among the foreground rubble to brood over the misery around him. Bonnard's thinned pigment catches the rain-sodden atmosphere of a place pummelled almost beyond recognition by the brutal imperatives of battle.

The terrain where soldiers braved shells, machine-gun bullets and rifle fire as they advanced towards the enemy lines was, however, immediately recognisable. Moholy-Nagy, who served as an artillery officer in the Austro-Hungarian army before being wounded and confined to field hospitals in Odessa and Galicia, defined its gruesome identity in *Landscape with Barbed Wire* (Pl. 202). Instead of confining the wire to one area of the paper, Moholy allows his black crayon to cover most of the hillside with its linear network. The entanglements are evoked rather than represented in any detail, and yet

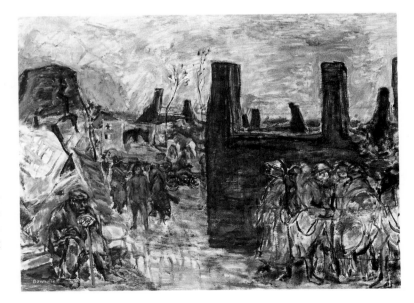

201 Pierre Bonnard *Village in Ruins near Ham* 1917. Oil on canvas, 63 × 85 cm. Musée d'Histoire Contemporaine – BDIC, Hôtel National des Invalides, Paris.

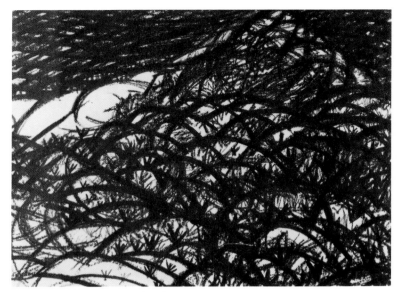

202 Laszlo Moholy-Nagy *Landscape with barbed wire* 1916. Crayon on paper, 48 × 63 cm. Hattula Moholy-Nagy.

Moholy's reliance on a dynamic interplay of burgeoning arcs succeeds in saying a great deal about the smothering, trap-like efficacy of the wire. Although tufts of grass can be seen among its interstices, the coils impose their authority on nature. By filling the sky with an even denser mesh of lines, so that impenetrable night is denoted, he makes any thought of evading the wire's embrace seem still more remote.

Anyone without first-hand experience of the Front line might have imagined that nightfall brought merciful obscurity to the horrors strewn across the battlefield. Dix, however, knew better. In *Signal Flare*, one of his most shocking wartime images, he lets the bursting red and white lights reveal a terrible scene in No Man's Land (Pl. 203). Ensnared in the barbed wire which Moholy had seen as such an inescapable menace, a cluster of dead soldiers are illuminated by a ghastly green glare. Judging by some of their faces, already turning into skulls, the bodies have been lying there for a long time. Such a spectacle became increasingly common as the war proceeded, for armies often found themselves fighting over territory which had been disputed, inch by painful inch, more than a year before. The photograph of a German corpse lying outside a dugout in November 1916, with one arm flung across his neck in a futile attempt to ward off danger, proves that Dix was not indulging in a skeletal fantasy when he produced *Signal Flare*. The more the war dragged on, the more these ravaged landscapes became strewn with rotting reminders of mortality.

Dix, who had been profoundly influenced before the war by Nietzschean ideas about the cycle of growth and decay dominating the world (see Pl. 16), found himself preoccupied with duality in the terse crayon drawings he made during active service. Working with great speed and urgency, in order to make the most of the intervals between battles, he returned again and again to the juxtaposition of life and death surrounding him. *Two Riflemen* are shown, resting their weapons on dead comrades as they crouch and fire (Pl. 204). The corpses survive as bulwarks, fit only for stopping the enemy's bullets. Moreover, one of the riflemen squats on a man's twisted body as he defends himself against an attack.

Eventually, Dix realised, the corpses would be claimed by the earth on which they sprawled. Although the *Dying Warrior* has only just fallen, and still manages to thrust one defiant, protesting arm up

in the air, his body is already beginning to sink into the churned ground. The further these victims merge with the land, though, the more they nourish it and enable fresh growth to spring from the pummelled soil. *Grave (Dead Soldier)* is supremely aware of this paradox. The soldier has almost become indistinguishable from the earth: only his protruding boots, talon-like fingers and collapsed face are readily discernible, along with the tilted helmet still evident on the nearby brow of a hill. The rest of his figure has fused with the landscape so completely that it already appears to be feeding the earth, and generating the flowers scattered across the scene like blooms planted by a mourner.

Dix was fascinated by the realisation that death might end up nourishing new growth in such a perverse manner. Another 1917 drawing shows the flowers shooting up on the very edge of the gash made by a trench. He seems to imply that the blood spilled by the young men who once inhabited this fissure-like channel was rich enough to foster fresh leaves and petals, despite the absolute barrenness of the rest of the locale. In an extraordinary drawing called *Lovers on Graves* he went so far as to propose that burial grounds carried an erotic charge, prompting people to copulate there even though corpses lie decomposing beneath them (Pl. 205). As their bodies writhe beside the wooden crosses, they take on a defiant aspect. The lovers appear to be revelling in their ability to assert the life force when death is so near. The Nietzschean cycle continues to maintain its momentum, and only when under fire on the Somme did Dix feel driven to agree with a quotation from Jeremiah: 'Cursed be the day on which I was born; the day on which my mother gave birth must have been unblessed.'[12]

Apart from such moments of despair, Dix had not yet arrived at the vehement anti-war stance which informs so many of his post-Armistice paintings and prints (see Pls. 366–75). He still saw the conflict in terms of a natural event, even though his 1917 drawings reveal the bestiality of battle with a passion wholly lacking in the contemporaneous war images of Jean-Émile Laboureur. He had already announced his playful attitude in 1916, with a copperplate engraving of *Spring in Artois* celebrating a soldier's dalliance with a young woman (Pl. 206). Carried out with a consummate elegance of line, this witty paean to the pleasures of courtship in a budding landscape conveys no hint of the terrible events Laboureur himself must have witnessed. Although he served as a French interpreter with the British army on the Western Front, he remained temperamentally averse to relaying the grimness of his experience even when Vernant published, in August 1917, a portfolio of his engravings called *Small Images of the War on the British Front*. The collection was prefaced with a quotation from Burton's *The Anatomy of Melancholy*, which declared that 'I hear new news every day, and those ordinary rumours of war . . . of towns taken, cities besieged in *France, Germany, Turkey, Persia, Poland*, etc., daily musters and preparations, and such like, which these tempestuous times afford, battles fought, so many men slain, monochamies, shipwrecks, piracies and sea-fights, peace, leagues, stratagems and fresh alarms.' But none of Burton's pessimism can be detected in the nine engravings Laboureur supplied for the portfolio. He delights instead in the innocent spectacle of balletic soldiers tripping through town, beating drums and playing on attenuated fifes. The choreography of marching engages his attention far more than the reality of war. He prefers to restrict himself to harmless scenes between soldiers and servant girls in the streets and cafés of provincial French towns. The final print does acknowledge the existence of the battlefield, but even here the scene is dominated by the stylish figure of an officer in spruce uniform and gleaming boots.

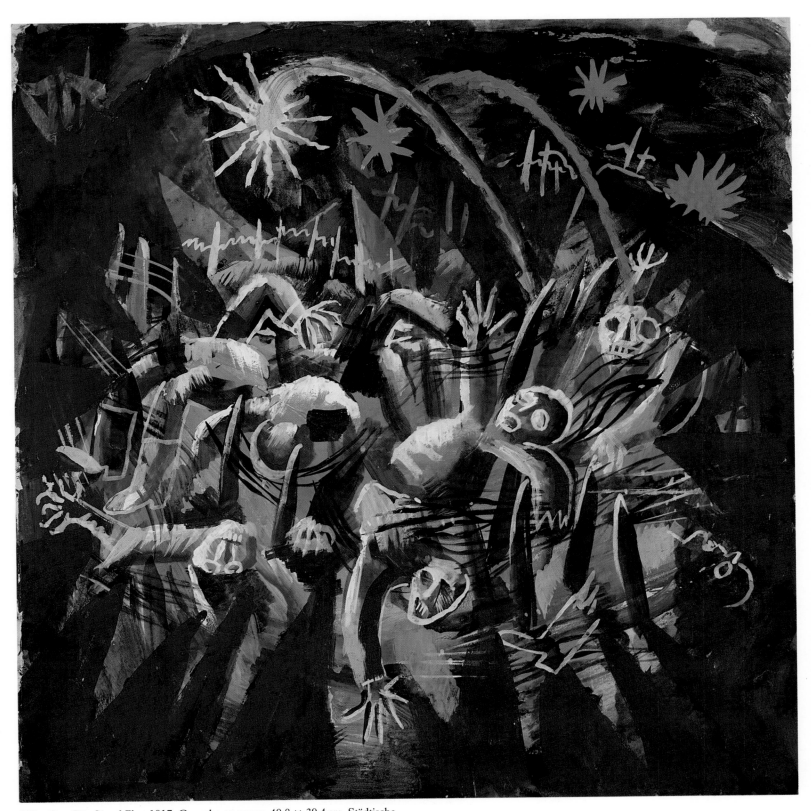

203 Otto Dix *Signal Flare* 1917. Gouache on paper, 40.8 × 39.4 cm. Städtische
Galerie, Albstadt. Stiftung Sammlung Walther Grosz.

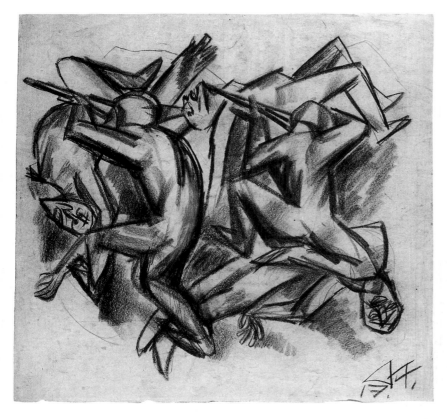

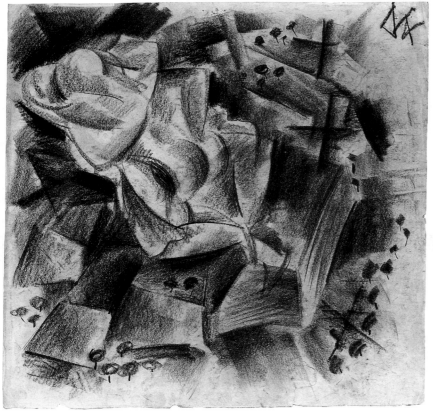

204 Otto Dix *Two Riflemen* 1917. Charcoal on paper, 39.5 × 41 cm. Galerie der Stadt, Stuttgart.

205 Otto Dix *Lovers on Graves* 1917. Black crayon on paper, 39.5 × 40 cm. Staatsgalerie, Stuttgart.

206 Jean-Emile Laboureur *Spring in Artois* 1916. Etching on paper, 13.5 × 17 cm. British Museum, London.

Pausing near the flowers clustered in the foreground, he adjusts his tie in front of a tent while troops and horses gather on a sunny hilltop like riders preparing for the excitement of a hunt.

Such a lighthearted tribute to the enduring virtues of sang-froid might have been understandable at the beginning of the war, when Dufy issued some propagandist prints which surely exerted a considerable influence on the development of Laboureur's style (see Pls. 54, 55). By 1917, though, such frivolity seemed jarringly misplaced. Too many soldiers had died, and Laboureur's whimsical detachment allied him with the values of fashion rather than of art. During the war it was possible for one writer to observe, of a presentation by French couturiers at the San Francisco international exhibition, that 'in the history of heroism Paris has created its wartime elegance, a cheerful and athletic elegance, and untrammelled, permitting the utmost ease of movement, should it even be that of raising up a wounded man or brandishing a weapon.'[13] Laboureur, devoted to the cut of a uniform rather than the tragedy of conflict, found his true niche in the luxurious *Almanach des Lettres et des Arts* for 1917. Here he published an advertisement for the Rosine perfume 'Mam'zelle Victoire' showing a French soldier leaping blithely over a minefield among a profusion of blooms.

André Lhote turned a similar Cubist-influenced style to more trenchant effect when he produced an incisive print of an artist painting a soldier's likeness – and then gave it the chilling title *Portrait of Someone who is about to Die* (Pl. 207). For the truth was that everyone had by now been forced to recognise, however reluctantly, that the soldiers involved in the war would be fortunate to emerge from it unscathed. More and more artists were prepared to let this realisation inform their images of the ordinary fighting man. In Gustave Pierre's *Soldiers Marching Off*, two of the *poilus* burdened with baggage gaze out at us as they begin their arduous journey. Their expressions are resigned and weary, as though they only expected more of the suffering encountered so many times before. The feeling was reciprocated on the German side, too. Meidner's ink study of *Soldier Karl Stein* portrays a grizzled campaigner, battered by his accumulated experience of front-line warfare, staring glumly into a distance that contains no hope of victory. The *poilu* slumped at the

superiority of his captors, Vuillard offers a direct, honest representation of the incident. He does, admittedly, view it from the vantage of the French officer who conducts the proceedings: we are invited to look over his shoulder as he questions the prisoner. But Vuillard does not disguise the shabbiness of the room, let alone elevate the interrogation with a spurious grandeur. The officer's desk is cluttered with bureaucratic paperwork, and the tarnished old heater occupies a prominent position next to the captive. A pipe extending diagonally from the heater to a rudimentary hole in the wall is presented in all its unsightliness, and Vuillard even includes a hook or noose dangling from the ceiling with unexplained yet ominous intent. Pale winter light falls on the floorboards and the panelled door, accentuating their dilapidation. The entire scene could hardly be further removed from all those warm, well-upholstered and sumptuously patterned domestic interiors which Vuillard had delighted in painting earlier in his career. No wallpaper alleviates the spartan sobriety of these grey walls. The room remains deeply inhospitable; and all the prisoner can do is stand, blanched and expressionless, behind surrendered possessions laid out like unwanted goods at a jumble sale.

207 André Lhote *Portrait of Someone who is about to Die* 1917. Etching on paper. Musée d'Histoire Contemporaine – BDIC, Hôtel National des Invalides, Paris.

208 Edouard Vuillard *Interrogation of the Prisoner* 1917. Distemper on paper laid down on canvas, 110 × 75 cm. Musée d'Histoire Contemporaine – BDIC, Hôtel National des Invalides, Paris.

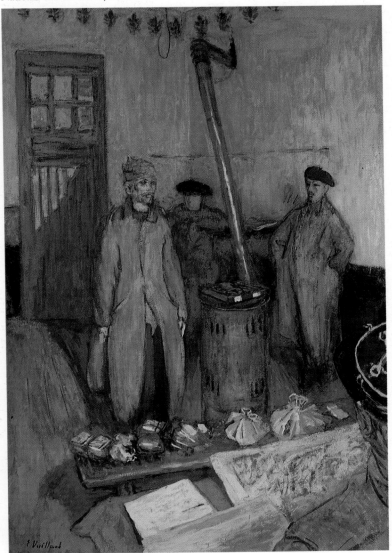

table in Dunoyer de Segonzac's *At the Bistro* exudes a related sense of helplessness, accentuated by the blankness of eyes determined to prevent him from reliving the ordeals he has undergone.

This deliberate adoption of detachment was a last resort, the only way of coping with a reality which would otherwise become intolerable. Vuillard found it in the gaunt face of the captured German soldier under interrogation, a ritual he had observed on several occasions during his spell as an official war artist. Although the middle-aged painter had not relished his previous spell of duty, guarding the approach to the Gare de Lyon in the winter of 1914, he responded to Clemenceau's invitation, early in 1917, by spending three weeks at the Front with another artist, Paul Baignères. It was cold and uncomfortable at Gérardmer in the Vosges, where Vuillard spent much of his time making pastel studies of *The Sentinel* scanning a snow-laden forest with binoculars. But his diaries disclose that the soldiers resented the presence of the privileged artist, and he produced his most memorable war image after returning to the seclusion of his Paris studio.

Interrogation of the Prisoner is a bleak painting, utterly devoid of any attempt to invest the scene with patriotic significance (Pl. 208). Far from gloating over the humiliation of an enemy, and stressing the

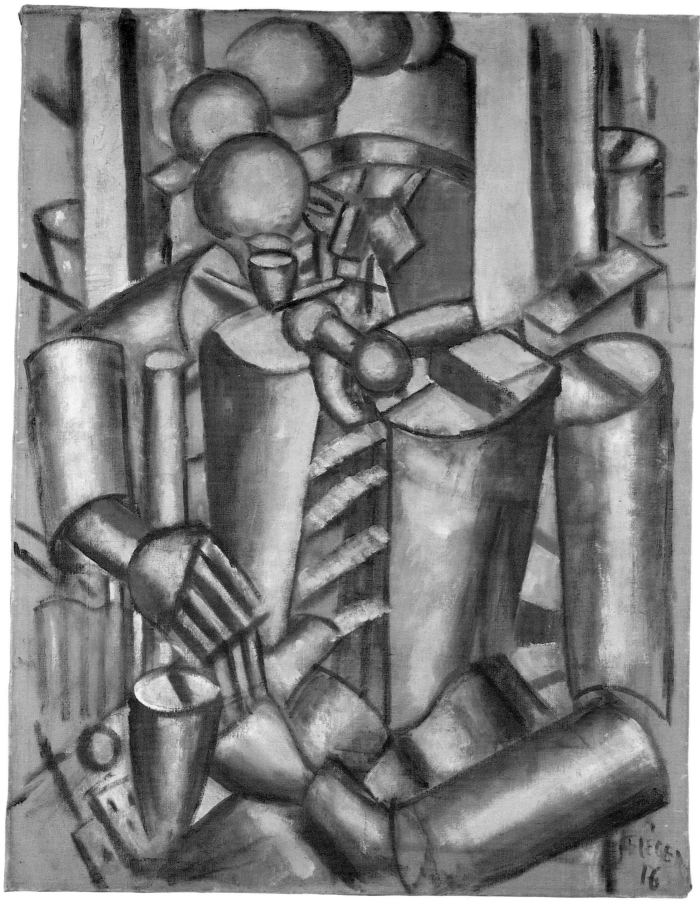

209 Fernand Léger *Soldier Smoking* 1916. Oil on canvas, 130 × 97 cm. Kunstsammlung Nordrhein-Westfalen, Düsseldorf.

Even Léger, who had produced work in the early part of the war stressing the purposeful dynamism of his fellow-soldiers, was affected by the drabness Vuillard defined. On leave in Paris during the summer of 1916, he managed to paint a large picture which dispenses with the clangorous palette of his pre-war work. *Soldier Smoking* is virtually restricted to a subdued range of white, sepia and umber, roughly handled on a pale brown canvas (Pl. 209). An unexpected area of scarlet sings out from the man's cheek, perhaps reflecting the fact that the picture derived from studies of a wounded soldier waiting with a bandaged head at the Verdun Front. But apart from this inflamed segment, and two patches of deeper red on the *poilu*'s right arm and hand, austerity prevails. Sitting in his dug-out for a period of rest, the soldier puffs at his pipe and attempts to relax. Léger does not, however, present a figure who has cast aside the discipline and vigilance required in front-line duty. On the contrary: this *poilu* remains rigidly erect, and his body seems to have been assembled from mechanical components rather than flesh and blood. The piston-like arms are treated as a sequence of separate parts, riveted at the elbows, and the armour-plated sections of his coat open at the middle to reveal equally metallic structures within.

Soldier Smoking elaborates on a grand scale Léger's vision of the *poilu* as an embodiment of the machine age. Formidable even in repose, and puffing clouds of smoke as round and solid as cannon-balls, he fills most of the picture-space with his bulk. This doughty figure exemplifies Léger's realisation that his period of 'abstraction' before the war had now been superseded by 'four years that threw me suddenly into a blinding reality that was entirely new to me ... I found myself on an equal footing with the whole French people. Posted to the sappers, my new comrades were miners, labourers, artisans who worked in wood or metal. I discovered the people of France. And at the same time I was suddenly stunned by the sight of the open breech of a .75 cannon in full sunlight, confronted with the play of light on white metal ... It came as a total revelation to me, both as a man and as a painter.'[14] The revelation prompted him to paint *Soldier Smoking* as if the 'light on white metal' gleamed on the *poilu*'s buttressed figure as well.

But as time went on, even Léger was obliged to recognise that his new-found friends in the French army could not all remain as impregnable as his mechanistic vision implied. Maybe the flaring red side of the soldier's face was meant to signify blood – grim evidence that the wound he had sustained might eventually weaken his proud, redoubtable stance. By October 1916, Léger was certainly prepared to admit the vulnerability of the two dead soldiers he had found in a shell-hole on the Fleury road (Pl. 210). He sent this small but unusually elaborate drawing as a postcard to Yvonne Dangel, marking the retaking of Douaumont. The image may have been indebted, as Christopher Green has suggested,[15] to a photograph of two dead soldiers published on the cover of the widely-read *Le Miroir* a fortnight earlier (Pl. 211). But the differences between the two pictures are significant enough to indicate that Léger also based his drawing on an observed scene. As the caption in *Le Miroir* confirms, the photograph shows a French soldier with his German opponent, and they both lie side by side like a couple of friends sleeping together. In Léger's drawing, on the other hand, they remain apart. Death isolates rather than unites the two bodies, and the upper figure's outstretched fingers fail to make contact with the soldier sprawled beside him.

If humans could shed their metallic invincibility, and end up crumpled and alone in the gouged earth, so too could machines themselves. However much Léger admired the glinting mass of a

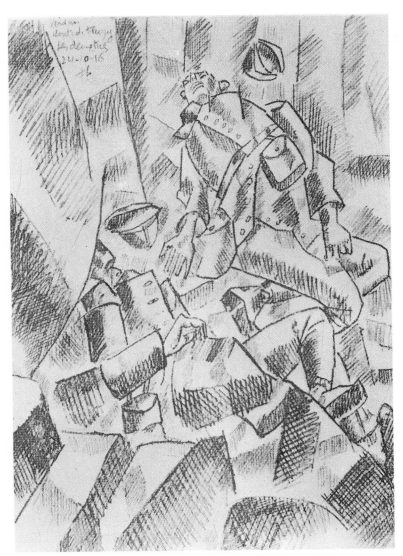

210 Fernand Léger *On the Fleury Road, two killed* 1916. Pen and ink on postcard, 12 × 8.25 cm. Private collection, France.

211 Cover of *Le Miroir*, 8 October 1916.

212 Fernand Léger *The Crashed Aeroplane* 1916. Watercolour on paper, 23.5 × 29.5 cm. Musée National Fernand Léger, Biot.

cannon's breech blocks, he also took the trouble to base two water-colours on *The Crashed Aeroplane* (Pl. 212). In one respect, it is a jaunty image: the brilliant red, white and blue markings on the undulating yellow wing dominate the composition, and the fresh green smudge of dancing foliage above proves that nature has retained its verdancy after the smash. But the fact remains that the plane is now useless. It can no longer be ranked with the proud, intact machinery Léger relished as he surveyed his army's weaponry. Rather is it closer to the damaged form of *The Wounded Soldier* he finally painted in 1917.

This hunched and twisted figure is incapable of occupying the canvas with the robust certitude of *Soldier Smoking*. All that iron repose has been lost, and in its place a victim appears. His face seems larger than the torso beneath, which lacks the stern, four-square expansiveness of the earlier *poilu*-as-machine. However much Léger continued to rejoice in the comradeship of his fellow-soldiers, and the 'essence and meaning'[16] of the objects around him at the Front, the mounting damage sustained by the French army obliged him in 1917 to modify the proud dynamism of his earlier war pictures.

There was a personal reason for the shift in vision, too. Having been fortunate enough to escape serious injury himself, Léger finally succumbed to a gas attack on the Aisne Front in the spring of 1917 and was invalided out of his regiment. The experience made him predisposed to acknowledge the plight of the soldiers he encountered in hospital, and plans to make a grand painting from a series of festively coloured *Trench-digger* studies were abandoned.[17] All the same, the monumental canvas he executed later in the year, during his convalescence at the Hôpital Villepinte just outside Paris,[18] returned to a theme Léger had explored two years before. *The Card Players*, the painting he had executed with the aid of coloured scraps of paper on a shell-crate in 1915 (see Pl. 104), served as the starting-point form this ambitious new picture. He retained the fundamental idea of three men grouped at a table, but in most other respects the image underwent a profound transformation. The players in the 1915 picture were seen out of doors, in a shelter surrounded by trees. Léger now moved them away from the spaciousness of this open-air

setting, lodging the figures in a claustrophobic dug-out instead. He took his cue from an ink drawing made on the Aisne Front early in 1916, where the subterranean location is already implicit (Pl. 213). The move indoors led him to minimize the figures' context, however. Everything is focused on a close-up of the players, rearranged so that one of them is placed on the right to balance the design. The symmetry of Cézanne's card-players is thereby invoked, no doubt deliberately as an act of homage. Even so, the mood of the final *Card Game* painting is quite different from the quiet, pacific concentration of Cézanne's Provençal peasants (Pl. 214).

Dispensing with the two candles that give the ink drawing its intimacy, Léger also decided to widen the table so that the players seem to be pursuing their game across the ridged surface of a bare, uncompromising arena. The mustard yellow deployed here promotes a feeling of parched, almost bilious unease, as if the convalescent artist were still affected by nauseating memories of the gas attack he had suffered. There are other signs that Léger regarded *The Card Game* as a chance to exorcise, on a monumental scale, the gathering disquiet he had experienced over the previous year. For this strange painting makes the card-playing soldiers he depicted in 1915 seem innocent by comparison. However machine-like they may have been in the shell-crate painting, the figures there lack the tense, heavily metallic deliberation of the men who confront each other in *The Card Game*. The width of the canvas enables Léger to build up the *poilus* into mechanistic presences more awesome by far than their pre-decessors among the trees of Argonne. There is no suggestion, now, that the players are simply amusing themselves. They appear to be engaged in a momentous activity, a war game requiring them to deploy the full resources of the twentieth-century armour in which they have been clad.

The stance assumed by the player on the right of the composition undoubtedly derives from his counterpart in the 1916 ink drawing, but he has now been transformed into a thorough-going robot. His face is painted in the same gunmetal grey as the helmet wedged so firmly on his head, and any distinguishing features he may once have possessed are replaced by an anonymous mask. Although the pipe he puffs should be peaceful, it emits smoke palpable enough to bombard

213 Fernand Léger *The Game of Cards* (fragment) 1916. Pen and ink on paper, 16.4 × 22.3 cm. The Museum of Modern Art, New York. Gift of Mr and Mrs Daniel Saidenberg.

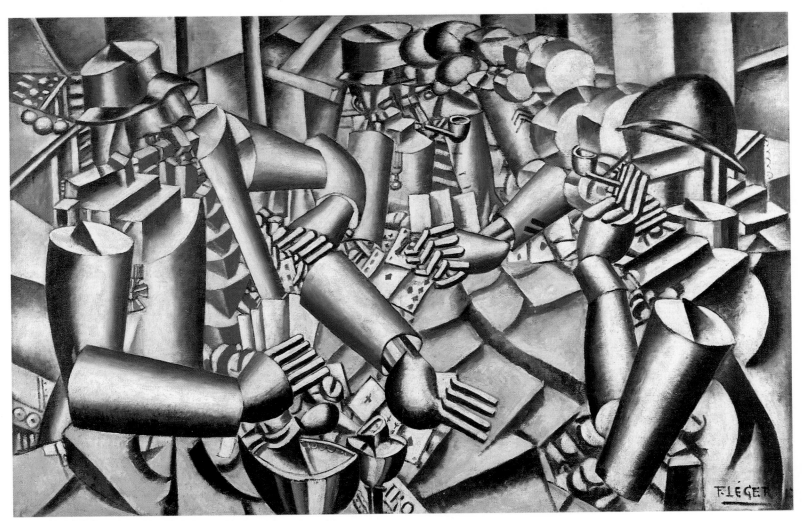

214 Fernand Léger *The Card Game* 1917. Oil on canvas, 129 × 193 cm.
Kröller-Müller Museum, Otterlo.

his neighbour with clouds as solid as his limbs. The smoke issuing from the latter's pipe is equally substantial, and so the two rivals do battle with each other in the air as well as on the card table. Utimately, though, the soldier on the left ensures that most of the pictorial action is concentrated on the players themselves. The bulkiest of all the figures, he takes up an immense amount of space in a strenuous attempt to turn the game in his favour. While his left elbow juts out in an aggressive sideways direction, so that it threatens to collide with his companion, his right arm rests on the table as masterfully as a seasoned champion. The medal partially visible on his chest proclaims the extent of his courage in the field, and through the gap in his jacket a formidable spine of triangular red segments mounts towards his head. Flesh and blood are replaced, within as much as without the body, by the machine-age geometry Léger himself admired.

There is no room for unnecessary sentiment in this impersonal world, and the man surveys his opponents with a cold, ferocious eye. While they keep their hands close to their sides, he lays out his cards with a forearm and hand that seem, uncannily, to have become detached from the rest of his left arm. Since no such intention can be discerned in the 1916 ink drawing, it is tempting to conclude that Léger was motivated here not just by a desire simultaneously to represent successive stages in an arm's movement, but also by a

fascination with the mechanical limbs he might well have seen in the Hôpital Villepinte. His profound involvement with machine metaphors would have predisposed him to be impressed by such appliances, and their relationship with patients who had to rely on artificial limbs. The stiff, pronged fingers take up a prominent position in the painting as they stretch across the table, implying a belief on Léger's part that the war had brought man and the machine into a new, conclusive unity.

Despite its disturbing vision of a game played out with cold, dehumanized violence, *The Card Game* is not fundamentally a pessimistic image. It savours the players' iron resolve, and remains devoid of the corrosive loathing and disgust that led Grosz, in the very same year, to turn another game of cards into a celebration conducted by three sex-murderers after raping and dismembering their female victim. Léger's painting has nothing to do with such brutality and degradation. It possesses immense statuesque dignity, and he later described it as 'the first picture in which I deliberately took the subject from my own time'.[19] Its grand realist engagement with an almost sculptural grasp of the modern world decisively replaced his earlier exploration of the fragmentation inherent in 'dynamic divisionism'. This precisely organized, elaborate and assured painting was a demonstration of his ability to recover from the trauma of war-injury, and it ushered in his sturdy engagement with post-war society.

215 Ossip Zadkine *Wounded Soldier* 1917. Charcoal on paper, 34 × 26 cm.
Musée d'Histoire Contemporaine – BDIC, Hôtel National des Invalides, Paris.

Study for The Card Game, a painting executed the following year, shows how Léger still regarded the machine age in an optimistic light. Active service at the Front had been, for him, an overwhelmingly positive experience, and in 1925 he even felt able to claim that 'I find a state of war far more desirable than a state of peace . . . Current life is a state of war, that is why I have such a deep admiration for my epoch: a hard and shrill one, but which, with its immense spectacles sees clearly and strives to see ever more clearly.'[20]

Only later would Léger's views on war alter significantly, in response to the advent of a further world conflict. But other artists who shared his awareness of wounded soldiers in the Great War were more prepared, in 1917, to emphasize the vulnerability and pathos of the patients around them. When Léger drew the interior of the Hôpital Villepinte, he subordinated the occupied bed and slippers to the side of an image dominated by the hospital stove.[21] Zadkine, by contrast, gave his ward's inhabitants a central role in the charcoal drawings he produced after gruelling service as a stretcher-bearer in the Epernay ambulance unit, picking up the wounded at the Front and helping them back to shelter. Ionel Janou recorded that Zadkine's 'close contact with human suffering and death upset him terribly',[22]

but even after severe gassing he was prepared to return to the same ambulance unit at Reims. His compassion, anguish and commitment inform the drawings inspired by these experiences. A swift, confident study of a crippled soldier finds room for the contours of several starkly defined iron beds (Pl. 215). Even so, Zadkine brings most of his attention to bear on the figure with a truncated leg who hobbles through the ward. The dangling stump is isolated against the bare floor, and the patient's unsteadiness is accentuated by the conflicting perspectives adopted in the drawing. Whereas Zadkine looks down on the beds from a high vantage, he abandons this aerial position when defining the soldier's figure. This deliberate disparity, practised with confidence by an artist who had been conversant with Cubist ideas in his pre-war sculpture, evokes the dizzying sensation experienced by the cripple as he struggles to cope with his disability.

Compared with many of the soldiers who sustained severe injuries at the Front, though, this patient was lucky. He had at least survived, presumably with the help of the medical service whose activities Zadkine drew in another disorientating charcoal study, *Red Cross Stretchers and Vans*. A lot of the wounded had no such assistance and were forced to fend for themselves in the aftermath of battle. Forain's drypoint *The Milestone – Verdun* shows just such a victim (Pl. 216). With blood flowing freely from his downturned head, the *poilu* has given up the struggle for life. Since the milestone itself bears the inscription 'VERDUN 11 Kil.', he may have managed to stagger or crawl some distance from the battle before death occurred. But Forain, who had joined the army at the age of 62 in 1915 before working as a roving correspondent for *Le Figaro* and other publications,[23] shows fallen soldiers lying behind the *poilu*. In the four successive states of this print he darkened the area around the milestone to intensify the inevitability of death. Although Forain was capable elsewhere of depicting the war with knockabout humour, most memorably in his rousing illustration of a French soldier kicking a German opponent vigorously in the buttocks, he preferred to concentrate on the horror of war as it affected both army and civilians. Like Goya before him, Forain reserved his greatest pity for the women and children martyred by the conflict, but in the *Milestone* print he invested the sprawling *poilu* with an elegiac intensity.

216 Jean-Louis Forain *The Milestone – Verdun* 1916. Typogravure on paper, 28.4 × 40.4 cm. Musée d'Histoire Contemporaine – BDIC, Hôtel National des Invalides, Paris.

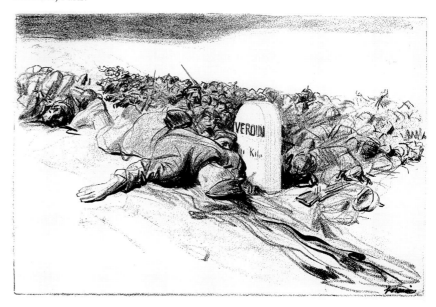

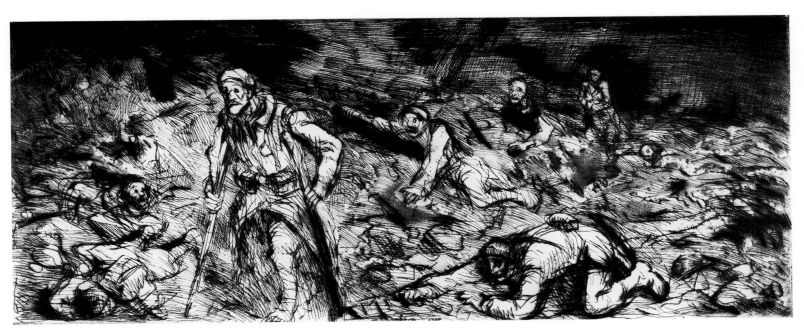

217 Théophile-Alexandre Steinlen *Land of Terror* 1917. Etching on paper,
20 × 43.4 cm. Musée d'Histoire Contemporaine – BDIC, Hôtel National des
Invalides, Paris.

Another version, smaller and lighter than its predecessor, eliminates the reference to Verdun from the milestone. White and empty beside the ungainly form of the body, it now resembles a tombstone left blank to reflect the anonymity of his death.

Some *poilus* were both ready and strong enough to carry their comrades away from the field, as Steinlen revealed in his wash drawing of *The Two Friends*.[24] But such initiatives remained vastly outnumbered by the occasions when no assistance was available. In a despairing image called *Land of Terror*, executed the same year, Steinlen abandoned all hope of merciful intervention on the victims' behalf (Pl. 217). He knew that it was often fanciful to suppose that help would be forthcoming for most of the men left maimed on the darkened battlefield. The surviving figures strewn across the corpse-laden ground look up in vain for support. One musters sufficient strength to raise an entreating arm, while another crawls on all fours towards the sole man left upright. He has been crippled himself, however, and lurches away from the carnage with the melancholy resolve of someone who knows there is one selfish course of action left to pursue.

As life at the Front became harder to bear, an increasing number of soldiers were driven to attack their own bodies in a last-ditch protest. Even the optimistic Franz Marc had admitted, in the war's early months, that 'I understand for the first time why suicide would be proper in this wasteland.' Marc himself never put this momentary insight into action, but later in the war it became far more difficult to resist. 'Self-inflicted wounds weren't uncommon on the Western Front', recalled Siegfried Sassoon, 'and brave men had put bullets through their own heads . . . especially when winter made trench warfare unendurable.'[25] Bomberg, who had enlisted in the Royal Engineers towards the end of 1915, stopped well short of attempting suicide. All the same, his existence became so intolerable that he was impelled to make a despairing gesture. The death in 1917 of the critic T.E. Hulme, who had championed his work before the war, must have worsened Bomberg's depression. He had already lost a brother in the war, along with countless army friends, and at one stage planned a monument to Hulme with the bowed figure of a mourning soldier in attendance. But grief and hopelessness engulfed him so powerfully that he 'deliberately put the gun to his foot and pulled the trigger.'

Bomberg never offered a detailed explanation for this drastic act, apart from telling his first wife that 'life in the trenches had had that effect on him and he was beyond caring about the rules of the war game.' He wanted to forget the incident after telling her about it on his return from the Front, and yet he had been quite open in confessing to his superiors. Ignoring the Adjutant's attempt to make him 'say that it was an accident', Bomberg 'insisted that he had fired the shot deliberately, because he had found life too hard to bear – and must make some protest, whatever punishment it brought.' In the event his sentence was light for such a serious offence: self-inflicted wounds had by now grown too common to be handled with the maximum severity. When his recovery was complete, moreover, Bomberg found that he 'had no fear now that he had made his protest'. Even so, a double-sided wartime drawing can be related to the experience he initially underwent after 'the shot was heard and he was quickly bandaged up and put in hospital.'[26]

While recovering from his injury, Bomberg doubtless witnessed the arrival of wounded soldiers. On one side of this vivid study, where preliminary pencil lines have been strengthened by forceful strokes of ink, several men cluster round a prone figure on a table (Pl. 218). One of the attendants clasps the patient's left arm, and on the other side a helper leans urgently forward as though to administer life-or-death resuscitation. The outcome of their efforts is in doubt, for the wounded man lies motionless with eyes closed. Bomberg's whiplash contours convey the strenuousness of the orderlies' commitment to their task, and in this respect he offers grounds for hope. But the other side of the drawing is more pessimistic (Pl. 219). Although the assistants continue their attempts to revive the victim, the contrast between their anxious energy and his stillness is ominous. Compared with the body on the reverse version, he seems to have become more rigid. His face is reminiscent of a death-mask, and the body has assumed a corpse-like stiffness. Despite the manifest involvement of the orderlies, who appear almost to be willing some of

218 David Bomberg *Figures Helping a Wounded Soldier* c. 1916–17. Recto. Pen, ink and pencil on paper, 12.5 × 17 cm. Private collection, London.
219 David Bomberg *Figures Helping a Wounded Soldier* c. 1916–17. Verso. Pen, ink and pencil on paper, 12.5 × 17 cm. Private collection, London.

their vitality into his figure, the struggle now looks futile.

Bomberg's prompt return to active service meant that he had no opportunity to develop this powerful little study into a painting: the Adjutant decreed, perhaps as part of his punishment, that Bomberg was 'given the post of Runner for his Unit, which meant going through the hottest part of the firing.'[27] Here, no doubt, he encountered the grisly human remains which led him to write a bitter, protesting poem:

> What's left of the soldier-man, killed on
> patrol, some months back? Only
> a shrapnel hat, turned upside
> down; — lying apart, some
> sun-burnt bones, a hard
> tanned hairy hide, and rags
> mouldering in the flowering
> thistle-down.[28]

None of this anger is detectable in a careful pencil study called *Field of Fire*, which suggests that Bomberg was encouraged to use his skills as a draughtsman for purely military ends, plotting the position of two Observation Posts commanding 'all movement on the railway and

tracks during the day & when observation is possible'.[29] In its precision, Bomberg's drawing recalls the earlier plan produced by Louis Marcoussis for artillery and camouflage emplacement in the French army. Both he and Bomberg would have been commended for devoting their abilities as artists to such practical ends. But if Bomberg had executed a full-scale painting on his wounded soldiers theme, the authorities would surely have prevented him from exhibiting it. As Nevinson discovered, in his new-found role of official war artist, the British government forbade the public display of any images which showed its soldiers in an unfavourable or distressing light.

Nevinson's appointment by the Department of Information in April 1917 was therefore something of a surprise. It reflected well on his employers, for they wanted to commission work more arresting than the tame pictures already produced by Bone (see Pl. 177) and Dodd. But they were to be disappointed. Having shed most of his Futurist language, Nevinson failed to find an alternative style which would produce equally compelling results. Removed from the close involvement with suffering which had fed his earlier war paintings, he lost his critical edge. A luxurious billet in the Château d'Harcourt probably nurtured a more accepting mood, and he became caught up in the heroic choreography of aeroplane pictures. Nevinson later claimed that they were 'the finest work I have done. The whole newness of vision, and the excitement of it, infected my work and gave it an enthusiasm which can be felt.'[30] But they entirely lack the questioning moral anger of his previous war canvases (see Pls. 76–7), and Nevinson was unwilling to admit in these uniformly valorous images that pilots often ended up dead on the ground. Even the Futurist Sironi conceded, in his stark tempera painting of a ditched aeroplane, that an ignominious fate awaited the war machines which had flown triumphantly through the sky in pictures he executed only a couple of years before (see Pl. 68). But Nevinson's love affair with aerial conflict prevented him from tackling its tragic aspects, and his bureaucratic patrons felt disappointed with the outcome. C.F. Masterman, head of the propaganda department, complained that Nevinson had 'abandoned his own *metier* in order to produce *official* (perhaps dull) pictures', and exhorted him to 'develop his own genius – however bitter and uncompromising.'[31]

Nevinson, however, was never able to satisfy his new employers. When he did produce two tougher pictures, and proposed to include them in his second one-man show at the Leicester Galleries the following year, Colonel Lee stepped in to suppress them. One of the paintings, *A Group of Soldiers*, seems unexceptional to the point of banality today. But Lee censored it because 'the type of man represented is not worthy of the British Army',[32] and he was afraid that if the disputed canvas 'ever gets into German hands I will lay a shade of odds that the Germans will use it against us.'[33] Nevinson believed such fears were absurd, and he protested to Masterman with all his old uninhibited fire: 'I will not paint "castrated Lancelots" though I know this is how Tommies are usually represented in illustrated papers etc. – high souled eunuchs looking mild-eyed, unable to melt butter on their tongues and mentally and physically incapable of killing a German. I refuse to insult the British army with such sentimental bilge. I might mention that all these four men in this particular picture, are portraits, men I chose quite haphazard [*sic*] from the Tubes as they came from France on leave.'[34] In this instance, although Masterman supported Lee's objection, John Buchan intervened in his new capacity as Director of the Department of Information. Perhaps he sympathized with the sarcasm of Nevinson's request that 'if you would just let me know what you consider a pretty

man, I will in future paint all my soldiers up to your ideal.'[35]

The final clearance won by *A Group of Soldiers* was not, however, extended to Nevinson's other controversial painting (Pl. 220). It bore the title *Paths of Glory*, a phrase often used by patriotic writers of the period and more than acceptable to the government authorities. But Nevinson, presumably aware that the complete line described how 'the paths of glory lead but to the grave', used the phrase ironically. He showed two soldiers, their British nationality clearly displayed by uniforms and prominent helmets, lying dead in a morass of water-logged mud and barbed-wire fencing which snares their bodies. Nevinson may well have based the painting on first-hand observation, for he explained in the catalogue of his second one-man show that 'all of my work had to be done front rapid short-hand sketches made often under trying conditions in the front line.'[36] Moreover, he claimed later that 'what I had painted in "The Paths of Glory" was reality.'[37]

No one could have disputed his assertion about the authenticity of the picture, and yet it challenged the euphemistic view of the British soldier in death put forward by newspapers like the *Daily Mirror*, where W. Beach Thomas claimed of the slaughtered Tommy: 'Even as he lies on the field he looks more quietly faithful, more simply steadfast than others.'[38] Accordingly, the War Office objected to the painting's inclusion in the exhibition because dead soldiers were depicted. Nevinson was informed that, since 'no photographs of the dead were allowed',[39] *Paths of Glory* was unacceptable. While Major Lee had no objection to paintings of dead Germans (see Pl. 263), he refused to countenance pictures of slaughtered Tommies. Although Lord Derby refused to open the show when he 'heard of the trouble I was having with the censors',[40] Nevinson insisted on including the disputed canvas. 'Under the belief that the censors would pass it at the last moment I had it hung,' he recalled, 'and when permission was finally refused I pasted brown paper over it rather than leave a hole on the wall, and wrote "Censored" across it in the manner of French newspapers.'[41] When the *Daily Mail* published a photograph of the exhibit,[42] with the diagonal strip covering most of the soldiers' bodies, Nevinson received a summons to the War Office. He was 'severely reprimanded for using the word "Censored", which appeared to be a word forbidden by the Defence of the Realms Act (D.O.R.A.).'[43]

220 Christopher Nevinson *Paths of Glory* 1917. Oil on canvas, 45.7 × 61 cm. Imperial War Museum, London.

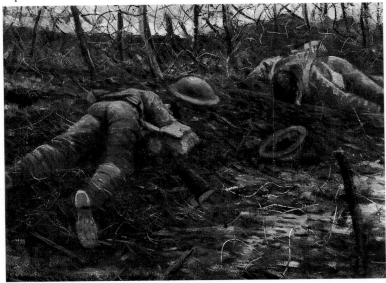

221 Henry Moore *Roll of Honour* 1917. Oak, 172.7 × 76.2 cm. Castleford High School.

The artist himself admitted in the catalogue of his one-man show that 'this exhibition differs entirely from my last in which I dealt largely with the horrors of War as a motive.'[44] The poster he produced for the event, where red silhouettes of bayonets stab the air, presented an image belligerent enough to be used as government propaganda for the British army's continuing invincibility. Indeed, it appears to have become popular in official circles for this very reason. Nevinson wrote to Masterman asking him to 'advise me as to whom to apply on the War Bond Poster Dept as I want to give them my red bayonet poster. They seem to want it as I notice they are always cribbing it – and none too well – in some effect or other.'[45]

The only public manner in which it seemed permissible fully to acknowledge the ever-mounting human cost of war was through the Roll of Honour, a dignified list of names installed in most British schools. At Graham Greene's school, Berkhamsted, his headmaster father spoke proudly of the Old Boys who had volunteered for the sake of their country. The school's Roll of Honour was intended, in that sense, to salute their bravery, but Greene himself remembered it as a sombre record of carnage: 'outside the school chapel there was a list of old boys killed, plaque after plaque in double column, to remind us of the recent years.'[46] As the death toll grew, so the strain on Greene's father became more difficult to bear. Claud Cockburn, also a pupil at the time, described how 'most of the sixth form was wiped out, year after year, and he'd sit there teaching the sixth form, then they were called up and 80 per cent of them would be killed. I know when I was in the sixth form, I think only about ten per cent or so of the previous year were still alive, and we thought that was life. So it was, so it was, but it must have been an appalling experience for a man of his great liberal mind.'[47]

Whether or not the headmaster of Henry Moore's Secondary School at Castleford shared this anguish, he commissioned his pupil to carve a rather more elaborate Roll of Honour (Pl. 221). Soon after the war commenced he had read out a telegram from Lord Kitchener commending the Yorkshire town for its high number of army volunteers, and the headmaster ensured that the Roll of Honour occupied a prominent position in the school's entrance hall. It provided the young Moore with the opportunity to make what he later described as 'the first serious wood carving I did.'[48] He never forgot 'the pleasure I felt when I first used a hammer and chisel'[49] to incise the name of the school and the roll itself at the top of the tall oak panel. His previous carving had been carried out with a penknife,[50] and access to his art teacher's carving tools proved a revelation. As if to celebrate his delight, he cut a spirited little caricature of his headmaster on the back of the panel, along with the proud inscription 'DESIGNED AND EXECUTED BY H.S. MOORE'. The commission was instrumental in making him realise that 'I like carving as a physical occupation, better than modelling'.[51] It thereby helped him to define his early identity as a sculptor, but the list of names in gold paint on the panel's three columns grew longer and more melancholy as the war proceeded. 'By 1917 quite a number of old students of the secondary school had joined the armed forces', Moore recalled, 'and some had already lost their lives or been wounded.'[52] An early photograph reveals that the base supporting the Roll of Honour originally bore an extract from a popular war song:

> Though our lads are far away
> They dream of home.

Far from stressing military valour or nationalist pride, the words reflect the sadness which grew in Castleford as more and more young men left school to fight at the Front. Eventually the Roll of Honour bore the names of ninety-one former pupils, a formidable number for such an institution, and Moore's own name was among them.

He sent back a jaunty ink sketch of himself as *Private H.S. Moore* in a letter to his art teacher (see frontispiece). But no drawings survive from his subsequent period of active service at Cambrai, where he was gassed in November 1917 and sent back for convalescence to England. Although he was fortunate enough to make a complete recovery, and never afterwards made work overtly alluding

222 Max Ernst *Battle of the Fish* 1917. Watercolour on paper, 14 × 20.5 cm. Private collection.

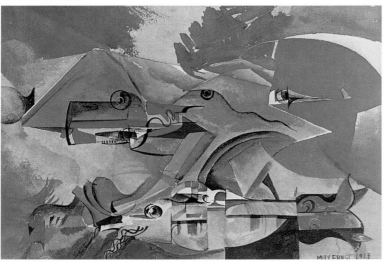

to his experience in the trenches, Moore's war period may well have informed the most vulnerable of his later sculptures. Unlike the majority of his figures they are, significantly, male—as his comrades at the Front had been. Although he explained that *Warrior with Shield* 'evolved from a pebble I found on the seashore in the summer of 1952, and which reminded me of the stump of a leg amputated at the hip',[53] the pebble could have stirred memories of similar deformations Moore observed at Cambrai. He saw many of his fellow-soldiers receive fatal wounds during an attack on Bourlon Wood; and after the effects of gas obliged him to walk to the field hospital, the patients he found there could easily have included soldiers with bodily truncations as grievous as the amputated warrior Moore modelled thirty-five years later.

The traumatic effects of military service should never be underestimated, even on someone as fortunate as Moore who served for only a short time at the Front. Although some of the artists serving in the armed forces may have wanted to avoid reflecting the war in their work, they often ended up making images which relate to their experiences of battle. Max Ernst, who volunteered for the field artillery with his brother Carl as early as August 1914, had no wish to depict the hostilities directly. He met Grosz and Wieland Herzfelde in 1916, during an exhibition at the *Der Sturm* gallery, but did not share Grosz's commitment to using art as a pictorial weapon against the war. As Ernst's experience at the Western Front deepened, however, so did his hatred of the conflict. In 1917, when he was posted to the 36th Prussian Regiment, he finally embarked on a strange sequence of watercolours and a woodcut with titles that refer indirectly to the aggression surrounding him: *Battle of the Fish* (Pl. 222), *Machine-Menace* and *Victory of the Spindles*. Ernst came to realise that it was impossible to escape from the horror of war. 'Shouting, swearing, spewing get you nowhere,' he wrote afterwards, before adding that 'there's no point either in trying to wrap yourself up in contemplation.'[54] However hard he tried to regard his imaginative resources as a buttress against reality, the battlefield invaded his work and took the form of mysterious underwater engagements between the denizens of the sea.

Why did Ernst's 1917 watercolours concentrate on images of fish? One answer may be that he became fascinated by the illustrated accounts of the Imperial Navy's submarines, for they were published in many German periodicals at the time. The main reason, though, must surely lie in the environment Ernst was obliged to endure. Sent to the Eastern Front for a brief tour of duty, he found himself in a treacherous, lice-ridden area where reconnaissance patrols often sank forever into the marshes. The Western Front was even worse. Henri Barbusse once claimed that, to the soldiers stationed there, hell was water. By 1917 the entire Passchendaele landscape had degenerated into a panorama of mud, and torrential rain made the area virtually uninhabitable. In *Goodbye to All That*, Robert Graves related that 'only once, so far as I know, apart from Christmas 1914, did both sides show themselves in daylight without firing at each other: one February at Ypres, when the trenches got so flooded that everyone had to crawl out on top to avoid drowning.'[55] *Battle of the Fish* and its related images may therefore be metaphors for Ernst's experiences of a waterlogged wasteland, where heavy downpours came to be anticipated with dread. One trench newspaper described how 'this simple word, rain, which means next to nothing to the civilian, with a roof over his head, this word encapsulates the horror of the soldier in the field.'[56]

The nightmarish effect of heavy rainfall on the battlefield certainly

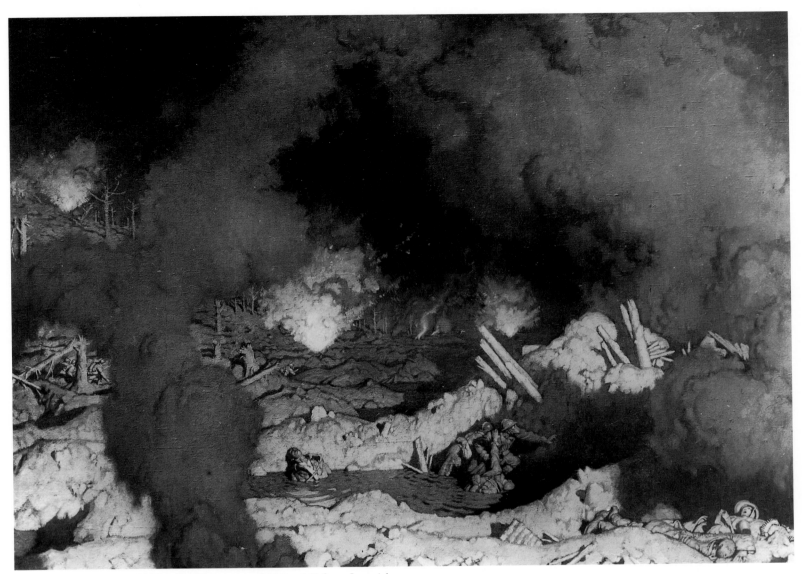

223 Georges Leroux *Hell* 1917–18. Oil on canvas, 114.3 × 161.3 cm. Imperial War Museum, London.

impressed itself on Georges Leroux, whose painting of *Hell* arose from a gruesome scene in Belgium which he had witnessed in 1917 (Pl. 223). 'When returning from a Camouflage Reconnaissance', Leroux wrote later, 'I saw a group of French soldiers sheltering in a big shell hole, the bottom of which was full of water, as was all the neighbouring district. The same evening I made a memory sketch and at the same time I made the necessary notes of the nature of the country in the sector.'[57] Smoke also plays a significant part in the macabre panorama he painted, and some of the soldiers wear masks to protect themselves from the asphyxiating fumes. But the water-heavy craters, where men have been left to drown, are equally disturbing. They help to explain why Ernst, in the very same year and in a far less academic vein, became obsessed by the underwater theme, and why Erich Maria Remarque could afterwards describe in *All Quiet on the Western Front* how a soldier planned to evade the enemy by resorting to a submarine expedient: 'I lie huddled in a large shell-hole, my legs in the water up to the belly. When the attack starts I will let myself fall into the water, with my face as deep in the mud as I can keep it without suffocating. I must pretend to be dead.'[58]

Ernst imagines an entire war fought out in this underwater region.

It is a predatory world, where fish sprout mechanistic appendages and glide silently to the attack. Mouths gape in anticipation of gorging themselves with their victims' carcasses. Everything seems focused on the act of killing, just as it must have seemed above the water where humans destroyed each other indiscriminately for the sake of puny territorial objectives. Indeed, Ernst may be suggesting that war has reduced the soldiers to the level of these machine-like creatures of the deep. Man, according to this vision, has thrown away centuries of civilization and reverted to the rudimentary state of the first living organisms, all of which existed beneath the sea. Only the instruments of violence have been retained, as sharp and potentially lethal as the spindle which gives the most murderous of these watercolours its eerie name.

During the course of 1917, several other artists were driven to see the war in terms of grotesque fantasy as well. The insane butchery infected their dreams, and the Swedish painter GAN (Gösta Adrian-Nilsson) devoted a large painting to the frenzy it engendered. Although his native country was not directly involved in the conflict, Sweden found itself affected by wartime inflation and obliged to introduce food rationing when shortages became severe. GAN, forced

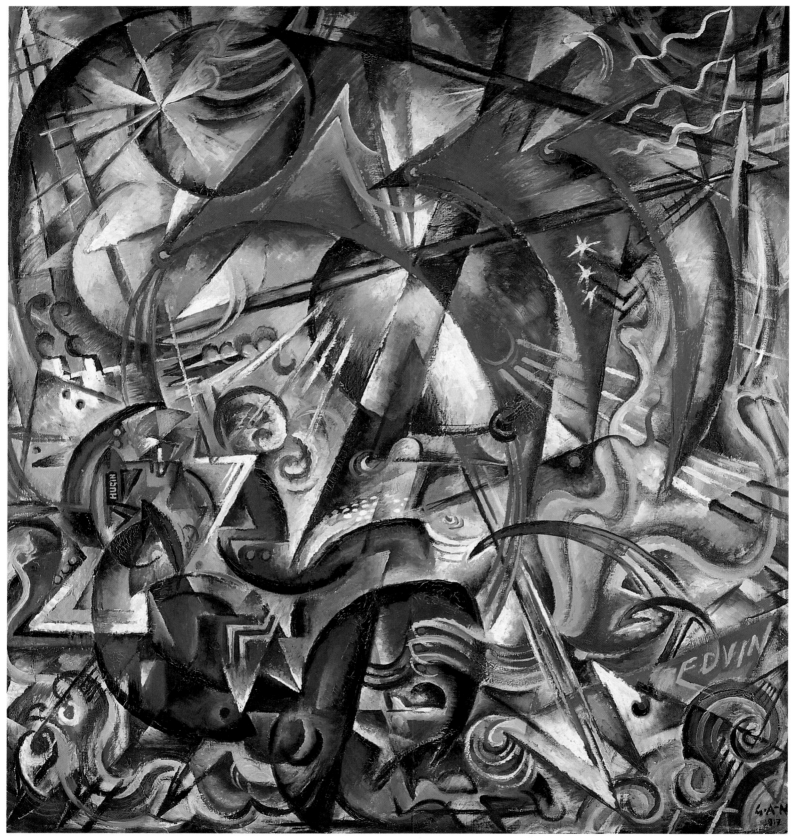

224 GAN *Sailors' Dream of War* 1917. Oil on canvas, 140 × 130 cm. Malmö
Museum.

to return to Sweden from Cologne after the outbreak of war, was instinctively fascinated by aggressive, Futurist-related subjects like a glowing furnace or the dynamism of an express train. In 1917 he produced an unusually monumental canvas called *Sailors' Dream of War* (Pl. 224). The entire composition appears to be blown apart by a shell-burst, sending out shafts which threaten to tear the red, star-spattered sails and dislodge the mast leaning at an unsteady diagonal in the central area of the picture. Everything is reacting to this massive disruption, bending and shuddering with convulsive rhythms. The sailors themselves, far from sleeping quietly on their bunks, are swept up in the maelstrom. Their blue-uniformed bodies sway in turbulent arcs as they struggle to withstand the force of the blast. However much GAN may have been excited by the prospect of such orgiastic violence, he could not give his sailors a heroic role in the composition. They are subservient to the awesome power of machine-age bombardment, and their dream of conflict has turned into a tempest of destruction. A closely related painting called *Death of the Sailor*, painted slightly later, fulfils the sleep-induced prophecy by showing the seismic moment when combat terminates in extinction.

The most excoriating visionary war images of 1917 far outstripped GAN's painting in their savagery. They originated in a commission which Max Slevogt undertook as an official war artist. When he completed and published his portfolio of twenty-one lithographs,[59]

225 Max Slevogt *The March into the Unknown* (from 'Visions') 1917. Stone lithograph on paper, 54 × 39 cm. Leicester Museum and Art Gallery.

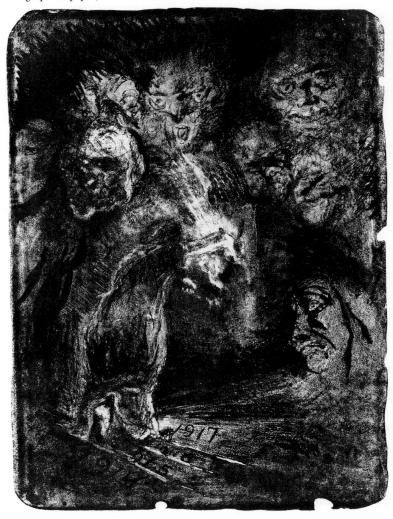

226 Max Slevogt *The Victor's Dream (An idol who allows himself to be worshipped)* 1916. Zinc plate lithograph on paper, 54 × 39 cm. Leicester Museum and Art Gallery.

however, it was ordered to be confiscated by the German authorities. The reason for their disapproval becomes obvious immediately the portfolio is examined. Slevogt called it *Visions*, and instead of recording the war as an enthralling or momentous event he condemned the savagery in a series of hallucinatory insights. Just as Goya warned that *The Sleep of Reason Produces Monsters* in his *Caprichos*, so Slevogt initiated his portfolio with a gaggle of phantoms who hover over a robed figure bravely embarking on *The March into the Unknown* (Pl. 225). Beneath the marcher's feet each year of the war is inscribed, and most of the light falls on 1917 as she steps on to it. But there is no sense of hope or improvement in her advance. The array of faces surrounding this solitary traveller frown, grimace and cackle as she stumbles forward into the dark, and the head nearest the ground stares across at her with an expression of despair.

By no means all the prints in this remarkably outspoken portfolio rely on melancholia to convey Slevogt's anger. Many of them employ black humour as their principal weapon, especially when dealing with

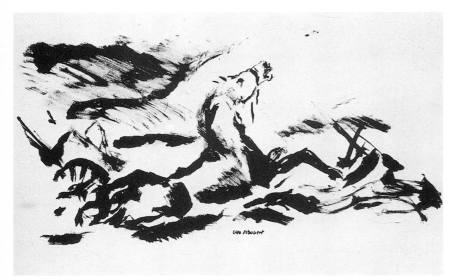

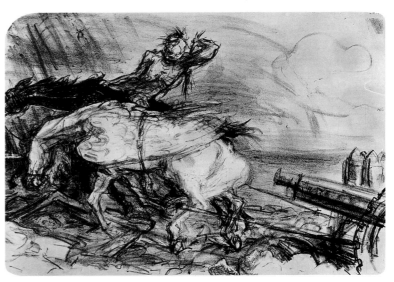

227 Otto Schubert *Under Shell Fire* (Plate 8 from *The Suffering of Horses in the War*) c. 1917. Lithograph on paper, 31.8 × 40.3 cm. Los Angeles County Museum of Art, Robert Gore Rifkind Center for German Expressionist Studies.

228 Max Slevogt *Pegasus forced into Military Service* 1917. Stone lithograph on paper, 39 × 54 cm. Leicester Museum and Art Gallery.

the men who are supposed to be responsible for failing to terminate the struggle. The diplomats are ridiculed in one of the most sprightly plates, as they strive to retain their balance on balls symbolizing the planet they seem bent on destroying. Clutching their nations' flags in a fatuous display of nationalism, they all appear doomed to fall on the swords projecting from the floor. One of the diplomats has already been impaled on a blade, to the raucous amusement of the crowd viewing the spectacle from the arena's side. Whether corpulent or blindfolded, the diplomats are clearly incapable of saving their respective countries from disaster. The futility of their antics goes a long way towards explaining why the foetal figure in *The Utopia of Peace* looks so apprehensive. Enclosed in a global container fragile enough to shatter with ease, he seems terrified that the men supporting him will soon tire of the task and drop their burden on the polished floor.

For no one, ultimately, can resist the lure of *The Call to Arms*. Equipped with helmet and drum, a militant woman strides enticingly towards a plinth where 'August 1914' is inscribed like a date to be honoured. She looks over her shoulder confident in the knowledge that a great crowd follows below, brandishing torches and weapons as they surge through the night. But the real manipulator of armies is a far more disconcerting apparition. In *The Supreme Command* Slevogt shows a bulky military leader consulting a gorgon-like head, which radiates light from the apex of a column. At once sorrowful and malevolent, this terrible face gazes up at the general as if to infect him with the virus of hatred. The disease is duly transmitted, judging by the diabolic behaviour pilloried in *The Victor's Dream* (Pl. 226). Contentedly surveying his enemies' decapitated heads as they swing above him, with fresh blood still dripping from their necks, the triumphant leader pulls on his opium pipe to generate even more repellent fantasies. He demands and receives obeisance from the figures who grovel in front of this self-appointed idol, fearful that they may otherwise end up with the other severed trophies dangling ignominiously in space.

When Slevogt's spiky, indignant line defines activities on the battlefield, he makes clear that the victor's barbarism extends to the troops as well. Like his fellow-countryman Otto Schubert, who devoted a whole series of protesting prints to the plight of horses

working in miserable conditions for the armed forces (Pl. 227),[60] he focused on the wretchedness experienced by the animals pulling battery guns through the mire of the Western Front (Pl. 228). Even Pegasus has been pressed into service, his wings trussed to his flanks while a skeletal rider beats him with a particularly vicious birch. This vision of earthbound suffering is contrasted, in the next plate, with the airborne antics of *Shellfire*. Spiralling crazily through a sky heavy with gunsmoke, missiles from both sides of the conflict are ridden by embodiments of Death. Revelling in the journey like children at a funfair, they pass each other and grin with mutual delight. The lethal power of their mounts only increases the perverted pleasure they feel. War, according to these crazed combatants, is a game to be savoured. In this context, Slevogt would have agreed with Gloucester in *King Lear*, when he complained:

> As flies to wanton boys are we to th' gods;
> They kill us for their sport.[61]

As the plates in the *Visions* portfolio proceed, so the orgiastic strain of the violence intensifies. It reaches a climax in the aptly named *Paroxysm of Destruction*, where spectres who have already suffered appalling bodily truncations persist in continuing the battle (Pl. 229). Urged on by a demonic drummer, beating out a rhythm with hands attached to arms only by slender lengths of skin, they seize their own severed limbs and fight on. One combatant lifts his sawn-off leg to his shoulder and, squinting along the blanched flesh, aims it like a rifle. His companion, lying below, raises two bones to his eyes as if they were a pair of binoculars. The killing must continue, even though it has long since cast all reason aside and deteriorated into a frantic charade.

So the numbers of the slaughtered multiply without end, filling mass graves which now stretch even further than they did in Barlach's drawing of 1915 (see Pl. 143). Slevogt, who may have been aware of Barlach's precedent, gives his image a powerful new dimension by incorporating the theme of maternal grief as well (Pl. 230). In *The Mothers* a long procession of mourners files past the rudimentary pit where bodies were unceremoniously deposited. Most of the women, doubtless unable to identify the sons they have lost, stumble on without a pause. But one of them suddenly recognises a corpse and

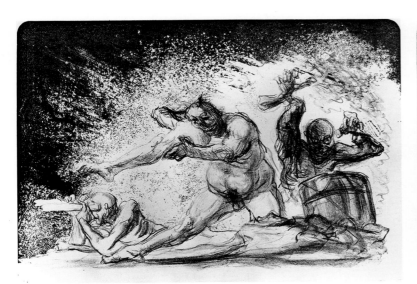

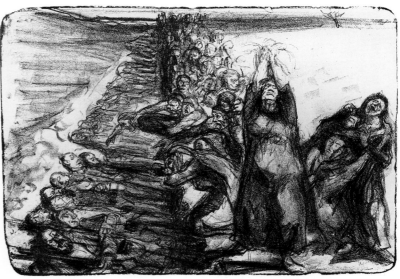

229 Max Slevogt *Paroxysm of Destruction (Spectres fight with their own severed Limbs)* 1916. Stone and zinc plate lithograph on paper, 39 × 54 cm. Leicester Museum and Art Gallery.

launches herself over the graveside, in a precipitate attempt to touch the dead man. Two other mothers, both screaming as loudly as her, try to hold back the demented woman. They cannot assuage her agony, however, and the mourners in the forefront of the scene wail over the sons they have likewise identified. Whether kneeling on the ground with hands clasping their heads, or reaching towards heaven in a hair-tearing gesture of despair, these wailing figures attain the sombre grandeur of the chorus in a Greek tragedy.

Slevogt's vision became so mordant by 1917 that he even imagined civilians overcome by a death-wish. In *The Suicide-Machine* an attenuated man buttoned up against the cold places a coin in the slot above a pistol (Pl. 231). Paying no attention to the plight of the bowler-hatted figure nearby, who has just been killed by an identical contraption, he awaits the fatal shot. There is nothing left to live for in the moral wilderness of a war apparently without end, and nothing is now exempted from the blood-crazed attention of professional killers. Not content with gunning enemy pilots down from the sky, *The Aviator* turns his weapon on the creatures of the Zodiac as well. Although the great bear rounds on his assailant with a growl, and gestures fiercely with his paw, he remains unwilling to approach the aviator's gun-barrel. As for his companions, they flee in consternation from the advent of an aggressor whose mechanized armoury renders their mythological weapons redundant.

Deprived of their help, humanity is left to the mercy of *The Answerable*, a masked and anonymous 'rough beast' who wades through an ocean of blood bearing the corpses of men and women alike (Pl. 232). Realising that this monster exists solely in order to carry layered heaps of bodies, Slevogt illuminates them more fully than the creature of darkness. But that does not diminish his baleful power. His very lack of identity is menacing in itself, and the two final lithographs in the *Visions* portfolio concentrate on the places where the corpses all come to rest. Slevogt describes them as *The Forgotten* in a penumbral, elegiac lithograph where a female figure of the Fatherland covers the bodies in mass graves. In order to ensure that no one mistakes his own attitude towards lingering German hopes of victory, he devotes the final print to an image of his country's eagle with broken wings. The impotent bird rests on an equally broken Standard surrounded by soldiers' graves, while the invalid with

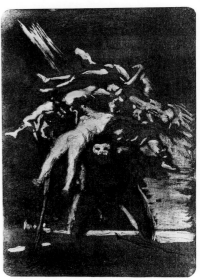

230 Max Slevogt *The Mothers* 1917. Stone lithograph on paper, 39 × 54 cm. Leicester Museum and Art Gallery.

231 Max Slevogt *The Suicide-Machine* 1917. Zinc plate lithograph, 54 × 39 cm. Leicester Museum and Art Gallery.

232 Max Slevogt *The Answerable (The Unknown, masked, wades with Innumerable Corpses on his Back through a Sea of Blood)* 1917. Stone and aluminium plate lithograph, 54 × 39 cm. Leicester Museum and Art Gallery.

crutches below heralds German artists' post-war obsession with crippled ex-combatants (see Pls. 340–2). In an attempt to hold out some hope amid the pervasive pessimism, Slevogt includes woodpeckers and songbirds who signify the future renewal of life. But they fail to carry as much conviction as the gloomier aspects of a portfolio which strikingly prophesies Germany's demise the following year.

The steady, concerted production of armaments played a central role in the eventual allied victory, and women proved indispensable as the workforce while their husbands and sons fought at the Front. In France, the most vivid and comprehensive paintings of a munitions factory were produced by Vuillard, who received a commission from its owner Lazare-Lévy to execute a decorative scheme on the subject. Although no stranger to such projects, Vuillard had never before depicted the industrial world. The hedonistic pleasures savoured by

233 Edouard Vuillard *Munitions Factory in Lyons. The Forge* 1917. Distemper on canvas, 75 × 154 cm. Musée d'Art Moderne, Troyes (Dépôt des Musées nationaux).

his bourgeois patrons had hitherto formed the subject of the majority of his decorative panels, and he might easily have shied away from painting such an alien world. But Vuillard, encouraged perhaps by the knowledge that his friend Thadée Natanson administered the factory, agreed to visit it in Lyons. Fascinated by the spectacle confronting him in the immense glass-roofed building on his arrival in March 1917, he noted in his diary that he found himself bombarded by a 'flux of sensations – terribly interesting – disordered – feverish.'[62] A considerable effort was required to make coherent pictorial sense of this unaccustomed chaos, and Vuillard must have wondered how his paintings could evoke the awesome dynamism of the 'active, ambitious figures and raging conflicts'[63] he found there.

In the end, he decided to represent the munitions factory by day and night in two panoramic horizontal panels.[64] The idea was, presumably, to emphasize the ceaseless activity of an industry geared to maximum production for the war effort, and in the daytime painting of *The Forge* he silhouetted the machinery against the cool light from the roof (Pl. 233). Figures from the predominantly female labour force can be discerned on the factory floor, attending to the production-line and stacking shells. They cannot be fully disentangled from the machines, and Vuillard's painting suggests that the women have almost become merged with the industrial plant around them. In the nocturnal panel, electric lamps cast them in a richer yellow light which enhances the significance of their exertions. By 1917, the superiority of the French, Russian and British industrial base had become a decisive advantage, and Vuillard had no need to resort to propagandist distortions when he conveyed the atmosphere of sustained, intent labour in the Lyons arsenal.

Germany, however, was temporarily heartened by the October Revolution. After the Provisional government's failure to beat German forces back behind the Russian border, Lenin and the Bolshevik

234 Aristarkh Vasilyevich Lentulov *Peace, Celebration, Liberation* 1917. Oil on canvas, 155 × 137 cm. S.A. Shuster and Ye.V. Kryukova Collection.

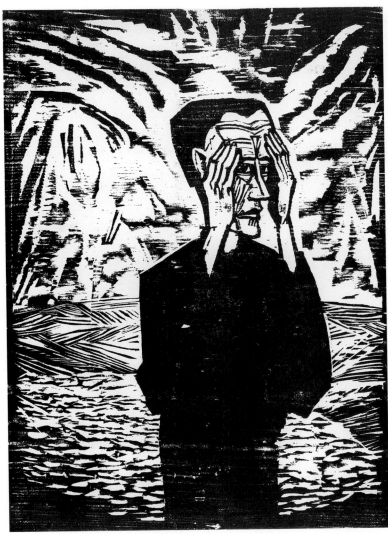

235 Erich Heckel *Man on a Plain* 1917. Woodcut on paper, 37.7 × 27.2 cm. British Museum, London.

year before (see Pl. 180). The emptiness of the terrain is now as oppressive as the sky, which seems to bear down on his head in a manner reminiscent of Munch's *The Scream*. He raises hands to forehead in an attempt to alleviate the psychic pressure, but the accumulated horror of the strife proves increasingly difficult to withstand.

A still more haunted reaction can be found in an album of ten woodcuts published in Geneva. Their maker, Frans Masereel, was by this time living in Switzerland like so many others who shared his pacifist convictions. After calling the album *The Dead Arise*, he added the subtitle *Infernal Resurrection*. For the mangled bodies depicted on the title page respond to the event with anguish, and succeeding prints make clear that suffering is now the only reasonable expectation. Although the three crosses on Calvary shine powerfully in the distance of one woodcut, they fail to ameliorate the agony experienced by the man bound to a stake in the foreground. He lifts up his head and utters a tortured cry, intensified by Masereel's harsh scoring of the block. The cry echoes and re-echoes through the album, issuing from the mouths of the soldiers caught on barbed-wire fencing or impaled on spikes which pierce their jaws (Pl. 236). Cries turn to screams in a particularly ferocious print, where two heads become skulls as the flames of an inferno consume them. But Masereel achieves his most disturbing image when the noise is stilled, and two decapitated soldiers carry a stretcher bearing both of their heads, mute and still (Pl. 237).

While most artists concentrated in their war pictures on the plight of the armed forces, Adolf Uzarski commenced his portfolio of lithographs with an image of civilian hunger (Pl. 238). Crouching in the ruins of their bombed home, the parents gaze down anxiously at their child's emaciated body. Uzarski's style is more meticulous than the bolder idioms deployed by both Masereel and Slevogt, but his partiality for detail does not detract from the harshness of his vision. Like Barlach before him (see Pl. 185) he sees the war as a dance of death, and in all twelve lithographs the skeletal figure accompanies the scene. In *Hunger*, he sits on a horse beside the family and looks the other way, as though unwilling to witness the child's pathetic death. When the scene changes to a military hospital, however, he crouches on the boiler and waits like a predator for the patient to expire.

As the portfolio proceeds, so Death displays a hideous versatility. Grown to an imposing height, he bestrides the battlefield like a conquering general and dispassionately observes the last twitches of life in the bodies below. Then he takes on the guise of stealth, lurking with a dagger behind a tree while his intended victim guards a nearby hill. He is capable of assuming colossal proportions and appearing like a ghost in the sky, beckoning with a bony hand towards the pilot incinerated in a burning aeroplane. He floats on the ocean and grabs hungrily at the vessel stricken by a mine. But he is equally adept at dressing himself as a tramp who stares, from a corner, at the skirmishes of a revolution in the street. Although a statuette of the Madonna and Child is installed above the street-lamp, its presence does nothing to prevent the violence. Nor can the sappers protect themselves from the outsize skull as it rises above the sandbags to preside over their subterranean activities.

In the concluding prints from this uniformly gruesome portfolio, Death takes a diabolic delight in joining the most destructive aspects of the conflict. He savours the drama of being blown into the sky by a direct hit, watching the soldiers' bodies disintegrate while his own skeleton remains paradoxically intact. Afterwards, as if intoxicated by the explosion, he marches into a retreating army and grasps dying

group were committed to extricating their country from the conflict. Lentulov, who had responded to the advent of war three years before with a painting anticipating an easy victory (see Pl. 45), now shared the widespread sense of relief within Russia that a treaty was imminent. He went so far as to greet the prospect in a large, festive canvas called *Peace, Celebration, Liberation*, where optimism about the new, post-revolutionary society merges with the elated recognition that Russia's humiliating struggle to defend its territory was about to end (Pl. 234). The figure who runs across the composition, like a harbinger of the new era, is lithe enough to derive from Lentulov's memories of Diaghilev's Russian Ballet. But the dancer is framed in a mandorla-like form suggestive of divinity as well, thereby enhancing the beneficence of this apparition as he bestows a cornucopia of exotic bounty on everything around him.

All the same, the abundant hopes expressed by *Peace, Celebration, Liberation* are hard to find in the contemporaneous work of artists outside Russia. Drawing once more on the war landscape he knew as a Red Cross orderly in Flanders, Heckel's powerful woodcut of a *Man on a Plain* makes an indirect but gloomy statement about the unbearable effect of a conflict without end (Pl. 235). The man portrayed here is Heckel himself, whose attitude towards the war had darkened considerably since he painted *Springtime in Flanders* a

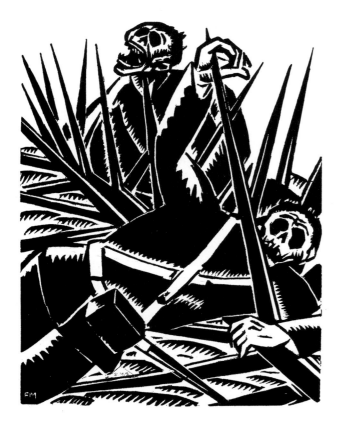

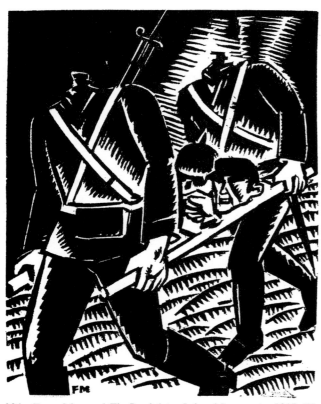

236 Frans Masereel *The Dead Arise, Infernal Resurrection* 1917. Woodcut on paper, 14 × 11 cm. Musée d'Histoire Contemporaine – BDIC, Hôtel National des Invalides, Paris.
237 Frans Masereel *The Dead Arise, Infernal Resurrection* 1917. Woodcut on paper, 14 × 11 cm. Musée d'Histoire Contemporaine – BDIC, Hôtel National des Invalides, Paris.

238 Adolf Uzarski *Dance of Death* 1916–17. Lithographs on paper, each 41 × 31 cm. Kunstmuseum, Düsseldorf.

figures by the fistful. He sits ghoulishly in a thick cloud of gas, willing the poisonous vapours to choke the men who run in terror from its fumes. Finally, in order to ensure that the battle continues even after everyone has been slaughtered, the tireless Reaper kneels among the corpses and takes aim with a machine-gun. Like the crazed phantoms in Slevogt's lithograph, who use their severed limbs as weapons, Death is here committed to the indefinite continuation of a war which nourishes and entertains him at every turn.

Uzarski's fellow-countryman Lovis Corinth, by contrast, came to feel that divine retribution would ultimately fall on those responsible for all the killings. Unlike most of the artists who dealt with the Great War in their work, he now elected to comment on it indirectly through a religious theme. Two years before, he had defined the vulnerability and gentleness of the painter Hermann Struck in his soldier's uniform (see Pl. 111). Already, in that early stage of the war, Corinth portrayed his sitter's lack of belligerence with instinctive sympathy. By 1917 his attitude towards the conflict had reached such a pitch of abhorrence that only the story of Cain could convey his true feelings. Accordingly, on a canvas of ample dimensions, he depicted the terrible moment when brother turns against brother with murderous intent (Pl. 239). By choosing such a subject, Corinth did not mean to condemn Germany's role in the struggle. He went on to

paint a portrait of von Tirpitz, after all, and an apparently patriotic full-length painting of a *Black Hussar* was also executed in 1917. But the *Cain* canvas reveals his most profound response to the war, which he saw fundamentally as a crime humanity was committing against itself.

Even though the Bible does not specify how Cain 'slew' his brother, Corinth shows him in the act of crushing Abel with heavy stones. The victim, helpless on the ground yet still alive, raises his arms in feeble protest. But Cain disregards his pleas, turning away from the prostrate body in order to stare wildly upwards at the sky. He may be distracted by the vultures filling the air with the turbulent beating of their wings. Corinth's brushwork, which had grown progressively looser after a stroke partially paralysed his right side in 1911, here accentuates the violence of his theme by manifesting a new wildness. The entire composition is infected by its slashing rhythms, suggesting that Van Gogh's example had helped Corinth discover how to give his handling of pigment a frenzied new intensity. By selecting the moment when Cain pauses and gazes towards heaven, he also ensured that his painting contained an awareness of the judgement God would deliver against this fratricidal crime. Although the powerfully built Cain has no intention of casting aside the rock clasped in his hands, he does appear momentarily shaken by the realisation that the Lord is witnessing the murder.

His qualms were justified, for the Bible relates that God visited Cain after the slaying was complete and asked: 'What has thou done? the voice of thy brother's blood crieth unto me from the ground. And now art thou cursed from the earth, which hath opened her mouth to receive thy brother's blood from thy hand; when thou tillest the ground, it shall not henceforth yield unto thee her strength; a fugitive and a vagabond shalt thou be in the earth. And Cain said unto the LORD, My punishment is greater than I can bear. Behold, thou hast driven me out this day from the face of the earth; and from thy face shall I be hid.'[65] The judgement was terrible indeed, reflecting the fact that Cain had irretrievably forfeited the right to divine mercy. By choosing this bleak theme for his dark and baleful painting, Corinth likewise implied that the war had shut humanity away from the redemption of God for ever.

239 Lovis Corinth *Cain* 1917. Oil on canvas, 139.7 × 114.3 cm. Kunstmuseum, Düsseldorf.

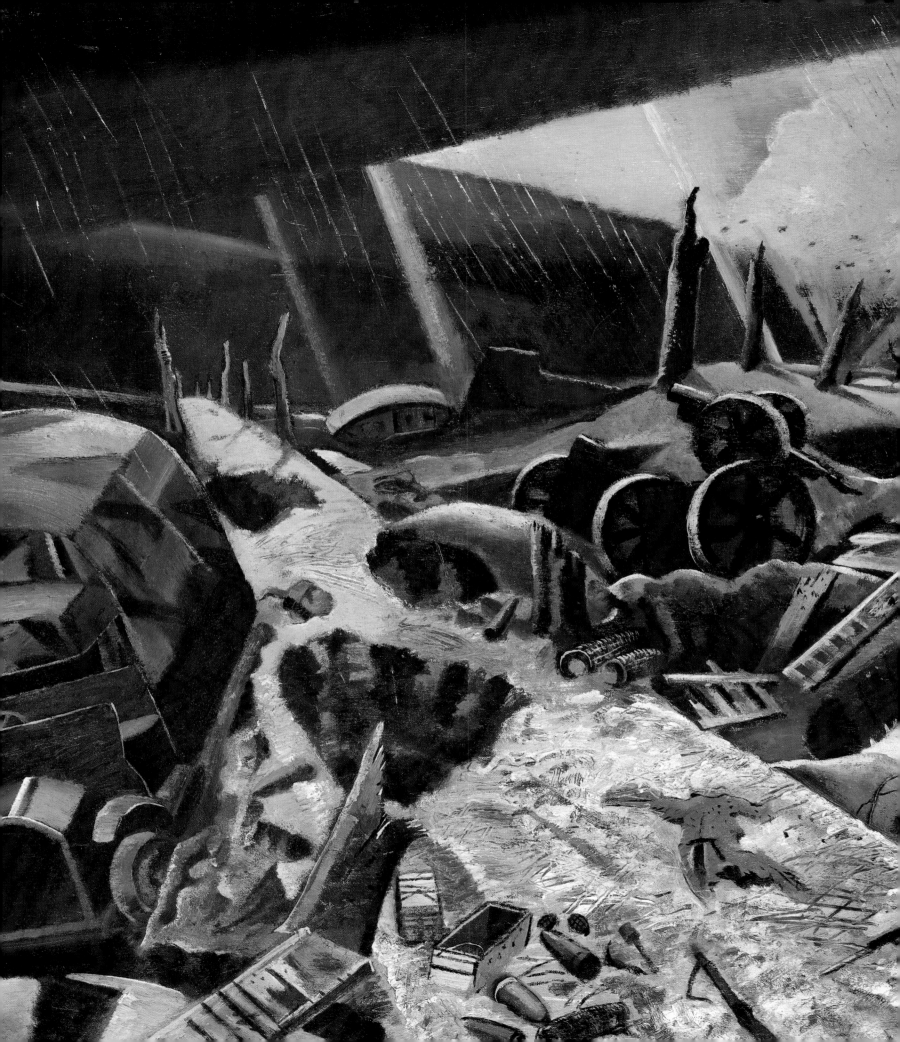

CHAPTER SEVEN
OFFENSIVE AND DEFEAT
(1918)

In the early months of 1918, Germany had good reason to suppose that the war might yet be won. The Russians' willingness to sign the Treaty of Brest-Litovsk, and cede enormous territories to Germany in return for peace, meant that Ludendorff could now concentrate his forces more effectively on the Western Front. Less than three weeks after the treaty with Russia was concluded, he launched a major March offensive on the Somme. Helped by dense fog, the Germans penetrated the enemy lines and forced the British to retreat a considerable distance. The Allies appeared, for the moment at least, to have suffered a decisive setback. Although the German advance was halted at Arras on 5 April, Ludendorff remained convinced that victory could be obtained. A few days later he succeeded in forcing the British troops to abandon Passchendaele, which they had won with such terrible casualties the previous year. The old stalemate appeared to be crumbling, but the slaughter on both sides reached proportions distressing enough to sicken any artist caught up in the turmoil.

Even though Beckmann had not been directly involved in the conflict since his breakdown three years before, it still haunted his imagination. In *Self-Portrait with Red Scarf* he turns away from the easel, as if his attention had suddenly been arrested by a disquieting thought (Pl. 240). The abrupt foreshortening of his right arm accentuates the sense of violence. With shirt open to disclose an emaciated chest, and scarf tied round his neck almost as tightly as a noose, Beckmann stares defensively towards an undefined source of danger. His body seems squeezed uncomfortably within the narrow, claustrophobic confines of a studio which affords him scant respite from the anxiety besetting his mind.

Nevertheless, Beckmann spent a great deal of time labouring over ambitious canvases which attempted, like Corinth and Heckel before him (see Pls. 123, 239), to convey his deepest responses to the war through religious themes. In 1917 he painted a powerful interpretation of *The Descent from the Cross*,[1] which revealed how drastically his style had altered to deal with the anguish war engendered in him (Pl. 241). Beckmann's decision to tackle this demanding theme was taken when his patron, the foundry-owner Georg Hartmann, accompanied him on a visit to a Frankfurt gallery. Both men found themselves examining a Gothic wood-carving of the *Pietà*, and Hartmann challenged him to paint a picture of equivalent power in the modern spirit.[2] Beckmann accepted with alacrity, for he had become increasingly impressed by the eloquence of the expressive distortion and austerity in Gothic art. As early as 1915, when he produced his etching of *The*

Morgue (see Pl. 118), references to Mantegna's *Dead Christ* were accompanied in the group on the right by an awareness of van der Weyden's *Lamentation of Christ*.[3] He also admired Holbein the Elder, Grünewald and the fifteenth-century Bavarian painter Gabriel Mälesskircher, but in the end Beckmann relied on his own experience of suffering to give *The Descent from the Cross* its formidable authority.

The figure who is being lowered with intense difficulty from the ladder is a blanched, etiolated form. *Rigor mortis* ensures that his pitifully thin arms remain outstretched from the position they held on the cross. Christ's right arm thrusts past the heads of the two men straining to hold the body, making their task even more arduous. His palm is bared to reveal a wound whose bloodiness appears to have infected the disconcertingly crimson colour of the sun beyond. Beckmann spares us nothing in his depiction of the martyr. Drawing on his memories of the shattered bodies he had scrutinized in the Flanders field-hospital, he allows the emaciated corpse to dominate the composition in all its ungainliness. Christ's hands almost seem to push at the bounds of the picture-frame, while his feet are turned up harshly so that both the nail-gashes can be exposed. The bald man in the black tunic, who is identifiable as Major von Braunbehrens, recoils from the gruesomeness of the figure he struggles to hold. So does the woman kneeling at the ladder's base, unable to gaze up at the reality of death. She turns away, shielding her face from the body above her and providing, at the same time, a support for her sorrowful companion to lean against. Within the severely compressed picture-space, Beckmann creates a wrenching sequence of zigzag rhythms and contradictory perspectives. While the mourning women are viewed from above, their male counterparts are seen from below. The hillside they inhabit rises steeply behind them, and even the arms of the cross tilt at an alarming angle. Everything is unsteady in this disorientating image, where Christ's death appears final enough to destabilize the entire world.

Nor did Beckmann provide any solace when he painted a colossal *Resurrection* (Pl. 242). He finally abandoned this complex, unfinished canvas in 1918, two years after starting it. Maybe he could no longer bear to contemplate the vision presented here, for *Resurrection* conveys no hope of the redemption its title implies. Beckmann's decision to opt for a horizontal composition was immensely significant. It implied that, from the outset, he would renounce the triumphant upward surge so spectacularly explored in his pre-war version of the subject. This precocious 1909 *Resurrection*, self-consciously vying with both El Greco and Rubens, had affirmed the young Beckmann's belief in the salvation of souls – seemingly irrespective of their sins on earth.

Left: Paul Nash *Void* 1918 (detail). See Pl. 271.

The naked figures ascend in two irrepressible columns, leaving behind the clothed, respectable observers who appear subdued by contrast. They include Beckmann himself, hand placed on heart as he stands to the left of the composition, and his mother-in-law Frau Tube nearby. She turns away from him to gaze up at the rush of bodies above her, apparently undismayed by the heretical notion that all sinners are here able to evade judgement and cast off their imperfections in the dissolving, purifying blaze of light at the painting's incandescent apex.

No such afflatus can be detected in Beckmann's wartime *Resurrection*. Its very shape ruled out the possibility of depicting a heavenward momentum, and none of the stricken figures who wanders across this ruined locale rejoices in the prospect of imminent transcendence. Rather are they reduced to the same level as the black cat at the base of the canvas, who throws back its head and utters a protesting cry against a world where salvation is unobtainable. Beyond the howling animal sprawls a corpse, reminiscent of the body laid out in the centre of *The Morgue* (see Pl. 118). The cadaver's limbs stir, and another body crawls from a grave behind. Levitation occurs directly above, where an old woman swathed in the remnants of burial bandages hovers above the ground. But she stays parallel to the earth, not rising to the sky like her liberated predecessors in the 1909 *Resurrection*. Trapped in a limbo from which escape seems unlikely,

240 Max Beckmann *Self-Portrait with Red Scarf* 1917. Oil on canvas, 80 × 60 cm. Staatsgalerie, Stuttgart.

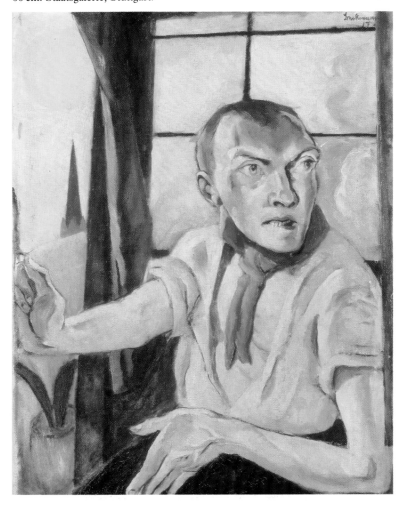

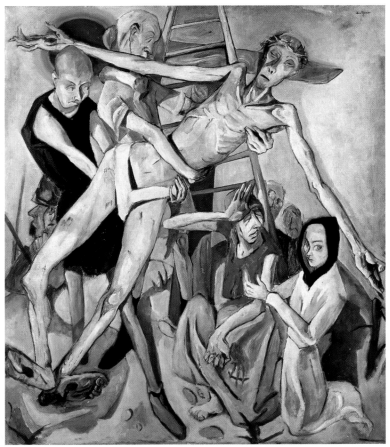

241 Max Beckmann *The Descent from the Cross* 1917. Oil on canvas, 151 × 129 cm. The Museum of Modern Art, New York. Curt Valentin Bequest, 1955.

she is as dejected as all the other figures condemned to wander across this white, sterile setting. Having clambered out of their graves, they appear stunned by the discovery that existence is confined to such a region. For Beckmann presents here a world of ultimate annihilation, presided over by a scorched disc rather than a nourishing sun. The 'sinister black hole'[4] which in 1915 he feared might lie behind the realm of superficial appearances had now become an incontrovertible reality, proving that humanity was doomed after death to endure 'this endless desolation in eternity. This loneliness.'[5] Everyone in this harrowing canvas is enclosed in isolation, and the principal figure standing at the centre bows his head in a forlorn attempt to shield the emptiness from view.

The devastation predicted by Meidner in his pre-war apocalyptic paintings (see Pl. 1) is here confirmed on the most panoramic scale imaginable. It leaves the inhabitants either crying out in pain or succumbing, at last, to madness. Among the circle of figures on the left, some still have the energy to bewail their fate. The bald mother lying with her baby, apparently having just emerged with difficulty from the cave beyond, utters an uncomprehending cry. So does one of the hollow-eyed men standing nearby, while his neighbour presses his left hand firmly over both eyes. He cannot hope for relief even from the hooded figure behind, whom Stephan von Wiese has reasonably identified as Death.[6] For his task is over, and he hurries away from the denizens of a hell more unbearable than anything he could devise. The agony is so excruciating that it drives the tormented figures on the right to insanity. One Lazarus-like man, still bandaged

242 Max Beckmann *Resurrection* 1918. Oil on canvas, 345 × 497 cm.
Staatsgalerie, Stuttgart.

from the tomb, lurches aimlessly forward as he jerks back his head
and contemplates the impossibility of ascending to a heaven which
does not exist. He seems just as crazed as the woman next to him,
who flings out both hands in a paroxysm of despair and twists her
face violently to one side. Both these figures seem caught up in a
hideously irrational ballet, and Beckmann's conception was indeed
influenced by the extravagant gestures he admired in a medieval
carving of a morris dancer.[7] Behind them lurks a cluster of stricken
souls, all reduced to lassitude by the predicament they have given up
struggling to confront.

Here is the definitive negation of all those pre-war Nietzschean
hopes about renewal arising from the embers of destruction. The
only outcome of war, for Beckmann, was a void far more terrifying
than anything he had dared to imagine before the conflict began.
But he was determined not to evade it. The artist depicts himself
emerging from a cave-like aperture with his wife, child and the
Battenbergs, who had shared their home with him in Frankfurt when
he left the army. Beckmann looks askance as he keeps half his face
hidden behind his wife – the woman he had chosen not to rejoin after

his breakdown at the Front. It was as if he wanted to come to terms
with the essential 'loneliness' of humanity before family life could be
resumed. He certainly appears to emphasize this sentiment in the
terse words inscribed on the canvas among the group of relatives and
friends: 'Get to the point.' That is why he shows them all gazing,
with inevitable trepidation, at the prospect ahead after they, too,
creep out of their graves.

At least they are facing the truth without resorting to religious
illusions – unlike the other group of soberly dressed figures huddled
on the left in prayer. The unfinished nature of *Resurrection* is par-
ticularly apparent here, preventing a confident identification of these
devout interceders. If Frau Tube is indeed the woman kneeling to
pray, she is now positioned much further away from Beckmann than
in the 1909 version of the subject. The distance is symbolic: by this
time, he felt profoundly out of sympathy with any belief that God
could somehow rescue humanity from nihilism. While Frau Tube
clasps her hands and loses herself in a plea to heaven, he keeps his
eyes open in order to survey the unpalatable truth about the world
beyond the tomb. As a result, the rawness of this incomplete yet

compelling masterpiece appears wholly commensurate with the bleak vision Beckmann presents.

Nor did he entertain any optimism about the next generation. His son Peter, glimpsed in *Resurrection* peering out of the cavity, was in his father's view alarmingly affected by his experience of the war. Around the time when the immense canvas was finally abandoned, Beckmann produced an etching called *Children Playing* (Pl. 243). At first sight, it looks like a sprightly twentieth-century variation on Bruegel's celebrated painting of the same subject.[8] After a while, though, the children's obsession with war games becomes clear. A rudimentary circle has been formed on the ground, and inside it boys lunge at each other with makeshift spears. One of them, yelling as he defends himself against a thrust, brandishes a shield decorated with a leering death's-head. His opponent wears a German helmet, either borrowed from his father or patched together to give a semblance of authenticity. Even a dog has been coerced into the bellicose proceedings, and outside the ring most of the younger children are aping their elders' pugnacity. The two girls playing on the left appear to be absorbed in more pacific pursuits. They are, however, positioned dangerously near the battle arena, and the solitary child who gazes out from the foreground seems about to stumble across the ring and become ensnared by the mock violence within. What hope can be held out for the future, Beckmann asks, when the warring spirit spreads among the emergent generation like an incurable virus?

The suffering had become so intense and widespread by 1918 that even Picasso, who had largely refrained from meditating directly on the war in his work, echoed Beckmann by taking up a religious theme. Although he married Olga Koklova in the summer and spent his honeymoon in Biarritz, Paris remained his base. Ludendorff's offensive made the French capital a threatened city once again, and the colossal German gun, Big Bertha, killed many of its citizens with a regular bombardment from a position seventy-one miles away. Along with this new awareness of war's capacity to slaughter civilians, quite indiscriminately, Picasso was also affected by the declining health of his old friend Apollinaire. Having posed for a portrait in his

243 Max Beckmann *Children Playing* 1918. Etching on paper, 24.8 × 29.8 cm. Kunsthalle, Hamburg.

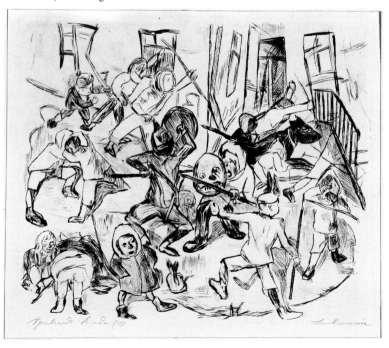

244 Pablo Picasso *Crucifixion* c. 1918. Pencil on paper, 36 × 26.6 cm. Musée Picasso, Paris.

uniform two years before, wounded yet recuperating (see Pl. 190), the poet was admitted to hospital in January 1918 with pulmonary congestion. Later in the year he died of Spanish influenza, and the tragedy may well have prompted Picasso to produce his pencil drawing of a *Crucifixion* (Pl. 244).[9]

Biblical themes are very rare in his work, and especially at this period. Another pencil study of a *Fisherman*, drawn in the same style, may have religious implications, but *Crucifixion* is surprisingly direct in its representation of Christ's agony. Executed with all the linear precision Picasso had recently perfected in his Ingres-like portrait drawings, it nevertheless seeks out older sources of stimulus ranging from medieval carving to El Greco. Every convoluted twist and furrow in Christ's body is defined with surgical exactitude. His arms appear to have been painfully distended by the men responsible for hammering him to the cross. Although Picasso gives him a physique more powerfully muscled than in many other artists' crucifixion images, the agony of martyrdom is defeating him. The capitulation is most distressingly apparent in Christ's head, collapsed on his shoulders without any support from the neck. It lolls there uselessly, no longer able to sustain a resilient position and lacking the inspirational force so evident in Schmidt-Rottluff's contemporaneous woodcut *Has Christ Not Appeared To You?*. This ecstatic image, from a series of ten monochrome prints entitled *Christ*,[10] was made while

245 Raymond Duchamp-Villon *Portrait of Professor Gosset* 1918. Large version. Bronze, 29.2 × 21.6 × 21.6 cm. Albright-Knox Art Gallery, Buffalo, New York. A. Conger Goodyear Fund.

during this long period of debilitation, but in May 1918 he was able to report that, like Kokoschka before him (see Pl. 149), he had started work on a portrait of his doctor.[12] Its modest size, probably dictated by Duchamp-Villon's physical weakness, does not lessen its intensity. His long-standing interest in formal simplification is taken to a new extreme of ruthlessness, as the planes of the Professor's face are reduced to a purity worthy of Brancusi.

This process in no sense forces Duchamp-Villon to relinquish his grasp of character, however. The distortions to which Gosset's features are subjected, oddly reminiscent of the far more erotic heads Picasso would model in the early 1930s, reinforce the image of a man gravely observing his patient. His eyes bulge with the effort involved in scrutinizing and attempting to combat the illness which continued to afflict the sculptor. Unlike Kokoschka's portrait of Dr von Neumann, though, there is a macabre quality about the Gosset bronze. At the same time as he portrays the professor, Duchamp-Villon seems to project on to this stern and vigilant face an awareness of his own imminent death. Its coldness is disconcerting and smacks of the grave, almost as if he suspected that his weakened condition would prevent him from resisting any further ailment. He was right: blood poisoning killed him in the military hospital at Cannes on 7 October, depriving European art of one of its most promising and innovative young sculptors.

While Duchamp-Villon was preoccupied in his last sculpture by intimations of his own death, Egger-Lienz spent much of 1918 painting immense canvases mourning the destruction of a nation. Two years before, in *The Nameless Ones*, he had already shown advancing troops reduced to fearful anonymity (see Pl. 147). Now, depressed no doubt by Austria-Hungary's failure to win the Italian campaign and the break-up of the Habsburg Empire, he embarked on a vast composition called *Missa Eroica* (Pl. 246). In its original state, this monumental elegy brought together six soldiers sprawled on the field of battle. They are all dead, and Egger-Lienz divests most of them of distinguishing facial features. Helmets cover the heads of the two nearest figures, one lying with his boots forward and the other in reverse. The man whose face hangs upside-down on a shell-crater's edge is rather more personalized, but the other corpses lapse into generalization once again. These inert bodies are meant to signify an entire generation of men, sacrificed for the sake of an Empire impossible to save. The futility of their loss is as inescapable as its sadness, and Egger-Lienz left no one in any doubt about his condemnation of the carnage.

This titanic indictment was, however, cut up after its completion. Only a fragment of the central portion survives, containing the isolated figure of a soldier who has fallen back into the main crater (Pl. 247). There he lies, his head jammed up against the side of the hole and feet jutting ignominiously over its edge. The unravelled strap on his right leg dangles down, a symbol of his uselessness. The hand propped against the crater's slope implies that he might, before the intervention of death, have tried to pull himself out again. But the shell-hole became his grave, and with his extinction died any lingering hopes Austria-Hungary may have harboured about an eventual victory. With extraordinary speed, hastened by Woodrow Wilson's promise of independence to the Czechs and Poles, the once-formidable Empire disintegrated. No wonder Egger-Lienz remained so preoccupied with death and dissolution in 1918, painting another large canvas entitled *Finale* where he concentrated on two dead soldiers in the mud. In order to ram home the picture's applicability to war, he included a sheet of paper with the dates '1914–18' prominent upon it. But it was hardly necessary. *Finale*'s

Schmidt-Rottluff was on the censor's staff at the Russian Front. The question takes on the character of a challenge issued to anyone who, like Beckmann, had lost sight of God's sustaining presence on the battlefield. 'The one eye is closed in pain', wrote a German critic; 'the other, open wide in prophecy: from there pierce glances of sorrow and oppression, which bore deep into one's mind. The forehead, however, is branded with the number 1918 as a reminder to humanity, which in these times has gone astray... The tragedy of a people on whom it suddenly dawns that it gave its best for iron instead of for the spirit trembles convulsively through these sheets.'[11]

The only face defined by Duchamp-Villon in 1918 belonged to one of the doctors who looked after him during his terminal illness (Pl. 245). Moreover, the bronze *Portrait of Professor Gosset* lacks the sense of divine faith which animates Schmidt-Rottluff's Christ. Duchamp-Villon had never really recovered from a severe bout of typhoid fever, contracted when he was stationed at Champagne in the final months of 1916. Although the fever eventually left him in 1917, he failed to regain his former strength during a protracted convalescence. Writing proved easier to accomplish than sculpture

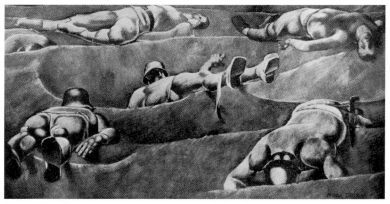

246 Albin Egger-Lienz *Missa Eroica* 1918. Original state, later cut up.

excoriation of the conflict would have been forceful enough without such an inscription. Too many men had died for anyone to be able to deny the hard, uncompromising accuracy of Egger-Lienz's protest.

Even Czech artists like Kubišta, who had good reason to hope that their country's independence might be wrested from the dissolution of Austria-Hungary, became obsessed by visions of mortality. A year before, he had managed to eacape thoughts of combat by painting idyllic seascapes in a holiday mood. Now, however, Kubišta felt compelled to return to the involvement with war he had manifested in the earlier years of the conflict. Unlike *Heavy Artillery in Action* (see Pl. 15) and *The Bombing of Pulju*, which both centred on moments in the inferno of battle, the small print he produced in 1918 echoed Egger-Lienz in its emphasis on the silent aftermath (Pl. 248). Indeed, it went further than *Missa Eroica* or *Finale* by showing a dead soldier stripped of his uniform, weapons, flesh and every other distinguishing

feature. Only the skeleton survives, its mouth widened into a hole which still conveys the shock and pain caused by the fatal wound. A water bottle lies nearby, its stopper tantalizingly open. Perhaps Kubišta meant to imply that the dying soldier tried crawling towards the vessel as his life ebbed away. The attempt was unsuccessful, leaving the man to return to the earth and, in a Dix-like paradox, nourish the flowers which spring up in defiance of the barbed wire beyond.

Another Czech artist, Ruzhena Zatkova, concluded that humanity's presence on the battlefield had now been superseded by the machinery of destruction. Her connections with the Italian Futurists might earlier have predisposed her to view the conflict in a positive light, as a purgative process leading to the elimination of everything rotten in the old society. By 1918, though, Marinettian aggression no longer had any appeal for her. *The Monster of War* is an unequivocally fearful work, inspired by a nightmarish vision of mechanical weaponry assuming a grotesque life of its own (Pl. 250). She attaches bands of metal to the picture, their rivets blatantly exposed to emphasize the ugliness of modern warfare. Colour is applied only to reinforce the brutishness of this apparition, blundering through a world wasted by its lethal maneouvrings. Haunted by the well-founded suspicion that the First World War had given birth to a gruesome new breed of armour-plated predators, Zatkova here envisions a menace that culminates three years later in the macabre advent of Ernst's lumbering *Celebes* (see Pl. 350).

The only figure who remains capable of moving with vigour and effectiveness through this machine-terrorized terrain is, paradoxically, Death himself. He is the protagonist in a remorseless series of prints by Kubin, another Austrian who shared Egger-Lienz's overriding sense of doom in 1918. *A Dance of Death*, published by Bruno Cassirer in Berlin, sets no limit on the skeletal spectre's ability to

247 Albin Egger-Lienz *Dead Soldier from Missa Eroica* 1918 (fragment). Oil and tempera on canvas, 84 × 169 cm. Heeresgeschichtliches Museum, Vienna.

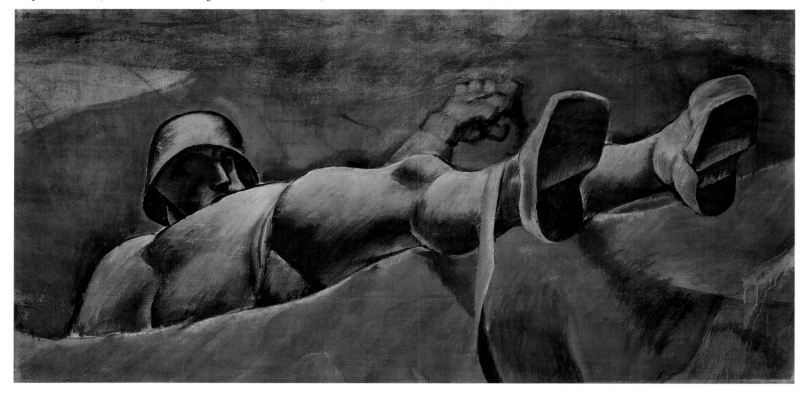

248 Bohumil Kubišta *Battlefield* 1918. Linocut on paper, 10 × 16 cm. Národní Galerí, Prague.
249 Alfred Kubin *A Dance of Death* 1918. Etching on paper, 26.5 × 21 cm. Musée d'Histoire Contemporaine – BDIC, Hôtel National des Invalides, Paris.

250 Ruzhena Zatkova *The Monster of War* 1918. Oil and metal (painted construction). Leonard Hutton Galleries, New York.

corpses, he rests on a coffin while a dog howls over its master's body (Pl. 249). But he is soon off on his marauding journey again, this time urging an emaciated mount through ravaged woodland towards a column of refugees scaling the mountainside beyond. Only in the final image does he appear to take time off from slaughtering humans and crouch in the foliage by a stream, eyeing the dragon-fly perched so unsuspectingly on his bony finger. But Kubin, who had predicted the horror of combat in his *Torch of War* drawing four years earlier (see Pl. 62), was not content to leave Death there. The macabre tail-piece to the series shows him reappearing, in the form of an incised skull and crossbones, on the artist's own tombstone. Although Kubin lived for several decades after the war, he insisted on acknowledging that Death could never be evaded in the end.

Grosz would have understood precisely why the skeletal agent of destruction was accorded such prominence in Kubin's cycle. Despite Germany's apparent success during the offensives of early 1918, he brought to completion a large canvas called *Dedicated to Oskar Panizza* where Death triumphs over a street filled with what he described as 'a teeming throng of possessed human animals' (Pl. 251).[13] Ludendorff's momentary gains on the Western Front meant nothing to Grosz, who was by now long-committed to a pacifist stance and set on painting a bilious 'protest against this world of mutual destruction.'[14] Pullulating in the interstices of a city, where impersonal façades teeter forward and back as if threatened by a seismic disturbance, an allegorical gaggle of leering, vomiting, trumpet-blowing grotesques act out a demented carnival. The picture-title paid homage to a psychiatrist and satirical writer who was twice taken

exterminate. In the first image he wanders through the nocturnal streets disguised as an ordinary pedestrian, relishing the prospect of deciding on his next victim. Kubin's scratchy line enhances the feeling of sadistic malevolence, as he sends Death riding into the desert on a camel in search of fighters to kill on the Arabian Front. Then, temporarily wearied by the effort of digging a mass grave for

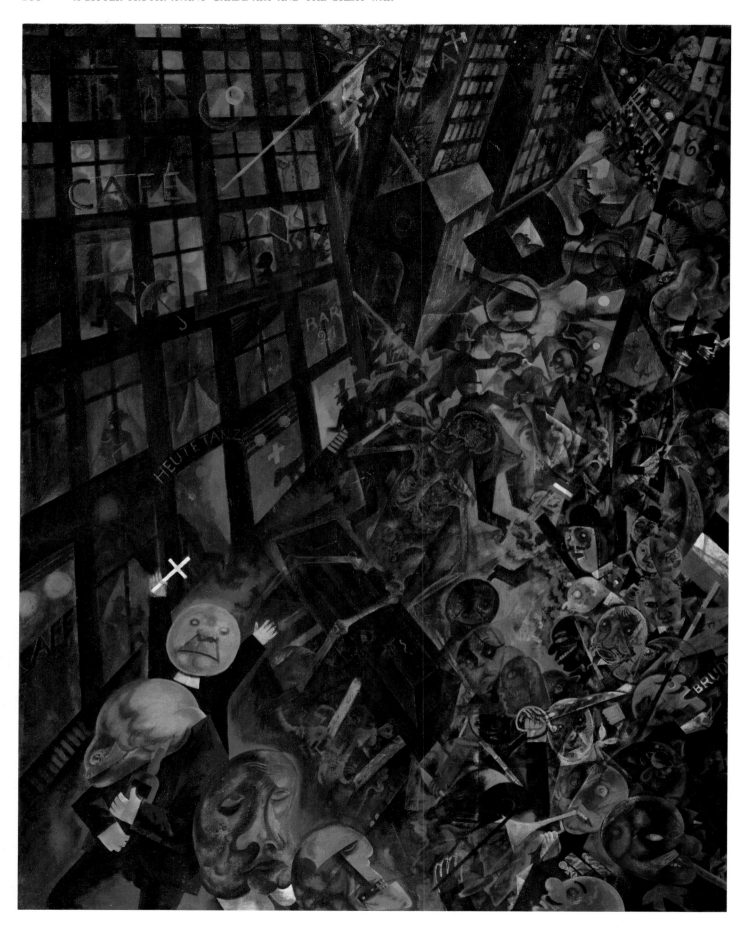

to court – the first time for blasphemy and then for *lèse majesté*. Grosz, who would be tried for blasphemy himself after the war, felt an instinctive kinship with Panizza's fantastical onslaughts. But he also saw himself in the tradition of Bruegel, Bosch, Goya and Daumier, and his description of the 'gin alley'[15] in *Dedicated to Oskar Panizza* indicates an admiration for Hogarth's moralizing satires.

Grosz's painting goes further than Hogarth in its prophecy of damnation, however. Although the pug-faced priest brandishing his white cross in the foreground of the canvas attempts to stem the rush of raddled figures, he is paid no more attention than the church hemmed in by skyscrapers beyond. A cacophony of signs advertising cafés, bars, strip-joints and 'Heutetanz' far outweighs the influence of religion, and the sword upheld in the mêlée on the right proves that militarism continues to thrive. Grosz himself identified 'Alcohol, Syphilis, Pestilence'[16] among the principal figures jostling for supremacy in this diabolic thoroughfare, and they all appear bent on hurtling to oblivion. Stylistic devices derived from Futurist simultaneity and collage help him to give the painting a sense of unstoppable catastrophe, as time and space are collapsed in a single eruption. 'I am unshaken in my view that this epoch is sailing down to its destruction,' he wrote in December 1917 while this apoplectic picture was in progress, enjoining his friend Otto Schmalhausen to 'think: that wherever you step, there's the smell of shit.'[17]

This outspoken verdict was shared by many artists in the USA, where war fever and anti-German feeling were now at their height. Just as painters and sculptors in Paris had already vented their fury on 'Munich' barbarism,[18] so the American entry into the war created what Milton Brown described as 'a violent, unreasoned emotion against the "Huns"'.[19] Hanfstängl, the art dealer, was widely attacked because of his German loyalties, and the campaign against him grew so ugly that he was eventually obliged to close down his premises. 'The more we learn of German methods, open and *secret*, the greater is the moral indignation of many Americans,' wrote T.S. Eliot's mother to Bertrand Russell, deploring the torpedoing of the cross-Channel steamer *Sussex* and adding that the word 'Germans' was 'a synonym for all that is most frightful.'[20] The nation's sense of disgust, fuelled by vitriolic propaganda, assumed its most disturbing pictorial expression in a vehement outpouring of lithographs and paintings by George Bellows. Earlier in the war he had adopted a detached attitude to the conflict, refusing to believe that America could become involved and producing a satirical print where a conventionally attractive young woman pins an admiring button on a gratified would-be volunteer.[21] By 1918, though, Bellows had grown sufficiently incensed to commence an extended and increasingly condemnatory series of images about the conflict.

His first lithograph, *Base Hospital*, is subdued enough.[22] Bellows later revealed that he had used photographs to help him with this depiction of 'a doctor's clinic at a dressing station in a cathedral',[23] and the ecclesiastical setting probably encouraged him to depict the scene with dignity and restraint. Compared with Beckmann's etching of an operation four years earlier (see Pl. 117), everyone appears still, composed and even statuesque in this near-sacramental image.

The mood did not last long. Bellows soon began to explore the darker and more brutal side of the war, turning his attention in print and painting to the murder of *Edith Cavell* (Pl. 252). The British Red Cross nurse's execution by the Germans in October 1915 had provoked widespread outrage at the time. Her only 'crime' had been

251 George Grosz *Dedicated to Oskar Panizza* 1917–18. Oil on canvas, 140 × 110 cm. Staatsgalerie, Stuttgart.

aiding the escape of wounded Allied soldiers, and she soon became a symbol of courageous martyrdom. Bellows decided to show her at the moment in the early morning when, dressed in night clothes, she was forced to leave her bed at the military prison of St Giles and face the firing squad. Lacking any exact information about the location, he devised a theatrical setting which allowed Nurse Cavell to make a dramatic descent down steep, narrow stairs. In the painting, which follows the lithograph very closely, the chiaroscuro is equally intense. Her pale robes lend the condemned woman a virginal, even saintly appearance, particularly in comparison with her uniformed captors – some of whom still sprawl and sleep. If there are echoes here of Raphael's *Deliverance of St Peter from Prison* in the Vatican's Stanza d'Eliodoro, Bellows would probably have been gratified by the connection. After all, when Joseph Pennell asked him how he depicted the event without witnessing it, he replied: 'It is true, Mr Pennell, that I was not present at Miss Cavell's execution, but I've never heard that Leonardo da Vinci had a ticket of admission to the Last Supper, either.'[24]

Bellows' involvement here with an episode derived from the German occupation of Belgium may have encouraged him to investigate other atrocities. His conscience was aroused so fiercely that he embarked on a long and shockingly uninhibited sequence of lithographs. They seem to have been produced in a feverish state of mind, for he later described these gruesome prints as his 'hallucinations.'[25] Even so, most of them are closely based on the account of the events published by the Bryce Committee Report. Viscount Bryce, who had been British Ambassador to the United States before the war, was chairman of the committee established to ascertain the truth about German 'atrocities' in both Belgium and France. How far he succeeded in verifying the stories investigated by his committee will never be known for certain. But they played an important part in arousing indignation among the Allied nations, and Robert Graves recalled that 'though I discounted perhaps twenty per cent of the atrocity details as wartime exaggeration, that was not, of course, sufficient.'[26] The full text of the Bryce Report filled three pages of the *New York Times* in May 1915, and at least seven of the War Series lithographs arise from incidents explored in that harrowing account.

252 George Bellows *Edith Cavell* 1918. Oil on canvas, 114.3 × 160 cm. Museum of Fine Arts, Springfield, Mass. James Philip Gray Collection.

253 George Bellows *Massacre at Dinant* 1918. Oil on canvas, 125.7 × 210.8 cm. Greenville County Museum of Art, Greenville, South Carolina.

Although some of Bellows' most forceful pre-war paintings had dealt with aggression in the boxing ring, none of them matched the War Series for unrelenting savagery. Atrocity stories ignited the dark side of his imagination to a highly charged extent, and in *Massacre at Dinant* he seized on the moment when entire families are herded into the street from their burning houses (Pl. 253). Finding corpses on the ground, some of them weep, faint or thrust a protesting fist in the cloud-choked air. Most of them stand there quietly, however, with hands clasped in prayer as they wait for the killing to resume.

Bellows had no intention of confining himself to such moments of expectation. Believing without hesitation in even the most question-able of the accusations dealt with by the Bryce Report, he decided in *Gott Strafe* to depict the heinous act of nailing a Tommy to a door. The Germans grin and joke with each other as they hold their victim down on the rough planks. A festive mood prevails, and it is made still more nauseous by the martyred figures already dangling in the background. Referring to incidents of this kind, Bryce concluded that 'once troops have been encouraged in a career of terrorism, the more savage and brutal natures, of whom there are some in every large army, are liable to run to wild excess, more particularly in those regions where they are least subject to observation and control.'[27] His words apply supremely to the barbarism denounced in *The Bacchanale*, where German soldiers carry impaled Belgian children on their bayonets while other troops gorge themselves on wine looted from the nearby houses. The almost documentary style of realism employed by Bellows, with careful attention paid to anatomical accuracy in his

handling of the skewered bodies, makes the image impossible to contemplate for long.

Several of the War Series prints directly tackle the helplessness of female civilians. In *The Last Victim*, the distraught Belgian girl screaming over the bodies of her father, mother and brother has clearly been spared for a purpose. The soldiers close in on her with undisguised hunger, and subsequent lithographs explore the degradation which ensued. *Belgian Farmyard* shows the aftermath of sexual crime, where the assailant dresses after raping and probably slaughtering his victim. By far the most appalling of the prints dealing with butchered women is, however, *The Cigarette*. After ransacking her house, cutting off her breast and bayoneting her hand to the wall, a bestial Lieutenant savours a contemplative smoke in the shadows.

Bellows was not in the least inhibited about exposing, as frankly as he knew how, sadistic acts which most other artists would prefer to avoid. His directness earned the attention of the American public, too. The government had sufficient confidence in the propagandist power of his work to use *The Germans Arrive* as an illustration in *Collier's*, advertising the US Government Bonds Fourth Liberty Loan. The lithograph centred on a German soldier who has just hacked off the hand of a semi-conscious Belgian, and the text accompanying the advertisement declared: 'This is Kultur. There is no sharper contrast between German Kultur and the civilization that our forefathers died for, than the difference in the attitude of the two civilizations towards women and children.'[28] When Bellows' large painting of the same subject was displayed in the window of Scott

and Fowles, one of the Fifth Avenue stores involved in what was described as the biggest exhibition staged for the American war effort, it provoked widespread comment (Pl. 254). While Knoedler Galleries' window was occupied by Blashfield's *Carry On*, an allegorical figure of Miss Liberty, the biggest crowds gathered in front of *The Germans Arrive*. The critic of the *Nation* explained why, arguing that 'the message should be delivered in strong, brutal language such as the horrible painting by S.J. Wolff where the soldier displays his hideous stumps of arms – or Bellows' scene of a Belgian who lies swooning in the arms of his torturers.'[29] Bellows agreed, and in an especially disturbing painting he showed a frieze of stripped Belgian civilians walking in front of the German soldiers as a human shield against the Belgian guns (Pl. 255). This image of *The Barricade*[30] is a poignant exposure of naked vulnerability. The row of raised arms gives the composition a Golgotha-like pathos, and echoes of Titian's late *The Flaying of Marsyas* reinforce the sense of intolerable human suffering.

No anguish was permitted to invade the consistently optimistic and patriotic flag paintings which Hassam carried on producing in 1918. The previous April, he had marked his country's entry into the war with a painting of Allied solidarity at the Union League Club (see Pl. 193). Now, exactly a year later, he celebrated the anniversary of that notable event in a painting which gives greatest prominence to the Union Jack. By placing the Stars and Stripes behind it, Hassam makes an unequivocal statement about the USA's support for Britain. His attitude to France is less easy to define, for the tricolour has been

254 George Bellows *The Germans Arrive* 1918. Oil on canvas, 125.7 × 201.3 cm. Estate of Emma S. Bellows.

relegated to a far smaller position above them. The relationship between America and the UK remains paramount here, and the Union Jack is the only area to have been painted at all thickly. It is emblazoned with heraldic force in a canvas otherwise handled with a spare delicacy befitting the soft April morning Hassam has chosen to evoke.

255 George Bellows *The Barricade* 1918. Oil on canvas, 126 × 212.7 cm. Birmingham Museum of Art, Birmingham, Alabama.

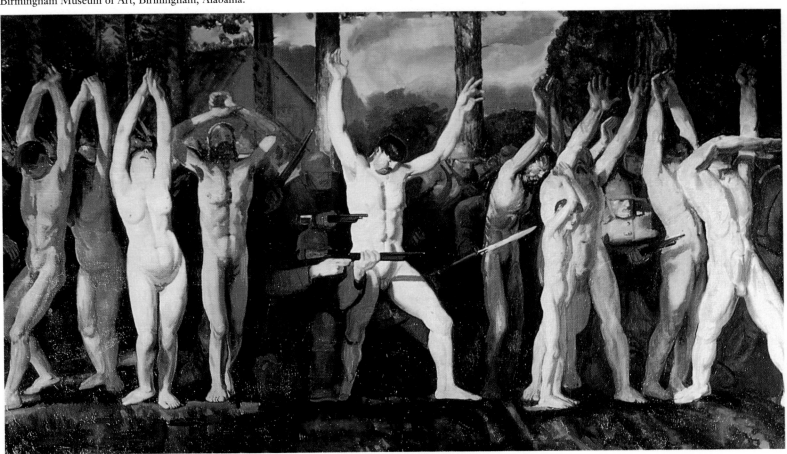

256 Childe Hassam *Red Cross Drive, May 1918* 1918. Oil on canvas, 90 × 59.7 cm. The Eleanor and C. Thomas May Trust for Christopher, Sterling, Meredith and Laura May.

During the course of 1918 Hassam, who was surely aware of Impressionist precedents like Monet's *The Rue Montorgueil, Festival of June 30, 1878*,[31] painted an extraordinary profusion of flag pictures. Intoxicated by the ready-made spectacle of the war parades, and driven as well by a mounting belief in the need to win a decisive victory against Germany, he returned again and again to the heady theme of flag-bedecked New York thoroughfares. But there was nothing belligerent about these festive canvases. One of the finest is devoted to the *Red Cross Drive, May 1918*, when a parade down Fifth Avenue was followed two days later by a display of Red Cross images across the city on immense banners and electrical illuminations (Pl. 256). Hassam, true to his belief that electric lights made New York look like 'a gigantic cut rate drug store',[32] concentrated on the banners. While an abundance of national flags festoons the sides of the street, the majestic pale red of the Greek cross isolated on a white ground dominates the picture-surface. But they all hang in space as

monumental affirmations of the need to offer humanitarian assistance to the wounded and dying.

The climax of Hassam's involvement with flag paintings occurred in the autumn of 1918, when he reacted to the Fourth Liberty Loan Drive by executing five substantial canvases in under three weeks. Their subjects directly reflected the fact that each Fifth Avenue block in central Manhattan was decorated in honour of one of the Allies, and that each day of the Drive was devoted to a particular Allied nation. With irrepressible zeal, Hassam painted in successive pictures celebrations of the French, Czechoslovak, Greek, Haitian, Guatemalan, Chinese and Belgian flags, but the most resplendent composition of all was given over to the British Empire. Once again an enormous Union Jack presides over the scene, handled with rich impasto to reinforce its prominence. Immediately behind, like planets dependent on the imperial sun, the merchant flags of New Zealand and Canada stir in the bracing breeze. Avoiding the congestion which mars other paintings in the series, Hassam is nevertheless able to specify the Brazilian and Belgian flags with brazen clangour behind. The Stars and Stripes are also clearly detectable in the distance, where a special Liberty Loan and United States display enlivened the Avenue. It was doubtless intended, in this picture, to signify the dependability of America's backing for the Allied cause, and Hassam's innate optimism charges the whole picture with a belief that freedom and liberty will ultimately prevail.

Although Bellows' baleful and accusatory painting *The Germans Arrive* was displayed in the selfsame event (Pl. 254), it could hardly have been further removed from Hassam's blithe confidence in the outcome of international solidarity. In this respect, the extended flag series is like the pictorial equivalent of the high-minded programme for peace and the League of Nations which his President, Woodrow Wilson, had announced in January 1918. Bellows' virulent anti-German propaganda was the antithesis of these idealistic Wilsonian proposals, and his hatred was representative of a formidable body of opinion in the USA. Other artists shared his sense of horror, and Max Weber began to condemn the brutality in his writing and art alike. *Der Krieg*, with its title pointedly in German, reveals the full extent of Weber's misgivings (Pl. 257). Abandoning his former commitment to Cubo-Futurism, and adopting instead an expressive figurative idiom paradoxically reminiscent of German art, he places a group of stricken figures in a Meidner-like locale. They seem unable to evade the destruction which ensnares their lives, even if they have so far been spared the violence which haunted Bellows' imagination.

Edward Hopper refused to join in the widespread willingness to vilify German culture as well as its military ambitions. Although his sympathies lay above all with French art, leading him to produce an affectionate wartime etching of three *poilus* talking attentively to a woman, Hopper remained ready even in 1918 to defend Germany's artistic achievements. When he entered a poster competition held by the United States Shipping Board, the contest officials encouraged applicants to produce 'American posters' and shun the 'German commercial art idea'.[33] But Hopper wrote them a lengthy letter proclaiming his belief that 'almost every poster maker in America has been influenced by the work of the modern Germans.' While affirming his own preference for French work, he declared that 'poster technic in Germany has been carried to a perfection that has been attained in no other country.'[34] However displeased the judges may have felt with this statement, it did not prevent them from awarding him the first prize of three hundred dollars for his four-colour design, *Smash the Hun* (Pl. 258).

Having emerged as the winner from 1,400 entries, Hopper enjoyed

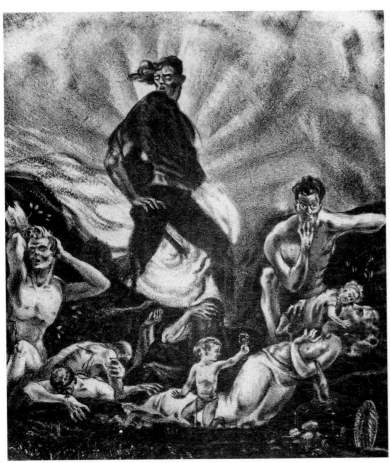

257 Max Weber *Der Krieg* 1918. Lithograph on paper, 28.5 × 24.5 cm. The Wolfsonian Foundation, Miami Beach, Florida, and Genoa, Italy. Mitchell Wolfson Jr. Collection.

a degree of attention he had never experienced before. His proposal was strong, concise and instantly understandable. The figure's energetic stance embodied something of the 'fire and vivacity'[35] he admired in French posters, and he described to the New York *Sun* how 'I tried to show the real menace to this country, as symbolized by the bloody German bayonets. The resistance of the worker to that menace is evident, I think, in his pose and the design. The way the worker's feet are spread out has a meaning to me of a certain solidity and force. They are set there for all time against this threatened invasion. The work to which the special appeal is directed is typified by a silhouette of a shipyard, smokestack and smoke.'[36] Hopper's explanation was as straightforward as the poster itself, which eschewed elaborate fantasy or allegory in favour of a down-to-earth assertion of his country's industrial prowess and stubborn resolve.

A similar priority asserted itself in Thomas Hart Benton's work when he found himself assigned by the navy, in the autumn of 1918, to make descriptive drawings of the buildings, ships and machinery at the base in Norfolk Harbor, Virginia. Although he realised that his 'perspective drawings of the new construction ... must be more accurate than artistic',[37] Benton did not find the work at all irksome. He particularly enjoyed a subsequent commission as a 'camoufleur' who cruised around the bay in a 40-foot motor boat sketching the newly arrived camouflage ships. Once again documentary recording was the aim, but it gave him plenty of opportunities to produce his own work as well. The watercolours he executed of Norfolk Harbor in his spare time are far more spirited and freely handled than the official sketches, and they disclose a lingering interest in the avant-garde form-language he had employed in his earlier art (Pl. 259).

All the same, Benton himself later came to feel that the act of studying these scenes had a decisive effect on his development. He even claimed that the Norfolk work 'was the most important thing that, so far, I had ever done for myself as artist. The mechanical contrivances of building, the new airplanes, the blimps, the dredges, the ships of the base, because they were so interesting in themselves, tore me away from all my grooved habits, from my play with colored cubes and classic attenuations, from my aesthetic drivelings and morbid self-concerns.'[38]

Viewed with hindsight, Benton's Norfolk watercolours may indeed seem to presage his subsequent renunciation of modernist experimentation. But when they were exhibited in December 1918 at Charles Daniel's New York gallery, the reviewers responded to his images of an observation balloon or a hydroplane as though they were the outcome of 'a cubist's holiday'.[39] One critic, writing for the New York *Herald*, went so far as to declare that it was 'the best one-man exhibition that has been produced by an American as a result of recent experiences'.[40] He omitted to point out that Benton's images

258 Edward Hopper, study for poster *Smash the Hun* 1918. Gouache on illustration board, 24.1 × 16.5 cm. The Charles Rand Penny Collection.

contained no hint of the violence and suffering which haunted Bellows and Weber. Forceful and essentially optimistic, these blithe watercolours conveyed more about America's machine-age dynamism than about the reality of the conflict itself.

Americans living through the war in Britain, by contrast, could not fail to be depressed by the accumulated sense of loss. Writing to his father from London, T.S. Eliot defined a widespread feeling of hopelessness when he admitted that 'everyone's individual lives are so swallowed up in the one great tragedy, that one almost ceases to have personal experiences or emotions, and such as one has seem so unimportant.'[41] A few months later he wrote that 'everything looks more black and dismal than ever, I think. The whole world lives from day to day.'[42] In such a context, most of the British artists producing war pictures found themselves impelled to acknowledge the grimness of this apparently unending struggle. In *The Ambulance*, John Copley stressed not just the pain of the blanched patient but also the stretcher-bearers' melancholy, straining upwards to carry the weight of a man they know is probably beyond all hope of a proper recovery (Pl. 260).

William Nicholson, who had largely refrained from admitting war references to his previous work, now decided to paint an uncharacteristically despondent scene: *The Ballroom of the Piccadilly Hotel during an Air Raid* (Pl. 261). Provoked by the onset of Zeppelin raids on London, where Nicholson had recently moved his studio to a mews near St James's Square, the canvas depicts an interior he had come to know well. Since the ballroom was underground, it provided a ready-made shelter for anyone wanting to evade the bombing above. While using it himself, Nicholson clearly became fascinated by the spectacle before him. The hierarchy of class and wealth which normally prevailed in the hotel had broken down, to be replaced by a bizarre cross-section of humanity. Tramps and prostitutes can be detected among the figures seated so self-consciously on the gilt chairs, and most of them seem marooned in isolation. Above all, though, the room itself provides this painting with its fascination. Nicholson accords a generous amount of his picture-space to the immense ceiling, thereby emphasizing its role as a bulwark against attack. But there is something claustrophobic about the way it presses down on the interior below, and the scene there is disconsolate. The

259 Thomas Hart Benton *Impressions, Camouflage: WW1* 1918. Watercolour on paper, 60 × 71.1 cm. Private collection.

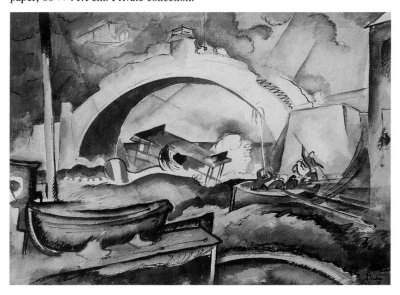

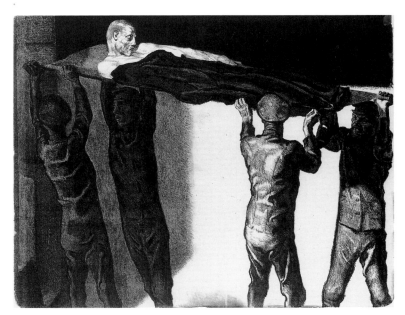

260 John Copley *The Ambulance* 1918. Lithograph on paper, 44 × 55 cm. Gordon Cooke.

room's crystal chandeliers and monumental proportions serve only to point up the lack of animation conventionally associated with a ballroom. The red carpet extending into the distance has been rolled up, so that it lies like a vast discarded streamer on the polished floor. More alarmingly, it also resembles a rivulet of blood, and the woman suckling her baby in the foreground cannot dispel the mood of forlorn, anxious alienation.

Desultoriness is even more marked in Walter Bayes' colossal, frieze-like painting of *The Underworld*, which examines the dour atmosphere as shelterers gather on a platform at the Elephant and Castle Tube station (Pl. 262). This time, the gaunt surroundings intensify the dejection of the figures waiting for the bombing raid to finish. At either end of the canvas, outbreaks of movement interrupt the lassitude: a woman touches her companion's shoulder, and a serviceman puts his arms around two friends. On the whole, though, gloom prevails. Nevinson's name is repeated on wall posters, as a reminder both of war's prevalence and the role an artist can play in the struggle. But the working-class mother changing her baby's nappy remains as impervious to its exhortation as the fur-lined woman sitting next to her. As for the shelterers laid out near the platform's edge, exhaustion and ennui have forced them to recline in positions anticipating the sleepers who would inhabit Henry Moore's brooding shelter drawings during the Second World War.

Bayes must have hoped that his ambitious yet dogged painting would lead to government commissions, and *The Underworld* was duly acquired by the newly established Imperial War Museum. But he never received the lavish state patronage bestowed on William Orpen who, after Bone (see Pl. 177) and McBey, was the earliest of the official war artist appointments. Far more renowned at that time than he is today, the Irish-born portraitist was regarded as a considerable *coup* by the authorities at the new Department of Information, where John Buchan had been appointed Director. But the truth is that Orpen remained an unlikely candidate for the task, and for a while he failed to produce any finished pictures at all. Even though his high reputation at the Royal Academy protected him from censure, he did not need to excuse himself indefinitely. For Orpen appears to have undergone something of a conversion after witnessing the full horror

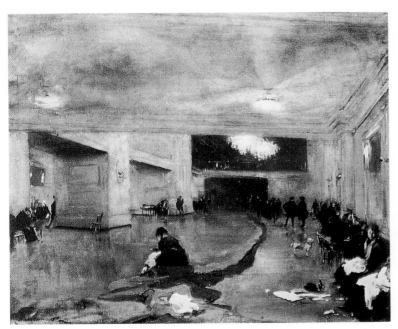

261 William Nicholson *The Ballroom of the Piccadilly Hotel during an Air Raid* 1918. Oil on canvas, 62 × 74 cm. Mr and Mrs C. Ch. Mout Collection.

of the Somme. The scene he surveyed there changed him from an accomplished and highly-paid darling of fashionable society into an aghast witness, who refused to make any profit out of the abundance of pictures he eventually presented *en bloc* to the government.

Travelling up and down the Line from his base at Amiens, Orpen came to realise just how appalling the devastation had been. He reported his response with an eloquence that discloses genuine indignation. 'Today when I had finished work, I went over some country that was really terrible,' he wrote, allowing his sentence to run on uncontrollably as his description of the carnage grew more excitable: 'it was fought over last about 3 weeks ago, and everything is left practically as it was, they have now started to bury the dead in some parts of it, Germans and English mixed, this consists of throwing some mud over the bodies as they lie, they dont even worry to cover them altogether, arms and feet showing in lots of cases, the whole country is obliterated ... miles and miles of Shell Holes bodies rifles steel Helmets gas Helmets and all kinds of battered clothes, German and English, and shells and wire, all and everything white with mud, and one feels the horrors the water in the shell holes is covering – and not a living soul anywhere near, a truly terrible peace in the new and terribly modern desert.'[43]

While they are undoubtedly sincere, Orpen's paintings do not match the raw consternation he managed to relay in that heartfelt letter. Many of them are disappointingly neat and bright, as if he needed to sanitize the scenes for the sake of his own peace of mind. Perhaps the most well-known of these canvases, *Thiepval*, accords great prominence to the skulls left among the debris of battle. But they fail to convey the horror he had felt, resembling props in front of a stage-set painted with a precision that excludes too much of Orpen's own impassioned response. He came nearer to expressing the shock in a less decorous painting, bluntly entitled *Dead Germans in a Trench* (Pl. 263). The pit where both corpses lie – one with his upturned boots thrust forward like a figure from Egger-Lienz's *Missa Eroica* (Pl. 246) – takes on the character of a grave. Its structure is already disintegrating, just as the bodies themselves seem about to dissolve in the snow. This deliberately graceless work does not suffer

from Orpen's usual need to manicure his paintings. It was considered alarming enough by the authorities to be listed in a group of works submitted to Major Lee, the officer responsible for arranging the artists' visits to the Front for censorship. The ban was subsequently lifted, for Orpen's picture was included in his one-man show of war work at Agnew's in May 1918.[44] The fact that Germans were depicted must have counted in its favour, unlike the dead Tommies in Nevinson's censored *Paths of Glory* (see Pl. 220).

All the same, the government's failure to publish Orpen's substantial body of war pictures probably reflects official unease over his readiness to depict gruesome scenes. The Department of Information proved far more willing to promote the commissioned work by John Lavery,[45] another Irish society portraitist who had been appointed around the same time as Orpen. Apart from an exceptional canvas such as *The Cemetery, Etaples*, where the pathos of the soldiers' graves is conveyed without sentimentality, Lavery's work was unable to transmit the revulsion he felt as a near-pacifist with an undimmed sympathy for Germany. In later life he was sufficiently honest to describe his war work as 'totally uninspired and dull as ditchwater ... Instead of the grim harshness and horror of the scenes I had given charming colour versions as if painting a bank holiday on Hampstead Heath.'[46] But the government found these bland exercises more palatable, for its particular purposes, than Orpen's feeling for the macabre.

No purpose could be served, from the official point of view, by stressing the obscenity of war. Orpen's attempts to acknowledge the conflict's worst aspects counted against him in political circles, even though one of his most elaborate canvases could be seen as a propaganda image. Like Bellows' war pictures, *The Mad Woman of Douai* focuses on a supposed victim of German savagery. She sits in the ruins, stunned and damaged irreparably by the persecution inflicted on her. The people peering at her all seem heartless, no more able to offer comfort than the crucifix still hanging on the battered fragment of church wall beyond. Although the theatricality which often mars Orpen's work détracts from the painting's effectiveness, he was at least prepared to confront the victims of war at their most wretched. And in a muted watercolour called *A Death Among the Wounded in the Snow*, his innate staginess is replaced by a less exaggerated sympathy both for the young soldier and the stretcher-bearers stunned by the finality of their loss (Pl. 264).

In the last analysis, however, Orpen's striving for an art of authentic tragedy pales before another snow scene painted as an official commission by John Nash (Pl. 265). *Over the Top*, one of the finest paintings he ever produced, was based very directly on memories of his worst experience as a soldier. Having enlisted in the Artists' Rifles

262 Walter Bayes *The Underworld* 1918. Oil on canvas, 254 × 549 cm. Imperial War Museum, London.

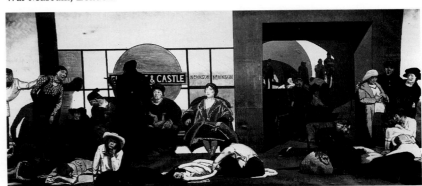

in September 1916, he was soon promoted and sent to the Front in June the following year. He went 'over the top' on several occasions, and after his appointment as a war artist in 1918 he set to work on a canvas depicting an event at Marcoing on 30 December 1917. 'The attack in daylight in the snow...was designed as a diversion to a bombing raid up a support trench on the left,' he wrote many years later, describing how he was shown a map beforehand but given only vague indications of where his company should make for. 'There was not a shot for a while, suddenly the Germans opened up and that seemed to be every machine gun in Europe,' Nash recalled. 'We never got to grips with the enemy but were stopped in sight of them. We had to "hole up" in craters and shell holes till nightfall and then got back to our original line. Casualties were very heavy. All officers killed or wounded and only one Sergeant left, and the Q.M.S. It was in fact pure murder and I was lucky to escape untouched.'[47]

Over the Top presents the moment of attack with extraordinary clarity. The soldiers have only just climbed out of their trench, and they wade off through the snow towards the unseen enemy. But casualties have already begun. Two of the men sprawl in the trench, a few more lie on the white ground, and another falls to his knees as if hit by a bullet. Since they all make easy targets against the snow, the advance looks futile before it has effectively begun. The line of resigned soldiers shuffling into the grey sky seems bound to meet with obliteration, and in the distance clouds part to disclose a pink light which makes the troops even more visible. The cold is evoked as painfully as the folly of an attack which should never have been launched in such adverse circumstances.

263 William Orpen *Dead Germans in a Trench* 1918. Oil on canvas, 91.4 × 76.2 cm. Imperial War Museum, London.

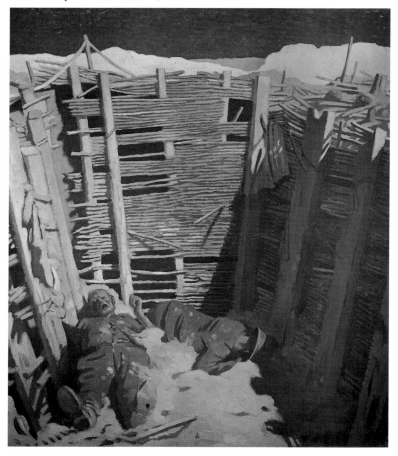

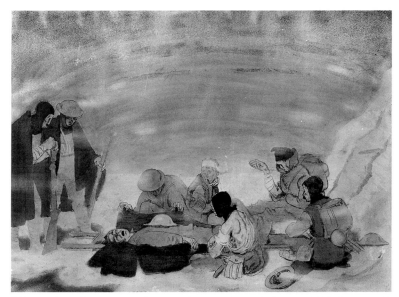

264 William Orpen *A Death Among the Wounded in the Snow* c. 1918. Pencil and watercolour on paper, 45 × 58.4 cm. Imperial War Museum, London.

This remarkable painting is intense enough to withstand comparison with the work of John Nash's brother Paul, whose official commissions of 1917–18 are, quite simply, the most impressive paintings and graphic works made by any British artist during the conflict. Now that the extent of Paul Nash's achievement in the final year of war is widely recognised, such a claim is easy to defend. Before the hostilities commenced, however, Nash would have seemed the artist least likely to place this lacerating event at the centre of his work. Confining himself to modest watercolours and drawings, he had gained a precocious reputation as a gentle landscapist with pronounced leanings towards the visionary. More indebted to the previous century than his own time, Nash was obsessed by Blake, Palmer and above all Rossetti. While many painters of his Slade-educated generation grappled with machine-age modernity, he hid himself away in sequestered corners of the English countryside to pursue his quest for the elusive spirit of a place.

Having joined the Artists' Rifles as a home defence private in September 1914, this nervous and highly imaginative young man was selected for officer training two years later and sent to the Western Front early in February 1917. Serving as a second lieutenant in the Hampshire Regiment, Nash could scarcely be expected to respond to a terrain so removed from anything he had cherished at home. But life in a front-line trench at St Eloi sharpened his senses with phenomenal swiftness. 'This has been the most interesting week of my life,' he wrote to his wife, explaining that 'my inner excitement and exultation was so great that I have lived in a cloud of thought these last days.'[48] Although the Ypres Salient was relentlessly shelled, Nash did not witness a major engagement or, probably, encounter a single corpse.[49] His awareness of destruction was at this stage countered by the joyful and consoling realisation that nature still reasserted itself throughout the blasted landscape – just as Dix had noticed in his charcoal drawings (see Pl. 205). Nash delighted in the sight of dandelions 'bright gold over the parapet',[50] and was even able to refer to 'those wonderful trenches at night, at dawn, at sundown.'[51] Filled with a spirit of zest and renewal, he found the time to make drawings of this enthralling new world and send them home.

They would, no doubt, have been very different if Nash's stay at

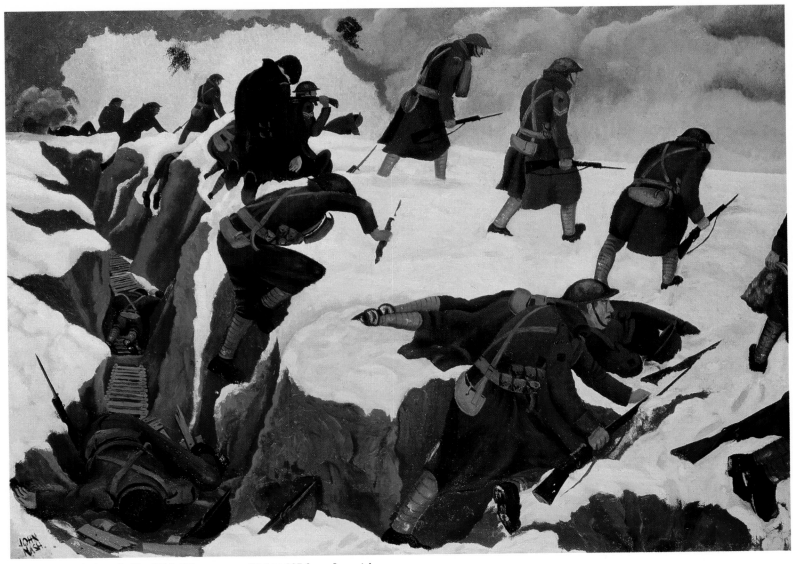

265 John Nash *Over the Top* 1918. Oil on canvas, 79.4 × 107.3 cm. Imperial
War Museum, London.

the Front had lasted longer. But in May 1917 a broken rib caused by
a fall at night sent him back to London for hospital treatment. It was
a fortuitous release: the Hampshires attacked Hill 60 only three days
later, and many of his fellow-officers were slaughtered. Although
the news of their deaths must have affected Nash, the drawings
completed during his recuperation concentrate on the land rather
than the soldiers who fought there. It was a wise decision. Human
figures would always be the weakest element in his work, which
now gained enormously from their virtual exclusion. His style also
changed, in order to encompass the vision he had confronted at the
Ypres Salient. The lines defining attenuated trees and gouged mud
took on a more jagged, Vorticist-like harshness, proving that Nash
was finally prepared to learn from the austere language of his most
innovative British contemporaries. Nevinson's earlier war pictures
were a particular source of stimulus. In March 1917, around the time
when he drew the spiky, almost surgical *Wytschaete Woods*, he asked
his wife: 'Do you remember Nevinson's small etching of the 2nd
bombardment (or was it the first) of Ypres? I should like to have it if
possible . . . It is part of the world I'm interested in .'[52] Nash probably
recalled this stark image of gutted, scorched houses from Nevinson's
one-man show at the Leicester Galleries. The two men met in July

1917, perhaps for the first time since they were students together at
the Slade,[53] and Nevinson's ability to define the Western Front in all
its staccato grimness elicited Nash's admiration at this crucial stage in
his development.

Even so, most of the work he displayed in a June one-man show at
the Goupil Gallery stopped a long way short of tragedy. One exhibit
bore the disconcertingly playful title *Chaos Decoratif*, and resembled at
first a woodland scene where a ladder, duckboard and shattered tree
hardly disrupt the prevailing mood of pastoral calm. None of these
early war pictures is informed by the profound sense of moral outrage
which fuelled his subsequent front-line work. Nash's experience of
the battlefield was at this stage too limited, unmarked by the horror
which could only be felt when hostilities were at their fiercest. But
the success of the exhibition prompted him to seek out a commission
as an official war artist. His request encountered considerable op-
position from some of the government's advisers. Campbell Dodgson
complained that 'Nash is decidedly post-impressionist, not cubist, but
"decorative", and his art is certainly not what the British public will
generally like.'[54] Buchan agreed, and yet he bowed with reluctance to
the enthusiasm of others. In November 1917 Nash returned to the
Salient with a plentiful supply of paper, crayons and chalks.

Some artists deteriorated once they gained this official status: Nevinson changed, in the main, from harsh denunciation of front-line conditions to heroic celebration of air combat. But despite the comforts of a life removed from active service, further cushioned by a manservant and chauffeur-driven car, Nash did not lapse into complacency. On the contrary: his expeditions to the battlefields transformed him into an angry, wholly engaged opponent of the war's destructive futility. His long-held belief in the sanctity of landscape hastened this inner metamorphosis. Nash's love of nature was outraged when he discovered the shocking change in the Salient. The terrain which had previously been replenished by signs of spring was now entering winter. Rain had been more or less incessant since August, and it gathered in muddy shell-holes rather than sinking beneath the clay. Nature, no longer capable of alleviating the damage wrought by incessant gunfire, appeared everywhere to have suffered irrevocable extinction. Passchendaele had been fought for three harrowing months while Nash was in London, and nothing could conceal the wounds it inflicted on the countryside. The battle of the mud, as Lloyd George so aptly dubbed it, claimed over 300,000 British casualties. Even the most hardened soldiers were demoralized by the inhuman conditions in which this purposeless struggle was enacted. When Haig's Chief-of-Staff visited the Passchendaele Front for the first time in November, and found his car shuddering with the effort of moving through the churned and waterlogged ground, he began to cry and said: 'Good God, did we really send men to fight in that?'[55]

No wonder Nash was so shaken by his investigations of this benighted region. The shelling nearly killed him at times, for the privileges available to war artists offered no guarantee of protection to a man bent on 'getting as near to the real places of action as it was possible to go.'[56] But he survived to set down his anguished reactions in image after image, using 'nothing but brown paper and chalks'[57] as he rapidly defined the reality of the killing fields. At the same time Nash attempted to write about the horror he had experienced, in the privacy of an eloquent letter to his wife. 'I have just returned, last night, from a visit to Brigade Headquarters up the line', he reported, 'and I shall not forget it as long as I live. I have seen the most frightful nightmare of a country more conceived by Dante or Poe than by nature, unspeakable, utterly indescribable. In the fifteen drawings I have made I may give you some idea of its horror, but only being in it and of it can ever make you sensible of its dreadful nature and of what our men in France have to face. We all have a vague notion of the terrors of a battle, and can conjure up with the aid of some of the more inspired war correspondents and the pictures in the *Daily Mirror* some vision of battlefield; but no pen or drawing can convey this country – the normal setting of the battles taking place day and night, month after month. Evil and the incarnate fiend alone can be master of this war, and no glimmer of God's hand is seen anywhere. Sunset and sunrise are blasphemous, they are mockeries to man, only the black rain out of the bruised and swollen clouds all through the bitter black of night is fit atmosphere in such a land. The rain drives on, the stinking mud becomes more evilly yellow, the shell holes fill up with green-white water, the roads and tracks are covered in inches of slime, the black dying trees ooze and sweat and the shells never cease. They alone plunge overhead, tearing away the rotting tree stumps, breaking the plank roads, striking down horses and mules, annihilating, maiming, maddening, they plunge into the grave which is this land; one huge grave, and cast up on it the poor dead. It is unspeakable, godless, hopeless. I am no longer an artist interested and curious, I am a messenger who will bring back word from the

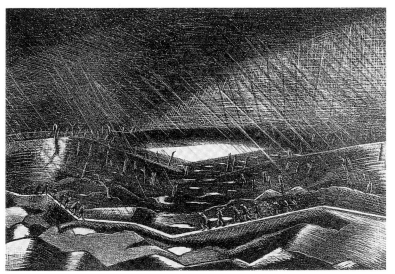

266 Paul Nash *Rain: Lake Zillebeke* 1918. Lithograph on paper, 25.5 × 36.2 cm. Imperial War Museum, London.

men who are fighting to those who want the war to go on for ever. Feeble, inarticulate, will be my message, but it will have a bitter truth, and may it burn their lousy souls.'[58]

It was not an attitude which Buchan, the effective paymaster of Nash's activities, would have been eager to promote. The aim of the war artists' scheme centred, after all, on propaganda for the British cause, and Nash's despair was hardly likely to boost the war-effort. To its credit, though, the Department of Information provided firm support after his final return to England in December. Armed with more than '50 drawings of muddy places'[59] produced at the Front, he worked in a frenzy to complete enough pictures for another one-man show in May 1918. Nash's fears that his work would be 'feeble, inarticulate' proved groundless. An impressive number of the images he produced during that period, when the memory of his visit was still at its most intense, did indeed turn out to possess 'a bitter truth'. Without degenerating into crude polemics, he defined the negation of a locale brutally shorn of either sustenance or hope.

Figures appear in some of the pictures, and they are handled with unusual conviction. *Nightfall. Zillebeke District* includes a number of soldiers walking in both directions along a narrow, zig-zagging duckboard. They are diminutive enough to ensure that Nash could draw them without any apparent difficulty, and their modest proportions also serve to emphasize man's helplessness in the face of overwhelmingly hostile surroundings. They look just as broken and vulnerable as the stripped trees projecting so nakedly from the land beyond. No shelter can be found against the rain as it lances down, piercing both troops and ground with the same needle-thin sharpness which Nevinson had earlier conveyed in his painting of a *Flooded Trench on the Yser* (Pl. 76). When Nash carried out a lithographic version of the Zillebeke scene, he changed the name from *Nightfall* to *Rain* and reinforced the assault of each stroke (Pl. 266). Instead of simply falling in one direction, they now form a criss-cross structure of stabbing lines. A few more figures can be discerned too, but they do not appear any more capable of withstanding the storm on their exposed and unstable pathway.

Perhaps emboldened by the expressive power of these beleaguered silhouettes, Nash also produced a lithograph where marching men play a more prominent role in the composition (Pl. 267). Nevinson's precedents are again evoked, most notably his early war painting

Column on the March which likewise makes use of a dramatic perspective.[60] The differences between the two images are, however, far more significant than their similarities. Nevinson's troops proceed in daylight under an open sky, and a considerable amount of vigour still animates their limbs. Nash's nocturnal travellers are, by contrast, huddled and forlorn. The legs of the men at the front are bent in a strangely uncertain way, as if physical collapse were imminent. Their bodies move along diffidently like a column in retreat, and the trees flanking them on either side accentuate the sense of oppression. Rather than offering protection, these tall columnar forms signify confinement. They almost seem to imprison the figures, condemning them to trudge in an apparently unending procession on a road as monotonous and inflexible as the war itself.

In the main, though, Nash's use of figures was more sparing. He became preoccupied by the belief that the wasteland of Passchendaele was inimical to human life, and in *After the Battle* a few corpses are the only soldiers visible in an otherwise deserted setting (Pl. 268). The foreground body is already sinking into the mud. In order to stress the anonymity of dissolution, Nash leaves the face without any distinguishing features. The figure near the centre, subsiding into the broken slats behind him, has already taken on a skeletal appearance. He looks as forsaken as the landscape around him, where everything is derelict. The duckboard at his feet has been severed; the trench is eroded by shell-holes and land slippage; and the barbed-wire fencing has been broken up into a mêlée of tilting stakes. They are almost as

sharp as the thin spears of rain falling from the sky. The dense ink hatching scored into the paper by Nash's surgical nib does not prevent him from summarizing the terrain in a sequence of bare structures, all redolent of desolation and despair.

But most of these elegiac drawings dispense with figures altogether, confronting us directly with the emptiness of a region which seems to have devoured everyone who previously inhabited it. Nobody could survive for long in *The Landscape – Hill 60*, where explosions tear through the sky above a pummelled mass of mud and wire. Even the water in the shell-crater is peppered with tracer-bullets, determined to ensure that any soldiers who might still be lurking there will never emerge. The intricate system of dykes and ditches which had drained the Flanders country for many centuries was obliterated by the bombardment of Passchendaele, giving way to the subdued, featureless morass defined in this image. If God had indeed abandoned the battlefield Nash scrutinized, he saw no reason to minimize the ensuing nullity.

Precisely because he had cherished nature with such visionary fervour in his pre-war work, his outrage over her subsequent desecration knew no bounds. In *Wire*, one of the largest and most powerful of all the 1918 drawings, he unleashes the full force of his indignation by emphasizing the shattered foreground tree (Pl. 269). Figures are no longer needed here, for the remains of this abused trunk are as pitiful as any human martyr. Enmeshed in barbed spirals, which circle around the tree like the thorns crowning Christ's head, the tree symbolizes the degradation and extinction of all living things. If there are echoes of the cross on Calvary, Nash nevertheless makes sure that no hint of a future resurrection is allowed to counter the prevailing emphasis on death. The coiled wire holds both the tree and the surrounding landscape in its possessive grip. Defilement could hardly be more thoroughgoing, and apart from the pale pink flaring in the sky he restricts the composition to the unrelieved chill and dampness of dull green, umber and grey.

Nash did not deal exclusively with the aftermath of battle. When he turned to oil painting early in 1918, for the very first time in his career, he was soon able to produce an arresting image of bombardment in progress (Pl. 270). Nash realised that the transition from drawing and water-colour to oil paint might prove difficult, and

267 Paul Nash *Men Marching at Night* 1918. Lithograph on paper, 51.5 × 42.1 cm. Imperial War Museum, London.

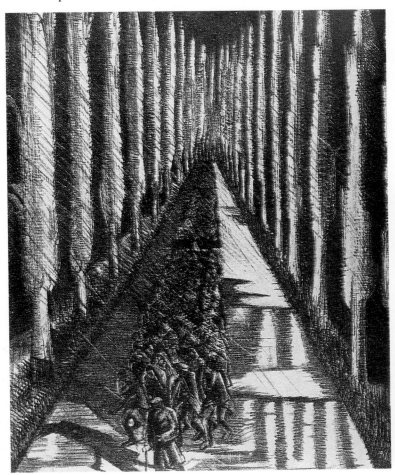

268 Paul Nash *After the Battle* 1918. Pen and watercolour on paper, 47 × 60.1 cm. Imperial War Museum, London.

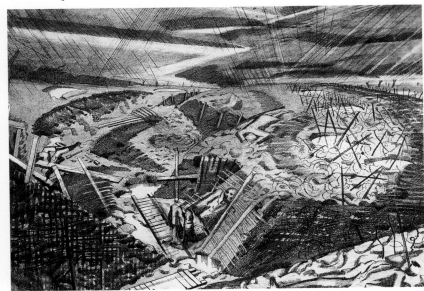

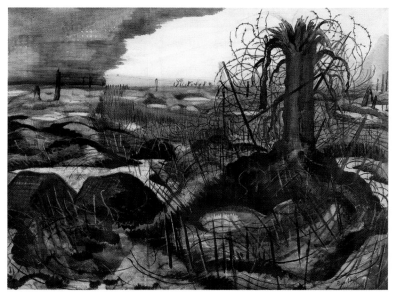

269 Paul Nash *Wire* 1918. Ink, pastel and watercolour on paper, 48.5 ×
63.4 cm. Imperial War Museum, London.

confessed that he felt guilty of 'a piece of towering audacity'[61] when
faced with a canvas. But the outcome was surprisingly assured. *The
Mule Track* is an impressive achievement, carrying over the intensity
of his graphic work to the new medium without any loss of conviction.
Indeed, a new emotional vehemence enters Nash's art with the
advent of oil painting. Some tiny silhouetted soldiers can be detected
at the heart of *The Mule Track*, struggling to prevent their pack
animals from panicking and falling off the crazily zig-zagging duck-
board. But the shelling around them is an absolute inferno, and they
could easily be overwhelmed by its savagery. One figure is already
plummeting into the water, while further up the duckboard an animal
has broken free and bolts through the mayhem like a demented
refugee.

The expressive resources of paint prompted Nash to be more
ambitious with colour than he had been hitherto. The trees which
were so sombre in his works on paper are irradiated, all over *The
Mule Track*, by ferocious yellows, oranges and mustards in the ex-
plosions. Colour used to frighten Nash, but he now deploys it to
arouse the sensation of terror in his viewers. Nor did he rely solely on
his imagination to give this image of bombardment its authenticity. As
an official war artist, he had consistently flouted the attempts by
General Headquarters at the Front to keep him safely away from
the conflict. Nash later remembered how he managed to 'evolve a
technique' which eventually enabled him to 'get where I want to
be.'[62] His desire to approach the battle area, and witness far more of
the action of war than he had experienced as a second lieutenant the
year before, was facilitated by his 'mad Irish chauffeur'. Once, while
travelling along the Menin Road, the driver 'pilotted the car so
skilfully, that he timed the constant shell bursts on the road, any one
of which might immediately have killed' them both.[63] Confrontation
with danger no doubt acted on Nash as an energizing force, stimu-
lating him into an enlarged awareness of what warfare really entailed.

All the same, the most profound and despairing of his 1918
paintings draw back from the thick of the fighting to meditate, once
again, on the waste of battle. One of these canvases, *Void*, still shows
the conflict proceeding in the distance (Pl. 271). A strafed aeroplane
appears to be falling towards the ground, and shells explode near a
duckboard where men carry out a slow, funereal retreat from the

maelstrom. The rest of the picture, however, is devoted to the terrible
stillness of a landscape already shattered and deserted by the opposing
armies. Nash concentrates on the violation of nature with even more
perturbation than before. The entire composition is sliced up into a
network of angry, disruptive diagonals. A damaged lorry has slewed
off the road, spilling its cargo of ammunition and rifles across the
foreground. There they lie, along with the body of a soldier who
appears to have been driven into the earth by a vehicle heedless of its
callous progress. He has become one more piece of detritus, a
discarded remnant like the helmet floating in water nearby. The guns
are equally useless, their heavy wheels bogged down in the mud
which grows ever more treacherous as the rain continues its assault.
Void justifies Nash's terse title by stressing the obliteration of a land
where everything has been abused, stricken and robbed of its former
identity. This pitiless emptying-out, summed up by the abject corpse
whose very substance is brutally flattened out on the furrowed
ground, haunted Nash's imagination. He called his May 1918 one-
man show at the Leicester Galleries *Void of War*, and accompanied it
with a monochrome poster design which reduced his memories of the
killing fields to a stark combination of trees, rain and dank, stagnant
craters.

Nash may well have owed the notion of a void to William Blake,
whose work he had venerated for many years. In September 1917 he
produced three illustrations for Blake's 'Tiriel', a gruelling poem
about a 'blind & aged' man whose Timon-like curses summon up a
vision of destruction as catastrophic as the scenes Nash was about to
witness at Passchendaele:

'Earth, thus I stamp thy bosom! rouse the earthquake from
 his den,
'To raise his dark & burning visage thro' the cleaving ground,
'To thrust these towers with his shoulders! let his fiery dogs
'Rise from the center, belching flames & roarings, dark
 smoke!
'Where art thou, Pestilence, that bathest in fogs & standing
 lakes?
'Rise up thy sluggish limbs & let the loathsomest of poisons
'Drop from thy garments as thou walkest, wrapt in yellow
 clouds![64]

270 Paul Nash *The Mule Track* 1918. Oil on canvas, 61 × 91.4 cm. Imperial
War Museum, London.

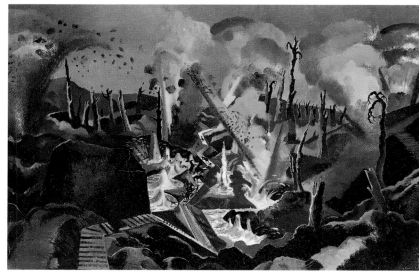

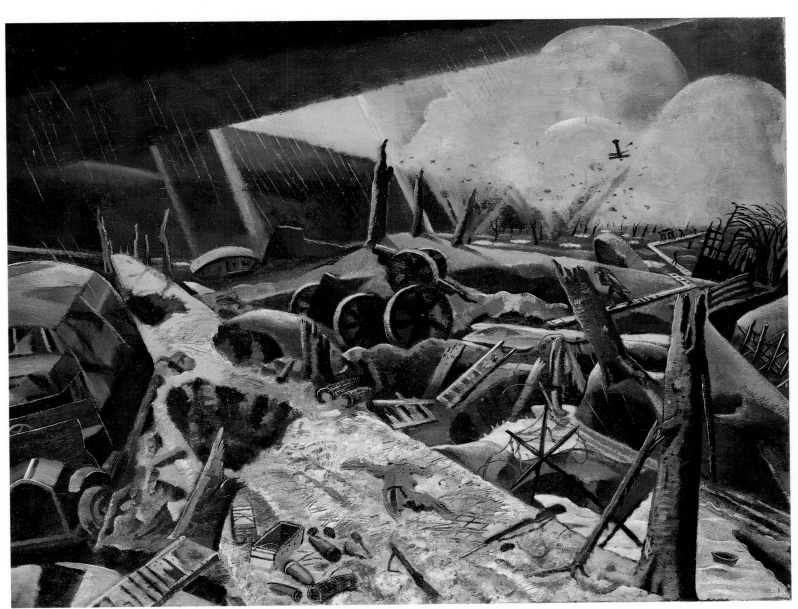

271 Paul Nash *Void* 1918. Oil on canvas, 71.4 × 91.7 cm. National Gallery of
Canada, Ottawa. Transfer from the Canadian War Memorials, 1926.

The apocalyptic virulence of this damnation may have returned to
Nash's mind as he surveyed the Front only a month after completing
his 'Tiriel' designs. But Blake deals with the void itself in his Second
Book of 'Milton', where the trembling Virgin Ololon responds 'in
clouds of despair' to Milton's insistence that

> 'All that can be annihilated must be annihilated
> 'That the Children of Jerusalem may be saved from slavery.'

In Ololon's reply, which Nash could well have read while executing
the 'Tiriel' pictures, she poses the kind of anguished question he
must have asked himself when surveying the wasteland of Flanders:

> 'O Immortal, how were we led to War the Wars of Death?
> 'Is this the Void Outside of Existence, which if enter'd into
> 'Becomes a Womb? & is this the Death Couch of Albion?
> 'Thou goest to Eternal Death & all must go with thee.'[65]

A similarly tragic mood informs the masterpiece of Nash's war
paintings, where he wonders whether regeneration can ever occur

after such wholesale destruction has prevailed. The image grew out
of a drawing called *Sunrise: Inverness Copse*, where a pale yellow sun
begins to illuminate a scene stripped of everything except trees and
mud. There is still a hope, in this otherwise dejected study, that light
and heat will one day nurture the graveyard of nature's forms. But by
the time Nash executed a painting of the same subject, he decided to
dispense with the reference to a particular locality and make the
prospect of a rebirth far more doubtful. *We are Making a New World* is
the bitterly ironic title he bestowed on his definitive, universalized
image of front-line devastation (Pl. 272). All the incidental detail
found in *Void* and *The Mule Track* has here been dispensed with, so
that we are forced to confront the issue of extinction alone.

No corpses, animals and abandoned equipment prevent the eye
from moving over the mounds of pummelled earth towards the
blackened, severed trunks punctuating the land beyond. They have
the pathos of amputated limbs, for Nash regarded trees almost as an
extension of his own body. In his pre-war work they had often played
the role of people, and long before hostilities commenced he took

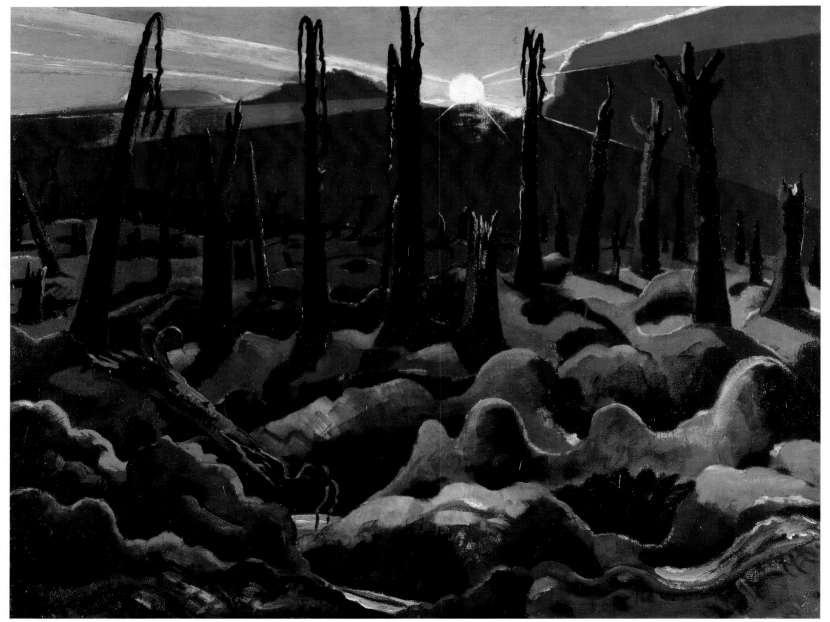

272 Paul Nash *We are Making a New World* 1918. Oil on canvas, 71.2 ×
91.4 cm. Imperial War Museum, London.

time off from depicting the elms in his family garden to tell Gordon
Bottomley that 'I have tried to paint trees as tho they were human
beings . . . because I sincerely love & worship trees & know that they
are people & wonderfully beautifuly [*sic*] people.'[66] Now, aghast at
the dismemberment of these cherished growths, he was able to
convey the horror of human carnage by focusing on the withered
stumps rising so mournfully from ground no longer capable of
nourishing their roots. One tree has fallen over already, its topmost
branches submerged in the water. The rest could easily follow, and
the emergent sun no longer seems capable of preventing their demise.
Unlike the disc in the *Inverness Copse* study, this new orb is restricted
to a cold whiteness. Moreover, the dull brown clouds in the drawing
have been transformed here into the colour of dried blood. The sun's
rays lighten the clouds a little, but cannot disperse them. They clog
much of the sky with their oppressive weight, as if all the blood

spilled on the Western Front had coagulated on the horizon and
threatened to choke nature altogether. Instead of responding to the
shafts of light, the trees remain despondent and inert. Their branches
dangle from the trunks like melancholy tresses of hair, implying that
the entire group of trees could be seen as chorus-like presences
mourning the death of the world Nash held dear.

Looking at this profoundly moving canvas today, we are confronted
not only with an image of Nash's belief that 'sunset and sunrise are
blasphemies, they are mockeries to man', but also with a reflection of
our own contemporary nightmare. For the parallels between the
extinction of Passchendaele, and the nuclear winter threatening the
planet now, are inescapable. They help to explain why *We are Making
a New World* continues to exert a special hold over our imaginations,
giving pictorial coherence to a prospect of total annihilation. The
warning which Nash sounded in 1918 has, if anything, grown in

pertinence, now that we contemplate the possibility of a global disaster far more calamitous than the devastation he forced himself to survey. When photographs of his war work were sent to Colonel Lee for censorship, however, they elicited a very different response. After dismissing the idea that 'Nash's funny pictures' could 'possibly give the enemy any information', the bewildered officer complained: 'I cannot help thinking that Nash is having a huge joke with the British public, and lovers of "art" in particular. Is he?'[67]

The answer, so far as most visitors to his *Void of War* exhibition were concerned, favoured Nash rather than the disgruntled Colonel. Moreover, the Department of Information supported his work by reproducing fifteen of the war pictures in Volume III of *British Artists at the Front*. Timed to coincide with the opening of his one-man show, it helped Nash's uncompromising vision gain a wide and receptive audience at home. His desire to be 'a messenger who will bring back word from the men who are fighting' was thereby fulfilled, and in the book of reproductions Jan Gordon, writing under the pseudonym 'John Salis', acknowledged Nash's ability to comprehend how the immensity of the tragedy could best be conveyed. 'It is not possible to paint truly how this war has swept man', conceded Gordon, 'because horror will not permit this truth to be said. It is possible to depict the devastation of Nature, partly because we cannot understand the full horror, and partly because through it we may come to a deeper realisation of what the catastrophe may mean to man.'[68] This meaning had nothing to do with crude polemics. In August 1917, before Nash had produced any of his finest war images, Francis Stopford told John Buchan that Nash's pictures of the Ypres Salient provided 'a much better understanding of German brutality and of the needless havoc and destruction which German armies are committing under orders in occupied territories.'[69] But the truth is that Nash's work of 1917–18 transcends propaganda entirely. Man's inhumanity in general is arraigned in these poignant pictures, which convey Nash's deep-seated revulsion at the barbarism inflicted by both sides on each other and, by extension, the whole of the natural world.

He was by no means alone in finding himself haunted by the tree-stricken terrain of conflict. By 1918 even the once-pugnacious Balla had become so affected by the slaughter that he put aside his militarist imagery and painted a large canvas of *Mutilated Trees* (Pl. 273). Without overtly linking these decimated forms with the wounds of

273 Giacomo Balla *Mutilated Trees* 1918. Oil on canvas. Private collection.

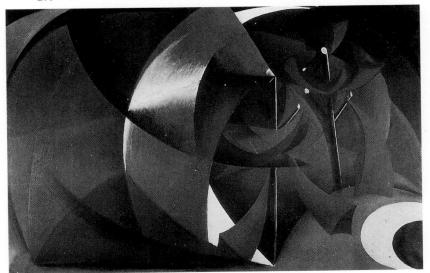

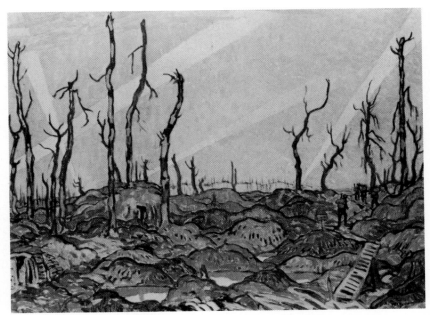

274 A.Y. Jackson *A Copse, Evening* 1917. Oil on canvas, 86 × 112 cm. Canadian War Museum, Ottawa.

battle, he uses them as a metaphor both for the death of friends like Boccioni and the damage sustained by his war-weary country. The familiar Futurist 'lines of force' are still deployed here, and they scythe outwards from the severed trees into the penumbral recesses of the wood. But their effect this time is elegiac rather than dynamic. The white tips of the newly-sliced branches and trunks gleam like tears in the violet-tinged darkness. Balla's former exuberance has given way to melancholy, and the old Futurist enthusiasm for martial intervention and the machine-age city now seems very far away.

The most outstanding Canadian war artists had come to a similar conclusion. After receiving a wound at Maple Copse in June 1916, A.Y. Jackson realised that 'the old heroics, the death and glory stuff, were obsolete.'[70] He also acknowledged that his former Impressionist style was incapable of dealing with the reality confronting him when he joined the Canadian troops at Passchendaele, Arras, Cambrai and Mons. As a landscape painter, Jackson shared Nash's desire to concentrate on the wasteland of war, and he was impressed by the English painter's London exhibition. He aimed for a parallel stark-ness in *A Copse, Evening*, with its searchlights and broken trees (Pl. 274). Compared with Nash, though, Jackson remains committed to decorative rhythms in the undulations of the branches and battered earth alike. He was aware of the dangers inherent in discovering beauty among the tragedies of battle: after admitting that 'Hill Blast Corner could look serene and colourful on a spring day', he insisted that 'these were only minor truths, which confused one trying to render an equivalent of something crowding on all sides.'[71] But the challenge of reconciling the grimness of war with his own ideas about the necessary refinement of art obliged Jackson to temper his anguish in the final painting.

Anger was far more evident in the work of his fellow-Canadian F.H. Varley, a portraitist and landscape painter who was one of the first to benefit from the Canadian government's war artists scheme. But Varley proved independent enough to produce images a great deal more questioning and indignant than his patrons can have expected. 'You in Canada', he wrote in an impassioned letter to his wife in October 1918, '. . . cannot realise at all what war is like. You

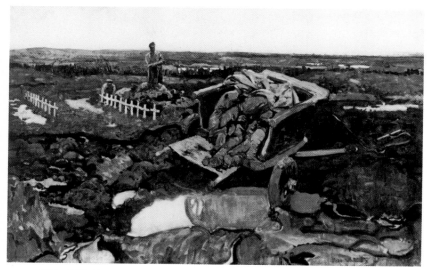

275 F.H. Varley *For What?* 1918. Oil on canvas, 148 × 184 cm. Canadian War Museum, Ottawa.

must see . . . your own countrymen unidentified, thrown into a cart, their coats over them, boys digging a grave in a land of yellow slimy mud and green pools of water under a weeping sky.'[72] In order to help Canadians at home understand what he had witnessed, Varley produced a large canvas where cart, corpses and grave-diggers are all marooned in the emptiness of a bare, flat landscape (Pl. 275). He gave the painting the Goyaesque title *For What?* – a question which summed up the disillusion of a man who told another Canadian war artist the previous May that the soldiers were caught up in a 'game of life and death [which was] nothing but a huge bluff conceived by some wise guys with business instincts.'[73]

All the same, no artist could match the sheer ferocity of Dix's war images in 1918. He continued wielding charcoal with all his former vigour, and in *Heavy Shell Fire* conveyed a new awareness of the soldiers' insignificance when assailed by the full power of machine-age warfare. At the beginning of the conflict, Dix had portrayed himself as a bull-necked warrior rushing towards the centre of events (see Pl. 112). But now, his drawing is dominated by an explosion ripping through earth and barbed-wire fences alike. The gesticulating figures who reel back from the force of the shell seem, in comparison, pathetically diminutive and unable to withstand such an overwhelming assault. By this time Dix was a battle-hardened veteran, lucky to have survived so long in active service. He may have intended to portray his own scarred, sceptical attitude in a rasping gouache called *Soldier with Pipe*, where a man brutalized by prolonged exposure to war puffs smoke through broken teeth (Pl. 276). No vision could be less sentimental. His soldier has been dehumanized into a bloodshot thug, and even the setting sun at Ypres takes on a blatantly aggressive force in another virulent gouache (Pl. 277). The boiling disc bursts in the sky like a bomb. Its rays project themselves into the surrounding landscape with the force of shrapnel, making the soldiers cower and splashing their faces with garish smears of scarlet. Everything seems abject and defiled in this apoplectic image, which might well reflect Dix's growing awareness that Germany's long struggle would soon end in disaster.

Not until the war was over would he be able to define his corrosive vision on canvases of appropriate dimensions. On the Allied side, by contrast, a number of artists now produced monumental paintings with the help of the Canadian War Memorials Fund. Established

in November 1916 to provide 'suitable Memorials in the form of Tablets, Oil-Paintings etc., to the Canadian Heroes and Heroines in the war',[74] the Fund was masterminded by the restless and energetic Sir Max Aitken, Officer in Charge of War Records for the Canadian government. Aitken, later Lord Beaverbrook, was joined on the Fund's committee by the newspaper magnates Lord Rothermere and Sir Bertram Lima, and their first commission was regrettable. The British portrait painter Richard Jack received an invitation to execute a colossal canvas depicting *The Second Battle of Ypres*, where the Canadians, in their first major engagement on the Western Front, retained the Salient despite a fierce German assault (Pl. 278). Although Jack laboured conscientiously on a picture nearly twenty feet in width, and Aitken described it as 'a most wonderful battle scene',[75] the outcome relied to a risible extent on the stereotypes of Victorian battle painting. They blinded him to the fact that the Canadians would have defended their position from trenches, not behind a wall of sandbags. Despite considerable research, Jack plumped for a cliché-ridden bandaged officer standing up in the gunfire to urge his troops forward. The entire painting looked like a blown-up version of the heroic 'reconstructions' which illustrators supplied to pictorial magazines of the period. Shamelessly catering to patriotic sentiment, it boded ill for the aesthetic standards of the Fund's commissions.

Prospects improved when P.G. Konody, the art critic of *The Observer*, became the scheme's 'artistic adviser'. Although he had been hostile to Vorticism in earlier years, Konody was now prepared to invite contributions from the avant-garde as well as Royal Academicians. But his willingness to embrace stylistic diversity was limited, and the Fund plumped for Augustus John as the artist best able to produce the biggest picture of all. E.A. Rickards drew up resplendent designs for the Canadian War Memorial building to house the Fund's paintings, and the proposed 'large decoration'[76] by

276 Otto Dix *Soldier with Pipe* 1918. Gouache on paper, 39.5 × 39 cm. Private collection.

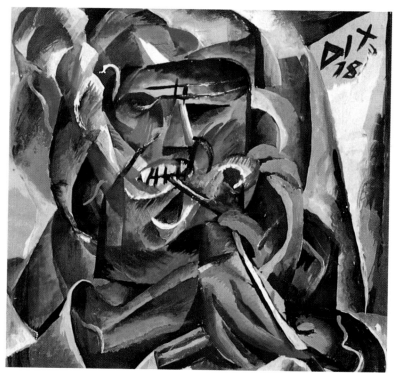

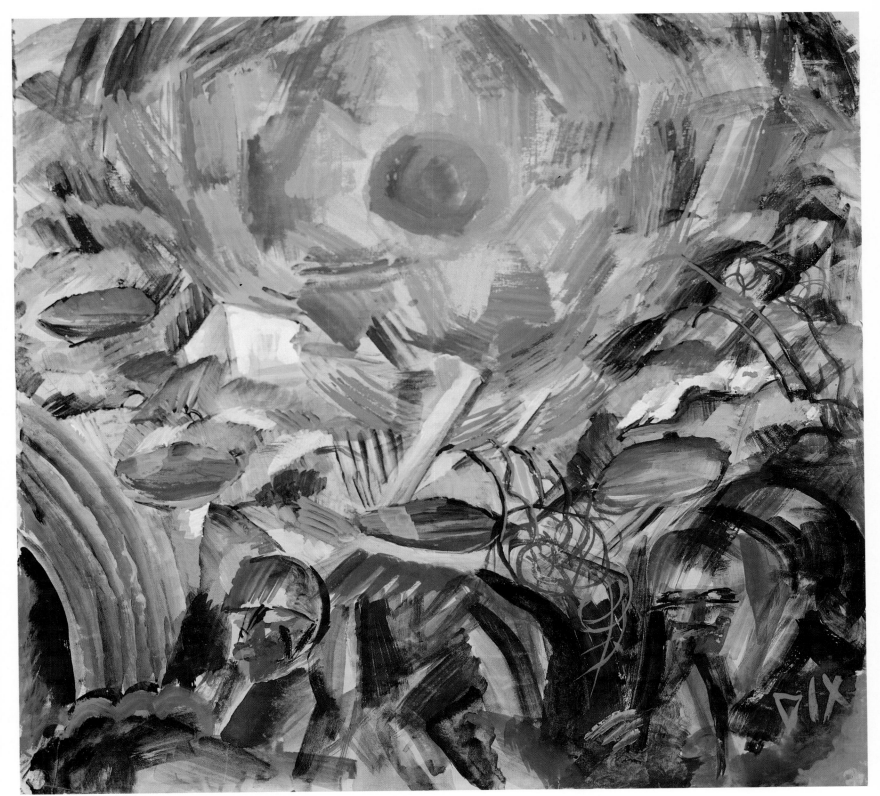

277 Otto Dix *Setting Sun (Ypres)* 1918. Gouache on paper, 39.2 × 41.3 cm.
Städtische Galerie, Albstadt-Ebingen.

278 Richard Jack *The Second Battle of Ypres, 22 April to 25 May, 1915–1917.* Oil on canvas, 371 × 596 cm. Canadian War Museum, Ottawa.

John would have played a central role in this domed edifice. Judging by the elaborate charcoal cartoon which survives, the painting might even have been curved like a panorama to fit into the rotunda under the dome (Pl. 279). Like so many of John's ambitious ventures, it was never executed. The cartoon discloses, however, that he envisaged a frieze-like gathering of soldiers and civilians in the neighbourhood of Liéven. Without striving for topographical accuracy, John did include the castellated towers of the Château de Rollencourt and, in the distance, the slag-heaps of Moeux les Mines. But the figures are far more important than the setting they inhabit. Canadian soldiers dominate the centre of this vast composition, resting before they resume their journey. They are intermingled with refugees from the town, escaping a German bombardment which has forced them to evacuate their homes. Even so, John does not indulge in anti-German propaganda. On the right of the cartoon German prisoners are shown quietly helping to carry wounded soldiers into the Field Dressing Station, and the wayside crucifixion above them seems to sanctify their efforts.

There is, nevertheless, a strange air of disengagement about this enormous 'synthetic' design. John seems determined to remain as distant from his subject as the immense balloon floating high above

the over-crowded scene. The cartoon's lassitude goes a long way towards explaining why the full-scale painting, promised to the Canadians when he accepted their generous offer of a Major's commission with full pay, was never completed.[77] Becoming a war artist had precipitated a crisis in John's mind, and during his visit to France he confessed to Cynthia Asquith that 'I am in a curious state – wondering who I am. I watch myself closely without yet being able to classify myself. I evade definition – and that must mean I have no *character*...When out at the front I admire things unreasonably – and conduct myself with the instinctive tact which is the mark of the moral traitor. A good sun makes beauty out of wreckage. I wander among bricks and wonder if those shells will come a little bit nearer...'[78] This strange, near-suicidal mood came to a climax when he knocked out a fellow-officer after an imagined insult. In order to save him from a possible court martial, Beaverbrook hurried the disorientated artist out of France, complaining later to a friend that 'I cannot tell you what benefits I did not bestow on him. And do you know what work I got out of John? – Not a damned thing.'[79]

With Konody's help, Beaverbrook did nevertheless obtain memorable work from younger artists. Charles Ginner, who had served as a private in the Royal Army Ordnance Corps and then as a sergeant in the Intelligence Corps, was given the opportunity to work on a grand scale. Although he spent most of his career painting pictures of modest dimensions, Ginner had already produced mural-size canvases for Madame Strindberg's cabaret club, the Cave of the Golden Calf.[80] The prospect of a vast canvas did not intimidate him, and he embarked with characteristically methodical zeal on depicting the interior of a shell-filling factory in the Midlands (Pl. 280). Since it was under the command of a Canadian officer, the factory's English location was deemed acceptable to the Fund. The subject was equally appropriate, coinciding with the Canadians' desire to devise 'a schedule of subjects embracing every sphere of Canadian war preparation and war activity, at home and abroad, on land, on water, and in the air.'[81] Women had played a vital role in the making of munitions while men were serving at the Front, and Ginner honours the discipline with which they carry out their tasks in the cool, orderly finishing room.

Perhaps he saw a correlation between his own *modus operandi*, as a 'Neo-Realist' aiming at 'the plastic interpretation of life through the intimate research into Nature',[82] and the women's calm, meticulous

279 Augustus John *The Canadians Opposite Lens* 1918. Charcoal on paper, 370 × 1,230 cm. National Gallery of Canada, Ottawa. Gift of the Massey Foundation, Port Hope (Ontario), 1972.

280 Charles Ginner *The Shell Filling Factory* 1918. Oil on canvas, 305 × 366 cm. National Gallery of Canada, Ottawa.

professionalism. At all events, his picture conveys none of the strain and clangour which Mabel May depicted in her Canadian painting, *Women Making Shells*. In their high-roofed, clinical surroundings, the figures in Ginner's canvas resemble hospital staff more than factory workers. They show no trace of weariness as the empty shells are received from the long corridor on the left and passed through several presses before the final operations commence. Ginner's precise understanding of the building's structure, which he defined with the eye of a man who had once studied in an architect's office, lends an unusual clarity to the scene. The criss-cross network of metal bars in the roof is delineated with as much exactitude as the lines curving along the floor below, where trolleys are pushed with so much care. The patient deliberation is absolutely necessary, for the

neatly labelled boxes on the right spell out the potential volatility of their contents: 'EXPLODERS' and 'T.N.T. 2'. Hence the almost religious sense of dedication pervading this spacious, pellucid chamber. The women are performing exceptionally demanding tasks, and Frances Loring stressed their lithe Amazonian dignity in a chaste bronze relief of *Noon Hour in a Munitions Plant* (Pl. 281).

By no means all the 'home front' images possessed such direct relevance to the conflict. When Ginner's 'Neo-Realist' friend Harold Gilman was sent over to Nova Scotia in 1918 to visit Halifax, where a disastrous explosion had recently occurred, he avoided making any reference to the catastrophe in his painting (Pl. 282). He could easily have studied the district of Richmond, devastated when the French munitions ship *Mont Blanc* blew up in the harbour and killed

281 Frances Loring *Noon Hour in a Munitions Plant*. Bronze relief, 89 × 187 cm. Canadian War Museum, Ottawa.

hundreds of sailors and civilians. But Gilman turned his back on the tragedy, opting instead for a view from the Richmond side of the bay towards the less damaged Halifax. Rather than seizing on the pictorial vitality of the dazzle-camouflaged ships, as Wadsworth would do in his Canadian canvas a year later (see Pl. 313), he relegates them to a scarcely perceptible distance. The centre of attention in his panorama is a dredger with a derrick, giving no hint of wartime concerns. Gilman's painting is a perversely peaceful work, revelling in the beneficent solitude of an unruffled harbour at sunset. Although it received praise for its 'satisfying serenity',[83] this placid canvas had little to do with the struggle still convulsing Europe.

When Konody accepted Wyndham Lewis's application for a Canadian commission in December 1917, by contrast, the Fund obtained the services of an artist eager to paint a large canvas based on his embattled experience of the Western Front. He had volunteered as a gunner in the Royal Artillery in March 1916, and for a while regarded his training in England with sardonic humour. Sending a postcard to Ezra Pound of soldiers moving a heavy gun, he wrote: 'Herewith a picture of a stubborn looking object, sufficiently stupid, sullen and phallic.'[84] Even after he was moved to the 'firing line' in France the following year, the levity continued. 'Whizzing, banging, swishing and thudding completely surround me', he reported in June 1917, 'and I almost jog up & down on my camp bed as though I were riding in a country wagon or a dilapidated taxi.'[85] A few days later, however, a trip to 'the forward intelligence' led Lewis through a 'never-ending and empty' terrain which prompted a more

282 Harold Gilman *Halifax Harbour at Sunset* 1918. Oil on canvas, 198 × 335.8 cm. National Gallery of Canada, Ottawa. Transfer from the Canadian War Memorials, 1921.

sombre mood. Describing his destination as 'the corner of a demolished wood', he wrote that 'the place is either loathsomely hot, or chilly according to the time of day at which you cross it. It is a reddish colour, and all pits, ditches & chasms, & black stakes, several hundred, here & there, marking the map-position of a wood. Shells never seem to do more than shave the trees down to these ultimate black stakes, except in the few cases where they tear them up, or a mine swallows them.' The eeriness he found here is akin to the desolation which haunted Nash, and Lewis declared that 'the moment you get in this stretch of land you feel the change from the positions you have come from. A watchfulness, fatigue and silence penetrates everything in it. You meet a small party of infantry slowly going up or coming back. Their faces are all dull, their eyes turned inwards in sallow thought or savage resignation; you would say revulsed, if it were not too definite a word. There is no regular system of trenches yet; this is the bad tract, the narrow and terrible wilderness.'[86]

The nearest Lewis came to defining this unnerving locale, in the drawings he executed after securing the Canadian commission, is *Officer and Signallers* (Pl. 283). Led by a figure who seems unaffected by injuries, the soldiers struggle to continue their journey through a lunar landscape pitted with craters and devoid of growth. A shell erupts nearby, causing three of them to duck, and its deep orange vehemence casts a rust-coloured glow on the earth. But there is no doubt that the men will continue their walk despite the danger of a direct hit, and their stoicism reflects Lewis's own attitude towards the likelihood of death. 'Yesterday', he told Pound, 'as we got within a hundred yards of the road there was suddenly a swooping whistle: my commanding officer shouted *down*: we crouched in a shell-hole, and a 5.9 burst about 15 or 20 yards away, between us & the wood – about 3 shell holes away, you could say, they were so regular thereabouts. Another came over about 15 yards nearer the wood, & at the third, actually in the wood, we concluded it was the wood corner they were after, & proceeded.'[87]

Lewis's dispassionate tone in this letter, neither self-consciously heroic nor fearful for his life, typifies his way of looking at the war. But he was fascinated, for a while at least, by the new sensations he experienced at the Front. As early as 1917 his correspondence discloses that he was beginning to revise his Vorticist theories and admit that his former involvement with near-abstraction might be giving way to an alternative view. 'There is nothing there you cannot imagine', he wrote to Pound from the battle zone, 'but it has the unexpected quality of reality. Also the imagined thing and the felt are in two different categories. This category has its points.'[88] The awakening of Lewis's interest in 'reality' meant that he found it easier to adopt a more figurative idiom than some of his fellow-Vorticists. He produced an impressive quantity of war drawings in 1918; and while retaining the harsh formal discipline of his pre-war work, they often convey a great deal of representational information about the soldiers and their surroundings. Lewis was fortunate, in this respect, to find himself inhabiting such an utterly denuded place. 'War, and especially those miles of hideous desert known as "the Line" in Flanders', he declared later, 'presented me with a subject-matter so consonant with the austerity of that "abstract" vision I had developed, that it was an easy transition.'[89]

Lewis only just escaped death on many occasions, and Pound was so worried about his friend's safety that he wrote: 'I wish you would get a decent and convenient wound in some comparatively tactful part of your anatomy. Say the left buttock.'[90] Although Lewis admitted that 'you meet plenty of dead men',[91] he did not include them in his war images. Apart from a few drawings of heavy shelling, like the

dark green eruptions punctuating the *Drawing of Great War No. 2*, he likewise refrained from depicting the battle itself. Most of his 1918 work concentrated on battery positions, where figures are seen engaged in shell-humping, preparing for an attack, pulling in a siege battery or lighting cigarettes as they wait for a barrage to begin. A mysterious stillness prevails in many of these terse studies, far removed from the protesting anger of Nash's contemporaneous work. It attains an unearthly stasis in the immense painting which Lewis produced for Konody, after reporting from the Canadian Corps Headquarters in France that 'I have located a dandy gun-pit: 2 weeks, perhaps 3, and I shall have got my material together.'[92]

He chose to concentrate on the business of laying a heavy gun, which absorbs the energies of the two men turning the wheel and adjusting the sights (Pl. 284). Battle has yet to commence, and the third figure standing by the gun with hands in pockets seems uncertain of his function. So do the men presiding over the ranks of shells resting, for stability's sake, on sturdy wooden planks. The mask-like rigidity of their faces is severe, and the catalogue of the Canadian Fund's first exhibition felt obliged to point out that they 'are not intended to be anything but rugged in the matter of physiognomy.'[93] Perhaps Lewis intended them to play the role of a tragic chorus, grimly meditating on the destructive power which would be unleashed once these immense shells were hurled towards the enemy lines. He certainly emphasized the missiles' weight by giving foreground prominence to the muscular efforts of one of the West Indians who had been attached to Lewis's battery as lifters of shells.[94] His black arms and pale pink shirt make him the most unexpected, arresting figure in the painting, and he handles the shell with as much practised caution as the women in Ginner's *Shell Filling Factory* canvas (Pl. 280).

Lewis approached his task in a similarly circumspect manner. The innovator has here been replaced by a painter who, as John pointed out in a malicious letter, was 'striving to reduce his "Vorticism" to the level of Canadian intelligibility – a hopeless task I fear.'[95] While John was correct to stress the difficulties Lewis faced, he had no right to regard *A Canadian Gun Pit* as a futile endeavour. For the outcome, although stylistically uncertain and laborious, is more impressive than

John's own irresolute cartoon (Pl. 279). The implacability of war is harshly conveyed in Lewis's canvas. He may have protested, on its completion, that 'Konody had succeeded in making me paint one of the dullest good pictures on earth . . . What a nightmare this wicked war has been!'[96] But he did at least believe that it was a 'good' painting, and *A Canadian Gun Pit* commands respect for its determination to present 'the zone of the heavy guns'[97] with appropriate severity. Apart from the West Indian, whose presence in the composition is so refreshing, all the soldiers seem oppressed by their involvement with the business of preparing for war. They seem dehumanized as well, and the man next to the West Indian is depicted in a columnar way that equates him with the forms of the shells he guards. His complicity in their destructive purpose is thereby implied; and the shells, in their turn, echo the equally stark trees clustered on the distant hillside. There, in a landscape which has already fallen victim to bombardment, the outcome of a gun-pit's activities is disclosed in all its desolation against a darkening sky.

Nevertheless, the quietness Lewis experienced while he was studying the gun-pit on the Vimy Ridge gives his painting a strangely becalmed air. 'This battery seldom fired,' he recalled. 'Everything was different in this part of the Line – so different that to start with I could scarcely believe my eyes, or ears . . . Away in the distance, over in the ruins of Lens, a shell would fall occasionally. That was all; like a big door banging far away . . . After my recent experiences this peace was almost uncanny.'[98] It could hardly have offered a greater contrast to the subject which Lewis's old Vorticist ally, William Roberts, was given by the Canadian scheme. When he met Konody in London to settle the details, Roberts was informed that 'all except one [subject] had been allocated and that concerned the gas attack upon the Canadians at Ypres. Although I was without experience of that kind of cloud gas warfare, and told Konody so, I accepted the commission.'[99] It was a brave decision. Roberts had no way of studying such an event at first hand, and without the kind of research Lewis was able to conduct at Vimy Ridge he ran the danger of producing a canvas as divorced from the reality of war as Jack's *The Second Battle of Ypres* (Pl. 278). Moreover, the Canadians made clear that he would have to work in a style radically removed from his pre-war Vorticist paintings. 'I would be glad to know whether, providing you are given the necessary facilities and leave, you are prepared to paint the picture at your own risk, to be submitted for the approval of the committee,' ran the letter from the Canadian War Records Office. 'The reason for this request is that the Art Adviser informs us that he is not acquainted with your realistic work and Cubist work is inadmissible for the purpose.'[100]

Roberts did, however, know a great deal about the harshness of the battlefield. He was also familiar with the Ypres area, and his own service since 1916 as a gunner in the Royal Field Artillery equipped him to imagine what conditions would have been like in the Canadian Field Battery when the gas attack commenced. It occurred one afternoon in April 1915, and according to the official history of the event 'the first to feel the effect of the poisonous fumes were the French soldiers on the Canadians' left. The French troops, largely made up of Turcos and Zouaves, surged wildly back over the canal and through the village of Vlammertinghe just at dark. The Canadian reserve battalions (of the 1st Brigade) were amazed at the anguished faces of many of the French soldiers, twisted and distorted by pain, who were gasping for breath and vainly trying to gain relief by vomiting.'[101]

The nearest Roberts came to experiencing the peculiar horror of gas warfare was at Le Havre, towards the end of his active service.

283 Wyndham Lewis *Officer and Signallers* 1918. Pen, ink, crayon and watercolour on paper, 25.4 × 35.6 cm. Imperial War Museum, London.

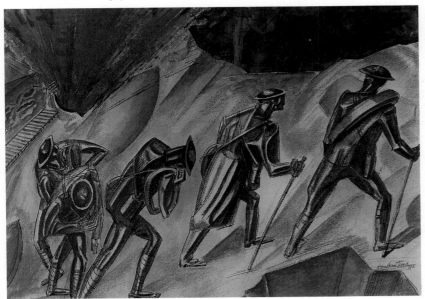

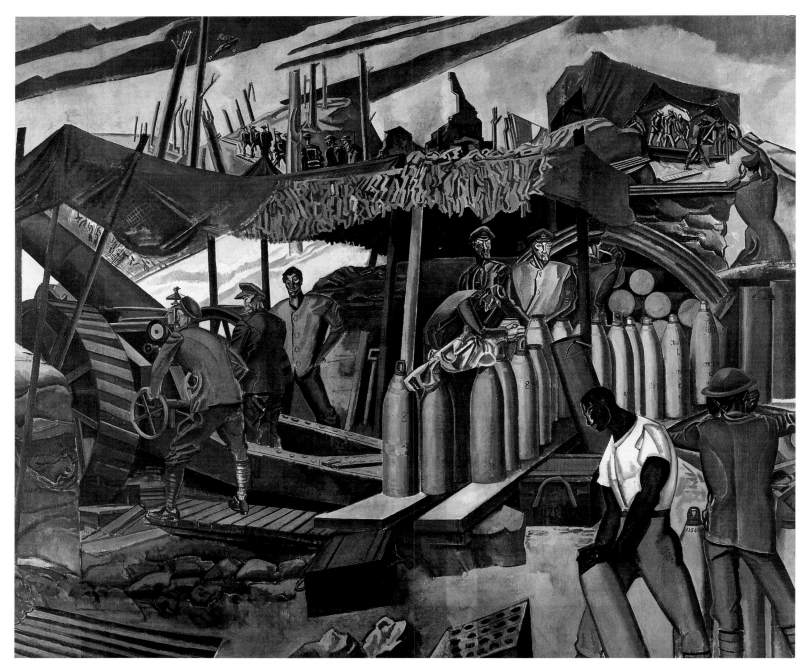

284 Wyndham Lewis *A Canadian Gun Pit* 1918. Oil on canvas, 305 × 362 cm.
National Gallery of Canada, Ottawa.

He spent ten days there at the base depot employed in camp fatigues, and later recounted how 'by way of a change we did gas-mask drill. Wearing our gas-masks, we had to pass through a narrow covered trench or dug-out blanketed at both ends and filled with poison gas.'[102] The episode surely informs one of his finest and most disturbing war drawings, *The Gas Chamber* (Pl. 285). Roberts' Vorticist discipline still informs the harsh, diagonally organized structure of the soldiers' surroundings. But the figures themselves are handled in a more representational idiom than earlier war images like *Machine Gunners* and *Combat* (see Pl. 81). Roberts' stabbing ink contours convey the awkwardness and uncertainty of the men who, summoned by the bellowing officer on the right, struggle to acquaint themselves with the alienating protective devices. The appliances transform them

into eerie presences, robbed of the humanity they possessed before the masks forced their faces to assume the guise of unidentifiable automatons.

The robot-like figures who had animated Roberts' Vorticist work here find their grotesque fulfilment in the reality of war, even though *The Gas Chamber* marks such a significant retreat from his earlier exploration of a semi-abstract language. Groping and stumbling their way towards the underground shelter, these disorientated soldiers also appear far more vulnerable than any of their predecessors in his war images of 1915. Active service had exposed Roberts to all the savagery which modern, mechanized conflict could inflict. At Arras he witnessed the death of 'tall, gaunt Tom Gunn', and remembered that 'as we stood by his corpse someone lifted the blanket that

covered his face. It was emaciated and the colour of pale ivory.'[103] Roberts was even more disturbed, the following day, to discover that another member of his gun crew 'had died from shell shock. He stood upright by the wheel of his gun unmarked but quite dead.'[104] Although a 4.5 howitzer could give the illusion of safety to those responsible for loading and firing, they could at any second be wiped out. Darkness afforded no extra protection, as he discovered one night when 'A. Sub-section's gun-pit received a direct hit that blew up the gun, its crew, and Corporal Garrity the No. 1, who were sheltering there. One incident I especially remember of that hectic night, is the picture of Major Morrison on his hands and knees among the ruins searching by candlelight for survivors.'[105] When Roberts painted a small, densely compressed canvas of a howitzer team, he stressed the dour labour involved in continually servicing the gun while attempting to prevent the ears being deafened by its incessant roar. Compared with this grim scene, where the men all appear to be oppressed by the din and effort of handling the weapon and its orange shells, Severini's earlier painting of a *Cannon in Action* seems almost irresponsibly frivolous (see Pl. 70). Sequestered in Paris, the Italian painter had amused himself by orchestrating the noises of bombardment like an intoxicated composer, whereas Roberts knew how serious the business of killing really was.

In the large Canadian painting all the accumulated trauma of his artillery years was discharged in a clangorous *tour de force*, which refused to temper the agony of gas warfare for fear of offending civilian sensibilities. A preliminary drawing, squared for transfer to part of the canvas, announces an almost Expressionist emphasis on the anguish suffered by the contorted French infantry as they stagger, choking, into the Canadian Field Battery. Roberts wields his pencil, ink and chalk with a harshly scored vehemence reminiscent of Grosz or Dix, and the painting itself is further envenomed by the rasping colours he employs (Pl. 286). Despite the amount of representational detail required by the commission, Roberts never forgets that he is dealing with a flat surface alive with the distorted forms of humanity *in extremis*. A startling aerial viewpoint is established, enabling him to counteract spatial recession and give the panic-stricken soldiers at the top of the composition as much strident pictorial significance as the sturdier artillerymen below. This steeply inclined vantage also accentuates the disequilibrium of the Turcos and Zouaves, blinded by the noxious grey-green clouds behind them, as they tumble hysterically between the guns. A Canadian soldier, identified very clearly by the label on his shoulder, is perceptible among them. The bandage encircling his forehead is stained with blood from a wound, and his visible eye stares out with the wildness of someone who has witnessed horrors greater than anything he could ever imagine. But he is not, ultimately, as helpless as the Frenchman beside him, who covers his face with both hands in a futile bid to prevent the gas destroying his vision. Like the afflicted soldier in front of him, whose head lolls back as he stumbles towards the gunners, he seems unaware of the moustachioed victim already sprawling on the ground. This prostrate figure is unconscious, mercifully oblivious of the fact that his comrades will trample him underfoot in their blundering efforts to evade the fumes.

Roberts turns the crimson caps, jacket linings and trousers of the beleaguered Frenchmen to powerfully discordant account, making them blare like a collective outburst of alarm among the Canadians' khaki uniforms. Although the onrush of bodies is halted halfway down the canvas, turbulence continues unabated in the convolution below. Roberts seizes on the action of picking up shells, and dramatizes the muscular effort expended by the two broad-backed

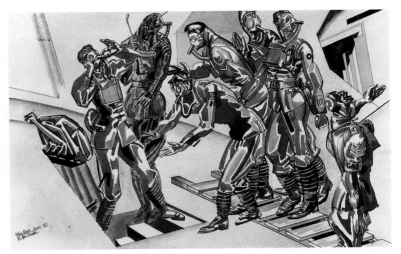

285 William Roberts *The Gas Chamber* 1918. Ink, pencil and watercolour on paper, 31.8 × 50.8 cm. Imperial War Museum, London.

men – one green-shirted, the other yellow-vested – as they both lean over to grasp the equipment they need. The gunners around them are scarcely less exclamatory, however. Caught between servicing their battery and acknowledging the cascade of dazed figures above them, they twist, jerk and lurch in a precisely choreographed welter of gesticulating forms. The finesse with which Roberts organizes this tumultuous press of bodies does not impair his ability to convey all the confusion and strain inherent in such a scene. As if to ensure that the jarring collisions are maintained throughout the canvas, he allows a gunner's puce shirt to sound a particularly grating colour-note in the foreground, where its wearer roars with a full-throated urgency matched by his flailing arms. But in case the plight of the gassed victims is forgotten among the chaos of sinewy Canadian figures, Roberts allots the lowest position in the painting to a French infantryman. Although he has reached a comparatively safe position behind the guns, his suffering has only just begun. Nauseated by the fumes polluting his lungs, he claps hands over mouth in a forlorn attempt to prevent himself from vomiting.

Only an artist similarly sickened by the brutality of destruction could have produced this powerful canvas. Writing many years later, in a pamphlet ironically entitled *Memories of the War to End War*, Roberts still recalled the appalling moment in his battery one midday when, 'as several of the gunners were sitting outside the dining-room shelter having a lunch of bully-beef stew, a "Bosch" shell burst among them, killing two. The dead were placed on the dining table and wrapped in blankets as their blood oozed over the zinc table.'[106] On another occasion, he was detailed to join a stretcher-party carrying a wounded driver to a field-dressing station about half a mile away. 'We struggled and stumbled in the dark over the broken ground,' Roberts wrote, 'striving to avoid the shell holes and barbed wire, doing our best to hold the stretcher level and cursing every obstacle in our path'.[107] The grimness of such an experience is conveyed in a subsequently destroyed painting, where a battalion runner barges past the gaunt, straining bearers as they struggle through a landscape of craters and denuded trees (Pl. 287).[108] But Roberts remembered that the worst moment on his journey came when 'we reached, at last, the dug-out that served as a dressing station. Pushing aside the ground sheet that covered the entrance, we staggered inside, placed our burden on the ground, and waited. An

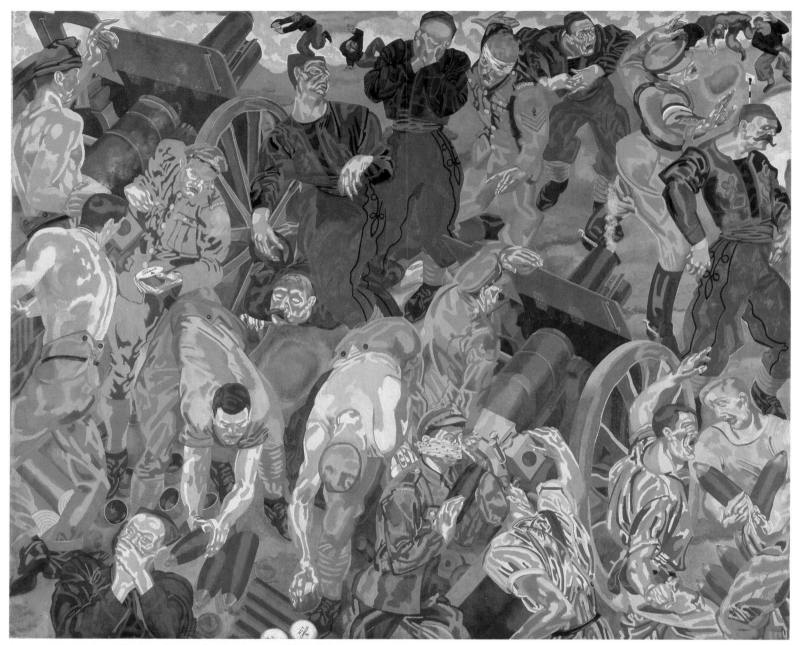

286 William Roberts *The First German Gas Attack at Ypres* 1918. Oil on canvas, 304.8 × 365.8 cm. National Gallery of Canada, Ottawa. Transfer from the Canadian War Memorials, 1921.

orderly who had been attending to some other wounded came to us and lifted the blanket from the driver's face, let it fall again, remarking as he turned away: "This man is dead." There was resentment in his voice as if he considered we had played him a trick bringing a corpse to the dressing station'.[109]

Eventually, as his active service drew to a close, Roberts gave vent to a wrenching, indignant despair. 'If you lived out here', he wrote to his future wife Sarah, 'you would understand why I have not written. Marching on the road for days on end with but a few hours sleep at night, then travelling in cattle trucks and working like niggers, with practically no food, whilst, as a welcome at the journey's end, there are bursting shells to greet you. I believe I possess the average amount of hope and patience, but this existence beats me.' Later in the same letter, he confessed: 'I am feeling very bitter against life

altogether just at present. But there is one thing I curse above all others in this world, and that's "open warfare". I could strafe it, as "Fritz" never did strafe Ypres, and if you saw that place you would understand the full extent of my hate.'[110]

In view of the near-terminal exhaustion of body and spirit revealed in this letter, Roberts' ability to channel his hatred of war into a work as impressive as *The First German Gas Attack at Ypres* seems even more remarkable. At the age of twenty-three he had produced an excoriating masterpiece, and it earned praise from the most perceptive visitors to the exhibition of Canadian painting at Burlington House. Sargent, who was engaged on an even larger commission with a 'gassed' theme (see Pl. 298), described Roberts' canvas as 'a hideous post-impressionist picture, of which mine cannot be accused a crib'.[111] But visitors more sympathetic to contemporary developments

in painting were impressed, and Laurence Binyon described his astonishment at encountering the 'torrent of Turcos and Zouaves pouring headlong down the canvas, convulsed, grimacing and sick.' He decided that 'the crimson of the French soldiers' uniforms mixed with the khaki makes a wild colour-pattern like a great bed of tulips. It is queerly compounded of stylistic elaboration and utter realism, and from a human point of view strikes me as rather horribly cold-blooded. Mr Roberts is still a very young artist but his great gift is undeniable and his future excites interest.'[112] The even more youthful Kenneth Clark was equally appreciative, recalling in his autobiography that the Canadian canvases by both Roberts and Lewis were 'an eye-opener to me, and I immediately tried to imitate them. In fact . . . I might have been a follower of Wyndham Lewis (although he would certainly have rejected me).'[113]

The plight of gassed soldiers prompted another painter to excel himself, this time on commission from the British government. Kennington's pioneering picture, *The Kensingtons at Laventie*, had earned the dislike of both Buchan and Masterman for its painful depiction of front-line weariness as early as 1915 (see Pl. 92). But he finally secured official war-artist status in August 1917, and proceeded to execute a quantity of diligent chalk or pastel drawings recording the ordinary soldiers' existence in France. His admiration for the heroic individual meant that he was temperamentally unsuited to seeking out the most disillusioning aspects of life in the trenches. After his return, Kennington admitted in 1918 that he 'did not attempt to depict any of the horrors & tragedy, realising that it was too vast, & that I was not capable.'[114] Most of his war drawings refuse to pursue the uncomfortable insights offered in his Laventie

287 William Roberts *The Battalion Runner on the Duckboard Track* no date. Oil on canvas, approx. 60.9 × 50.8 cm. Lost.

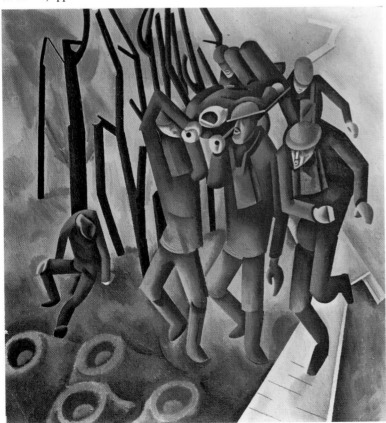

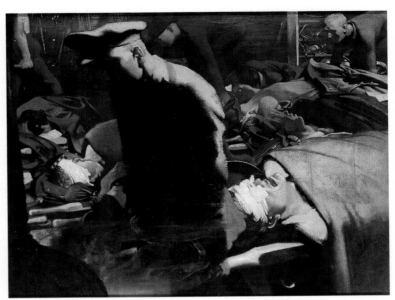

288 Eric Kennington *Gassed and Wounded* 1918. Oil on canvas, 71.1 × 91.4 cm. Imperial War Museum, London.

painting, but the sight of gas-attack victims in French field hospitals did prompt him to produce a few disquieting images.

Blinded Soldier is conspicuous for its quiet compassion, and Kennington's characteristic unwillingness to declare his emotional involvement here lends the drawing an unforced authority. In a painting of *Gassed and Wounded*, however, he did allow his own mournful response to invade the penumbral scene (Pl. 288). The raw pink flesh of the patients, their eyes bandaged as they lie in silence on improvised pillows, is distressingly exposed. But the stretcher-bearers themselves embody the most melancholy emotions in this unflinching canvas. Kennington repeats the stooped pose, with minor variations, three times over. The uppermost of the three looks particularly gaunt as he bends to lay down his burden. But the foreground bearer conveys the deepest sadness of all. His features almost obliterated by shadow, he bows under the stretcher's weight with a sense of resignation bordering on hopelessness. He has seen too many terminal cases, too much agony. Experience has taught him not to hold out any large hopes for the survival of the men he carries. Around his legs swirl vapours which may still be seeping from the bodies of the gassed soldiers, and the bearer knows that survivors will be marked by the fumes' onslaught for the rest of their lives.

The dejection pervading Kennington's Stygian picture reflects the mood in Allied armies even after Ludendorff's last great offensive faltered in the summer of 1918. At the end of the first week in August, the German commander realised that the attacks mounted by the Canadian, Australian, French, British and American troops were poised to break his line, from Ypres right down to Verdun. Although the threatened collapse never came, Ludendorff conceded by the middle of the month that the war could now only terminate in a negotiated settlement. All his lingering thoughts of victory evaporated altogether; and after the grand Allied offensive commenced towards the end of September, Germany became more and more beleaguered. Its morale plummeted still further when Bulgaria, beaten by the French offensive at Salonika, withdrew from the struggle and left Southern Europe dangerously exposed to Marshal Francet d'Esperey's victorious advance. Combined with the continuing collapse of Austria-Hungary, these events finally persuaded Germany to

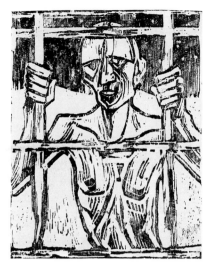

289 Christian Rohlfs *The Prisoner* 1918. Woodcut on paper, 61.3 × 46 cm. The Museum of Modern Art, New York. Purchase.

ask President Wilson for an armistice on 4 October. From then on, hastened by the disillusion of the Ottoman Empire's support for Germany, morale in the German forces reached its lowest point. While the armies on the Western Front doggedly maintained their defensive positions, the crews of the High Seas Fleet began to mutiny in the face of their admirals' calls for battle. The revolution spread so quickly that a republic was declared in Berlin on 9 November and the Kaiser abdicated soon afterwards. Then, early in the morning of 11 November, a Draconian armistice was signed in a railway carriage at Compiègne forest. The deliberate crushing of the old Germany had commenced in earnest, and the harshness of defeat is reflected in outspoken images by several of its artists.

Christian Rohlfs, who had condemned the conflict three years earlier in his gruesome painting called *War* (see Pl. 134), now concentrated on the prisoners' predicament (Pl. 289). Conscious that an unprecedented number of his countrymen were interned in enemy camps, he presents their suffering in the starkest manner imaginable. The figure grasps the bars of the cell with a ferocity which reveals a great deal about his frustration, and a desperate desire to prise them apart. But they remain firm, stamping their cruel, grid-like authority across his emaciated body. Rohlfs cuts his woodblock savagely enough to convey the prisoner's anguish, riddling his torso with striations reminiscent of lashes administered by a whip. The deepest scoring is reserved for the man's face, where furrows bite into his forehead and cheek with the force of an assailant on the battlefield. Incapable of fulfilling his urge to escape, the prisoner turns his thwarted rage inwards where it undermines his physical well-being so grievously that he may not survive for long.

It could also undermine his sanity. Trapped in a cage for the duration of a conflict which threatened to go on indefinitely, this ravaged man might easily lose mental as well as corporeal health. Conrad Felixmüller dramatized just such a tragedy in his lithograph *Soldier in a Madhouse* (Pl. 290). Like Rohlfs' inmate, the figure clutches at the bars of his window. His grip is far looser, however. He might even be using the window to support himself, for his body lurches unsteadily within the murky interior. Rather than staring outwards, in order to yearn for on unattainable freedom beyond, the forlorn soldier lets his head hang down towards the floor. He seems overcome by his plight, and Felixmüller's scratchy, at times feverish lines drive home the bitterness he must be experiencing. The man may well have lost his sanity on the battlefield, and the crazily tilted angles of windows, limbs and furniture convey his dizzy apprehension

of a world near to collapse.

Around the same time, Heinrich Vogeler arrived at an even more extreme conclusion in his apocalyptic etching *The Seven Vials of Wrath* (Pl. 291).[115] Before the war he had been a successful print-maker, illustrator, architect and interior decorator, working with conspicuous versatility in an Art Nouveau idiom poised halfway between Mackintosh and the Viennese school. The wistfulness of his work at this period was abruptly terminated by the war. After volunteering for the army in 1914, and serving as a draughtsman in a number of army units, he underwent a momentous Expressionist conversion. Although influential supporters had ensured that Vogeler never risked his life at the Front, he could not contain a mounting sense of outrage. In January 1918 his anger finally erupted, and he wrote a furious letter to the Kaiser condemning the conditions imposed on Russia at the treaty of Brest-Litovsk. The rash protest ended his army career and he was consigned to the asylum at Bremen, the city of his birth.

As its title indicates, *The Seven Vials of Wrath* is based on the book of Revelation, where St John the Divine 'saw another sign in heaven, great and marvellous, seven angels having the seven last plagues; for in them is filled up the wrath of God.' Having been given 'seven golden vials' by 'one of the four beasts', the angels poured their vials one after another on the world. The destruction was total, with 'a great earthquake, such as was not since men were upon the earth.'[116] Vogeler organizes this seismic scene with impressive authority. The elongated angels look mournful yet resolute in the darkness of the sky, as they empty their vessels on the earth. One figure in the centre of the maelstrom below raises his hands, as if in the belief that he might somehow be able to halt the heavenly bombardment. But he gestures in vain. While a capsized boat and its occupants sink in the river, and animals stumble over each other as they try to escape, another figure is blown upwards by an explosion reminiscent of a shell-burst. The entire landscape is convulsed, forcing church domes and buildings to sway, subside and sink into oblivion. Acknowledging the scale of the havoc, a woman cowering in the foreground bows towards the riven ground and hides her face in her arms. Realising that nothing can prevent this Götterdämmerung from laying waste to her country, she wearily submits to the fury and awaits extinction without any further protest.

290 Conrad Felixmüller *Soldier in a Madhouse* 1918. Colour lithograph on paper, 38.4 × 31 cm. Los Angeles County Museum of Art, Robert Gore Rifkind Center for German Expressionist Studies.

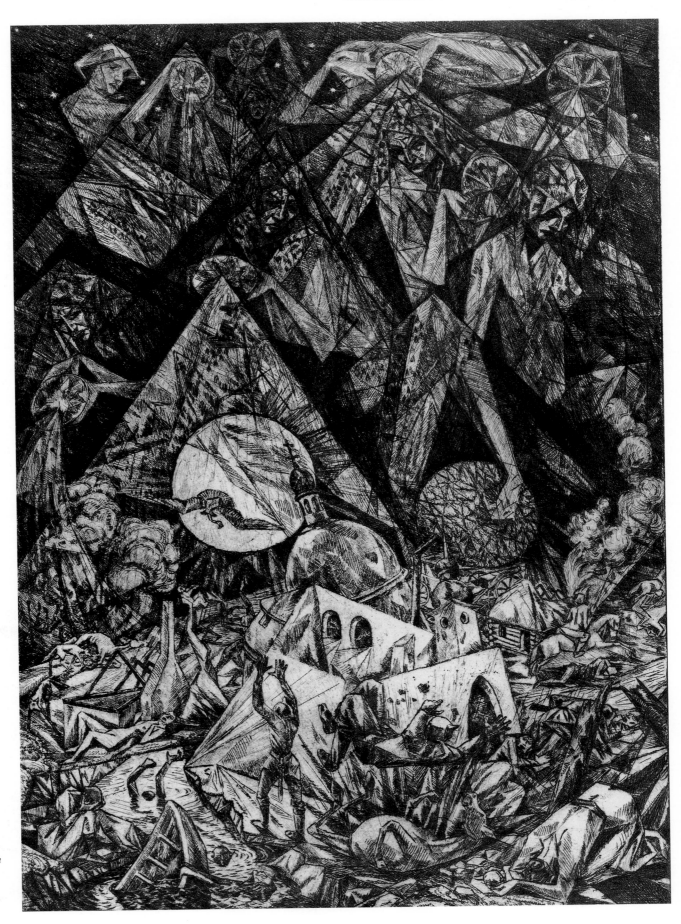

291 Heinrich Vogeler
The Seven Vials of Wrath
1918. Etching and
drypoint on paper,
35.4 × 25.8 cm. British
Museum, London.

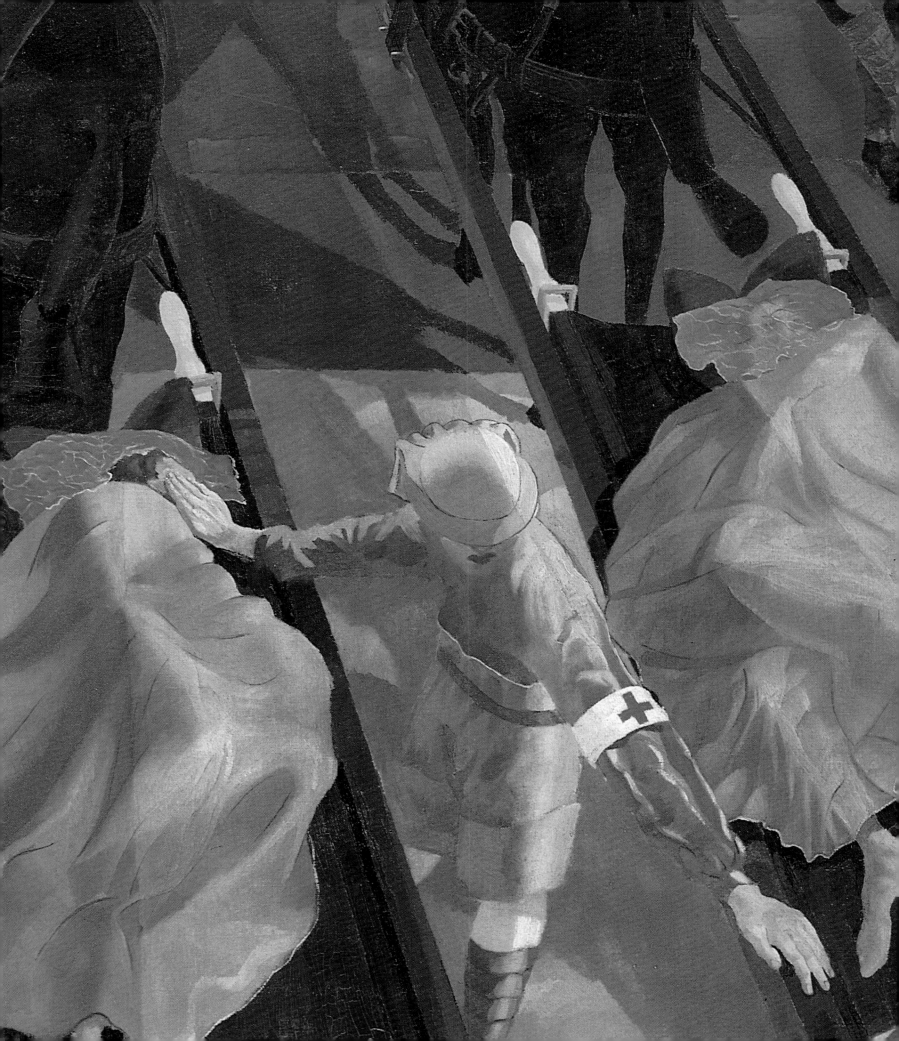

CHAPTER EIGHT
AFTERMATH
(1919)

Of all the major nations embroiled in the Great War, the USA was the least affected by loss of life. There was, as a result, an innocent enthusiasm about the celebrations which swept through New York on Armistice night. George Luks produced the most exuberant painting of the occasion, conveying on a panoramic canvas the animation of the crowd as it surged through the streets (Pl. 292). Luks' admiration for the brushwork of Hals, first manifested when he was a member of The Eight in pre-war years, helped him to catch the boisterousness of the moment. The presence of the Allied flags, billowing over the figures, suggests Luks' awareness of the sustained series of flag paintings which Childe Hassam had been producing since 1916 (see Pls. 193, 256). But *Armistice Night* is handled in a far more ebullient spirit than the well-mannered Impressionist canvases of Hassam. In this sense, Luks' painting is closer to the brazen urban modernity of Russolo's pre-war *Revolt*, with its raucous celebration of a crowd's resurgent power (see Pl. 5). In every other respect, though, the gap between this Futurist call to arms and *Armistice Night* is immense. Russolo's untrammelled and callow delight in aggression is replaced, at the end of a protracted, debilitating conflict, by a thirst for the unaccustomed pleasures of peace.

When the fighting stopped, at 11 o'clock on the morning of 11 November, neither soldiers nor civilians could believe that the war was really over. Only a month before, the newspaper magnate Lord Northcliffe, as well-placed as anyone to predict the outcome of the struggle, had remarked that 'none of us will live to see the end of the war.'[1] The suspicion that it would last for ever had become in-grained, and at first everyone felt stunned by the news of a ceasefire. Before long, full-scale rejoicing began with a jubilance all the more intense for succeeding the former pessimism. The French were momentarily ecstatic, and André Fraye defined the climax of their delight in a deft, lyrical study called *The Armistice* (Pl. 293). As indebted as Hassam had been to the flag-bedecked painting Monet made of the *Fête de la Paix* thirty years before,[2] Fraye uses a Cubist-derived language to summarize the hectic activity filling a street festooned with the stripes of the tricolour.

Beneath the exuberance of the crowds, however, lurked a vengeful bitterness which erupted into murderous displays of hatred against Germany. When René Gimpel made his way to the Champs-Elysées in the early afternoon of 11 November, he noticed among the 'cries, songs, hilarious processions' a macabre spectacle: 'Suddenly I saw hanging from the end of a long pole a dummy – Wilhelm II. He was dragged along and shoved onto a cannon which some workmen had

set up on the edge of the pavement. The Kaiser was wearing black trousers, a cap, and a pimp's red sash. His conquering moustache was made of straw, and a white placard had been hung around his neck with the word *Assassin* in red. He was hauled before the statue of Strasbourg and there he was burnt, but the placard was not consumed and the word *Assassin* was not obliterated.'[3] No Dada sculpture could have been more trenchantly improvised and destroyed than this spontaneous expression of popular venom.

After a while, the numbing dimensions of French losses took their toll, and Paris grew quieter once the initial outburst of joy had expended itself. Over in London a similar duality could be detected even at the height of the first night's fervour. William Nicholson, whose desolate painting of *The Ballroom of the Piccadilly Hotel during an Air Raid* had caught the fear of wartime London a few months before (see Pl. 261), now found himself caught up in the delirious throng. Along with his model Marie, he was 'swept into Piccadilly Circus, which was a mêlée of traffic, surging in all sorts of directions, of servicemen trying to find their girls, or their buses, or both, of excited, tipsy, happy people. William, assuming all the authority of which he is, at moments, disconcertingly capable, leapt into the traffic stream, checked it by imperiously holding up his hand, wrenched open the door of a Rolls-Royce filled with fat women in sables, thrust in a couple of Tommies while others swarmed upon the roof, slammed the door and shouted "Drive on!"'[4]

Nicholson's instinctive support for ordinary soldiers, at the expense of those who had profited from the war, led him to invest his painting of *Armistice Night* with an awareness of the occasion's darker aspects (Pl. 294). At first glance it seems a fluent and spirited picture, delighting in the ease with which he finds himself able to silhouette the gun against a festive blaze of light beyond. Most of the figures are drawn towards the illumination, but two crippled soldiers become visible among the foreground shadows as they hobble on crutches in the opposite direction. Their hunched isolation contrasts with the high spirits of the figures on the gun, waving caps in the air and performing gymnastic feats on the barrel. The wounded men, dis-regarded by the crowd, give the lie to the celebrations around them. Their dejection surely reflects a mood of melancholy within Nicholson himself, for only a month earlier his son Tony had been killed in France. The shock of this loss, combined with the death of his wife in July, must have prevented the artist from viewing the Armistice with the blitheness of someone relatively unaffected by the war.

As the rejoicing continued the mood became more hysterical, with complete strangers copulating in public to prove that the forces of

292 George Luks *Armistice Night* 1918. Oil on canvas, 94 × 174.6 cm. Whitney Museum of American Art, New York. Gift of an anonymous donor.

extinction had been overcome. Roberts caught the raucousness in a strident watercolour called *War Celebrations*, where civilians and soldiers join hands in a frenzied dance of victory (Pl. 295). The flags clustered behind them heighten the feeling of patriotic fervour, but their patterns are restricted to monochrome. Roberts reserves the full force of his colour for the figures, who are suffused in rasping washes of scarlet. One of them brandishes a bottle in his upraised hand, and their brutish faces signify aggression rather than harmless enjoyment. The equally abandoned revellers cavorting down the street towards them could easily become entangled in a fight, for police had to break up the celebrations after the crowds grew destructive. Far from savouring the advent of peace, Roberts remains troubled by the suspicion that the post-war world will continue to be riven by belligerence.

No such pessimism affected the plans to create a noble Hall of Remembrance in London, filled with large-scale war paintings specially commissioned for its panelled walls. The plan sprang from the British War Memorials Committee, established in March 1918 with Lord Beaverbrook and Arnold Bennett as its most prominent members. Beaverbrook, now the Minister responsible for Information, was naturally eager to enlarge the government's patronage of war artists until it matched his earlier scheme for an imposing Canadian War Memorial building in Ottawa. Urged on by Muirhead Bone and Robert Ross, two of the new committee's advisers,[5] he soon won agreement for an immense edifice which would house paintings of the war in all its aspects – on the home front as well as abroad. By April the members were already debating the size of the pictures in the Hall of Remembrance, and Ross proposed that they should be

the same dimensions as Velázquez's *The Surrender of Breda*.[6] His suggestion implied that the images in the Hall should aim for the highest standards achieved by the history painters of the past. In the event, the committee settled for the somewhat more modest size of Uccello's *Battle of San Romano*, a series which had already inspired

293 André Fraye *The Armistice* 1918. Watercolour on paper, 34 × 43 cm. Musée d'Histoire Contemporaine – BDIC, Hôtel National des Invalides, Paris.

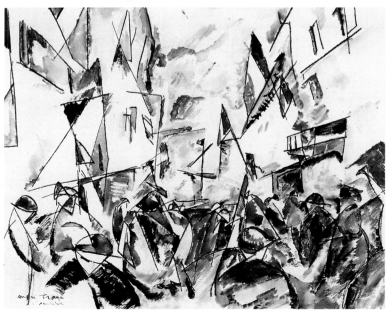

a prophetic Man Ray and an ebullient war painting by Aristarch Lentulov in 1914 (see Pls. 22, 45). But there would also be room for a few 'super-pictures' twenty feet in length, devoted to the theme of Allied cooperation, as well as a larger number of canvases no more than six feet high.[7]

The more enthusiastic the committee felt about the Hall, the more audacious their thinking became. They decided in May that the building 'was to be an integrated whole, in which architecture and sculpture would play almost as important a part as the pictures themselves.'[8] Charles Holden, who had given Epstein his first important commission for the façade of the British Medical Association headquarters in 1908, was entrusted with the task of preparing designs. Although they do not appear to have survived, Holden's supporter Bone maintained that the Hall should be envisaged as 'a kind of Pavilion', surrounded by a garden on a site at Richmond Hill and exemplifying 'a choice modest beauty of conception.' While stressing that artists with experience of active service should play an important role in the venture, he argued that the overall aim ought to centre on a dedication to peace. Music would be performed in one of the Hall's galleries, while the principal space containing the 'super-pictures' and the 'Uccello' canvases might culminate in an oratory with a decoration devoted to '"the coming Brotherhood of Man", for which we all pray.'[9]

Such an elevated proposal courted aesthetic disaster, imposing on the artists an impossibly idealized obligation. But it was never realised. Augustus John, having been invited to produce a vast painting on the uninviting theme of 'The Junction of Our Lines with the French', eventually submitted a far smaller work copied in a crude, hasty manner from a popular wartime postcard called 'A "Fag" after a Fight'. The only finished 'super-picture' came from the hand of John Singer Sargent, seemingly the least likely artist to react with an

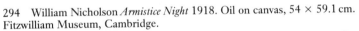

294 William Nicholson *Armistice Night* 1918. Oil on canvas, 54 × 59.1 cm. Fitzwilliam Museum, Cambridge.

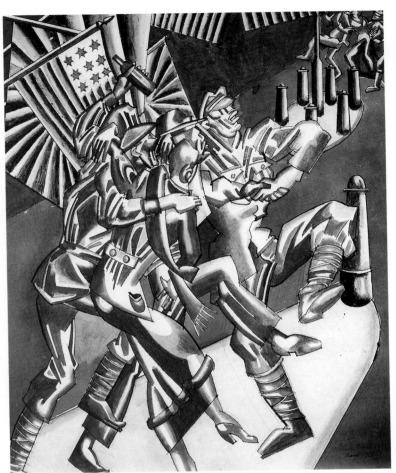

295 William Roberts *War Celebrations* 1919. Pencil, pen, ink and watercolour on paper, 41 × 35.6 cm. Thyssen Foundation, Madrid.

adequate amount of *gravitas* to the challenge. He was asked to tackle the 'fusion of British and American forces'[10] – a bizarre undertaking for a society portraitist long renowned as 'the Van Dyck of our times'. Although the committee considered that Sargent's nationality qualified him splendidly for the task, he experienced understandable difficulties in making sense of the proposal. The 62-year-old painter had, after all, spent the past few years largely ignoring the war, and in the winter of 1917 he revelled in escaping to the Renaissance-inspired delights of Vizcaya, an ornate palazzo built by an old friend in Florida.

How might this sheltered man, who read no newspapers and remained profoundly ignorant of the world's affairs, produce a convincing image of the conflict? The committee's members could not have known the answer when they took the considerable risk of engaging Sargent's services in May 1918, aided by a hand-written letter of invitation by Lloyd George from Downing Street. But Sargent had given an intriguing hint of his potential ability four years before. In August 1914 he found himself unable to leave the Austrian Tyrol when war was declared. One of his friends, Colonel Armstrong, was interned on suspicion of spying, and for three months Sargent was forced to remain in enemy territory. While showing scant curiosity about the progress of the conflict, he did admit to his sister that 'this war is upsetting everything everywhere it seems.'[11] Soon afterwards, his favourite niece Rose-Marie lost her husband in one of the Western Front's first battles, and the work Sargent executed during his

Tyrolese confinement amounted to an indirect meditation on the carnage. He began to frequent graveyards, producing a melancholy watercolour of the ironwork markers either leaning unsteadily in their allotted positions or fallen outright on the grass. Other pictures included wooden crucifixes and confessionals, implying that Sargent was undergoing a rare preoccupation with suffering and death. The elegiac mood passed once he secured his return to England, but it may well have been reawakened by the death of Rose-Marie herself in 1918, when a French church was hit by German shells. Devastated by the news, Sargent wrote to his sister that 'I can't tell you how sorry I am for you, and you all, and how I feel the loss of the most charming girl who ever lived.'[12]

The tragedy must, at the very least, have made Sargent more aware of the human suffering caused by war. It surely helped him, in the end, to invest his commissioned painting with an uncharacteristic amount of compassion. Accompanied by his old friend Tonks, he travelled to France in July 1918 and, after staying briefly at General Headquarters as Earl Haig's guest, joined the Guards Division under General Feilding near Arras. At first, judging by his strangely detached painting *Ruined Cathedral* (Pl. 296), Sargent's ability to remain untouched by the destruction persisted during his months at the Front. He even amused himself by producing lighthearted watercolours of soldiers bathing or stealing berries with mischievous delight. For a long time the appropriate theme for his Hall of Remembrance canvas eluded him, and he complained to a friend in September 1918: 'How can there be anything flagrant enough for a picture when Mars and Venus are miles apart whether in camps or front trenches. And the farther forward one goes the more scattered and meagre everything is. The nearer to danger the fewer and the more hidden the men – the more dramatic the situation the more it becomes an empty landscape. The Ministry of Information expects an epic – and how can one do an epic without masses of men? Excepting at night I have only seen three fine subjects with masses of men – one a harrowing sight, a field full of gassed and blindfolded men – another a train of trucks packed with "chair à cannon" – and another frequent sight a big road encumbered with troops and traffic,

296 John Singer Sargent *Ruined Cathedral, Arras* 1918. Oil on canvas, 54.6 × 69.8 cm. The Marchioness of Cholmondeley.

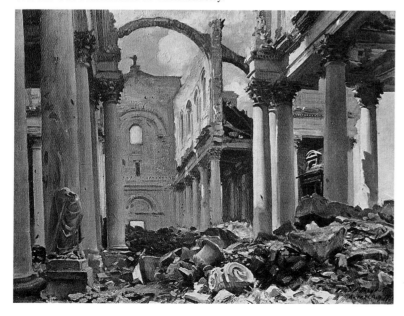

I daresay the latter, combining English and Americans, is the best thing to do, if it can be prevented from looking like going to the Derby'.[13]

Ultimately, though, Sargent decided to drop the 'big road' idea and plump for the 'harrowing sight' instead. He was right to do so. The death of his niece must have helped him realise that the 'gassed and blindfolded men' summed up the underlying horror of war, and in late September another experience doubtless reinforced his growing belief that the Hall of Remembrance painting should attempt to encompass human suffering at its most intense. While staying with an American division in the Ypres district, wet weather brought on a bout of 'flu. He was consigned to a hospital tent for a week, and later described his ordeal there 'with the accompaniment of groans of wounded, and the chokings and coughing of gassed men, which was a nightmare.'[14] Their plight surely helped to persuade him that the gassed victims should be represented in his big painting, which he commenced soon after returning to England in October and complaining to the committee that 'I think the picture would be infinitely better and much less impossible to execute if it were half the size.'[15]

Although the chosen subject did not include American soldiers, the committee approved it and reassured him about the advisability of tackling what Sargent described as 'an awfully long strip of a picture.'[16] The immense canvas was only completed in 1919, but he inscribed it with the date 'Aug. 1918' in order to acknowledge the importance of the scene he had witnessed at le-Bac-du-Sud. The 4th and 6th Army Corps had mounted an attack on the Germans near Ayette, and Tonks recalled how the two artists 'started out in Sargent's car together along the road to Doullens'. They were searching for the advance of the Guards Division, and towards evening discovered the scene which impressed itself on Sargent's imagination. 'The Dressing Station was situated on the road,' Tonks wrote, 'and consisted of a number of huts and a few tents. Gassed cases kept coming in, led along in parties of about six just as Sargent has depicted them, by an orderly. They sat or lay down on the grass, there must have been several hundred, evidently suffering a great deal chiefly I fancy from their eyes which were covered up by a piece of lint. The gas was mustard gas . . . Sargent was very struck by the scene and immediately made a lot of notes. It was a very fine evening and the sun toward setting.'[17]

These 'notes' were supplemented, after Sargent's return to London, by a sequence of charcoal and stump drawings from models apparently posed in his studio. He needed to make them if he was ever to achieve the difficult transferral from on-the-spot sketches to a monumental painting, capable of arresting and maintaining attention as the focal point in the Hall of Remembrance. Sargent's protracted labours on the mural decorations for the Boston Public Library had undoubtedly given him the confidence to work on the grand scale. The hieratic figures ranged in severely frontal positions on the medieval end of the murals have a Ravenna-like gravity which he carried over to *Gassed*. But the frieze of soldiers owes more, finally, to the row of prophets on the Hebraic end of the Library decorations. For these heavily robed patriarchs are linked with each other rather than standing in statuesque isolation, and their faces reveal an emotional range which their medieval counterparts abstain from displaying. Sargent, who enjoyed the relative simplicity and nobility of the draperies in his Boston murals, sighed at the prospect of painting 'a lot of life-size buttons and buckles and boots'.[18] Nevertheless, the studio drawings for *Gassed* show how seriously he approached the task of representing the paraphernalia of helmets, straps and packs. However much he resented the effort it cost him, working against the

grain ended up forcing Sargent to attain an intensity which the Library decorations had never achieved.

As the finest of these preparatory studies attest, he approached *Gassed* with a far greater compassionate engagement than his other war work possessed. Perhaps the most significant drawing concentrates on the orderly at the head of the principal frieze, supporting the first soldier and at the same time swivelling round to clasp the elbow of the man behind (Pl. 297). This double gesture plays an important role in the final canvas, signifying the help offered to the blinded figures as they stumble back from the Front (Pl. 298). But the *Gassed* canvas emphasizes that the orderly cannot cope with the soldiers in his care. He has no hope of dealing adequately with the rest of the long, melancholy line stretching across so much of the picture's width. The soldiers are left to cope on their own, clinging to each other's backs as they struggle forward like some stoical re-enactment of the sightless tottering towards calamity in Bruegel's great painting *The Parable of the Blind*. The men in Sargent's picture are more resigned to their fate than Bruegel's anguished procession, and they are in no imminent danger of collapse. All the same, there is pathos in their fortitude, and towards the back of the line one soldier threatens to break the support chain as he lurches sideways, vomiting on to the figures lying nearby.

Like any artist, Sargent must have regarded their loss of eyesight with special horror. Between his principal figures an army football match can be glimpsed in the distance, and the players' energetic co-ordination contrasts poignantly with the shuffling limbs of the gas victims. As if to drive home their plight, Sargent ensures that the raised limb of the man kicking the ball is echoed in the leg lifted up by the third soldier in the line. Nothing could be further removed from the player's dynamism than this halting movement, made in order to negotiate the duckboard step. Moreover, the abundance of bodies strewn across the earth shows how long these new arrivals will have to wait before medical attention is given. With uncharacteristic frankness, Sargent forces them on our attention by letting their khaki bulk fill the entire foreground area. They lie there, blindfolded, weary and resigned to an interminable delay without the solace of

297 John Singer Sargent *Study for Gassed* 1918–19. Charcoal and stump on paper, 46.9 × 62.2 cm. On loan to the Imperial War Museum, London.

returning vision. They have plenty of time to worry about permanent loss of sight, and nothing to distract them from the pain their bodies feel. Among the recumbent figures one man manages to prop himself up, perhaps in the hope that his nausea might thereby be alleviated. Another soldier drinks from his water-carrier, desperate to assuage the sting of gas in his throat. The rest, however, succumb to lassitude, depressed by the realisation that their suffering will continue for a long time to come.

The war which brought them to such a pitiful condition is still being waged over on the right, where the minuscule forms of fighter planes punctuate the sky and maneouvre to avoid the anti-aircraft eruptions around them. But their buzzing activity fades into insig-

298 John Singer Sargent *Gassed* 1918–19. Oil on canvas, 229.8 × 609.6 cm. Imperial War Museum, London.

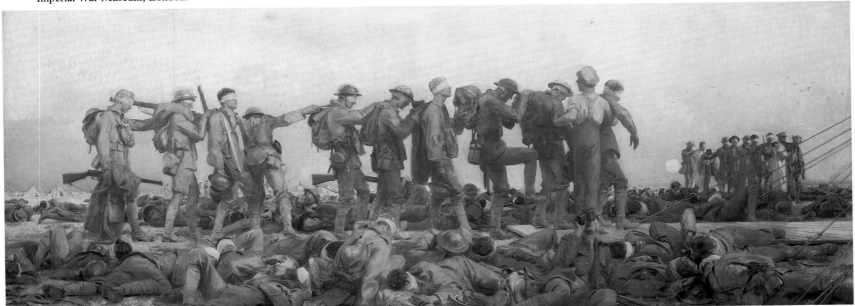

nificance compared with the agony of the troops. Another column of blinded victims totters in from the horizon, with the failing soldier at its head propped up by a white-coated orderly. Most of the men in this slow, dejected procession succeed in remaining upright, striving to retain their composure and fend off the panic which must be rising within them. One of their number leans forward and retches, very violently. No one else reacts to his affliction. Most of them will have suffered from similar bouts of sickness, and the figures heaped on the ground beneath add up to a grim prophecy of the exhaustion which must eventually overcome them all. Far from approaching the dressing station with a sense of relief, they move towards it like a funeral parade oppressed by intimations of death. The pale sun descending immediately behind the last soldier in the line confirms this feeling of finality. Despite the temporary radiance in the pink-tinged sky, everyone is aware that it will soon be succeeded by a darkness as profound as the shadowy region already shrouding the soldiers' eyes.

Gassed is surely Sargent's most untypical achievement, extending the range of a painter who had come, understandably, to feel trapped by his success as an accomplished society portraitist.[19] Firsthand observation of these afflicted young men on the Arras-Doullens Road moved him enough to produce, even within the constraints of a demanding official commission, a testament to the pity of war rather than a tribute to the victorious outcome of the Anglo-American alliance. While its restraint enabled Sargent to avoid the twin pit-falls of sentimentality and melodrama, he could never be accused of evading the sorrow of the battlefield. This elegiac canvas is courageously removed from the subject initially requested by his patrons, and William Orpen wryly commented to the committee's secretary: 'One thing I think you must have learnt by now & that is – don't tell an artist what to do . . . instead of "America & France" you have *Gassed* by J.S.S. . . . So much for ordering artists about.'[20]

All the same, Sargent's determination to focus singlemindedly on the soldiers' suffering earned him the respect of most visitors to the Royal Academy when it was exhibited there in 1919. Hailed as the 'picture of the year', it provided the putative Hall of Remembrance with a centrepiece far more coherent and quietly impassioned than John's equivalent focal decoration for the Canadian War Memorial building. When Sargent examined John's immense Cartoon (see Pl. 279), which was twice the width of his own painting, he rightly concluded that it was 'without beauty of composition. I was afraid I

should be depressed by seeing something in it that would make me feel that my picture is conventional, academic and boring – whereas.'[21] Sargent never again managed to convey the full extent of his troubled response to the war: the stupefying dullness of his group portrait, *Some General Officers of the Great War*, was succeeded by some thoroughly unconvincing wall decorations for the Widener Memorial Library at Harvard, commemorating the University's contribution to the war. They prove how banal Sargent could become when he exchanged direct experience of the conflict for an insipid allegorical alternative. But the sustained pathos of *Gassed* demonstrates that even an artist ill-equipped by temperament to interpret the brutality of the conflict could manage, within limits, to produce a distillation of the tragedy he had witnessed in France.

According to the plan drawn up for the Hall of Remembrance, Sargent's canvas would have been flanked by two 'Uccello-sized' paintings by Sir David Young Cameron and Charles Sims. Cameron, who arranged for *Gassed* to be exhibited at the Royal Scottish Academy in the summer of 1920, pointed out that the size and subject of his painting, *The Battlefield of Ypres*, obliged him to depart radically from the '"ragged and jagged" heights' familiar from his customary images of mountainous Highland scenes (Pl. 299). Nor was he happy about the committee's suggestion that all the landscapes in the Hall of Remembrance should have the same horizon. He refuted the idea, while conceding that it would be 'a very decided advantage to the decorative beauty of these pictures' if he and Sims agreed on 'an Horizon and furthermore an approximate time, so that we might paint light rather than dark or vice versa.'[22] Both artists visited the Western Front, but the war was over by the time they scrutinized their respective sites.[23] Perhaps that helps to account for the absence of powerful emotion in both their paintings. They seem more eager to court 'decorative beauty' than convey any feelings of sorrow or outrage about the destruction they surveyed. In Cameron's canvas there is a hint of the simplification Vallotton employed for his Yser painting, and the Scottish artist does achieve a more melancholy mood than Sims. After visiting France early in 1919, Cameron explained that his picture 'is not a portrait of any one spot (photographers can do all that) but is founded on my notes on the road from Ypres to Menin – really the road to the front.'[24] Even so, he remains far more detached than Paul Nash, whose own 'Uccello' canvas dealt with a very similar theme.

Commenced in June 1919, when Nash shared a herb-drying shed

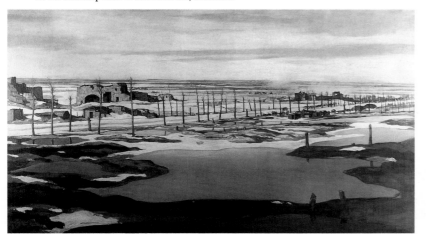

299 David Young Cameron *The Battlefield of Ypres* 1919. Oil on canvas, 182.8 × 317.8 cm. Imperial War Museum, London.

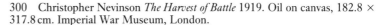
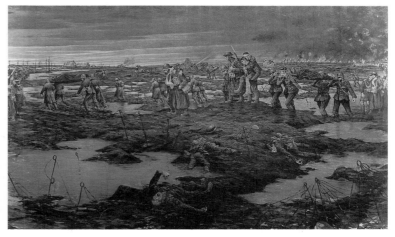

300 Christopher Nevinson *The Harvest of Battle* 1919. Oil on canvas, 182.8 × 317.8 cm. Imperial War Museum, London.

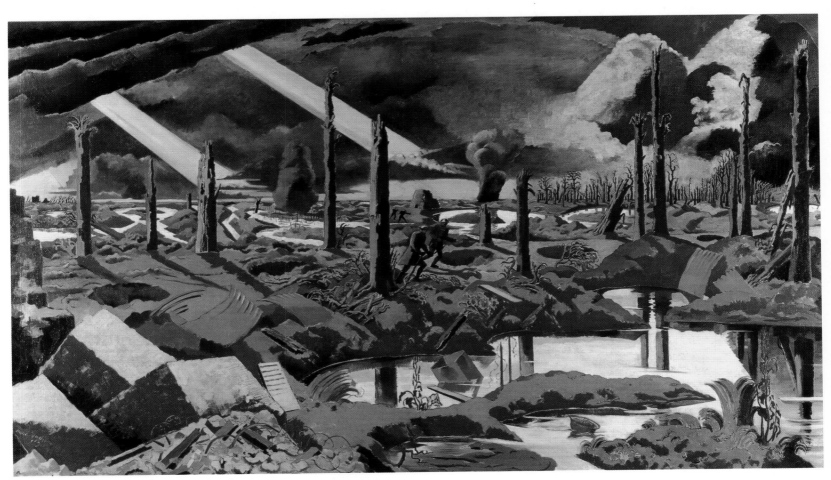

301 Paul Nash *The Menin Road* 1919. Oil on canvas, 182.9 × 317 cm. Imperial
War Museum, London.

at Chalfont St Giles with his brother John, *The Menin Road* is by far
the largest of his Great War paintings (Pl. 301). It was originally to
have been called *A Flanders Battlefield*, but the final title refers more
specifically to the artery leading into the German lines – a road
bombarded and wrecked by successive struggles as the opposing
armies fought again and again over the same battered territory. Nash
sees it essentially as a wasteland, punctuated by the weird, primordial
forms of stripped tree-trunks reflected in waterlogged shell craters.
Brown, shrivelled plants can still be found among the devastation, but
the terrain is further defiled by the wire, rubble, corrugated iron and
other detritus left behind when the combatants moved on. 'How
difficult it is, folded as we are in the luxuriant green country, to put it
aside and brood on those wastes in Flanders, the torments, the
cruelty & terror of this war,' Nash admitted soon after commencing
The Menin Road, before insisting that 'it is on *these* I brood for it
seems the only justification of what I do now – if I can rob the war of
the last shred of glory, the last shine of glamour.'[25]

All the same, this incessantly ravaged dumping-ground is not quite
as irredeemable as the landscapes Nash had painted a year earlier
(see Pl. 272). Soldiers can now clearly be seen, moving across the
scarred surface of an earth once seemingly unable to sustain any
more life, human or otherwise. Alleviating shafts of light lance
through the turbulent clouds, which part towards the right and dis-
close areas of a more optimistic blue. Passionate indignation still
informs this canvas, just as it runs through the chilling *Over the Top*
painted by John Nash in the same makeshift studio (see Pl. 265). The

war was over, however, and *The Menin Road* inevitably lacks the
savage, protesting pessimism which had turned *We are Making a New
World* into a masterpiece of anger and despair.

The most openly anguished painting produced for the Hall of
Remembrance was Nevinson's Uccello-sized *The Harvest of Battle* (Pl.
300). Inspired by the commission to move away from the blandness
of his aircraft pictures, he aimed at recapturing the austerity and
disillusion of his earlier war work. But now that Nevinson had
jettisoned the Cubo-Futurist idiom of *Flooded Trench on the Yser* and
La Mitrailleuse (see Pls. 76, 77), he no longer commanded a language
forceful enough to convey his bitterness. The naturalistic idiom
deployed here seems timid and uncertain, awkwardly at odds with the
strength of emotion he wanted to transmit. Conscious perhaps of this
inadequacy, Nevinson places the upturned face of a corpse in the
most prominent foreground position, his mouth gaping, while an up-
raised arm hangs locked in *rigor mortis*. It looks melodramatic rather
than genuinely moving, however – the work of a man who, having lost
his most potent style, struggles hard to compensate by manipulating
the viewer's response with a bludgeoning lack of subtlety.

Part of the problem may have lain with the difficulty inherent in
sustaining a full emotional response to the war after the Armistice
was declared. Roberts, who had excelled himself in the vehemence of
The First German Gas Attack at Ypres (Pl. 286), was unable to carry the
same level of vitality over to his 'Uccello' painting. Having declared
that he wanted to depict some aspect of trench warfare, he formulated
in his first watercolour study a frieze-like design far removed from

302　William Roberts *A Shell Dump, France* 1918–19. Oil on canvas, 182.8 × 317.8 cm. Imperial War Museum, London.

the flailing abandon of the Canadian canvas. In order to revive more specific memories of shell-handling scenes, Roberts travelled down to Bramley Dump near Reading in December 1918. But the highly finished pencil drawing he squared up in preparation for the final painting sacrificed much of the first sketch's freedom. A mass of representational minutiae has accreted around the fluent contours of Roberts' initial design, slowing its movement and impairing the sensitive interplay between the figures and the wooden duckboards which had once articulated their movements. This deadening process is taken further still in the canvas itself, where the energy of men working in a concerted chain is buried under the weight of accumulated paraphernalia (Pl. 302). The former aerial vantage has sunk to a point almost level with the soldiers themselves, so that the underlying structure of duckboards no longer counts for anything. In their place, Roberts has heaped up a dogged depository of shells, boxes and tarpaulins which claim as much pictorial attention as the motion of labouring bodies.

Never again would Roberts burden his work with such a profusion of descriptive information. Perhaps he felt oppressed by the demands of a committee which, after warning the Vorticist-influenced Frank Dobson that 'service men are not enthusiastic in regard to the artistic treatment of such scenes and require an almost literal interpretation',[26] rejected his tense painting of *The Ration Party* where figures move gingerly through a cramped trench (Pl. 303). Without the pressures of official patronage Roberts worked far more successfully, arriving at a powerful image when he depicted the apparently mundane act of hanging camouflage screens at Roclincourt. The soldiers energetically slinging the heavy tarpaulin between two trees

are supposed to be contributing to a defensive strategy, which will save lives. So indeed it might, but Roberts infuses the scene with his own gaunt, ironic awareness of potential tragedy as well. For the positioning of figures, trees and ladders, no less than the great billowing fabric itself, triggers unmistakeable memories of the Deposition. Although the protective screen is almost in place, Roberts' funereal picture implies that the tarpaulin may soon turn into a winding-sheet for the mutilated victims of a successful enemy raid.

Then, in the deceptively modest dimensions of a pastel drawing, he depicted the melancholy ritual of *Burying the Dead after a Battle* (Pl. 304). Although the conflict continues nearer the horizon, where a town lies in ruins and a plane plummets towards tanks negotiating their path through shell-bursts, the soldiers attending the ceremony seem oblivious of danger. Overcome by grief, they stand beside the newly-dug grave with heads bowed in silent remembrance of their comrades. Roberts may have based this scene on his memories of the morning after an especially ferocious bombardment. 'We buried our own dead', he recalled, 'together with some left over from the infantry's advance, shoulder to shoulder in a wide shallow grave, each in his blood-stained uniform and covered by a blanket. I noticed that some feet projected beyond the covering, showing that they had died with their boots on, in some cases with their spurs on too.'[27] Although a considerable amount of representational detail is incorporated in the drawing, it remains an incisive depiction of the soldiers' sense of loss. Its concentrated intensity compares favourably with *A Shell Dump, France* which, for all its seriousness and ambition, marks some stylistic unease as Roberts strives to move away from Vorticism towards an idiom commensurate with the committee's expectations.

Faced with the same difficulty, his old ally Lewis resolved it with greater éclat in his canvas for the Hall of Remembrance (Pl. 305). He approached *A Battery Shelled* with a built-in advantage, for one of Uccello's San Romano pictures had already been singled out in Lewis's 1915 essay on battle paintings as an outstanding example of war art. After scorning the nineteenth-century legacy of Meissonnier, Etienne Beaumetz and Edouard Detaille, he asked: 'Shall we conclude from this that War-painting is in a category by itself, and distinctly inferior to several other kinds of painting? That is a vulgar modern absurdity: painting is divided up into categories, Portrait, Landscape, Genre, etc. Portrait being "more difficult" than Landscape, and "Battle Pictures" coming in a little warlike class of their own, and admittedly not such Very High Art as representations of Nude Ladies.' Lewis had no patience with such hierarchical prejudice, asserting that 'Soldiers and War are as good as anything else. The Japanese did not discriminate very much between a Warrior and a Buttercup. The flowering and distending of an angry face and the beauty of the soldier's arms and clothes, was a similar spur to creation to the grimace of a flower. Uccello in his picture at the National Gallery formularized the spears and aggressive prancing of the fighting men of his time till every drop of reality is frozen out of them.'[28]

Lewis aimed at a similar petrification in his 'Uccello' canvas. Most of the picture-space is devoted to the destruction caused by severe bombardment. Unlike his Canadian painting, which showed an intact

303 Frank Dobson *The Ration Party (In the Trenches)* 1919. Oil on canvas, 76.2 × 63.5 cm. Private collection.

304 William Roberts *Burying the Dead after a Battle* 1919. Pastel on paper, 50.8 × 45.7 cm. Imperial War Museum, London.

gun-pit where heavy fire had never been experienced (see Pl. 284), *A Battery Shelled* draws on Lewis's own plentiful experience of enemy attack. Judging by his letters to Pound from the Front, August 1917 at Nieuwpoort was a particularly ferocious period. 'We have been under shell fire all day – as all days, and all nights,' Lewis wrote. 'They have got a direct hit on our dugout 4 days ago as we were having lunch. We were shelled this morning with 11 inch, just before breakfast. Craters big enough to put a horse & cart in. It is a bad spot.'[29] A few days later he reported that 'last night three shells fell slap in the middle of my gun-pit,' and vividly described how 'no hour has passed so far that I have not heard the song of the hot little hunks that pass over or by you, or come down "plock" at your feet.'[30] Although Lewis remained extraordinarily resilient, he began to question whether anyone could survive such intensive assaults for long. Near the end of the month he reported that 'our place has had five direct hits now, & today we are building it up anew. In the last twenty-four hours several shells have fallen 5 yards from our front door (& only ingress & exit). My sleeping bag, airing in the doorway, has been brutally transpierced. If we get any very heavy stuff over here ever our shelter would be smashed up at once. It is a matter of pure chance, under these circumstances, when, how and how much you get pipped. Sooner or later it is difficult to see how it can be avoided.'[31]

In the event Lewis came through the war physically unscathed, but *A Battery Shelled* shows how much he wondered at his ability to escape harm. The earth has been pounded into an acid-green lunar landscape, furrowed with maze-like patterns of mud. These gouged channels make movement difficult and dangerous, for unexploded missiles may lurk unseen within the craters. In 1917, just after an

305 Wyndham Lewis *A Battery Shelled* 1919. Oil on canvas, 182.8 × 317.8 cm.
Imperial War Museum, London.

especially severe bombardment, Lewis wrote that 'a few men move about the stumps of trees all draggingly and as though wounded, because they know it is no good moving quickly.'[32] The rusty orange figures in *A Battery Shelled* display a similar caution as they twist themselves into tortuous positions and search the pummelled ground. Their angular, metallic bodies are more mechanistic than their counterparts in Lewis's Canadian canvas, and in that respect the 'Uccello' picture is closer to the concerns of his earlier war images like the 1914 *Combat* drawings (see Pl. 34). Throughout this principal area of the painting an ingenious style, poised halfway between Vorticism and the more representational idiom demanded by the committee, is incisively sustained. The splintered forms zig-zagging their way through the chilled grey-white sky are difficult to distinguish from the equally shattered trunks of trees. Machine-age weapons and natural growths have both suffered catastrophic damage; but in the distance all this churned and fragmented complexity leads on to a silent, bleached terrain, ominously prophetic of the 'winter' world described by analysts of nuclear annihilation today.

Although this portion of the canvas remains corrosively faithful to the landscape Lewis described in 1917 as 'our particular Hell',[33] he juxtaposed it with three bulky figures who contemplate the devastated scene. They could almost be embodiments of Freud's belief, in his 1915 'Reflections upon War and Death', that 'our own death is indeed, unimaginable, and whenever we make the attempt to imagine it we can perceive that we really survive as spectators.'[34] They are handled in a far more representational idiom than the rest

of the picture, and at least two of them were apparently intended as portraits. Wadsworth, who is known to have posed for the purpose,[35] is recognisable as the man in profile with a pipe, while Lewis himself is probably the moustachioed figure next to him.[36] The third figure remains unidentified, but he may be another member of the Vorticist movement which Lewis was now wondering whether to revive.[37] The presence of these artists in the most conventional segment of the picture is paradoxical in the extreme: before the war, none of them would have wanted to produce figures as traditional as the trio standing so prominently in *A Battery Shelled*. Lewis, however, was surely aware of the paradox. The stylistic clash between the two parts of the painting is so incongruous that it must have been quite deliberate. Lewis presumably wanted these three large figures to embody his own realisation that 'the war was a sleep, deep and animal, in which I was visited by images of an order very new to me. Upon waking I found an altered world: and I had changed, too, very much. The geometrics which had interested me so exclusively before, I now felt were bleak and empty. They wanted filling. They were still as much present to my mind as ever, but submerged in the coloured vegetation, the flesh and blood, that is life.'[38] By making the three figures stand apart from the rest of the scene, both physically and in stylistic terms, Lewis may have wanted them to signify his own post-war mood, newly awakened from this 'sleep' and questioning the viability of the more 'geometrical' idiom employed in the shell-wrecked landscape. The former Vorticists look as if they might be outside the canvas altogether, removed from a way of seeing which

now belongs to a past beyond recovery.

Another painting intended for the Hall of Remembrance dealt with the theme of shelling in a more spectacular manner. Henry Lamb, who had served with the Royal Army Medical Corps in Salonika and Palestine before being posted to Northern France, was awarded the Military Cross for gallantry in September 1918. A month later he was gassed, but by 1919 had recovered sufficiently to start work on *Irish Troops in the Judaean Hills surprised by a Turkish Bombardment* (Pl. 306). One of the smaller works commissioned for the Hall,[39] it invests an incident from the Eastern Front with a strange, almost hallucinatory quality. When the picture was exhibited a year after its completion, the catalogue explained that 'it is about an hour before evening "Stand to," and men of the 10th Irish Division, surprised by the first few shells of a high-explosive bombardment, are hastily taking cover under the vertical walls of the terraces.'[40] The description takes no account of the startlingly steep aerial viewpoint Lamb has adopted, doubtless in order to accentuate the panic and dizziness experienced by the victims of this sudden onslaught. His long experience with the Field Ambulance probably prompted him to include the figures carrying their wounded comrade to shelter. But their calmness is contrasted with the gesticulating alarm of the other soldiers. Unable to shelter in the bivouacs and bell tent installed over on the rocks, they shield their ears from the whining din or fling themselves on the stony land. One man throws out his arm in desperation while another, cowering among the foreground shadows, presses himself against a hedge in an attempt to escape the onslaught.

Lamb's canvas, close in both style and visionary intensity to Stanley Spencer's work, complements the picture of similar dimensions which Spencer himself executed for the Hall of Remembrance. While Lamb concentrated on the moment when the soldiers are at greatest risk of injury or death, Spencer depicted a compassionate attempt to help the wounded with comfort and surgical assistance after a battle. The outcome was a masterpiece, the finest and most moving of all the paintings commissioned for the scheme. Drawing on his experience serving as a medical orderly in Macedonia between 1916 and 1917,

306 Henry Lamb *Irish Troops in the Judaean Hills Surprised by a Turkish Bombardment* 1919. Oil on canvas, 182.9 × 218.4 cm. Imperial War Museum, London.

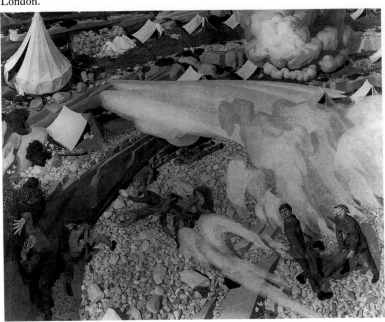

Spencer based his picture on memories of an event at a dressing station during an attack by the 22nd Division on Machine Gun Hill in the Dorian-Vardar Sector around mid-September 1916. 'I was standing a little away from an old Greek Church, which was used as a dressing station and operating theatre.' he recalled, 'and coming [there] were these rows of travoys with wounded and limbers crammed full of wounded men. One would have thought that the scene was a sordid one, a terrible scene...but I felt there was a grandeur about it.'[41] Although his initial drawing of the event had been lost in a bath-house at Smol, along with all the other sketches Spencer produced in Macedonia, he was able to recreate it in a pencil and wash study for the commissioned canvas. Modest in itself, the drawing already focuses on a group of mules and travoys waiting outside the brilliantly lit entrance to the rudimentary operating theatre. But the composition is dominated by the officer standing in the foreground, and beyond him other mules are included as well as a partially sliced-off Red Cross sign.

When he addressed himself to the final canvas, in his bedroom studio at Cookham, Spencer wisely decided to enlarge the operating theatre until it became the sole focus of the image (Pl. 307). The Red Cross sign has been deleted, along with the expanse of brick wall above the theatre entrance, and the foreground officer is replaced by a far less commanding figure who appears to be walking away from the dressing station with his arm newly supported by a fresh white sling. Even he feels compelled to stare back over his shoulder at the source of solace, however. Everything else in the composition follows the direction of his gaze, converging on the great expanse of light where the surgeons perform their tasks. Some of the wounded waiting on their stretchers must be suffering a great deal, and they appear to be confronted by an interminable wait before their pain is alleviated. But Spencer emphasizes the extraordinary serenity of the mules silhouetted against the brightness, and the devoted efforts of the orderlies to comfort the men in their care. The aerial viewpoint enables him to show how carefully they steady the stretchers ranged in a fan-like formation around the radiance beyond. One man inserts his body between two stretchers, in order to prevent them colliding with a jolt. Another orderly extends his left arm to steady the stretcher behind and, at the same time, presses his right hand down on the face of the figure huddled beneath a grey blanket.

This gesture, perhaps intended to protect the afflicted man's face from flies or the light, sums up Spencer's intentions throughout the image. As the fingers touch the patient's skin, they offer an affirmation of sympathy and human support after the impersonal brutality of battle. 'All these wounded men were calm and at peace with everything,' Spencer remembered, 'so that pain seemed a small thing with them. I felt there was a spiritual ascendancy over everything.'[42] Even the blankets seem to add a caressing source of relief as they flow over the reclining limbs like soft waves of balm. Spencer does not sentimentalize the solace available: the figures swathed in the protective embrace of these undulating expanses of cloth might die at any second, and they already bear a disturbing resemblance to corpses. But the harshness so evident in Beckmann's despairing etching of *The Morgue* (see Pl. 118) plays no part in this canvas. While Beckmann stresses the nullity of death, in a cold room where the corpses await nothing except the ignominy of a makeshift coffin, Spencer ensures that his painting is suffused with the warmth and hope emanating from the theatre. The travoys, orderlies and mules attend the surgeons with the rapt expectancy of the figures and animals who gathered around the Nativity. In this respect, the converted Greek church still retains its sacred significance. Always pre-

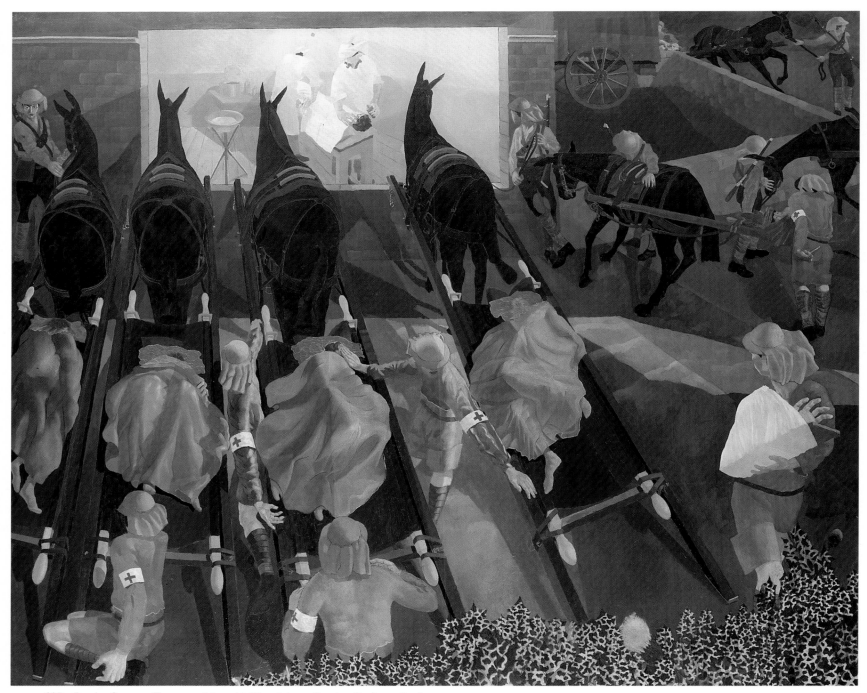

307 Stanley Spencer *Travoys arriving with Wounded at a Dressing-Station at Smol, Macedonia* 1919. Oil on canvas, 183 × 218.5 cm. Imperial War Museum, London.

pared to discover a religious dimension in even the most quotidian scene, Spencer here invests the surgeons and their illuminated chamber with a healing aura. As one man leans over the patient with a chloroform bottle in his hand, and his colleague performs an operation lower down the body, the entire ritual becomes an affirmation of Spencer's desire to redeem the suffering of war through his sturdily compassionate art.

Encouraged by the outstanding quality of the *Travoys* canvas, the committee became eager to acquire more Macedonian paintings from Spencer. But the loss of his drawings in Smol was a handicap, and he felt unable to take his war pictures any further. 'I very much regret having to throw up this job, as I am still very keen on it,' he wrote in July 1919, 'but somehow I seem to have lost the thread of my "Balkanish feelings" and I do not like doing things which are not absolutely my best works.'[43] Although the committee renewed its efforts to persuade him, Spencer was determined to avoid carrying out a half-hearted painting. 'No, its off Mr Yockney, and you can let the Finance Committee know on the receipt of this letter,' he replied

later in the month, before revealing that 'I still have hope in the next few years to do something good out of my Balkan experiences. The thing is this Mr Yockney, as artists we can do just what we like (that sounds very nice) BUT WE MUST NOT DO WOT WE DONT LIKE, woe unto us if we break this law.'[44]

Spencer was undoubtedly wise to refuse, for his Slade contemporary Bomberg did not enjoy forcing himself to comply with the wishes of the Canadian committee. The invitation to paint a monumental canvas had arrived at the end of 1917, when Bomberg received the same warning that Roberts was given before painting his Canadian picture (see Pl. 286). The outcome, so far as Roberts' contribution was concerned, satisfied the committee. But the initial letter Bomberg received, asking him 'to paint this picture at your own risk' and insisting that 'cubist work would be inadmissible for the purpose',[45] turned out to cause him considerable anguish. At first, in an incisive and dynamic oil and watercolour study, he toyed with the idea of producing an image defiantly in the style of his pre-war work (Pl. 309). The allotted subject, celebrating the efforts of Canadian and British sappers who in 1916 tunnelled under the enemy-held salient at St Eloi and blew it up,[46] concentrated on strenuous physical activity in enclosed surroundings. It therefore accorded well with Bomberg's most important earlier paintings, *In the Hold* and *The Mud Bath*, and his oil and watercolour study of sappers could have formed the basis of an impressive canvas. He must soon have realised, however, that its uncompromisingly mechanistic idiom would be unacceptable to the committee. Besides, his own attitudes had been altered by the war. He no longer regarded the machine in a positive light, as an agent of construction. The carnage of battle, culminating in the death of his old friend the poet and artist Isaac Rosenberg, made him realise how destructive mechanization could be. In one of Rosenberg's last drawings, the elegiac *Self-Portrait in a Steel Helmet*, a faint, almost ghost-like head emerges from the crumpled brown wrapping-paper (Pl. 308). His old air of vigilance is still discernible, but softened now by a terminal sense of weariness. Rosenberg's grasp of form here seems on the verge of dissolution, as though prophesying his death on night patrol in April 1918. A few months before, during a devastating period in the wintery forward trenches, he had written that 'what is happening to me now is more tragic than the "passion play". Christ never endured what I endure. It is breaking me completely.'[47]

In later years Bomberg turned away from the machine age completely, and the small ink and wash drawings he made during the war

308 Isaac Rosenberg *Self-Portrait in a Steel Helmet* c. 1916. Chalk and gouache on wrapping paper, 24.1 × 19.7 cm. Patric Dickinson Collection.

chart the beginnings of this new vision. The urgent outlines of *Figures Helping a Wounded Soldier* had initiated the process, probably as early as 1917 when Bomberg was driven by despair to administer a self-inflicted wound at the Front (see Pls. 218, 219). But his return to a more figurative style became more evident in a group of spirited drawings the following year. In *Gunner Loading Shell*, the man is clearly distinguishable from the weapon he services. The *Soldier Patrolling Tunnel* is equally identifiable as a flesh-and-blood figure, and Bomberg must have concluded that his Canadian painting should likewise emphasize the humanity of the men labouring in their subterranean locale. After all, he described the canvas as 'a tribute to the heroic miners',[48] and they could hardly be lauded in a picture which made them appear as anonymous and machine-like as the implements they wield.

The first version of *Sappers at Work* was, accordingly, carried out in an idiom poised halfway between his earlier obsession with 'Pure Form' and a more representational alternative (Pl. 311). Bomberg later recalled that 'the aim was to extinguish the phase of war – I had had enough of that – and wanted the relief – and the sublimation of creating the forms of war not in the dank, death-smelling underground mine – like a coal pit – but in the open-air, bathed in sunlight.'[49] That is why the first *Sappers* canvas possesses such a strangely festive atmosphere. As flat and heraldic as a banner, it stresses the close-knit collaborative efforts of men who are now allowed to declare their fleshy identity without reserve. Near the centre of the composition, one bending labourer thrusts out his green-trousered bottom at the viewer. Bomberg clearly relishes its plumpness and splashes it with generous segments of light. The other figures are likewise enlivened by the flickering play of colours which range audaciously through the spectrum, from puce and orange to purple and chocolate. A startlingly bright blue is the most dominant of all, and it gives the underground chamber an unearthly radiance. The sappers, some of whose poses appear to be inspired by the vigorous *contrapposto* of El Greco's *Christ Driving the Traders from the Temple*,[50] all seem to be energized by this exalted mood. As if in defiance of their cramped surroundings, they shovel, pull and carry with uninhibited *élan*. Rather than feeling oppressed by their environment, these vigorous figures execute the tasks in a joyful spirit. Bomberg's handling matches the new buoyancy, too: his brushwork is looser and more animated than the dry, impersonal application of pigment in his pre-war canvases.

Since it inaugurated a zestful new direction for Bomberg's work in the aftermath of war, and tried at the same time to acknowledge the Canadian commission's needs, he must have felt proud of the painting before delivering it for inspection in 1919. But when his wife came home in the afternoon, she found 'David huddled in his chair by the fire – in tears.' He was shattered by the hostile reception accorded to the canvas by Konody, the Canadians' art adviser, who had told Bomberg: '"You submit to me the most wonderful drawings – yours is the last panel to be fixed before Government House can be opened, and you bring me this futurist abortion. What am I to say to my Committee?" And a great deal more to that effect, while he wrung his hands in annoyance, and stamped round and round the offending painting which had been laid out on the floor for his inspection. (Konody had a club foot and wore a built-up sole to his boot, which made him "stamp" still more drastically).'[51] Bomberg's devastated reaction to this dismissal suggests that it delivered a fresh shock to a nervous system still recovering from the traumatic effects of war. Konody's vituperation demoralized the young painter so severely that he accepted his wife's proposal to negotiate for a revised version of

the *Sappers* picture. She succeeded in doing so, even to the extent of promising Konody that 'no "cubist abortions" should creep into the work.'[52] It was a humiliating compromise for any artist to endure, but Bomberg's weakened condition and transitional aesthetic standpoint combined to persuade him that the committee's irksome demands should be met.

With scarcely a pause, he set to work on the revised version, which Konody remembered was finished 'in an incredibly short time.'[53] The strongest aspect of the second *Sappers* canvas lies in its depiction of the tunnel itself (Pl. 310). By reducing his figures in size, Bomberg made room for a dramatic criss-cross structure of angular beams intersecting with the curved bands stretching over the roof. They appear to ensnare the men labouring below, and the subdued colours employed in their limbs and uniforms give the entire picture an oppressive air. The sappers are no longer masters of their surroundings, blithely carrying out a triumphant venture. They seem frozen in position, more like models dutifully assuming stances devised by the painter in his studio. The vivacity and gusto of the men who enlivened the first version have been replaced by a dour alternative. It doubtless reflects the feelings of the artist himself, obliged to employ a figuration far more academic than anything he would have countenanced on his own. As if to signify the weary reluctance he felt, Bomberg portrayed himself as the sapper in the right foreground bearing a heavy beam on his shoulders. The execution of this 'authorized' painting must have been just as unwelcome a burden, and Bomberg made sure that he never again resorted to the cold, dogged idiom adopted here.

The dilemma so painfully exposed in the troubled history of *Sappers at Work* did not, on the other hand, affect the painting which Edward Wadsworth produced for the Canadians in 1919. As a former member of the Vorticist movement he would, like Roberts and Lewis before him, have been cautioned about the importance of avoiding extremism. But in the event, he settled on a subject commensurate enough with his earlier avant-garde concerns to solve the stylistic problem at once. Wadsworth had a quiet war, serving as an

310 David Bomberg '*Sappers at Work*': *A Canadian Tunnelling Company* (Second Version), 1919. Oil on canvas, 305 × 244 cm. National Gallery of Canada, Ottawa.

309 David Bomberg *Study for 'Sappers at Work': A Canadian Tunnelling Company* c. 1918. Oil and watercolour on paper, 24 × 32 cm. Anthony d'Offay Gallery, London.

Intelligence Officer for the Royal Naval Volunteer Reserve on the Mediterranean island of Mudros. His experiences were so peaceful that he felt unable to deal with the conflict in any of the woodcuts produced at that time. The old obsession with machine-age angularity disappears for a while, swept away by a preoccupation with maritime flow which reaches a climax in *Disruption*.[54] Its title suggests that a violent theme may have played a part in the genesis of the woodcut. But aggressive Vorticist imagery appears to have been replaced by the surge and swell of the Ægean sea, and the influence of Kandinsky's most dreamlike abstractions dominates the orchestration of the design.[55]

Only after Wadsworth had been invalided home did he become involved in a venture that brought his art into contact with the combat zone. On recovering, he gained employment supervising the dazzle camouflage of ships, largely at Bristol and Liverpool. He probably owed this congenial task to Lieutenant-Commander Norman Wilkinson, an academic marine painter with no apparent interest in experimental art.[56] Wilkinson masterminded the spectacular development of dazzle painting on ships after coming to the conclusion that invisibility offered no escape from submarine attack. The crucial question was whether the vessel's course could be accurately deter-

311 David Bomberg '*Sappers at Work*': *A Canadian Tunnelling Company* (First Version), 1918–19. Oil on canvas, 304 × 244 cm. Tate Gallery, London.

mined by the enemy, and he saw dazzle painting as the most reliable way of frustrating a submarine's aim. In a paper delivered at the Newcastle Victory Meeting in 1919, he defined dazzle as 'a method to produce an effect (by paint) in such a way that all accepted forms of a ship are broken up by masses of strongly contrasted colour.'[57] A classroom at the Royal Academy became the centre where Wilkinson's ideas were put into eye-bending practice, largely by a female work-force. Assistants in the Dazzle Section, all of whom had art-school training, prepared models of ships swathed in the most vehement stripes imaginable. After tests in a studio, the approved designs were sent to the major British ports where ten lieutenants supervised the painting of the ships themselves.

Surviving photographs testify to the extraordinary boldness of the applied patterns (Pl. 312). The explosive diagonal and zig-zag bands had a wild, ragtime impact. Hulls and funnels alike were transformed into crazily festooned apparitions, intended to disorientate any U-boat Commander scrutinizing them through his telescope. They look so attention-seeking that the whole notion of camouflage might seem self-defeating. Far from turning the vessels into instant targets, however, these delirious exercises in optical deception were deemed effective. Wilkinson reported that dazzle saved many ships from de-struction. Although a number of the decorated vessels were hit by torpedoes, 'a far larger percentage of these made port than ships painted light grey, owing to the submarine making an erratic shot, and so injuring the vessel in a less vital spot.'[58]

As Thomas Hart Benton discovered in Norfolk Harbor around the same time (see Pl. 259), the sight of the *Aquitania* or the great white star liner *Olympia* covered in dizzying, hard-edge stripes proved irresistible for artists. Horace Brodzky, who knew the Vorticists and looked after their 1917 exhibition in New York, executed a lively little woodcut of *Two Camouflaged Ships* which implied that the waves' rhythm was carried over into the patterns on the hulls above. But the finest work on the subject was produced by Wadsworth, who within a single year became responsible for supervising the application of designs on over two thousand ships. The spectacle of the mighty vessels receiving their dazzle in drydock provided him with ready-made subjects for his art. During 1918 he made an outstanding sequence of woodcuts, each one of which revelled in the optical vivacity of the bands surging across the ship's surface. In *Dazzled Ship in Drydock*, he divests the vessel of almost everything except these stripes, and they make it merge to a confusing extent with the

equally stark ribs of the bridge arching behind. Although it helps to disguise the fact that Wadsworth has adopted a more conventional approach than in any of his Mudros works, the move towards orthodoxy became clearer in a celebrated print called *Drydocked for Scaling and Painting*. Here the vessel is easily identifiable within the perspectival recession established by the dynamic white-on-black diagonals which dramatize the dock's looming sides. They provide a taut container for the curving bands on the back of the ship, its aggressive capacity announced by the gun-barrels projecting like porcupine's quills from the topmost edge.

When Wadsworth held an exhibition of these incisive, energetic woodcuts in 1919, his former Vorticist ally Frederick Etchells claimed in the catalogue that dazzle camouflage 'would probably never have developed as it did had it not been for the experiments in abstract design made by a few modern artists during the years immediately prior to 1914'.[59] This assertion, so reminiscent of Picasso's remarks to Gertrude Stein during the war's opening months,[60] is hard to justify in view of Wilkinson's role as the originator of dazzle. But he might, conceivably, have been influenced on a subliminal level by the work of the avant-garde, for *The Illustrated London News* opined that 'the "Pathan" in her "dazzle" paint of stripes, angles and quadrilaterals' was 'suggestive of futurism or cubism'.[61] The vessels reproduced by the magazine in January 1919 certainly supported that view, and at least one French observer considered that a camouflaged vessel was 'like an enormous cubist painting with great sheets of ultramarine blue, black, and green, sometimes parallel but more often with the sharp corners cleaving into one another, and although you don't quite make it out, you can divine a reason, a plan, a guiding principle, a scheme.'[62] It seems reasonable to suppose that Wadsworth's appointment as a camouflage superviser must have arisen from Wilkinson's acknowledgement of the links between Vorticism and the designs sent to the ports from Burlington House. At all events, Wadsworth remained sufficiently excited by the striped vessels to make them the subject of his outstanding Canadian canvas, *Dazzle-Ships in Drydock at Liverpool* (Pl. 313).

This awesome canvas celebrates the vitality of the asymmetrical patterns as they turn the ship's bulk into a battleground of crisply orchestrated diagonal and vertical bands. Wadsworth's return to a more representational vision has not, in this case, been accompanied by a diminution of the tense formal dynamism which Vorticism had enabled him to develop. He is assisted by the frenetic impact of the camouflage itself, and faithfully reproduces it on the vessel's towering sides. But he takes considerable liberties elsewhere in the canvas, to ensure that the eye-assaulting patterns are all of a piece with the shooting recession lines at either side and two more dazzled ships behind. The diagrammatic rendering of the distant dockside – the factory chimneys, the trio of orange gasometers, and the severe geometry of warehouse windows – also encourages us to view the painting as a flat, kaleidoscopic assertion of segmented form. Ulti-mately, though, Wadsworth resolves all this heady pattern-making into a surprisingly accurate record of maritime defences. The fore-ground figures painting the hull with their elongated orange brushes are depicted with a greater degree of naturalism than their counter-parts in *Liverpool Shipping*, his more simplified woodcut version of the same scene. As well as giving a sense of scale to the daunting bulk of the vessel, the four men in the Canadian canvas show how insig-nificant humanity appears in relation to the ship they are labouring to

312 Photograph of SS *New York City* at Bristol, April 1918, with dazzle camouflage supervised by Wadsworth.

313 Edward Wadsworth *Dazzle-Ships in Drydock at Liverpool* 1919. Oil on canvas, 304.8 × 243.8 cm. National Gallery of Canada, Ottawa. Transfer from the Canadian War Memorials, 1921.

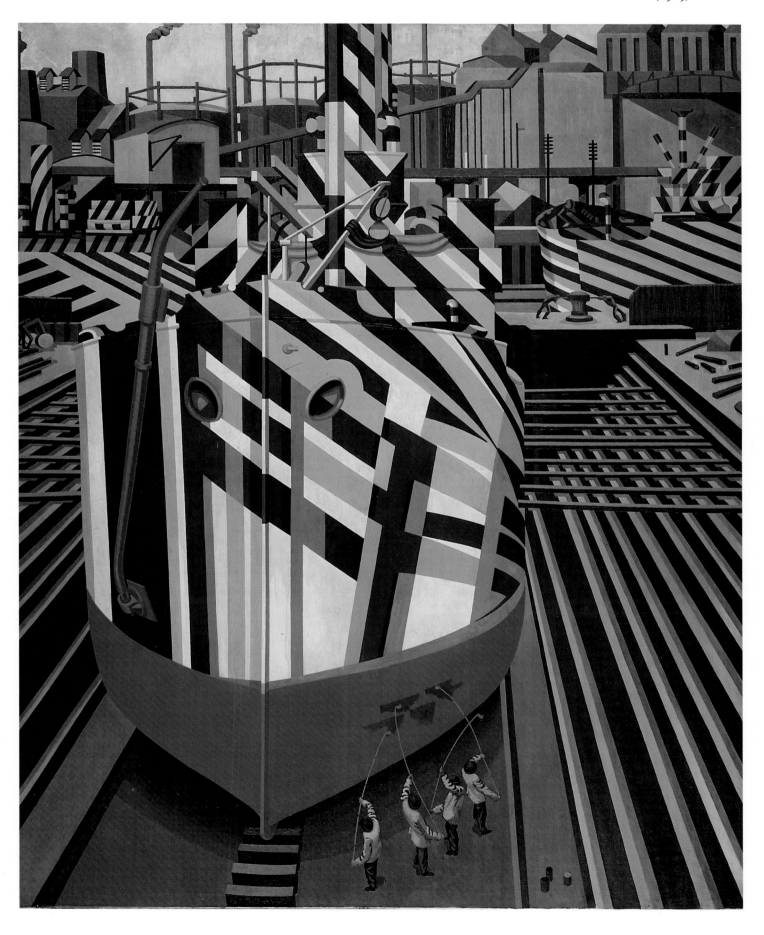

disguise. Indeed, there is something ferocious about these hard-edged, slanting shafts of black, grey and white. Quite apart from frustrating the enemy's aim, they possess a hard, cold, martial zeal which asserts the Allies' will to defeat the German submarine threat without delay.

If Wadsworth ever saw damaged destroyers during his camouflage work, he ignored them in his art. Such a subject would have been unacceptable to the Canadian committee, and when the Scottish painter J.D. Fergusson admitted them to his work he met with a marked lack of official approbation. Provisionally invited by the British government to paint dockyard scenes at Portsmouth, he became intrigued by the sight of crippled destroyers berthed for repairs (Pl. 314).[63] The stripes on the sides of the alarmingly tilted vessel had been, in this instance at least, of little avail in preventing hostile attack. But the robust, Léger-like vigour with which Fergusson marshals the other elements in his composition – most notably the great bronze wheel, the burnished drum and the circular scarlet

314 J.D. Fergusson *Portsmouth Docks* 1918. Oil on canvas, 76.2 × 73.7 cm. Imperial War Museum, London.
315 George Clausen *Returning to the Reconquered Land* 1919. Oil on canvas, 271 × 391 cm. Canadian War Museum, Ottawa.

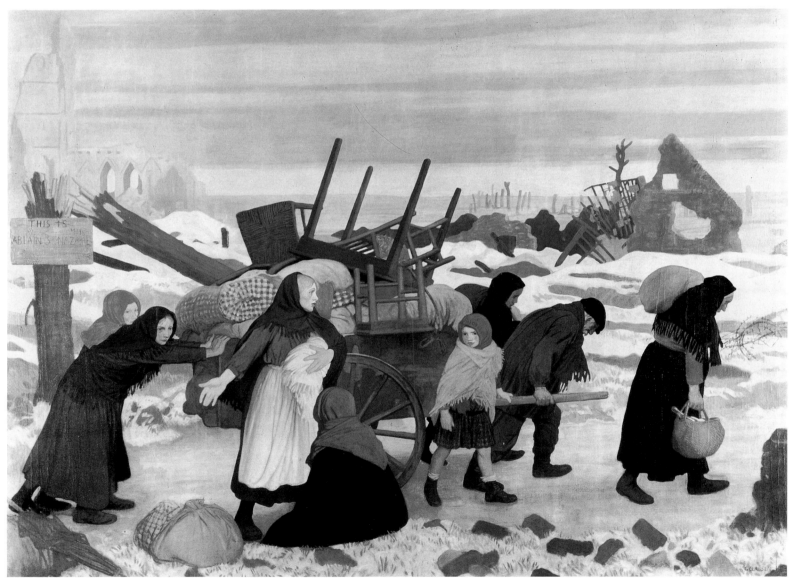

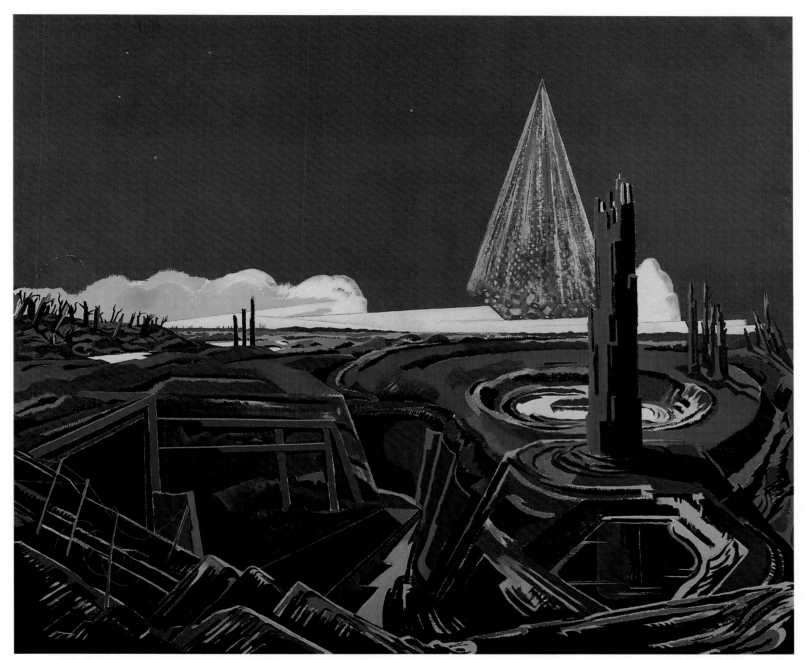

316 Paul Nash *A Night Bombardment* 1918–19. Oil on canvas, 182.9 × 214.4 cm. National Gallery of Canada, Ottawa. Transfer from the Canadian War Memorials, 1921.

signal – counters the image of a ship ailing beyond repair. The assurance of his Portsmouth work shows just how engrossed he became there, and Fergusson even told the British war artists' committee that the docks had provided him with an inspiration 'I have not had before in my work'.[64] None of his paintings was purchased by the committee, however, presumably because damaged destroyers did not accord well with the government's view of the war.

Tensions of this kind were bound to arise when artists put forward an interpretation of the conflict more questioning than their officially sponsored patrons deemed desirable. Even Eric Kennington, who had on the whole become far less sceptical since he painted *The Kensingtons at Laventie* (see Pl. 92), fell foul of the Canadian committee. His large canvas of the 16th Canadian Scottish regiment

marching from Arras to relieve the beleaguered British army at Amiens was originally called *The Victims*. The title invites viewers to regard these 'war-hardened storm troops',[65] as they are described in the official Canadian catalogue, in a far from optimistic light. One of the kilted men striding beneath the shattered tree-trunk has disturbingly sightless eyes, and Kennington places them all in a landscape festooned with shattered weapons and other ominous portents of the suffering these soldiers will soon encounter. On the request of a Colonel in the 16th Canadian Scottish, however, the painting's name was changed: first to *The Victors* and then, even more belligerently, to the title it now bears – *The Conquerors*. Anything less victorious would not, presumably, have satisfied the government, who displayed Kennington's picture in a Canadian National Exhibition dedicated to

317 Charles Sargeant Jagger *No Man's Land* 1919–20. Bronze relief, 127 × 330.2 cm. Tate Gallery, London.

celebrating 'the final triumph of allied and more particularly Canadian arms.'[66] The *Christian Science Monitor* was indignant about such shameless manipulation of Kennington's intentions. 'This is a pity for the picture is a statement by the artist,' the magazine commented, adding that 'it is very easy to see why he called it *The Victims*.'[67]

The same title could reasonably have been applied to Clausen's monumental Canadian canvas, *Returning to the Reconquered Land* (Pl. 315). Inspired by a trip undertaken early in 1919 to the snow-laden villages of Arras, Bapaume, Cambrai and Lens, it shows a frieze of peasants struggling back with their belongings towards the remains of their homes. The subject was unusual, marking a welcome attempt to deal with the experience of civilians rather than the armed forces. Theatricality mars the gesture of the young woman by the roadside, who motions towards some discarded bundles as though to dramatize her inability to continue the exhausting journey. But Clausen's attempt to emphasize the refugees' hardship is sincere enough, and the desolation of the country around them shows how wretched their post-war lives may continue to be.

The most disconsolate of all the paintings executed for the projected Canadian War Memorial building was, however, contributed by Paul Nash (Pl. 316). He started work on the large canvas in the summer of 1919, and it turned out to be his final statement on the war. While lacking the fierce revulsion which makes his finest 1918 work so powerful (see Pl. 271), this formidable image summarizes Nash's sense of tragedy with uncompromising bleakness. As if to signify that the picture would be his parting testament to Passchendaele, he settled on a night scene. The entire landscape seems even more funereal than before, and the absence of figures implies that human life is impossible to sustain in the dank trench system with its putrefying pools. Although the black rectangle of a dugout entrance can be clearly seen in the foreground, it looks more like the mouth of a tomb than a place where survivors can find protection. The only forms left upright in this exposed terrain are trees, slicing through the emptiness in isolated clusters. But they are even more etiolated and dismembered than their counterparts in *The Menin Road* (see Pl. 301), mere stumps left behind by the battle.

In order to stress the extent of their degradation, Nash places one of these pitiful trunks in a prominent position, and allows its reflection to emerge dully from a water-logged crater. It could hardly

be further removed from the richly foliated elms he used to celebrate in his family garden at Iver Heath, for he told Mercia Oakley in the optimistic innocence of those pre-war years that 'I will be your tree, your friend thro good and evil', asking her: 'Do you realise the full significance of "tree" or what it would try to mean to you: A shelter, a shade, a consoling old thing, a strong kind friend to come to.'[68] Such images are the very antithesis of the tree in the foreground of his Canadian painting. Shorn of everything which once made it enhance the countryside, this abject fragment is incapable of offering shelter, strength or consolation to anyone. For Nash, it represented the nadir of everything he had scrutinized at the Western Front, and the lateral pink flashes on the horizon of this picture show that destruction continues to annihilate humanity and the landscape alike. The sole source of wonder in his canvas is the mysterious pyramid of light exploding like a firework against the flat, deep green sky. In an official Canadian catalogue it was described, doubtless with the aid of information supplied by Nash himself, as the 'illumination of an aeroplane rocket which is seen descending in a huge cone-shaped shower of light'.[69] Although it introduces an unexpected radiance to a scene otherwise devoid of hope, this flaring apparition is only momentary. In a few seconds it will have vanished, leaving the terrain around to become even gloomier than the no man's land defined here.

Only one of the sculptors commissioned for memorial work by the British and Canadian governments attempted to deal with the war as unflinchingly as Nash. Charles Sargeant Jagger, who had been wounded at Gallipoli and more severely at the battle of Neuve Eglise in April 1918, was awarded the Military Cross for his bravery. When invited to make a plaster bas-relief of *The First Battle of Ypres* for the Hall of Remembrance, he produced a conventionally belligerent image of Germans frowning as they bayonet square-jawed British defenders. Even if its compressed movement benefits from Jagger's admiration for the Assyrian bas-reliefs in the British Museum,[70] the plaster's rhetoric conveys nothing of his own experiences in the battlefield. Only when he escaped from the straitjacket of an official commission, and embarked in March 1919 on another relief for the British School at Rome, did Jagger feel at liberty to convey his true feelings about the war. In later years he still felt haunted by his period at Gallipoli, and the trauma of that disastrous expedition lay

behind his decision to make an immense relief called *No Man's Land* in lieu of the Rome scholarship granted to him before the war began (Pl. 317).

He commenced work on a maquette, in plasticine and other materials, while convalescing from his second wound. Working in private, without a committee to inhibit him, Jagger finally produced a disturbing bronze strewn with the victims of battle. Unlike *The First Battle of Ypres*, which relies on the melodrama of over-emphatic gesturing to project the heroism of the British forces, this sculpture contains no movement. Everything is frozen in terminal stasis, for most of the figures slumped on the earth are lifeless. Jagger had no intention of undermining the judgement of those responsible for conducting the Allied campaign, and the lines from Beatrix Brice-Miller's *To the Vanguard* which he placed on the plaster version[71] show how sincerely he wanted to praise the soldiers' valour:

> O little mighty band that stood for England
> That with your bodies for a living shield
> Guarded her slow awaking.

All the same, the deathly paralysis prevailing in *No Man's Land* makes the whole notion of an 'awaking' seem remote. Even though one man remains alive and vigilant, leaning over the edge of the trench to gaze past his comrades' bodies towards the enemy lines, he is scarcely distinguishable from the corpses around him. They predominate and hold our attention in this shallow, painfully compressed space as we discover how one of them is impaled on a barbed-wire fence, while several more seem to belong to a stretcher party struck down by a callous fusillade. The upturned poles of the stretcher itself project into the air, reminiscent of splayed human limbs petrified by *rigor mortis*. But perhaps the most chilling area of the relief is devoted to a pair of bare legs on the left, dangling down from a muddy mound where the rest of the body must be buried. Jagger may have relied here on memories of a moment at Gallipoli when he dug a fellow-officer out of a landslide precipitated by a rainstorm.[72] Here, however, he leaves the body prone in the ground, and before casting the bronze version Jagger removed Brice-Miller's trite verses from the sky. He must have realised that they were inappropriate in a sculpture remarkable for its refusal to soften the bleak finality of death.

If *No Man's Land* had been installed as a memorial in a civic space, rather than donated to the Tate Gallery and then consigned to the storeroom for many years,[73] it might well have been vilified. For war memorials, as Jagger would subsequently discover when his Royal Artillery Memorial was unveiled (see Pl. 377), often became the focus of powerful emotions and intense public debate. In London, the Cenotaph commissioned from Lutyens by Lloyd George to commemorate the British Empire dead was erected in a temporary wood and plaster version for the Peace Celebrations in July 1919, and won widespread approval.[74] William Nicholson's painting of the chaste monument, white against the oppressive darkness of the building behind, defined the extreme simplicity and refinement of an elemental structure from which all trace of conventional religious symbolism had been expunged. In France, by contrast, a colossal Cenotaph for the War Dead designed for the great Bastille Day parade in the same month was subjected to vituperative attack. Although its principal designer André Mare had served in the war, both he and his colleagues, Gustave Jaulmes and Louis Süe, found their gilded monument denounced as a national embarrassment. The four Victories on the sides of the Cenotaph, each one backed by a pair of real wings from French military aircraft, seem as unexceptional now as the inscription, swags and brazier (Pl. 318). But several critics attacked

the monument as it approached completion on a sensitive site beneath the Arc de Triomphe. The final blow was delivered by Prime Minister Clemenceau, who declared with characteristic bluntness that it was 'ignoble' and then, according to *Le Pays*, 'spoke of "Boche art" of "Munich inspiration". Finally – since everything in France just now ends up by being demolished – he gave the order to demolish it.'[75]

To Clemenceau's great credit, however, the Parade which marked the official French victory celebrations was led by wounded soldiers. Many other nations would have refused to allow such grievously deformed figures to head a procession through the capital's main thoroughfares. But on 14 July 1919, a group of maimed and blinded *mutilés de guerre* – a fraction of the terrible total of four-and-a-quarter million Frenchmen wounded in the war – openly displayed their suffering to the accompaniment of the *Marseillaise*. It was, perhaps, a therapeutic experience for the men involved, who found themselves continually blessed and fêted by the crowds. Their deformities were recorded with clumsy frankness by Jean Galtier-Boissière, in an image which makes no attempt to disguise the soldiers' anguished

318 Gustave Jaulmes, André Mare and Louis Süe *Cenotaph for the War Dead* Peace Festivities, Paris, 14 July 1919. Destroyed.

faces as they stagger on crutches, stare through bandages, shuffle along blindfolded and clasp each other's arms for support (Pl. 320). The most pitiful victim is unable even to remain upright. He lies in a rudimentary cart and waves the stump of his severed right arm while a dejected sailor pushes him along a *voie triomphale* bedecked with flamboyant banners.

Matisse, on the other hand, responded to the euphoria of the Bastille Day parade by painting one of his most sumptuous flower pieces (Pl. 319). The effervescent bouquet explodes from its vase like the floral equivalent of fireworks at the fourteenth of July celebrations. Its impact is heightened by the arresting blue of the textile pattern behind. As if to honour the exceptional importance of the festivities, Matisse re-employs the same basket-and-arabesque hanging which he had used in one of his most triumphant pre-war canvases, the great *Harmony in Red* of 1908–9.[76] His decision to use it again a decade later reinforces the mood of a painting which spectacularly revels in Matisse's relief at the return of peace. The war had threatened his family and contributed to the sombre, brooding rigour of paintings like *Bathers by a River* and *The Moroccans*, which caused him such protracted labour that he confessed to Charles Camoin in 1916: 'I may not be in the trenches, but I am in one of my own making.'[77] Now, however, with the Allied victory thoroughly consolidated, Matisse's disquiet was alleviated. The *Bouquet for the 14th of July*, subtly retaining a distinction between the flowers and the textile pattern even as they combine in a unified flourish of joy, signals the return of a more buoyant vision.

319 Henri Matisse *Bouquet for the 14th of July* (*Flowers, 14th of July*) 1919. Oil on canvas, 116.2 × 80.9 cm. Private collection.
320 Jean Galtier-Boissière *Procession of the Mutilated, 14 July 1919* 1919. Gouache on paper, 43 × 75 cm. Musée d'Histoire Contemporaine – BDIC, Hôtel National des Invalides, Paris.

decided to depict himself encountering a war cripple in a nocturnal street (Pl. 322). The artist, respectably dressed in civilian clothes, stares with anguish at the wounded face of a uniformed veteran. Lit by the harshness of a street lamp, his disfigurement contrasts with the untouched face in Küpper's painting. The soldier's battered features recall the horrible facial injuries Beckmann had depicted in successive states of his earlier etching *The Grenade* (see Pl. 119). This time, though, the cripple is seen in the back streets of a city where prostitutes and snarling dogs are his only company. Beckmann's hand reaches out to touch the man's artificial arm, half in horror and half in pity. This lacerating lithograph is the second in a series of eleven prints published under the title *Hell* in 1919. They reveal without any compromise Beckmann's determination to define the wretchedness of life in his defeated and dissension-torn country. 'Just now, even more than before the war', he wrote, 'I feel the need to be in the cities among my fellow men. This is where our place is. We must take part in the whole misery that is to come. We must surrender our heart and our nerves to the dreadful screams of pain of the poor disillusioned people.'[79]

During this terrible period, when national humiliation, famine and unemployment were accompanied by violent insurrections and even

321 Will Küpper *After the War* 1919. Oil on canvas, 70 × 55 cm. Stadtmuseum, Düsseldorf.

322 Max Beckmann *Going Home* (from *Hell*) 1919. Lithograph on paper, 74 × 48.8 cm. Scottish National Gallery of Modern Art, Edinburgh.

Such a festive comment on the war's conclusion could never have been produced by a German artist in the aftermath of defeat. Several painters became preoccupied with images of the wounded, but unlike Galtier-Boissière's *Procession of the Mutilated* these victims are removed from any reassuring display of national gratitude or pride. The man on crutches in Will Küpper's *After the War* is utterly alone (Pl. 321). He limps through streets where the cold white walls and doorways all seem shut against him. Unlike Dix, whose later images of war cripples stress their grotesque, even repellent aspects (see Pls. 340, 341), Küpper shows a figure unmarked by distressing wounds. But his bowed form is clearly intended to elicit sympathy, as he clutches his chest with attenuated fingers and gazes down at the road ahead without hope. Küpper was still studying at the Düsseldorf Akademie when he painted this forlorn image, and his compassion for the alienated man borders on sentimentality. Rudolf Schlichter's pencil study of a wounded vagrant is more restrained, suggesting through the beggar's narrowed eyes a stubborn disdain for the charity on which he relies. Schlichter had himself been obstinate enough to leave the army in 1916 after going on hunger strike, and his drawing conveys a comparable sense of resolve. Beneath its reticent precision, though, this study is strengthened by the artist's fundamental awareness of 'how many people were maltreated and suffered a terrible fate' – an injustice so grievous that it made him imagine 'an animal roared within me, I howled, raved, shouted with rage, twisted and turned like a worm.'[78]

Beckmann's consternation was more starkly expressed when he

323 Max Beckmann *The Night* 1918–19. Oil on canvas, 133 × 154 cm.
Kunstsammlung Nordrhein-Westfalen, Düsseldorf.

more savage repression, Beckmann devoted the major part of his energies to a painting where those 'dreadful screams' were given unforgettable pictorial form (Pl. 323). *The Night* is the most harrowing canvas he ever produced, and its indictment of sadism reflects the treatment meted out to revolutionary luminaries like Karl Liebknecht and Rosa Luxemburg. Her mutilated body was recovered from the Landwehr Canal in Berlin while Beckmann's painting was in progress, and the woman occupying much of the foreground in *The Night* is also subjected to brutality. Lit by a candle positioned alarmingly near her exposed buttocks, the woman was doubtless raped before being tied to the window-frame by her assailants. One of them, the bearded man who has grabbed a frantic child under one arm, uses his

other hand to pull a drape over the window. Just as a peaked cap shields his own eyes from the scene, so he wants to prevent anyone else from witnessing the violence he perpetrates.

The crimes enacted within this compressed, claustrophobic attic primarily arise from Beckmann's reaction to the internecine turbulence which plagued post-war German life. But *The Night* also contains references to the scenes he had observed during his period as a medical orderly in Flanders. Memories of the wounded soldiers' agony continued to harry him, four years after a nervous breakdown had led to his discharge from active service. It is no accident that the strangling of the man takes place on a table: much of the suffering Beckmann saw in the war occurred on similar surfaces, as his etchings

ruthlessness only reinforced Beckmann's need to expose the malaise in a large-scale painting, where the torment experienced by one family ultimately stands for the tearing apart of an entire nation in the wake of humiliating defeat.

Grosz arrived at a similar conclusion when he completed, in the same year, a large-scale political painting entitled – after Heinrich Heine – *Germany, a Winter's Tale* (Pl. 324). This complex, teeming canvas hinges, like *The Night*, on a centrally positioned table-top. Unlike Beckmann's masterpiece, however, the table now acts as a repository for everything cherished by the greedy bourgeoisie. A plump and moustachioed reserve officer sits at his meal, with upright knife and fork presented like weapons before him. Under one elbow lies a substantial cigar and a copy of the nationalist newspaper, *Lokal-Anzeiger*, while on the other side a bottle of the most patriotic beer has already been poured into a glass and partially consumed. The remains of a roast supper on the plate implies that the diner is satisfied, and beneath his feet support takes the form of a smug triumvirate: the smiling embodiment of the Church, his arm raised in benediction; the belligerent scowl of a heavily medalled general from the Army; and the blinkered, portly teacher personifying the School, grasping a volume of Goethe while a cane festooned with ribbons rests menacingly on his shoulder.

Grosz declares contempt for these hypocritical guardians of the establishment by placing his own profile beneath the priest, jutting his chin forward with undisguised aggression. The subversive im-

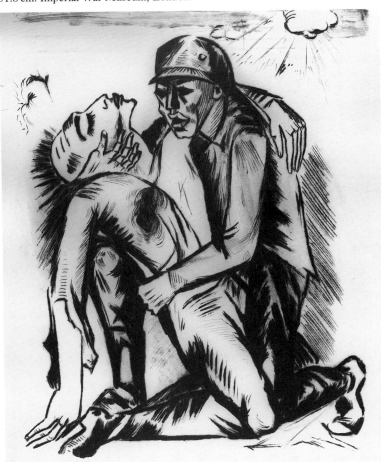

325 Max Pechstein *Somme – 8* 1918. Etching with drypoint on paper, 39.5 × 31.8 cm. Imperial War Museum, London.

324 George Grosz *Germany, a Winter's Tale* 1917–19. Oil on canvas. Size and whereabouts unknown.

of an *Operation* and *The Morgue* testify (see Pls. 117, 118). The strangled man's upturned feet recall those of the corpse on the right of *The Morgue*, whose head bandages have now been transferred to the pipe-smoking aggressor in *The Night*. His savage twisting of the dying man's arm is like a perversion of the gesture made by a nurse in *Operation*, as she gently lifts the arm of the patient awaiting surgery on the table. In Beckmann's nightmares, his recollections of the war must have become monstrously distorted when they persisted in plaguing him. *The Night* can be seen as an attempt to define, with surgical exactitude, the full horror of these visions. If the strangled man is a self-portrait, as some historians have suggested,[80] Beckmann perhaps intended to portray himself as a man throttled by his own delirious inability to banish the experience of war from his mind. In *The Night* it sunders the husband from his wife and child, invaded at their home by thugs showing no hesitation in aping the most callous behaviour of the soldiers who had pillaged Europe during the conflict. The fact that post-war Germany was afflicted by similar outbreaks of

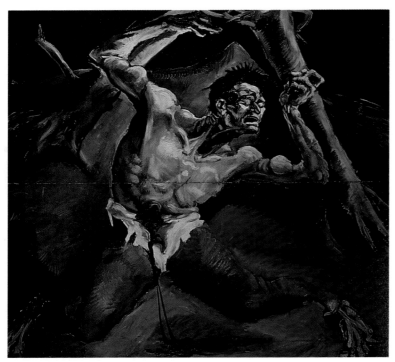

326 Gert Wollheim *The Wounded Man* 1919. Oil on wood, 156 × 178 cm. Private collection, Berlin.

patience he displays here is echoed elsewhere in the composition, which becomes progressively unsteadier as it moves upwards. Even the reserve officer looks perturbed, realising how his table sways in acknowledgement of the seismic pressure undermining the city around him. Although his dog sleeps on, buildings topple and a prostitute rushes towards a sailor – 'a symbol', wrote Grosz, 'of the revolution.'[81] They thrive on the unrest affecting everyone who moves through the interstices of this reeling metropolis. While trains continue to rush headlong under bridges and out into the mountainous landscape beyond, the church tilts as helplessly as the factories and office blocks. The Kaiser's spiked helmet rears up towards the apex of the maelstrom, like the dome of a militaristic cathedral. But Grosz knew, as well as the rest of his bewildered and angry countrymen, that the monarch no longer counted for anything in a rudderless nation lurching towards disaster.

Behind the hysteria dramatized in this monumental painting, the prophetic work of a man who increasingly saw himself as 'a German Hogarth, deliberately realistic and didactic',[82] lay a widespread German obsession with death. It is apparent throughout the sequence of prints comprising Max Pechstein's portfolio 'Somme 1916', a meditation on the searing experiences which had driven the artist to ask for a transfer from active service at the Front. In *Somme-8* a helmeted soldier clutches his fatally wounded companion with an intensity reminiscent of the grief-stricken Virgin tending her dead son (Pl. 325). Supporting the inert body with his knee as well as his hands, the mournful infantryman assumes a statuesque gravity which suggests that thoughts of a secular Pietà were uppermost in Pechstein's mind. The victim's head is thrown back beyond the gaze of his would-be comforter, and his closed eyes pointing towards the sky imply that the man's soul has already departed from his body.

But the most excoriating manifestation of the German preoccupation with mortality was produced by Gert Wollheim, a young, second-generation Expressionist painter who had finished studying at

the Hochschule für bildende Kunst in Weimar only a year before the outbreak of war. Severely wounded in 1917, he afterwards based several condemnatory war paintings on drawings executed at the Front. *The Wounded Man* (Pl. 326) originally formed the central panel of a large triptych, but the other portions have failed to survive. The extant image is abrasive enough to stand on its own, and Wollheim does everything in his power to convey the soldier's agony. Stomach wounds invariably precipitate an excruciating, protracted death, and the cavity in this figure's pierced belly could scarcely be more heinous. Dark blood spurts on to the ground, and the victim has clearly ripped off his shirt in order to discover the extent of his injury. Now that he is able to see the cleft for himself, and realises the futility of attempting to close it up , the deranged man only has one resort left. His splayed legs terminate in claw-like feet as gnarled as the partially exposed roots of the trees behind, and he raises both arms in a despairing gesture which echoes the diagonal direction of the trunks. While he tears at the air with his fingers, the soldier thrusts his face upwards as if to plead or remonstrate with God. But the closed eyes already imply that he harbours no real hope of divine contact, and the pallor of his skin confirms death's inevitability. It is closing in on him, just as night has already covered the no man's land beyond in a black embrace.

Wollheim launched such a visceral assault on his viewers' sensibilities that he cannot have been surprised when *The Wounded Man* provoked a shocked reaction. In 1920, after it was displayed at the Kunsthalle in Düsseldorf as one of the latest acquisitions, public indignation became so inflamed that it was withdrawn from the collection. Wollheim was later reduced to giving it away, and even then met with no success until the Düsseldorf art dealer Johanna Ey courageously agreed to hang it over her bed. 'I didn't dare go to bed that night,' she recalled, 'and I spent three nights with my bedding on the floor, just to get accustomed to it gradually.'[83] She would have consoled herself with the knowledge that Wollheim's terrifying panel was, in the end, an authentic reflection of the scream which continued to reverberate through the German psyche long after the war had terminated.

A related howl must have been in Ernst's mind when, on his return from active service, he produced a strange collage called *The Bellowing of Savage Soldiers* (Pl. 327). In his case, however, the hysteria

327 Max Ernst *The Bellowing of Savage Soldiers* 1919. Block-pull and pen on paper, 38.5 × 19 cm. Arturo Schwarz, Milan.

underlying the work was not expressed in a volcanic onrush. Rather did Ernst filter it through the cool, detached irony of Dada. In 1919 Hans Arp moved to Cologne, bringing with him the irrational and subversive ideas which had nourished the riotous Dada performances in Zürich. Ernst, who had contributed to a Dada exhibition two years before, now joined forces with Arp and the far-left activist Johannes Baargeld. They disrupted a patriotic play and fulminated against the rise of proto-Fascism. Ernst channelled his prevailing sense of absurdity into collaged 'mechanical drawings', begun when he gathered up some discarded line blocks at the printing works where a Dada publication was being produced. *The Bellowing of Savage Soldiers*, assembled from these plates and then altered with pen and ink, exemplifies the spirit of witty, Picabia-like negation he deployed to undermine conventional aesthetics. The lightness of touch informing his theatrical, mechanistic vision may reflect the influence of Klee, whom Ernst visited in Munich the same year. But beneath the Dada effrontery lay an anger as ferocious as Wollheim's. In retrospect, Ernst considered that he had died on 1 August 1914, and on his 'return to life' with the Armistice he was bent on unleashing all his pent-up indignation and despair. 'Contrary to general belief,' he explained later, 'Dada did not want to shock the bourgeois. They were already shocked enough. No, Dada was a rebellious upsurge of vital energy and rage; it resulted from the absurdity, the whole immense *Schweinerei* of that imbecilic war. We young people came back from the war in a state of stupefaction, and our rage had to find expression somehow or other. This it did quite naturally through attacks on the foundations of the civilization responsible for the war.'[84]

In 1919 German artists of very different stylistic and ideological persuasions became united by their need to utter similar shouts of protest. The most primal came from Dix, whose wartime pictures of 1918 had already attested to an awakening sense of horror (see Pl. 277). Now, using the woodcut medium to score a rasping image, he produced *The Cry* (Pl. 328). The howling face looks as if it has been scratched on to a prison or asylum wall, by an inmate who could express his agony in no other way. The rawness of a *graffito* is combined with the economy of an artist who had learned, through countless swift drawings of the conflict, precisely how to summarize his outrage in the most terse and urgent manner. While the man's stubbly chin juts upwards in a block-like mass, he punches the air with his fist. As for the cry, it erupts from a tooth-jagged mouth like the shell-bursts Dix had so often witnessed at the Front. *The Cry* seems to be intended as an emetic, forceful enough to rid the artist of his visions of the battlefield. But Dix's subsequent work shows that his revulsion continued for many years afterwards.

The finality of death was not, of course, the exclusive preserve of German artists. On the Allied side mourning also found its way into painting, albeit with more restraint than the Expressionists wanted to display. One of the first paintings produced by Jacques Villon after returning from active service was a large, elegiac tribute to his brother Raymond Duchamp-Villon, who had died only a month before the Armistice was declared. In order to emphasize how much European art had lost with Raymond's death, Villon based his painting on a 1914 sculpture called *Seated Woman*. Since it was then in the family collection,[85] Villon could meditate on the sculpture with ease. He held it in particularly high regard, having already executed a painting as a free variation on *Seated Woman* five years before.[86] But the mood of his 1919 canvas, *In Memoriam*, is utterly removed from the earlier picture. In 1914 the woman holds her head upright on a long, alert

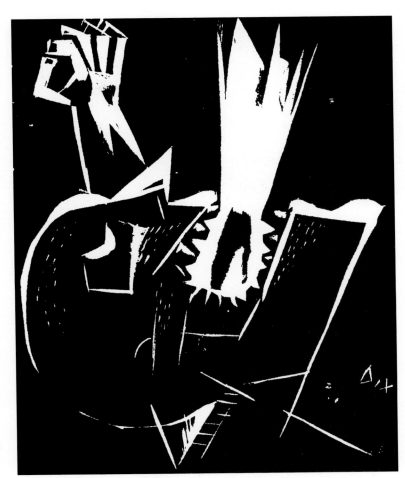

328 Otto Dix *The Cry* 1919. Woodcut on paper, 17.8 × 14 cm. Kunstgalerie, Gera, Saxony.

neck. The triangular planes with which she is constructed do not prevent Villon from specifying her facial features, and the rest of her body is alive with a sharp-edged, angular vigour which directly honours the energy of the sculpture itself. In the later variation, by contrast, the woman has become mournful and inert. Viewed from above, so that her head and torso appear to turn in a melancholy downward direction, she takes on the aspect of a grieving mother. The brittle planes of the earlier painting are replaced by slow-moving curves, which suggest that the woman is shrouded in a heavy veil. As the title indicates, she has been transformed into an embodiment of hooded lamentation, and the burnished orange, brown and green deployed by Villon imply that this inconsolable figure might well form part of a tomb sculpture.

By no means everyone saw death as the end, however. Epstein's *Risen Christ*, completed in 1919, persisted in holding out hope for regeneration after the battle (Pl. 329). This hieratic figure, conceived as an unofficial memorial to the war, had originated two years earlier when Epstein paid a visit to the Dutch composer Bernard van Dieren. His friend was ill in bed, and Epstein recalled how, 'watching his head, so spiritual and worn with suffering, I thought I would like to make a mask of him. I hurried home and returned with clay and made a mask which I immediately recognised as the Christ head, with its short beard, its pitying accusing eyes, and the lofty and broad brow, denoting great intellectual strength.' From there, he soon envisaged an entire figure extending downwards from the mask, and began modelling it as 'a pillar firmly set on the two naked feet –

Christ risen supernatural, a portent for all time.'[87] The applicability of such an image to wartime conditions was clear, and in a pencil study for the sculpture Epstein stressed its columnar identity as a severely simplified figure. Although the final bronze would depart in several respects from the robed presence which this drawing outlines, the fundamental conception was already realised in 1917. But Epstein had to abandon work on the armature he had constructed when the call came for his enlistment, in September, as a Private in the Jewish 38th Battalion of the Royal Fusiliers.

It was a fate he had struggled to evade for a long time. While stopping short of a pacifist stance, Epstein abhorred war and had already conveyed its tragedy in his second, pathetically dismembered version of the *Rock Drill* (see Pl. 174). Attempts to gain exemption from military service failed, and so did a proposal to gain employment as an official war artist. The Director of the Imperial War Museum, Sir Martin Conway, supported the suggestion that Epstein might 'make a series of typical heads of private soldiers serving in the various contingents which make up the British Army . . . Jews, Turks, infidels, heretics and all the rest.'[88] The broad racial range would undoubtedly have been congenial to a sculptor of Epstein's disposition, but a letter from the influential Royal Academician Sir George Frampton appears to have killed off any prospect of official employment at that stage. The subsequent removal of Frampton's letter from the files indicates that its contents were vituperative, and Epstein found himself training in a barracks near Plymouth. 'It is a life of mental rot and for me a peculiar kind of exasperation,' he complained to van Dieren, 'knowing as I do the forces that have worked against me and that have been so successful in achieving their object: my decease as an active artist.'[89]

By the following spring, his preoccupation with the belief that enlistment was tantamount to creative extinction caused Epstein to suffer a nervous collapse. It was precipitated by the announcement of his regiment's departure for the Middle East, and when the embarkation day arrived he went missing on Dartmoor. 'I have passed through a severe mental crisis as you can imagine,' he told van Dieren in a letter from 'the detention room' soon afterwards, 'and am under observation of the medical officer . . . How horrible that what amounts to my incarceration for an indefinite future should be looked upon as right, almost a fit punishment for my sins as an artist. I have got into a wretched state of nerves, so much so that I cannot sleep and feel an incessant desire for movement. I walk about like a caged animal incapable of sitting down for even a few minutes.'[90] Like Beckmann, Grosz and Kirchner before him, Epstein had been reduced by the war to a state of 'complete breakdown',[91] as he described it to his patron John Quinn. Recognising the gravity of his ailment, the army sent him to Mount Tovy Hospital in Plymouth, where he made tense pencil studies of fellow inmates like the stoical yet stunned and sad-eyed *Wounded Soldier* (Pl. 330).

After being invalided out of the army in the summer of 1918, Epstein realised how impossible it was to recapture the pre-war context which had stimulated him so well. T.E. Hulme, his most stalwart critical champion, had been killed in the trenches. The loss of Gaudier-Brzeska removed from British sculpture Epstein's most talented contemporary, and he must have felt peculiarly isolated in the post-Armistice world. Muirhead Bone, having commissioned him to produce a bronze bust of the courageous Fifeshire miner *Sergeant D.F. Hunter V.C.*, attempted to persuade the government to let Epstein

329 Jacob Epstein *Risen Christ* 1917–19. Bronze, 218.5 cm high. Scottish National Gallery of Modern Art, Edinburgh.

produce a 7½-feet-high relief of the Moeuvres battle where Hunter had shown exceptional bravery. But the project never received the requisite approval, and when Epstein finished his *Risen Christ* he was rewarded with hostility of the most vicious and hysterical kind.

The controversy seems difficult to understand once his tall, dignified bronze is examined (Pl. 329). For Epstein invested the figure with a gaunt, sober stillness which seeks neither to excite nor disturb. There is nothing, here, of the ecstatic triumph that marks so many depictions of Christ's resurrection. Instead, a weary and attenuated man stands before us, the thinness of his limbs emphasised by the winding sheet clinging to their contours. Epstein has dispensed with the loose robe proposed in the preliminary pencil drawing, and the result is an increase in vulnerability. This Christ still seems affected by the trauma of his martyrdom, and the miraculous renewal he embodies is hard-won. Just as Epstein and many other artists were haunted by the ordeal of war, so Christ struggles to reaffirm his vitality after the travail of the cross and the tomb. He displays anger as well as compassion, holding out his upturned right hand to display the gash in its palm. With what Epstein described as an 'accusing finger'[92] he points to the wound, silently conveying his censure of the suffering it caused. But the mortified hand also signifies the desire to confer a blessing on humanity; and this profound ambiguity, poised between anguish and forgiveness, is reminiscent of the figure in Wilfred Owen's *Strange Meeting*:

> Then, as I probed them, one sprang up, and stared
> With piteous recognition in fixed eyes,
> Lifting distressful hands as if to bless.[93]

The severity with which Epstein represented this stern yet redemptive presence seems wholly understandable today. Anything less stark, after the long ordeal and sacrifice of the war, might easily have appeared complacent in its assumption of Christ's regenerative power. Like Gill a few years later when defending his Leeds memorial (see Pl. 355), Epstein stressed that he wanted to portray a God capable of inspiring 'fear as well as devotion. He drove the moneychangers out of the Temple. He could blaze out in righteous wrath, and voice justifiable indignation. [It] is this complex Christ that I have endeavoured to body forth.'[94]

Despite Epstein's return to a more representational way of working, with its echoes of the Old Testament carvings in the central doorway of the West Portal at Chartres,[95] *Risen Christ* provoked a racist attack by Father Bernard Vaughan. After scrutinizing the bronze he 'felt ready to cry out with indignation that in this Christian England there should be exhibited the figure of a Christ which suggested to me some degraded Chaldean or African, which wore the appearance of an Asiatic-American or Hun-Jew, which reminded me of some emaciated Hindu, or a badly grown Egyptian swathed in the cerements of the grave.'[96] Refusing to be unnerved by such an outburst, which reveals far more about the cleric's xenophobia and anti-Semitism than about their target, Epstein stood firm. Rather than

330 Jacob Epstein *Wounded Soldier* 1918. Pencil on paper, 35.6 × 25 cm. Private collection.

pleading that he had adhered to the conventional image of a gentle Christ, he insisted that the solemnly gesturing figure 'stands and accuses the world for its grossness, inhumanity, cruelty and beastliness, for the World War.'[97] Indeed, he was unrepentant enough to reveal that 'I should like to make it hundreds of feet high, and set it up on some high place where all could see it, and where it would give out its warning, its mighty symbolic warning to all lands. The Jew – the Galilean – condemns our wars, and warns us that "Shalom, Shalom", must be still be watchword between man and man.'[98]

CHAPTER NINE
THE MEMORY OF WAR

Although Epstein was never granted the opportunity to enlarge his *Risen Christ* and instal it in a prominent public location, countless other sculptors received commissions for memorials to 'the fallen', as the slaughtered millions were so euphemistically described. Many of the resultant images were decorous to a fault, and so anxious to avoid upsetting the bereaved that they ended up conveying nothing about the tragedy their makers were supposed to commemorate.

Sir George Frampton, having prevented Epstein from becoming a War Artist, resorted to chivalric platitude when he carried out a commission to memorialize Lieutenant Francis Mond (Pl. 331). His bronze St George, one hand supporting a banner while the other grasps an elaborately ornamental shield, remains proud and erect. Both sculptor and patron must have drawn solace from the intact, resplendently armoured bearing of a figure whose mythical poise seemed to have emerged unsullied and gleaming from the long years of devastation. Looking at such an image today, we are entitled to balk at the self-conscious striving for a noble, exalted monument to heroism. In 1919 Herman Hesse, writing an essay on 'Self-Will', offered a timely corrective by declaring that 'it is an abuse of language to say – as is now fashionable, especially among stay-at-homes – that our poor soldiers, slaughtered at the front, died a "heroic death". That is sentimentality. Of course the soldiers who died in the war are worthy of our deepest sympathy. Many of them did great things and suffered greatly, and in the end they paid with their lives. But that does not make them "heroes." The common soldier, at whom an officer bellows as he would at a dog, is not suddenly transformed into a hero by the bullet that kills him. To suppose that there can be millions of "heroes" is in itself an absurdity.'[1]

The concept of a memorial dedicated to individual soldiers, rather than the celebration of a victory, was of relatively recent origin. So even the most resourceful sculptors experienced difficulty in finding appropriate imagery for the task, and Bourdelle struggled through several commissions searching for the elusive solution. His first opportunity arrived as early as 1916, when his brother-in-law's family asked him to produce a figure of *Saint Barbe* as a protective votary for their son in the army. Bourdelle made a tender, archaizing statue in coloured cement, originally installed in the church of St Julien de l'Herm near Lyons.[2] It was maternal enough not only to look after the young artilleryman, but also to excite rumours among worshippers at the church that the saint was pregnant and would therefore promote fecundity in the congregation. Bourdelle was delighted by the story, exclaiming: 'Bravo! I'm repopulating France.'[3] The statue,

however, seemed to belong to a remote past, ultimately incapable of affecting the world where the artilleryman and so many of his compatriots risked their lives in a murderous machine-age war against the German invader.

A similar sense of inapplicability detracted from Bourdelle's maquette for a *Monument to the Deputies who died for France*. Commenced in 1916 and then revived three years later, the project takes its cue from a figure of his friend Isadora Duncan made for his earlier Monument to Falcon. She had initially been shown dancing the Marseillaise, and an ecstatic pose was re-employed for the Deputies maquette. Symbolizing the *Victory of Justice*, Isadora is now made more militant by the addition of a heavy sword and an enormous Greek shield which she carries with conspicuous strength. Bourdelle ensured that the shield would fit in the central niche of the Palais Bourbon's Salle du Roi, where he wanted his memorial to chime with the paintings Delacroix had carried out in the room. Hence, perhaps, the echoes of *Liberty Guiding the People* in Bourdelle's figure, whose ample draperies explode from her body with the force of a shell-burst. Another eruption emanates from the gorgon's head on the back of the shield, but none of these spectacular passages impressed the politicians responsible for commissioning the monument. They rejected the project, possibly because Isadora Duncan's scandalous reputation was considered too unseemly for such a noble scheme.

Bourdelle was, however, able to realise his next war memorial, the *Monument to the Dead, in the War 1914–18, of Montceau-les-Mines* (Pl. 332). Perhaps chastened by the failure of his Deputies proposal, he moved away from the attempt to concentrate solely on the notion of the conflict's victorious conclusion. Moreover, disregarding his new patron's liking for triumphal arches, he decided this time to root the memorial in the mining life of the region. The great stone monument was crowned by a severely simplified miner's lamp, presiding like an industrialized equivalent of a symbolic beacon over the town and its inhabitants. This indispensable source of illumination succeeded, Bourdelle implies, in leading Montceau-les-Mines through the darkness of the war years. But he also pays tribute to the men who held it as they worked in the mines, thereby enabling France to maintain its vital power-supplies and manufacturing capacity during the struggle. One of the reliefs installed in the centre of the memorial depicts *Miners Underground*, gazing defiantly through their tunnel as they brandish the lamp and rest pickaxes on the ground. In order to stress the vital role played by miners at the Front as well, Bourdelle devoted another of these reliefs to the subject of *Sappers*. Unlike their muscular counterparts in the mine-shaft, these clothed and semi-naked

Left: Otto Dix *Skat Players* 1920 (detail). See Pl. 342.

331 Sir George Frampton *Saint George* 1918. Memorial to Lieutenant Francis Mond RFA RAF. Bronze, 57.5 × 21 × 14 cm. Imperial War Museum, London.

figures seem burdened by their task. All the same, they succeed in performing the caryatid-like function of holding the beam in the tunnel's roof and propping it up with a sturdy tree-trunk. The authenticity of the sappers' uniforms is carried over into the most allegorical relief, where a winged personification of France clutches a severely wounded soldier with fierce, protective zeal (Pl. 334). It might have been mawkish compared with the other panels on the monument, but Bourdelle charges the gesture with so much ardency that France becomes as impassioned as a mother attempting to save her son from death.

A transfusion of fervent feeling ensured that his most celebrated war memorial evaded triteness in its use of religious symbolism. Bourdelle received the commission for the *Virgin of the Offering* from his pupil Leon Vogt, who owned potash mines in Alsace. He carried out his mother's promise in 1914 that she would finance a sculpture of the Virgin if family property avoided devastation during the war. She died before hostilities ceased, and Bourdelle executed a small maquette for the project in 1919. It lacks both the grandeur and the rhythmic flamboyance of the intermediate version completed in 1921, which was installed above the altar in the crypt of the Ossuaire des Morts Inconnus at Hartmannswillerkopf. Bourdelle also produced

the mighty *Winged Angels of Victory* guarding the entrance to the crypt, where the remains of well over ten thousand unidentified soldiers are buried (Pl. 333). Bourdelle's confident ability to integrate these angels with the piers they support carries complete structural conviction, bearing out his belief that 'sculpture must graft itself to architecture like fruit grafts itself to the tree.'[4] These calm yet sombre presences, resting on their swords with the same resolve as the miners of Montceau-les-Mines and their pickaxes in repose, demonstrate Bourdelle's command of elegiac restraint. He was, however, able to invest his final, large-scale version of the *Virgin of the Offering* with a more complex, ambiguous emotion, poised halfway between tragedy and delight.

The immense stone monument, placed according to Mme Vogt's wishes on the slope of a thickly wooded hill above Niederbruck, Alsace, was unveiled in 1922 (Pl. 335). Cléopatre Bourdelle posed for the Virgin in the head-dress she wore to keep dust out of her hair in the studio, but in the statue this modest wimple takes on a full-blown divine authority. It enables Bourdelle to enlarge the discreet veil worn by the Virgin in the first maquette, who holds her child with relative diffidence. Now, in order to generate a gesture capable of being seen and comprehended from a considerable distance, the Virgin leans outwards so expansively that Bourdelle can define an uninterrupted curve from head-dress to forearm. As Peter Cannon-

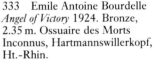

332 Emile Antoine Bourdelle *Monument to the Dead, in the War 1914–18, of Montceau-les-Mines* 1919–30. Stone, 11.5 m overall. Place Bourdelle, Montceau-les-Mines.

333 Emile Antoine Bourdelle *Angel of Victory* 1924. Bronze, 2.35 m. Ossuaire des Morts Inconnus, Hartmannswillerkopf, Ht.-Rhin.

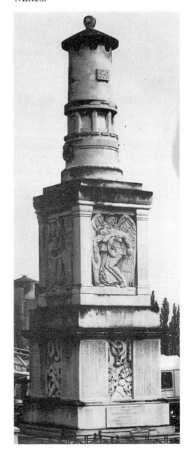

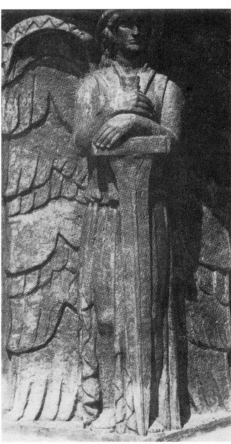

334 Emile Antoine Bourdelle *France supporting the Wounded Soldier* 1924–8. Stone, 2.4 × 1.45 m. Place Bourdelle, Montceau-les-Mines.

Brookes pointed out,[5] the swaying rhythm is surely derived from the fructifying amplitude of *Saint Barbe*.

Here, however, the powerful swing initiated by the Virgin ends up directing attention towards the child, who rises above her with arms outstretched to embrace the world. Firmly supported by his mother, Christ occupies his commanding position with a subtle blend of modesty and assurance. Even so, his arms carry an unmistakeable reminder of the martyrdom he will eventually undergo. Once the full duality of his pose becomes apparent, the *Virgin of the Offering* takes on an almost sacrificial significance. The woman standing so majestically on the Alsace hillside to gaze across the valley of Manavaux seems, in the end, to be presenting her crucified son as a divine acknowledgement of the suffering enduring by humanity during the war.

The most important war memorial in Prague, however, offers unequivocal affirmation through the agency of a female figure. When the Bank of the Czechoslovak Legion (Banka Legii) commissioned Josef Gočár to design a new building on a prominent site in the city centre, he produced a powerful Roman facade indebted to Bramante's Casa di Raffaello (Pl. 336). Not content with making his

own architecture as sculptural as possible, Gočár asked two leading Czech sculptors to produce major works for his vigorous frontage. Integrated remarkably well with the building, they nevertheless retain a robust and independent character. Surmounting the four idiosyncratic pilaster forms at the base of the bank, Jan Štursa's great limestone consoles all show deeply cut clusters of military figures who represent the four principal regions where Czech legionaries were stationed. Their urgent, straining gestures prove that they are still embroiled in battle, whereas Otto Gutfreund's monumental relief above deals with the consoling theme of the soldiers' return.[6] Working in an idiom more naturalistic than his earlier Cubist style, Gutfreund here produced his most ambitious and impressive postwar sculpture. Hugely influential, it simplifies the homecoming legionaries into robust, sturdy figures. But there is nothing triumphant about them. They are tired rather than swaggering, and Gutfreund emphasizes moments of reunion with women who have laboured at home. The heartening spirit which gives this relief a restrained dignity and warmth reaches its apogee in the centre, where a maternal figure reaches out from her throne-like chair to welcome and gather the soldiers into a redemptive embrace.

She might have strayed from a Renaissance relief, and Gutfreund certainly gives her the *gravitas* of a healing Virgin. So far as Henry Lamb was concerned, however, divine intervention could not be

335 Emile Antoine Bourdelle *Virgin of the Offering* 1922. Stone, 6 m. Niederbruck, Alsace.

336 Facade of the Bank of the Czechoslovak Legion (Banka Legii) in Prague, 1922, designed by Josef Gočár with four limestone consoles by Jan Štursa, 1922–3, and (above) Otto Gutfreund's frieze *The Return of the Legionaries*.

expected to alleviate the suffering of war's victims. Still afflicted by the after-effects of a gas attack, he managed in 1920 to execute a monumental commission from Manchester City Art Gallery (Pl. 337). Using as his starting-point a sketch called *Succouring the Wounded in a Wood on the Dorian Front*, he spent most of the summer painting the large canvas in a Dorset village. In a letter to the gallery's curator, Lamb discussed the urgency of his need 'to reconstruct the bellicose atmosphere' he had experienced in Salonika.[7] But the finished picture, executed with local villagers as models, concentrated on suffering rather than pugnacity.

Like his friend Spencer before him (see Pl. 307), Lamb avoided any direct representation of the fighting. *Advanced Dressing Station on the Struma, 1916* shows only the consequences of battle, with prominence given to the wounded figure lying on a stretcher near the foreground. Unlike Spencer's painting, though, most of the stretcher-bearers do not attend to the stricken men in their charge. While one of them, tea-mug in hand, strips to his shirt-sleeves and leans energetically towards the head of an inert figure, his colleagues remain curiously uninvolved. Standing around in awkward groups, they eat, sip tea, feed the donkey or stare apprehensively towards the overcast, purple sky. A recent rainstorm has left the foliage gleaming, and Lamb enjoys delineating the freshness of each grass-blade and bramble-leaf. But he contrasts nature with the bearers' stunned weariness. Two of them, overcome by exhaustion, slump down beside the stretchers. The hope extended in Spencer's painting by the redemptive, warmly lit operating theatre is nowhere to be seen, and what Lamb described as his 'melancholy scheme of colours'[8]

intensifies the feeling that nothing, ultimately, can prevent the wounded from prolonged agony as they endure an interminable wait for medical assistance. Viewed in this light, the empty space dominating the foreground takes on an ominous significance. Hollowed out of the dark earth, it resembles a grave newly dug for those who die before the doctors get around to tending them.

The ending of the war seems to have released even the most conservative of painters from any obligation they may earlier have felt to present it in a wholly positive light. Lady Butler, the most celebrated and redoubtable battle artist in late nineteenth-century Britain, lived long enough to witness the Great War in its entirety. Writing in the privacy of her diary in September 1914, when she visited her eldest son in a New Forest infantry camp, Butler gave vent to considerable misgivings about 'the biggest war the world has ever been stricken with . . . To think that I have lived to see it! It was always said a war would be too terrible now to run the risk of, and that nations would fear too much to hazard such a peril. Lo! here we are pouring soldiers into the great jaws of death in hundreds of thousands, and sending poor human flesh and blood to face the new "scientific" warfare.'[9] All the same, the drawing she made for him then conveyed nothing except patriotic optimism (see Pl. 75). Butler could not bring herself to reflect that insight in her work. As long as the war lasted, her pictures remained unquestioning and heroic, presumably because she believed so ardently in the justice of the Allied cause. She even had some patriotic stationery printed with a gung-ho ink drawing of a galloping Royal Horse Artillery gun team, close in mood to Lucy Kemp-Welch's painting (see Pl. 163) and

captioned with her own exuberant title *Action Front!!* The elegiac realism with which she had painted some of her finest war pictures in the 1870s played no part in her romanticized canvases of Dorset yeomanry overwhelming the enemy in the Libyan desert. Although Butler produced faithful likenesses of all the officers in this commissioned canvas, she glowingly admitted that 'their own mothers would not know the men in the heat, dust, and excitement of a charge.'[10]

After the Armistice, however, her inner understanding of the tragedy was finally allowed to surface in the paintings she produced. The most monumental, displayed in 1920 as the last picture she ever exhibited at the Royal Academy, recorded a British defeat rather than a victory (Pl. 338). It shows a squadron of the royal horse guards retreating from Mons in 1914. They were supposed to be covering the exposed left flank of the British Expeditionary Force, but the fatigue in the limbs of the bandaged cavalrymen indicates that their fighting abilities are seriously impaired. The prevailing air of resignation leaves no room for the callow ebullience of the earlier Libyan canvas, and Butler now allows herself to include a desolate vista of ditched guns, dead horses and riderless mounts led along the muddy track by men who must have wondered whether they would be able to survive the dispiriting journey much longer.

Even if they did survive, many soldiers never recovered from the atrocious damage their bodies had suffered on the battlefield. While artists in the Allied countries preferred to avoid depicting these victims, Dix became obsessed by the most gruesome manifestations of war injury. He had been fortunate enough to emerge from active service without serious physical disability, but his mind was far from unscathed. More, perhaps, than any other artist who had fought in the war, Dix was unable to shake off the experience in the post-Armistice period. Indeed, his work suggests that war memories dogged him as relentlessly as they invaded the dreams of a funeral monument

337 Henry Lamb *Advanced Dressing Station on the Struma, 1916* 1920. Oil on canvas, 186.6 × 212.3 cm. Manchester City Art Galleries.

338 Lady Butler *In the retreat from Mons: the royal horse guards* 1920. Oil on canvas. Durban Art Gallery.

director in Erich Maria Remarque's novel *The Black Obelisk*. He had been buried by an explosion in 1918, and five years later the novel's narrator wakes on a quiet Sunday morning to find that 'suddenly a dreadful scream breaks the stillness and is followed by gasping and groaning. It is Heinrich Kroll, who sleeps in the other wing. He is having his nightmare again.'[11] Like most Germans of his generation, Dix would have agreed with the conclusion reached by Remarque's narrator, who is disturbed by the extreme, confusing disparity between memories of pre-war childhood and the ensuing horror: 'You cannot simply push it away. It keeps bobbing back disconcertingly, and then you are confronted by irreconcileable contrast: the skies of childhood and the science of killing, lost youth and the cynicism of knowledge gained too young.'[12]

No post-war artist could have been more cynical than Dix, who turned his anger on the military in a corrosive painting called *Souvenir of the Mirrored Halls in Brussels* (Pl. 339). The scarlet-faced officer bares his teeth as if to bite off the nose of the prostitute on his lap. While one hand is outstretched in a carousing gesture, the other clutches her pendulous breast with predatory greed. Dix employs a crude, cartoon-like style to emphasize the callousness of this barking maniac, who seems to equate lust with cruelty. The war has dehumanized him so completely that he is nothing more than a barbarian, who lifts his hobnailed boot like a bully determined to stamp out anyone rash enough to oppose his brutality. Dix enhances the nightmarish atmosphere of his ironically named 'souvenir' by surrounding the principal scene with a flurry of reflections – above, to the side and even below, where the whore's vagina is finally revealed. The use of multiple mirrors makes the image resemble an insane, endlessly repeated ritual, and in these reflections the sexual act is depicted with an increasingly rancid sense of revulsion and shame.

Dix also felt repelled by the sight of ex-soldiers exposing their deformations in the street. They became, for him, a symbol of the disillusionment engendered by the war, which he had initially greeted with such bull-necked aggression in 1914 (see Pl. 112). Now all the

Nietzschean hopes of renewal through destruction had vanished, and the enraged Dix devoted most of his energy in 1920 to an obsessive, savage and immensely disturbing sequence of war-cripple paintings. The largest, now lost, shows four of these veterans parading in a frieze-like progression along a harshly patterned pavement. It was exhibited, with Grosz's *Germany, A Winter's Tale* (see Pl. 324) and equally outspoken satirical images, at the Berlin 'Dada Fair' of 1920, where the gallery was dominated by a stuffed soldier hanging from the ceiling (Pl. 340).

Dix also produced an etched version of his *War Cripples* painting, and it makes clear that these pitifully maimed figures persist in wearing their uniforms and medals with obstinate pride. The man leading the procession sports an iron cross ostentatiously on his chest, while confirming his apparent cockiness by puffing on an outsize cigar with the aid of a hook attached to his artificial arm. Even the terrible gash in his face resembles a self-satisfied leer, and he leads the cripples on with martial briskness. They cannot, of course, hope to match the vigour of a real soldiers' march: even the standing figure at the parade's end only remains on two feet with the aid of mechanical joints which Dix outlines on greatcoat and trousers alike. Their resolve is undeniable, however, and the imperious hand of an

339 Otto Dix *Souvenir of the Mirrored Halls in Brussels* 1920. Oil on canvas, 124 × 84 cm. Private collection.

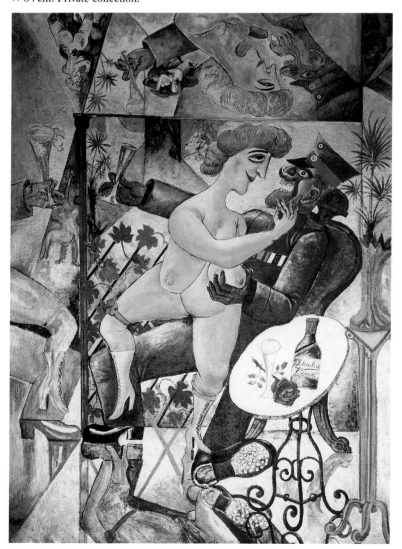

340 The Berlin 'Dada Fair', 1920. A stuffed 'soldier' dangles from the ceiling. Dix's lost *War Cripples* hangs on the left, Grosz's lost *Germany, a Winter's Tale* on the right. Those present include Raoul Hausmann (in cap, left), Johannes Baader (with beard), Hannah Höch (seated, left) with George Grosz and John Heartfield (standing, right).

advertising sign directing them ironically towards a shoemaker's shop accentuates the military mood.

The pointing hand also directs the viewer's attention towards Dix's own surname, inscribed with the date on the keystone of a window. The same three capital letters reappear on a plate next to the door where his *Match Vendor* sits, scanning the street for customers as he props a box-full of wares on his false leg. The empty sleeves of his jacket, pinned up uselessly against the cloth, reinforce the notion that he is pleading. None of the pedestrians seems interested, though. They hurry past him, legs stretched wide as they try to escape with the greatest possible despatch from his contaminating presence. Dix makes them appear even more callous by cutting each figure off near the waist, thereby depersonalizing them and, in a curious way, subjecting them to pictorial amputations which parallel the bodily severings suffered by the match-seller himself. Even the dog swerves away, cocks his leg and urinates on the cripple as if impelled by an instinctive horror of deformation. The man's position on Dix's doorstep confirms the feeling that veterans are inescapable, burdening with an intolerable sense of guilt everyone fortunate enough to have survived the war with body intact.

All the same, Dix was not prepared to depict himself in anguished confrontation with these victims, as Beckmann had done in a lithograph the previous year (see Pl. 322). He wanted to arraign the whole of post-war German society in his paintings of cripples, showing how they take their place at the very bottom of a social order riddled with cruelty, racial prejudice and greed. In *Prague Street*, the disabled veteran does not even have any matches to sell (Pl. 341). He is reduced to begging, and his outstretched palm only receives a token postage stamp from the passer-by's immaculately gloved hand. On the other side of the picture an overweight woman swathed in a puce dress rushes away, her heavy platform shoes adding to the suspicion that she would think nothing of trampling the mendicant under-

341 Otto Dix *Prague Street* 1920. Oil and collage on canvas, 101 × 81 cm. Galerie der Stadt, Stuttgart.

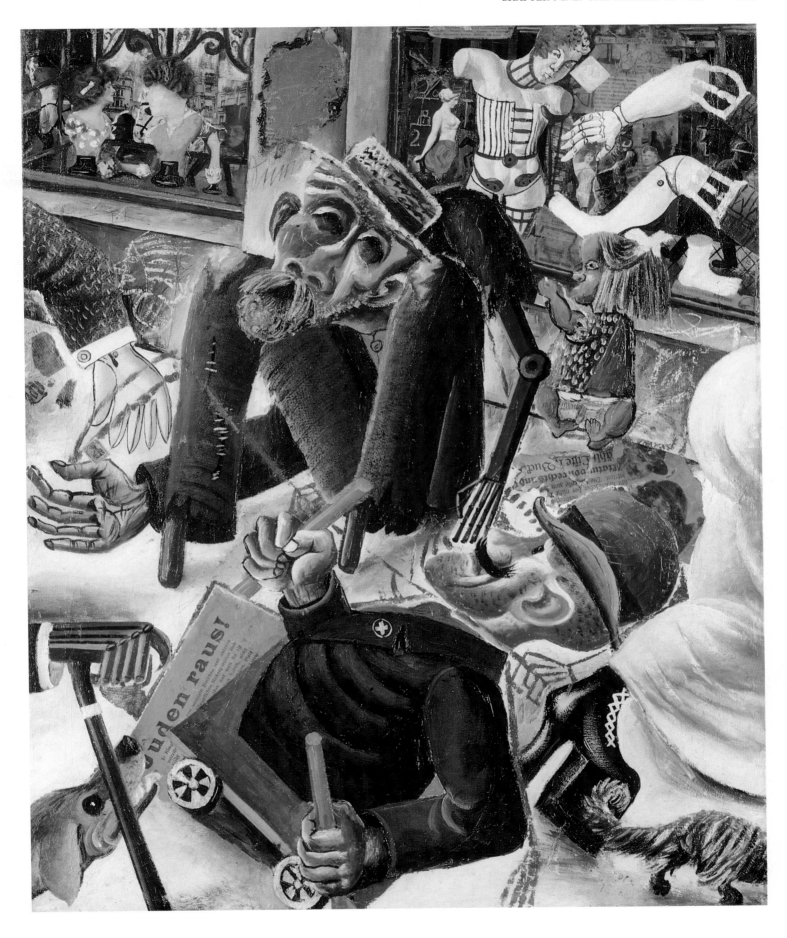

foot. He would be unable to resist such an invasion, for the poles protruding from his torn trousers are still more rudimentary than the match-seller's wooden leg. All he can do is sit on the ground, with one artificial arm jutting from his hunched shoulders, while a ragged girl scrawls graffiti on the wall behind. The shop-windows above mock his predicament with their profusion of corsets, wigs, legs and arms better crafted by far than his wretched appliance. He even seems to be scorned by the fierce, moustachioed man in bowler hat and bemedalled jacket who bustles past on a trolley. Although his body has been grievously truncated, he does at least command a manoeuvrability denied to the wreckage of a man beyond him. The indifference of the big city, envenomed by a snarling dog and anti-Semitic propaganda headlined 'Jews Out!', is defined with rasping accuracy in a picture which prophesies the complete disintegration of civic order and responsibility in post-war German society.

The most macabre of all Dix's cripple paintings is located indoors, away from the casual brutality of street life (Pl. 342). Three war veterans play cards, their wooden legs difficult to distinguish from the equally dark legs of the chairs and table. Their faces are far more grotesque than any of the cripples Dix had depicted out on the pavement, and each crudely stitched set of features amounts to an

342 Otto Dix *Skat Players* 1920. Oil and collage on canvas, 109.8 × 85 cm. Private collection, Germany.

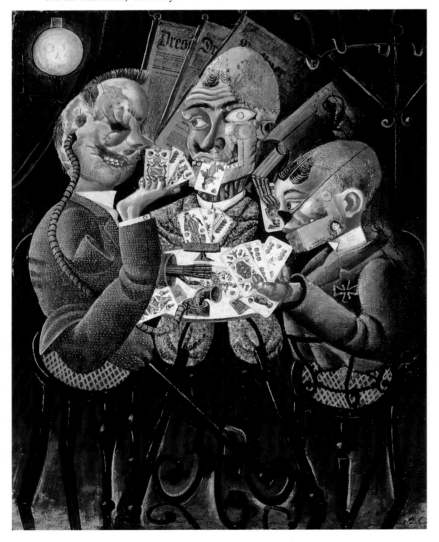

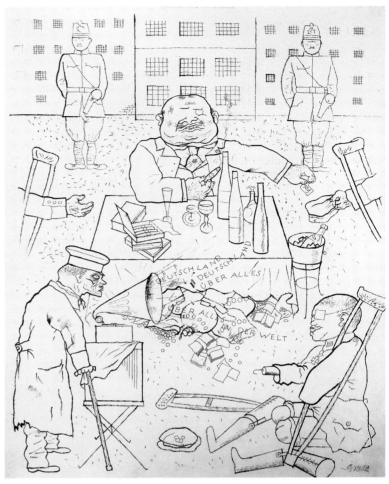

343 George Grosz *These war invalids are getting to be a positive pest!* Ink on paper, 52.8 × 41.2 cm. Nierendorf Gallery, Berlin.

indictment of the hasty cosmetic surgery inflicted on the injured soldiers. The man on the left, whose pink and scarred flesh testifies to hideous burning, has lost most of his hair and the whole of his right ear. A gruesome blue tube snakes down from his ear-drum to a listening instrument positioned on the table-top, and he overcomes the lack of a right arm by lifting his intact leg towards his chin. There, in a disconcertingly convoluted position, his toes act as surrogate fingers and display the cards for inspection. Although he surveys them with an apparently sightless eye, the contortionist is at least able to hold his cards with greater aplomb than the man in the centre, who resorts to clutching a King between his teeth. The rest of this player's head is still more distressingly damaged than his neighbour's. Half his brain has been crudely patched up with a plaster-like material, on which someone has drawn an obscene cartoon of a female nude. Painfully evident stitching runs down his forehead, and an outsize artificial eye stares into nothingness with manic intensity.

He appears, as a result, more detached than the eager figure on the right. Trimly dressed, and with a neat parting in his partially shaven hair, he seems undefeated by the loss of both legs. His trunk rests firmly on the cane seat as he hoists his artificial arm high in the air and then plunges it down towards the table. This fiercely angular movement is reminiscent of the cranking limbs deployed by the mechanistic participants in Léger's *The Card Game* three years earlier

(see Pl. 214). A comparison between the two paintings reveals, however, just how disenchanted Dix's view of war has now become. Léger's painting, for all its sinister undertones, still adheres to a belief in the forcefulness of modern combat. But Dix's cardplayers have been reduced to grotesque caricatures of their former, soldierly selves. The machine age, having invented the weapons which tore through their bodies on the battlefield, is unable to provide anything other than the most rudimentary technology to repair their shattered jaws, eyes and arms.

Although Grosz shared Dix's willingness to anathematize post-war society, he was readier to point an accusing finger at the underlying cause of the malaise. After joining the new Communist Party with John Heartfield and Wieland Herzfelde at the end of 1919, he took on a more sharply polemical note in drawings which denounce the evils of capitalist exploitation. In *These war invalids are getting to be a positive pest!* (Pl. 343), the foreground is inhabited by veterans almost as severely maimed as Dix's street cripples. But they are defined with greater pathos than their counterparts in Dix's rasping images. Moreover, the centre of Grosz's drawing is occupied by the corpulent figure of a magnate savouring fine wines and cigars at his dinner-table. While deigning to drop a niggardly bank-note into a veteran's proferred cap, he sneers at the invalids and rests his feet on a mound of bags stuffed with cash. It should be hidden from view under the table. Grosz, however, lifts the cloth and juxtaposes the heaped-up wealth with the patriotic words spewing out of the loudspeaker: 'Deutschland, Deutschland Über Alles, Über Alles In Der Welt.' The attempt to rouse nationalist sentiment could only, in Grosz's view, lead once again to war, and he makes sure that the bloated plutocrat is framed by military guards who survey the scene with standardized severity.

Grosz despised the belligerent patriots who revived the fighting spirit that had led Germany to disaster between 1914 and 1918. He saw them as hollow men powered by clockwork rather than human feelings, and *Republican Automatons* reveals the mechanical cogs and wheels which make a dinner-jacketed figure emit a routine cheer ('1, 2, 3, HURRA') through his brainless head. His truncated arms and brazenly displayed iron cross suggest that he is a war veteran. But his sleek attire and complacent bearing prove that he is prospering, and his bowler-hatted companion likewise seems determined to overcome the disability signified by his wooden leg. He raises the tricolour of the new republic in an apparent attempt to rouse patriotic sentiment, and yet his blank face stamped with numerals reveals that he is nothing more than a mindless cipher. Grosz's target here was the kind of jingoistic veterans who met for an annual jamboree in Marburg. He described in his autobiography how disabled carousers bellowed patriotic songs and then, at the climax of their singing, took off their artificial limbs and roared three cheers to their courageous army years.[13] *Republican Automatons* lays bare the idiotic conformity behind such antics. The façades of the buildings echo this uniformity, with their insistent reiteration of empty, impersonal windows.

This numbing sense of dreariness and alienation receives its most overt expression in a painting now called *Grey Day* (Pl. 345). The same monotonous office blocks proclaim their depressing anonymity in the distance, accompanied this time by factory chimneys whose thick smoke fouls the already overcast sky. A featureless worker carrying a shovel walks past them, his head bowed in an attempt to avoid looking at the oppressive environment. Another figure, bespectacled and bowler-hatted, lurks by the street-corner as though waiting to secure a deal on the black market. But most of the picture-space is devoted to a pair of sharply contrasted pedestrians: the war

344 Hubertus Maria Davringhausen *The Profiteer* 1920. Oil on canvas, 120 × 120 cm. Kunstmuseum, Düsseldorf.

veteran hobbling past on a stick, and the moustachioed bureaucrat who turns away from the cripple as he struts in the opposite direction. When Grosz displayed this painting in a 1925 *Neue Sachlichkeit* exhibition at Mannheim, he gave it the far more specific title *Council Official for Disabled Veterans' Welfare*. But this spruce and rigid figure, whose rapier-scarred face bears witness to a militaristic past, does not even acknowledge the existence of the haggard, uniformed victim whose future is supposed to depend on his ministration. Instead, his eyes converge crazily on his nose as he avoids looking at both the cripple and the post-war society which, in his view, compares so poorly with the pre-1914 world. The black band on his sleeve indicates that he mourns the demise of the old imperial order, even though a wooden L-square implement under his arm suggests that he is actively engaged in erecting the walls of the new world he detests. Perhaps this pompous official derives satisfaction from realising that the bricks rising up behind will soon segregate him from the veteran altogether, thereby reinstating the pre-war social hierarchy symbolized by the imperial colours borne like a badge of loyalty on his trim lapel.

He remains, nevertheless, an absurd and antiquated anomaly in post-war Germany, where Klee likewise ridiculed the twirled moustache and helmet-shaped head of a figure whose sympathies lie entirely with the Kaiser-dominated past. The real power and wealth now belonged to men like *The Profiteer* whom Davringhausen portrayed around the same time (Pl. 344). Unlike the protagonists in two of his earlier paintings, the madman and the prisoner (see Pl. 179), this sleek personification of commercial cunning has benefited from the war. He sits in his ruthlessly geometrical office with ample views of the other, equally dehumanized buildings which have helped to make his fortune. Vintage wine and cigars give his table a luxurious air, but the up-to-date telephone is far more essential from the business point of view. So is the compass lying on the paper where, pencil grasped in a determined hand, he makes his calculations

345 George Grosz *Grey Day*
1921. Oil on canvas, 115 ×
80 cm. Staatliche Museen zu
Berlin – Preussischer
Kulturbesitz, Nationalgalerie.

for even more lucrative ventures in the future. The precision of Davringhausen's *Neue Sachlichkeit* style catches the cold, machine-like certitude of a man bent solely on expanding his bank balance. He is untroubled by the melancholy afflicting the otherwise similar profiteer in Nevinson's moralizing portrait *He Gained a Fortune But He Gave a Son*, where no amount of wealth can compensate the bald entrepreneur for the tragedy he suffered during the conflict (Pl. 346).

A more outspoken sense of melancholy afflicts the women in Egger-Lienz's *War Wives* (Pl. 347). Having marked the official termination of the conflict with several monumental images of slaughtered soldiers (see Pls. 246, 247), this independent artist might reasonably have concluded that he had nothing more to say on the subject. Over the next few years, however, he turned his attention to the plight of people for whom the war would never wholly end. Condemned to worry about the men who had left them for the battlefield, the women in Egger-Lienz's large painting make no attempt to disguise their anguish. Apart from the younger woman who gazes in at the window, and the figure viewed from behind at the other end of the room, the assembled wives are almost unable to cope with the trauma they undergo. Enclosed in a chamber almost as claustrophobic as the attic in Beckmann's *The Night* (see Pl. 323), they find no relief in their monotonous tasks. The boredom entailed in this drudgery only encourages them to brood over their husbands' plight, fighting a war which Egger-Lienz's nation was doomed to lose with heavy casualties. The inevitability of defeat hangs in the air, making the room still more oppressive. Combined with the use of distorted perspective, which makes the wooden floor rise up with precipitous steepness, this despondent mood appears to acknowledge the likelihood that the wives will soon become widows. They certainly look inconsolable, lowering their eyes as if in trance-like anticipation of the bereavement which may well blight their post-war lives.

The dread conveyed here found more innovative and disturbing expression when Ernst resumed work after the Armistice. Marriage to Louise Strauss, a student of art history, was swiftly followed by his involvement with the German Dadaists, who loudly announced in the 1918 Berlin Dada Manifesto their contempt for Expressionism and

346 Christopher Nevinson *He Gained a Fortune But He Gave a Son* 1918. Oil on canvas, 40 × 50.6 cm. University Art Gallery, Hull.

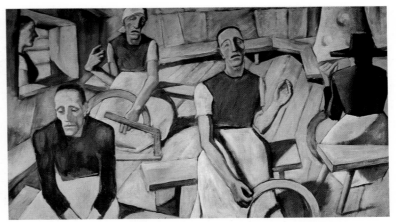

347 Albin Egger-Lienz *War Wives* 1918–22. Oil and tempera on canvas, 145 × 247 cm. Museum Schloss Bruck, Lienz.

belief that 'Life appears as a simultaneous muddle of noises, colours and spiritual rhythms, which is taken unmodified, with all the sensational screams and fevers of its reckless everyday psyche and with all its brutal reality...Dada is the international expression of our times, the great rebellion of artistic movements, the artistic reflex of all these offensives, peace congresses, riots in the vegetable market.' Ernst and his colleagues had no intention of lapsing into a pacific or nostalgic vein, like so many artists who returned from combat with a desperate need for quietism.

Among the photographic collages Ernst made in a prodigious flurry of activity between 1919 and 1920, defining a 'topsy-turvy world' distorted by his memories of the battlefield, two images of his continuing obsession with the war stand out. One, *The Massacre of the Innocents*, seems to refer to the aerial bombardment inflicted on civilians during the conflict (Pl. 349). The aeroplane, bearing a paradoxical resemblance to the macabre creatures who had struggled with each other under the water in Ernst's wartime work (see Pl. 222), floats like a grotesque, multi-winged predator in the night sky. The three figures leaping towards the edges of the picture appear to be escaping. But they are all drawn from the same stencil, and might just as plausibly represent the empty outlines left behind in the ground by bodies incinerated during an air raid. The idea of brutal flattening is reinforced by the structures reminiscent of railway tracks, which give the collage so much of its disorientating power. As Werner Spies has confirmed, they are in fact derived from the façades of Venetian buildings.[14] Partially transformed here into archetypes of a machine-age metropolis, they imply that neither renaissance cities nor their twentieth-century equivalents can be protected from the pounding inflicted by modern armaments.

The threat of attack from the air also inspired a tiny yet unforgettable collage called *The Murderous Aeroplane*, which shows the aggressor hovering over the earth as a monstrous apparition (Pl. 348). The flat, featureless landscape offers no protection from the marauder, whose womanly arms wave playfully in the air as they relish the prospect of inflicting further damage. The ground has already been stripped of all identifying features by successive bombardments, and the soldiers carrying a wounded comrade have scant hope of reaching their destination alive. They dare not look up at the hybrid menace above them, part machine and part seductive harbinger of death. Compared with the angels bringing destruction from the sky in Goncharova's 1914 lithograph *The Doomed City* (see

348 Max Ernst *Untitled, or The Murderous Aeroplane* 1920. Collage of photographs on paper, 6.7 × 14.3 cm. The Menil Collection, Houston.

Pl. 44), this airborne hallucination is at once more beguiling and more lethal. Its spiked metal helmet is curiously reminiscent of the nickname Ernst himself was given after being twice wounded: 'the man with the head of iron'.[15] But there is no suggestion that the helmet encloses anything as reassuring as the artist's own features. Anonymous and devoid of conscience, the murderous aeroplane takes an inhuman delight in calculating its next onslaught.

The threat posed by instruments of war was not ousted from Ernst's mind after he had executed this venomous collage. On the contrary: it grew to such monstrous proportions that the following year he devoted a large canvas to an apparition more gruesome by far than the aeroplane (Pl. 350). Ernst called the painting *Celebes*, the name of a substantial Indonesian island near Borneo. He afterwards

349 Max Ernst *The Massacre of the Innocents* 1920. Collage with photographic elements, pastel, watercolour and ink, 21.5 × 29 cm. Mrs Edwin A. Bergman, Chicago.

told Roland Penrose, though, that the title really derived from some cheerfully obscene verses chanted by Ernst and his fellow schoolboys in pre-war Germany:

The elephant from Celebes
has sticky, yellow bottom grease

The elephant from Sumatra
always fucks his grandmamma

The elephant from India
can never find the hole ha-ha[16]

The *Celebes* painting itself is, however, a great deal more threatening and macabre than these couplets would imply. Although the lumbering, dark green presence occupying so much of the picture has elephantine aspects, its armour-plated surface and other appendages are removed from any conclusive kinship with an animal. It possesses a boiler-like, clanking menace quite divorced from the photograph of a Sudanese corn-storage bin which Ernst used as the primary visual source for his behemoth.[17] The corn-bin was photographed at the same angle as the principal image in *Celebes*, and looks very similar, but in every other respect the painting transforms its starting-point entirely. Instead of positioning the monster in southern Sudan, where the Konkombwa tribe used the corn-bin communally, Ernst removes it to a cooler and more militaristic locale. The mechanistic beast's legs – oddly reminiscent of the stumps which war cripples were forced to cope with after amputation – stand on flat, marked-up ground reminiscent of an airfield. The suggestion is strengthened by the distant smoke-trail falling through the sky, apparently referring to the descent of a blazing aeroplane.

All the same, Ernst has no desire to be pinned down to a single, unarguable interpretation of his setting. Two fish, one of them startlingly elongated, swim in the sky. They indicate that he was still haunted by the submarine metaphors employed in his series of fish pictures executed during the war (see Pl. 222). The presence of the

350 Max Ernst *Celebes* 1921. Oil on canvas, 125.4 × 107.9 cm. Tate Gallery, London.

fish also proves how determined Ernst was to set his painting in a disorientating, dream-like region, related only obliquely to the conflict he had witnessed. *Celebes* is a transitional work, retaining elements from his Dada period but exploring the irrationality of the emergent Surrealist movement as well. It carries the forceful yet inexplicable charge of a recurrent nightmare, suffered by a man who had survived the war years and now struggled to exorcise their lingering legacy in his work. If the headless woman who beckons from the foreground can be related to the death of Ernst's elder sister in 1897,[18] she is equally redolent of the damage inflicted on countless human bodies between 1914 and 1918. Ernst draws a visual parallel between the rod balanced on the woman's gaping neck and the similar device resting on the strange tree-form beyond. Both are truncated, and Paul Nash would have understood why Ernst wanted to link human with tree as victims of war's destructive power.

For all her mannequin-like rigidity, though, the woman seems to retain a semblance of life. Her seductive gloved hand flirts with the monster, perhaps in an attempt to entice him forward. The gesture provokes a response, in the sense that the brutish phantasm appears to acknowledge the existence of this siren. But its horned head seems to have eye-sockets as empty as the black hole bored through the centre of its body. Despite the phallic swagger of the coiled, tubular neck projecting from its upper section, the horned head may well lack the intelligence to command the rest of the monster to follow the woman. A pair of sharply pointed tusks protruding from the left suggests that another head might lurk on its other side. Moreover, the true seat of sentience is probably to be located in the cluster of mechanistic structures on top of the monster. Reminiscent of propellors, fins, observation turrets and other components from modern weapons of war, they contain an aperture where a white eyeball presides vigilantly in the darkness. It may be about to take aim, like the commanders of the tanks which terrorized German troops for a while during the Somme campaign.

Ultimately, however, the machine-age menace dominating *Celebes* takes on the baleful significance of a threat without a name – a mythical aggressor whose invasive potential seems limitless in comparison with the murderous instruments Ernst had encountered at the Front. It is the shape of things to come, borne of the deepest fears he underwent during the war and the belief that, sooner than anyone cared to expect, the world might be overshadowed by a destructive force of hitherto unimagined capacity. W.B. Yeats was obsessed by a similar presentiment, for in the very same year that Ernst painted *Celebes* he published 'The Second Coming.'[19] After lamenting that

> Things fall apart; the centre cannot hold;
> Mere anarchy is loosed upon the world,
> The blood-dimmed tide is loosed, and everywhere
> The ceremony of innocence is drowned . . .

Yeats reluctantly arrives at an apocalyptic conclusion:

> Surely some revelation is at hand;
> Surely the Second Coming is at hand.

The 'vast image' which troubles the poet's sight, and is in many ways compatible with Ernst's vision, possesses

> A gaze blank and pitiless as the sun,
> Is moving its slow thighs, while all about it
> Reel shadows of the indignant desert birds . . .
> And what rough beast, its hour come round at last,
> Slouches towards Bethlehem to be born?[20]

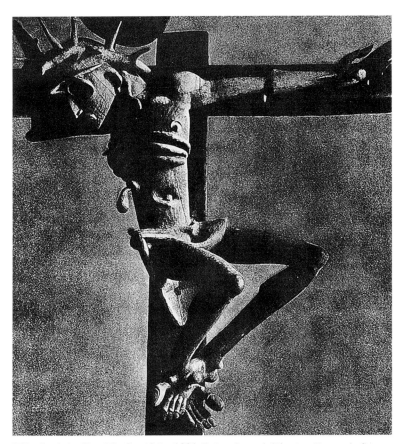

351 Ludwig Gies *The Crucifixion* 1921. Painted wood, life-size. Formerly St Marienkirche, Lübeck. Destroyed.

If Ernst had ever attempted to convey his savage perturbations in the form of a public war memorial, he would have been execrated by a significant proportion of the German public. In the same year that *Celebes* was painted, the Expressionist sculptor Ludwig Gies encountered the most intolerant and vicious opposition when he carved a life-size wood crucifix as his entry for a war memorial competition held in Lübeck (Pl. 351). Gies produced the image specifically for the north German Gothic nave of St Marienkirche, and his passionately distorted language chimed with the architecture of the building where he hoped *The Crucifixion* would find a permanent home. The pulled-up legs jutted out sideways in a triangular form which honoured the nearby arches and vaults as closely as the sharply pointed edges protruding from the rest of the sculpture. Like Beckmann before him (see Pl. 241), Gies ensured that its conception and style were in keeping with the sculptural achievements of fifteenth-century Germany, and the 'artistically educated members of the congregation's progressive governing body'[21] responded warmly to his aims. They displayed the carving for a while in the ambulatory of the cathedral, 'against a plain white wall, the right hand's blessing a phantasmal silhouette before the tall church window'. According to an eye-witness, 'the effect was astonishing . . . a work of modern craftsmanship and spirit proved to be equal to the architectural power of the Middle Ages.'[22]

Some lay observers, however, reacted violently to the sculpture. If Gies had executed it simply as a crucifix, it might not have aroused any hostility: the image of Christ's suffering at its most extreme had, after all, played a central role in German art for many centuries. But this carving was intended as a memorial, and it impressed the

director of the Lübeck Museum für Kunst und Kulturgeschichte so profoundly that he declared: 'it would be hard to find a symbol which would impress posterity more powerfully and deeply with the meaning of the World War and its fallen heroes.'[23] Such sentiments were anathema to a growing number of Germans. They wanted nothing to do with an image of the war which stressed their nation's recent humiliating plight.

True to his Expressionist convictions, Gies had been uninhibited in his dramatization of Christ's experience on the cross. He went out of his way to retain the rough-hewn character of the original oak blocks in the finished sculpture. Moreover, he heightened its gruesome emotional impact by staining the body green-blue, deploying red freely on the blood-stained planks forming the cross, and making the polished plate of the gilded nimbus reflect the head's ghostly green hue. Such a highly emotive use of colour meant that the image's emphasis on incipient death was impossible to ignore. Instead of a beatific figure, serenely resigning himself to martyrdom and inwardly envisaging the resurrection to come, Gies's Christ is as battered and helpless as his predecessor on the Isenheim altarpiece. Hideously swollen toes bulge out from the nails piercing his feet, and a gobbet of blood bursts from his gashed side to hang in space. Gies, working in collaboration with the Expressionist sculptor Otto Hitzberger, stressed the cadaverous etiolation of Christ's physique by scoring harsh furrows in his torso to signify a ribcage starved of sustenance. His equally gaunt head hangs down with hollowed eyes in the direction of his tormentors below, while the spikes surmounting the crown of thorns find an answering echo in the left hand's bony fingers as they splay outwards from the cross.

This bowed and pinioned victim was, in the eyes of its detractors, far too abject to be accepted as a memorial to Germany's role in the war. Protests began in the newspapers, where enraged observers 'spoke of blasphemy, of folly, of a public disgrace that demanded expiation.'[24] It took the form of a ritualistic decapitation. Some of the townspeople entered the Marienkirche, knocked off Christ's head and threw it into the local millpond. Supporters of the sculpture retrieved the mutilated part from the water before successfully returning it to the sculpture. Soon afterwards, Gies's restored masterpiece was displayed in the hall of the Bauhaus at the *Deutsche Gewerbeschau* in Munich. Subsequently, however, it was destroyed completely. The crucifix's supposed defeatism could never be accepted by those who wanted above all to avenge their country's downfall and make Germany triumphant over its adversaries.

Only the most optimistic war images could satisfy them, and another remarkable Expressionist memorial remained unscathed precisely because it conveyed a spirit of resurgence (Pl. 352). Bernhard Hoetger had no intention of regarding his monumental Worpswede memorial to the men killed in action from Lower Saxony as an incitement to German militarism. He called it *Peace Memorial*, and made his political affiliations clear by dedicating another public carving to the workers who had died in the November Revolution at Bremen.[25] But his great brick structure at Worpswede was sufficiently phoenix-like to escape the condemnation of vandals, and it remains *in situ* as the winged fulfilment of Hoetger's exalted belief that 'the artist is the purification-vessel for the most beautiful and most awful experiences, a frightening aestheticist, a dancer on the fields of the dead, a filter, a detoxifier.'[26]

Now that memorials to the Great War are so often taken for granted and even overlooked, it has become easy to underestimate the significance they possessed when unveiled. Even modest communities insisted on erecting them as a tribute to the memory of the men from their locality who had died. Sometimes, as in the stacked, deliberately primitivist monument built high above the sea at Swanage, they eschew figurative imagery in favour of a structure symbolizing rudimentary yet stubborn endurance. The refinement of an artist's hand appears to play no part in the Swanage memorial, which looks across the water towards a still more weather-worn range of Dorsetshire cliffs.

Surprisingly ambitious and elaborate works of art were, however, commissioned for places smaller by far than seaside resorts. At Steep, near Petersfield, Muirhead Bone commissioned Spencer to paint a picture for the club-room of the Memorial Hall in 1921. Bone, who lived in the village, invited Spencer to stay in his house while working on the project. It appealed to Spencer, prompting him to overcome his earlier resistance to the notion of producing a successor to his great *Travoys* canvas (see Pl. 307). Having lost his 'Balkanish feelings' in 1919, he now recovered them sufficiently to commence work on a *Crucifixion* rooted in his soldiering experiences. The strange location Spencer chose for his painting derived from wartime memories of

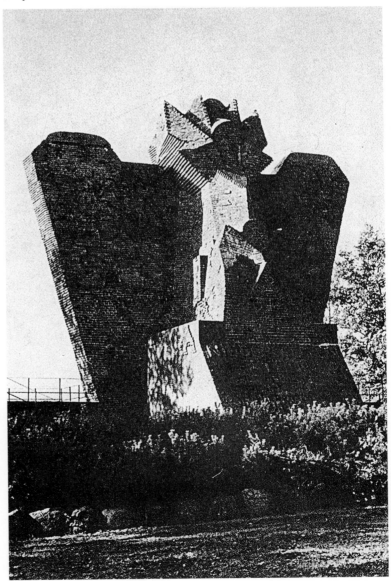

352 Bernhard Hoetger *Peace Memorial: Lower Saxony Monument* 1915–22. Brick. Worpswede.

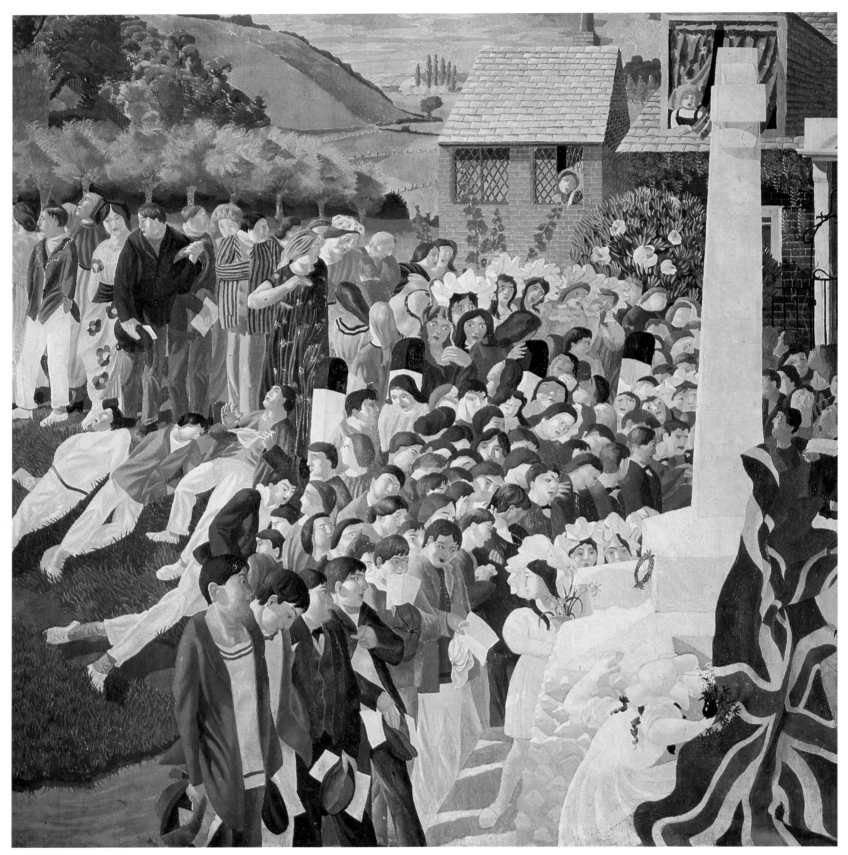

353 Stanley Spencer *Unveiling Cookham War Memorial* 1922. Oil on canvas,
155 × 147.4 cm. Private collection.

a mountain in a range dividing Macedonia from Bulgaria. He remembered seeing it 'away behind' his quarters, and thinking that 'it would be wonderful to be on it: it seemed so remote, so long since gathered to the mountains of its forefathers.'[27] The optimistic feelings it had generated within him at the time made Spencer imagine that the mountain might provide an appropriate setting for an ascension picture. After executing a watercolour study in Steep, however, he abandoned the idea and began working on an alternative. He later described how 'I wanted to bring the geography . . . of the mountain into one state of being and expression with some great human happening.' The fact that 'three long gashes'[28] seemed to have been taken out of the mountain convinced him that it would lend itself to a crucifixion instead. So he produced an elaborate oil study on paper, placing each of the three crosses at the bottom of a ravine.

The white-robed men nailing and tying the condemned figures are therefore able to balance on the ravines' edges. Their precipitous poses emphasize the drama of the event; and the grieving Virgin, having 'slithered down the escarpment side', sprawls at an awkward angle at the base of the cross. Even the nearby cluster of priests adopt expressive poses, 'wagging their heads'[29] at the crucified forms. Only the Centurion, isolated in the foreground and leaning against his horse, lacks this agitation as he gazes across at Christ hanging between the ridges. Spencer intended ultimately to paint a larger *Crucifixion*, which would have included at the top of the composition the walls of Jerusalem, the rending of the veil of the temple,[30] and a group of newly resurrected figures arrayed in their funeral shrouds. The last of these additional scenes suggests that he was close, now, to the theme of joyful renewal which provided him with the culminating image of his Memorial Chapel at Burghclere several years later (see Pl. 399). The Steep project collapsed in July 1922, when Spencer described to a friend how 'Bone has given me the sack . . . Of course, it was a great blow to me, because I loved the idea of doing that place at the back of my mind and I wanted to cogitate about it for years.'[31] The work he carried out at Steep was not, however, wasted. His ability to combine biblical and wartime themes in the *Crucifixion* painting prepared the way for a similar, albeit far more sustained and ambitious fusion on the walls of the Burghclere chapel.

By the time Bone terminated the Steep commission, Spencer had moved to a house in Petersfield with a view guaranteed to stimulate his thoughts of resurrection. In February 1922 he excitedly told Henry Lamb that, since his rented room overlooked Petersfield churchyard, 'I am in immediate communication with the dead. They are buried in the side of a bank, so that they only have to push the gravestones a little bit forward and lo! they are in my room, like extinct gentlemen – a very Cookhamesque place, as you can see.'[32] The vision he outlined in this letter with the aid of a swift pencil sketch led on directly to his epic canvas *The Resurrection, Cookham*, commenced two years later. But it also played a part in his decision to paint at Petersfield a powerful picture called *Unveiling Cookham War Memorial* (Pl. 353). Produced in response to a commission from the distinguished collector Sir Michael Sadler for 'a sort of religious picture',[33] this intensely personal image has nothing to do with the dutiful recording of a pompous ceremony replete with officialdom. Dignitaries are nowhere to be seen in Spencer's canvas. They might, perhaps, have stood behind the memorial, making speeches and ensuring that reporters and photographers registered their presence at the event. Spencer excluded them from the painting, however, and does not bother to show who was responsible for the unveiling. He had no desire to let a local politician or councillor deflect attention from his altogether more heightened vision of the event.

In a detailed preparatory drawing, he outlined a large vase of flowers tended by a girl in front of the memorial. In the painting itself, though, the vase is replaced by a rumpled Union Jack. As well as increasing the vivacity of the scene, the flag looks as if it has only just been removed from the monument and fallen, still billowing gently, towards the ground. This concentration on the moment of disclosure enhances the wonder which pervades the whole picture. The crowd of Cookham villagers assembled there, with programmes in their hands, seem awed by the sudden advent of the simple white cross. While a couple of the young men at the front seem more interested in the girls surrounding the memorial's base, the majority stand and gaze silently at the monument or press forward eagerly from behind to gain a better view. After finishing the canvas, Spencer claimed that he had deployed 'what I call my Ascot fashions, my sweet-pea colours'.[34] But this lighthearted, slightly deprecating description does no justice to the remarkable luminosity of the painting itself. The cross's pristine stonework glows in the sun, luxuriating in its heat as much as the hollyhocks, wisteria and warm brown brickwork of the cottages beyond. They induce a mood of irresistible high-summer drowsiness, which becomes still more seductive once the village ends and the picture opens out into the richly foliated Berkshire countryside.

Several figures succumb to the temptation offered by the edge of Cookham Moor and lounge on its grass. Others standing above them appear dazed by the sunlight, while the row of girls' bonnets nearby flower as expansively as the petals in the shrub behind them. There is a universal sense of unfolding and burgeoning after the long privation of the war years, and Spencer aimed at contrasting this beneficent image of Cookham life with the misery commemorated by the monument. He later explained that the painting 'was intended to express the absence of hurry . . . and to express the peaceful life that I visualized people could live if there was no war.'[35] Hence, perhaps, the particular importance he attached to the figure of the foreground girl kneeling by the side of the memorial. Dressed in the white of innocence, she places one reverential hand on the stonework and, with the other, instals a black vase of daisies on its base. Although her face is hidden by a bonnet, she could easily be kissing the memorial in a spontaneous gesture of respect for the dead. She might also be pushing aside the flag of nationalistic pride in order to make room for the alternative values symbolized by the small yet potent flowers in her grasp. Spencer appears to attach special significance to the proximity of feminine grace and austere monument. He ensures that the apex of the cross is juxtaposed with a girl resting on the sill of an upper window. Caressed by the flower-spattered curtains blowing around her, she seems to bestow on the memorial a tacit blessing which affirms the need for a future liberated at last from the cyclical curse of war.

Although the Cookham monument was devoid of carved imagery, plenty of sculptors found themselves commissioned to produce figurative work for memorials elsewhere in the country. Many of them were timid or merely hackneyed, conveying little except their makers' inability to reflect on the war and transmit an authentic, heartfelt response to the tragedy. But alongside this failure of nerve, by sculptors and patrons alike, a few projects did succeed in rising above the prevalent banality. Eric Gill, who had demonstrated his capacity to carve on a monumental scale in his wartime *Stations of the Cross* for the nave of Westminster Cathedral, was invited to produce memorials and plaques for a range of small communities across southern England.[36] They reject the rhetoric which mars most of their grandiloquent counterparts in major urban centres, and ex-

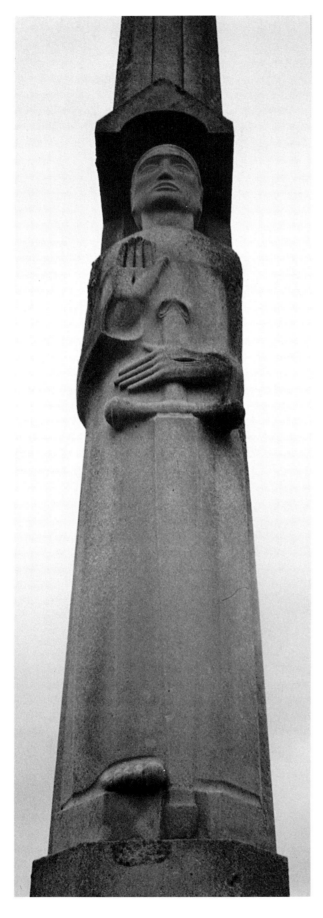

emplify Gill's passionate determination to provide even the humblest of locations with modest yet memorable images.

The most resonant of all his village monuments is the Cross erected at Briantspuddle in Dorset (Pl. 354). It occupies a commanding position, at the point where a quiet road lined with thatched houses ends and open countryside begins. The full-length figure of Christ gazes over the fields, with one hand clasping the handle of a sword and the other solemnly raised to expose the nail gash in his palm. This gesture is reminiscent of the hand upheld by Epstein's *Risen Christ* (see Pl. 330). Perhaps Gill had been impressed by his old friend's bronze, for the Briantspuddle Christ shares the same sense of gaunt resignation. The presence of the sword does not give the figure a belligerent air. On the contrary: Christ appears to be robbing the weapon of destructive force by pressing it into his robe, and the gashed hand laid over its handle implies a warning about the brutal consequences of unleashed aggression. Gill allies the figure so completely with the narrow verticality of the cross that Christ's slenderness is taken to the point of outright etiolation. He looks burdened by his awareness of the lost lives inscribed on the arched stone block beneath him, and the quotation from Julian of Norwich surmounting the list of names issues a melancholy moral: 'It Is Sooth That Sin Is Cause Of All This Pain.'

Although the names continue on the sides of the Briantspuddle memorial, the sense of intolerable anguish eases at the rear. For here, sheltering within a sturdy porch supported by thick metal columns, a veiled Virgin sits with offspring on lap. Her expression is sombre as she offers her breast for the reassuringly plump child to suckle. Although she is united in mood with the attenuated figure on the other side of the cross, the woman does possess a consoling amplitude. She embodies the form as well as the spirit of redemptive nurture, and dedicates herself to feeding the generation who will emerge in the wake of war. This time, the niches below are devoid of tragic names, while the accompanying inscription, again from Julian of Norwich, affirms: 'And All Manner Of Thing Shall Be Well.'

No such comforting emotion lay behind Gill's most ambitious war memorial, completed for Leeds University in 1923 (Pl. 355). The strange idea of taking as his subject *Our Lord driving the Moneychangers out of the Temple* had occurred to him as early as 1916, when he proposed a design for a large bronze memorial to the London County

354 Eric Gill *The Cross* (front and back views) 1920. Stone. Briantspuddle, Dorset.

355 Eric Gill *Our Lord driving the Moneychangers out of the Temple* 1923. Portland stone, 168 × 459 cm. The University of Leeds.

Council's dead employees. While sitting for his portrait, and trying to decide 'between thinking about women (in some detail) and thinking what I could do for the LCC Monument', Gill suddenly realised 'that the act of Jesus in turning out the buyers and sellers from the Temple when he did was really a most courageous act and very warlike'.[37] The proposal, not surprisingly, was turned down, and Gill supposed that the LCC 'took fright, or were insulted at the awful suggestion that London were a commercial city or that England were a Temple from which a money-changer or two might not be missed.'[38] While feeling just as angry about the war profiteers as Grosz or Davringhausen (see Pls. 343, 345), he believed that the money-changers story justified the British decision to take up arms against Germany. 'Thus for all time', he wrote of Christ's precipitate action, 'the use of violence in a just cause is made lawful.'[39] More alarmingly, Gill argued that houses of God required purging in the twentieth century just as urgently as in Christ's day. When he heard about the damage inflicted on Reims by the German advance, he angrily insisted in a letter to a friend on the 'need to construct a whip of thongs wherewith to drive the money-changers out of the Temple of England. God has found a whip of German guns wherewith to deprive the money changers of the temples of France. Why should Paris be indignant? What was Reims to it? A blooming museum – a kind of provincial branch of the Louvre.'[40]

It was an odd, overheated attitude to adopt, and Gill's apparent sanctioning of a great cathedral's destruction would hardly have commended him to a patron capable of commissioning the memorial he wanted to produce. All the same, Michael Sadler became interested in the proposal. Before the war he had been Kandinsky's first supporter in Britain (see Chapter One), and the remarkable audacity Sadler had shown at that time resurfaced when he considered Gill's scheme. Having recently commissioned a war memorial picture from Spencer (Pl. 353), who in 1921 painted his own interpretation of *Christ Overturning the Money Changers' Tables*,[41] Sadler would not have been surprised by Gill's interest in the same subject. Besides, as Vice-Chancellor of Leeds University, Sadler had recently received a £1,000 legacy from a Yorkshire lady to be used for the University's benefit.[42] So he decided to spend it on Gill's memorial, and did not

even waver when the sculptor gleefully announced that 'I'm thinking of making it a pretty straight thing – modern dress as much as poss., Leeds manufacturers, their wives & servants, don't you see.'[43] Both Gill and his patron must have known that such an image would cause deep offence, especially among local businessmen who had suffered the loss of sons during the war and expected a far more decorous, conventionally dignified monument. But Gill was bent on assuming Christ's purifying role when he carried out this 'revolutionary job',[44] and Sadler managed to obtain the university's consent for the inflammatory carving.

In one respect alone did Gill temper his onslaught on the sensibilities of the people he criticized. The biblical inscription running along the cornice of his immense relief declared: 'Go to now, you rich men, weep and howl in your miseries which shall come upon you. Your riches are putrid.'[45] He decided, however, to carve this execration in Latin, and employed the same language for the inscription on the right of the relief where the expulsion story is summarized.[46] Beneath the words, incised with all the skill and elegance Gill commanded as a letter-cutter, the hound of the Lord rushes past an overturned money-changer's table with a burning torch gripped between his teeth. He initiates the movement which runs through the entire frieze, and the curve of his tail is echoed by the seven cords swinging from the whip in symbolic recognition of the Seven Deadly Sins. Christ flings back this scourge to aim it at the targets of his scorn, and his draped figure is handled in a deliberately archaizing idiom – as if Gill's long-held admiration for the far more deeply scored early medieval stone carvings of Christ at Chichester Cathedral had been filtered through his love of the smoother and more sinuous rhythms of Indian sculpture.

These influences, carried over in part from his *Stations of the Cross* reliefs in Westminster Cathedral, are countered in the rest of the relief by Gill's determination to attain contemporary relevance. The depiction of figures in twentieth-century clothes is carried out in a style commensurate with the work of contemporaries like William Roberts, who had himself recently painted a characteristically rigid and angular interpretation of the money-changers story. Although the five fleeing men in Gill's relief are supposed to represent, from right

to left, two financiers, a politician, a pawnbroker's clerk and his master, they all look strangely similar. Even their movements echo each other, like a Muybridge-derived Futurist sequence of successive stages in the motion of a single figure. Perhaps Gill wanted to convey his scorn of the ousted crowd by the mocking deployment of repetitious, robot-like poses. There is a comic-strip air about these cowed, scurrying outcasts, and the absurdity is heightened by the contrast between their bunched-up ungainliness and the cool, austere dignity of the arches running behind them. Ridicule is spiced with a hint of salaciousness near the end of the relief, where the pawnbroker carries the balls symbolic of his profession. Gill slyly makes sure that only two of them are visible, and allows the 'fashionable woman' to grasp one of the poles supporting the balls. The gesture is surreptitious: her hand sidles out behind her dress, and might easily be mistaken for the pawnbroker's. Once seen, however, her brazen fingers imply that the woman is just as stealthy in the pursuit of her own interests as her male companions. She holds up her vanity bag with a possessive zeal reminiscent of the clerk hugging the ledger with 'LSD' inscribed so prominently on the cover. Gill clearly wanted to scotch any illusions on the viewer's part that expulsion may have humiliated the money-changers into repenting of their venality.

When the memorial was installed on an exterior wall[47] near the university library in 1923, it provoked fierce controversy. The Conservative *Yorkshire Post* even attempted to 'cancel or delay'[48] the Dedication ceremony, and a defiant Gill exacerbated the scandal by publishing a thoroughly contentious pamphlet about the memorial's political aims. It confirmed, to the disgust of his detractors in a town renowned as a financial centre, that he was obsessed by modern war's relationship with the generation and accumulation of capital. Sadler, for his part, found himself besieged by journalists on his arrival at Southampton from a trip to Canada. Although he was privately angry about Gill's pamphlet, and later complained in his diary that the sculptor had 'departed egregiously (without telling me until it was too late) from the earlier design he had chosen',[49] the Vice-Chancellor supported the carving in public. By championing the artist's right to make an image in direct opposition to the social order, Sadler proved himself a courageous patron. All the same, he harboured reservations about the emphatic way Gill had underlined his polemical intentions, in pamphlet and sculpture alike. While saluting Gill's robust independence, and admirable refusal to modify his convictions in the face of antagonism, Sadler may still have wondered if such a heavily debunking image was an appropriate means of commemorating the soldiers' deaths.

Down in London, the summer of 1923 likewise proved a controversial period for another artist memorializing the war. William Orpen had already expended a great deal of effort on two government-sponsored paintings of the Peace Conference in France. Observing at close quarters the assembled statesmen of Europe pursuing their own arrogant ends generated within him an accelerating anger and disgust. Memories of the horrors he had witnessed on the battlefield and attempted with varying degrees of success to paint (see Pls. 263, 264) were still alive in his mind. They made the manoeuvrings of the sleek and self-regarding politicians nauseate an artist plagued in addition by an attack of blood-poisoning. He dismissed the pomposity of the proceedings as 'an *opéra bouffe*', and pointed out that 'all these "frocks" seemed to me very small personalities in comparison with the fighting men.'[50]

The Signing of Peace in the Hall of Mirrors, Versailles duly subordinates the assembled heads of state to the gilded ornamentation of their surroundings. Although each individual is conscientiously portrayed,

they all look like mannequins relegated to the base of a composition which implies their insignificance. The centre of the canvas is devoted to the disjointed reflections in a mirrored wall. Its shimmering glass panels offer an unstable glimpse of two silhouetted figures at the other side of the Hall. They appear to be gazing outwards, as though in contemplation of the uncertain future confronting Europe after the ratification of these profoundly ill-advised negotiations. Orpen's insistence on fracturing the tall windows adds to the sense of unease in a painting only too prophetic of the divisions ahead.

At this stage, however, his misgivings remained covert rather than nakedly expressed. Only in 1923 did he unleash the full extent of his dissent by displaying, at the Royal Academy summer exhibition, an indignant painting called *To the Unknown British Soldier in France* (Pl. 356). It was supposed to have been the third of Orpen's conference pictures, and he had previously spent nine frustrated months working on the same canvas to produce a dutiful image of thirty-six statesmen and armed forces' representatives positioned in the ironically named Hall of Peace. Then, tired of coping with all the meticulous little portrait-heads required by the commission, he painted them out. 'It all seemed so unimportant somehow,' he declared in an interview with the *Evening Standard*, relating how 'I kept thinking of the soldiers who remain in France for ever.'[51] Accordingly, he replaced the group of dignitaries with a far more emotive and, indeed, protesting reference to the war: a lone coffin, draped in the British flag, with partially naked soldiers standing at either side. Based on the dishevelled and shell-shocked Tommy in Orpen's war drawing *Blown-Up – Mad*, their reciprocal stances mock the theatricality of artificial posing, and Orpen injects further mordant satire into the picture by adding a pair of cherubs. They cavort above the soldiers with absurdly inappropriate garlands, emphasizing the contrast between the Tommies' ragged etiolation and the splendour of the polished marble and chandeliers around them. Here, the picture seems to be insisting, is the true legacy of the conflict. Once the calculating negotiators have left the Hall, reality remains in the form of two tattered infantrymen guarding their comrade's corpse.

Orpen can have been no more surprised than Gill at Leeds by the strength of feeling which his painting eventually aroused. At first, when it was inspected in his studio by the Secretary of the Imperial War Museum, the reaction was guarded. 'It is very difficult to get sentiment out of Orpen,' the Secretary reported to Sir Alfred Mond, 'but I rather gather that his idea is that after all the negotiations and discussions, the Armistice and the Peace, the only tangible result is the ragged unemployed soldier and the Dead.'[52] The museum decided to hold its option on the picture open until it was displayed at the Royal Academy summer show, where the trustees would all be able to study it and arrive at a conclusive verdict. So far as the exhibition's visitors were concerned, the painting's disillusionment was both valid and memorably expressed. By voting it 'Picture of the Year', the viewing public demonstrated its solidarity with Orpen's emphasis on the futility of the war and its despicable aftermath. But most of the exhibition's reviewers condemned the picture for its bad taste and technical ineptitude. True to its name, *The Patriot* proclaimed that the painting was nothing more than 'a joke and a bad joke at that.'[53] The *Liverpool Echo* was almost alone in opining that 'the shadowy legions of the dead sleeping out and far will applaud it with Homeric hush.'[54]

The museum's representatives could hardly be expected to echo such sentiments. They rejected the painting, on the grounds that 'it does not show what we wished shown',[55] and Orpen found himself contesting the Treasury's proposal to deduct nearly £1,000 from his

356 William Orpen *To the Unknown British Soldier in France* (first version) 1922. Oil on canvas, 152.4 × 128.3 cm. Altered later. Imperial War Museum, London.

payment. The outcome of this financial wrangling is unclear,[56] but in the end official disapproval affected the artist's attitude to his picture. Five years after its controversial triumph at the Royal Academy, he contacted the museum and offered to obliterate the offending soldiers, garlands and cherubs. Perhaps he thought that the human cost of war was still underlined by the proposed repainting: the coffin may have been covered by a Union Jack, but it was still impossible to ignore. The museum, however, greeted his suggestion with gratified relief. The amended canvas was duly accepted by the trustees, who clearly felt that the coffin no longer seemed objectionable in its new and more respectful context. After all, Orpen was now presenting it to the museum as a memorial to Earl Haig, so no disrespect was suspected. Nor can it really have been intended, for the altered version of *To the Unknown British Soldier in France* seems a disappointingly neutered affair compared with its bilious predecessor.

No such accusation could be levelled at Rouault. Again and again in an anguished sequence of prints inspired by the war, he hammered home the gravest consequences of the bestiality it had fostered. If Rouault the painter often seems indebted to the burnished colours and thickly leaded structure of medieval stained-glass windows,

Rouault the print-maker here announces his fascination with the Dance of Death imagery which originated in the same period. Like Kubin, de Bruycker and Uzarski before him (see Pls. 250, 178, 238), he appropriates the skeletal figure who rampaged through so many morality plays in the late middle ages. Death then personified the plague which decimated Europe relentlessly in those centuries. By re-employing this fell figure for his own purposes in the *War* prints, Rouault implies that the conflict assailing the same geographical area between 1914 and 1918 was just as devastating in its consequences.

Religious faith offers no protection against the struggle's ruthless advance. In *This will be the last time, dear father!* (Pl. 357), a young soldier makes this promise by kneeling as near as he can to his frowning confessor. Their physical proximity carries echoes of the prodigal son's return: the intimacy of the penitent's whisper, and the hand he brings to rest on the older man's right arm, suggest a parent/child relationship rather than the formality of a church confessional. The soldier affirms that he will never sin again, without any awareness of the potential irony involved in such an assurance. Rouault, however, makes the promise unavoidable by placing Death immediately behind the young man. Baring his teeth in a predatory leer, the skeleton closes on his victim with a resolve which guarantees the soldier's demise. Once the skeleton's intentions have become clear, the expression on the confessor's face takes on a new meaning. As well as responding to the gravity of the penitent's sin, he seems oppressed by a reluctant recognition of the slaughter to come.

In order to confirm the inevitability of Death's presence, Rouault produced *'Man is wolf to man'*. Now the skeletal figure stalks the battlefield itself, dominating the composition with even greater forcefulness than in the previous print. Unlike his predecessor, he wears an army cap and his face possesses more flesh. This time, too, his mouth remains shut, but it is widened in a smile which conveys the extent of his perverted satisfaction. Wherever he strides, extinction ensues. The skulls on the bare earth testify to his lethal powers, and his deeply shadowed eye-socket suggests that he has no need of sight to carry out his purpose. For Death's exterminating will is implemented without discrimination. He simply stretches out his forearms and extends bony fingers towards the ground. This simple gesture is sufficient, and Rouault's use of etching acid ensures that the darkened sky flickers with a corrosive light generated by the figure's malevolence. Writing of *'Man is wolf to man'* in the middle of the Second World War, Wyndham Lewis asked: 'How can man be otherwise than degraded and blasted to the bone and to the bottom of the soul by the awfulness of his servitude to evil? – And how could a "painter of original sin" look at things otherwise than that?'

Rouault dealt with Christ's redemption later in the *War* series (Pl. 360), but for the moment he wanted to concentrate on the plight of those endangered indirectly by the conflict. *'War, hated by mothers'* looks at first like an affirmation of the intimacy between a woman and her child (Pl. 358). There is, however, nothing at all reassuring about their relationship. The son belies his youth by kneeling on his mother's lap and trying to face her. Far from burrowing into her body and rejoicing in their proximity, he asserts his autonomy. With an erect back, and legs ready to rise up, he reaches out to the woman in a decisive gesture more akin to leaving than embracing. For her part, the mother seems aware of the boy's incipient desire for independence. She bows towards him, as though anxious to enfold her child in an arc of protective affection. Her lowered head ends up, nevertheless, in tacit acknowledgement of the fact that the boy's growth will eventually make him eligible for the battlefield. Although her hand still grasps his body, she seems defeated by the inevitability

357 Georges Rouault *This will be the last time, dear father!* 1927. Etching, aquatint and heliogravure, 58.8 × 43 cm. City Art Gallery, Birmingham.

358 Georges Rouault *'War, hated by mothers'* 1927. Etching, aquatint and heliogravure, 58.4 × 44 cm. City Art Gallery, Birmingham.

of loss in a world where men are condemned at an increasingly young age to conscription and death. Darkness has already intervened between the two figures, as a presage of the final separation to come.

In *My sweet country, where are you?*, Rouault reveals the alienation awaiting these young soldiers once they become embroiled in active service. Although the figures in this scene may once have been eager to leave their native country and fight in foreign territory, lassitude has overtaken them in a town they do not even bother to scrutinize. The fatigue and disorientation they experience is more thorough-going than the mood conveyed in Nevinson's comparable painting of *Troops Resting* (see Pl. 170). Instead of bunching together in a jagged pyramid of uniforms and equipment, they sprawl on the ground like the sleepers in the underground shelter images drawn by Henry Moore during the Second World War. The fires ascending into a sky apparently choked with smoke-fumes imply that destruction has taken place, perpetrated either by the soldiers or their opponents. Some houses and a tower still stand, but they have been denuded of identifying features and look as anonymous, now, as the buildings in Bonnard's *Village in Ruins near Ham* (see Pl. 201). Their bleakness echoes the feelings of the men, who seem so demoralized that they may not even know which country they inhabit. All they do recognise is a profound longing for the land of their birth, and a fear that

it could have become equally desolate during their prolonged, see-mingly interminable absence.

In the rest of the *War* series, Rouault emphasizes that none of these mournful figures is likely to return home. Death reappears to stalk the battlefield, and nothing else can be seen on the deserted ground he occupies. The skeletal figure has prevailed over everything, and yet he is no longer the indomitable figure who strode across *'Man is wolf to man'*. Death himself now seems to falter, as though stricken by the same malady he administered to so many others. His right forearm falters as it rises up to deal the next fatal blow, and his knees sag inwards with the effort of struggling to stay upright. Even Death, Rouault appears to be indicating, finds that the unparalleled slaughter of the Great War ultimately has a debilitating effect on him. Gorged on a superfluity of corpses, the exterminator seems to be afflicted by nausea at the height of his triumphal progress. The 'bed of nettles' alluded to in the title of this complex image suggests an intolerable pain, and no amount of killing can ameliorate his malaise.

In the next plate, Rouault stresses the suffering that death imposes on the victim's relatives (Pl. 359). The woman and child, who bear an unmistakeable resemblance to the figures in *'War, hated by mothers'* (Pl. 358), stand stricken at the soldier's feet. They are inconsolable, and incline their heads towards each other in a vain attempt to share

359 Georges Rouault *'The just man, like sandalwood, perfumes the blade that cuts him down'* 1926. Etching, aquatint and heliogravure, 58.5 × 42.2 cm. City Art Gallery, Birmingham.

360 Georges Rouault *'Obedient unto death, even the death of the cross'* 1926. Etching, aquatint and heliogravure, 58 × 42 cm. City Art Gallery, Birmingham.

the grief. Unlike *'War, hated by mothers'*, however, some consolation is at last offered elsewhere in the print. Rouault's title emphasizes that *'The just man, like sandalwood, perfumes the blade that cuts him down'*, thereby hinting at the purifying power of the soldier's sacrifice. Moreover, the upper half of his body does not lie abandoned on the earth. It has been lifted up in anticipation of a rebirth, and the angel supporting him is a muscular, broad-necked protector whose ample wings are eminently capable of enfolding the corpse in a redemptive embrace. In order to reinforce the affirmative meaning of the image, Rouault ensures that the darkness shrouding the main group gives way to a suggestion of daybreak beyond the door. Regeneration is imminent, not only in nature but through contact with Christ as well. For his head, isolated on the veil of Veronica, floats above this twentieth-century Deposition like a promise of the celestial consummation awaiting the dead man. The aureole around Christ pierces the shadows, attesting to the potency of the Godhead presiding over the sorrow below.

The beneficial effect of this divine presence is revealed in the concluding prints from the series, where Rouault finally allows himself to admit an element of hope. *'Arise, you dead!'* concentrates, like Spencer at the Burghclere chapel, on the prospect of a resurrection. Unlike Spencer, though, Rouault does not suppose that the re-

emergent bodies resemble their former selves. Instead, they are as skeletal as the figure of Death who haunted earlier images in the *War* cycle. Their rising is, moreover, unaccompanied by a sense of triumph. Rouault presents it as a painful process, with one corpse on the left hardly seeming capable of heaving the rest of his body from the earth. He stretches his stiff arms with hesitation, unable to convince himself that the grave's constriction has given way to the freedom of the open air. Crosses on the horizon remind him of the incarceration he has endured, and his upturned head flinches as he finds another skeleton descending on him. Spencer's universal feeling of awakened wonder and relief is replaced, here, by an altogether bleaker mood. The central corpse reels backwards to avoid the outflung elbow of the commanding skeleton, whose dark eye-sockets and bared teeth betray no sign of joy.

He does, even so, wear a soldier's cap and appears vigorous enough to resume an independent existence beyond the boundaries of the grave. Rouault's mood is ultimately less excoriating than Masereel's in his 1917 woodcuts, where the same cry of 'Arise, you dead' is interpreted with a sharper amount of mortified despair (see Pls. 236, 237). However gruesome the future may seem for Rouault's wavering cadavers, as they emerge into the blackness of a world where extinction has prevailed for so long, they receive their impetus

from the artist's belief in the idea of redemption through suffering.

In the end, Rouault had faith in the transforming power of Christ's sacrifice, and *'Obedient unto death, even the death of the cross'* affirms the central significance of Calvary (Pl. 360). The figure who dominates this image is in the throes of final anguish, and his sagging head lacks the poise of the face Rouault had depicted on the veil of Veronica (Pl. 359). Moreover, his emaciated body is as vulnerable as the torso of the man subjected to such callous inspection in *Face to face*. Pinioned to a cross from which there is no escape, Christ undergoes the agony of a prolonged and humiliating martyrdom. All the same, in this supreme act of 'obedience' Rouault identifies a source of solace. For the crucified man is transfigured by the light irradiating his head. Its luminosity spreads outwards, penetrating the darkness and offering hope to those slaughtered on the battlefields.

Such consolation is notable by its absence from another great post-war print sequence which sought to confront the human cost of the hostilities. Käthe Kollwitz's series of seven woodcuts called *War* derive their intensity from the anguish she experienced soon after the conflict began. In October 1914 her younger son Peter was killed in Flanders, having volunteered for active service during the initial wave of martial enthusiasm. Devastated by his death, Kollwitz became obsessed by the image of a grief-stricken mother who insists on clutching and hugging a dead child. After 1914, when Peter Kollwitz's loss plunged his mother into bitter mourning, her preoccupation with this theme was understandable enough. Eleven years before the tragedy, however, she had produced a print of a naked woman who enfolds her lifeless offspring in an embrace so fiercely possessive that she seems determined never to let the corpse go. Uncannily, Kollwitz disclosed at the time that the print was based on a drawing, executed with a mirror's help, of herself clasping the seven-year-old Peter in her arms.[57] The woman depicted in the print could almost be trying to breathe some semblance of life back into the pale body, and the attempt disturbingly foreshadows Kollwitz's own frantic desire, after her son's death, to recover him through art.

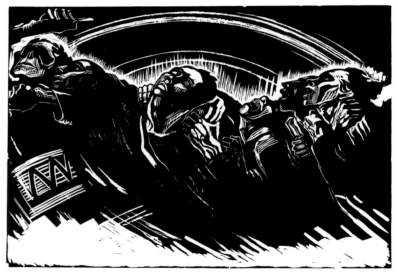

She fought a depression so severe that it threatened to incapacitate her completely, and for years Kollwitz failed to resolve the struggle. In August 1916, for instance, she confessed her dissatisfaction with a new drawing of 'the mother who takes up her dead son in her arms. I could make hundreds of pictures like this but they still wouldn't bring me closer to him. I seek him. As though I would be able to find him in the work. And everything I am able to do is so childishly weak and unsatisfactory . . . I am crippled, exhausted by crying, weakened. I feel like the poet in Thomas Mann: he can only write; to live what he writes is beyond his powers. It's the opposite with me. I no longer have the strength to shape what I have lived. A genius could do it, and a man. But I cannot.'[58]

Eventually, though, Kollwitz did succeed in embarking on a sustained sequence of prints dealing very powerfully with her attitude to the pain of war. In June 1920, impressed by some Barlach woodcuts displayed in the Secession, she began experimenting with the same medium. The initial outcome, a large and tragic *Memorial sheet for Karl Liebknecht*, was so successful that Kollwitz felt encouraged to tackle more personal themes with the greater directness and harsh

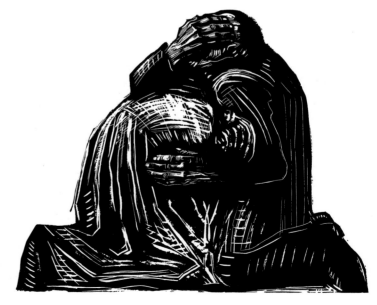

361 Käthe Kollwitz *The Victim* 1922–3. Woodcut, 37 × 40 cm. Kunsthalle, Bielefeld.
362 Käthe Kollwitz *The Volunteers* 1922–3. Woodcut, 35 × 49 cm. Kunsthalle, Bielefeld.
363 Käthe Kollwitz *The Parents* 1923. Woodcut, 35 × 42 cm. Kunsthalle, Bielefeld.

simplicity she had achieved by scoring the wood with her knife. In *War* she wielded her cutter's tool unsparingly, carving into the block like a surgeon intent on slicing with such sureness that every diseased tissue is exposed and eradicated. Just as a surgeon is impelled by the need to discover the truth, and thereby hope to bring about a change for the better, so Kollwitz aimed at locating and combating the anguish she dissected. The outcome went some way towards satisfying even her most demanding standards. 'I have repeatedly attempted to give form to the war,' she told the novelist Romain Rolland in 1922. 'I could never grasp it. Now finally I have finished a series of woodcuts, which *in some measure* say what I wanted to say . . . These sheets should travel throughout the entire world and should tell all human beings comprehensively: that is how it was – we have all endured that throughout these unspeakably difficult years.'[59]

Her central involvement with the mother-child relationship is disclosed in the first *War* print, *The Victim*, which explores the duality of death and new life, protection and loss (Pl. 361). Kollwitz had at last succeeded in defining the image of 'the mother who takes up her dead son in her arms', and she reinforces its sombre mood by juxtaposing the vulnerable white figures with an enveloping black cloak. Its theme is similar to Rouault's '*War, hated by mothers*' (Pl. 358), but Kollwitz intensifies the woman's suffering by giving her a far more demonstrative relationship with the child. Her upraised arms strain with the effort involved in holding her offspring, and she struggles to prevent him from eluding her grasp. Rouault's mother seems, by contrast, resigned to the inevitability of her fate.

This protesting emotion is dramatized still more forcefully in *The Volunteers*, where the physical bond between mother and child is sundered as the army moves off to the Front (Pl. 362). A trio of howling women give vent to their chorus-like distress, and Kollwitz accentuates the fragmentation of their lives by breaking off their figures well before the bottom of the composition. The jagged strokes convey the wrenching pain of departure, and one distraught mother still insists on clutching her son's hand. The grip has already loosened, however. The young soldier, his eyes closed and head thrown back in a trance-like state, is swept along by the irresistible surge of motion propelling him towards the battlefield. Kollwitz makes this suicidal onrush even more formidable by incising an arc in the sky. The ecstatic volunteer submits himself to it, unaware of the fact that a fellow soldier has already been enfolded in a mortal grip by Death. With his other hand, the skeletal leader of the march raises a stick in

365 Käthe Kollwitz *The People* 1922–3. Woodcut, 36 × 30 cm. Kunsthalle, Bielefeld.

the air to beat his drum, confident that the young men will all feel compelled to obey its peremptory rhythm.

Instead of following the volunteers to the Front, Kollwitz devoted the rest of *War* to the plight of those left behind. By doing so, she remained faithful to her own experience of the conflict, and the remaining five prints close in on different aspects of the bereavement theme. In *The Parents* she shows how a grief-stricken mother and father try to support each other (Pl. 363). The woman pitches towards her husband and buries her face in his left arm, thereby locking them into a single dark mass. Kollwitz isolates them against an empty white background, which stresses their bulk and helps to explain why she responded so profoundly to Barlach's work. Since Kollwitz was already planning the memorial figures she eventually erected in a Belgian military cemetery (see Pl. 393), the sculptural emphasis of *The Parents* is comprehensible enough. They both appear to have been hewn from the same rock, and rise up like a mountain of sorrow from the ground.

In so far as the cemetery monument separated the inconsolable man from the woman, to drive home their isolation more strongly, it seems bleaker than *The Parents* print. Despite their physical proximity, though, the interlocked figures in the woodcut are burdened by a more intolerable sense of woe. Without the support provided by her husband's arm, the wife would very probably collapse altogether. The straggling lines cut into her dress transmit the woman's frailty with distressing clarity, whereas in the memorial sculpture she is able to

364 Käthe Kollwitz *The Widow II* 1922–3. Woodcut, 30 × 40 cm. Kunsthalle, Bielefeld.

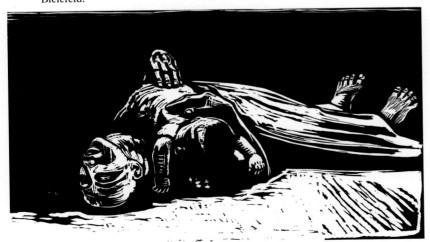

maintain a kneeling position on her own. Compared with his stoical counterpart in the Belgian cemetery, the father here likewise gives vent to a storm of sorrow. He, in turn, relies on his wife's body to support the arm raised towards a face mercifully hidden from view. Although Kollwitz denies us access to his features, we have little difficulty in imagining how contorted they must appear beneath the shielding fingers.

Kollwitz was in no mood to minimize suffering, and her next print strips a grieving woman of all the comfort a husband can provide. For this figure is a widow, and she has been left alone to deal with her loss unalleviated by any help from relatives or friends. She turns inwards, unable to prevent her exhausted head from subsiding on to her shoulder. Two hands stand out, veined and calloused against the funereal blackness of her garment, and they strive without success to supply the comfort she needs. There is something terminal about the grief assailing this woman, whose bedraggled hair and drab clothes surely identify her as one of the working-class patients Kollwitz used to study when they visited her husband's surgery in a poor district of Berlin. The widow in this woodcut may even be pregnant, and the advent of a baby will only make survival more difficult. Deprived of the economic support her husband used to supply, she could easily succumb to the fate of the widow in Kollwitz's fifth *War* print (Pl. 364).

Here, the position of the woman stretched out on the hard floor is reminiscent of Manet's *The Dead Toreador* – a figure itself based on a painting once thought to be by Velázquez.[60] There is the same emphasis on the upturned feet, the hand resting on the body, and the midnight void beyond. Kollwitz, however, injects a far greater degree of expressive emotion into her image. The feet are bare, and the woman's robe is as rough as the bark of a tree. Manet savours the elegance of the toreador's costume, and admits no trace of the suffering he must have experienced during his final encounter with the bull. Kollwitz, on the other hand, tips the widow's upturned face towards the viewer, so that her agony is fully exposed. Moreover, an equally motionless child lies across her breast. Although the mother's hands at one stage tried to protect the infant, Kollwitz's elegiac print implies that the struggle has ended in death for both of them.

As if in panic-stricken reaction to such a fate, the women in *The Mothers* huddle together in a defensive mass. Some children peer out apprehensively from the tightly-packed throng, and two of the mothers press babies against their own faces with wirily resolute hands. The woman on the left appears to be pleading with the forces that threaten them, but her features betray the extent of her alarm. All the offspring are at risk, and there is no guarantee that the solidarity so evident here will offer permanent protection. The arms which reach out to cover other women's backs cannot stay raised for ever. No one is safe from the demands of a war-machine greedy for human fodder, and in the final woodcut Kollwitz shows how easily a mother can feel marooned within a society riven by the conflict (Pl. 365).

Instead of a maternal crowd united by a common resolve to resist, the gaunt woman now finds herself obliged to look after her child alone. Around her jostle faces demented by grief. They look menacing, as though perversely determined to force on the central figure the anguish they are scarcely able to endure. For her part, she glances at them with wary concern. Scarred by privation, this blanched and spectral woman exemplifies what Kollwitz described as 'the gravity and tragedy of the most miserable kind of proletarian existence'.[61] The hand covering her child is resolute in its desire to ward off danger, but the faces encircling her indicate that disaster will be

366 Otto Dix *The Trench* 1920–3. Destroyed.

impossible to avoid. That is why the *War* cycle carries far more conviction than '*No More War!*', a poster Kollwitz produced for the Central German Youth Day at Leipzig in August 1924. Each underlined word possesses the urgency of graffiti scrawled on a street wall, but the fiercely uplifted arm thrusting between them seems powerless to implement its almost frantic belief in the beleaguered cause of pacifism.

The despair laid bare in Kollwitz's *War* sequence was redoubled in the greatest post-war cycle of prints devoted to the conflict. Obsessed by the disparity between his pre-war Nietzschean hopes of a purged and renewed world after the holocaust of battle, and the grotesque reality of carnage and defeat, Otto Dix continued to brood over his experiences as a soldier long after completing the war-cripple pictures of 1920 (Pls. 341, 342). During the same year he began to plan and lay in an extraordinarily elaborate painting called *The Trench* (Pl. 366). Finally completed in 1923, after he had moved into a studio with Wollheim and perhaps been stimulated by the latter's harrowing *The Wounded Man* (see Pl. 326), this elaborate image used heavy impasto and an almost hallucinatory accumulation of detail to condemn the destruction. In this respect, it represented a dramatic departure from the brusque, Dada-influenced style he had employed in the cripple pictures. For all its Expressionist vehemence, *The Trench* marks Dix's definitive move towards Verism and the *Neue Sachlichkeit*. The erstwhile Cubo-Futurist revolutionary now allied himself squarely with a native tradition extending at least as far back as Grünewald. Like Beckmann before him (see Pl. 241), Dix was now proud to draw inspiration directly from the early German school, and he cultivated a pictorial technique which placed great emphasis on a degree of skill and finish redolent of the old masters. Since he had never worked in such a meticulous manner before, *The Trench* absorbed an inordinate amount of his energy. Dix himself complained

that he had undertaken it 'in defiance of all economic sense',[62] and this determination to carry it through demonstrates the urgency of his need to arrive at the heart of his war memories.

The Trench shows just how gangrenous those recollections really were. A few years earlier, while he was still on active service, Dix had drawn a swift charcoal study of two riflemen continuing defiantly to defend their trench by firing over their dead comrades' bodies (see Pl. 204). Now, by contrast, the militarist spirit has been extinguished. Gouged almost beyond recognition by successive bombardments, the trench itself is nothing more than a dumping-ground for the soldiers' shattered corpses. If the macabre landscape of *The Temptation of St Anthony* in the Isenheim altarpiece is evoked, Dix goes further than Grünewald in stressing the desolation of his locale. Very little sky is admitted to a painting where the pummelled mounds of earth are defined with claustrophobic insistence. The only figure who remains outside the accumulation of putrefying flesh and broken weaponry is the man lying on twisted metal above the trench's remains. But he is hideously battered, and his outflung arms and legs have long since been paralysed by *rigor mortis*.

As for the bodies below, they have tumbled down the side of the trench to end up in an open-air charnel-house of festering remains. Occasionally an inverted face or a twisted hand can be discerned among the human detritus. Most of the soldiers are, however, so disfigured that they have been robbed of their individual identity and reduced to anonymous carcasses fit only for worms to feed on. Compared even with the skin afflictions defined with such disconcerting clarity in the Isenheim altarpiece, these victims represent a far more extreme degradation. No residue of heroism is detectable in Dix's rubbish-pit, an image aimed above all at those who were working so hard to rekindle thoughts of martial ardour and revenge among the German people.

They soon exacted their punishment. After completing his suppurating masterpiece, Dix was able to sell it to the Wallraf-Richartz Museum in Cologne. He was paid the substantial sum of 10,000 Reichsmarks, but hostile voices quickly mounted a campaign of vilification against the painting. 'Brains, blood, and guts can be so painted as to make one's mouth water,' protested Julius Meier-Graefe in the *Deutsche Allgemeine Zeitung*, asserting that *The Trench* was 'not just badly but atrociously painted' and 'makes you puke'.[63] Dix might well have been gratified to learn that his picture had induced nausea. It was certainly his intention, and a number of German artists rallied support for the painting in the wake of this attack. 'I consider Dix's painting to be one of the most important works of the post-war period,' Max Liebermann wrote to the Wallraf-Richartz Museum's director. In 1914 Liebermann had been prominent among the artists who produced belligerent propaganda for a swift German victory (see Pl. 61), but now he told the director that 'particular credit is due to you for acquiring Dix's painting for the museum, though I cannot help regretting that it did not find its rightful place in the Nationalgalerie in Berlin.'[64]

Although praise from such an eminent quarter should have been enough to guarantee *The Trench*'s survival, the influence commanded by its enemies was now formidable. The painting was hung behind a curtain and in 1925, only two years after its purchase, the Mayor of Cologne Dr Konrad Adenauer revoked the museum's acquisition and dismissed the director from his post. Such a vindictive action, by the man who would later become West Germany's first Chancellor, was a measure of the militaristic feeling then approaching its hysterical ascendancy throughout the country. Amends were made in 1930, when Saxony's state collections purchased the painting. The respite

was, however, all too brief. Three years later *The Trench* was included in the Nazis' first attempt to discredit artists opposed to their cause. *Images of the Decadence in Art* was the title of this exhibition, a predecessor of the still more pernicious *Degenerate Art* show which hounded so many painters of Dix's generation. *The Trench*, a prime target for all those who wanted to eradicate the humiliation of defeat from Germany's history, became the centrepiece of the Munich *Degenerate Art* exhibition in 1938, and was subsequently toured through Germany as 'a witness to the attempt to undermine the German people's attempt to defend itself'. Then, the following year, the Nazis probably burned it along with Dix's equally uncompromising painting of *War Cripples* (Pl. 340).

A similar reception met the publication, in 1924, of Dix's outstanding print sequence. Its terse title, *War*, belies the epic scale of a cycle encompassing fifty often very elaborate images, many of which deserve to be counted among his outstanding achievements. The Berlin art dealer Karl Nierendorf, who included *The Trench* in a touring pacifist exhibition called *Never again war!*, agreed to publish and promote the series in the misplaced hope that Dix's work would thereby attract a wide audience. For his part, Dix dedicated to Nierendorf an end paper drawing for the cycle (see frontispiece). Entitled *This is How I Looked as a Soldier*, it portrays the artist as a battle-scarred veteran – the man who had fought on both the Western and Eastern Fronts and sustained several wounds as he struggled to survive at Flanders, Champagne and the Somme. He returned to Dresden at the war's end with the Iron Cross (Class II) and the Friedrich-August medal, honours reflecting the tenacity with which he had conducted himself throughout the campaign. Dix remained proud of his toughness, and the drawing defines the narrowed eyes and clenched, stubbly jaw of a man determined to withstand all the bestiality of prolonged combat. 'You have to be able to say yes to the human manifestations that exist and will always exist,' he explained later, pointing out how 'that doesn't mean saying yes to war, but to a fate that approaches you under certain conditions and in which you have to prove yourself.'[65]

At the same time, however, *This is How I Looked as a Soldier* conveys an implicit self-accusation. Six years after the Armistice, Dix is here looking back on the man with the battered helmet and detecting a strain of dehumanized, almost demoniac ferocity in his frowning features. This is a man trained to kill, and he cradles his machine-gun with an intimacy which suggests a disturbing identification between soldier and weapon. Whether or not Dix accepted a measure of responsibility for his metamorphosis into an efficient slaughterer, he certainly admits in his unsettling self-portrait that the military system had brutalized him and, by extension, everyone else caught up in its collective insanity. As if to reveal the consequences of this nightmare, the *War* cycle commences with an image of a *Soldier's grave between the lines*. Indeed, nearly all the ten prints in the first of Dix's five portfolios are concerned with the dying, dead and decaying victims of the martial zeal he defines so frankly in *This is How I Looked as a Soldier*. Even when the depicted soldier is still alive, as in *Wounded (Autumn 1916, Bapaume)*, the man's death throes are presented with such horrifying, contorted conviction that his fate is effectively settled.

The abundance of drawings Dix brought back from the Front helped him to depict the mud-smeared world which still visited his dreams (see Pls. 203, 204, 205). Many years later, he defined the difference between the young man who endured active service and the artist he became a decade later, explaining that 'you don't notice, as a young man you don't notice at all that you were, after all, badly

367 Otto Dix *Wounded man fleeing (Battle of the Somme, 1916)* 1924. Etching on paper, 19.7 × 14 cm. British Museum, London.

affected. For *years* afterwards, at least ten years, I kept getting these dreams, in which I had to crawl through ruined houses, along passages that I could hardly get through. The ruins were constantly in my dreams.'[66] Accordingly, the studies he made for *The Trench* (Pl. 366) formed the basis of several prints in the sequence. But Dix relied on a diverse array of other sources as well. In an ambitious attempt to convey the true extent of his complex feelings about the conflict, he fused personal memories with inspiration derived from artists of the past. During a visit to Switzerland, he found particular fascination in 'Goya, Callot, and earlier still, Urs Graf – I asked to be shown prints of theirs in Basle'.[67] He also drew skulls in the Palermo catacombs during the winter of 1923, and scrutinized with special care photographs from Ernst Friedrich's anti-war publication *Krieg dem Kriege*, enlarged for him by the photographer Hugo Erfurth. In addition, Dix supplemented his own recollections of corpses on the battlefield by attending anatomy classes, where he executed watercolour studies of dead bodies, exposed entrails and brains.

On a technical level, his preparation was no less intensive. Realising that the knowledge of intaglio methods he had gained from previous drypoints left a great deal to be desired, Dix studied etching techniques with Herberholz at the Düsseldorf Academy. The time he

spent there paid off, for the prints in *War* are handled with a consummate grasp of the medium's expressive resources. He knows just how to vary the technique according to the distinct aim of each image. In *Wounded man fleeing*, the dramatic culmination of the first portfolio, he relies on the direct, stabbing force of line alone (Pl. 367). The bandaged face, glimpsed with snapshot swiftness at the Battle of the Somme and never forgotten, harbours the frenzied eyes of a soldier who has encountered sights appalling enough to threaten his sanity. Blood streams from the victim's gashed head and spurts out of his bandaged hand as well, causing him to gasp as he staggers away from the carnage. Dix's brusque and staccato lines echo the man's stumbling motion, confirming the disorientation and panic which transform his features into a macabre mask.

The same whiplash attack is deployed to define total lunacy, when a woman deranged by mourning kneels beside a dead child in the ruins of St Marie-à-Py. Dix's linear ferocity, which stiffens the woman's spiky hair as it explodes from her head in a black outburst of grief, prevents any sentimentality from impairing his work. His etching needle assails the plate with as much singleminded belligerence as the British aeroplane dropping its bombs on Lens, where screaming civilians scatter while the pilot dives low on the pummelled street. Dix concentrates his figures in the foreground and the dis-

368 Otto Dix *Visit to Madame Germaine at Méricourt* 1924. Etching and aquatint on paper, 25.7 × 19.3 cm. British Museum, London.

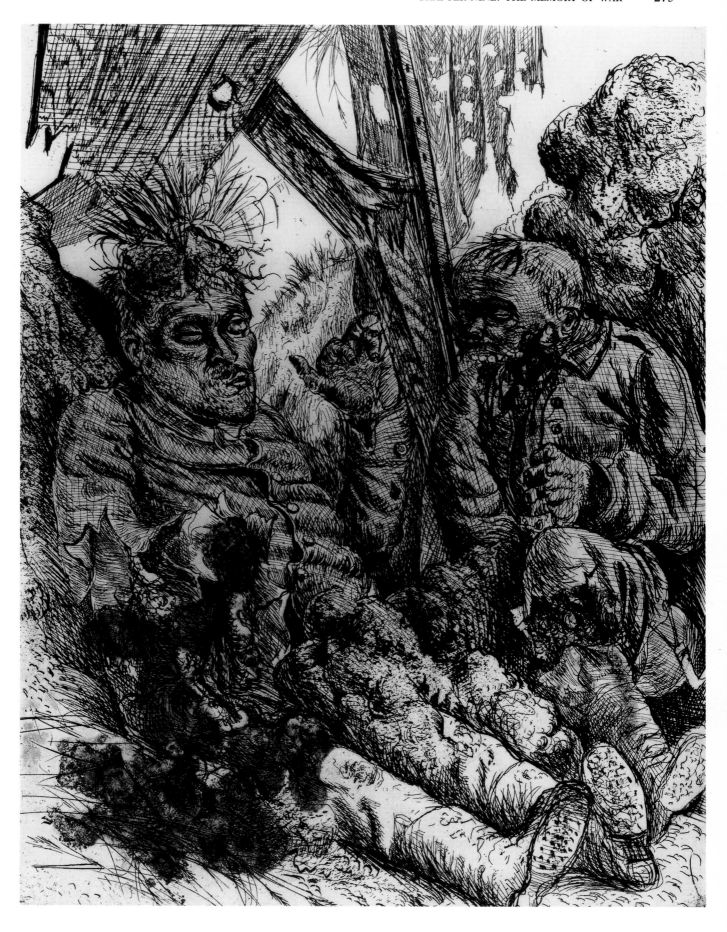

369 Otto Dix *Seen at
the steep slope at Cléry-
sur-Somme* 1924.
Etching and aquatint
on paper, 25.7 ×
19 cm. British
Museum, London.

370 Otto Dix *Skull* 1924. Etching on paper, 25.5 × 19.5 cm. British Museum, London.

tance, leaving the rest of the street so empty that the plane's shadow can register its faint yet eerie presence on the road. This bare thoroughfare also helps him to accentuate the swiftness of the bomber's advent, for the street frontages race back to the horizon with the same unnerving speed and vigour that the airborne apparition commands. Even so, Dix ensures that our eyes finally come to rest on the human cost of the attack, personified in the wild-eyed old woman who almost seems to push herself out of the picture-space as she lurches, screaming, away from the bomber's path.

When the focus shifts in *War* from moments of sudden terror to slower and still more insidious themes, Dix introduces other technical resources. The macabre spectacle of shell-craters near Dontrien lit up by flares is given a chilling edge by the use of relief etching. Its white lines strike through the night with a phantom-like force reminiscent of Urs Graf's woodcuts several centuries before. With their help, Dix delineates a landscape as alien from the natural world as a lunar desert. The craters stretch into the nocturnal void like an array of wounds long since deprived of essential nourishment. Nothing else appears to survive in this abused locale, where extinction has blighted the land with the enveloping finality of a nuclear winter.

At their most unnerving, though, the prints in *War* rely extensively on a corrosive use of aquatint. It enables Dix to expose the decay infecting so many of the scenes he investigates. Sometimes the subject is alive, like the repellent Mme Germaine who still plies her

syphilitic trade at a Mérincourt brothel despite the putrefaction riddling her slack-bellied body (Pl. 368). With one predatory hand clasping the soldier's shoulder and an equally nauseating leg straddling his thigh, she closes on her client like a fatal epidemic. The hypnotized man does not appear to care about the condition of the whore's flesh. Dix implies that he has encountered far too many horrors at the Front to be disconcerted by Mme Germaine's pox-ridden condition. The fact that her upper arm is visible through his cheek suggests a gruesome fusion of the two figures, ensuring that he becomes infected by her proliferating diseases. Perhaps the soldier has concluded that he would rather die in the pestilential brothel than return to the wasteland of war.

Just how unnerving the battlefields have become, in Dix's memory, is clear from the prints which focus unflinchingly on bodies in an advanced stage of decomposition. The third image of the series introduces us to the spectacle of *Men killed by gas*, laid out on a hillside to rot. Their blackened faces and hands already reveal a gruesome amount of decay – so extreme, indeed, that they are no longer identifiable as individuals. The two red cross orderlies standing beside them appear dazed by the corpses and uncertain how to proceed. Paradoxically, however, they also seem less substantial than the dead soldiers. Although disfigured beyond recognition, the gas victims are invested with a grotesque presence which makes the orderlies look strangely flimsy by comparison. The dead, in Dix's

371 Otto Dix *Skin graft* 1924. Etching and aquatint on paper, 19.9 × 14.9 cm. British Museum, London.

372 Otto Dix *House destroyed by bombs (Tournai)* 1924. Etching, engraving and aquatint on paper, 29.7 × 24.4 cm. British Museum, London.

perverse world, are more mesmeric than those left alive.

Take the two soldiers seated on a steep slope at Cléry-sur-Somme (Pl. 369). They appear, at first, to be still conversing. Frozen in the positions they must have held when the enemy arrived, their bodies are prevented by *rigor mortis* from subsiding on to the ground. But the putrescence oozing from the gashes in their uniforms confirms that death arrived long ago. Aquatint helps to give the stains shadowing their bodies a terrible authenticity, while blades of wild grass sprout from the clotted hairs and mangled jelly in one man's exposed brain. It is a vision even more repellent than the spectacle recorded by Robert Graves during the Somme campaign, when he discovered 'a certain cure for lust of blood' in Mametz Wood:

> Where, propped against a shattered trunk,
> In a great mess of things unclean,
> Sat a dead Boche; he scowled and stunk
> With clothes and face a sodden green,
> Big-bellied, spectacled, crop-haired,
> Dribbling black blood from nose and beard.[68]

Some of Dix's most disturbing meditations centre on decay's ability to sustain and indeed nourish new life. The grisly study of a *Dying Soldier* shows wounds in eye, cheek and hand which are crawling with murky activity. While dead leaves flutter down to settle in his gaping mouth, insects appear to burrow through the penumbral yet ominously glinting cavities inflicted by shrapnel elsewhere in

his head. The extinction of humanity breeds ghoulish alternatives, nowhere more repugnantly than in the print called *Skull* (Pl. 370). Every crevice is alive, here, with worms. They coil out of the nose-hole and wave sickeningly in the air. The few tufts of hair that still project from the skull's head attract their burrowing attention as well. Curling with serpentine relish from teeth-stumps, eye-sockets, moustache and jawbone, the worms give the etching an ironic vivacity. They demonstrate that existence of a kind persists even when apocalypse has reduced the terrain of war to a universal burial-ground.

Dix makes clear, however, that these signs of renewal are no substitute for the lives already sacrificed. In a particularly despairing print, *Destroyed trenches*, the gouged hollow acts as an unofficial grave for the corpses slumped in its shadows. They seem this time to be merging with the earth, producing a ghastly compost that threatens to breed diabolic phantoms instead. Because the print is close to the Grünewald-inspired world of *The Trench* (Pl. 366), no sane limit can be set on the monstrous aberrations which might eventually spring from the darkness. Only hybrids, Dix appears to be asserting, can thrive in such desolation.

As for the wounded who managed to survive, *Skin graft* has no hesitation in confronting the true awfulness of their disfigurements (Pl. 371). Dix goes much further than Tonks's earlier studies of facial injuries (see Pl. 176). He juxtaposes the two sides of the patient's face with unflinching frankness. The relative normality of the fea-

373 Otto Dix *Nocturnal meeting with a madman* 1924. Etching and aquatint on paper, 25.8 × 19.4 cm. British Museum, London.

tures on one side makes the agglomeration of mashed and twisted fragments on the other even more disconcerting. The base of the man's elephantine nose has been broken off and wrenched towards his cheek, leaving a dark hole in its place. Beside the reconstituted mouth are remnants of its battered predecessor, pushed violently away from the natural position and still leaving a clutch of teeth exposed to view. The soldier himself bears this hallucinatory damage with numbed resignation. His one normal eye seems glazed as he awaits the next painful bout of operations. Dix is careful to define the man's pyjama jacket with aquatint, stressing his vulnerability and the likelihood that his stay in hospital will be prolonged. The stripes on his jacket echo the iron bedstead behind, which curves round the patient's head like the bars in a prison window. They act as a metaphor for the plight of a man trapped within a face so misshapen that he will never escape from the limitations it imposes.

But at least he is still living, unlike most of the people whose agony is laid bare in the unrelenting images of *War*. Far more typical of the portfolio is the woman dangling upside-down from the exposed structure of a house shattered by a bombing-raid at Tournai (Pl. 372). The form assumed by her body is a direct tribute to Goya's *Ravages of War* in the *Disasters* cycle – a precedent which had already been saluted in Jaeckel's remarkable print sequence of 1914–15 (see Pl. 131). Dix may well have been impressed by Jaeckel's achievement, but *House destroyed by bombs* is the product of an independent vision as well. Unlike either Goya or Jaeckel, Dix frames his composition with the building's broken walls. Its corner has been blown apart to disclose the devastation within, where naked legs are suspended among the rafters while night-clothes and bedding hang forlornly from splintered floorboards. A possible echo of Kollwitz's *The Widow II* (Pl. 364) can be found at the bottom of the sheet—a dead mother whose blood-smeared baby lies motionless across her body.

The stimulus provided by Goya's *Disasters* cycle undoubtedly spurred Dix in his ambition to create a graphic series of extraordinary power and authority.[69] *War*, however, is not excessively dependent on his profound and accelerating respect for tradition. Just as he must have admired Goya's resolve to let the *Disasters* rest on a secure foundation of personal testimony, so he made sure that his prints stayed close to the obscenity of the carnage witnessed with his own eyes at the Front. Dix specified the locations of the scenes in many of his captions, so that even an image as spectral as *Meal-time in the ditch (Loretto heights)* is firmly anchored in first-hand observation. Wrapped up against the cold, a soldier feeds himself from a rudimentary can without paying any overt attention to the skeleton decomposing beside him. But the skull might once have been the face of a comrade, and its presence here suggests that the soldier no longer has enough energy to accord him a proper burial. All he seems capable of doing is staying alive, and his staring eyes suggest that the unreality of the surroundings have driven him insane.

Several prints in *War* deal with outright lunacy, most notably a phantasmic image called *Nocturnal meeting with a madman* (Pl. 373). Wandering among the ruins of a village, a youth whose head seems too large for his emaciated body looms out of the debris. Although he stands in near-silhouette against the moonlit devastation beyond, his ribs are visible beneath the shirt and both eyes shine out like glowworms from his otherwise obliterated features. We do not need to see any more of his face in order to appreciate the extent of its derangement. Shell-shocked and doubtless crazed by the death of family and friends as well, this anonymous itinerant confronts the unseen artist like a startled animal.

Another etching, *Dug-out*, proves that Dix has no intention of

374 Otto Dix *Dug-out* 1924. Etching and aquatint on paper, 19.5 × 28.7 cm. British Museum, London.

presenting that madness as the preserve of civilians (Pl. 374). For the hunched figure clasping his hands in the foreground of the shallow, claustrophobic space bears a distinct resemblance to the nocturnal madman. He cowers in the lamplight, behaving so strangely that the card-player behind appears to be shouting at him. Quite apart from dreading the prospect of another day's warfare, the semi-naked soldier might easily have been unnerved by the stifling conditions in this makeshift shelter. Dix emphasizes the severe compression of space, so that everyone seems crammed together to an intolerable extent. Compared with these beleaguered card-players, their counterparts in Léger's great painting of 1917 enjoy a far greater amount of elbow-room (see Pl. 214). The constriction in the dug-out is almost intolerable, and the men attempting to sleep are slotted into low, narrow niches redolent of a mortuary. Like the men stretched out in the predella panel of Dix's later *War Triptych* (see Pl. 402), they appear to hover between survival and extinction.

Ultimately, though, this gruelling cycle insists on the inescapability of death. Despite the intimations of renewal in some prints, Dix would never have permitted himself to betray the horror of his experiences by stressing regeneration too often. *Shell crater with flowers*, one of the few etchings directly dependent on a wartime drawing, lacks the conviction of the most impassioned images in the series. Its restraint borders on the picturesque, whereas *Dance of death, 1917 (the dead man's mound)* is charged with a wild, raw vehemence which reveals the full measure of Dix's engagement (Pl. 375). Although the title attests to his awareness of Holbeinesque precedents, there is nothing self-consciously historicist about this print. It derives above all from the urgency of the artist's own need to come to terms with a memory of soldiers impaled on barbed wire and stakes after a futile advance. The ungainliness of their outflung and contorted limbs gives these corpses a ghastly animation for an instant, as blazing light picks them out in the gloom. This is the choreography of slaughter, where bodies take on a paradoxical vitality in the frozen flamboyance of their death throes. Fascinated by such grisly contradictions, Dix devoted the final image in the sequence to a pair of decayed heads grimacing and snapping at each other. The title discloses that he had seen them in front of the position at Tahure, doomed to appear forever exclaiming over the fate which condemned them to such an end. Caught halfway between screeching and snarling, they exemplify Dix's determination to confront even the most repellent of the de-

375 Otto Dix *Dance of death, 1917 (the dead man's mound)* 1924. Etching and aquatint on paper, 24.4 × 29.9 cm. British Museum, London.

pradations he had come across during his years in active service.

When *War* was published, in an edition of seventy sets, many critics greeted it with acclaim. The portfolios were exhibited in several German and Austrian cities, and a reasonably priced book edition containing twenty-four offset reproductions with an introduction by Henri Barbusse sold well. Barbusse, already celebrated as the author of the fiercely anti-war novel *Le Feu*, confirmed the condemnatory strain in the cycle. Erich Maria Remarque shared Barbusse's admiration, telling Dix in later life how much *All Quiet on the Western Front* was anticipated by the imagery employed in *War*. Remarque's response to the prints accorded with the sentiments expressed by the critic of *Berliner Zeitung am Mittag*, who declared that 'anyone who sees these images and does not vow to oppose war with heart and soul can hardly be called human.'[70]

In one significant respect, though, such calls had a counter-productive effect. However loudly the reviewers demanded that *War* should be acquired by all the important graphic art collections, most of the prints failed to sell. Only one set from the edition of seventy was purchased, by a private individual. Although 1924 had been declared International Anti-War Year, German museum directors, aware of the controversy surrounding Cologne's acquisition of *The Trench* (Pl. 366), probably felt nervous about the political consequences of buying Dix's latest reflections on the conflict. Friedrich Heckmanns has argued that 'the history of the work is, to an exemplary degree, the history of its suppression'.[71] As the humiliating Armistice receded in time, more and more Germans refused to accept the verdict which Dix had so bravely insisted on delivering. The memory of war was already being traduced, and in years to come it would endanger the lives of those who continued the struggle to tell the truth.

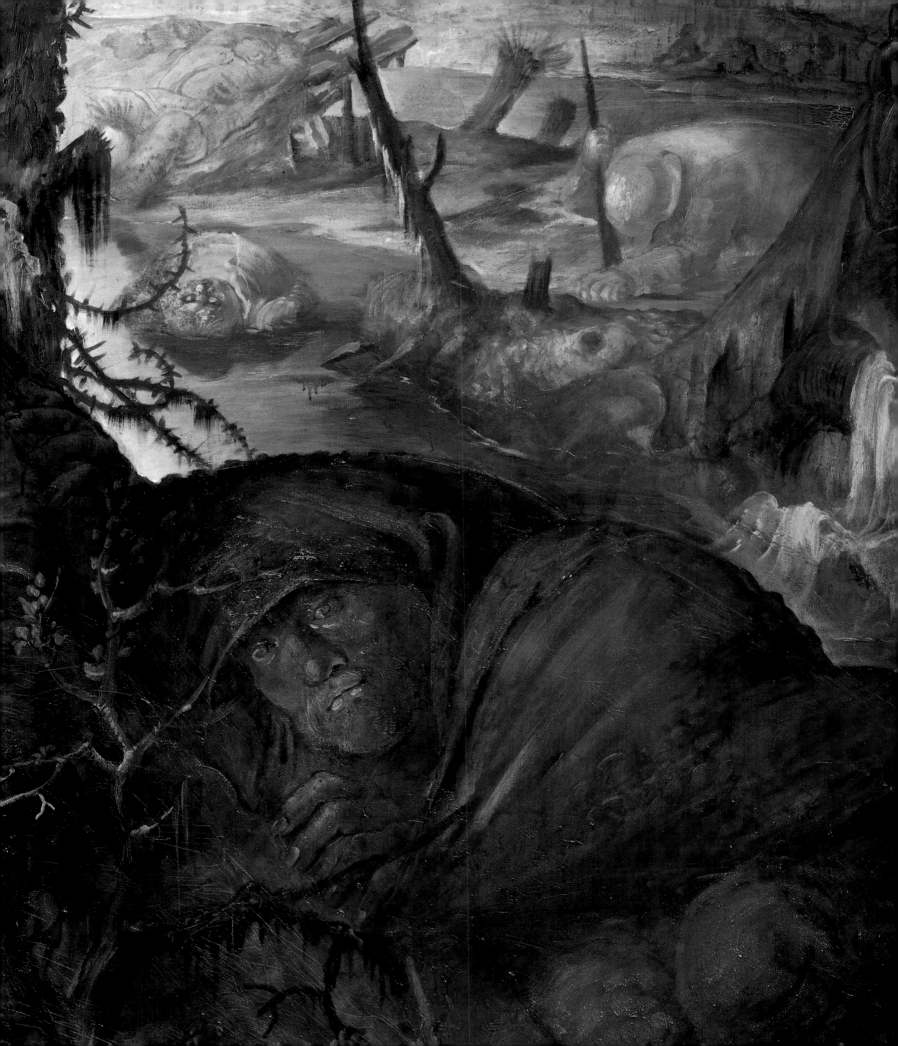

CHAPTER TEN
DESPAIR AND REDEMPTION

As the economic slump deepened during the 1920s, many war veterans even in the victorious countries began to suspect that their contribution had been overlooked. Growing unemployment and niggardly pensions for the disabled seemed a grotesque reward for men who had fought so hard to win the peace, and the immediate euphoria of the post-war period soon gave way to a widespread sense of resentment. The new society which they had hoped to see rising from destruction never transpired, and on most war memorials the former soldiers looked in vain for a direct representation of the part they had played at the Front. 'Allegorical figures mean little to the average person,' observed James Stevens Curl, 'while lugubrious angels, naked heroes in classical poses, and mock-heroic images of war can attract ridicule or induce a sense of outrage in those who have taken part in the deadly, numbing, dehumanizing horrors of battle.'[1]

Charles Sargeant Jagger, who had been wounded twice during the conflict and awarded the Military Cross for his courage, was in a better position than most sculptors to appreciate the importance of the soldiers' efforts. From the outset of his prolific career as a carver and modeller of war memorials, he had placed the ordinary Tommy at the centre of the monuments he planned. Images of soldiers storming a barricade, bandaging an arm, brandishing broken chains and carrying a kit bag dominate the preparatory drawings he produced around the time of the Armistice. Jagger would have liked every memorial he executed to concentrate on such figures, for he often argued in favour of 'showing the Tommy as I knew him in the trenches'.[2] Two commissions he undertook for Bedford and Brimington in the early 1920s depict chivalric, medievalized warriors, but he seems to have made them with reluctance. They lack the conviction of the memorials where Jagger dealt with contemporary imagery. In 1921 he described how 'some elderly members of a memorial committee came to my studio to look at a figure of a soldier. It did not please them. They thought the putties were done up too untidily, that the tin hat was too much on one side, and that altogether the Tommy wasn't respectable or smart enough for their memorial. In the end they decided not to have the soldier but a pretty symbolical figure of Victory instead.'[3]

The gap between the priorities voiced by these 'elderly members' and the needs of war-veteran spectators resulted in memorials as remote from present-day reality as Adrian Jones's predictable Cavalry Memorial in Hyde Park. The armoured figure raising his sword towards heaven belonged to a mythical and frankly archaic world

Left: Otto Dix *Flanders* 1934–6 (detail). See Pl. 404.

which had long since lost its power to reflect the experience of machine-age war. Jones's only direct reference to the cavalry's activities at the Front was relegated to a frieze running round the base of the sculpture.

Such an approach was rejected by Jagger in the majority of the memorials he produced during the 1920s. At Hoylake and West Kirby in Lancashire, he ensured that the side of the monument bearing the principal inscription was accompanied by a bronze figure of a contemporary soldier braced for action. The commissioning body had at one stage suggested that the memorial's obelisk might stand alone, unaccompanied by any representations of army life.[4] But Jagger's insistence on a rugged and unsentimental Tommy, bareheaded and holding a rifle across his body to block the enemy's path, prevailed in the end. This is a workaday soldier, grimly capable of killing the German enemy whose helmet lies like a trophy at his feet. He stands free from the obelisk, whereas the personification of *Humanity* on the other side of the Hoylake memorial is buttressed by projecting stone blocks. Draped in medieval robes and bearing a child in a mandorla, the woman seems utterly removed from the realism Jagger employed in the soldier. If she symbolizes the peace which the Tommy is determined to protect, the Art Nouveau style used throughout her figure points towards the past rather than the future. *Humanity*'s late nineteenth-century form-language suggests that Jagger was unable to visualize, let alone believe in, the compassionate new world which was supposed to flower after the war.

Still haunted by memories of his experiences at Gallipoli, which had lent such conviction to his earlier *No Man's Land* relief (see Pl. 317), Jagger was incapable of indulging in optimistic rhetoric about the future. He admitted, when invited to produce a crucifixion in the 1920s, that his mind 'had been troubled by doubts about whether it was possible to have faith in a God who allows wars to happen'.[5] Hence his determination, when he secured a major commission to produce the Royal Artillery Memorial for a prime site at Hyde Park Corner, to shun any expression of facile hope or harmony. Anodyne figures of naked heroes, like the muscular youth who posed for Frederick Derwent Wood's statue on the Machine Gun Corps Memorial (Pl. 376), were disgracefully irrelevant and Jagger wanted nothing to do with them.

But what could he provide instead? An image of protest might seem the only adequate response, and yet a condemnation of war would easily upset people whose relatives had been killed. Nobody suffering from the loss of a husband, wife, fiancé or children desired a monument angrily advancing the view that the conflict had been a gory farce. Nor would Jagger have dreamed of supplying such a

memorial, even in the unlikely event that his patrons might have accepted it. On the other hand, he was sympathetically disposed to those who had fought the war and then discovered that poverty was their only reward in peacetime. They would have been understandably offended by a monument which proposed that the Armistice was ushering in an era of triumphant fulfilment.

Although there was no easy answer to the problem, Jagger was fortunate enough to deal with a body of men who welcomed his standpoint. The minutes of the Royal Artillery War Commemoration Fund Committee have survived intact, and they reveal that both Lutyens and Derwent Wood were strongly favoured on the initial shortlist for the memorial. When asked to place a realistic gun on top of the mighty stone block, however, they both refused. Such a literal reference to the instruments of war was wholly unpalatable, whereas Jagger raised no objection when invited in 1921 to produce a scale model of the scheme. Surmounting the memorial with a gun was commensurate with the priorities of a sculptor who wanted the monument to be 'distinctive of Artillery and of its period'.[6] Moreover, he told the *Daily News* in July that 'his experience in the trenches persuaded him of the necessity for frankness and truth ... "I got to love the Tommy in the trenches and I've tried to show him as I knew him – not as he looked on parade at home." '[7] Accordingly, Jagger resisted any notion of incorporating the symbolism of peace in the Artillery Memorial. Since it was supposed to commemorate men killed on active service, the imagery he employed should not be diluted by references which detracted from a rightful emphasis on the soldiers themselves, arrayed in the correct accoutrements and accompanied by the equipment they would have used.

Work on other memorials, to which he had given prior commitment, prevented him from executing the final monument immediately after his scale model was accepted. But Jagger remained faithful to the priorities he had outlined in 1921. With the help of the architect Lionel Pearson, who would later assist Spencer when the Burghclere chapel was built, he settled eventually on a stone pedestal incorporating four reliefs, each including a depiction of a different type of gun to supplement the massive 9.2 Howitzer on top. In addition, three bronze figures of a Gunner, an Officer and a Driver would stand on the north, east and west side of the memorial respectively. At the south end, the plan was to instal 'a feature in bronze',[8] the subject of which had yet to be decided. In retrospect, Jagger's unwillingness to reveal the identity of this image until the last moment can be seen as a shrewd tactical calculation.

The memorial itself turned out to be his masterpiece, and in the bronze figures he concentrated on a stern, gaunt and unsentimental portrayal of men standing guard over the dead (Pl. 377). Wisely discarding any trace of the heroism he had flirted with in his drawings around 1918, Jagger opted for absolute stillness. His professor at the Royal College of Art had been a friend of Jules Dalou, whose restrained and authentic figures of workers for a projected *Monument to Labour* surely helped Jagger arrive at the unselfconscious *gravitas* of the men who preside over the Artillery monument. The Driver's outstretched arms quietly evoke the crucified Christ, but none of the figures strains for a spurious significance. Solemn without becoming portentous, and disdaining any indulgence in grand rhetorical gestures, they personify the dignity of the soldiers who had earned Jagger's admiration during the war years.

He was even allowed, at a late stage in the execution of the commission, to include a bronze body of a dead Tommy on the south end, anonymous beneath a coat shrouding the top of his face (Pl. 378). If Jagger had argued for its inclusion any earlier, he might well

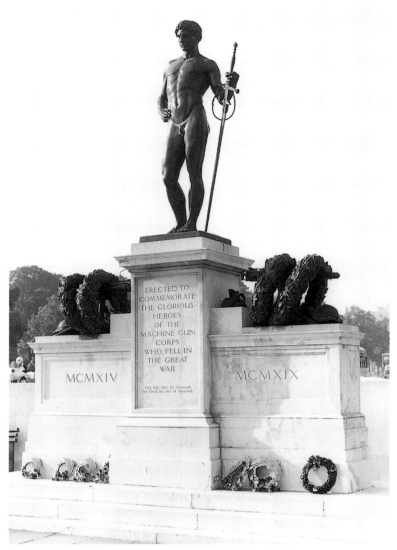

376 Frederick Derwent Wood *Machine Gun Corps Memorial.* Stone and bronze. Hyde Park Corner, London.

have been refused permission. Some members of the committee complained about its 'gruesomeness', and Colonel Lewin tried to prevent it. Jagger, he thought, had no right to use the war memorial 'as a means of forcing home on the minds of the public the horror and terror of war'.[9] In the end, though, the committee accepted that the recumbent soldier gave the memorial a 'proper finish', and approved of the argument that it thereby commemorated the dead as well as the living.

This ultimate embodiment of Jagger's refusal to glorify war sums up the obstinacy of a monument which sacrifices glib jingoism in order to assert a more deeply felt level of feeling. Lord Curzon complained after the unveiling in 1925 that the memorial looked like 'a toad squatting, which is about to spit fire out of its mouth ... nothing more hideous could ever be conceived.'[10] But initial denunciation of, among other things, 'the dead man behind'[11] eventually gave way to the widespread realisation that, as a young gunner commented at the unveiling, 'he is real. All the [bronze] men are real.'[12] Jagger's stoical, resolutely prosaic figures answered a profound need to acknowledge, without martial posturing, the central role of the ordinary soldier in the conflict, and even the crowning image of the howitzer

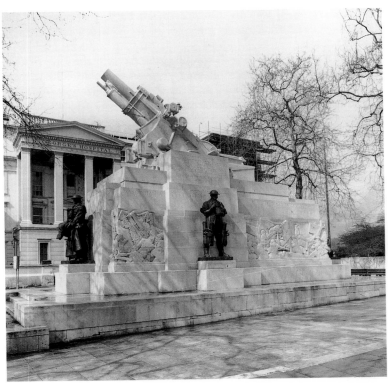

377 Charles Sargeant Jagger *Royal Artillery Memorial* (east side) 1921–5. Stone and bronze. Hyde Park Corner, London.

evaded any brazen assertion of militaristic values. In bronze, this redoubtable weapon would have unbalanced the entire ensemble and become oppressively menacing. In stone, however, it looks as blanched as the Assyrian-inspired reliefs which run round the base of this curiously frozen monument. They all appear to inhabit a region of glacial melancholy, petrified by the tragedy of the conflict which ensnares their tense, straining bodies. At Hyde Park Corner Jagger was able to translate this perception into a memorial which fuses pathos with endurance, and achieves in the end a hard-won stoicism from its confrontation with death.

Although the war was now seven years distant, 1925 also witnessed the completion of another monumental assertion of its continuing unavoidability. Like Jagger, Marcel Gromaire insisted in *The War* that the common soldier deserved a prominent place in an image of the conflict (Pl. 379). Gromaire did not, however, share Jagger's willingness to depict the fighting man as a poised, dignified figure. Nor did *The War* ally itself with the almost documentary realism employed in the Royal Artillery Memorial's bronzes. Aware of Post-Impressionism and Cubism alike, Gromaire strips his soldiers' features and uniforms of all the incidental detail which Jagger found so engrossing. The clenched, block-nosed fighters who inhabit *The War* seem as metallic as the armoured observation shield behind them. Along with the even more morose and visored men staring out of the trench beyond, they imply that the war spirit will never go away. An implacable belligerence still lurks throughout Europe, waiting to be reawakened. Hence the sense of grim expectancy in these men, who appear to have settled permanently into the dun-coloured declivity behind them.

Gromaire enjoyed general acclaim when he exhibited *The War* at the Salon des Indépendants in 1925. Many critics were impressed by

the certitude with which he presented the principal trio, encased in their blue granite greatcoats against the cold. A year later his painting of *The Banks of the Marne*,[13] exactly the same size as *The War* and possibly conceived as its counterpart, again won praise – this time for its optimistic celebration of bathing and rowing at a location where the war had once been at its fiercest. The inference here was that the French army's victory made this riverside idyll possible, but *The War* still offered an implicit reproach to anyone who imagined that the tensions responsible for the Great War no longer existed. Dour and immoveable, the soldiers have wedged themselves into the battle zone like diehard veterans who refuse to relinquish the front-line positions they fought so hard to maintain.

However grim Gromaire's conclusions may have seemed to the Parisian audience who viewed *The War* at the Indépendants, they were certainly borne out by contemporary events in Germany. Unrest in this inflation-ridden, humiliated and resentful society was developing apace. The chronic instability prompted Grosz to set about painting a sequence of what he described as 'modern historical pictures'[14] diagnosing Germany's gathering post-war malaise. In many respects, the results were a continuation of the large-scale canvases he had produced several years earlier – the inferno-like *Dedicated to Oskar Panizza* and its lost successor *Germany, a Winter's Tale* (see Pls. 251, 324). Throughout the intervening period Grosz had concentrated largely on graphic works which achieved far wider circulation than the easel paintings and earned him considerable notoriety. Among the most elaborate is a 1921 drawing entitled '*We are coming before our righteous Lord to pray!*', where the embodiments of social authority already pilloried in *Germany, a Winter's Tale* are subjected to even greater indignities. In 1926, realising the potential of this rasping image, Grosz took it as the starting-point for an unprecedentedly irreverent and, indeed, scatological canvas called *Pillars of Society* (Pl. 380).

Unlike *Germany, a Winter's Tale*, where the representative of the church merely lifts his hand in hypocritical benediction, this new painting is dominated by a sadistically leering priest who flings out both arms to greet the advent of violence. His plump hands appear to condone the destruction of the building above, and they could even be fanning the flames which rush from its blackened windows. At the same time, the treacherous cleric closes his eyes and turns his head away from the two offensive armies wading into war with blood-smeared swords and other weapons freely brandished. Grosz distinguishes between the left-wing worker-soldiers who charge to the left,

378 Charles Sargeant Jagger *Recumbent figure, Royal Artillery Memorial* 1921–5. Stone and bronze. Hyde Park Corner, London.

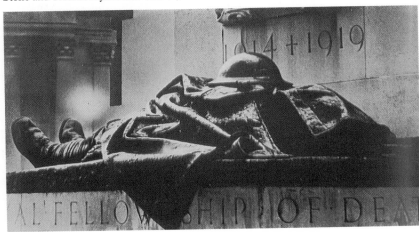

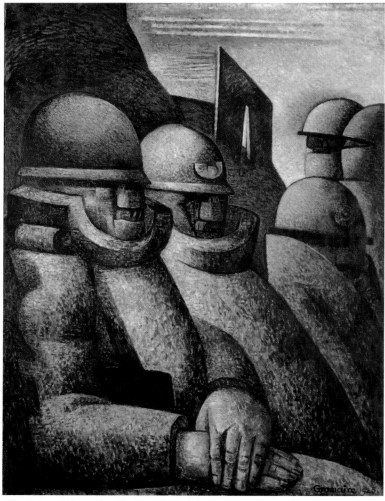

379 Marcel Gromaire *The War* 1925. Oil on canvas, 127.6 × 97.8 cm. Musée d'Art Moderne de la Ville de Paris. Girardin Collection.

and the right-wing officers advancing in the opposite direction. He had, by now, become disillusioned with the unquestioning Communist solidarity favoured by friends like Herzfelde and Rudolf Schlichter. 'You're right,' he told Otto Schmalhausen, 'someone who mocks and fails to respect the fetishes of his comrades in the proper and prescribed way finds himself out on his own in the end. My crime was to have poked gentle fun at left-wing fetishes, Communist Party bosses, worthy functionaries, salaried soldiers of the revolution... How quickly such Marxist authorities become offended. And what about me? Well, I must come to terms with the usual role: "That one's a traitor, he is... he's a petty-bourgeois anarchist." '[15]

While the loosening of Grosz's Communist Party ties is reflected in *Pillars of Society*, its principal venom is reserved for the reactionary figures arraigned below the armies and the church. One of them, a portly figure who stares with glazed eyes through a pince-nez, clutches a pamphlet called *Socialism Means Work*. His jingoist leanings are brandished by the childish nationalist flag he clutches in his fleshy paw, and his head is cut open to disclose a pile of freshly deposited excrement still steaming in the fetid air. His companion professes pacifist tendencies by waving a palm leaf, but his sharp little teeth and irritable frown reveal an innate pugnacity. The nationalist newspapers bunched so possessively under his arm likewise indicate

bellicose priorities, and the absurdity of his views is mocked by the inverted chamberpot enclosing his brain like a caricatured military helmet.

All the same, Grosz reserves his greatest bile for the vicious, monocled Nazi who thumps his beer-glass on the table. The fencing scars wriggling across his inflamed cheek recall similar rapier slashes on the face of the cross-eyed council official in *Grey Day* a few years earlier (see Pl. 344). This time, though, he clasps an upraised sword and sports a swastika on his trim blue tie. With a prophetic accuracy quite remarkable in 1926, Grosz identifies emergent Fascism as the

380 George Grosz *Pillars of Society* 1926. Oil on canvas, 200 × 108 cm. Staatliche Museen zu Berlin – Preussischer Kulturbesitz, Nationalgalerie.

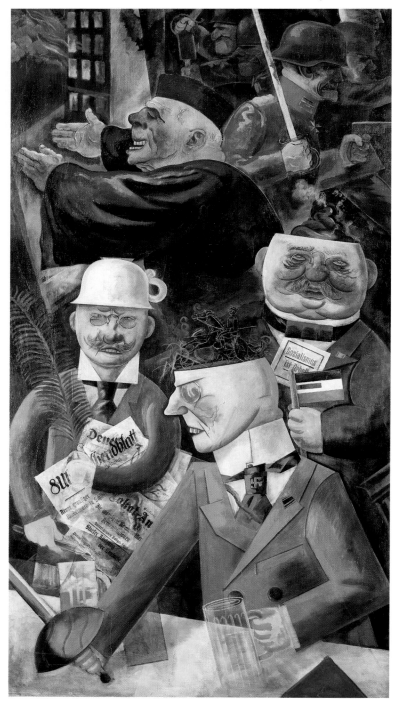

most alarming threat of all. Moreover, the Hitlerian ruthlessness of the future is foreshadowed with uncanny precision in the Nazi's sliced-off head. For a cavalryman rides out from the otherwise empty skull, trampling on the pages of the German constitution as he emerges from obscurity. No image could more succinctly summarize the contempt for the law shown by the unprincipled militarism which would dominate Germany over the following decade. In 1937, Hitler and his advisers revenged themselves on Grosz by including his pictorial indictments in the notorious *Degenerate Art* exhibition, where they were branded as 'Deliberate Sabotage of National Defence.'

No one knew better than Grosz how the forces of Fascism cloaked all their constitutional violations in a show of political respectability. This is the theme of a still larger allegory painted in the same year, although its title, *Eclipse of the Sun*, directs the viewer's attention towards the economic pressures behind Germany's post-war sickness (Pl. 381). Hovering above a screen at the top of the picture, the sun's disc has been covered by a dark dollar sign. It alludes to the stifling effect of the Dawes Plan, instituted two years before in order to stabilize the inflationary Deutschmark. Grosz realised that it left German politics obsessed by the issue of the annual reparations debts – a burden which pushed the country's rulers towards an ever more belligerent stance. In *Eclipse of the Sun* the extinguished disc presides over a governmental meeting attended by four decapitated statesmen. Their stiff wing collars, coat-tails and spats display a spruceness which belies the abject passivity of their politics. The papers lying on the green baize table in front of them are blank, and they connive at the rampant bellicosity of a President whose attitudes were shaped as a general during the Great War. Flushed and snarling, the laurel-wreathed Hindenburg thrusts his medal-bedecked chest towards the table and leans on it with proprietorial arrogance. The anti-clerical feeling revealed in *Pillars of Society* reappears here in the form of the President's crucifix, swathed in the red, white and black of the nationalist stripes. He could almost be praying in front of it, but the bloody and tasselled sword jutting across the baize shows where his priorities really lie. Nothing, not even the church, can prevent militarism from gaining ascendancy in this conference chamber. The only person to have the President's ear is the top-hatted armaments manufacturer, whose pink-jowled head leans forward and whispers to Hindenburg. The cluster of machines and weapons under the magnate's arm proves that he is already producing the instruments of war in profusion, but his industrial ambitions make him greedy for more.

In a preparatory drawing for *Eclipse of the Sun*, Grosz placed a gun carriage in the centre of the table. By the time he executed the painted version, however, it had been replaced by a donkey whose eyes are covered with blinkers bearing the imperial eagle. Instead of occupying the middle of the table, the animal is obliged to stand on a yellow board near the edge. All it can see are the transparent papers stacked in a manger which rests on a section of the board projecting into space beyond the table. Once the donkey shuffles forward to eat, like a blindfolded victim forced to walk the plank, it will tip up the board and plummet downwards. Even if the animal did not disrupt its precarious equilibrium, a skeleton lurks below ready to tug the board off the table. Close examination discloses that an eyelet, lodged in the end of the board, is attached to the skeleton by means of an undulating white cord. A swift pull, and the donkey tumbles into a penumbral region akin to the charnel house of war.

If Grosz intended the blinkered animal to symbolize the stupidity and myopic gullibility of the German people, *Eclipse of the Sun* warns that Hindenburg and his cronies will soon pitch their country into

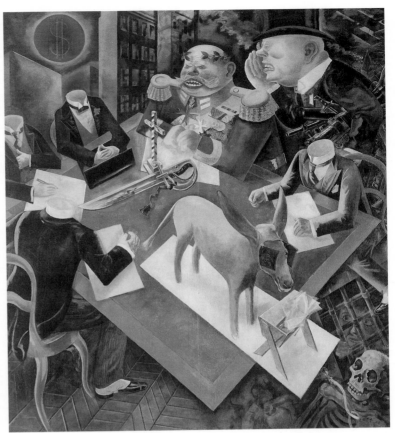

381 George Grosz *Eclipse of the Sun* 1926. Oil on canvas, 218 × 188 cm. Collection of the Heckscher Museum, Huntington, New York. Museum purchase.

another disastrous bloodbath. But what of the boy staring so apprehensively through the bars of a cell sunk into the floor beneath the table? M. Kay Flavell proposed that the young prisoner 'can be read as a representation of Grosz himself . . . reliving the fear provoked by his father's death.'[16] However well-founded this speculation may be, Grosz surely had no desire to confine the boy's significance to such an autobiographical source. If he stands for the artist, he also personifies the children of Germany as a whole. Trapped within a subterranean prison from which he cannot escape, this helpless embodiment of the emergent generation anxiously waits for his country to descend once more into armed barbarity.

Despite the prescience with which Grosz diagnosed his nation's ills in this pessimistic satire, he soon came to feel that his target should be more specific. Hindenburg, an ageing relic of the military past, could no longer be regarded as a fundamental threat. The true menace was posed by the prodigious rise of Hitler, who had lost no opportunity after the publication of *Mein Kampf* in 1925 to hector, bully and lie if such tactics furthered his propagandist cause. By 1928 Grosz was ready to pillory this ruthless manipulator of patriotic emotion in a painting, and *The Rabble Rouser* was the agitated result (Pl. 382). The archetypal teutonic philistine portrayed a decade before in *Germany, a Winter's Tale* (see Pl. 324) has now lost his complacency altogether. This hectic little orator seems galvanized by hysteria. Steam rises from his apoplectic face as he shouts out the slogans of racism, jingoism and martial resurgence. The tongue protruding from his mouth implies that his frenzy is akin to an epileptic fit, but beneath the florid outburst of hatred and indignation lurks a calculating tactician. Although Grosz mocks the childishness

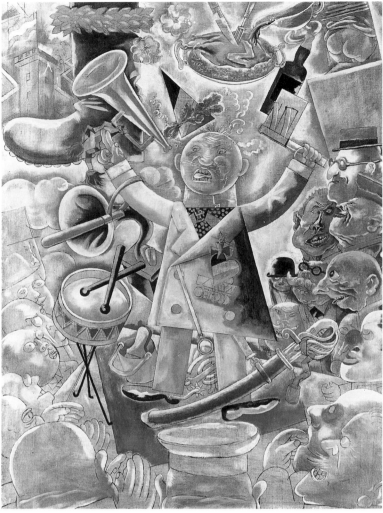

382 George Grosz *The Rabble Rouser* 1928. Oil on canvas, 108 × 81 cm. Stedelijk Museum, Amsterdam.

of the demagogue's sentiments by placing a dunce's cap above his head and a toy rattle in his left hand, the presence of a loudhailer, drum and gramophone show how determined he is to broadcast his views so loudly that alternative voices cannot be heard.

The effectiveness of his message is disclosed in the uppermost area of the composition, where military glory is coupled with other, more immediately seductive images. An outsize army boot, replete with studs, spurs and triumphant laurel wreath, stands guard next to a crenellated tower surmounted by a flag. But these symbols are placed near a roast chicken, alcohol and the plump, provocative cheeks of a woman's bared buttocks. Sex, food and drink are equated with the escalation of martial strength, and the medals festooning the agitator's coat display pride in his supposed prowess as a fighter in the last war. Even his gingerbread heart is divided into the ubiquitous red, white and black stripes, and the colossal sword dangling from his trousers evokes – like Hindenburg's blood-stained blade in *Eclipse of the Sun* – a nostalgia for a romanticized form of hand-to-hand combat removed from the mechanized reality of modern warfare.

Although Grosz stopped short of giving the rabble rouser Hitler's features, he made the identity of the propagandist clear enough. For a brush lies in a bucket of paint at the agitator's feet, and Hitler's detractors had already nicknamed him 'The House-Painter'. However preposterous his strutting may appear, Grosz did not make

the mistake of underestimating the ranter's appeal. The proletarian and petty-bourgeois crowd assembled on the right are just as appreciative as the upper-class audience on the left of the podium. The ideologue has succeeded in concocting an argument with broad appeal, and the fervour with which it is received by his grinning listeners shows how popular he has become. Grosz by now saw no room for a Communist triumph in this feverish manipulation of the national mood. The swastika pinned to the rabble rouser's spotted necktie proclaims his Nazi loyalty without equivocation, and his aggressive delivery shows how Fascism rose to dominance by playing quite shamelessly on the Germans' growing need to overcome the humiliation they had undergone.

383 Otto Dix *Metropolis* (left panel of triptych) 1928. Mixed media on wood, 181 × 101 cm. Galerie der Stadt, Stuttgart.

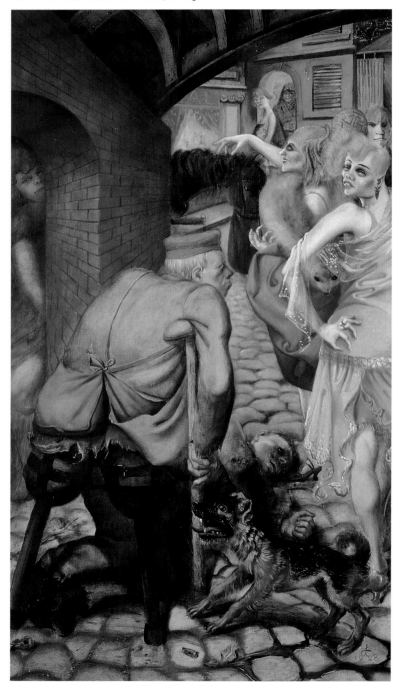

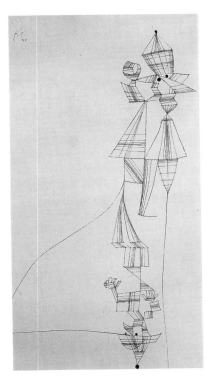

384 Paul Klee *Statuettes of Disabled War Heroes* 1927. Ink on laid paper mounted on light cardboard, 26.7 × 13.7 cm. The Metropolitan Museum of Art, New York. The Berggruen Klee Collection, 1984.

In this mood, the plight of the war's victims was deliberately overlooked. The few artists who persisted in depicting them knew that such images flouted the national impatience with negative references to the past. Dix, displaying characteristic obstinacy, devoted one wing of his large *Metropolis* triptych to a street scene where prostitutes swagger scornfully in front of a war cripple (Pl. 383). He is depicted now in a more conventional style than the disabled figures who had peopled Dix's paintings of the early 1920s (see Pls. 341, 342). His humiliation, however, is conveyed with equal severity. While a dog barks at his wooden legs, the veteran leans on his crutch and stares frustratedly at the whores who belittle him with every glance. He is as much of an outcast as the homeless man slumped on the cobbles beside him, and their privation is starkly contrasted with the Jazz Age revels elsewhere in the triptych. By according the despised and marginalized figure a prominent place in his painting, Dix deliberately incensed all those who wanted to disregard these symbols of Germany's shame.

No wonder that Klee saw the cripples as wispy, vulnerable beings when he drew them in 1927. *Statuette of a One-Armed Officer* outlines a fragile, toy-like creature who teeters uncertainly on one side of an otherwise empty sheet. His strangely detached legs scarcely seem capable of maintaining their balance as they perch, with the utmost difficulty, on a line sloping downwards at a precipitous angle. In a related drawing called *Statuettes of Disabled War Heroes*, the principal figure seems slightly more substantial in his billowing cloak (Pl. 384). But the spindly ink contours defining him still emphasize that he may at any moment snap in half, and his companion dangles upside-down like a discarded marionette who no longer serves any purpose in society.

These poignant little drawings seem, as Sabine Rewald observed, to be 'made out of thin black wire'.[17] Around the same time Picasso resorted to wire itself when making some proposals for a monument to Apollinaire. He had been asked to design it by a committee of Apollinaire's friends, who wanted to instal the memorial on the poet's grave in Père Lachaise cemetery. Picasso submitted several drawings

and maquette-sized sculptures, including a *Metamorphosis* of swollen and twisted limbs related to his contemporaneous paintings of bathers. The most austere and memorable proposals were, however, a group of somewhat larger constructions in metal wire (Pl. 385). While based on the human figure,[18] they cut loose from anatomical restraints as Picasso develops the idea of drawing in three dimensions. The outcome, while paying tribute to Apollinaire's innovative *élan* in a suitably experimental manner, also possesses a rigour bordering on harshness. Some of the lines traverse the body of the sculpture with a piercing severity. They evoke wounds rather than *joie de vivre*, and suggest that Picasso's appreciation of Apollinaire's achievement as a writer was overshadowed by a sense of loss. For Apollinaire, weakened by a head injury sustained in battle, had succumbed to Spanish influenza at the very moment when Paris was celebrating the Armistice. Picasso was grief-stricken, and his wire sculpture seems above all else a stark elegy to a friend whose life had been senselessly cut short by the war. Fourteen years after he had portrayed Apollinaire as a volunteer artilleryman in a spirited little sketch (see Pl. 53), his final meditation on their relationship was redolent of melancholy, etiolation and sacrifice.

Although enough money had been raised to produce the memorial, it was never erected. None of Picasso's proposals satisfied the committee, and he remarked later that 'I can't make a muse holding a torch just to please them.'[19] The wire sculptures were probably considered too astringent, but they now seem a wholly understandable and appropriate distillation of the emotions which Apollinaire's death had aroused in his old friend. The committee contented itself with a monolith designed by Serge Férat instead, and the full power of Picasso's proposed monument only became evident in 1972 when he gave a much-enlarged version of the repudiated *Wire Construction* to the Museum of Modern Art in New York.[20]

In contrast to the abortive story of Picasso's Apollinaire memorial, Paris did succeed in acquiring a great monument to the peace when Monet's sublime water-lilies decoration was officially dedicated at the Musée de l'Orangerie on 17 May 1927 (Pl. 386). The artist himself had died six months before, faithfully attended by the politician responsible for bringing the ambitious mural scheme to fruition as a tribute to France's victory in the war. Clemenceau had long been an ardent admirer of Monet's work, and as early as 1895 he published an article complaining that nobody had purchased the complete series of *Rouen Cathedrals* to preserve them *in toto* as the artist hoped. Clemenceau roundly berated the French President, Félix Faure, for failing to secure them as a national treasure. The Rouen series would, he claimed, ensure that 'France will be celebrated long after [Faure's] name will have fallen into obscurity.'[21]

Although Monet was no rampant patriot, and had avoided military duty by fleeing the country when the Franco-Prussian War commenced in 1870, he did possess a profound love of France. The sequences of paintings he devoted to grainstacks, poplars and Rouen during the 1890s can be seen, respectively, as hymns to his country's fecundity, liberty and artistic past. What Paul Hayes Tucker described as Monet's 'deep-rooted feelings for his homeland'[22] should not be underestimated, especially when taken in conjunction with his desire to see Impressionism accepted as the great national movement in French art of the late nineteenth century. In 1893 these impulses led him to create at Giverny his own garden idyll, complete with water-lily pond and Japanese bridge. Four years later he began painting this aquatic nirvana, and at the same time Monet envisaged a special installation of water-lily canvases. 'One imagines a circular

385 Pablo Picasso *Wire Construction* (offered as a maquette for a monument to Apollinaire) 1928. Metal wire, 50.5 × 40.8 × 18.5 cm. Musée Picasso, Paris.

room', he told a reporter in the summer of 1897, 'the walls of which, above the baseboard, would be entirely filled by water dotted with these plants to the very horizon, walls of a transparency by turns toned green and mauve, the still water's calm and silence reflecting the opened blossoms; the tones are vague, lovingly nuanced, as delicate as a dream.'[23]

Monet's hopes of working on such a scale were first hinted at five years earlier, when his friend Rodin nominated him for a government commission to paint murals in the Paris City Hall. He was rejected on that occasion, but when the initial water-lily paintings were displayed at Durand-Ruel's Paris gallery in 1900 he found himself hailed by some critics as a national glory. According to *La Chronique des Arts*, the series exemplified 'the genius of an impassioned and measured people', and 'to discredit it is to discredit France.'[24] Such sentiments help to explain why the ultimate water-lilies decoration would be accepted by the state as a memorial to the war, and why Clemenceau was so eager to revive Monet's long-postponed interest in the project when the Great War broke out.

In his capacity as president of the armed forces committee, responsible for mobilizing the nation's military, Clemenceau now regarded his neighbour Monet as an embodiment of the cultural richness which Germany's offensive threatened to destroy. There was no suggestion at this stage that the water-lilies sequence should become a celebration of France's hoped-for victory, but in 1915 Monet did attribute his new-found energy to the advent of war. 'I am working a great deal,' he wrote to a dealer, 'which is still the only way

to avoid thinking so much about what is happening.'[25] He was worried not only about the danger facing his country, but the safety of his son Michel fighting at the Front. Living in near-solitude, Monet followed the events of the conflict each day in the newspapers and was often able to hear gunfire in the distance. The lines of wounded soldiers passing his gates distressed the painter profoundly, but he had no desire to leave the house and move to a less alarming locality.

Planning the unprecedented vastness of the water-lily panels afforded him relief from his anxieties, and Clemenceau helped him to obtain materials and a work-force for the construction of a large new studio commenced in July 1915. Its completion enabled Monet to work on the panoramic scale he wanted for the water-lily venture, buoyed up immeasurably by the government's willingness to commandeer trains and bring colossal canvases from Paris, along with supplies of oil paint and coal to heat the studio. Monet immersed himself in the project, pausing in the summer of 1917 only to consider carrying out a government commission for a painting of Reims Cathedral after it was damaged by German bombs. By August the following year he could invite René Gimpel and his friend Georges Bernheim to enter the studio and view what an astounded Gimpel described as 'a strange artistic spectacle: a dozen canvases placed one after another in a circle on the ground, all about six feet wide by four feet high: a panorama of water and water lilies, of light and sky. In this infinity, the water and the sky had neither beginning nor end. It was as though we were present at one of the first hours of the birth of the world.'[26]

As the size of the paintings indicates, this was not the series ultimately installed in the Orangerie. But a few months later, the defeat of Germany prompted Monet to make Clemenceau a momentous proposal. On 12 November, only one day after the Armistice was signed, he told his old friend that 'I am on the threshold of completing two decorative panels that I want to sign on the day of victory, and I am going to ask you as my intermediary to offer them to the state. It's not so very much, but it's the only way in which I can participate in the victory. I would like the two panels to be placed in the Museum of Decorative Arts, and I would be happy if they were chosen by you.'[27] Clemenceau lost little time in visiting Monet to discuss the selection of a water-lily painting and a weeping willow canvas. As Charles F. Stuckey pointed out, 'the former could be understood as a symbol of the triumph of light over the forces of darkness, and the latter as a symbol of national grief.'[28] In the end, though, Clemenceau persuaded his friend to reconsider the gift and think instead of giving the nation the whole sequence of water-lily pictures in honour of the French victory.

Although Clemenceau's electoral defeat in January 1920 delayed the finalization of the scheme, Monet remained for the moment firmly in its favour. The ending of the long war meant a great deal to him, as René Gimpel had discovered when he visited Giverny soon after the Armistice. A discussion about London 'led us to talk of King George V's arrival today in Paris,' Gimpel wrote, 'and of the departure of the troops and their scheduled parade under the Arc de Triomphe. "You'll come and see them?" Bernheim said to Monet. "No, I think not," he replied. "I'm too susceptible; I'll die of emotion."'[29] But he was determined to convey his feelings on the grand scale in his decorations, and the first plan centred on a custom-built gallery in the grounds of the Hôtel Biron where Rodin's Museum had recently been created. Worries about gaining Parliamentary approval for the cost of such a building led to an alternative scheme involving either the Jeu de Paume or the Orangerie. Dissatisfied with

386 Claude Monet *The Grandes Décorations* (Room 2) with *Clear Morning with Willows* and *Reflections of Trees* 1927. Musée de l'Orangerie, Paris.

both of them, Monet angrily told the Fine Arts Minister Paul Léon in 1921 that 'if I have proceeded with this large project, it has been with the idea of a special room in which each of the different motifs ought to be shown along a curve. You must recall, moreover, that from the outset I made this a formal condition. Today, with the Orangerie, given the room's insufficient width, I would need to show the different motifs absolutely straight and thus pervert what I wanted to do. I well know that there are important reasons that prevent you from acting as you would wish, and that is why I perceive the necessity to renounce [the scheme].'[30]

The entire venture might have terminated here, but by the end of the year the government agreed to renovate the Orangerie by installing the curved walls Monet wanted. On 12 April 1922 he signed a legal contract of donation, which stipulated that nineteen canvases would be submitted two years later and glued to the walls. Although the process ended up flattening his expressive impasto, Monet probably wanted to ensure that his paintings would never be removed from the interior designed to contain them. He had, after all, expended an enormous amount of time on the project already, and the revised Orangerie interior meant that he was obliged to modify the canvases already executed. It was a period of intense frustration, further exacerbated by the deterioration of Monet's eyesight and the operations he underwent to avoid the onset of blindness. His attempt to meet the deadline proved 'a veritable torture for me, given the condition of my vision.'[31] He obtained an extra six months from an increasingly impatient Ministry and then, in October 1924, Clemenceau finally decided to step in. Threatening never to see Monet again if the canvases were not transported to Paris, he castigated the artist for conceiving 'the absurd idea of improving' pictures 'of which the majority were and still are masterworks, if you have not ruined them . . . You requested the postponement of yours, and with my intervention you obtained it. Myself, I was of good faith and do not wish that you would have me pass for a flatterer who committed a disservice to art and to France in order to submit to the whims of a friend. You must conclude artistically and honourably

because there is no "if" in the obligation you have undertaken.'[32]

By this time, however, Monet was an infirm octogenarian who could not be persuaded to relinquish his decorations. 'I no longer sleep because of it,' he complained, describing how 'at night I do not cease to be haunted by what I am attempting to realise.'[33] Clemenceau reluctantly accepted that the old man should be allowed to fulfil his aim, and the canvases were never despatched to their destination during Monet's lifetime. Only after his death in December 1926 were the decorations at last installed in the two-room interior designed for them by the architect Camille Lefevre according to plans submitted by the artist.

Visitors entering the oval rooms, austere in their simplicity but still surprisingly intimate, found no direct reference to the war in any of Monet's paintings. The consistent serenity of the world created here does, nevertheless, issue from his passionate belief in the salvation to be found in a close relationship with nature. By presenting as his monument to peace a vision of paradise undefiled, Monet offered a healing alternative to the wartime images by Vallotton, of French landscapes ravaged by unprecedented destruction (see Pls. 198, 199, 200). His devoted nurturing of the garden at Giverny can be seen as the antithesis of the battering inflicted on the countryside elsewhere. This cosseted oasis of flowers, water and foliage had maintained its luxuriant buoyancy throughout the long years of combat and devastation. Five years before the war broke out, when he exhibited forty-eight of his earlier water-lily paintings at Durand-Ruel's gallery, Monet outlined his developing ideas about a circular dining-room adorned with *nymphéas* images. 'Carried the length of the walls,' he explained, 'enveloping the entire interior with its unity, it would attain the illusion of a whole without end, of a watery surface without horizon and without banks; nerves overstrained by work would be relaxed there, following the restful example of the still waters, and to whomsoever lived there, it would offer an asylum of peaceful meditation at the centre of a flowery aquarium.'[34] Once war had been declared, however, and Monet came to realise the horrifying extent of the damage inflicted on France's countryside and inhabitants alike,

his ideas about the need for such a haven would have intensified immeasurably. The Orangerie decorations testified to the survival and regeneration of nature after the near-extinction it had suffered in the war zone. Although a mortar shell damaged two of the canvases[35] during the Second World War, they have survived along with the rest of the installation as a testament to the enduring resilience of the Eden Monet cherished.

Nothing in the oval rooms was permitted to disrupt the overall mood of calm, contemplative fulfilment. While working on these canvases, Monet had also been capable of producing images as agitated and inflammatory as the *Weeping Willow* now in the Musée Marmottan.[36] But the Orangerie panels are utterly serene, and concentrate on motifs as nebulous as the reflection of clouds in water, or the feathery descent of willow branches towards the lily-pond's edge. The presence of willows in several of the decorations raises the possibility that Monet might have regarded them as symbols of mourning (Pl. 387). It would, however, be unwise to pin them down to such a role. Although the widest canvas in the entire scheme is devoted to *The Two Willows*, hanging at the narrow end of the second room, it cannot be described as a melancholy image. Positioned at either side of the acutely curving picture, the trees arch over the petal-strewn water with a delicacy and artifice which precludes any full-blown expression of grief. Indeed, they seem incidental compared with the principal area of the painting, where deliquescence predominates with soothing consistency.

The size of the decorations, and their ability to surround the spectator with an enveloping panorama, reinforces this emphasis on melting expanses of colour. Throughout the two rooms Monet relies largely on a soft, pervasive blend of blue, violet and green, which promotes a sense of rapt quietude. When the canvases are approached for closer examination, they quickly engulf the viewer in a sea of endless dissolution. It transcends all normal cognitive expectations, conflating sky with water and solid forms with the reflections they cast in the tranquillity of the lily-pond. The all-embracing water appears to have no definable limits; and the presence of dawn and evening in the same room defies temporal boundaries, so that the entire diurnal round is distilled into a single, gently encircling experience. Only one canvas departs from the tonal discretion of the installation as a whole: the superb *Setting Sun* on the west wall of the first room. It flares into an outburst of pink and yellow radiance which brings the decorations to an efflorescent close, for visitors on their way out are obliged to return to the first room and encounter this image at the end of their tour as well as the beginning. It is an appropriate finale, summing up Monet's consolatory awareness that the waning of the light can be just as resplendent as the advent of day.

387 Claude Monet *The Grandes Décorations* (Room 2) with *The Two Willows* and *Clear Morning with Willows* 1927. Musée de l'Orangerie, Paris.

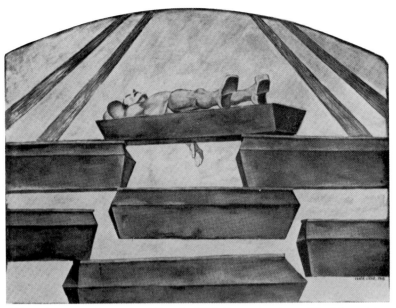

388 Albin Egger-Lienz *Death Sacrifice* 1925. Fresco on plaster. War Memorial Chapel, Lienz.

By this time, however, artists elsewhere in Europe were experiencing conflicts with authority over the memorials they produced. The final phase of Egger-Lienz's career was much taken up with the planning and execution of murals in a war memorial chapel at Lienz. Since he had been born in Stribach, Lienz, the project was something of a home-coming for the artist. As the son of a well-known church painter, he might also have regarded the decoration of the chapel as his contribution to a family tradition. There was, however, nothing conformist about his approach to the chapel paintings. Egger-Lienz regarded them as an opportunity to arrive at a final summation of his most uncompromising earlier war images. One of the 'practice-pieces' he executed in 1925 to familiarize himself with the fresco technique was *Attack*, a partial reworking of the gaunt, crouching soldiers who had advanced across a bleak terrain in his formidable 1916 painting *The Nameless Ones, 1914* (see Pl. 147). The remarkable similarity between the two pictures shows how little his view of the war had altered in the intervening years. He still saw the combat as an ordeal, reducing all its hunched and apprehensive participants to the level of anonymous victims whose faces already acknowledged the near-certainty of their imminent extinction.

No gratification could be found in the chapel for those who, like Egger-Lienz's fellow-countryman Hitler, wanted to avenge the defeat of 1918. Instead, on one wall the finality of the grave was rammed home in a severe fresco called *Death Sacrifice* (Pl. 388). Nothing could be more forbidding than the figure of the soldier, still dressed in his army uniform and laid out on the coffin which will soon enclose his body. Compared with the dead Tommy in Jagger's Royal Artillery Memorial, who was unaccompanied by a coffin and had at least been covered by a coat (see Pl. 378), Egger-Lienz's corpse is far more chilling. Preliminary pencil studies and a charcoal cartoon[37] for the soldier's face testify to the trouble he took over the delineation of the man's upturned features. His mouth still gapes open as it did in the moment of death, and no attempt has been made by a mortician to lessen the signs of the soldier's agony. Egger-Lienz has left a large space beneath the coffin so that the corpse's left hand is clearly visible, dangling in the void. His position can be related to the similar figure in the centre of *Missa Eroica*, the funereal canvas painted

during the final year of the war (see Pl. 246). The upturned boots in both images are almost identical, but *Death Sacrifice* shows the soldier with his head thrown back and helmet lying loose behind him. Moreover, the other corpses strewn across the cratered earth in *Missa Eroica* have given way to a series of stacked coffins, assembled in an eerie vault. *Missa Eroica* still held out the possibility that one or two of the inert soldiers might still be alive. No such hopes can be entertained in *Death Sacrifice*, where the grim array of wooden boxes forecloses any speculation about survivors from the battlefield.

The only solace offered by Egger-Lienz is the resurrection fresco on the east wall of the chapel (Pl. 389). Naked except for a minimal loin-cloth, Christ is shown standing within his open coffin. His steady gaze and erect bearing exude an assurance which counters the haggardness in his face. He is clearly determined to arise from death, and the flag beside him is beginning to unfurl with a hint of buoyancy. All the same, Egger-Lienz stops well short of the triumphant ascendancy found in so many resurrection images. This is a Christ as exhausted by the protracted agony as Epstein's bronze figure (see Pl. 329). He is far closer to the slow, ashen deity emerging from the tomb in Piero's San Sepolcro fresco than to the soaring apparition who irradiates the night sky in the Isenheim altarpiece, which provided Dix and other German artists with inspiration for

389 Albin Egger-Lienz *The Resurrection* 1925. Fresco on plaster. War Memorial Chapel, Lienz.

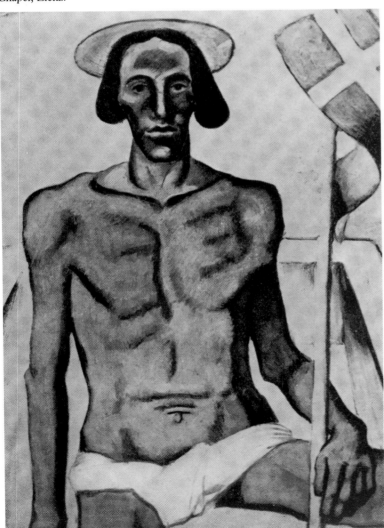

their images of the conflict. By resisting the urge to give his Christ any airborne afflatus, Egger-Lienz remained true to his resolutely dour vision of the war. The integrity of his imagination provoked a severe penalty from the church, however. Soon after its completion, the memorial chapel received an edict from the Vatican forbidding services to be held there. It was still in force when Egger-Lienz died the following year, and a quarter of a century passed before the ban was finally lifted.

All the same, his frescoes were at least executed and permitted to survive on the chapel walls. In this respect, Egger-Lienz proved more fortunate than Frank Brangwyn, who in 1924 had been asked to produce a sequence of wall-paintings in the Royal Gallery of the Palace of Westminster. The scheme was initiated by Lord Lincolnshire, the Lord Great Chamberlain. He decided that such a cycle of decorations would make an appropriate contribution to the war memorial which the members of the House of Lords planned in commemoration of their slaughtered sons and brothers. Once Lord Iveagh had agreed to finance the venture, Brangwyn enthusiastically accepted the invitation to carry out a scheme which would, in theory, enable him to realise his ambitions as a muralist on the grand scale.

No doubt conscious of the fact that he was about to embellish a highly sensitive site, at the heart of the British Empire's parliamentary system, Brangwyn insisted on a single proviso. He asked his patrons to agree 'that he should be left entirely alone to carry out the work, that when his decorations were completed, *and not before*, they should be placed in the Royal Gallery for which they were designed, and then, when the complete series was executed and visible as a whole, the whole scheme could be accepted or refused.'[38] Once Lords Lincolnshire and Iveagh had given their consent to this important stipulation, the artist devoted all his redoubtable energies to the venture.

Part of this preliminary caution may reflect Brangwyn's awareness that his prolific work during the war as a poster designer had aroused controversy. He was criticised in Britain for depicting 'the seamy side of war',[39] and there certainly is a Bellows-like fascination with violence in some of his designs. For a poster captioned *Put Strength In The Final Blow: Buy War Bonds*, Brangwyn had no hesitation in showing a Tommy thrusting his bayonet into an adversary who, stunned by the force of the blow, falls backwards off a precipitous rocky outcrop. Nothing so ferocious can be found in the images produced for the Royal Gallery scheme. One panoramic panel was given over to the theme of *The Call to Arms and the Departure for the Front*, where no hint of violence can be detected among the jostling figures who gather for embarkation on the quayside of a great port.

There is, however, a significant difference between the studies for some of the large paintings and the final images. In his preparatory design for *The Gun*, most of the battery crew seem wholly absorbed in the business of loading and firing. By the time Brangwyn executed the definitive picture, he had decided that several of the most prominent figures should be pausing from their labours and staring, in consternation, at a comrade lying prone on the ground. A similar change is traceable during the evolution of *The Tank*. In the study, the foreground is largely occupied by a group of soldiers standing at ease, while the up-ended tank appears to rest in a declivity. The finished painting, though, offers a far more agitated scene (Pl. 390). The once-quiescent infantrymen are now shown in the middle of an advance, and as they run over the debris of bombed buildings their attention is caught by a falling soldier. As for the tank, it has grown in size and rears up behind them like a monstrous harbinger of mechanized warfare. The confusion and tumult of battle are con-

390 Frank Brangwyn *A Tank in Action* 1925–6. Tempera on canvas, 366
× 376 cm. National Museum of Wales, Cardiff.

veyed with all the illustrative dexterity at Brangwyn's command. Most
of the soldiers seem dazed and apprehensive while they stumble over
the rubble, and the air behind them is dark with dense, acrid smoke.

Although Brangwyn spent two years working on this elaborate
mural sequence, and completed a number of monumental paintings,
it was summarily rejected. When Lord Iveagh saw the scheme, he
became 'reluctant to perpetuate' scenes which 'inevitably tended to
remind spectators of the "miseries of war." '[40] Brangwyn had felt
impelled to include something, at least, of the horror of battle. But

his patron was presumably hoping for a more sanitized presentation
of combat, and flinched at the explicit references to violence and
death. Perhaps Iveagh had been envisaging images closer in spirit to
David Ewart's stirringly entitled *These Shall Our Hearts Remember*,
a dogged attempt by an Edinburgh portrait painter to mark the
Armistice's tenth anniversary with an evocation of stoical endurance.

At all events, Brangwyn found himself obliged to put the entire
scheme aside and start all over again, hampered by the strange new
condition that the war memorial should not contain any direct refer-

ences to war itself. With typical ebullience, he tried out a variety of alternative themes, including the heraldic, and opted in the end for a wholly symbolic solution celebrating the Eastern and Western parts of the British Empire. 'Renouncing all idea of depicting historical events and actualities,' Frank Rutter wrote, 'Mr Brangwyn conceived a synthetic panorama of the beauty of Greater [*sic*] Britain. Instead of showing, as in the first scheme, what our soldiers, sailors and airmen fought *with*, in this second scheme Mr Brangwyn reveals what the Forces of the Empire fought *for*. All these peoples, all this wealth of material resources, this luxuriant beauty of fruit and flowers, forest and animal life which the fighting forces had preserved for the Empire, these should be the subject of the British Empire Panels.'[41] The outcome was an exuberant scheme, banishing the pain of war and insisting that the tragedy of young soldiers' deaths should give way, perversely, to unequivocal rejoicing in the richness of 'Greater' Britain's world-wide and eminently exploitable possessions.

While Brangwyn worked on them, the political climate throughout Germany grew even more intolerant of war memorials which openly acknowledged the reality of defeat and death. Erich Maria Remarque, who set his novel *The Black Obelisk* in the premises of a Funeral Monuments company called Heinrich Kroll and Sons, described how German attitudes towards the conflict underwent a complete transformation. 'The war which almost every soldier hated in 1918', he wrote, 'has slowly become, for those who survived intact, the great adventure of their lives.'[42] In Kroll and Sons' business, the change is symbolized by the fate of 'a huge sandstone block' waiting to be carved in the workroom. 'A dying lion is to be created out of it, but this time not one bowed with toothache but roaring a last defiance, a broken spear in its flank. It is to be a war memorial for the village of Wüstringen where there is a particularly belligerent veterans' organization under the command of Major Wolkenstein, retired. The sorrowing lion was too much like a washrag for Wolkenstein. What he would really like is one with four heads spewing fire from all its mouths.'[43] In 1918, Remarque explained, the veterans' organization had been pacifistic. Now, however, 'it has become strongly nationalistic. Wolkenstein has adroitly transformed the memories of the war and the feelings of comradeship, which almost all of them had, into pride in the war. Anyone who is not nationalistic desecrates the memory of our fallen heroes – those poor, mistreated fallen heroes who would all have loved to go on living.'[44]

This kind of thinking sealed the fate of the memorial which Barlach was invited to make for the dead of the Great War in Güstrow Cathedral. He relished the opportunity. At long last, the commission offered him the 'sacred room' he wanted for his sculpture, and he produced a bronze figure of an angel suspended above the tomb of the war's victims (Pl. 391). Although the angel's eyes are closed, he seems omniscient and gravely aware of the tragedy over which he presides with compassionate dedication. Barlach's desire for absolute simplicity led him to dispense with the wings which another, more ostentatious sculptor might have been tempted to flourish. Everything is focused on the calm, hovering steadfastness of a mourner whose permanent presence seems intended to protect and bless the dead soldiers below. Even if Barlach's beliefs kept him at a distance from the Christian church, the Güstrow Memorial is ideally suited to its austere ecclesiastical setting. Moreover, it fully atones for the callow enthusiasm with which he had greeted what he once called *The Holy War* in his militant *The Avenger* of 1914 (see Pls. 38–39).

To the Nazis, though, the Güstrow angel was unacceptably melancholy. They removed the angel in 1937 and melted it down, and

391 Ernst Barlach *War Memorial* 1927. Bronze, 71 × 74.5 × 217 cm. Güstrow Cathedral.

censorship was also meted out to the wood memorial which Barlach had been invited to carve for the cathedral at Magdeburg. With the assistance of two young sculptors, Bernhard and Marga Böhmer, he was able to carry out the complex task of cutting the six figures from three separate tree-trunks (Pl. 392). Flanked by two standing soldiers representing youthful ignorance and seasoned obedience to the military system, a monumental figure dominates the assembly. Unlike his companions he wears no helmet. Eyes fully visible, he gazes forward with a sombre alertness which contrasts favourably with the unquestioning expressions of the soldiers beside him. In his hands he holds a cross bearing the dates of each year of the war, and they descend towards a trio of far more disturbing figures below. Death is in the centre, his skeleton disguised by a helmet and army coat. Two of his victims flank him, one of them an old man who closes his eyes and clutches his head with etiolated fingers. The gas mask hanging from his chest implies that he has witnessed atrocities, and the woman on Death's right looks as if she is engulfed in bereavement. Her fists are

so eloquent of anguish that we do not need to see her face, shrouded by a mercifully enveloping shawl.

The uncompromising bitterness of the Magdeburg memorial aroused vociferous hostility in a nation now thirsting to avenge the defeat of 1918. Barlach fought back, accusing his critics of wanting 'victory monuments, surreptitiously if it can't be done openly and directly, sops to your vanity which can't help the dead.'[45] His counterattack was accurate, and four years after its installation the memorial was removed from the cathedral by the Magdeburg church council. A year later it was consigned to storage in the Berlin National Gallery, where Käthe Kollwitz managed to see it. 'Here the true war experience from 1914 to 1918 has been held fast,' she wrote in her diary. 'Impossible of course for the supporters of the Third Reich; true for me and many others.'[46] Now that the Magdeburg carving has been returned to its original location, after yet another disastrous war precipitated by his detractors, it is possible to appreciate the justice of Kollwitz's assessment. Moreover, when Barlach died in 1938, the Güstrow angel was placed over his coffin. Anticipating the destruction of the original bronze, he had hidden a cast which subsequently enabled his admirers to restore the Güstrow memorial as well.

Kollwitz, who courted Nazi disapproval by attending Barlach's funeral, had undergone a more personal struggle to provide her own child with a fitting monument. The death of her younger son Peter in 1914 confirmed the inconsolable artist in her obsession with the theme of the grieving mother, and it dominated much of the work she went on to produce (see Pl. 361). But her projected *Memorial to the Fallen* concentrated on two bereaved figures. For several years, she remained dissatisfied with her attempts to model them in clay. Perhaps the weight of her own sorrow hampered Kollwitz whenever she unwrapped the incomplete figures and then, overwhelmed by dissatisfaction, covered them up again. Perhaps, too, her relative unfamiliarity with the medium of sculpture bred a sense of uncertainty. She was, after all, determined to produce a major memorial worthy not only of Peter, but of a whole generation of young Germans slaughtered on the battlefield. It was a daunting challenge for a woman unable to recover from mourning her own loss, and only in 1926 did Kollwitz at last receive the stimulus she had needed for so long.

Informed by the authorities that her son's body was being transferred from a single grave to an official, collective soldiers' cemetery at Roggevelde, near the small Belgian town of Diksmuide, she travelled there with her husband Karl in the summer to find out how the new site might lend itself to her proposed memorial. After losing their way and passing the burial ground by mistake, they met a 'kind young man' who redirected them to the cemetery beside the road. 'The entrance is just a gap in the surrounding hedge,' Kollwitz wrote to her other son, 'and the young man untwisted the wire that stretched across the gap and then left us alone. The total impression: Cross after cross! On some of the graves, the original large wooden cross had weathered and been taken down; however, mostly there were the usual low crosses of yellow wood. A small tin plate in the middle gave name and number. That was how we found our grave.'

Searching for a way of personalizing their son's anonymous resting-place, Kollwitz and her husband decided on a simple gesture. 'The hedge was a mass of wild roses,' her letter continued, 'so we cut three of them and stuck them in the ground before the cross. His remains lie in one of a row of graves, all flat, with no distinguishing mounds. Just the identical little crosses, quite close to one another. The whole cemetery is like this, mostly bare yellow earth. Here and there, relations have planted flowers, mainly wild roses, and they look

beautiful as the shoots overgrow the grave and arch above it, often spreading to the untended graves nearby, for at least half of them say simply "Allemand Inconnu" (unknown German soldier).'[47]

Visiting the cemetery spurred Kollwitz into an immediate reconsideration of how to instal her long-postponed memorial. She noticed that 'a kind of monument' had already been erected in the centre, 'a short round column set on a square plinth, without any inscription. Although it looks good in its way, I would rather it were not there.' The presence of the column robbed Kollwitz of the most obvious site for her figures, and she rejected several alternative positions as well. 'It is no good putting them among the graves,' she wrote, 'the rows are far too close together . . . One possibility is near the entrance, but the ground slopes and as the edge of the cemetery dips right down to the ditch by the side of the road, you stand too low there to get a good view of the burial ground as a whole. So that wouldn't do justice to the figures.' In the end, both Kollwitz and her husband decided that 'the best place for them would be directly opposite the entrance, by the hedge . . . Here the two kneeling figures would have the whole cemetery lying before them.' Although a 'fairly tall row of columns' stood nearby, 'a sort of memorial placed there by one of the regiments', Kollwitz was relieved to discover that 'no one has put up any decorative figures.' Pleased by the setting, she found it conducive to planning the completion of her memorial. 'The total effect is one of utter simplicity and loneliness,' she wrote. 'Apart from two small farms, there are no houses near, and the graveyard lies among fields. Everything is still but the larks are singing for joy.'[48]

Kollwitz was, nevertheless, under no illusions about the melancholy region surrounding the burial ground. On her journey home she found traces of the war still scarring the landscape everywhere. In Diksmuide itself she was horrified to come across the ruins of 'the Minoterie where the Germans dug themselves in', and noted that 'it is ghastly to see how the metre-thick retaining walls of the dug-outs

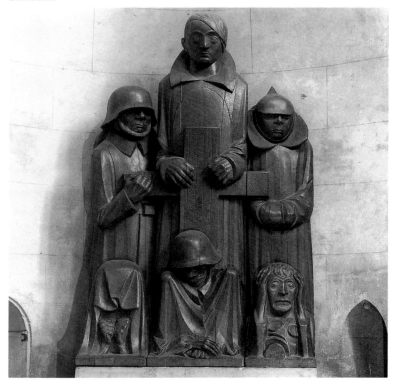

392 Ernst Barlach *War Memorial* 1929. Wood, 255 × 154 × 75 cm. Magdeburg Cathedral.

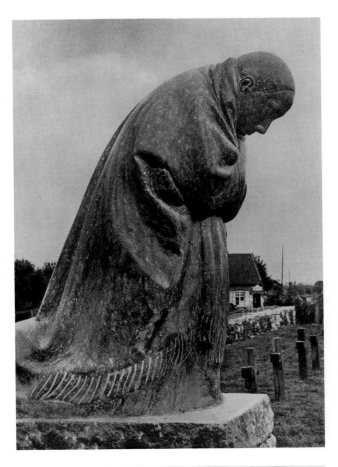

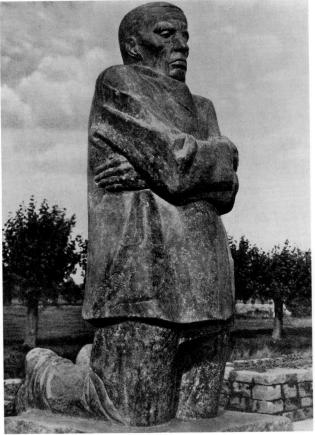

were blown to pieces. In this area alone 200,000 Germans are said to have been killed.' Although eight years had passed since the Armistice, the conflict was still fiercely alive in the memories of the Belgians whom Kollwitz met. 'They break into Flemish and tell you with passionate gestures how the position was fought for, forward and back, forward and back, without any respite.'[49] Listening to their vivid accounts must have confirmed her in the belief that the sculpture she was planning should avoid the anodyne detachment found in so many war memorials. They implied that the conflict was now safely in the past, removed from any need to convey the pain suffered by those caught up in it. Kollwitz, however, was convinced that the tragedy of war still blighted the lives of its survivors, and that the tensions which caused it had not gone away. After travelling to Ostend she found herself visited by a terrible presentiment. 'Last night I dreamed there would be war again, a new outbreak was imminent,' she wrote. 'And in my dream I imagined that only if I abandoned my work altogether, only if I got together with others to preach against it with all the power at our command could we stop it.'[50]

This disturbing revelation did not, fortunately, prompt Kollwitz to leave her memorial unfinished. It may have contributed to further delay, for several more years passed before she managed to complete the figures. In the end, though, the dream may have helped her to invest the work with the emotional gravity she deemed appropriate. The only way to arrive at the heart of her purpose was, she decided, to make a pair of separate statues representing a father and mother in grief (Pl. 393). Moreover, the two figures should bear the facial features of her husband and herself. Their identification with the memorial in a lonely Belgian field had therefore become total, even though the *Memorial to the Fallen* was intended to encompass every young soldier of Peter Kollwitz's generation who had been killed.

After finishing the figures in conditions of great secrecy, when even her husband was forbidden to enter the studio, the plaster models were finally exhibited at the Academy in 1931. Her friend and fellow-artist Otto Nagel attended the opening, and later described how he had 'experienced at first-hand the stir they caused. These sculptures were the artistic sensation of the day. I had never seen Käthe as excited as she was then, which is understandable, for she was showing publicly for the first time the result of more than fifteen years' intensive work. Her work was highly praised by her colleagues, and established Käthe Kollwitz as a sculptor as well as a graphic artist.'[51]

The following year the figures were completed in granite, and the Kollwitzs prepared themselves to travel back to Belgium for their installation. Karl Kollwitz was delighted with the carved versions, feeling that 'they radiate a wonderful life of their own. They are so successful that I keep going to see them on a kind of pilgrimage, to yield myself entirely to their effect.'[52] The moment of deepest response occurred, however, once the memorial had been erected in the cemetery at Roggevelde. Kollwitz's 'most beautiful memory' of the statues occurred on their last afternoon, during a farewell visit to the burial ground. 'We went from the figures to Peter's grave,' she wrote in her diary, 'and everything was alive and deeply felt. I stood before the woman and looked at her – my own face – I cried and stroked her cheeks. Karl was standing just behind me. I did not know he was there until I heard him whisper: "Yes, yes." How much together we were at that moment.'[53]

393 Käthe Kollwitz *Memorial to the Fallen* installed 1932. Granite. Soldiers' cemetery, Roggevelde, near Diksmuide.

The emotional power of the figures themselves depends, however, on the tension between their ability to share suffering and an equally evident awareness of each mourner's isolation. They are positioned on the same modest plot of land, and draw undoubted comfort from this physical proximity. At the same time, however, mother and father kneel on separate blocks. Instead of reaching out to touch and reassure one another, as *The Parents* do in her earlier cycle of *War* (Pl. 363), they wrap their arms around their own bodies – as if in the belief that nobody else, ultimately, can keep them warm. These gestures are subtly differentiated: while the father's hands remain visible, emerging from his jacket sleeves, the mother's are shrouded in the heavy folds of a fringed shawl. As a result, the man seems more exposed than his partner. He chooses to remain upright, in a position which accentuates his exposure to the elements. The woman, by contrast, leans forward and stares down directly at the ground.

Although she thereby protects herself to a greater extent than the father, Kollwitz is alert to the ambiguity inherent in both their poses. For his erect stance could well be interpreted as a sign of greater resilience, whereas her bowed form might signify less of an ability to bear the burdensome amount of grief. By gazing straight at the earth, she seems embroiled in haunting thoughts of the son buried beneath it. Her husband, on the other hand, appears more capable of retaining a connection with the world of the living as well as the dead. There is, all the same, nothing optimistic about the position he adopts. Transfixed by an overwhelming sense of loss, he struggles to withstand and survive the knowledge of his son's slaughter. Whether or not the father and mother succeed in dealing with their sorrow, they are bound to be permanently marked by the trauma. In this respect, Kollwitz's *Memorial to the Fallen* emphasizes the fact that wars continue long after their official termination, blighting the consciousness of all those condemned to endure for the rest of their lives the finality of premature bereavement.

The loss of a relative gave one enlightened patron the impetus to commission the greatest of all British memorials to the First World War: Spencer's painted chapel at Burghclere, completed in the same year that Kollwitz's carvings were finally installed in the burial ground. Mary Behrend, who with her husband Louie already owned two of Spencer's earlier paintings,[54] wanted this ambitious project to commemorate her brother Lieutenant Henry Sandham. He had died in 1919 after an illness contracted during the war in Macedonia, where Spencer himself served. The Behrends would not, however, have thought of commissioning such an elaborate cycle of wall-paintings without the stimulus provided by drawings which the artist had already executed, in a characteristic frenzy of concentrated work, during the early summer of 1923.

'Since I have been here', he wrote to his wife Hilda from Poole, 'I have hardly been out at all; I have been so much moved by a scheme of war pictures that I have been making compositions for, that all my time here has been on this.'[55] The working drawings for the two sides of a projected interior prove that, from the outset, Spencer had 'a whole architectural scheme'[56] in mind. The plan they outline, with its predella panels running beneath arched pictures surmounted in turn by extensive horizontal scenes, is remarkably close to the side walls of the completed chapel. The drawings also confirm that Spencer was guided, throughout the long and complex realisation of the venture, by a desire to combine memories of his first military service at Beaufort War Hospital near Bristol with images reliant on his experiences at Salonika. He was never able to deal with all the

394 Stanley Spencer *Convoy of Wounded Soldiers Arriving at Beaufort Hospital Gates* 1927. Oil on canvas, 213.4 × 185.4 cm. Sandham Memorial Chapel, Burghclere.

ideas outlined in this early letter to Hilda, which proposes painting 'a sergeant of the Berks named Challenger, who always reclined on the top of the parapet, when heavy shelling was going on (in the night of course), while we stood trembling in the trench. When the shell burst, the light of the shell lit him up in a ghostly way, and made him appear like a kind of angel.'[57]

Spencer's description of this unrealised scene exemplifies his desire throughout the chapel to find an affirmative revelation in even the most mundane, irksome or frightening moments of army life. He had started focusing on the discovery of these epiphanies soon after enlistment, as a means of countering loneliness and depression. Having begun to feel that 'I was dying of starvation, spiritual starvation', Spencer became consumed by the need 'for spiritual life. "I must find it. Where is it? I used to find it in painting pictures. Where is it now?"' The answer lay all around him, just as it had previously done in Cookham village: 'suddenly I began to see and catch hold of little particles of this life in the scrubbing of a floor or the making of a bed, and so, gradually, everything began to reveal to me... until at last I felt I could reveal the whole progress of my soul by stating clearly these impressions of my surroundings... So at last things became sacred to me by association.'[58]

The intensity with which Spencer outlined this vision in his preliminary drawings convinced the Behrends, as early as September 1923, that they should finance the entire chapel scheme. 'Louie Behrend thought it was the best thing I had ever done,'[59] wrote Spencer delightedly, predicting in an excess of optimism that the paintings would take only 'two to three years to do'.[60] He would, of course, have preferred to erect the building at Cookham, but the Behrends wanted to position it near their home in the Hampshire

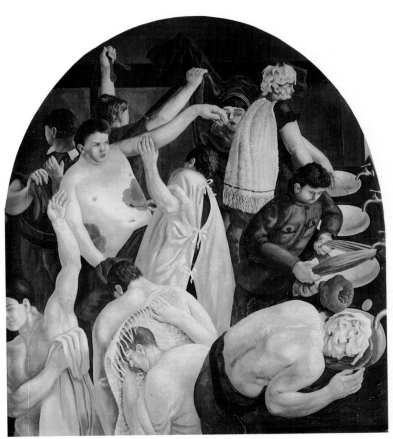

395 Stanley Spencer *Ablutions* 1928. Oil on canvas, 213.4 × 185.4 cm. Sandham Memorial Chapel, Burghclere.

village of Burghclere. Although their wish prevailed, Spencer seems to have enjoyed *carte blanche* over the type of building he required. 'It ought to be plain outside, just like a box,' he told Henry Lamb in October, insisting that there should be no 'architectural ornament or features outside whatever.'[61] He also agreed with his brother-in-law Richard Carline, who had pointed out 'that the Padua Chapel was just a plain block sticking straight out of the ground.'[62] Even though his initial eagerness to paint the cycle in fresco came to nothing, Spencer wanted the venture to pay homage to the Arena Chapel. 'What ho, Giotto!'[63] he exclaimed to the Behrends while discussing the scheme, and the building was dedicated as the Oratory of All Souls on 25 March 1927 – the day chosen for the consecration of the Arena Chapel over six centuries before.

A couple of months later the chapel's construction was complete. Designed by Spencer with help from the architect Lionel Pearson, who had recently worked with Jagger on the Royal Artillery Memorial (see Pl. 377), its exterior was as austere as the artist had originally envisaged. Flanked by two adjoining almshouses, which reflected Spencer's early wish that the chapel 'be attached to some hospital',[64] it acts as an utterly unpretentious foil for the overwhelming richness of the paintings within. Immediately visitors enter this intimate, wood-raftered space, Spencer's paintings surround them and lead their eyes towards the immense painting of a soldiers' resurrection at Salonika which fills the entire east wall (see Pl. 399). In 1923 he had admitted to Hilda that this culminating image, 'as far as what it appears like, is at present the vaguest, and yet it will, I know, be the best.'[65] The spirit of hope embodied in this aspirational *tour de force* behind the altar sums up Spencer's governing aim throughout the interior. Having recently celebrated the importance of the resurrec-

tion at Cookham in a magisterial canvas,[66] he now wanted to let this beneficence embrace the totality of his war experience as well.

The successful completion in 1926 of *The Resurrection, Cookham*, extending eighteen feet in width, must have given him the confidence he required to commence such an awesome task on site from May 1927 onwards. It is significant, however, that the first painting he completed was relatively modest in size – a predella picture called *Scrubbing the Floor*, executed in Hampstead before he started work in the chapel itself. While by no means the most memorable of the Burghclere paintings, this oddly frenzied image derives from a drawing of menial activities at Beaufort Hospital executed by Spencer for the 1921 Memorial Hall project at Steep. He later revealed that the figure stretched out so frantically on the floor was based on a shell-shocked soldier who threw himself down to scrub with disconcerting intensity.[67] The shadowy desolation of the hospital corridor accentuates the strangeness, but Richard Carline pointed out that Spencer had 'kept the colour subdued' in order 'to secure a unity throughout'[68] the predella sequence.

There is, however, nothing subdued about the first of the large round-arched paintings positioned above it (Pl. 394). Based on Spencer's recollections of wounded soldiers arriving at the hospital gate in a crowded bus, this introductory image might easily have been as elegiac as the great *Travoys* canvas he had produced for the government in 1919 (see Pl. 307). 'The gate was as massive and as high as the gates of hell,' he remembered, describing it as 'a vile cast-iron structure' operated by a terrifying keeper whom 'I could imagine . . . cutting my head off as easily as I imagined him cutting off chunks of beef.'[69] While this bull-necked official is portrayed in all his scowling pugnacity as he pulls the gate open, the rest of the picture is surprisingly joyful. The bus seems to be forcing its way through a riotous mass of rhododendrons. Their full flowering, inspired by blooms Spencer observed in the roads near Burghclere, dispels any potential distress. Even the wounded passengers look boyishly eager as they await admission, and their white arm-slings have the jauntiness of sails afloat on a choppy sea.

So the symbolic opening of the gates, which invites visitors to enter the imaginative world depicted with such humane conviction on the rest of the chapel's walls, conveys a sense of release. However many arduous tasks are performed within the other paintings, the figures carrying them out all seem animated by delight rather than weighed down with resentment or fatigue. *Ablutions*, the next large picture on the left wall, is a festive scene highlighting the comradely vigour with which orderlies towel their patients dry or brush on iodine as carefully as Spencer must have applied his pigment to the canvas (Pl. 395). The entire scene might well have been intended as a metaphor for the cleansing process Spencer wanted to undertake in the chapel as a whole, purging his war memories of their violence and stressing instead all the most positive and heartening aspects of military life.

That is why, at an early stage in the painting sessions at the chapel, he decided to reject his earlier plan to include an explicit image of a surgical operation. Its painfulness would have looked anomalous in a cycle dedicated to healing rather than dissecting the wounds of war. Even when the focus shifts in the main panels from hospital to active service, Spencer avoided representing aggression, suffering and death. He preferred to concentrate on those moments when the young men found, albeit temporarily, solace and release from dehumanizing routine or fear. At first sight, *Kit Inspection* may seem like one of those oppressive rituals which army existence insisted on conducting. It is, especially in terms of colour, one of the

most subdued paintings in the entire chapel. After a while, though, its heartening implications become clear. Each RAMC volunteer training at Tweseldown Camp appears to derive considerable satisfaction from laying out his kit in the prescribed manner. Spencer, dissatisfied with the rigid angles he had outlined in his preliminary sketch, gave the groundsheets enveloping curves. They promise to enfold the trainees in a reassuring embrace, and one figure sprawls among his possessions as if hungry for contact with the sustaining identity they provide.

Related moments are savoured in the predella panels, filled with tributes to the pleasure Spencer found in the hospital laundry room or a ward at teatime, with slabs of his favourite white bread and jam piled precipitously high on plates. The intimacy and seeming spontaneity of these scenes contrast, however, with the more formal style adopted in the Macedonian paintings. Directly above the boisterous teatime picture is a remote and mysterious image based on Spencer's recollections of a *Convoy of Wounded Men Filling Water-Bottles at a Stream* (Pl. 396). The two mules in the foreground lean down from either side of the composition to drink. Their heads appear to merge as they do so, and the aura of unity is enhanced by the tenderness of the man holding the bridles beside them. One young figure, reminiscent of the artist himself,[70] crouches underneath the spotted mule's neck as though deriving comfort from the warmth and shelter it affords. The sense of beneficence reaches its climax above, where several men cluster around what Spencer described as 'a Greek fountain or drinking-water trough'.[71] They sprawl on ledges in the hillside and hold their bottles beneath the liquid flowing from the slit in the marble. Spencer, however, gives them an unexpectedly airborne *élan*. Their army mackintoshes fan out from their shoulders like wings, investing these eager figures with the grace of angels as they converge on the life-giving spring.

A simple act of replenishment is thereby transformed into a miraculous scene, replete with benediction. Time and again on the walls of the chapel Spencer closed on such incidents, when soldiers were able to remove themselves from the grim round of duties and rediscover emotions they might easily have lost. In *Map Reading* an officer, the only one to be represented anywhere in the cycle, occupies the centre of the painting. He reads his orders and locates his destination on an ample map spread across the neck of the mule supporting him. It implies that his troops are approaching a battle zone, and in this respect the officer's action carries an ominous reference to future danger. For the moment, however, the men in his charge are permitted to relax and sleep on the soft roadside grass, where they can dream of an alternative reality akin, perhaps, to the snug *Bed Making* scene depicted with enticing homeliness in the predella directly underneath. The map-reading panel reaches an ecstatic level in the bilberry patch behind the officer. Hungry soldiers dart and stretch among leaves as luxuriant as the rhododendrons in the first arched painting. They lunge towards the wild fruit as ardently as the men filling their water-bottles in the neighbouring panel, and the flowering plants transport them into a region as exalted as Eden itself.

These heightened images amply fulfilled the ambition Spencer had outlined in 1923, when he told his sister Florence that the chapel paintings were intended as 'a sort of Odyssey... They don't look like war pictures; they rather look like Heaven, a place I am becoming very familiar with.'[72] In another artist's hands, such a preoccupation could easily have fostered insipidity. Spencer, however, retained a supple balance throughout the chapel between the sacramental and the quotidian. In the continuous paintings which run across the top

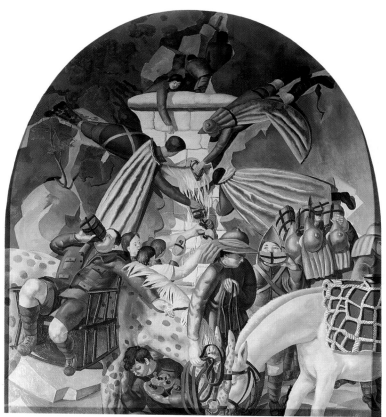

396 Stanley Spencer *Convoy of Wounded Men Filling Water-Bottles at a Stream* 1932. Oil on canvas, 213.4 × 185.4 cm. Sandham Memorial Chapel, Burghclere.

of the arched panels on both the side walls, his love of frank references to ordinary existence is conveyed with special relish. Cans of meat clearly inscribed with the 'Fray Bentos' trademark are heaped in one of the spandrel-like spaces between the arches, while nearby Spencer himself moves around the camp at Karasuli skewering stray pages of the *Balkan News* with his bayonet. These slices of mundane life anchor the pictures in a far more robust reality than his obsession with heaven might suggest. On the other wall, soldiers scrub jackets and underpants on boulders in a riverbed at Todorova. Their workaday vigour lends an extra poignancy to the activity above, where men lay out on the ground a red cross from broken rocks and tiles as an identification signal to aircraft. Spencer had painted the same scene on its own in a small picture as early as 1919,[73] but here he stresses the reverence and pride with which each seated or reclining figure assembles this instantly recognisable symbol of their commitment to the saving of lives.

While a member of the Royal Army Medical Corps, serving as an orderly for the 68th Field Ambulances in Macedonia, Spencer knew precisely where his priorities lay. He was devoted to the overriding belief that humanity should be protected rather than destroyed, and his paintings return incessantly to this affirmative theme. Sometimes the threat is posed by natural disaster, and one large panel depicts the solemn ritualistic burning of grass round a camp in order to ward off the threat of fire. The soldiers igniting paper spills, torn from pages of the *Balkan Times*, bear an unforced resemblance to priests participating in a candlelit ceremony. Their safety for the night now seems assured, and another large painting shows how mosquito nets shielded them from insect attack in the morning (Pl. 397). Each figure in this remarkable picture, which fuses the documentary

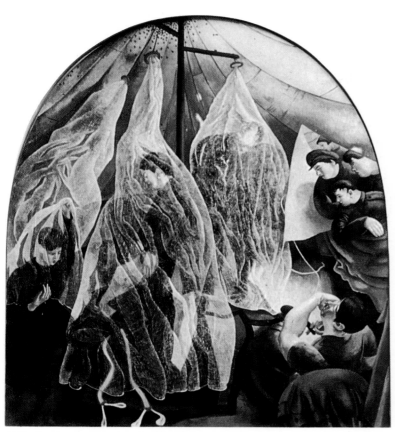

397 Stanley Spencer *Reveille* 1929. Oil on canvas, 213.4 × 185.4 cm. Sandham Memorial Chapel, Burghclere.

and the mystical with deceptive ease, is safe within his transparent cocoon. The menace posed by the mosquitoes gathered at the apex of the tent remained real enough, and Spencer was himself sent back to England with malaria near the end of the war. In pictorial terms, though, the insects are insignificant compared with the men dressing beneath. Although their nets are reminiscent of shrouds, they have risen from their beds charged with the renewal of energy which a fresh day can bring. 'I shall try', wrote Spencer, 'but may not succeed so well, to express the fact that though this is a "Reveille" scene, yet the idea is . . . really the Resurrection.'[74] Hence the wonderment on the faces of the figures staring in through the tent-flap, like witnesses awed by their accidental proximity to a full-blown religious revelation.

Reveille had, in fact, initially been envisaged as part of the grand resurrection planned for the east wall. Its 'mixture of real and spiritual fact' was intended to foster what Spencer defined as 'a great feeling of peace and happiness.'[75] The same words could equally well be applied to *Dug-out or Stand-to*, the other painting originally supposed to take its place in the culminating resurrection image (Pl. 398). Once again, it centres on the idea of a momentous awakening. Unlike *Reveille*, however, the soldiers no longer feel impelled to protect themselves within nets and tents. They have emerged from their tomb-like trenches with blanched faces and stand there, dazed in the unaccustomed glare of day. The sergeant, based on a grenadier whom Spencer had admired for his exceptional bravery, stands calmly at the entrance of his dug-out festooned with camouflage and weapons. He seems ready for action, as the alternative title *Stand-to* indicates clearly enough. But among his men a strange uncertainty prevents them from wholeheartedly seizing the equipment laid out in readiness on the parched, pale earth.

Even as some of their hands grasp the leather straps, the soldiers pause and look around. One of them leans his head on the side of the trench and stares outwards, absorbed in a reverie. No one seems able to comprehend the full significance of their ability to emerge from shelter, unshielded by helmets, without setting themselves up as immediate targets for shells or snipers. They are still cautiously assessing the implications of the eerie silence and concomitant lack of danger. Spencer explained that the painting arose from 'thinking how marvellous it would be if one morning, when we came out of our dug-outs, we found that somehow everything was peace and that war was no more.'[76] The peculiar potency of his painting, however, derives from the sense of bafflement and disbelief which paralyses the soldiers, preventing them from rejoicing in the advent of a wholly unexpected Armistice. One figure still stares up at the dark, tangled mass of barbed wire strewn across no man's land beyond, doubtless wondering whether the protracted hostilities really have ceased.

In the understandable conviction that this outstanding picture possessed elements of a resurrection, Spencer placed *Dug-out or Stand-to* next to the end wall. It acts as an ideal preparation for the climactic scene above the altar, and at one stage he toyed with the notion of 'filling the whole end wall with barbed wire. Inside the wire and influencing the shape of the wire were men in different attitudes, but all praying to a figure supposed to be Christ, who is disentangling them.'[77] After making several studies, however, he relegated the barbed wire to less prominent places in the composition. It was probably a wise decision, for the completed resurrection painting gains much of its power from the feeling that the soldiers are themselves responsible for rising from their graves in the aftermath of death (Pl. 399).

398 Stanley Spencer *Dug-out or Stand-to* 1928. Oil on canvas, 213.4 × 185.4 cm. Sandham Memorial Chapel, Burghclere.

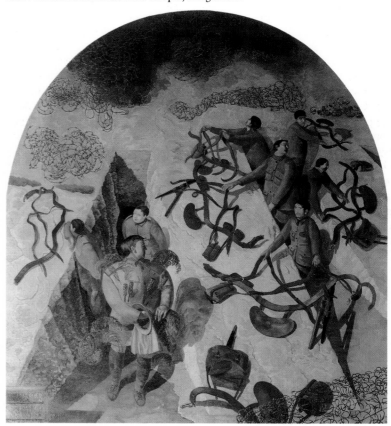

Spencer took a surprisingly long time to arrive at this conclusion. A working cartoon for the painting, which now survives only as a photograph, proves that at an advanced stage of his preparations in 1927 the foreground was occupied simply by fallen, foreshortened soldiers whose lolling limbs gave no hint of their imminent ability to stand upright. Presumably dissatisfied with the inertness of these figures, whose feet would have thrust down awkwardly towards the altar, Spencer replaced the two most substantial bodies with a complex cluster of crosses. It was an inspired alteration. The entire foreground area now became charged with the intersecting geometry of white planks leaning at a variety of angles, uprooted and pushed aside by the triumphantly emerging young men.

Some of the soldiers on the left of this scene help their comrades out of the ground by clasping their outstretched hands in greeting. The relief they experience in discovering fraternity after the isolation of the grave is palpably conveyed by these linked arms. No such animation can be found nearer the altar, where each resurgent figure seems quietly overcome by his proximity to the most sacred part of the chapel. One of the soldiers looks across at the hand-clasping figures, and grasps his own hands in respectful imitation of their gestures. On the whole, though, the faces immediately behind the altar are divided from each other by the crosses, which form a series of frames around them. They resemble devotional portraits of saints or donors contemplating the miracle of renewal, and Spencer himself explained that 'the men looking at the crosses are meant to be expressing happiness . . . which is the result of certainty; the certainty in this case being clearly understanding . . . the meaning of "He that loses his life for my sake shall save it." '[78] The knowledge that salvation is near prompts two of the soldiers, above the men shaking hands, to embrace their crosses as ardently as lovers.

Further up the wall, however, Spencer is not afraid to introduce reminders of the war's horror. One standing figure is still encircled in the barbed wire which once played such an important role throughout the composition. He struggles to free himself from its vicious constriction, helped by a comrade who holds out a pair of cutters to slice through the entanglement. They are balanced on the other side of the painting by another standing man, who rolls up the long, ribbon-like strip of puttee as it unwinds from his left leg. The idea occurred to Spencer when he remembered how, after carrying several wounded men through barbed wire, he noticed 'my puttee not undone but neatly cut clean through and trailing along the ground. And so I have imagined that when a man is wounded or killed that his puttee might get cut as mine did.'[79] The act of winding it up takes on a ritualistic import in the painting, where the soldier indicates that he no longer has need of the protection and support which the puttee used to provide. With one leg already bare, he seems to be looking forward to the time when his entire uniform can be cast aside for ever.

Unlike his comrades in the foreground, this substantial figure directs his gaze towards the horizon. He helps to lead the viewer's eyes away from the most prominent crosses, and the momentum is reinforced by the two central mules who turn their heads in the same direction. Spencer attached enormous importance to animals in this painting. A jackal and tortoises are included over the right-hand door, and the significance accorded to the mules as they regain consciousness and spring back to life reflects his awareness that 'there were nearly as many mules in Macedonia as there were men'.[80] The soldier sandwiched between the pair in this painting rests an arm across one of them, in a manner intimate enough to suggest close kinship between man and mount. Spencer must have shared

this feeling, for he lets both mules stare back towards the distant Christ as if they, too, could share the benediction He offers.

Just as the other chapel pictures honoured the ordinary soldier and scarcely represented the officer class, so the resurrection painting is in no sense dominated by Christ. He is placed so far back in space that his diminutive white-robed figure is difficult, initially at least, to make out. With typical obstinacy, Spencer gives a more important place to the man lying on the cross in front of Christ. Propped up on one elbow, he appears engrossed in meditating on the significance of the crucifix and the hope it holds out after suffering has come to an end. 'The truth that the cross is supposed to symbolize in this picture', Spencer wrote, 'is that nothing is lost where a sacrifice has been the result of a perfect understanding.'[81] This ideal accord certainly seems to give the soldier a sense of infinite satisfaction, as he places his body on the cross in imitation of the man who died to provide humanity with eternal life.

The men beyond throng around Christ, handing in their crosses as eagerly as most soldiers divested themselves of military equipment at demobilization time. The entire scene resembles a laying-down of arms, and now that the resurrection has taken place, they no longer need any of their worldly possessions. An air of homecoming pervades this area of the painting. The nearby village is based on Spencer's memory of Kalinova, 'where I spent the happiest time I had during the War.'[82] Its emptiness here seems welcoming, and its proximity to the men gathered around Christ indicates that they can find security inside its protective walls. As sunlight penetrates the centre of the clouds on the horizon, a feeling of reassurance spreads across the top of the whole resurrection image. Spencer must have shared the catharsis enjoyed by the soldiers once he had completed his prodigious nine-month labour on the east wall. A few years after finishing the decorations in the summer of 1932, he explained that 'I have avoided any too unpleasant scene . . . because in this scheme, as in all my paintings, I wish to stress my own redemption from all that I have been made to suffer.'[83] Painting the Sandham Memorial Chapel was tantamount to a purgative experience which freed him, at last, from the otherwise unendurable tragedy.

The need to exorcise the evil spirit of war should never be underestimated among artists who had fought at the Front. In the case of Horace Pippin, a black self-taught painter from Pennsylvania, it was a matter of overcoming a crippling disability inflicted on him during the fighting in France. Shot through the shoulder by a German sniper in 1918, he lay in a shell-hole after his wound had been bound by a fellow-soldier. 'I thought I could crawl out and get to a first aid station', he recalled, 'but a sniper kept me in the hole so long that I lost too much blood to get out on my own power. It was late in the afternoon when the French snipers came by. One stopped at the shell hole where I was shot and I beckoned to him to get down and tried to explain that the sniper was there and would get him. While I was trying to explain to him, a bullet passed through his head and it didn't even knock his helmet off. And he stood there for at least ten seconds before he slipped down and when he did slid down on top of me I had lost so much blood by this time I couldn't even move him.'[84]

Eventually Pippin was rescued and shipped back to America, where he received his discharge in May 1919. His right arm was bound to his body and utterly useless, but his memory of the sketches he had made of the battlefield impelled him to devise a novel method of image-making. Although his arm was still paralysed, Pippin forced himself to start work by scorching wood panels with a hot poker. The experiment succceeded, and in 1928 he began the painful, laborious

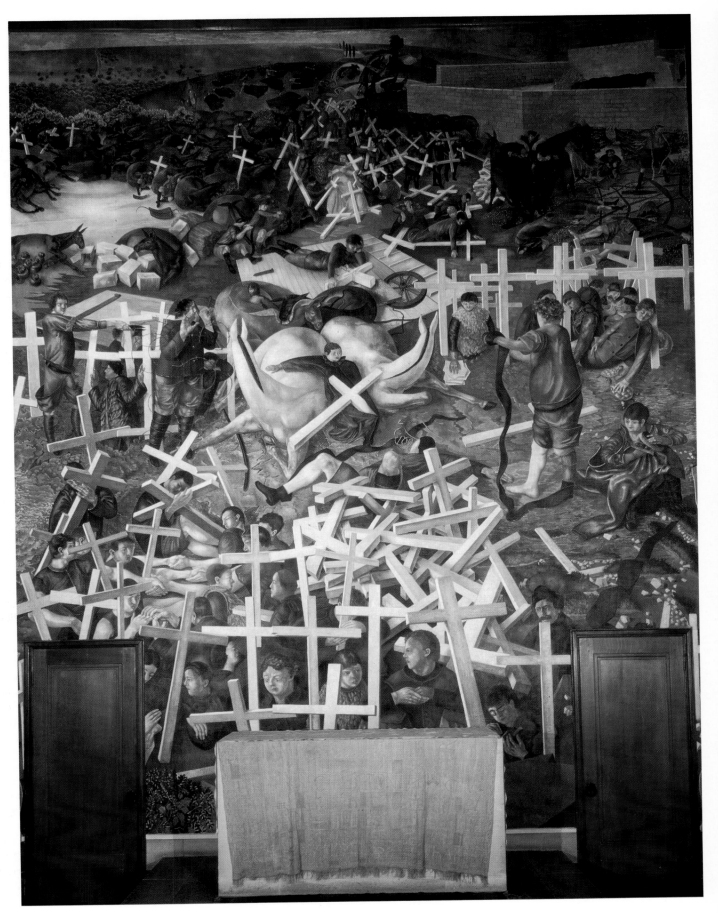

399 Stanley Spencer
*The Resurrection of the
Soldiers* 1928–9. Oil on
canvas. Sandham
Memorial Chapel,
Burghclere.

400 Horace Pippin *The End of War: Starting Home* c. 1931. Oil on canvas, 63.5 × 81.3 cm. Philadelphia Museum of Art.

process of painting his first picture: *The End of War: Starting Home* (Pl. 400). It was, as Leon Anthony Arkus pointed out, 'a means of ridding himself of the nightmarish encounters of war'.[85] The physical strain amounted, however, to an excruciating ordeal. While holding the brush in his right hand, Pippin was obliged to grasp the wrist with his other hand. The painting, therefore, was effectively carried out by using his left arm to manipulate the paralysed right arm.

It is a measure of Pippin's urgent need to paint his war experience that he was prepare to undergo such a tortuous procedure. Working at his easel during the night, and up to sixteen hours at a stretch, he covered his canvas again and again with short strokes of unusually slender brushes. The painting took three years to complete, and by that time it was encrusted with multiple layers of impasto. It retains, nevertheless, a vivid sense of actuality. Black soldiers from Pippin's division, a New York regiment which was made an integral part of the 161st French division at the Front, are shown charging the German line. The barbed-wire entanglements are depicted as meticulously as the trees in the wood beyond, and Pippin does not hesitate to focus on the bayoneting in the foreground. Despite the painting's title, the heat of battle is the essential subject. But a victorious outcome appears assured, with German arms raised in surrender and enemy aircraft plummeting from the sky in flames. Around the picture's frame Pippin assembled strange replicas of tanks, rifles, grenades and helmets. Even though they look like trophies, their miniature dimensions reduce them to the level of toys. In this respect, they rob weaponry of its menace and imply that war has been superseded by a more pacific alternative.

The memory of war refused, however, to be ousted from the minds of many who had fought in it. Pippin himself continued to paint pictures based on his experiences of combat until he died, and during the 1930s a few German artists stubbornly persisted in disclosing the full extent of their revulsion. Like Pippin, Josef Scharl was wounded in the right arm during the war and paralysed. But in contrast to Pippin, he recovered in physical terms and decided to produce a painting which confronts the carnage he had witnessed (Pl. 401). Fourteen years after the Armistice, the battlefield was still

festering sufficiently in Scharl's imagination to make him execute this gangrenous image. Grievously wounded on the right side of his chest, the stricken man has collapsed among the barbed-wire fences of no man's land. Impaled on the spikes, which may well have prevented him from crawling to safety, the soldier expires in a nocturnal landscape black enough to admit no hope.

Scharl inscribed his signature in red at the corner of the canvas, as if writing with his own blood. He knew about the agony of a man whose wound renders him helpless, and the victim's face – with its yellow-green pallor and slack mouth hanging open – is realised with particular conviction. *Fallen Soldier* was painted in the same year that Spencer completed his memorial chapel, and a comparison between them is enlightening. For the figures still sprawling on the earth in Spencer's resurrection picture (Pl. 399) are about to rise up and be united with their God, whereas Scharl's soldier enjoys no such prospect. Twisted in his death-agony and pinioned by spikes almost as vicious as the crown of thorns placed on Christ's head before the crucifixion, his body conveys no hint of a levitation to come. He is more likely to sink by degrees beneath the ground in a Dix-like process of decomposition, and the night sky remains unalleviated by any sign of heavenly intervention. *Fallen Soldier's* emphasis on the finality and degradation of death is even more pessimistic than Wollheim's lacerating *The Wounded Man*, painted only a year after the Armistice (see Pl. 326). In view of the ascent of Nazi militarism during the intervening period, it was inevitable that Scharl should find himself branded as a degenerate. His despairing painting could not be countenanced for a moment by the forces who were bent on preparing Germany once again for war.

With an admirable disregard for the censors who had launched such a vitriolic attack on his earlier painting of *The Trench* (see Pl. 366), Dix refused to be intimidated by these bullying tactics. In 1932, when he was a professor at the Dresden Akademie, he produced a tall picture which obstinately returned to the same vision as before. He even stirred memories of the previous painting by calling the new panel *Trench Warfare*. The helmeted figure who dominates the image is a survivor, however. In contrast to the putrescent corpses mashed into the earthwork of the earlier picture, he is still able to move through the war zone with his rifle slung over his shoulder. There is, all the same, no air of triumph in this figure. Furtive rather than belligerent, he lowers his head partially beneath a torn and mudcaked greatcoat as if bracing himself for an onslaught. Dix highlights the blank eyes in an otherwise dark and anonymous face, too stunned to bother scanning the area for possible danger. They give him a mask-like appearance, devoid of individuality and any human emotion apart from an automatic commitment to walking. He seems oblivious of the fact that his foot tramples on the skull-like head of a dead soldier, or that a gasmasked comrade crawls along the ground nearby. The shattered trees around him belong to a landscape so brutalized and shorn of vegetation that it seems inimical to life of any kind. So however upright this soldier may at the moment appear, his isolation in such a stricken locale indicates that he can hardly continue for long.

At one stage, though, Dix intended *Trench Warfare* to form the right-hand panel of an ambitious and even more rancid *War Triptych* which he had been working on since 1929 (Pl. 402). Accompanied by a predella, and executed on wood panels with all the technical finesse and elaboration of an early German master like Grünewald, this immensely impressive work assumes the form of an altarpiece only in order to emphasize the paradoxical absence of God. Dix underlined the profanity of his triptych by declaring that he would like it dis-

played, not in a church but in 'a bunker built in the midst of a big city's sound and fury.'[86] A miraculous Spencer-like resurrection had no place in Dix's angry, nauseated vision of a world racked by barbarity at its least redeemable. He must have favoured the idea of a bunker installation because only there, protected from the Fascist vandals who would have liked to destroy the triptych, could an appropriately terminal silence be guaranteed for an image given over, above all, to extinction.

The left-hand panel still asserts the existence of soldiers who march off to the Front and muster enough animation to converse with each other. Already, however, Dix invests them with an ominously disembodied quality. Mists invade them like premonitions of a gas attack, robbing their legs of the substance which a conventional, patriotic image of an advancing army would possess. As a result, they move through the landscape as slowly as sleepwalkers who have only

the haziest idea of their purpose or destination. Fiery clouds prophesy the Götterdämmerung ahead as they boil in the sky with a molten frenzy above the helmets of the men advancing towards oblivion.

Just how gruesome the conflict proved in reality is disclosed by the central panel, which outstrips even *The Trench* in its unrelenting horror. At least one figure, hanging over the scene like an avenging angel, echoes the body positioned against the sky in the earlier painting (see Pl. 366). This time, however, the corpse looks down rather than up, and his outflung arm points accusingly at the carnage below. Indeed, his open mouth suggests that he may have died yelling imprecations at those responsible for the devastation. The only soldier left alive in this monstrous aggregation of ruined buildings, charred tree-stumps and mangled bodies wears a gas-mask. He needs it to protect himself from the stench of human flesh, for the corpses

401 Josef Scharl *Fallen Soldier* 1932. Oil on canvas, 81 × 100 cm. Städtische Galerie im Lenbachhaus, Munich.

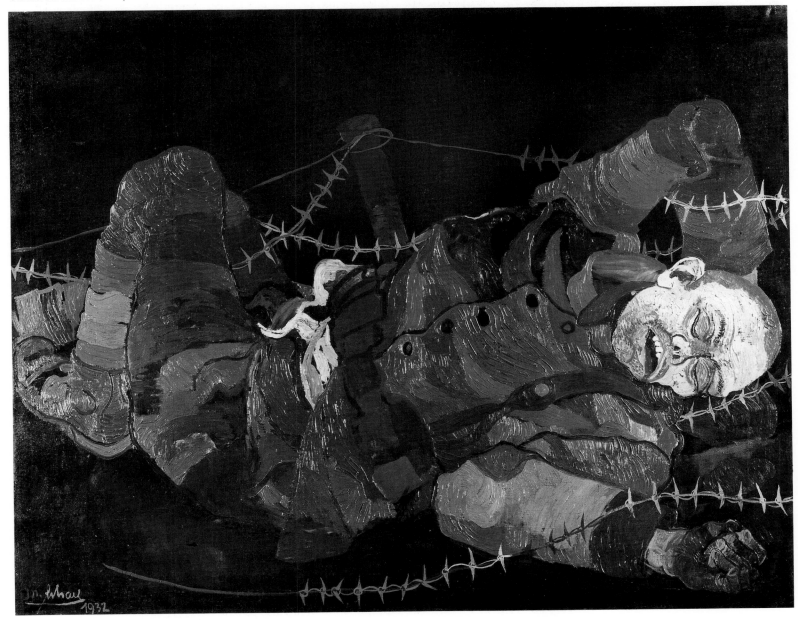

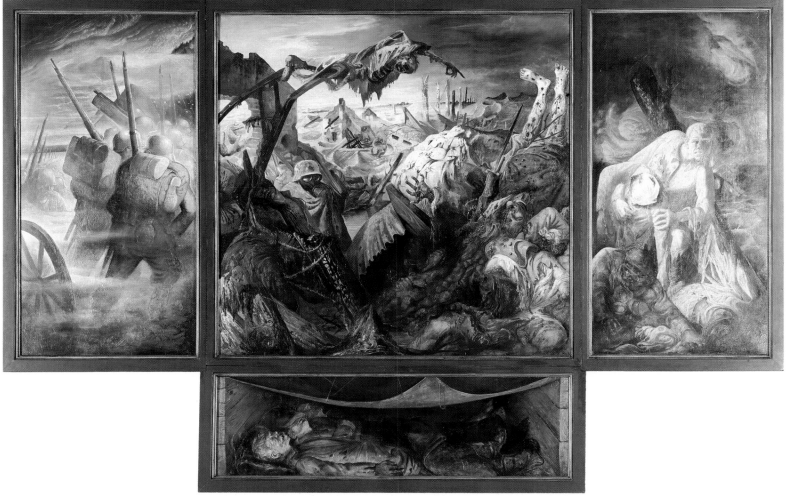

402 Otto Dix *War Triptych* 1932. Oil and tempera on wood, centre panel 204 × 204 cm, side panels each 204 × 102 cm, predella 60 × 204 cm. Staatliche Kunstsammlungen, Gemäldegalerie Neue Meister, Dresden.

clotting the foreground with their jellied, fly-blown remains are in an advanced state of decay.

It is instructive to compare this panel with the preparatory cartoon Dix drew in 1930 (Pl. 403). There the principal bodies are relatively intact. Despite their hideously distorted poses, they remain easy to distinguish as recognisable forms. In the painting, by contrast, the head of the soldier dangling down on the left has torn itself loose and dropped to the ground. It lies there, blackened beyond recognition, while a stream of repellent matter gushes from the gaping neck above. As if this exposure of rotting tissue were not enough, Dix goes on to explore even more distressing atrocities elsewhere in the foreground. According to the cartoon, the central area should be occupied by another masked soldier, alive and crawling under the twisted sheet of corrugated iron. By the time Dix executed the painting, though, he had dispensed with this figure altogether. In its place, he deposited a grotesque heap of mangled human remains. They fester in the murkiness of a bombed-out shelter, defying anyone to sort out precisely how they once related to an identifiable human body.

In his determination to expose the absolute nadir of war's obscenity, Dix gave this putrid deposit an inescapable prominence in the main panel. But he also departed radically from his preliminary conception on the right side of the panel, inhabited in the cartoon by corpses largely undisfigured by serious wounds. No such discretion marks

their counterparts in the painting. The topmost soldier is now inverted, so that his legs stick up in the sky as stiff as branches projecting from a trunk. While the real tree-stump in the foreground of the panel is blackened and glistening, both these legs are so blanched that they must have been drained of blood. Riddled with bullet-holes, they rise towards the heavens in mute protest against the degradation below. The rest of the body proves, however, that the legs' owner has long since been robbed of the ability to exclaim against his fate. At one stage in his death-throes, he thrust out his left arm and clawed the air with talon-like fingers. His exclamatory hand is now green with gangrene, though. And the body he rests on has been still more savagely abused, by an explosion which ripped open his abdomen and left it gaping. This repulsive cavity could be regarded as a metaphor for Dix's intentions throughout the main panel, which burrows inside the images outlined in his far less harrowing cartoon and exposes the gelatinous nausea within.

To some extent, the right-hand panel of the *War Triptych* counters the negation laid bare in the central painting. Whitened either by flares or a death from which he is only just emerging, Dix himself staggers into view. He hauls a fellow-soldier whose wounds are so grievous that a blood-smeared bandage covers his head completely. Like the bespectacled soldier on his hands and knees below, Dix appears to be escaping from the battlefield. All the same, the prospect

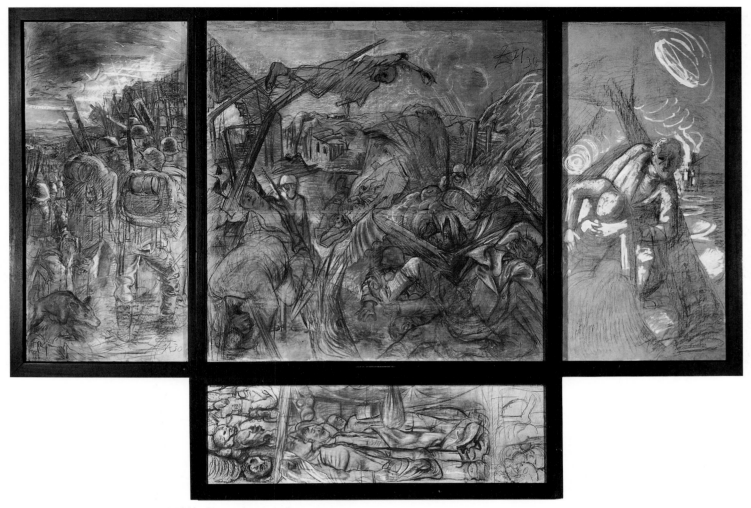

403 Otto Dix *Cartoon for War Triptych* 1932. Charcoal and chalk on paper, centre panel 204 × 204 cm, side panels each 204 × 102 cm, predella 60 × 204 cm. Kunsthalle, Hamburg.

of salvation is undermined by the ferocity beyond, where burning ruins are conflated with a sunset even more inflammatory than the sky irradiating the left-hand panel. Unlike the visionary sky in Altdorfer's *The Battle of Alexander*,[87] which surely inspired Dix in his handling of this incandescent event, it seems to presage an apocalypse. Moreover, the shell-shock and exhaustion so evident in Dix's haunted features hold out no hope for an event as transcendent as a resurrection. He glares out accusingly from the wilderness of craters and severed trees like a messenger who, heedless of his audience's squeamishness, remains bent on bearing angry witness to the catastrophe around him.

After the turbulence of the principal panels, stillness prevails in the predella below. When he prepared himself for this section of the painting in his cartoon, Dix flanked the reclining soldiers with skeletons. Their proximity made it likely that the setting was a charnel-house, but in the finished predella he jettisoned the whole notion of an attendant *memento mori*. The soldiers occupy the entire picture-space, prone in a narrow wooden box made more claustrophobic by the hammock-like material hanging over them. The resemblance to a coffin is ready-made, and yet the soldiers do not look as if they have been laid to rest. A blanket still curves across their legs, so they might be sleeping in a structure similar to the niches enclosing the recumbent men in Dix's 1924 *Dug-out* etching from the

War series (see Pl. 374).

Like them, however, these inert bodies seem to waver in an uncertain condition, half alive and half dead. They certainly appear worn out by the conflict, and the holes in their uniforms suggest that they have not escaped injury. The foremost figure is so grizzled that he may well have been prematurely aged by his ordeal at the Front. There are unmistakeable echoes of the lifeless Christ stretched out in the predella panel of the Isenheim altarpiece, ready to be placed in the tomb by his distraught mourners. In the end, though, a comparison with Grünewald's masterpiece only accentuates the despair informing the *War Triptych*. For the Isenheim Christ eventually triumphs in a resurrection of hallucinatory power, whereas the principal panels in Dix's work offer no such hope.

Only a year after completing this outspoken ensemble, which was exhibited just once before 1951, Dix found himself dismissed from his professorship at the Dresden Akademie and retreated into an isolated existence at Lake Constance. The letter of dismissal claimed that his work threatened to sap the will of the German people to defend themselves, but Dix later explained that the triptych had been painted as a response to 'a lot of books in the Weimar Republic once again peddling the notions of the hero and heroism, which had long been rendered absurd in the trenches of the First World War. People were already beginning to forget what horrible suffering the war had

404 Otto Dix *Flanders (After Henri Barbusse 'Le Feu')* 1934–6. Oil and tempera on canvas, 200 × 250 cm. Staatliche Museen zu Berlin – Preussischer Kulturbesitz, Nationalgalerie.

brought them . . . I did not want to cause fear and panic, but to let people know how dreadful war is and so to stimulate people's powers of resistance.'[88] In 1934 he was forbidden to exhibit altogether, but censorship did not prevent him from executing another major meditation on the war. This time he located the painting more specifically on the Western Front by calling it *Flanders* (Pl. 404). But none of the soldiers ranged across the foreground exhibits the mutilations found in the *War Triptych*. They seem to be suffering, not so much from their wounds as from an exhausted inability to extricate themselves from the mire of the battlefield. Their limbs are embedded in mud, and they will soon sink into the quagmire completely. Dix, however, insists on depicting them at a moment when their forms still dominate the landscape. He wanted them to remain in his painting as a perpetual reminder of the human agony which warfare entails, and the barbed wire encircling the tree-stump above them equates their

ordeal with Christ's agony when crowned with thorns.

There is a dogged persistence about the figures in *Flanders*. They bear a curious resemblance to castaways marooned on fragments of land, where they struggle to sustain life for as long as possible. The recumbent soldier on the right has wrapped his coat around him and burrowed into the ground, like a man determined to survive. His staring eyes likewise indicate that he will maintain a spirit of vigilance to the end, as if loath to admit that all hope has gone. A similar obstinacy characterizes the figure behind him, whose hand still grasps a twisted branch. His eyes are open, too, and the makeshift tent above him suggests how determined he must have been to protect himself. Even in this environment, the depiction of which owes a significant amount to Barbusse's celebrated anti-war novel *Le Feu* as well as Dix's own memories, humanity clings on to the remotest prospect of salvation.

Their efforts will soon prove futile. Incessant downpours, combined with heavy shelling, have transformed the entire *Flanders* landscape into a barren and bog-like region where life cannot be sustained much further. Behind the figures, craters filled with rainwater stretch back to the horizon. Although they are interspersed with thin strips of sodden earth, the soldiers sprawling there can hardly withstand their treacherous environment for long. Some of them have already merged so profoundly with the mud that they are no longer easy to discern. Nature seems to be reverting to a primordial state, incapable of supporting human existence. Within the water, where living creatures originated, a soldier's body floats ignominiously. As for the sky, where a flaring sunset on one side is balanced on the other by an enigmatically emergent moon, it confirms the feeling that momentous forces are at work. Dix's handling of the clouds once again pays homage to Altdorfer's *The Battle of Alexander*, but *Flanders* does not share the earlier painting's desire to celebrate a victory. Altdorfer's panel was commissioned by Duke William IV of Bavaria to commemorate Alexander the Great's exemplary triumph over the Persian army led by King Darius III. Dix, by contrast, depicts an unequivocal defeat, and the woebegone figures occupying his canvas seem intended as a warning to anyone tempted by the spurious excitement involved in planning another world war. *Flanders* seeks to keep the memory of one disastrous Armageddon alive so that its successor might be thwarted. Only thus, Dix implies, can we dare to hope that peace might emerge like the new shoot springing so tentatively from the shattered tree in the centre of the painting. Within a year of its completion, however, 260 of his works were confiscated by the Nazis. After being exhibited once, at a Zurich gallery in the summer of 1938, *Flanders* was never granted the opportunity to influence opinion and challenge Fascist belligerence in the way that Dix had hoped.

All the same, he could hardly regret the two years devoted to this elegiac image. It was a painting which he needed to execute on a deeply personal level, irrespective of whether the outcome might dissuade war-mongers from pursuing their aims. His continuing readiness to flout Nazi edicts is openly declared, with astonishing defiance, in the subtitle he attached to the *Flanders* painting: (*After Henri Barbusse 'Le Feu'*). It was Dix's stubborn way of affirming the importance of a writer who had first played an overt part in his work over a decade earlier, when Barbusse wrote a preface to a publication promoting the great sequence of *War* etchings (see Pls. 367–375). By the mid-1930s, Dix's attitude to the war coincided so strongly with the vision informing *Le Feu* that he was willing to base *Flanders* on the novel to a remarkably dependent extent. The debt becomes clearest of all in the passage where Barbusse describes how, 'half dozing, half sleeping, continually opening and closing our eyes, paralysed, shattered and freezing, we stare in disbelief at the return of the light.' The narrator discovers that 'next to me lie three completely disfigured shapes', and he goes on to survey a 'lead-grey plain with its murky expanses of water' which bears an inescapable resemblance to the terrain in Dix's painting. 'You can't see any trenches anywhere,' Barbusse wrote. 'The canals are flooded trenches. – Floods, as far as the eye can see. – The battlefield is not asleep, it is dead. It's possible that, over there, in the distance, life goes on, but you can't see that far.' After realising how pervasive the silence has become, 'in the midst of this ghostly frozen world', the narrator wonders where all the men have gone. Then, 'slowly, gradually you discover them. Not far away a couple of them are asleep, collapsed, covered with mud from head to toe, as if each of them had long since become a dead thing. Are they really not dead? – shapeless lumps float, like rounded

reefs projecting from the water, on the surface of a flooded trench in a section particularly mauled and grooved by the artillery. They are drowned men. The earth has become a ghostly resting place. This is the end.'[89]

The urgency of the imperative guiding both Barbusse and Dix would have been immediately understandable to David Jones, who had served on the Western Front with the Royal Welch Fusiliers between 1915 and 1918. Although most of his trench drawings were destroyed during the war, he never lost the ambition to devote a major part of his remaining energies to defining the experience of combat. Jones spent many years writing *In Parenthesis*, an epic poem about the Great War which derived its strange title from Jones's belief that 'for us amateur soldiers (and especially for the writer, who was not only amateur, but grotesquely incompetent, a knocker-over of piles, a parade's despair) the war itself was a parenthesis – how glad we thought we were to step outside its brackets at the end of '18.'[90]

The poem was eventually published in 1937, a year after the completion of *Flanders*, and in his preface Jones wrote of his soldiering experience with a haunted eloquence which parallels Dix's reluctance to banish the war from his mind. For Jones remembered how curious it was to see his fellow soldiers 'react to the few things that united us – the same jargon, the same prejudice against "other arms" and against the Staff, the same discomforts, the same grievances, the same maims, the same deep fears, the same pathetic jokes; to watch them, oneself part of them, respond to the war landscape; for I think the day by day in the Waste Land, the sudden violences and the long stillnesses, the sharp contours and unformed voids of that mysterious existence, profoundly affected the imaginations of those who suffered it.'[91]

Perhaps inevitably, Jones's acute visual sense ensured that *In Parenthesis* is permeated with passages strikingly reminiscent of the war images produced by his British contemporaries. Spencer's abhorrence of representing violence is confirmed, in the preface, by Jones's assertion that 'I should prefer it to be about a good kind of peace – but as Mandeville says, "Of Paradys ne can I not speken propurly I was not there; it is fer beyonde and that for thinketh me. And also I was not worthi." We find ourselves privates in foot regiments. We search how we may see formal goodness in a life singularly inimical, hateful, to us.'[92] The last sentence might well be used to sum up the prevailing redemptive mood in the Sandham Memorial Chapel (see Pl. 399), and Spencer would surely have approved of Jones's decision to dedicate *In Parenthesis* to, among others, 'the enemy front-fighters who shared our pains against whom we found ourselves by misadventure.'[93] Jones savoured the sense of universal brotherhood as keenly as Spencer, and the latter's images are paralleled with particular warmth in the section where the soldiers of 'B' Company 'rested cosily at night in thick straw. They crowded together in the evening – hours full of confused talking; the tiny room heavy with the haze of smoking, and humane with the paraphernalia of any place of common gathering, warm, within small walls.'[94]

Other passages in the poem recall the paintings of less reassuring artists. Paul Nash's horrified response to the extinction of nature on the Western Front (see Pls. 268–272) is echoed in Jones's description of the obliterated battlefield filled with 'slime-glisten on the churnings up, fractured earth pilings, heaped on, heaped up waste; overturned far throwings; tottering perpendiculars lean and sway; more leper-trees pitted, rownsepykèd out of nature, cut off in their sap-rising.'[95] Jones's pacific leanings did not prevent him from evoking the violence of a machine-age onslaught with nerve-battering precision. Nevinson's

405 David Jones *Jesus Mocked* 1922–3. Oil on tongue-and-groove boards, 112.1 × 105.4 cm. National Museum of Wales, Cardiff.

cataclysmic paintings of explosions (see Pls. 78, 194) are the pictorial equivalent of the moment in Jones's poem when John Ball is subjected to a sudden bombardment: 'Out of the vortex, rifling the air it came – bright, brass-shod, Pandoran; with all-filling screaming the howling crescendo's up-piling snapt. The universal world, breath held, one half second, a bludgeoned stillness. Then the pent violence released a consummation of all burstings out; all sudden up-rendings and rivings-through – all taking-out of vents – all barrier-breaking – all unmaking.'[96]

Time and again in Jones's text war-pictures seem to leap out fully formed, as though he were describing the paintings he had thought about executing during the conflict. One passage in particular suggests that he would have relished the chance to produce a 'Uccello'-size canvas for the projected Hall of Remembrance. When the battalion is being paraded for overseas duty at the beginning of the poem, Private Ball's attention is held for a moment by a quattrocento figure: 'From where he stood heavily, irksomely at ease, he could see, half-left between 7 and 8 of the front rank, the profile of Mr Jenkins and the elegant cut of his war-time rig and his flax head held front; like San Romano's foreground squire, unhelmeted; but we don't have lances now nor banners nor trumpets. It pains the lips to think of bugles – and did they blow Defaulters on the Uccello horns.'[97]

Even as he pinpointed the similarity between Private Jenkins and his Florentine forerunner, Jones was acutely aware of the gulf separating the Battle of San Romano from modern warfare. In his Preface to the poem, he argued that 'we feel a rubicon has been passed between striking with a hand weapon as men used to do and loosing poison from the sky as we do ourselves. We doubt the decency of our own inventions, and are certainly in terror of their possibilities.'[98] Indeed, Jones's decision to limit *In Parenthesis* to the

period between December 1915 and July the following year reflects his belief that an irreversible change overtook his life as an infantry-man after the Somme offensive. 'From then onward things hardened into a more relentless, mechanical affair, took on a more sinister aspect,' he wrote, explaining how 'the wholesale slaughter of the later years, the conscripted levies filling the gaps in every file of four, knocked the bottom out of the intimate, continuing, domestic life of small contingents of men, within whose structure Roland could find, and, for a reasonable while, enjoy, his Oliver.'[99]

Hence, no doubt, Jones's unwillingness or inability to depict the most horrifying aspects of the battle in his own art. Soon after the Armistice he attempted to plan a war-related picture in a series of drawings. They prove that he could only approach the experience through biblical analogy, showing the crucifixion administered by soldiers in modern uniforms. The idea recalls the wayside Calvaries which encouraged soldiers fighting in Flanders to identify their suffering with the passion of Christ. In the crucifixion drawing, though, the Tommies are held responsible for Christ's martyrdom, and the same guilt-ridden preoccupation informs a painting called *Jesus Mocked* several years later. The style Jones deploys on the rough surface of his tongue-and-groove boards is similar to the idiom in the fourteen *Stations of the Cross*, carved for Westminster Cathedral

406 David Jones *Frontispiece to 'In Parenthesis'* 1937. Pencil, ink and watercolour, 38.1 × 28 cm. National Museum of Wales, Cardiff.

during the war by his close friend Gill. But while those epic reliefs drew an implicit parallel between Christ's agony and the soldiers' plight, Jones once again insists on arraigning the Tommies (Pl. 405).[100]

This time, the helmeted infantrymen are even more culpable, for they pour scorn on their trussed victim, hit him and advance on his naked torso with a whip. The admission of human sin is as overt as in Gill's contemporaneous Leeds War Memorial (see Pl. 355), although Jones's painting does contain one figure who realises the extent of his transgression. He falls to his knees and prays before Christ like a man begging forgiveness. Jones ensures that Christ's gaze is directed at the penitent alone, thereby revealing how paradoxical the other soldiers' participation in the mockery really is. While the painting argues that the Tommies should be counted among the flawed humanity whose wrong-doing brought about the need for Christ's agony, Jones also shows how their imperfection ultimately leads to the resurrection and absolution of mankind.

The same belief underlies the frontispiece and tailpiece he produced for *In Parenthesis* fifteen years afterwards. Both images were intended as designs for engravings, but the frontispiece in particular benefits from a virtuoso display of Jones's prowess with pen, pencil and watercolour (Pl. 406). It is dominated by a young soldier at the Front, and seems at first devoid of the biblical references which permeated his previous war pictures. The Tommy, however, is naked; and his stance among the rat-infested entanglements of No Man's Land gradually assumes a sacrificial significance. Paul Hills speculated that the soldier's 'donning of his army jacket is a figure for Christ's assumption of the frailty of our mortal nature.'[101] He certainly looks vulnerable enough as his upper arms extend in a horizontal imitation of Christ's position on the cross. His pose also appears to chime with the severed trunks and branches beyond, thereby suggesting a Nash-like identification of human and tree-forms. Despite the injuries they have sustained, which make them resemble the crosses on Calvary, the trees continue to arch and undulate with obstinate resilience. The soldier is similarly unbowed, and the frontispiece derives much of its power from his ability to stand among the devastation with his poise and dignity intact.

For all the figure's frailty, his redemptive potential remains as formidable as the healing power of the animal dominating the tailpiece design (Pl. 407). At one stage, Jones inscribed a Latin quotation from the Book of Revelation below this picture: 'I beheld and lo ... stood a lamb as it had been slain.'[102] He later rubbed the words out, but the sacrificial status of the lamb remains evident enough. Pierced by a spear, which causes it to bleed from the side, the animal is more of a victim than its counterpart in the frontispiece design. All the same, it

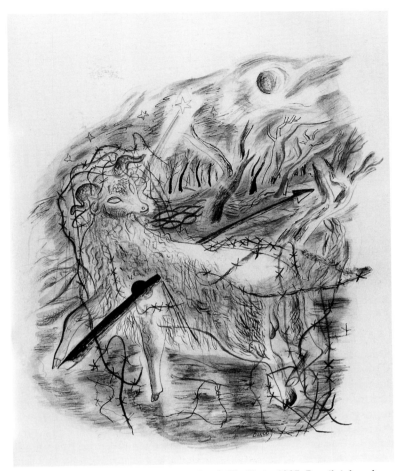

407 David Jones *Tailpiece to 'In Parenthesis': The Victim* 1937. Pencil, ink and watercolour, 38.1 × 28 cm. National Museum of Wales, Cardiff.

shares the naked soldier's capacity to remain upright amid the mud and barbed wire. Moreover, the lamb embodies a protective meaning, for Jones pointed out in the notes to *In Parenthesis* that 'short jackets made from the hide of sheep or goats or other beasts, were issued to the troops in the line against the cold.'[103] Sustainer as well as martyr, the lamb is able to raise its front leg in a confident forward move, while turning its head to acknowledge the reality of the weapon thrust through its flanks. The wire caught up in the horns mimics the crown of thorns, confirming the animal's Christ-like role as the redeemer of everyone buried within the amputated woods beyond.

EPILOGUE

The ultimate attempt to commemorate the war dead with a work of aspiration and ascension was made in Rumania. Brancusi, who had been born in the peasant village of Hobitza, ran away to nearby Tirgu-Jiu at the age of eleven. Here, in this small rural community at the foot of the Carpathian Mountains, he spent his adolescence. And in 1934, long after he had left his homeland, Brancusi's relationship with Tirgu-Jiu was renewed in the most gratifying manner imaginable. Aretia Tătărăscu, in her capacity as President of the Women's League of the Province of Gorj, visited Brancusi in his Paris studio and discussed the possibility of creating a monument to the war. Soon afterwards he received a formal invitation to submit a design for a memorial honouring the Rumanians who had repulsed the German offensive on the Jiu River in October 1916. It was not the first time he had received a commemorative commission from his native country: as early as 1907 Brancusi was asked to produce a memorial, now in Dumbrava Cemetery, Buzau, to Petre Stanescu. At Tirgu-Jiu, though, the project presented a challenge far more taxing and ambitious than the relatively conventional combination of bust and naked mourner for the Stanescu commission. On this occasion the venture was backed by the formidable authority of Mrs Tătărăscu's husband, Rumania's Prime Minister and himself a native of the Tirgu-Jiu district. He made sure that Brancusi had at his disposal the spaciousness of a public park near the river where Rumanians had died in defence of their country.

The sculptor himself had been exempt from French military service during the war, and kept working steadily throughout it. But his detachment from first-hand experience of the conflict in Rumania did not mean that he lacked strong feelings for the land of his birth. On the contrary: Brancusi had long harboured dreams of making a monumental outdoor work in the country whose indigenous art he admired so much, and he was delighted when the Tirgu-Jiu commission received formal confirmation. 'I have a great longing for our white, snow-swept plains that I haven't seen since my childhood days,' he wrote in February 1935 to his former pupil Militza Petrașcu, who had played an influential part in obtaining the commission for Brancusi. '. . . I have now decided to come out in May and cannot tell you how happy I am to carry out something in our country. I thank you and Mrs Tătărăscu for the privilege she offers me. All the things I began so long ago are now reaching completion, and I feel like a novice on the eve of his apprenticeship. So the proposal could not arrive at a better time.'[1]

On 25 July 1937, the same year in which Jones published *In Parenthesis*, he finally arrived in the town to choose the setting for his memorial. Since he attached immense importance to the symbiosis of sculpture and setting, Brancusi spent a long time appraising the location he had been given. He photographed and filmed the park and its surroundings, just as he had taken careful account of the site in Ploiesti where his abortive monument to I.L. Caragiale was to have been placed six years before. Ion Alexandrescu, his stonemason on the Tirgu-Jiu venture, remembered how Brancusi often pondered the possible solutions, and changed his mind in the long run.[2] Drawings on photographs of the proposed settings have survived, and they testify to a close concern for the overall character of the places his sculpture would inhabit. Eventually, however, cogitation was succeeded by decisiveness. In a lucid plan, Brancusi settled on a multi-stage work, spanning just over a mile, which would make full and eloquent use of the landscape he had explored with such tenacity.

He started on the river embankment near the bridge, in recognition of the end of the defensive line in the battle which had been fought there. Another sculptor might well have concluded that an image of martial prowess was called for, celebrating the Rumanians' success in driving back the German invader. According to the inscription on a memorial plaque installed on the bridge, where some of the fiercest fighting occurred, the aggressors were rebuffed by a motley yet resolute band of 'old people, women, boy scouts and the children of Gorj.' Their courage must therefore have been remarkable indeed, but Brancusi opted for the antithesis of bellicosity. Rather than concentrating on the fury of combat, he produced a simple and wholly pacific *Table of Silence* where twelve round stools are gathered round a circular slab of bampotoc limestone (Pl. 408). The empty seats suggest a melancholy awareness, on the sculptor's part, of the defenders who never survived to join their relatives and friends around dining-tables after the war. They cannot, however, be confined to such an interpretation alone. The central slab is reminiscent of the plaster dining-table in Brancusi's Paris studio, and he wanted the ensemble to have an inviting air as well. 'I have carved this Table and these stools in stone for people to dine and rest,'[3] he explained, and this calm assembly exemplifies his insistence throughout the Tirgu-Jiu project on a spirit of openness, unity and repose.

Although Brancusi himself gave *The Table of Silence* its meditative title, he resisted any attempt to enlarge on its possible meaning. After the work was installed in the autumn of 1937 and the sculptor returned to Paris, local officials presumptuously decreed that an explanatory text be carved on the upper face of the table itself, complete with his name. Brancusi reacted with justifiable indignation on his return in 1938, and ordered the inscription's removal. But the erasing process involved changing the table's proportions, so he then ordered a larger table and base from the 'Pietroasa' Society of Deva.

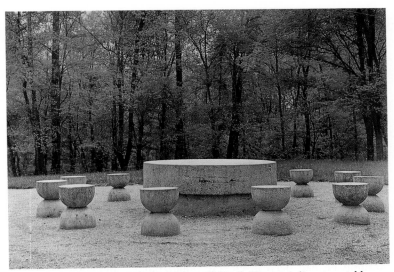

408 Constantin Brancusi *Table of Silence* 1937–8. Bampotoc limestone table (two superimposed cylindrical slabs), upper, height 45 cm, diameter 215 cm; lower, height 45 cm, diameter 200 cm. Twelve stools (superimposed hemispheres): each height 45 cm, diameter 55 cm. Tirgu-Jiu.

When they arrived, the sculptor decided to turn the upper slab from the initial table into a new base, resting the fresh upper slab on top of it. His manoeuvres did not, however, prevent other interpretations of the work from proliferating, along with an array of alternative titles. Some, like *The Family Table*, emphasized its probable indebtedness to Brancusi's childhood memories of the small round table in his parents' house. Others, including *The Table of the Last Supper* and *The Table of the Hungry after Mind and Spirit*, point to its links with the circular communion tables in the sanctuaries of several village churches in the Gorj district. While Brancusi was surely right to keep the work's resonance as open as possible, both the domestic and the ecclesiastical readings help to account for its appeal. For the *Table of Silence* does possess familial connotations which promote the notion of brotherhood, and it simultaneously resembles the site of a religious ritual. At once secular and sacred, its elemental quietude nevertheless manages in the end to invest the work with a predominantly sacramental aura. The sculptor himself once pointed out the link between the table's encirclement by twelve seats and Christ surrounded by the Apostles,[4] thereby confirming that he had intended *The Table of Silence* to possess sacrificial implications.

In his initial plan, Brancusi envisaged the stone stools ranged round the table in pairs – perhaps to accentuate the graceful way in which each seat is comprised of two hemispheres serenely touching one another. The idea of coupling assumes overriding importance at the end of a short walkway which extends eastwards from the river. Here, near the park entrance, he installed the monumental *Gate of the Kiss* (Pl. 409). Its original position was supposed to have been beside a new road, but Brancusi then wrote to Mrs Tătărăscu asking 'for the Gate to be built a little way inside the garden, because if we place it at the edge as planned, it cannot function either as an enclosing element or as an independent entity. If we shift the location to just inside [the garden], not only could people then walk round it, but two stone benches could be placed at the sides.'[5] In other words, Brancusi wanted the work to occupy a place where viewers would enjoy easy and intimate contact with it. Mrs Tătărăscu had specifically urged him 'to build a "triumphal arch"',[6] but he resisted the grandiosity implicit in such a proposal. Brancusi wanted to avoid martial pomp in favour of a tender alternative. The *Gate*, despite its austere and

architectonic finality, is above all the distillation of his long involvement with two figures locked in an embrace so complete that they almost merge into a single mass.

Even in the earliest versions of *The Kiss*, however, Brancusi treated his impassioned theme with conspicuous calm. Perhaps he intended it as an antidote to the rhetoric of Rodin's celebrated carving, for Brancusi had worked briefly in the older sculptor's studio and ended up reacting against his outspoken emotionalism. Nothing disturbs the absolute serenity of Brancusi's lovers, wedged together so tightly that they emphasize at every turn the original block of stone from which they have been carved. In his 1910 full-length version of *The Kiss*, placed on the grave of Tatiana Rachewsky at the Montparnasse Cemetery in Paris, Brancusi arrived at the form which runs across the *Gate of the Kiss* over a quarter of a century later. Hieratic rather than erotic, the tightly packed organization of entwined and pressing limbs in the 1910 carving already strives for a columnar identity. By 1916 he had taken this line of thought to its logical conclusion in a plaster *Study for Column of the Kiss*, a lost work which shows how keenly Brancusi wanted to develop his ideas on an architectural scale.

He was obliged to wait until the Tirgu-Jiu commission for a chance to fulfil this ambition. Although a plaster *Column of the Kiss* nearly ten feet high was included in his 1933–4 one-man show,[7] and described as part of a proposed *Temple of Love* designed for the Maharajah Holkar of Indore, the project never reached fruition. Only in the *Gate of the Kiss* was he able to realise his long-nurtured plans on the grand scale, and as if to celebrate their fulfilment he incised[8] sixteen identical kiss motifs in both the front and back friezes on the stone lintel. Four more appear on each of the sides, so that the figures succeed in embracing the immense block of bampotoc travertine as completely as they close on one another's bodies.

Brancusi's handling of the figures could hardly be more simplified. Determined to purge them of all carnal passion, he reduces their intertwined forms to a single plane and defines each pair of eye-sockets as a circle divided by a vertical line. The arms become three horizontal lines, while the squatting legs are summarized in a gentle curve. Only the undulating strands of hair beside the eyes introduce a hint of motion to a frieze which otherwise constitutes the quintes-

409 Constantin Brancusi *Gate of the Kiss* 1938. Bampotoc travertine, height 513 cm, width 645 cm, depth 169 cm. Tirgu-Jiu.

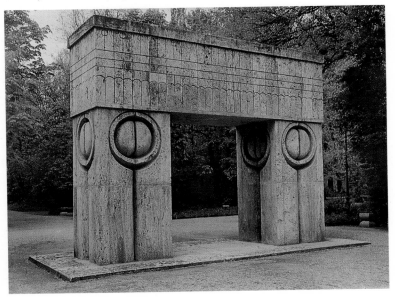

sence of calm refinement. Supported by the mighty columns below, where the concentric rings of the eyesockets are enlarged and given an amplitude denied to their counterparts above,[9] the *Gate of the Kiss* exudes serenity.

It also possesses the festive formality of a multiple marriage ceremony, and there are pertinent similarities between the lintel and the geometrical patterns incised on traditional Rumanian rural dowry chests. Radu Varia even speculated about Brancusi's debt to Egyptian precedents – most notably the western façade of the Temple of Hathor, the goddess of the kiss who was supposedly in sole command of the ability to open the temple's gates.[10] While there are undoubted similarities between the *Gate of the Kiss* and the portico of the Temple of Hatshepsut at Dêr El-Bahari, where columns support a lintel incised with hieroglyphs, there is nothing awesome or forbidding about Brancusi's monument. Massive without seeking to make the spectator feel insignificant, it is built on a human scale and invites anyone to penetrate its embracing portal. Far from signifying cabalistic mysteries, like the secret erotic symbolism on the Temple of Hathor, Brancusi's celebration of the kiss seems eminently accessible. Its open willingness to affirm the delights of physical and spiritual intimacy is ideally attuned to the idea of a war memorial available to all. Conscious of the gate's public role, he made sure that anyone could grasp the significance of a monument dedicated to the antithesis of the warlike impulse. Far from fighting each other, the figures ranged around his lintel are locked in mutual adoration. 'What is left behind when you are no more?', Brancusi asked when explaining the intention of the gate. 'It is the memory of the eyes, of your looks that imparted love for man and people. These figures are a representation of the amalgamation of man and woman through love.'[11]

In this respect, the *Gate of the Kiss* is as redemptive as Spencer's memorial chapel at Burghclere (see Pl. 399). Brancusi stressed the sacred element in the Tirgu-Jiu complex by incorporating the Church of the Holy Apostles on the long, specially created road leading beyond the gate and out of the park to the culminating point of the installation, the *Endless Column*. Originally erected in 1747, the church was rebuilt between 1927 and 1937 in memory of 'the heroes who laid down their lives for the unity of their nation' in 1916.[12] Although in no sense responsible for the design of the church, Brancusi recognised its importance in the commemorative scheme and tried hard to make the building an integral part of the axis, perpendicular to the river, which ran through the north of the town from the *Table of Silence* to the *Endless Column*. He would sit on the banks of the Jiu and align the church's belfry cross with the top of the tall *Column* beyond. The distances between the elements in his ensemble played an important role in its overall meaning, and the road leading from the gate to the church had been given the symbolically charged name 'Avenue of the Heroes'. When Brancusi was asked why such a long walk separated the *Table* from the *Column*, he replied: 'the Way of the Heroes is always hard and long.'[13]

So there was, perhaps, an element of suffering and endurance built in to this otherwise affirmative memorial. The idea of the road to Calvary does suggest itself as visitors move past the church and beyond the railway tracks towards the final circular landscaped space enclosing the climactic form of the *Endless Column* at the apex of a low hill (Pl. 410). The title of this aspirant work immediately implies that Brancusi aimed at evoking an ascent to infinity. It is, in fact, just over ninety-six feet tall, and the sculpture's spiritual connotations are reinforced by the process devised for its assembly. After Brancusi carved a module in basswood, the fifteen elements and two half-elements comprising the complete work were cast in iron and then

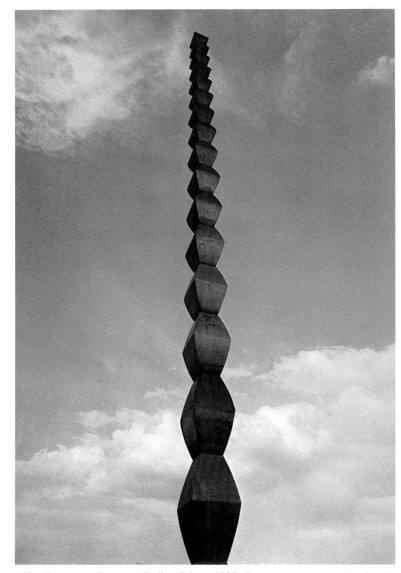

410 Constantin Brancusi *Endless Column* 1937. Cast iron, copper coating, height 29.35 m. Tirgu-Jiu.

threaded, like the beads of a rosary, on to the square internal column of steel. The idea of a prayer rising from earth to the firmament therefore seems implicit in its very structure, and the religious dimension is further enhanced by the resemblance between the module and the serrated capitals above the wooden columns of a church porch built by the sculptor's great-grandfather in the village where Brancusi was born.

By making the *Column* emerge from the ground, without the mediation of an intervening plinth, he also gave the work an unexpectedly organic conviction. It appears to spring out of the soil like a tree, suggesting that Brancusi had recalled the custom of planting fir-trees at the heads of graves in his birthplace, Hobitza. Indeed, he once told the sculptor Malvina Hoffman that 'nature creates plants that grow up straight and strong from the ground; here is my Column, it is in the beautiful garden of my friend in Rumania. Its forms are the same from the ground to the top, it has no need of pedestal or base to support it, the wind will not destroy it, it stands there solid and vigorous on its own feet, unmoveable.'[14]

The notion of planting his column in a natural setting had fired his imagination at least as far back as 1920, when he erected an early wooden version in Edward Steichen's garden at Voulangis, on the

outskirts of Paris. A photograph of this subsequently severed work shows how its gently swollen rhomboids rose to a height of twenty-three feet among the surrounding foliage.[15] Its rigidity and absolute regularity contrasted with the natural forms on every side, whereas at Tirgu-Jiu the vastly extended cast-iron version rises in isolation from a bare, circular area. The effect is starker and more uncompromising than at Voulangis. Whether Brancusi intended it or not, the *Endless Column* refers more to the stripped tree-trunks punctuating the shattered landscapes of the Western Front than to normal parkland (see Pl. 272). By allowing his sculpture to soar so triumphantly into space, however, he appears to insist that even the most savagely dismembered trees from the war zone might one day surge upwards in defiance of the damage they had once sustained.

This spare yet richly allusive image gained another possible layer of meaning when, in November 1937, it was sprayed with a coat of gold-yellow brass. For many years it glistened in the Rumanian sunlight, asserting a presence as magical as the equally glowing bronze birds which Brancusi had produced with obsessive frequency over the previous quarter of a century. A few years after the completion of the Tirgu-Jiu installation he made several exceptionally streamlined versions of the *Bird in Space*, polishing the bronzes so that they acquired a lustrous surface comparable in its aura with the brass-coated column. Although the smooth and slightly swelling forms of the elongated birds are quite distinct from the modules in *Endless Column*, they are united by a shared preoccupation with upward flight. The transcendence of *Bird in Space*, as it glides towards the sky, chimes with a similar desire in the culminating sculpture at Tirgu-Jiu. For the column soars effortlessly from its earthly foundations with a hint of beating wings, and the yellow sheen which Brancusi wanted it to give out possesses the hypnotic radiance of a being released at last from all terrestrial constraints.[16]

If Brancusi avoided making any literal reference to the Rumanians whose deaths had brought about the commissioning of the *Endless Column*, it nevertheless honours the national tradition of placing tall funerary poles on young men's graves. These wooden memorials, carved with geometrical designs reminiscent of the form-language he favoured here, can be found in village cemeteries at Roman, Laz, Săscior and many other locations. Just as they were meant to point towards the possibility of spiritual ascendancy over death, so Brancusi's column strives for a parallel victory. It was once called *The Column of Infinite Gratitude*,[17] and during the closing session of Tirgu-Jiu's Communal Council in November 1937 the claim was made that 'the memory of the place for which the heroes of Gorj fought is linked with the idea of infinite gratitude symbolized by the Column.'[18] So the idea emerges of an ever-ascending, heartfelt thank-offering, so fervent and steadfast in the will to remember that its permanence compensates for the transience of the soldiers' brief existence.

Whether Brancusi wanted to go further still, and make his column stand for the triumph of the resurrection, remains open to question. For all his interest in other religions, he regarded himself as an orthodox Christian; and in 1938 he suggested to Mrs Tătărăscu that they should call the column 'a stairway to Heaven'. When she reacted with puzzlement, he added: 'Let's call it then the *Endless Remembrance*'.[19] But Brancusi persisted in thinking of his masterpiece as a bridge between earthly life and the hereafter, following on from his declaration in a 1933 exhibition catalogue that an earlier version of the *Column without End* was intended, 'when enlarged', to 'support the arch of the firmament'.[20] He later voiced the same ambition on being asked why he had erected the *Endless Column*. 'So that it would

sustain the vault of heaven,'[21] Brancusi replied, as though the sculpture had been intended to uphold the existence of an after-life in the minds of people whose faith had been undermined by the carnage of the Great War. The column undoubtedly looks strong enough to perform such a herculean task. It rises from the Rumanian earth like an immense vertebral shaft – a symbol, perhaps, of the spirit of a young defender who, having met his death on the banks of the Jiu over twenty years before, now forms an unwavering backbone between the country where he fell and the empyrean.

The *Endless Column* stands as a resilient, consoling assertion of hope and faith. If Brancusi's memorial begins with a horizontally inclined image of loss, reconciliation and unity by the river's edge, before moving on to the generative and loving embrace on the gate, it ends with a singlemindedly vertical thrust away from earthly existence towards an unadulterated spiritual dimension. The *Column* attains an authentic sublimity, and serves as an ideal corrective to all the debased war memorials Brancusi loathed elsewhere in Europe. 'On a pedestal one finds invariably a crow which one might with some good will mistake for an eagle,' he complained, before declaring that 'all these flocks of crows should be destroyed, with dynamite, because they spoil the beauty of our countryside.'[22]

Although Brancusi deliberately left his ensemble open to as wide a range of interpretations as possible, the fundamental progression from earth to heaven would have been evident to anyone who moved thoughtfully through the installation after its completion. War veterans were among the crowd who gathered for the dedication ceremony on 27 October 1938. Mrs Tătărăscu presided over the proceedings, which commenced in the morning with a celebration of Mass by sixteen priests. Holy water was sprinkled on the *Endless Column* before the congregation walked towards the Church of the Holy Apostles for a Mass devoted to the memory of the defenders of the district of Gorj. Then, after a final service was held in honour of the *Gate of the Kiss*, speakers expressed their thanks to Mrs Tătărăscu and Brancusi himself, 'that great sculptor and native son of Gorj, who has expressed in iron and stone the country's gratitude to the heroes of the Resistance.'[23]

In the very same month that Brancusi's healing memorial was dedicated, though, events in neighbouring countries took a decisive turn away from the path of love and reconciliation. However ardently everyone assembled for the ceremony at Tirgu-Jiu may have prayed for a continuation of peace, they were already aware of the fact that another period of serious international conflict threatened to erupt. On 5 October Hitler had walked over the border into Czechoslovakia to claim the Sudetenland. The cheering crowds who greeted him at Eger could not disguise the ominous implications of Germany's decision to annex Czech Silesia. It was the beginning of Hitler's ruthless advance across Czechoslovakia and Poland, which finally forced Britain and France to declare war on the Nazi aggressor. Rumania would itself be invaded and occupied by German and Italian troops, crushing the spirit of resistance which had withstood the advance on the River Jiu in 1916. Just over twenty years after the termination of 'the war that will end war',[24] another savage and protracted struggle between the same nations had begun.

An unintentionally ironic photograph survives, taken in October 1939, of English troops with rifles on shoulders marching towards Cambridge railway station (Pl. 411). They turn their heads to look at their predecessor on the local war memorial as he strides in the opposite direction – an idealized young Tommy in bronze, whose helmet is crowned with a laurel wreath as he returns home to 'Alma

Mater Cantabrigia' from the trenches.[25] A moment later, the soldiers' faces will revert to the road ahead, their brief acknowledgement of the previous conflict already fading from their minds. By then, as Paul Fussell pointed out, 'the Great War had receded into soft focus, and no one wanted to face the terrible fact that military successes are achieved only at the cost of insensate violence and fear and agony, with no bargains allowed.'[26] The reality of war, and the need to define it in images conveying 'a bitter truth', would have to be discovered all over again.

411 Cambridge soldiers *en route* to the station, October 1939. Photograph published in the *Cambridge Daily News*.

NOTES

INTRODUCTION

1. See *The Fallen. An Exhibition of Nine Artists Who Lost Their Lives In World War One*, ed. Tim Cross, with essays by Richard Cork, Patrick Elliott, Hans Georg Gmelin, Ann Kodicek, Jill Lloyd and Wilhelm Weber (Oxford, Museum of Modern Art, 1988).
2. Paul Nash to Margaret Nash, mid-November 1917, *Outline. An Autobiography and Other Writings* (London, 1949), p. 211.
3. See, for example, the wealth of illustrations of British war art in Robert Giddings, *The War Poets* (London, 1988).
4. Ezra Pound, *Gaudier-Brzeska. A Memoir* (London, 1916), p. 17.
5. Henri Gaudier-Brzeska, 'Vortex Gaudier-Brzeska (Written From The Trenches)', *Blast No. 2*, ed. Wyndham Lewis (London, 1915), p. 34.
6. Lady Butler, quoted by Paul Usherwood and Jenny Spencer-Smith, *Lady Butler. Battle Artist, 1846–1933* (London, National Army Museum 1987), p. 138.
7. Lady Butler, diary entry, 22 September 1914, ibid.
8. Samuel Hynes, *A War Imagined. The First World War and English Culture* (London, 1990), p. 108.
9. *Politische-Anthropologische Revue*, November 1912.
10. Kenneth E. Silver, *Esprit de Corps. The Art of the Parisian Avant-Garde and the First World War, 1914–1925* (London, 1989).
11. Max Beckmann, letter of 24 May 1915, *Briefe im Kriege* (Munich, 1955), p. 63.
12. Wyndham Lewis, 'The Six Hundred, Verestchagin and Uccello', *Blast No. 2*, op. cit., p. 25.
13. Muirhead Bone to Ffoulkes, 31 March 1929, Imperial War Museum, London, Bone file.
14. Julian Barnes, *A History of the World in 10½ Chapters* (London, 1990 edn.), p. 137.

1. BEFORE THE WAR

1. Ludwig Meidner, 'Ein denkwürdiger Sommer', *Der Monat*, 16, August 1964, p. 75.
2. Donald E. Gordon, *Expressionism. Art and Idea* (New Haven and London, 1987), pp. 40, 41.
3. Daniel Paul Schreber, *Memoirs of My Nervous Illness*, translated by Ida Macalpine and Richard A. Hunter (London, 1955), p. 84.
4. Ludwig Meidner, *Im Nacken das Sternemeer* (Leipzig, 1918).
5. Quoted by Hans von Brescius, *Gerhart Hauptmann – Zeitgeschehen und Bewusstsein in unbekannten Selbtszeugnissen* (Bonn, 1977), p. 53.
6. Stefan Zweig, 1910, quoted by Donald E. Gordon, op. cit., p. 101.
7. Georg Heym, 'The War', translated by Frederick

S. Levine, *The Apocalyptic Vision. The Art of Franz Marc as German Expressionism* (New York, 1979), p. 112.
8. Georg Heym, 'Umbra Vitae', translated by Michael Hamburger and Christopher Middleton, eds., *Modern German Poetry* (New York, 1964), p. 155.
9. Thomas Grochowiak, *Ludwig Meidner* (Recklinghausen, 1966), p. 38.
10. Ludwig Meidner, 'Ein denkwürdiger Sommer', op. cit., p. 75.
11. Wieland Schmied, 'Points of Departure and Transformations in German Art 1905–1985', *German Art in the 20th Century* (London and Munich, 1985), p. 26.
12. *Politische-Anthropologische Revue*, November 1912.
13. *Das Neue Deutschland*, 17 May 1913.
14. Ludwig Meidner, quoted by Wolf-Dieter Dube, *Expressionists and Expressionism* (Geneva, 1983), p. 92.
15. Stefan Zweig, *The World of Yesterday. An Autobiography* (New York, 1943), pp. 196–8.
16. F.T. Marinetti, *Initial Manifesto of Futurism*, 20 February 1909. The translation used here is taken from *Exhibition of Works by the Italian Futurist Painters*, the catalogue of the Futurists' first London exhibition, held at the Sackville Gallery in March 1912 and subsequently reprinted in Joshua C. Taylor, *Futurism* (New York, 1961), pp. 124–5.
17. Ludwig Meidner, 'An Introduction to Painting Big Cities', *Kunst und Künstler*, vol. 12, 1914.
18. F.T. Marinetti, 'Tod dem Mondschein! Zweites Manifest des Futurismus', *Der Sturm*, May 1912.
19. From *Exhibition of Works by the Italian Futurist Painters*, op. cit.
20. The size and whereabouts of *The Deluge* on glass are unknown. It was reproduced in Hans K. Roethel and Jean K. Benjamin, *Kandinsky* (Oxford, 1979), p. 102.
21. From a free translation of Kandinsky's statement on *Composition VI*, first published in the *Sturm Album*, p. xxv, and quoted in English by Hans K. Roethel and Jean K. Benjamin, *Kandinsky*, op. cit., p. 100.
22. Ibid.
23. Ibid.
24. Sir Michael Sadler, quoted by W.T. Oliver, 'Sadler as Art Collector', *Michael Sadler* (Leeds, 1989), p. 19. Kandinsky's painting, now entitled *Fragment 2 for Composition VII* (1913) is in the Albright-Knox Art Gallery.
25. Quoted by Michael Sadler, 'Premonitions of the War in Modern Art', unpublished lecture delivered in Leeds, 26 October 1915, Brotherton Library, Leeds University.
26. Ibid.
27. Quoted by W.T. Oliver, 'Sadler as Art Collector', op. cit., p. 19.

28. Wassily Kandinsky to Arthur Jerome Eddy, quoted by Eddy, *Cubists and Post-Impressionism* (Chicago, 1914), pp. 125–6.
29. Roger Fry, *The Nation*, 2 August 1913. *Improvisation 30 (Cannons)* was exhibited at the Allied Artists Salon, London, in 1913.
30. Germain Seligman, *Roger de La Fresnaye* (Greenwich, Ct., 1969), p. 32.
31. Robert Rosenblum, *Cubism and Twentieth-Century Ary* (New York, 1976), p. 179.
32. *Daily Telegraph*, 10 March 1912.
33. Patricia Leighten, 'Picasso's Collages and the Threat of War, 1912–13', *The Art Bulletin*, December 1985, p. 653.
34. David Cottington, 'What the Papers Say: Politics and Ideology in Picasso's Collages of 1912', *Art Journal*, Winter 1988, p. 357.
35. According to Pierre Daix and Joan Rosselet, who recently redated Picasso's Cubist works, the newspaper in *Guitar, Sheet-Music and Glass* is the earliest they have been able to discover (*Picasso. The Cubist Years, 1907–1916*, London, 1979).
36. Translated by Patricia Leighten, op. cit., p. 665.
37. Quoted by Pierre Cabanne, *The Brothers Duchamp* (Boston, 1976), p. 74.
38. Ibid., p. 73. Villon contrasted this 'synthesis' with the 'disintegrated leaps, which is a purely cinematographic process', favoured by the Futurists.
39. Camilla Gray, *The Great Experiment. Russian Art 1863–1922* (London, 1962), pp. 134–6.
40. John Golding, 'The Black Square', *Studio International*, March/April 1975, p. 103.
41. *Yellow Quadrilateral on White*, 1916–17, in the Stedelijk Museum, Amsterdam.
42. Marsden Hartley to Gertrude Stein, 7 June 1913, quoted by Abraham A. Davidson, *Early American Modernist Painting 1910–1935* (New York, 1981), p. 24.
43. Marsden Hartley to Gertrude Stein, 29 April 1913, quoted ibid.
44. Marsden Hartley to Alfred Stieglitz, quoted by Barbara Haskell, *Marsden Hartley* (New York, 1980), p. 32.
45. Christopher Nevinson, *Paint and Prejudice* (New York, 1938), p. 77.
46. F.T. Marinetti, *Zang Tumb Tuuum. Adrianopoli Ottobre 1912. Parole in Libertà* (Milan, 1914), p. 145.
47. Friedrich Nietzsche, *Thus Spoke Zarathustra. A Book for Everyone and No One*, trans. with an intro. by R.J. Hollingdale (Harmondsworth, 1966), p. 74.
48. Ibid., p. 44.
49. Ibid., p. 43.
50. Ibid., pp. 44–5.
51. Ibid., p. 45.
52. Franz Marc, letter dated 22 May 1915, published in August Macke and Franz Marc, *Briefwechsel*

(Cologne, 1964), p. 163.

53. Franz Marc, quoted by Barry Herbert, *German Expressionism. Die Brücke and Der Blaue Reiter* (London, 1983), p. 187.

54. Wolf-Dieter Dube, *Expressionists and Expressionism*, op. cit., p. 91.

55. Douglas Goldring, *South Lodge. Reminiscences of Violet Hunt, Ford Madox Ford and the English Review Circle* (London, 1943), p. 71.

56. Wyndham Lewis, 'Kill John Bull With Art', *The Outlook*, 18 July 1914.

57. Wyndham Lewis, *Blasting and Bombardiering* (London, 1937), p. 39.

58. Ibid., p. 4.

59. Wyndham Lewis, 'Our Vortex', *Blast No. 1* (London, 1914), p. 148.

60. *The New Weekly*, 20 June 1914.

61. Frank Rutter, *Some Contemporary Artists* (London, 1922), pp. 182–3.

62. A.J.P. Taylor, *The First World War. An Illustrated History* (Harmondsworth, 1982), p. 20.

63. *Slow Attack* has been lost, and is known only through a reproduction in *Blast No. 1*, op. cit., plate vi.

64. Frank Rutter, *Some Contemporary Artists*, op. cit., p. 183.

65. Wyndham Lewis, *Blasting and Bombardiering*, op. cit., p. 4.

66. Hans K. Roethel and Jean K. Benjamin, *Kandinsky*, op. cit., p. 109.

67. The Revelation of St John The Divine, 6: 5–8.

68. Dating according to James Thrall Soby, *Giorgio de Chirico* (New York, 1955), p. 69.

69. Giorgio de Chirico, *The Memoirs of Giorgio de Chirico*, trans. Margaret Crosland (London, 1971), p. 18.

70. Ibid., p. 25.

71. Ibid.

72. Man Ray, *Self Portrait* (London, 1988), p. 49.

73. Ibid.

74. Ibid.

75. *A Book of Divers Writings* by Adon Lacroix was published by Man Ray in 1915.

76. Dorothy Shakespear Pound, *Etruscan Gate* (Exeter, 1971), p. 11.

2. HOSTILITIES COMMENCE (1914–15)

1. Thomas Grochowiak, *Ludwig Meidner*, op. cit., p. 38.

2. Matthias Eberle, *World War I and the Weimar Artists* (New Haven and London, 1985), p. 77.

3. Max Beckmann, *Leben in Berlin. Tagebuch 1908/09*, ed. Hans Kinkel (Munich, 1966), p. 22.

4. Max Beckmann, quoted by Peter Beckmann, *Max Beckmann* (Nuremberg, 1955), p. 16.

5. Marc Chagall, *My Life* (Oxford, new edition 1989), pp. 123–4.

6. Susan Compton, *Chagall* (London, 1985), p. 188.

7. The journal was called *Ogonek*.

8. Marc Chagall, *My Life*, op. cit., p. 124.

9. John Russell, *The Meanings of Modern Art* (London, 1981), p. 144.

10. Max Ernst, quoted by Edward Quinn, *Max Ernst* (London, 1977), p. 44.

11. August Macke to Elisabeth Macke, 9 September 1914, quoted by Jill Lloyd, 'August Macke 1887–1914', *The Fallen*, op. cit., p. 36.

12. August Macke to Elisabeth Macke, 11 September 1914, quoted ibid.

13. Franz Marc, quoted by Tim Cross, 'The Accident of the Individual Death', ibid., p. 3.

14. 'Manifesto', *Blast No. 1* (London, 1914), p. 30.

15. Wyndham Lewis, 'The New Egos', *Blast No. 1*, op. cit., p. 141.

16. Wyndham Lewis, 'Our Vortex', ibid., p. 148.

17. Kenneth Pople, *Stanley Spencer. A Biography* (London, 1991), p. 62.

18. James Thrall Soby, in *Giorgio de Chirico*, op. cit., p. 101, argues that the title of *The Sailors' Barracks* suggests that it was 'painted after the outbreak of war.'

19. Giorgio de Chirico, *The Memoirs of Giorgio de Chirico*, op. cit., pp. 68, 85.

20. Ibid., pp. 68–9.

21. August Macke to Elisabeth Macke, 11 September 1914, quoted by Jill Lloyd, 'August Macke 1887–1914', op. cit., p. 36.

22. Julius Meier-Grafe, editorial, *Kriegszeit*, 31 August 1914.

23. Rupert Brooke, '1914. I. Peace', *The Poetical Works of Rupert Brooke*, ed. Geoffrey Keynes (London, 1960), p. 19. The sonnet was first published in December 1914.

24. *The Holy War* was reproduced in *Kriegszeit* on 16 December 1914.

25. Ernst Barlach, diary entry dated 3 August 1914, quoted by Carl Dietrich Carls, *Ernst Barlach* (London, 1969), p. 97.

26. The original plaster of *The Avenger* is in the Robert Gore Rifkind collection, Los Angeles. Barlach drew *The Holy War* from this sculpture while its modelling was in progress. It should not be confused with the larger wood version carved in 1922.

27. Ernst Barlach, 5 September 1914, in Naomi Jackson Groves, *Ernst Barlach. Life in Work: Sculpture, Drawings, and Graphics; Dramas, Prose Works, and Letters in Translation* (Königstein im Taunus, 1972), p. 69.

28. Apart from *David and Goliath*, perhaps the finest of Weisgerber's Old Testament paintings is the dramatic *Absalom II*, 1914 (Hamburger Kunsthalle, Hamburg).

29. See Mary Chamot, *Goncharova. Stage Designs and Paintings* (London, 1979), p. 54.

30. Larionov was invalided out of the army, after a period of recuperation in hospital, early in 1915.

31. Revelation, 18: 21.

32. See the catalogue of *Retrospective Goncharova*, Maison de la Culture de Bourges (Bourges, 1973), no. 26.

33. See Vladimir Goriainov, 'Aristarch Lentulov', *XLIII Esposizione Internazionale d'Arte. La Biennale di Venezia* (Venice, 1988), p. 239.

34. For a detailed account of the historical rout depicted by Uccello, see John Pope-Hennessy, *The Complete Work of Paolo Uccello* (London, 1950), p. 151.

35. Larissa A. Zhadova, *Malevich. Suprematism and Revolution in Russian Art 1910–1930* (London, 1982), p. 28.

36. Vladimir Mayakovsky, 'The Civilian Shrapnel – To those who lied with the brush', *Collected Works*, Vol. 1 (Moscow, 1955), p. 309.

37. Kasimir Malevich to Mikhail Matyushin, 12 December 1914, quoted by Larissa A. Zhadova, *Malevich*, op. cit., p. 121, fn. 42.

38. Walter Sickert to Ethel Sands, quoted by Wendy Baron in *Sickert Paintings* (London, 1992), p. 244.

39. Walter Sickert to Nan Hudson, ibid.

40. Walter Sickert to Ethel Sands, ibid., p. 239.

41. Ibid.

42. Robert Graves, *Goodbye To All That* (London, 1929; Penguin edn., 1960), p. 60.

43. Walter Sickert to Lady Hamilton, *Sickert Paintings*, op. cit., p. 239.

44. Walter Sickert to Nan Hudson, ibid.

45. Quoted by Wendy Baron, ibid.

46. Ibid.

47. Renoir commented, on seeing *The Execution of the Emperor Maximilian*, that it was 'a pure Goya, but nevertheless Manet has never been more himself.'

48. Now in the Kunsthalle, Mannheim.

49. Walter Sickert to Ethel Sands, *Sickert Paintings*, op. cit., p. 239.

50. Ibid., p. 240.

51. Walter Sickert to Ethel Sands, quoted by Baron, 'Introduction', *Sickert* (London, Arts Council, 1978), p. 28.

52. Walter Sickert to Ethel Sands, ibid.

53. Walter Sickert to Ethel Sands, *Sickert Paintings*, op. cit., p. 239.

54. Walter Sickert to Ethel Sands and Nan Hudson, December 1914, quoted by Baron, *Sickert* (London, 1973), p. 366.

55. *The Sunday Times*, 17 January 1915.

56. See Lilian Browse, *Sickert* (London, 1960), p. 33.

57. Roland Penrose, *Picasso. His Life and Work* (Harmondsworth, 1971), p. 199.

58. Juan Gris to Daniel-Henry Kahnweiler, 16 August 1914, *Letters of Juan Gris*, trans. and ed. Douglas Cooper (London, 1956), p. 9.

59. Jacques Villon, quoted by Pierre Cabanne, *Pablo Picasso. His Life and Times* (New York, 1977), p. 171.

60. Gertrude Stein, *Picasso* (New York, 1984; first published London, 1938), p. 28.

61. Kenneth E. Silver, *Esprit de Corps*, op. cit.

62. Gertrude Stein, *The Autobiography of Alice B. Toklas* in *Selected Writings of Gertrude Stein*, ed. Carl Van Vechten (New York, 1972), pp. 84–5.

63. Gertrude Stein, *Picasso*, op. cit., p. 30.

64. Henri Matisse to Hans Purrmann, 1 June 1916, quoted by Alfred H. Barr, Jr., *Matisse. His Art and His Public* (New York, 1951; new edn., London, 1975), pp. 181–2.

65. André Derain, *Lettres à Vlaminck*, ed. Maurice Vlaminck (Paris, 1955), p. 221.

66. After the war Derain sold these sketchbooks to Walther Halvorsen, and they subsequently vanished.

67. Gwen John to John Quinn, 25 September 1914, quoted by Cecily Langdale, *Gwen John* (New Haven and London, 1987), pp. 51–2.

68. See Chapter One, note 16.

69. Umberto Boccioni to his family, 16 September 1914, quoted by Ester Coen, *Umberto Boccioni* (New York, 1988), p. xxxiii.

70. Wyndham Lewis, *Blasting and Bombardiering*, op. cit., p. 37.

71. Umberto Boccioni, letter dated 22 September 1914, quoted by Ester Coen, op. cit., p. 190.

72. *La Grande Illustrazione*, January 1915.

73. *Kriegszeit No. 2*, 7 September 1914.

3. DEADLOCK (1915)

1. The Allies offered Tyrol, Trieste, northern Dalmatia and part of Asia Minor if Italy decided to enter the war on their side; whereas Germany offered Tyrol and Trieste as the reward for Italy's continuing neutrality.

2. Several brass versions of *Boccioni's Fist* have been made in recent years after the original drawings for the sculpture.

3. Umberto Boccioni, *Gli Avvenienti*, quoted by Maurizio Fagiolo dell'Arco, *Balla The Futurist* (Milan, 1987), p. 106.

4. The treaty was signed on 26 April 1915.

5. *Le Mot*, no. 19, 15 June 1915.

6. Wyndham Lewis, 'The Six Hundred, Verestchagin and Uccello', *Blast No. 2* (London, 1915), p. 25.

7. Umberto Boccioni to Giacomo Balla, quoted by Maurizio Fagiolo dell'Arco, op. cit., p. 106.

8. Umberto Boccioni, war diary, August-December 1915, quoted by Ester Coen, op. cit., p. xxxv.

9. Ibid.

10. *Nord-Sud* is now owned by the Brera, Milan.

11. 'Futurist Painting: Technical Manifesto', 11 April 1910, signed by Boccioni, Carrà, Russolo, Balla and Severini. English translation published in the

catalogue of the Futurist Exhibition at the Sackville Gallery, London, March 1912.

12. Severini's *Maternité*, 1916, is now owned by the Museo dell'Accademia Etrusca, Cortona.

13. Christopher Nevinson, *Paint and Prejudice*, op. cit., p. 77.

14. For a detailed account of Marinetti and Nevinson's attempt to win over other British artists, see Richard Cork, *Vorticism and Abstract Art in the First Machine Age. Vol. 1: Origins and Development* (London, 1975), chapter nine.

15. The Scottish painter Stanley Cursiter had a short-lived Futurist phase, but he enjoyed no close personal contact with members of the movement.

16. Christopher Nevinson, interview with the *Daily Express*, 25 February 1915.

17. Christopher Nevinson, *Paint and Prejudice*, op. cit., pp. 95–6.

18. Wyndham Lewis, 'The London Group. 1915 (March)', *Blast No. 2*, op. cit., p. 77.

19. Christopher Nevinson, *Paint and Prejudice*, op. cit., p. 104.

20. *Daily News*, 2 February 1915.

21. Lady Butler, quoted by Paul Usherwood and Jenny Spencer-Smith, *Lady Butler Battle Artist 1846–1933* (London, 1987), p. 138.

22. Christopher Nevinson, *Paint and Prejudice*, op. cit., p. 107.

23. Ibid., p. 106.

24. From the caption accompanying the photograph, reproduced in the *Daily Graphic*, 11 September 1915.

25. For a discussion of the sculpture, and its relationship with a pre-war Nevinson drawing called *The Chauffeur*, see Richard Cork, *Vorticism* Vol. 1, op. cit., pp. 221–2.

26. Christopher Nevinson, *Paint and Prejudice*, op. cit., p. 110.

27. J.H. Morris, quoted by Paul Fussell, *The Great War and Modern Memory* (Oxford, 1975), p. 302.

28. Wyndham Lewis, 'The Six Hundred, Verestchagin and Uccello', *Blast No. 2*, op. cit., p. 25.

29. In the Tate Gallery Archive several cordial letters from Severini to Nevinson are preserved, where the Italian expresses interest in Nevinson's war paintings and informs him of the latest developments in Paris.

30. Gino Severini to Christopher Nevinson, 18 December 1916, Tate Gallery Archive.

31. Guillaume Apollinaire, 'Echos et on-Dit des Lettres et des Arts', *L'Europe Nouvelle*, 20 July 1918, reprinted in *Apollinaire. Chroniques d'Art (1902–1918)*, ed. L.C. Breunig (Paris, 1960).

32. Walter Sickert, 'O Matre Pulchra', *The Burlington Magazine*, April 1916.

33. Christopher Nevinson, *Paint and Prejudice*, op. cit., p. 110.

34. *The Observer*, 28 November 1915.

35. The title under which *Searchlights* was shown at the Leicester Galleries in September 1916. It is now owned by Leeds City Art Gallery.

36. Francis Bacon, interview with David Sylvester, *Francis Bacon. Paintings of the Eighties* (New York, Marlborough Gallery, 1987), p. 5.

37. William Roberts, *Memories of the War to End War 1914–18* (London, 1974), p. 1.

38. *Evening News*, 23 April 1915.

39. It was simply called *Drawing* in *Blast No. 2* (op. cit., p. 87), but Roberts later explained that Lewis had failed to print its proper title, *Machine Gunners* (William Roberts, *A Reply to My Biographer, Sir John Rothenstein*, London, 1957, pp. 13–14).

40. *Manifesto*, *Blast No. 1*, op. cit., p. 148.

41. Wyndham Lewis, 'The Six Hundred, Verestchagin and Uccello', *Blast No. 2*, op. cit., p. 25.

42. T.S. Eliot, 'Reflections on Contemporary Poetry', *The Egoist*, 10 November 1917.

43. Ford Madox Ford, *Antwerp* (London, 1915).

44. Wyndham Lewis, 'A Super-Krupp – Or War's End', *Blast No. 2*, op. cit., p. 14.

45. *Blast No. 2*, op. cit., p. 34.

46. Henri Gaudier-Brzeska to Ezra Pound, 24 October 1914, in Ezra Pound, *Gaudier-Brzeska. A Memoir* (London, 1916; new edn. Hessle, 1960), p. 56.

47. Henri Gaudier-Brzeska, 'VORTEX GAUDIER-BRZESKA (Written from the Trenches)', *Blast No. 2*, op. cit., p. 33.

48. Henri Gaudier-Brzeska to Edward Wadsworth, 16 December 1914, quoted by Barbara Wadsworth, *Edward Wadsworth. A Painter's Life* (Salisbury, 1989), pp. 58–9.

49. Henri Gaudier-Brzeska to Edward Wadsworth, 15 February 1915, ibid., p. 60.

50. Henri Gaudier-Brzeska, 'VORTEX GAUDIER-BRZESKA', op. cit., p. 34.

51. Ibid., p. 33.

52. Ibid., p. 34.

53. Wyndham Lewis, 'The London Group. 1915 (March)', *Blast No. 2*, op. cit., p. 78.

54. Ford Madox Ford, *The Outlook*, 31 July 1915.

55. Wyndham Lewis to Ezra Pound, 1 January 1918, *Pound/Lewis. The Letters of Ezra Pound and Wyndham Lewis*, ed. Timothy Materer (London, 1985), p. 113.

56. Ezra Pound to Felix Schelling, June 1915, *The Letters of Ezra Pound, 1907–1941*, ed. D.D. Paige (London, 1951), p. 106.

57. Wyndham Lewis, *Blasting and Bombardiering*, op. cit., p. 114.

58. Vanessa Bell to Clive Bell, April 1915, quoted by Richard Shone, *Bloomsbury Portraits* (Oxford, 1976), p. 141.

59. Only one of them, *Essay in Abstract Design*, is identifiable today (Tate Gallery collection).

60. Margaret Nash, 'Memoir of Paul Nash 1913–1946', c. 1950, Victoria & Albert Museum Library, quoted by Judith Collins, *The Omega Workshops* (London, 1983), p. 293.

61. The painting was exhibited as *Three Men in Long Military Cloaks* (or *German General Staff*) in the Retrospective Exhibition of the London Group, 1928.

62. Pamela Diamand, interview with the author, 27 January 1984.

63. See Judith Collins, *The Omega Workshops*, op. cit., p. 293.

64. Alice Mayes, 'The Young Bomberg, 1914–1925', memoir dated 1972, Tate Gallery Archive, p. 4.

65. Ibid.

66. O.F. Bailey and H.M. Holler, *The Kensingtons, 13th London Regiment* (Regimental Old Comrades Association, 1935), pp. 22–3.

67. *The Times*, 20 May 1916.

68. Angela Weight, 'The Kensingtons at Laventie – a twentieth century icon', *Imperial War Museum Review No. 1*, 1986, p. 16.

69. See Meirion and Susie Harries, *The War Artists. British Official War Art of the Twentieth Century* (London, 1983), p. 46.

70. A.J.P. Taylor, *The First World War*, op. cit., pp. 110–11.

71. Pavel Filonov, quoted in the catalogue of *Russian and Soviet Paintings 1900–1930* (Washington, 1988), p. 72.

72. For example, in *The Rebirth of Man*, 1914–15, now owned by the State Russian Museum, Leningrad.

73. See note 71.

74. Oskar Kokoschka to Kurt Wolff, end of September 1914, in Oskar Kokoschka, *Briefe*, ed. Olda Kokoschka and Heinz Spielmann, Vol. 1, 1905–1919 (Düsseldorf, 1984), pp. 182–3.

75. Oskar Kokoschka to Alma Mahler, end of July 1914, ibid., p. 176.

76. The prostrate figure was identified as Kokoschka by Edith Hoffmann, *Kokoschka. His Life and Work* (London, 1947), pp. 132–3.

77. Oskar Kokoschka, *Briefe*, Vol. 1, op. cit., p. 231.

78. The Gospel according to St Matthew, 27: 46.

79. Oskar Kokoschka to Adolf Loos, 6 August 1915, *Oskar Kokoschka Letters 1905–1976* (London, 1992), p. 69.

80. Oskar Kokoschka, 'In Letzter Stunde', quoted in Dieter Schmidt (ed.), *'In Letzter Stunde'* (Dresden, 1964), pp. 94–5.

81. Egon Schiele, quoted by Frank Whitford, *Egon Schiele* (London, 1981), p. 164.

82. Donald E. Gordon, in *Expressionism. Art and Idea*, op. cit., p. 143, suggests that Schiele's poster image may have been partially inspired 'by the risk of being drafted'.

83. Egon Schiele, quoted by Frank Whitford, *Egon Schiele*, op. cit., p. 168.

84. Albert Gleizes' *Return* was reproduced in *Le Mot*, no. 20, July 1915.

85. Albert Gleizes, *Le Mot*, no. 17, 1 May 1915.

86. Amédée Ozenfant, *L'Elan*, no. 1, 15 April 1915.

87. Fernand Léger, quoted by Douglas Cooper, introduction to *Fernand Léger, dessins de guerre 1915–16* (Paris, 1956).

88. Fernand Léger, quoted by André Verdet, *Fernand Léger et le dynamism pictural* (Geneva, 1955).

89. Ibid.

90. Georges Rouault, August 1914, quoted in the catalogue of *Rouault* (London, Tate Gallery, 1966), p. 38.

4. DISILLUSION (1915–16)

1. Marsden Hartley, quoted by Milton W. Brown, *One Hundred Masterpieces of American Painting from Public Collections in Washington, D.C.* (Washington, 1983), p. 132.

2. John Russell, *The Meanings of Modern Art* (London, 1981), p. 160.

3. Marsden Hartley, quoted by Milton W. Brown, op. cit., p. 132.

4. Marsden Hartley, 'Tribal Esthetics', *Dial*, November 1916. In 1914 Hartley had already painted several pictures in homage to his new enthusiasm, e.g. *American Indian Symbols*, collection John J. Brady, Jr., Des Moines, Iowa.

5. Marsden Hartley to Alfred Stieglitz, quoted by Barbara Haskell, *Marsden Hartley*, op. cit., p. 44.

6. Milton W. Brown, *American Painting from the Armory Show to the Depression* (Princeton, 1955; new edn. 1972), p. 76.

7. Otto Dix, interview, December 1963, quoted by Dieter Schmidt, *Otto Dix im Selbstbildnis* (East Berlin, 1978), p. 237.

8. Max Beckmann, letter of 11 October 1914, *Briefe im Kriege*, op. cit., p. 15.

9. See Chapter Two, note 3.

10. Max Beckmann, letter of 27 March 1915, *Briefe im Kriege*, op. cit., pp. 31–2.

11. Max Beckmann, letter of 30 March 1915, ibid., p. 34.

12. Ibid., p. 36.

13. Matthias Eberle, *World War I and the Weimar Artists*, op. cit., p. 92.

14. Max Beckmann, letter of 8 June 1915, *Briefe im Kriege*, op. cit., p. 69.

15. Max Beckmann, letter of 24 May 1915, ibid., p. 63.

16. Ibid., p. 60.

17. Max Beckmann, letter of September 1915, quoted by Stephan von Wiese, *Max Beckmanns zeichnerisches Werk 1903–1925* (Düsseldorf, 1978), pp. 171–2, note 125.

18. Max Beckmann, letter of 8 June 1915, *Briefe im Kriege*, op. cit., pp. 72–3.

19. Although the word 'Strassburg' is inscribed beneath the signature in this self-portrait, it was probably painted in Frankfurt.
20. Wyndham Lewis, 'Note (on some German Woodcuts at the Twenty-One Gallery)', *Blast No. 1*, op. cit., p. 136.
21. The *Ostend Madonna* was destroyed in the Second World War.
22. Donald E. Gordon, *Expressionism. Art and Idea*, op. cit., pp. 108–10.
23. Erich Heckel to Gustav Schiefler, Christmas 1915, quoted by Wolf-Dieter Dube, *Expressionists and Expressionism*, op. cit., p. 101.
24. George Grosz and Wieland Herzfelde, *Die Kunst ist in Gefahr* (Berlin, 1925), p. 19.
25. Ibid., p. 21.
26. George Grosz to Otto Schmalhausen, 15 March 1917, quoted by Hans Hess, *George Grosz* (New Haven and London, 1985), p. 47.
27. George Grosz to Robert Bell, September 1915, quoted by Uwe M. Schneede, *George Grosz. His Life and Work* (London, 1979), p. 30.
28. George Grosz to Robert Bell, probably May 1915, quoted by Hans Hess, op. cit., pp. 47–8.
29. George Grosz to Robert Bell, probably late 1915 or early 1916, quoted by Uwe M. Schneede, op. cit., p. 32.
30. George Grosz to Robert Bell, end of September 1915, quoted by Hess, op. cit., p. 50.
31. George Grosz to Robert Bell, postmarked 28 June 1915, ibid., p. 51.
32. George Grosz to Robert Bell, end of September 1915, ibid., p. 50.
33. *Stick It Out!* appeared in *Die Neue Jugend* in July 1916.
34. *Rightly or Wrongly*, plate 2 in the *Disasters* sequence, is related to *The Third of May 1808*, but it depicts a fight rather than the execution of a helpless, unarmed man.
35. See the catalogue of the exhibition *Schrecken und Hoffnung* (Hamburg, Munich, Moscow and Leningrad, 1987–88), p. 150.
36. See Frances Carey and Anthony Griffiths, *The Print in Germany 1880–1933. The Age of Expressionism* (London, 1984), pp. 112–13.
37. Ernst Ludwig Kirchner to Hannes Meyer, 11 July 1923, quoted by Donald E. Gordon, *Ernst Ludwig Kirchner* (Cambridge, Mass., 1968), p. 101.
38. Ernst Ludwig Kirchner to Karl Ernst Osthaus, quoted by Wieland Schmied, 'Points of Departure and Transformations in German Art, 1905–1985', op. cit., p. 26.
39. Ernst Ludwig Kirchner to Dr Carl Hagemann, 3 December 1915, quoted by Donald E. Gordon, *Ernst Ludwig Kirchner*, op. cit., p. 26.
40. Ernst Ludwig Kirchner to Gustav Schiefler, 27 July 1919, quoted ibid., p. 102.
41. Ernst Ludwig Kirchner to Gustav Schiefler, 28 March 1916, quoted ibid., p. 27.
42. Ernst Ludwig Kirchner, 1916, quoted by Wolf-Dieter Dube, *Expressionists and Expressionism*, op. cit., p. 101.
43. Franz Marc, quoted by Tim Cross in *The Fallen*, op. cit., p. 3.
44. Franz Marc, December 1914, quoted by Jill Lloyd, ibid., p. 47.
45. Ibid., p. 51.
46. Franz Marc, 1915, quoted by Barry Herbert, *German Expressionism*, op. cit., p. 186.
47. Franz Marc, letter of 12 April 1915, quoted by Frederick S. Levine, *The Apocalyptic Vision. The Art of Franz Marc as German Expressionism* (New York, 1979), p. 164.
48. Franz Marc, letter from the field, June 1915, quoted by Jill Lloyd, *The Fallen*, op. cit., p. 48.
49. Ibid., p. 51.
50. Ibid., p. 4.
51. Franz Marc to his wife, February 1916, ibid., pp. 5–6.
52. Ibid., p. 50.
53. Franz Marc to his mother, 17 February 1916, *Briefe aus dem Felde* (Berlin, 1940), pp. 133–4.
54. Hans Schilling, in Klaus Lankheit, *Franz Marc im Urteil Seiner Zeit* (Cologne, 1960), pp. 171–2.
55. Paul Klee, diary, quoted by Barry Herbert, *German Expressionism*, op. cit., p. 187.
56. Ibid.
57. Paul Klee, diary 1916, quoted by Will Grohmann, *Paul Klee* (London, 1954, new edn. 1965) p. 58.

5. THE GREAT CARNAGE (1916)

1. See Paul Fussell, *The Great War and Modern Memory*, op. cit., p. 12.
2. Jacques Darras, 'Remembering the Somme', 1989 Reith Lectures: 4, *The Listener*, 14 December 1989.
3. Carry Hauser revealed the origins of *Against the War* when he sold the watercolour to its present owner in 1988 (information kindly conveyed to the author by Jutta Fischer).
4. Oskar Kokoschka, *A Sea Ringed with Visions*, trans. Eithne Wilkins and Ernst Kaiser (London, 1962), p. 47.
5. Frank Whitford, *Oskar Kokoschka. A Life* (London, 1986), p. 108.
6. Oskar Kokoschka to Albert Ehrenstein, July 1916, quoted by Katharina Schulz in *Oskar Kokoschka 1886–1980* (London, 1986), p. 342.
7. Oskar Kokoschka, letter of 17 July 1916, *Briefe*, ed. Olda Kokoschka and Heinz Spielmann, op. cit., p. 242.
8. Oskar Kokoschka, postcard to Adolf Loos, 30 July 1916, ibid., p. 244.
9. Oskar Kokoschka to Herwarth Walden, 5 August 1916, ibid., p. 245.
10. Oskar Kokoschka to his mother, 26 November 1916, ibid., p. 259.
11. Ibid.
12. Oskar Kokoschka to Herwarth Walden, 8 December 1916, ibid., p. 260.
13. Reproduced in Fritz Novotny and Johannes Dobai, *Gustav Klimt* (London, 1968), p. 358.
14. Agnieszka Ławniczakowa, *Malczewski: A Vision of Poland* (London, Barbican Art Gallery, 1990), p. 107.
15. Kuzma Petrov-Vodkin, quoted by Lev Mohalov, *Kuzma Petrov-Vodkin* (Leningrad, 1980), p. 6.
16. Leonid Andreyev, 'Petrov-Vodkin's Painting', *Russkaya Volia*, 23 February 1917.
17. Yury Rusakov and Nina Barabanova, *Kuzma Petrov-Vodkin 1878–1939* (Leningrad, 1986), p. 98.
18. Olga Rozanova to A. Shemshurin, Manuscripts Department, State Lenin Library, Shemshurin fond 5/14.
19. Olga Rozanova, quoted by N. Punin, 'Flat No. 5', Manuscripts Department, State Tretyakov Gallery, fond 4/1568.
20. Khlebnikov's text was published in 1914.
21. Sometimes forms which appear in certain copies of the book are omitted from others.
22. M.N. Yablonskaya, *Women Artists of Russia's New Age 1900–1935* (London, 1990), p. 88.
23. Per Krohg, interview, autumn 1916, quoted by Jan Askeland, *Norsk malerkunst* (Oslo, 1981), p. 301.
24. *Daily Mail*, 3 July 1916.
25. Ibid.
26. Stuart Sillars, *Art and Survival in First World War Britain* (Basingstoke and London, 1987), p. 57.
27. According to information written by the artist on the back of an oil study for the painting, dated 1916 and now in the National Army Museum, London.
28. Obituary notice on Lucy Kemp-Welch, *The Times*, 28 November 1958.
29. Sims had moved to Fittleworth, West Sussex, around 1916 and set many of his works there.
30. *The Times*, 29 April 1916.
31. *The Connoisseur*, 45, 1916.
32. See MaryAnne Stevens, *The Edwardians and After. The Royal Academy 1900–1950* (London, 1988), p. 146, for an extended discussion of this picture's reception by the critics.
33. Charles Aitken, note to Blaikey, 6 December 1929, Imperial War Museum file.
34. Kenneth McConkey, *Sir George Clausen, R.A. 1852–1944* (Bradford, 1980), p. 89.
35. Derek Hudson, *James Pryde 1866–1941* (London, 1949), p. 64.
36. *The Red Ruin* is in the Cowdray collection.
37. Later in the war Pryde was invited to paint a picture of *Ruins in the War Zone* for the government, but nothing ever came of the scheme.
38. In 'Gilman's Subjects: Some Observations', *Harold Gilman 1876–1919* (London, 1981), pp. 31–2, Richard Thomson observed that 'there is a suggestion of the war's presence in Gilman's pictures, not as a subject, of course, but as a mood. A number of paintings of, say, 1916 and 1917 are permeated with a mood of loneliness and melancholy.'
39. Christopher Nevinson, *Paint and Prejudice*, op. cit., p. 96.
40. Ibid., pp. 96–7.
41. There was also one 'sculpture', listed in the catalogue as *The Mechanic*.
42. Christopher Nevinson, *Paint and Prejudice*, op. cit., p. 118.
43. Ibid.
44. *The Times Literary Supplement*, 5 October 1916.
45. *The Nation*, 30 September 1916.
46. Wilfred Owen, 'Exposure', *The Collected Poems of Wilfred Owen*, ed. C. Day Lewis (London, 1967 edn.), p. 48.
47. Jacob Epstein, *Let There Be Sculpture. The Autobiography of Jacob Epstein* (London, 1942 edn.), p. 89.
48. Ibid., pp. 88–9.
49. A plaster version, with epaulettes and arms, is owned by the National Maritime Museum, Greenwich.
50. Jacob Epstein, *Let There Be Sculpture*, op. cit., p. 89.
51. D.S. MacColl, 'Uncommissioned Art', *The Burlington Magazine*, Vol. 32, 1918.
52. For an extended account of the first version of *Rock Drill*, see Richard Cork, *Vorticism*, op. cit., Vol. 2, pp. 467–77.
53. Arthur Marwick, *The Deluge. British Society and the First World War* (London, 1965), p. 142.
54. Jacob Epstein, *Let There Be Sculpture*, op. cit., p. 56.
55. Mark Gertler to Lytton Strachey, May 1916, *Mark Gertler Selected Letters* ed. Noel Carrington (London, 1965), p. 111.
56. Mark Gertler, 3 May 1916, quoted by John Woodeson, *Mark Gertler. Biography of a Painter 1891–1939* (London, 1972), p. 224.
57. Mark Gertler to William Rothenstein, 4 April 1916, *Mark Gertler Selected Letters*, op. cit., p. 110.
58. Mark Gertler to Dora Carrington, quoted by John Woodeson, *Mark Gertler*, op. cit., pp. 225–6.
59. Mark Gertler to Dora Carrington, 20 May 1916, *Mark Gertler Selected Letters*, op. cit., p. 113.
60. Lytton Strachey to Lady Ottoline Morrell, quoted by John Woodeson, op. cit., p. 226.
61. D.H. Lawrence to Mark Gertler, 27 September 1916, *Mark Gertler Selected Letters*, op. cit., p. 129.
62. D.H. Lawrence to Mark Gertler, 9 October 1916, quoted by John Woodeson, op. cit., p. 226.

63. D.H. Lawrence, *Kangaroo* (London, 1954 edn.), p. 240.
64. D.H. Lawrence, *Women in Love* (London, 1954 edn.), p. 414.
65. D.H. Lawrence to Mark Gertler, 5 December 1916, *Mark Gertler Selected Letters*, op. cit., p. 133.
66. D.H. Lawrence, quoted by Richard Aldington, introduction to *Women in Love*, op. cit., p. viii.
67. See note 62.
68. St John Hutchison to Mark Gertler, quoted by John Woodeson, op. cit., p. 228.
69. See *Mark Gertler Selected Letters*, op. cit., p. 106.
70. Adrian Allinson, quoted by John Woodeson, op. cit., p. 228.
71. Mark Gertler to Dora Carrington, 30 November 1916, *Mark Gertler Selected Letters*, op. cit., p. 133. The carving has not survived, and may not have been finished.
72. Henry Tonks to D.S. MacColl, quoted by Joseph Hone, *The Life of Henry Tonks* (London, 1939), p. 127.
73. Sir Harold Gillies, quoted by Julian Freeman in *Henry Tonks and the 'Art of Pure Drawing'*, ed. Lynda Morris (Norwich, 1985), p. 40.
74. See Tonks file, Imperial War Museum.
75. Wilfred Owen to his mother, 19 January 1917, *Collected Letters of Wilfred Owen* (Oxford, 1967), p. 429.
76. Muirhead Bone to Ffoulkes, 31 March 1929, Bone file, Imperial War Museum.
77. Edmund Blunden, 'The Somme Still Flows', *The Listener*, 10 July 1929.
78. Ernst-Gerhard Güse, 'Das Kunstwerk des Monats' (Munster, 1978).
79. Heckel's *The Madman*, 1914, is now owned by the Städtisches Museum, Geisenkirchen.
80. Wieland Schmied, 'Points of Departure and Transformations in German Art 1905–1985', op. cit., p. 27.
81. See Will Grohmann, *Paul Klee*, op. cit., p. 61.
82. James Thrall Soby, *The Prints of Paul Klee* (New York, 1947), p. xi.
83. See Sabine Rewald, 'An Interview with Felix Klee', *Paul Klee* (London, Tate Gallery, 1989), p. 28.
84. Paul Klee, quoted by Will Grohmann, op. cit., pp. 58–9.
85. 'An Interview with Felix Klee', op. cit., p. 28.
86. Paul Klee, quoted by Grohmann, op. cit., p. 59.
87. Reinhold Hohl, 'Wilhelm Lehmbruck: A German Preserve', *German Art in the 20th Century*, op. cit., p. 439.
88. Paul Westheim, *Frankfurter Zeitung*, 2 March 1916.
89. The sculpture has also been known as 'Bent Figure', 'The Mourner' and 'Thinker'.
90. See Reinhold Heller, *The Art of Wilhelm Lehmbruck* (Washington, 1972), p. 198.
91. Ernst Barlach to Reinhard Piper, 1916, quoted by Carl Dietrich Carls, *Ernst Barlach* (London, 1969), p. 98.
92. Pierre Albert-Birot, 'Tradition/Mort, France Vie', *Sic*, April 1916.
93. Raoul Dufy to Simon Bussy, 30 May 1916, quoted by Pierre Schneider, *Matisse* (New York, 1984), p. 734.
94. Raymond Duchamp-Villon to Walter Pach, 1915, trans. Patrick Elliott in *The Fallen*, op. cit., p. 7.
95. Auguste Rodin, quoted in 'De l'Art Français et des Influences qu'il ne doit pas subir', *La Renaissance*, 15 September 1916.
96. Jean Cocteau to Valentine Hugo, 1 May 1916, quoted by Francis Steegmuller, *Cocteau. A Biography* (Boston, 1970), p. 147.
97. Kenneth E. Silver, *Esprit de Corps*, op. cit., p. 86.
98. *Italian Pride* was drafted in October 1915 and published the following January by the Direzione del Movimento Futurista. It was signed by Mar-

inetti, Boccioni, Russolo, Sant'Elia, Sironi and Piatti.
99. Umberto Boccioni to Vico Baer, July 1916, quoted by Ester Coen, op. cit., p. xxxv.
100. See Chapter One, note 16.
101. Carlo Carrà, quoted by Ester Coen, op. cit., p. xxxvi.

6. CATASTROPHE AND CENSORSHIP (1917)

1. The red flag in this painting was identified as Russian by Robert Macbeth in a letter to Frederic Allen Whiting, director of the Cleveland Museum of Art, 21 August 1918, quoted by Ilene Susan Fort, *The Flag Paintings of Childe Hassam* (Los Angeles, 1988), p. 44.
2. Hassam's initials are inscribed above this figure's head.
3. *Just off the Avenue. Fifty-Third Street. May 1916*, 1916, collection Mr and Mrs Richard J. Schwartz.
4. General Joffre and Arthur Balfour were the emissaries sent over to New York and Washington by their respective countries.
5. George Grosz to Otto Schmalhausen, 15 March 1917, in George Grosz, *Briefe 1913–1959* ed. Herbert Knust (Reinbeck, 1979), p. 48.
6. George Grosz, *Ein kleines Ja und ein grosses Nein* (Reinbeck, 1974), p. 110.
7. George Grosz to Otto Schmalhausen, 18 January 1917, quoted by Hans Hess, op. cit., p. 68.
8. A group of these small paintings are preserved in the Musée d'Histoire Contemporaine – BDIC, Hôtel National des Invalides, Paris.
9. Henry Valensi, 'Colour and forms', *Montjoie!*, November-December 1913.
10. Félix Vallotton, diary entry 10 March 1916, quoted by K. Tobler, 'A New Model. Félix Vallotton's War Landscapes', *Kulturmagazin*, September 1984.
11. Félix Vallotton, diary entry 18 May 1917, ibid.
12. Otto Dix, war diary, quoted by Otto Conzelmann, *Der andere Dix – Sein Bild vom Menschen und vom Kriege* (Stuttgart, 1983), p. 133.
13. Paul Adam, *Gazette du Bon Ton*, summer 1915, quoted by Jean-Paul Bouillon, *Art Deco 1903–1940* (Geneva, 1989), p. 130.
14. Fernand Léger, quoted by Douglas Cooper, introduction to *Fernand Léger, dessins de guerre 1915–16* (Paris, 1956).
15. Christopher Green, *Léger and the Avant-Garde* (New Haven and London, 1976), p. 102.
16. See note 14.
17. One of the more finished studies is inscribed 'drawing for the trench-diggers.'
18. On the back of *The Card Game*, Léger wrote that it was painted 'in Paris, while convalescing, December, 1917'.
19. Fernand Léger, quoted in the catalogue of *Fernand Léger 1881–1955* (Paris, Musée des Arts Decoratifs, 1956), p. 104.
20. Fernand Léger, 'The Aesthetic of the machine, geometrical order and truth', *Functions of Painting* (Paris, 1965), pp. 65, 66.
21. The painting of *The Stove* which Léger went on to produce in 1918 is owned by the Guggenheim Museum, New York.
22. Ionel Janou, *Zadkine* (Paris, 1964), p. 33.
23. An illustration of the same scene was published in *Le Figaro*, 21 March 1916.
24. In 1917 Steinlen also produced a variant on the theme entitled *Two poilus carrying a wounded man*.
25. Siegfried Sassoon, *The Complete Memoirs of George Sherston* (London, 1940 edn.), p. 421.
26. Alice Mayes, 'The Young Bomberg, 1914–1925', op. cit., pp. 21–2.
27. Ibid., p. 22.
28. David Bomberg, 'What's left of the Soldier-man',

Poems and Drawings from the First World War by David Bomberg, ed. Neville Jason (London, Gillian Jason Gallery, 1991), p. 43.
29. David Bomberg, inscription on *Field of Fire*. The drawing is reproduced in *Poems and Drawings from the First World War by David Bomberg*, ibid., on the endpapers.
30. Christopher Nevinson, *Paint and Prejudice*, op. cit., p. 130.
31. C.F. Masterman to Hudson, 29 October 1917, Imperial War Museum, London, Nevinson file.
32. Alfred Yockney to Dodgson, 21 November 1917, ibid.
33. Colonel A.N. Lee to Alfred Yockney, 13 December 1917, ibid.
34. Christopher Nevinson to C.F. Masterman, 25 November 1917, ibid.
35. Ibid.
36. Christopher Nevinson, preface to the catalogue of his Leicester Galleries exhibition, March 1918.
37. Christopher Nevinson, *Paint and Prejudice*, op. cit., p. 143.
38. *Daily Mirror*, 22 November 1916.
39. Christopher Nevinson, *Paint and Prejudice*, op. cit., p. 143.
40. Ibid.
41. Ibid., p. 148.
42. *Daily Mail*, 2 March 1918.
43. Christopher Nevinson, *Paint and Prejudice*, op. cit., p. 148.
44. Christopher Nevinson, preface to the catalogue of his Leicester Galleries exhibition, March 1918.
45. Christopher Nevinson to C.F. Masterman, 21 July 1918, Imperial War Museum, London, Nevinson file.
46. Graham Greene, *A Sort of Life* (Harmondsworth edn., 1974), p. 63.
47. Claud Cockburn, interview with Norman Sherry, 18 June 1977, *The Life of Graham Greene. Volume One: 1904–1939* (London, 1989), p. 59.
48. Henry Moore, *Henry Moore Wood Sculpture* (London, 1983), p. 54.
49. John and Vera Russell, 'Conversations with Henry Moore', *The Sunday Times*, 17 and 24 December 1961.
50. Moore's first chance to carve had occurred in 1913, when he was asked to cut the lettering in a school notice-board.
51. 'Conversations with Henry Moore', op. cit.
52. Henry Moore, *Henry Moore Wood Sculpture*, op. cit., p. 54.
53. Henry Moore, letter of 15 January 1955, *Henry Moore on Sculpture*, ed. Philip James, op. cit., p. 250.
54. Max Ernst, quoted by Uwe M. Schneede, *The Essential Max Ernst* (London, 1972), p. 15.
55. Robert Graves, *Goodbye to All That*, op. cit., p. 162.
56. *L'Horizon*, July 1918.
57. Georges Leroux to Herbert Jones, 14 December 1926, Imperial War Museum, London, Leroux file.
58. Erich Maria Remarque, *All Quiet on the Western Front* (Boston, 1929), p. 234.
59. Although the portfolio was printed at Panprefue in 1917, by R. Hoberg and H. Lulfing, some of the plates had been produced the previous year.
60. Otto Schubert's *The Suffering of Horses in the War* portfolio contained twelve lithographs in all.
61. William Shakespeare, *King Lear*, Act IV, Scene I, lines 35–6.
62. Edouard Vuillard, journal, March 1917, quoted by Belinda Thomson, *Vuillard* (London, 1988), p. 119.
63. Ibid.
64. The original decorative scheme contained four subjects in all.
65. Genesis 5: 10–14.

7. OFFENSIVE AND DEFEAT (1918)

1. The pendant to *The Descent from the Cross* is *Christ and the Woman Taken in Adultery*, 1917 (City Art Museum of St Louis, Missouri).
2. The *Pietà* is reproduced by Erhard and Barbara Göpel, *Max Beckmann – Katalog der Gemälde* (Berne, 1976), Vol. 1, p. 577.
3. See Chapter Four for a discussion of the relationship between *The Morgue* and van der Weyden's *Lamentation*.
4. Max Beckmann, letter of 24 May 1915, *Briefe im Kriege*, op. cit., p. 63.
5. Ibid.
6. Stephan von Wiese, *Max Beckmanns zeichnerisches Werk 1903–1925* (Düsseldorf, 1978), p. 106.
7. This source was identified by Alexander Dückers in the catalogue of *Max Beckmann. Die Hölle* (Berlin, 1983), p. 82.
8. Bruegel's painting, executed in 1560, is now owned by the Kunsthistorisches Museum, Vienna.
9. The precise date of *Crucifixion* is disputed. William Rubin ascribes it to 1918 in the catalogue of *Pablo Picasso. A Retrospective* (New York, 1980, p. 204), but the catalogue of the Musée Picasso's *The Body on the Cross* exhibition (Paris, 1992, Pl. 11) ascribes it to 1915–18.
10. The full title of Schmidt-Rottluff's portfolio was *9 Woodcuts (Christ)*. The tenth woodcut takes the form of an initial title sheet.
11. Valentiner, 'Karl Schmidt-Rottluff', *Der Cicerone*, quoted by Ida Katherine Rigby, 'The Revival of Printmaking in Germany', *German Expressionist Prints and Drawings* (California and Munich, 1989).
12. Raymond Duchamp-Villon to Walter Pach, 20 May 1918, quoted by Pach, *Raymond Duchamp-Villon* (Paris, 1924), p. 25. The *Gosset* portrait has sometimes been mistakenly dated 1917.
13. George Grosz to Otto Schmalhausen, 15 December 1917, quoted by Uwe M. Schneede, *George Grosz*, op. cit., p. 54.
14. George Grosz, 'Notes for the trial 3 December 1930', p. 2, quoted by Hans Hess, *George Grosz*, op. cit., p. 80.
15. See note 13.
16. See note 14.
17. See note 13.
18. See Chapter Five.
19. Milton Brown, *American Painting from the Armory Show to the Depression* (Princeton, 1972 edn.), p. 76.
20. Charlotte C. Eliot to Bertrand Russell, 23 May 1916, *The Letters of T.S. Eliot*, Vol. 1 1898–1922, ed. Valerie Eliot (London, 1988), p. 139.
21. The print was entitled *Prepare America*, and executed in 1916.
22. *Base Hospital, First Stone* was reproduced in the August 1918 issue of *Vanity Fair* with the caption: 'The First of a Series of Lithographs of the Great War by George Bellows'. Lauris Mason, in *The Lithographs of George Bellows* (New York, 1977, p. 97) thinks it was probably 'one of the first prints made for the War Series'.
23. George Bellows, quoted by Mason, op. cit., p. 96.
24. Ibid., p. 98.
25. Ibid., p. 95.
26. Robert Graves, *Goodbye to All That*, op. cit., p. 60.
27. The Bryce Committee Report, quoted by Lauris Mason, op. cit., p. 100.
28. *Collier's*, 28 September 1918.
29. *Nation*, 26 October 1918.
30. In print form, *The Barricade* exists in two versions, one a reversed image of the other.
31. Monet's flag-bedecked painting, executed in 1878, is now owned by the Musée d'Orsay, Paris.
32. 'New York the Beauty City', interview with Childe Hassam, *Sun* (New York), 23 February 1913.
33. Quoted by Gail Levin, *Edward Hopper. The Art and the Artist* (New York, 1980), p. 34.
34. Edward Hopper, in an undated 1918 *Sun* (New York) clipping quoted by Levin, op. cit., p. 34.
35. Ibid.
36. Ibid., p. 68 (note 68).
37. Thomas Hart Benton, quoted by Henry Adams, *Thomas Hart Benton. An American Original* (New York, 1989), p. 86.
38. Ibid., p. 87.
39. *New York Times*, 22 December 1918.
40. New York *Herald*, 22 December 1918.
41. T.S. Eliot to his father, 23 December 1917, *The Letters of T.S. Eliot*, op. cit., p. 214.
42. T.S. Eliot to his mother, 4 March 1918, ibid., p. 221.
43. William Orpen to Henry Tonks, n.d., quoted by Bruce Arnold, *Orpen – Mirror to an Age* (London, 1981), p. 316.
44. Two pictures entitled *Dead Germans in a Trench* were listed in the Agnew's catalogue (nos. 6 and 86).
45. The issue of *British Artists at the Front* devoted to Lavery's work was published in the spring of 1918, the second in this official series.
46. John Lavery, *The Life of a Painter* (London, 1940), p. 148.
47. John Nash to David Brown, 15 January 1974 and conversation with Brown, 4 March 1974, quoted in *We Are Making A New World* (Edinburgh, Scottish National Gallery of Modern Art, 1974), entry no. 32.
48. Paul Nash to Margaret Nash, 4 April 1917, *Outline: An Autobiography and Other Writings* (London, 1949), p. 193.
49. According to Ruth Clark, reported by Andrew Causey, *Paul Nash* (Oxford, 1980), p. 67.
50. Paul Nash to Margaret Nash, wrongly dated 7 March but probably mid-May 1917, *Outline*, op. cit., p. 187.
51. Paul Nash to Margaret Nash, 6 April 1917, ibid., p. 194.
52. Paul Nash to Margaret Nash, end of March 1917, ibid., p. 192.
53. Paul Nash told Edward Marsh, in a letter of 7 July 1917, that he had just met Nevinson (see Causey, op. cit., p. 73, note *f*).
54. Campbell Dodgson to C.F. Masterman, 18 October 1917, Imperial War Museum, London, Nash file.
55. Quoted by A.J.P. Taylor, *The First World War*, op. cit., p. 194.
56. Paul Nash, letter in Imperial War Museum, London, Nash file, quoted in *Paul Nash Through The Fire: Paintings, drawings and graphic work from the First World War* (London, 1988).
57. Paul Nash to C.F. Masterman, 16 November 1917, Imperial War Museum, London, Nash file.
58. Paul Nash to Margaret Nash, mid-November 1917, *Outline*, op. cit., pp. 210–11.
59. Paul Nash to C.F. Masterman, 22 November 1917, quoted by Anthony Bertram, *Paul Nash. The Portrait of an Artist* (London, 1955), p. 95.
60. *Column on the March* was reproduced as the colour frontispiece in Nevinson's *Modern War Paintings* (London, 1917), a publication which Nash was bound to have seen.
61. Paul Nash to Gordon Bottomley, 16 July 1918, *Poet and Painter, Being the Correspondence between Gordon Bottomley and Paul Nash, 1910–1946* ed. C.C. Abbott and Anthony Bertram (London, 1955), p. 98.
62. Paul Nash, *Outline*, op. cit., p. 216.
63. James King, *Interior Landscapes. A Life of Paul Nash* (London, 1987), p. 85.
64. William Blake, 'Tiriel', *William Blake. Complete Poetry and Prose*, ed. Geoffrey Keynes (London, 1939), pp. 156–7.
65. William Blake, 'Milton: Book The Second', ibid., p. 431. As Andrew Causey points out in *Paul Nash*, op. cit., p. 77, Nash painted a picture with the Blake-like title *Defence of Albion* in the Second World War.
66. Paul Nash to Gordon Bottomley, 1 August 1912, *Poet and Painter*, op. cit., p. 42.
67. A.N. Lee to Alfred Yockney, 2 May 1918, Imperial War Museum, London, Nash file.
68. C.E. Montague and John Salis (Jan Gordon), *British Artists at the Front*, Vol. 3 (London, 1918).
69. Francis Stopford to John Buchan, 16 August 1917, Imperial War Museum, London, Nash file.
70. A.Y. Jackson, 'Reminiscences of Army Life, 1914–1918', *Canadian Art*, Ottawa, autumn 1953.
71. A.Y. Jackson, 'The War Memorials: A Challenge', *Lamps*, Toronto, December 1919.
72. F.H. Varley to Maud Varley, mid-October 1918, quoted in Christopher Varley, *F.H. Varley. A Centennial Exhibition* (Edmonton, 1981) p. 38.
73. F.H. Varley to Arthur Lismer, 2 May 1918, McMichael Canadian Collection, quoted by Maria Tippett, *Art at the Service of War. Canada, Art, and the Great War* (Toronto, 1984), p. 67.
74. Application for Registration in the matter of the War Charities Act, 1916, Records Office, London Guildhall, 7 November 1916.
75. Max Aitken to Kemp, 6 September 1917, quoted by Tippett, op. cit., p. 27.
76. *Canadian War Memorials Exhibition* (London, Burlington House, 1919), entry 25.
77. An oil sketch of the proposed painting, measuring 37 × 122 cm, is in the Beaverbrook Art Gallery, Fredericton, New Brunswick.
78. Augustus John to Cynthia Asquith, 1918, quoted by Michael Holroyd, *Augustus John. A Biography* (Harmondsworth, 1976 edn.), p. 554.
79. Lord Beaverbrook to Sir Walter Monckton, 30 April 1941, ibid., p. 555.
80. For a full account of the Cave and its decorations, see Richard Cork, *Art Beyond the Gallery in Early 20th Century England* (New Haven and London, 1985), Chapter Two.
81. Unsigned preface to the catalogue of *Canadian War Memorials Paintings Exhibition – 1920 – New Series. The Last Phase* (Montreal, 1920), p. 7.
82. Charles Ginner, 'Neo-Realism', *The New Age*, 1 January 1914.
83. *The Burlington Magazine*, February 1919. Gilman's painting was exhibited, 'unfinished' according to the catalogue, in the 1919 Canadian War Memorials Exhibition at Burlington House (no. 5).
84. Wyndham Lewis to Ezra Pound, 20 August 1916, *Pound/Lewis*, op. cit., p. 55.
85. Wyndham Lewis to Ezra Pound, 6 June 1917, ibid., p. 73.
86. Wyndham Lewis to Ezra Pound, 14 June 1917, ibid., p. 75.
87. Ibid., p. 76.
88. Ibid.
89. Wyndham Lewis, *Rude Assignment. A Narrative of My Career Up-to-Date* (London, 1950), p. 128.
90. Ezra Pound to Wyndham Lewis, 25 August 1917, *Pound/Lewis*, op. cit., p. 99.
91. Wyndham Lewis to Ezra Pound, postmarked 22 September 1917, ibid., p. 105.
92. Wyndham Lewis to Ezra Pound, 9 January 1918, ibid., p. 113.
93. *Canadian War Memorials Exhibition*, op. cit., p. 7.
94. In *Blasting and Bombardiering*, op. cit., p. 158, Lewis recalled that 'we had attached to us a lot of West Indian negroes, principally for the purposes of shell-humping.'
95. Augustus John to Alick Schepeler, February 1919, quoted by Holroyd, op. cit., p. 553.

96. Wyndham Lewis to Herbert Read, 17 December 1918, *The Letters of Wyndham Lewis*, ed. W.K. Rose (London, 1963), p. 102.

97. *Canadian War Memorials Exhibition*, op. cit., no. 66.

98. Wyndham Lewis, *Blasting and Bombardiering*, op. cit., pp. 198–9.

99. William Roberts, *Memories of the War to End War 1914–18*, op. cit., p. 32.

100. Captain Harold Watkins to William Roberts, 28 December 1917, ibid., p. 24.

101. *Canada in Flanders, Vol. I*, quoted in *Canadian War Memorials Exhibition*, op. cit., p. 7 (entry 67).

102. William Roberts, *Memories of the War to End War 1914–18*, op. cit., p. 31.

103. Ibid., p. 16.

104. Ibid.

105. Ibid., p. 17.

106. Ibid., p. 22.

107. Ibid.

108. The only record of this painting (size and date unrecorded) is a photograph kindly sent to the author from the Mayor Gallery's archive.

109. As note 107.

110. William Roberts to Sarah Kramer (later Roberts), 7 December 1917; ibid., p. 45.

111. John Singer Sargent, quoted by Michael Holroyd, *Augustus John*, op. cit., p. 555 (note).

112. *New Statesman*, 8 February 1919.

113. Kenneth Clark, *Another Part of the Wood* (London, 1974), p. 77.

114. Eric Kennington to Alfred Yockney, 6 June 1918, Imperial War Museum, London, Kennington file.

115. In 1920 Vogeler used this etching as the basis of the first fresco in a cycle he painted in his house, the Barkenhoff, when he transformed it into a children's home. In 1927, a year after the frescoes' completion, they were denounced for their moral corruption and curtained over. In 1939, on the eve of another world war, they were destroyed.

116. Revelation: 15, 16.

8. AFTERMATH (1919)

1. Lord Northcliffe, quoted by A.J.P. Taylor, *The First World War*, op. cit., p. 211.

2. See Chapter Five, note 31.

3. René Gimpel, *Diary of an Art Dealer* (London, 1986), pp. 68–9.

4. Marguerite Steen, quoted by Duncan Robinson, *William Nicholson. Paintings, Drawings & Prints* (London, 1980), p. 27.

5. The other advisers were Campbell Dodgson, P.G. Konody and the artist and lecturer Thomas Derrick.

6. *The Surrender of Breda* measures 120 × 144 in.

7. The precise size of these smaller paintings was 72 × 86 in.

8. Meirion and Susie Harries, *The War Artists*, op. cit., p. 93.

9. Ibid., p. 94.

10. Alfred Yockney to John Singer Sargent, 26 April 1918, Imperial War Museum Archives, London.

11. John Singer Sargent to Emily Sargent, 1 August 1914, quoted by Richard Ormond, *John Singer Sargent. Paintings, drawings, watercolours* (London, 1970), p. 77.

12. John Singer Sargent to Violet Ormond, 1918, ibid., p. 98 (note 199).

13. John Singer Sargent to Hon. Evan Charteris, 11 September 1918, quoted by Charteris, *John Sargent* (London, 1927), p. 214.

14. John Singer Sargent to Isabella Stewart Gardner, n.d., ibid., p. 216.

15. John Singer Sargent to Alfred Yockney, 14 October 1918, Imperial War Museum Archives, London.

16. Ibid.

17. Henry Tonks to Alfred Yockney, 19 March 1920, Imperial War Museum, London, Sargent file.

18. John Singer Sargent to Alfred Yockney, 4 October 1918, Imperial War Museum, London, Sargent file.

19. 'I *hate* to paint portraits!' he once exclaimed to Walter Tittle ('My memories of John Sargent', *Illustrated London News*, CLXVI, 1925).

20. William Orpen to Alfred Yockney, 18 April 1919, Imperial War Museum, London, Orpen file.

21. John Singer Sargent to Hon. Evan Charteris, 1919, quoted by Michael Holroyd, *Augustus John*, op. cit., pp. 555–6 (n).

22. Sir David Young Cameron to Alfred Yockney, 28 September 1918, Imperial War Museum, London, Cameron file.

23. Sims set out for France at the end of October 1918, and Cameron's visit took place as late as January and February the following year.

24. Sir David Young Cameron to Alfred Yockney, 8 November 1919, Imperial War Museum, London, Cameron file.

25. Paul Nash to Gordon Bottomley, 16 July 1918, *Poet and Painter*, op. cit., p. 99.

26. Ministry of Information to Frank Dobson, 11 April 1919, Imperial War Museum, London, Dobson file.

27. William Roberts, *Memories of the War to End War 1914–18*, op. cit., pp. 17–18.

28. Wyndham Lewis, 'The Six Hundred, Verestchagin and Uccello', *Blast No. 2*, op. cit., p. 26.

29. Wyndham Lewis to Ezra Pound, postmarked 20 August 1917, *Pound/Lewis*, op. cit., pp. 95–6.

30. Wyndham Lewis to Ezra Pound, August 1917, ibid., p. 97.

31. Wyndham Lewis to Ezra Pound, 26 August 1917, ibid., p. 100.

32. Wyndham Lewis to Ezra Pound, August 1917, ibid., pp. 97–8.

33. Ibid., p. 97.

34. *Sigmund Freud: Character and Culture*, ed. Philip Rieff (New York, 1963), p. 122.

35. William Roberts, 'Wyndham Lewis, the Vorticist', *The Listener*, 21 March 1957.

36. See Barbara Wadsworth, *Edward Wadsworth. A Painter's Life* (Salisbury, 1989), p. 78.

37. The little-known Cuthbert Hamilton has been suggested as a likely model for this figure.

38. Wyndham Lewis, *Rude Assignment*, op. cit., p. 129.

39. Several painters, including Lamb and Stanley Spencer, were asked to paint pictures according to this smaller format.

40. *The Nation's War Pictures* (Manchester City Art Gallery, 1920), entry 125.

41. Stanley Spencer to Hilda Carline, summer 1923, quoted by Richard Carline, *Stanley Spencer at War* (London, 1978), p. 112.

42. Ibid.

43. Stanley Spencer to Alfred Yockney, 12 July 1919, Imperial War Museum, London, Spencer file.

44. Stanley Spencer to Alfred Yockney, 27 July 1919, Imperial War Museum, London, Spencer file.

45. Harold Watkins to David Bomberg, 29 December 1917, Tate Gallery Archive, London.

46. For a detailed account of the subject chosen for Bomberg's painting, and its subsequent troubled genesis, see Richard Cork, *David Bomberg* (New Haven and London, 1987), pp. 112–122.

47. Isaac Rosenberg to Edward Marsh, 26 January 1918, quoted by Joseph Cohen, *Journey to the Trenches. The Life of Isaac Rosenberg 1890–1918* (London, 1975), p. 3.

48. David Bomberg, unpublished memoir, c. 1957, Tate Gallery Archive, London.

49. David Bomberg, unpublished memoir, 11 April 1957, Tate Gallery Archive, London.

50. Bomberg admiringly equated El Greco with Cézanne in a 1922 lecture, and in later years he gave his second wife Lilian a large colour reproduction of *Christ Driving the Traders from the Temple* as a birthday present.

51. Alice Mayes, 'The Young Bomberg', op. cit., pp. 27–8.

52. Ibid., p. 29.

53. *The Observer*, 12 February 1928.

54. *Disruption* used to be known as *Scene for a Fairy-Tale*, but a copy of the print has now been found with the correct title inscribed by Wadsworth.

55. In 1914 Wadsworth published a selection of translations from Kandinsky's *The Art of Spiritual Harmony* in *Blast No. 1*, the Vorticists' magazine.

56. Wadsworth's daughter Barbara told the author that she had always been under the impression that Wilkinson was instrumental in securing Wadsworth his camouflage job.

57. Norman Wilkinson, 'The Dazzle Painting of Ships', paper delivered to the Victory Meeting at Newcastle-upon-Tyne, 10 July 1919, published in abridged form in *Camouflage* (Edinburgh, Scottish Arts Council, 1988).

58. Ibid.

59. Frederick Etchells, 'A Note', *Exhibition of Original Woodcuts and drawings by Edward Wadsworth* (London, Adelphi Gallery, 1919).

60. See Chapter Two, note 62.

61. 'Sea Camouflage Against U-Boats: The Art of "Dazzle-Painting"', *The Illustrated London News*, 4 January 1919.

62. René Gimpel, entry dated 30 May 1918, *Diary of an Art Dealer*, op. cit., p. 29.

63. Another of Fergusson's *Damaged Destroyer* canvases, c. 1918, is now owned by Glasgow Art Gallery and Museum.

64. J.D. Fergusson to Alfred Yockney, 4 August 1918, Imperial War Museum, London, Fergusson file.

65. *Canadian War Memorials Exhibition – 1920 – New Series. The Last Phase*, op. cit., entry 33.

66. Quoted by Maria Tippett, *Art at the Service of War*, op. cit., p. 95.

67. *Christian Science Monitor*, Boston, 15 November 1920.

68. Paul Nash to Mercia Oakley, n.d., quoted by Clare Colvin, *Paul Nash Places* (London, South Bank Centre, 1989), p. 12.

69. *Canadian War Memorials Exhibition – 1920 – New Series. The Last Phase*, op. cit., entry 109.

70. See Charles Sargeant Jagger, *Modelling and Sculpture in the Making* (London, 1933), pp. 64–5.

71. This plaster version is now owned by the Imperial War Museum, London.

72. See Ann Compton, 'A Sculptural Biography', *Charles Sargeant Jagger. War and Peace Sculpture* (London, Imperial War Museum, 1985), p. 15.

73. Only in recent years has *No Man's Land* once again been placed on view, albeit temporarily, at the Tate. It was donated to the collection by the British School at Rome in 1923.

74. The temporary version of the Cenotaph was dismantled the following January, and the permanent stone version was unveiled on 11 November 1920, the second anniversary of the Armistice.

75. André Chevalier, 'M. Clemenceau, Critique d'Art', *Le Pays*, 23 July 1919.

76. Before its repainting, *Harmony in Red* was entitled *Harmony in Blue*.

77. Henri Matisse to Charles Camoin, 1916, quoted by Nicholas Watkins, *Matisse* (Oxford, 1984), p. 134.

78. Rudolf Schlichter, *Das widerspenstige Fleisch* (Berlin, 1982), p. 149.

79. Max Beckmann, *Schöpferische Konfession*, ed. Kasimir Edschmid (Berlin, 1920), p. 63.

80. See, for example, Matthias Eberle, *World War I and the Weimar Artists*, op. cit., p. 92.

81. George Grosz, *Ein kleines Ja und ein grosses Nein* (Reinbeck, 1974), p. 116.

82. Count Harry Kessler, *Diaries of a Cosmopolitan* (London, 1971), p. 64.
83. Johanna Ey, 'Das rote Malkästle', *Das Kunstblatt*, 14, 1930.
84. Max Ernst, interview with Peter Schamoni, quoted by Uwe M. Schneede, *The Essential Max Ernst* (London, 1972), p. 16.
85. *Seated Woman* subsequently entered the collection of the Yale University Art Gallery, New Haven, Connecticut.
86. The painting is owned by the Galerie Louis Carré, Paris.
87. Jacob Epstein, *Let There Be Sculpture*, op. cit., p. 122.
88. Sir Martin Conway to Robertson, 13 December 1917, Imperial War Museum, London, Epstein file.
89. Jacob Epstein to Bernard van Dieren, n.d., quoted by Evelyn Silber, *The Sculpture of Epstein* (Oxford, 1986), p. 36.
90. Jacob Epstein to Bernard van Dieren, n.d., ibid., p. 36.
91. Jacob Epstein to John Quinn, n.d., quoted by B.L. Reid, *The Man from New York. John Quinn and His Friends* (Oxford, 1968), p. 374.
92. Jacob Epstein, *Let There Be Sculpture*, op. cit., p. 122.
93. Wilfred Owen, 'Strange Meeting', *The Collected Poems of Wilfred Owen*, op. cit., p. 35.
94. Jacob Epstein, interview in *The Sunday Evening Telegraph*, 15 February 1920.
95. As Evelyn Silber has pointed out, op. cit., p. 35.
96. *The Graphic*, 14 February 1920.
97. Jacob Epstein, *Let There Be Sculpture*, op. cit., p. 122.
98. Ibid.

9. The Memory of War

1. Herman Hesse, 'Self-Will', 1919, *If the War Goes On . . .*, op. cit., p. 73.
2. This version has since been consigned to the Musée St Pierre, Lyon, and a second cast in *ciment fondu* installed in the Place Publique, Boventin.
3. Emile Antoine Bourdelle, quoted by Peter Cannon-Brookes, *Emile Antoine Bourdelle* (London, 1983), p. 91.
4. Emile Antoine Bourdelle, quoted by Douglas Hall, 'Emile Antoine Bourdelle Heroic Post-Modernist', *Emile Antoine Bourdelle. Pioneer of the Future* (Yorkshire Sculpture Park, 1989), p. 32.
5. Peter Cannon-Brookes, op. cit., p. 93.
6. Gutfreund's bronze maquette for his relief was produced in 1921 and now belongs to the National Gallery, Prague.
7. Henry Lamb to Lawrence Haward, 4 May 1920, *Henry Lamb 1883–1960* (Manchester, 1984), p. 44.
8. Henry Lamb to Lawrence Haward, 10 August 1921, ibid., p. 45.
9. Elizabeth Butler, diary entry, 22 September 1914, quoted by Paul Usherwood and Jenny Spencer-Smith, *Lady Butler Battle Artist 1846–1933*, op. cit., p. 138.
10. Ibid., p. 148
11. Erich Maria Remarque, *The Black Obelisk*, trans. by Denver Lindley (New York, 1957), p. 33.
12. Ibid. p. 51.
13. George Grosz, *Ein kleines Ja und ein grosses Nein*, op. cit., p. 102.
14. Werner Spies, *Max Ernst Collages* (London, 1991), p. 75.
15. 'An Informal Life of M.E. (as told by himself to a young friend)', *Max Ernst*, ed. William S. Lieberman (New York, 1961), p. 10. Ernst received his wounds from the recoil of a gun and the kick of a mule.
16. Roland Penrose, *Max Ernst's Celebes* (Newcastle-upon-Tyne, 1972).
17. The corn-bin was illustrated in an English anthropological journal. Ernst subsequently confirmed that he had been inspired by it.
18. See Roland Penrose, op. cit.
19. 'The Second Coming' was published in Yeats's collection *Michael Robartes and the Dancer*, 1921.
20. W.B. Yeats, *The Collected Poems of W.B. Yeats* (London, 1950), p. 211.
21. Carl Georg Heise, 'The Crucifix by Gies', *Genius*, Vol. 3, no. 2, 1921.
22. Ibid.
23. Ibid.
24. Ibid.
25. The carving, entitled *Pietà for the Dead of the November Revolution of 1918*, was made in 1919–22 and destroyed by the Nazis in 1933.
26. Bernhard Hoetger, 'Der Bildhauer und der Plastiker', *Der Cicerone*, Vol. 11, 1919.
27. Stanley Spencer, note dated 4 September 1957, Tate Gallery Archive, London.
28. Ibid.
29. Ibid.
30. A small oil sketch (1921, private collection) shows how Spencer visualized the rending of the veil scene.
31. Stanley Spencer to Henry Lamb, 23 July 1922, quoted by Richard Carline, *Stanley Spencer at War*, op. cit., pp. 132–3.
32. Stanley Spencer to Henry Lamb, 2 February 1922, ibid., p. 131.
33. Stanley Spencer, quoted by Keith Bell, *Stanley Spencer RA* (London, Royal Academy, 1980), p. 81.
34. Stanley Spencer, recorded by Kate Foster in her diary, quoted by Richard Carline, op. cit., p. 130.
35. Stanley Spencer, note in his 1937 picture catalogue, Tate Gallery Archive, London.
36. See, for example, the work Gill produced for South Harting, Bisham and Chirk.
37. Eric Gill to William Rothenstein, 22 July 1916, *Letters of Eric Gill*, ed. Walter Shewring (London, 1947), p. 82.
38. Ibid., p. 98.
39. Eric Gill, *Art-Nonsense and other Essays* (London, 1929), p. 110.
40. Eric Gill to André Raffalovich, 24 September 1914, *Letters*, op. cit., p. 57.
41. The Spencer painting is now owned by the Art Gallery of Western Australia, Perth.
42. See Graham R. Kent, 'Sadler, Gill and the Money-makers', *Michael Sadler* (Leeds, 1989), p. 36.
43. Eric Gill to Geoffrey Keynes, 27 September 1917, *Letters*, op. cit., p. 99.
44. Ibid.
45. James, 5: 1–2.
46. The Gospel according to St John, 2: 15–16: 'And when he had made as it were a little whip of cords, he ejected all from the temple, and the money of the moneychangers he poured out and overthrew their tables. And he said, Do not make my Father's house a house of commercialism.'
47. The memorial has now been repositioned in the foyer of the university's Arts Building.
48. See Graham R. Kent, op. cit.
49. Michael Sadler, quoted by Robert Speaight, *The Life of Eric Gill* (London, 1966), p. 133.
50. William Orpen, *An Onlooker in France 1917–19* (London, 1921), p. 104.
51. William Orpen, interview with the *Evening Standard*, 7 May 1923.
52. Charles ffoulkes to Sir Alfred Mond, Imperial War Museum, London, Orpen file.
53. *The Patriot*, 5 October 1923.
54. *Liverpool Echo*, 10 May 1923.
55. Reported in the *Sunday Express*, 20 May 1923.
56. For a detailed account of these financial negotiations, see Bruce Arnold, *Orpen. Mirror to an Age*, op. cit., p. 380.
57. Käthe Kollwitz to Arthur Bonus, n.d., quoted in

Arthur Bonus, *Das Käthe-Kollwitz Werk* (Dresden, 1930), p. 7.
58. Käthe Kollwitz, diary entry dated 22 August 1916, quoted in *Käthe Kollwitz 1867–1945 the graphic works*, ed. Jeremy Lewison (Cambridge, 1981), p. 14.
59. Käthe Kollwitz to Romain Rolland, 23 October 1922, *Briefe der Freundschaft und Begegnungen* (Munich, 1966), p. 56.
60. The so-called *Orlando Muerto*, now in the National Gallery, London. Manet's painting, executed in 1863–4, is owned by the National Gallery of Art, Washington.
61. Quoted in *Käthe Kollwitz*, op. cit., p. 12.
62. Otto Dix, quoted by Friedrich Heckmanns, 'Das Junge Rheinland in Düsseldorf 1919–1929', *German Expressionism 1915–1925. The Second Generation* (Los Angeles, 1988), p. 92.
63. *Deutsche Allgemeine Zeitung*, 3 July 1924.
64. *Mannheimer Tageblatt*, 10 October 1924.
65. Otto Dix, quoted by Fritz Löffler, 'Otto Dix – Der Krieg', *Otto Dix* (Albstadt, 1976), p. 14.
66. Otto Dix, interview with Maria Wetzel, 1965, quoted by Dieter Schmidt, *Otto Dix im Selbstbildnis* (Berlin, 1981), p. 269.
67. Otto Dix, quoted by Hans Kinkel, *Vierzehn Berichte* (Stuttgart, 1967), p. 75.
68. Robert Graves, 'A Dead Boche', *Fairies and Fusiliers* (London, 1917), p. 33.
69. When *War* was published, many critics admiringly compared its achievement with Goya.
70. Quoted by Friedrich Heckmanns, op. cit., p. 93.
71. Ibid.

10. Despair and Redemption

1. James Stevens Curl, 'The Royal Artillery Memorial at Hyde Park Corner', *Charles Sargeant Jagger War and Peace Sculpture*, op. cit., p. 98.
2. Charles Sargeant Jagger, quoted by Ann Compton, 'A Sculptural Biography', op. cit., p. 21.
3. Charles Sargeant Jagger, interview in the *Daily News*, 14 July 1921.
4. According to the minutes of the Hoylake and West Kirby Memorial Committee, 11 September 1919; see John Glaves-Smith, 'Realism and Propaganda in the Work of Charles Sargeant Jagger and their Relationship to Artistic Tradition', *Charles Sargeant Jagger War and Peace Sculpture*, op. cit., p. 65.
5. Ann Compton, 'A Sculptural Biography', ibid., p. 47. The commission was for the Kelham Rood in the chapel at the Society of the Sacred Mission's priory. Jagger eventually carried it out in 1926–7.
6. Charles Sargeant Jagger, quoted by James Stevens Curl, 'The Royal Artillery Memorial', ibid., p. 84.
7. Charles Sargeant Jagger, interview with the *Daily News*, 14 July 1921.
8. James Stevens Curl, op. cit., p. 86.
9. Quoted ibid., p. 94.
10. Lord Curzon, quoted by a leader in *The Times*, 29 October 1925.
11. Major-General Lord Edward Gleichen, *London's Open-Air Statuary* (London, 1928), pp. 27–8.
12. Reported in the *Manchester Guardian*, 9 October 1925.
13. Although Gromaire painted *The Banks of the Marne* in the same year as *The War*, it was first exhibited early in 1926 at his large one-man show in the Galerie Barbazanges.
14. George Grosz, quoted by Count Kessler, *Diaries of a Cosmopolitan* (London 1971), p. 287.
15. George Grosz to Otto Schmalhausen, 1927, no exact date, quoted by M. Kay Flavell, *George Grosz. A Biography* (New Haven and London, 1988), p. 58.

16. Ibid., p. 63.
17. Sabine Rewald, *Paul Klee. The Berggruen Collection*, op. cit., p. 234.
18. As Roland Penrose pointed out, *Picasso. His Life and Work*, op. cit., p. 229.
19. Pablo Picasso to Roland Penrose, ibid.
20. This version is six feet high. Another version, in cor-ten steel and over twice that height, was also acquired for the Museum's Sculpture Garden in the same year.
21. Georges Clemenceau, 'Révolution des Cathedrales', *La Justice*, 19 May 1895.
22. Paul Hayes Tucker, 'Monet in the '90s. The Series Paintings' (Boston, New Haven and London, 1990), p. 36.
23. Maurice Guillemot, 'Claude Monet', *La Revue Illustré*, 15 March 1898.
24. Julien Leclercq, 'Le Bassin aux Nymphéas de Claude Monet', *La Chronique des Arts*, 1 December 1900.
25. Claude Monet to Joyant, 1915, quoted by Daniel Wildenstein, *Claude Monet: Biographie et catalogue raisonné* (Lausanne and Paris, 1985), Vol. IV, p. 392.
26. René Gimpel, entry dated 19 August 1918, *Diary of an Art Dealer*, op. cit., p. 60.
27. Claude Monet to Georges Clemenceau, 12 November 1918, quoted by Daniel Wildenstein, op. cit., pp. 399–400.
28. Charles F. Stuckey, *Monet Water Lilies* (New York, 1988), p. 21.
29. René Gimpel, entry dated 28 November 1918, *Diary of an Art Dealer*, op. cit., p. 74.
30. Claude Monet to Paul Léon, 24 April 1921, quoted by Daniel Wildenstein, op. cit., Vol. IV, p. 410.
31. Ibid., p. 418.
32. Georges Clemenceau to Claude Monet, October 1924, quoted by Georges Suarez, *La Vie Orguilleuse de Clemenceau* (Paris, 1930), pp. 625–7.
33. René Delange, 'Claude Monet', *L'Illustration*, 15 January 1927.
34. Claude Monet, quoted by Roger Marx, 'Les "Nymphéas" de M. Claude Monet', *Gazette des Beaux Arts*, June 1909.
35. *Green Reflections* and *Reflection of Trees*.
36. The *Weeping Willow* was painted around 1919.
37. These drawings are in private collections at Kitzbühel and Steyr.
38. Frank Rutter, *The British Empire Panels Designed for the House of Lords by Frank Brangwyn*, RA (Essex, 1933), p. 26.
39. Joseph Darracott and Belinda Loftus, *First World War Posters* (London, 1972), p. 17.
40. Frank Rutter, *The British Empire Panels*, op. cit., p. 27.
41. Ibid.
42. Erich Maria Remarque, *The Black Obelisk*, op. cit., p. 129.
43. Ibid., p. 109.
44. Ibid., p. 130.
45. Ernst Barlach, quoted by Carl Dietrich Carls, op. cit., p. 121.
46. Käthe Kollwitz, quoted ibid., p. 121.
47. Käthe Kollwitz to Hans and Ottilie Kollwitz, 11 June 1926, quoted by Otto Nagel, *Käthe Kollwitz*, trans. Stella Humphries (London, 1971), pp. 52–3.
48. Ibid., p. 56.
49. Ibid., pp. 56–7.
50. Ibid., p. 57.
51. Otto Nagel, *Käthe Kollwitz*, op. cit., p. 64.
52. Karl Kollwitz, ibid., p. 70.
53. Käthe Kollwitz, diary, 14 August 1932, ibid., p. 71.
54. *Mending Cowls, Cookham* (1915) and *Swan Upping at Cookham* (1915–19).

55. Stanley Spencer to Hilda Spencer, 31 May 1923, quoted by Richard Carline, *Stanley Spencer at War*, op. cit., p. 145.
56. Ibid.
57. Ibid., p. 148.
58. Stanley Spencer to Hilda Spencer, n.d., but posted in September 1923; ibid., p. 153.
59. Stanley Spencer to Hilda Spencer, 19 July 1923; ibid., p. 150.
60. Stanley Spencer to Florence Spencer, end of September 1923; ibid., p. 155.
61. Stanley Spencer to Henry Lamb, end of October 1923; ibid., p. 158.
62. Ibid.
63. Stanley Spencer, quoted by George Behrend, *Stanley Spencer at Burghclere* (London, 1965), p. 6.
64. Stanley Spencer to Henry Lamb, end of October 1923, quoted by Carline; op. cit., p. 159.
65. Stanley Spencer to Hilda Spencer, 31 May 1923; ibid., p. 145.
66. Now in the Tate Gallery, London.
67. George Behrend, op. cit., p. 6.
68. Richard Carline, op. cit., p. 177.
69. Stanley Spencer papers, 1918, Tate Gallery Archive, London.
70. Keith Bell, *Stanley Spencer RA*, op. cit., refers to this man as 'a small Spencer-like figure' (p. 109).
71. Stanley Spencer to Richard Carline, 1928, quoted by Carline; op. cit., p. 183.
72. Stanley Spencer to Florence Spencer, end of September 1923; ibid., p. 155.
73. The painting, oil on millboard, is called *Making a Red Cross* (private collection).
74. Stanley Spencer to Richard Carline, 1928, quoted by Carline; op. cit., p. 185.
75. Ibid.
76. Ibid., p. 184.
77. Ibid., pp. 186–90.
78. Ibid., p. 195.
79. Ibid., p. 194.
80. Ibid.
81. Ibid., p. 192.
82. Ibid.
83. Stanley Spencer, unpublished writings, 1936, Tate Gallery Archive, London.
84. Horace Pippin, *My Life's Story*, in Selden Rodman, *Horace Pippin. A Negro Painter in America* (New York, 1947).
85. Leon Anthony Arkus, *Hicks Kane Pippin* (Pittsburgh and Washington, 1966).
86. Otto Dix, quoted by Otto Conzelmann, *Der andere Dix – Sein Bild vom Menschen und vom Kriege* (Stuttgart, 1983), p. 205.
87. *The Battle of Alexander* is now in the Alte Pinakothek, Munich.
88. Otto Dix, interview in *Neues Deutschland*, December 1964, quoted in Dieter Schmidt, *Otto Dix im Selbstbildnis* (Berlin, 1981), p. 262.
89. Henri Barbusse, *Le Feu*, published in German as *Das Feuer. Tagebuch einer Korporalschaft* (Zurich, 1918). Quoted by Britta Schmitz, *Dix* (Stuttgart and Berlin, 1991), p. 270, and translated into English by Keith Hartley, *Otto Dix 1891–1969* (London, 1992), pp. 201–2.
90. David Jones, preface to *In Parenthesis* (London, 1937, new edn. 1987), p. xv.
91. Ibid., p. x.
92. Ibid., pp. xii–xiii.
93. Ibid., n.p.
94. Ibid., pp. 13–14.
95. Ibid., p. 39.
96. Ibid., p. 24.
97. Ibid., p. 2.
98. Ibid., p. xiv.
99. Ibid., p. ix.
100. Jones also includes them as guards in a 1922 drawing of *Christ Before Pilate*, in the National

Museum of Wales.
101. Paul Hills, 'The Art of David Jones', *David Jones* (London, Tate Gallery, 1981), p. 59.
102. R.L. Charles, 'David Jones – Some Recently Acquired Works', *Amgueddfa: Bulletin of the National Museum of Wales*, 22 (Cardiff, 1976), p. 7.
103. David Jones, *In Parenthesis*, op. cit., p. 193.

EPILOGUE

1. Constantin Brancusi to Militza Petraşcu, quoted by Radu Varia, *Brancusi* (New York, 1986), p. 305, note 3.
2. In his recent book on Brancusi (New York, 1989, p. 83), Eric Shanes records that Brancusi's initial plan in 1937 consisted only of the column, positioned in the Public Garden at the end of a Heroes Path leading from the bridge of the Jiu.
3. Constantin Brancusi, quoted by Claire Gilles Guilbert, 'Propos de Brancusi', *Prisme des Arts*, 12 (1957).
4. Recalled in 'How I Knew the Great Brancusi', *Constantin Antonovici, Sculptor of Owls* (Cleveland, 1975), p. 13.
5. Constantin Brancusi to Mrs Tătărăscu, quoted by Pontus Hulten, *Brancusi* (London, 1988), cat. 206.
6. Sanda Tătărăscu recalled her mother's wish in a discussion with Sanda Miller, 16 April 1978, *Burlington Magazine*, July 1980.
7. The exhibition was held in the Brummer Gallery, New York.
8. Brancusi brought drawings to the gate and transferred them to the stone, but the actual carving was executed by two assistants under his supervision.
9. Sidney Geist argued that 'on the columns of the *Gate* . . . the design is more strongly suggestive of the combined male and female genitals' ('Brancusi: The Centrality of the Gate', *Artforum*, October 1973).
10. Radu Varia, *Brancusi*, op. cit., p. 259. The Temple of Hathor is situated at Dendera.
11. Constantin Brancusi, quoted by Barbu Brezianu, *Brancusi in Romania*, op. cit., p. 143.
12. Ibid., p. 130, note 7.
13. Constantin Brancusi in conversation (c. 1937–8) with the Tirgu-Jiu high-school teacher Ecaterina Şerban-Mariotti, who communicated it to Brezianu, ibid., p. 130.
14. Constantin Brancusi, quoted by Malvina Hoffman, *Sculpture Inside and Out* (New York, 1939), p. 53.
15. Reproduced by Sidney Geist, *Brancusi. A Study of the Sculpture* (New York, 1968), Pl. 126.
16. The column's brass coating fell into disrepair, but was renewed with bronze paint in 1966.
17. Barbu Brezianu, op. cit., p. 129.
18. The session was held on 12 November 1937 under the mayor's chairmanship, and the quoted document is now preserved in the State Archives, Tirgu-Jiu, File 141/1937, note 3.
19. Conversation recalled by the architect Dan Iovănescu at a Brancusi celebration organised by MARSR, 27 May 1975, and quoted by Brezianu, op. cit., p. 134.
20. From the catalogue of the exhibition Brancusi held at the Brummer Gallery, New York, in 1933.
21. Constantin Brancusi, quoted by Radu Varia, op. cit., p. 265.
22. Constantin Brancusi in conversation with Petre Pandrea, quoted in *Portrate si Controverse*, Vol. I (Bucharest, 1945), p. 167.
23. From a report on the dedication ceremony in the local newspaper, *Gorjanul Tirgu Jiu*.
24. The phrase originates in H.G. Wells, *The War That Will End War* (London, 1914).
25. The Cambridge War Memorial, erected in 1922, was the work of R. Tait Mackenzie.
26. Paul Fussell, *Wartime. Understanding and Behaviour in the Second World War* (Oxford, 1989), p. 4.

BIBLIOGRAPHY

In order to prevent this bibliography from becoming unwieldy, I have concentrated solely on books and other publications dealing directly with artists and their work. The immense body of more general historical literature on the First World War is extensively listed elsewhere.

Abbott, Claude Colleer, and Anthony Bertram (eds.) *Poet and Painter. Being the Correspondence between Gordon Bottomley and Paul Nash, 1910–1946* (Oxford, 1955).

Adams, Henry, *Thomas Hart Benton. An American Original* (New York, 1989).

Ades, Dawn, *Dada and Surrealism Reviewed* (London, 1978).

Albert-Birot, Pierre, 'Tradition/Mort, France Vie', *Sic*, April 1916.

Alexander, Sidney, *Marc Chagall. A Biography* (London, 1978).

Alibert, P., *Albert Gleizes. Naissance et avenir du Cubisme* (Paris, 1982).

Alison, Jane, *et al.*, *Stanley Spencer. The Apotheosis of Love* (London, 1990).

Alley, Ronald, Introduction and Notes to *William Roberts ARA. Retrospective Exhibition* (London, 1965).

Andreyev, Leonid, 'Petrov-Vodkin's Painting', *Russkaya Volia*, 23 February 1917.

Arco, Maurizio Fagiolo dell' (ed.), *Gino Severini: Prima e dopo l'opera* (Cortona, 1983).

———, *Balla the Futurist* (Oxford, 1987).

Arkus, Leon Anthony, *Hicks Kane Pippin* (Pittsburgh and Washington, 1966).

Arnold, Bruce, *Orpen. Mirror to an Age* (London, 1981).

Askeland, Jan, *Norsk malerkunst* (Oslo, 1981).

Atterbury, Paul, 'Dazzle Painting in the First World War', *The Antique Collector*, April 1975.

Backes, D., *Heinrich Hoerle. Leben and Werk* (Cologne, 1981).

Baldewicz, Elizabeth Kahn, *Les Camoufleurs: The Mobilization of Art and the Artist in Wartime France, 1914–1918*. Ph.D. dissertation, U.C.L.A., 1980.

Giacomo Balla (1871–1958) (Rome, Galleria Nazionale d'Arte Moderna, 1971).

Ballo, Guido, *Boccioni* (Milan, 1964).

Ernst Barlach, 3 Vols. (Berlin, Altes Museum, 1981).

Barlach, Ernst, *Kunst im Kriege* (Bremen, 1953).

———, *Güstrower Tagebuch 1914–1917* (Munich, 1984).

Baron, Wendy, *Sickert* (London, 1973).

———, *Sickert* (London, Fine Art Society, 1973).

———, *Sickert* (London, Arts Council, 1977).

———, *The Camden Town Group* (London, 1979).

———, and Richard Shone (eds.), *Sickert Paintings* (London, 1992).

Barr, Alfred H., Jr., *Matisse. His Art and His Public* (New York, 1951).

Barron, Stephanie, *German Expressionist Sculpture* (Los Angeles, 1984).

———, (ed.), *German Expressionism 1915–1925. The Second Generation* (Los Angeles, 1988).

———, *et al.*, *German Expressionist Prints and Drawinngs*. Vol. 1: Essays, Vol. 2: Catalogue of the Robert Gore Rifkind Collection (Los Angeles, 1989).

———, *Degenerate Art: The Fate of the Avant-Garde in Nazi Germany* (Los Angeles, Country Museum of Art, 1991).

——— and Maurice Tuchman, *The Avant-Garde in Russia 1910–1930: New Perspectives* (Los Angeles, County Museum of Art, 1980).

Basner, E.V. and A.P. Gusarova, *Russian and Soviet Paintings 1900–1930* (Washington, 1988).

Max Beckmann. Das druckgraphische Werk (Zürich, 1976).

Beckmann, Max, *Briefe im Kriege* (Munich, 1955).

———, *Schöpferische Konfession*, ed. Kasimir Edschmid (Berlin, 1920).

Beckmann, Peter, *Max Beckmann* (Nuremberg, 1955).

Beeren, Wim, *et al.*, *Kazimir Malevich 1878–1935* (Leningrad, Moscow and Amsterdam, 1988).

Behr, Shulamith, *Women Expressionists* (Oxford, 1988).

Behrend, George, *Stanley Spencer at Burghclere* (London, 1965).

Bell, Keith, *et al.*, *Stanley Spencer RA* (London, 1980).

———, *Stanley Spencer. A Complete Catalogue of the Paintings* (London, 1992).

Belting, Hans, *Max Beckmann-Die Tradition als Problem in der Kunst der Moderne* (Berlin, 1964).

Berend-Corinth, Charlotte, *Die Gemälde Von Lovis Corinth* (Munich, 1958).

Bertram, Anthony, *Paul Nash. The Portrait of an Artist* (London, 1955).

Bird, Alan, *A History of Russian Painting* (Oxford, 1987).

Bollinger, Hans and Georg Reinhardt, *Ernst Ludwig Kirchner 1880–1938* (Munich, 1980).

Bonns, Arthur, *Das Käthe-Kollwitz Werk* (Dresden, 1930).

Boorman, Derek, *At the Going Down of the Sun. British First World War Memorials* (York, 1988).

Borg, Alan, *War Memorials* (London, 1991).

Bottomley, Gordon and Denys Harding (eds.), *The Collected Works of Isaac Rosenberg*. Foreword by Siegfried Sassoon (London, 1937).

Bouillon, Jean-Paul, *Art Deco 1903–1940* (Geneva, 1989).

Bowness, Alan, *et al.*, *British Contemporary Art 1910–1990. Eighty Years of Collecting by the Contemporary Art Society* (London, 1991).

Boyland, Patrick, *German Impressionism and Expressionism from Leicester* (London, Agnew's, 1987).

Bozo, Dominique, *The Musée Picasso, Paris* (London, 1986).

Braun, Emily (ed.), *Italian Art in the 20th Century* (London and Munich, 1989).

Breunig, L.C. (ed.), *Apollinaire. Chroniques d'Art (1902–1918)* (Paris, 1960).

Brezianu, Barbu, *Brancusi in Romania* (Bucharest, 1976).

Brodzky, Horace, *Henri Gaudier-Brzeska 1891–1915* (London, 1933).

Brown, David, *We Are Making a New World* (Edinburgh, 1974).

Brown, Milton W., *American Painting from the Armory Show to the Depression* (Princeton, 1955).

———, *One Hundred Masterpieces of American Painting from Public Collections in Washington D.C.* (Washington, 1983).

Browse, Lillian, *Sickert* (London, 1960).

Buckle, Richard, *Jacob Epstein, Sculptor* (London, 1963).

Burgess, Anthony and Simon de Pury, *Modern Masters from the Thyssen-Bornemisza Collection* (London, 1984).

Bussmann, Georg, *Lovis Corinth-Carmencita* (Frankfurt, 1985).

Cabanne, Pierre, *The Brothers Duchamp* (Boston, 1976).

———, *Pablo Picasso. His Life and Times* (New York, 1977).

Cain, Julien, *1914–18. Temoignages d'artistes et documents* (Vincennes, 1964).

Calvesi, Maurizio and Ester Coen, *Boccioni: L'Opera Completa* (Milan, 1983).

Calvocoressi, Richard, *Oskar Kokoschka 1886–1980* (London, 1986).

Camesasca, Ettore (ed.) *Mario Sironi. Scritti editi e inediti* (Milan, 1980).

Canadian War Memorials Exhibition. Catalogue (London, Royal Academy, 1919).

Canadian War Memorials Paintings Exhibition – 1920 – New Series. The Last Phase. Catalogue (Toronto and Montreal, 1920).

The Canadian War Memorials Fund. Its History and Objects. Pamphlet reprinted from *Canada in Khaki no. 2* (Public Archives, Ottawa).

Cannon-Brookes, Peter, *Emile Antoine Bourdelle* (London, 1983).

———, *et al.*, *Czech Sculpture 1800–1938* (London, 1983).

Carey, Frances and Anthony Griffiths, *The Print in Germany 1880–1933. The Age of Expressionism* (London, 1984).

———, *Avant-Garde British Printmaking 1914–1960* (London, 1990).

Carline, Richard, *Stanley Spencer at War* (London, 1978).

Carls, Carl Dietrich, *Ernst Barlach* (London, 1969).

Carpenter, Humphrey, *Serious Character: Ezra Pound* (London, 1988).

Carlo Carrà. Catalogue (Milan, Palazzo Reale, 1987).

Carrà, Massimo, *Carlo Carrà: Tutta l'opera pittorica*. 3 Vols. (Milan, 1967–8).

———— (ed.) *Carlo Carrà. Tutti gli scritti* (Milan, 1978).

Carrington, Noel (ed.), *Mark Gertler. Selected Letters* (London, 1965).

Causey, Andrew, *et al.*, *Paul Nash Paintings and watercolours* (London, Tate Gallery, 1975).

————, *Paul Nash* (Oxford, 1980).

————, *Harold Gilman 1876–1919* (London, Royal Academy, 1981).

Cayzer, Elizabeth, *William Roberts RA. 1895–1980. A Retrospective Exhibition* (London, McLean Gallery, n.d.).

Chagall, Marc, *My Life* (Oxford, 1989).

Chamot, Mary, Dennis Farr and Martin Butlin, *The Tate Gallery. The Modern British Paintings, Drawings and Sculpture*. Vol. I: A-L (London, 1964); Vol.II: M-Z (London, 1965).

Charles, R.L., 'David Jones – Some Recently Acquired Works', *Amgueddfa: Bulletin of the National Museum of Wales*. 22 (Cardiff, 1976).

Charteris, Evan, *John Sargent* (London, 1927).

Chevalier, André, 'M. Clemenceau, Critique d'Art', *Le Pays*, 23 July 1919.

Cianci, Giovanni (ed.), *Wyndham Lewis Letteratura/ Pittura* (Palermo, 1982).

Clair, Jean (ed.), *Vienne 1880–1938. L'Apocalypse Joyeuse* (Paris, 1986).

————, *et al.*, *Arturo Martini 1889–1947. Sculptures* (Milan, 1991).

Clark, Kenneth, *Another Part of the Wood* (London, 1974).

Clements, Keith and Sandra Martin, *Henry Lamb 1883–1960* (Manchester, 1984).

Coen, Ester, *Umberto Boccioni* (New York, 1988).

Cogniat, Raymond and Waldemar George, *Oeuvre complete de Roger de La Fresnaye* (Paris, 1950).

Cohen, Joseph, *Journey to the Trenches. The Life of Isaac Rosenberg 1890–1918* (London, 1975).

Cole, Roger, *Burning to Speak. The Life and Art of Henri Gaudier-Brzeska* (London, 1978).

Collins, Judith, *The Omega Workshops* (London, 1983).

————, *Eric Gill: Sculpture* (London, 1992).

Colvin, Clare, *Paul Nash Places* (London, 1989).

Comini, Alessandra, *Egon Schiele Portraits* (Berkeley, 1974).

Compton, Ann (ed.), *Charles Sargeant Jagger. War and Peace Sculpture* (London, 1985).

Compton, Michael (ed.), *Towards a New Art* (London, 1980).

Compton, Susan, *The World Backwards. Russian Futurist Books 1912–16* (London, 1978).

————, *Chagall* (London, 1985).

———— (ed.), *British Art in the Twentieth Century. The Modern Movement* (London, 1987).

Conway, Martin, *A Concise Catalogue of Paintings, Drawings and Sculpture of the First World War, 1914–1918* (London, 1963).

Conzelmann, Otto, *Otto Dix. Handzeichnungen* (Hanover, 1968).

————, *Der andere Dix – Sein Bild vom Menschen und vom Kriege* (Stuttgart, 1983).

Cooper, Douglas, *Fernand Léger et le nouvel espace* (London and Paris, 1949).

———— (ed. and trans.), *Letters of Juan Gris* (London, 1956).

————, *Fernand Léger. Dessins de Guerre 1915–16* (Paris, 1956).

————, *The Cubist Epoch* (London, 1971).

———— and Gary Tinterow, *The Essential Cubism 1907–1920* (London, 1983).

Corinth, Lovis, *Gesammelte Schriften* (Berlin, 1920).

————, *Von Corinth über Corinth* (Leipzig, 1921).

————, *Selbstbiographie* (Leipzig, 1926).

Lovis Corinth 1858–1925. Gemälde und Druckgraphik (Munich, Lenbachhaus, 1975).

Cork, Richard, Introduction, *Edward Wadsworth Early Woodcuts* (London, Christopher Drake Ltd, 1973).

————, *Jacob Epstein. The Rock Drill Period* (London, Anthony d'Offay Gallery, 1973).

————, *Vorticism and Abstract Art in the First Machine Age*, 2 Vols. (London, 1975 and 1976).

————, 'Machine Age, Apocalypse and Pastoral', *British Art in the Twentieth Century*, ed. Susan Compton (London, Royal Academy, 1987).

————, *David Bomberg* (New Haven and London, 1987).

————, 'The Visual Arts', *The Cambridge Guide to the Arts in Britain* (ed. Boris Ford), *Vol. 8: The Edwardian Age and the Inter-War Years* (Cambridge, 1989).

————, '"A Harrowing Sight": Sargent and *Gassed*', *Arts Review Yearbook 1990*.

————, '"A Bitter Truth": Paul Nash and the Great War', *Essays in Honour of John White*, ed. Helen Weston and David Davies (London, University College, 1990).

————, 'Bomberg's War Poetry', *Poems and Drawings from the First World War by David Bomberg*, ed. Neville Jason (London, Gillian Jason Gallery, 1992).

————, 'Gaudier-Brzeska and Vorticism', *Henri Gaudier-Brzeska* (Orléans, Musée des Beaux-Arts, 1993).

————, 'The Pity of War: Avant-Garde Art and the First World War', *"Die letzten Tage der Menschheit" – Bilder des Ersten Weltkrieges* (Berlin, Altes Museum, 1994).

Cottington, David, 'What the Papers Say: Politics and Ideology in Picasso's Collages of 1912', *Art Journal*, Winter 1988.

Coutin, Cécile, *Jean-Louis Forain. Chroniqueur-Illustrateur de Guerre (1914–1919)* (Paris, 1986).

Crawford-Flitch, J.E., *C.R.W. Nevinson. The Great War. Fourth Year* (London, 1918).

Crone, Rainer, and David Moos, *Kazimir Malevich: The Climax of Disclosure* (London, 1991).

Cross, Tim, *et al.*, *The Fallen. An Exhibition of Nine Artists Who Lost Their Lives in World War One* (Oxford, 1988).

————, Introduction, *The Lost Voices of World War I* (London, 1988).

Cumming, Robert, *Artists at War 1914–1918* (Cambridge, Kettle's Yard Gallery, 1974).

Curtis, Penelope, *Modern British Sculpture from the Collection* (London, Tate Gallery, 1988).

————, *et al.*, *W.R. Sickert. Drawings and Paintings 1890–1942* (London, 1989).

————, *Out of the Wood. Die Brücke Woodcut Techniques* (London, Tate Gallery, 1990).

————, *et al.*, *Dynamism. The Art of Modern Life Before the Great War* (London, Tate Gallery, 1991).

Dachy, Marc, *The Dada Movement 1915–1923* (New York, 1990).

Daix, Pierre and Joan Rosselet, *Picasso. The Cubist Years, 1907–1916* (London, 1979).

A Dance of Death. Images of Mortality in European Graphics of the First World War (London, Imperial War Museum, 1991).

Nils Dardel (1888–1943). Catalogue. (Stockholm, Moderna Museet, 1988).

Darracott, Joseph and Belinda Loftus, *First World War Posters* (London, 1972).

Davidson, Abraham A., *Early American Modernist Painting 1910–1935* (New York, 1981).

de Chirico, Giorgio, *The Memoirs of Giorgio de Chirico*, trans. Margaret Crosland (London, 1971).

————, *Il Meccanismo del Pensiero: Critica, Polemica, Autobiografia 1911–1943*, ed. Maurizio Fagiolo dell'Arco (Turin, 1985).

Delange, René, 'Claude Monet', *L'Illustration*, 15 January 1927.

Derouet, Christian (ed.), *Fernand Léger. Une Correspondance de Guerre a Louis Poughon, 1914–1918* (Paris,

Les Cahiers du Musée National d'Art Moderne, 1990).

Dieren, Bernard van, *Jacob Epstein* (London, 1920).

Otto Dix Inventory Catalogue, Preface by Johann-Karl Schmidt (Stuttgart, 1989).

Dodgson, Campbell and C.E. Montague, Introductions to *British Artists at the Front. I: C.R.W. Nevinson* (London, 1917).

Doezema, Marianne, *George Bellows and Urban America* (New Haven and London, 1992).

d'Offay, Anthony, Introduction to *Abstract Art in England 1913–1915* (London, d'Offay Couper Gallery, 1969).

Drew, Joanna, Catalogue of *David Bomberg 1890–1957* (London, Tate Gallery, 1967).

Driesbach, Janice Tolhurst, *German and Austrian Expressionism 1900–1920* (Indiana, 1977).

Dube, Annemarie and Wolf-Dieter, *Erich Heckel. Das Graphische Werk*, 3 Vols., 2nd edn. (New York, 1974).

————, *E.L. Kirchner. Das Graphische Werk*, 2 Vols., 2nd edn. (Munich, 1980).

Dube, Wolf-Dieter, *Expressionists and Expressionism* (Geneva, 1983).

Dube-Heynig, Annemarie, *E.L. Kirchner Graphik* (Munich, 1961).

Dückers, Alexander, *Max Beckmann, Die Hölle* (Berlin, 1983).

Earp, T.W., Introduction to *Edward Wadsworth 1889–1949. A Memorial Exhibition* (London, Tate Gallery, 1951).

Easton, Malcolm and Michael Holroyd, *The Art of Augustus John* (London, 1974).

Eberle, Matthias, *World War I and the Weimar Artists* (New Haven and London, 1985).

Eddy, Arthur Jerome, *Cubists and Post-Impressionism* (Chicago, 1914).

Ede, H.S., *A Life of Gaudier-Brzeska* (London, 1930).

————, *Savage Messiah* (London, 1931).

————, 'Un Grand Artiste Méconnu: Henri Gaudier-Brzeska', *Le Jardin des Arts*, Paris, November 1955.

Edwards, Paul, *Wyndham Lewis: Art and War* (London, 1992).

Zeichnungen Von Albin Egger-Lienz. Catalogue (Innsbruck, Galerie im Taxis Palais, 1971).

A. Egger-Lienz, 1868–1926 (Vienna, Heeresgeschichtliches Museum, 1976).

Elderfield, John, *Henri Matisse. A Retrospective* (London, 1992).

Eliel, Carol S. and Eberhard Roters, *The Apocalyptic Landscapes of Ludwig Meidner* (Los Angeles, 1989).

Eliot, Valerie (ed.), *The Letters of T.S. Eliot. Vol. 1: 1898–1922* (London, 1988).

Elliott, David, *New Worlds, Russian Art and Society 1900–1937* (London, 1986).

Elliott, David and Valery Dudakov, *100 Years of Russian Art 1889–1989* (London, 1989).

Elsen, Albert E., *Origins of Modern Sculpture: Pioneers and Premises* (London, 1974).

Emmons, Robert, *The Life and Opinions of Walter Richard Sickert* (London, 1941).

Epstein, Jacob, *Let There Be Sculpture. The Autobiography of Jacob Epstein* (London, 1940).

Epstein, Jacob and Arnold Haskell, *The Sculptor Speaks. A Series of Conversations on Art* (London, 1931).

Erben, Walter, *Marc Chagall* (London, 1957).

Erpel, Fritz, *Max Beckmann* (Berlin, 1985).

Etchells, Frederick, 'A Note', *Exhibition of Original Woodcuts and drawings by Edward Wadsworth*. Catalogue (London, Adelphi Gallery, 1919).

Expressionism. A German Intuition 1905–1920 (New York, Guggenheim Museum, 1980).

Ey, Johanna, 'Das rote Malkästle', *Das Kunstblatt* 14, 1930.

Fagiolo, Maurizio, *Balla the Futurist* (Milan and Oxford, 1987).

Farmar, Francis, *The Painters of Camden Town 1905–1920* (London, 1988).

Farr, Dennis, *English Art 1870–1940* (Oxford, 1978).

Farrington, Jane, *et al.*, *Wyndham Lewis* (London, 1980).

Faucherau, Serge, *La Revolution Cubiste* (Paris, 1982).

Felix, Zdenek (ed.), *Erich Heckel 1883–1970. Gemälde, Aquarelle, Zeichnungen und Graphik* (Munich, 1983).

Ferguson, John, *The Arts in Britain in World War I* (London, 1980).

Ferrari, Claudia Gian (ed.), *Mario Sironi 1885–1961* (Milan, Palazzo Reale, 1985).

Flam, Jack, *Matisse. The Man And His Art 1869–1918* (London, 1986).

Flavell, M.K., *George Grosz. A Biography* (New Haven and London, 1988).

Fonti, Daniela, *Gino Severini: Catalogo Ragionata* (Milan, 1988).

Foot, M.R.D., *Art and War. Twentieth Century Warfare as depicted by War Artists* (London, 1990).

Ford, Boris (ed.), *The Cambridge Guide to the Arts in Britain. Volume 8: The Edwardian Age and the Inter-War Years* (Cambridge, 1989).

Ford, Ford Madox, *Thus to Revisit. Some Reminiscences* (London, 1921).

———, *Return to Yesterday. Reminiscences, 1894–1914* (London, 1931).

———, *Mightier than the Sword. Memories and Criticisms* (London, 1938).

Fort, Ilene Susan, *The Flag Paintings of Childe Hassam* (Los Angeles, 1988).

Francia, Peter de, *Fernand Léger* (New Haven and London, 1983).

Freer, Allen, *John Nash: 'The Delighted Eye'* (Aldershot, 1993).

Friedman, Terry and Evelyn Silber (eds.) *et al.*, *Jacob Epstein. Sculpture and Drawings* (Leeds and London, 1987).

Fry, Roger, 'Gaudier-Brzeska', *Burlington Magazine*, August 1916.

———, *Duncan Grant* (London, 1923).

Fussell, Paul, *The Great War and Modern Memory* (Oxford, 1975).

Exhibition of Works by the Italian Futurist Painters. Catalogue (London, Sackville Galleries, 1912).

Futurism and the International Avant-Garde (Philadelphia, Museum of Art, 1980).

Gallatin, A.E., *Art and the Great War* (New York, 1919).

Gallwitz, Klaus, *Max Beckmann. Die Druckgrafik, Radierungen, Lithographien, Holzschnitte* (Karlsruhe, 1962).

Gardiner, Stephen, *Epstein: artist against the establishment* (London, 1992).

Garrould, Ann, 'Henry Moore 1898–1922', *Henry Moore Early Carvings 1920–1940* (Leeds, 1982).

Gaudier-Brzeska, Henri, 'VORTEX GAUDIER-BRZESKA (Written from the Trenches)', *Blast No. 2*, ed. Wyndham Lewis (London, 1915).

Gauthier, M., *Othon Friesz* (Geneva, 1957).

Geist, Sidney, *Brancusi. A Study of the Sculpture* (New York, 1968).

———, *Constantin Brancusi 1876–1957. A Retrospective Exhibition* (New York, 1969).

———, 'Brancusi: The Centrality of the Gate', *Artforum*, October 1973.

Gill, Eric, *Art-Nonsense and other Essays* (London, 1929).

———, *Autobiography* (London, 1940).

Gimpel, René, *Diary of an Art Dealer*, trans. John Rosenberg (London, 1986).

Glaesemer, Jürgen, *Paul Klee – Handzeichnungen I. Kindheit bis 1920* (Berne, Kunstmuseum, 1973).

———, *Paul Klee – Die farbigen Werke im Kunstmuseum Bern* (Berne, Kunstmuseum, 1976).

Glaser, Curt, *Die Graphik der Neuzeit vom Anfang des neunzehnten Jahrhunderts bis zur Gegenwart* (Berlin, 1923).

Glazebrook, Mark, Introduction and Notes, *Edward Wadsworth 1889–1949. Paintings, Drawings and Prints* (London, Colnaghi's, 1974).

Gleichen, Major-General Lord Edward, *London's Open-Air Statuary* (London, 1928).

Golding, John, *Cubism. A History and an Analysis 1907–1914* (London, 1959).

———, 'The Black Square', *Studio International*, March/April 1975.

Goldring, Douglas, *South Lodge. Reminiscences of Violet Hunt, Ford Madox Ford and the English Review Circle* (London, 1943).

Gollek, Rose, *Franz Marc 1880–1916* (Munich, Städtische Galerie im Lenbachhaus, 1980).

Gombrich, E.H., *et al.*, *Kokoschka* (London, Tate Gallery, 1962).

Retrospective Goncharova. Catalogue (Bourges, Maison de la Culture, 1973).

Göpel, Erhard and Barbara, *Max Beckmann – Katalog der Gemälde* (Berne, 1976).

Gordon, Donald E., *Ernst Ludwig Kirchner* (Cambridge, Mass., 1968).

———, *Expressionism. Art and Idea* (New Haven and London, 1987).

Goriainov, Vladimir, 'Aristarch Lentulov', *XLIII Esposizione Internazionale d'Arte. La Biennale di Venezia* (Venice, 1988).

Gray, Camilla, Introduction, *Kasimir Malevich, 1878–1935* (London, Whitechapel Art Gallery, 1959).

———, *The Great Experiment: Russian Art 1863–1922* (London, 1962).

Gray, Nicolete, *et al.*, *David Jones* (London, South Bank Centre, 1989).

Green, Christopher, *Léger and the Avant-Garde* (New Haven and London, 1976).

———, *Cubism and its Enemies* (New Haven and London, 1987).

———, *Juan Gris* (New Haven and London, 1992).

Grigson, Geoffrey, *A Master of Our Time. A Study of Wyndham Lewis* (London, 1951).

Grisebach, Lothar, *E.L. Kirchners Davoser Tagebuch. Eine Darstellung des Malers und eine Sammlung seiner Schriften* (Cologne, 1968).

Grochowiak, Thomas, *Ludwig Meidner* (Recklinghausen, 1966).

Grohmann, Will, *Paul Klee* (London, 1954).

———, *E.L. Kirchner* (Stuttgart, 1958).

———, *Wassily Kandinsky*, 2nd edn. (Cologne, 1981).

Marcel Gromaire (Paris, Musée d'Art Moderne de la Ville de Paris, 1980).

Grosz, George, *Die Kunst ist in Gefahr* (Berlin, 1925).

———, *A Little Yes and a Big No* (New York, 1946).

———, *Briefe 1913–1959*, ed. Herbert Kunst (Reinbeck, 1979).

George Grosz, Frühe Druckgraphik, Sammelwerke, Illustrierte Bucher 1914–1923 (Berlin, Staatliche Museen Preussischer Kulturbesitz, Kupferstichkabinett, 1971).

George Grosz. Seine Kunst und seine Zeit (Hamburg, Kunstverein, 1975).

Groves, Nancy Jackson, *Ernst Barlach: Life in Work: Sculpture, Drawings and Graphics; Dramas, Prose Works, and Letters in Translation* (Königstein im Taunus, 1972).

Guerin, M., *Jean – Louis Forain; lithographs: catalogue raisonné* (San Francisco, 1980).

Guilbert, Claire Gilles, 'Propos de Brancusi', *Prisme des Arts*, 12, 1957.

Guillemot, Maurice, 'Claude Monet', *La Revue Illustré*, 15 March 1898.

Güse, Ernst-Gerhard, 'Das Kunstwerk des Monats' on Davringhausen's *The Madman* (Münster, 1978).

Haesaerls, Paul, *James Ensor* (London, 1957).

Haftmann, Werner, *Chagall* (New York, 1972).

———, *Banned and Persecuted: dictatorship of art under Hitler* (Cologne, 1986).

Hahnloser-Bühler, Hedy, *Félix Vallotton et Ses Amis* (Paris, 1936).

Haiböck, L., *Der Maler Carry Hauser* (Vienna, 1960).

Hall, Douglas, 'Emile Antoine Bourdelle. Heroic Post-Modernist', *Emile Antoine Bourdelle. Pioneer of the Future*. Catalogue (Yorkshire Sculpture Park, 1989).

Hamilton, George Heard, *Painting and Sculpture in Europe, 1880–1940* (London, 1967).

———, and W.C. Agee, *Raymond Duchamp – Villon, 1876–1918* (New York, 1967).

Hamnett, Nina, *Laughing Torso* (London, 1932).

Handley-Read, Charles, *The Art of Wyndham Lewis* (London, 1951).

Hardie, William, *Scottish Painting 1837–1939* (London, 1976).

Harries, Meirion and Susie, *The War Artists. British Official War Art of the Twentieth Century* (London, 1983).

Harrington, Peter, *British Artists and War. The Face of Battle in Paintings and Prints, 1700–1914* (London, 1993).

Harrison, Charles, *English Art and Modernism 1900–1939* (Indiana and London, 1981).

Harten, Jürgen and Jochen Poetter (eds.), *Mario Sironi (1885–1961)* (Cologne, 1988).

Hartley, Keith, *et al.*, *Käthe Kollwitz 1867–1945* (Cambridge, 1981).

——— (ed.), *Otto Dix 1891–1969* (London, 1992).

Hartley, Marsden, 'Tribal Esthetics', *Dial*, November 1916.

Haskell, Barbara, *Marsden Hartley* (New York, 1980).

Heartfield, John and George Grosz, 'Der Kunstlump', *Der Gegner*, 1919/20.

Heise, Carl Georg, 'The Crucifix by Gies', *Genius*, vol. 3, no. 2, 1921.

Heller, Reinhold, *The Art of Wilhelm Lehmbruck* (Washington, 1972).

Henze, A., *Erich Heckel: Leben und Werk* (Stuttgart, 1983).

Herbert, Barry, *German Expressionism. Die Brücke and Der Blaue Reiter* (London, 1983).

Hergott, Fabrice, *Georges Rouault, Première période, 1903–1920* (Paris, Centre Pompidou, 1992).

Herman, Josef, *The Radical Imagination. Frans Masereel 1889–1972* (London, 1980).

Hess, Hans, *George Grosz* (New Haven and London, 1985).

———, *et al.*, *Art in Germany 1909–1936. From Expressionism to Resistance. The Marvin and Janet Fishman Collection* (Munich, 1990).

Hills, Paul, *The Art of David Jones* (London, 1981).

Hinz, Renate (ed.), *Käthe Kollwitz 1867–1945. Druckgraphik, Plakate, Zeichnungen* (Berlin, 1980).

Hobhouse, Janet, *Everybody Who Was Anybody. A Biography of Gertrude Stein* (London, 1975).

Hoffmann, Edith, *Kokoschka: His Life and Work* (London, 1947).

Hoffmann, Malvina, *Sculpture Inside and Out* (New York, 1939).

Hofmaier, J., *Max Beckmann: catalogue raisonné of his prints* (Berne, 1990).

Hohl, Reinhold, 'Wilhelm Lehmbruck: A German Preserve', *German Art in the 20th Century*, ed. Christos M. Joachimides, Norman Rosenthal and Wieland Schmied (London and Munich, 1985).

Holroyd, Michael, *Augustus John. A Biography*, revised edn., 1 vol. (Harmondsworth, 1976).

Hone, Joseph, *The Life of Henry Tonks* (London, 1939).

Hoog, Michel, *The Nymphéas of Claude Monet* (Paris, 1990).

Hopper, Robert, *True and Pure Sculpture. Frank Dobson 1886–1963* (Cambridge, Kettle's Yard, 1981).

Horn, Gabriel, *et al.*, *Rudolf Schlichter 1890–1955*

(Berlin, Staatliche Kunsthalle, 1984).

Hudson, Derek, *James Pryde 1866–1941* (London, 1949).

Hughes, Robert, *The Shock of the New. Art and the Century of Change* (London, 1980).

Hulme, T.E., *Speculations. Essays on Humanism and the Philosophy of Art*, ed. Herbert Read (London, 1924).
———, *Further Speculations*, ed. Sam Hynes (Minneapolis, 1955).

Hulten, Pontus, *Futurismo e Futurismi* (Milan, 1986).
———, *Brancusi* (London, 1988).

Humphreys, Richard, *et al.*, *Pound's Artists. Ezra Pound and the Visual Arts in London, Paris and Italy* (London, Tate Gallery, 1985).

Hynes, Samuel, *A War Imagined. The First World War and English Culture* (London, 1990).

Imiela, Hans-Jürgen, Introduction, *Liebermann. Slevogt. Corinth: Printed Graphics* (Stuttgart, 1979).

Isaacson, Joel, *Claude Monet. Observation and Reflection* (Oxford, 1978).

Jackson, A.Y., 'The War Memorials: A Challenge', *Lamps*, Toronto, December 1919.
———, 'Reminiscences of Army Life, 1914–1918', *Canadian Art*, Ottawa, Autumn 1953.

Jagger, Charles Sargeant, *Modelling and Sculpture in the Making* (London, 1933).

James, Philip, Introduction, *Epstein. An Exhibition held at the Tate Gallery* (London, 1952).

Jansen, E., *Ernst Barlach: Werke, Meinungen* (Vienna, 1984).

Janou, Ionel, *Zadkine* (Paris, 1964).

Jeffrey, Ian, 'Concerning Images of the Metropolis', *Cityscape 1910–39* (London, Royal Academy, 1977).

Jianu, I., *Bourdelle* (New York, 1966).

John, Augustus, *Chiaroscuro. Fragments of an Autobiography: First Series* (London, 1954).
———, *Finishing Touches*, ed. and intro. Daniel George (London, 1964).

Jones, Alun R., *The Life and Opinions of T.E. Hulme* (London, 1960).

Jones, Barbara and Bill Howell, *Popular Arts of the First World War* (London, 1972).

Jones, David, *In Parenthesis* (London, 1937).

Judd, Alan, *Ford Madox Ford* (London, 1990).

Kallir, Jane, *Egon Schiele. The Complete Works* (London, 1990).

Kamensky, Aleksandr, *Chagall. The Russian Years 1907–1922* (London, 1989).

Kandinsky. Oeuvres de Wassily Kandinsky 1866–1944 (Paris, Centre Pompidou, 1984).

Kandinsky, Wassily and Franz Marc, *Der Blaue Reiter* (Munich, 1912), ed. Klaus Lankheit (Munich, 1965).
———, *Rückblicke* (Berlin, 1913).
———, *Klänge* (Munich, 1913).
———, *The Art of Spiritual Harmony* (Munich, 1912) first English trans. M.T.H. Sadleir (London, 1914).
———, and Franz Marc. *Briefwechsel, mit Briefen von und an Gabriele Münter und Maria Marc*, ed. Klaus Lankheit (Munich, 1983).

Karsch, Florian, *et al.*, *Otto Dix. Das graphische Werk* (Hanover, 1970).

Karshan, Donald, *Malevich. The Graphic Work: 1913–1930* (Jerusalem, 1975).

Keegan, John and Joseph Darracott, *The Nature of War* (New York, 1981).

Kent, Graham R., 'Sadler, Gill and the Moneychangers', *Michael Sadler* (Leeds, 1989).

Kessler, Count Harry, *Diaries of a Cosmopolitan* (London, 1971).

Ketterer, Roman Norbert (ed.), *E.L. Kirchner. Zeichnungen und Pastelle* (Stuttgart, 1979).

Kiefer, Theodore, *James Ensor* (Recklinghausen, 1976).

King, James, *Interior Landscapes. A Life of Paul Nash* (London, 1987).

Kinkel, Hans, *Vierzehn Berichte* (Stuttgart, 1967).
———, Introduction, *Otto Dix. Etchings & Drawings* (London, Goethe Institute, n.d.).

Ernst Ludwig Kirchner, ed. Lucius Grisebach and Annette Meyer zu Eissen (Munich, 1979).

Kirschl, Wilfried, *A. Egger-Lienz, 1868–1926* (Vienna, 1977).

Klee, Felix (ed.), *Tagebucher von Paul Klee 1898–1918* (Cologne, 1956).

Klipstein, August, *Käthe Kollwitz. Verzeichnis des graphischen Werkes* (Berne, 1955).

Knowles, Elizabeth, *C.R.W. Nevinson* (Cambridge, Kettle's Yard, 1988).

Kokoschka, Oskar, *Dramen und Bilde* (Leipzig, 1913).
———, *Schriften 1907–1955* (Munich, 1956).
———, *A Sea Ringed with Visions*, trans. Eithne Wilkins and Ernst Kaiser (London, 1962).
———, *Mein Leben* (Munich, 1971).
———, *Briefe. Vol. 1: 1905–1919*, ed. Olda Kokoschka and Heinz Spielmann (Düsseldorf, 1984).
———, *Oskar Kokoschka Letters 1905–1976*, ed. Olda Kokoschka and Alfred Marnau (London, 1992).

Kolb, Eberhard, *et al.*, *Prints and Drawings of the Weimar Republic* (Stuttgart, 1987).

Kollwitz, Hans, *Käthe Kollwitz – das plastische Werk* (Hamburg, 1967).

Konody, P.G., *Modern War: Paintings by C.R.W. Nevinson* (London, 1917).
———, *Art and War: Canadian War Memorials* (London, n.d.).

Kornfeld, Eberhard W., *Verzeichnis des graphischen Werkes von Paul Klee* (Berne, 1963).

Kräubig, Jens, *Ernst Barlach. Lithographs, Woodcuts* (Stuttgart, 1989).

Krüger, Günter, *Das Druckgraphische Werk Max Pechsteins* (Hamburg, 1988).

Langdale, Cecily, *Gwen John* (New Haven and London, 1987).

Lankheit, Klaus (ed.), *Franz Marc im Urteil Seiner Zeit* (Cologne, 1960).
———, *Franz Marc. Katalog der Werke* (Cologne, 1970).
———, *Franz Marc. Sein Leben und seine Kunst* (Cologne, 1976).
———, *Franz Marc. Schriften* (Cologne, 1978).

Lavery, John, *The Life of a Painter* (London, 1940).

Lawniczakowa, Agnieszka, *Malczewski: A Vision of Poland* (London, Barbican Art Gallery, 1990).

Leclercq, Julien, 'Le Bassin aux Nymphéas de Claude Monet', *La Chronique des Arts*, 1 December 1900.

Lee, Jane, *Derain* (Oxford, 1990).

Fernand Léger (Paris, Grand Palais, 1971).

Léger, Fernand, 'The Aesthetics of the machine, geometrical order and truth', *Functions of Painting* (Paris, 1965).

Lehmann, Hans-Ulrich, *Otto Dix. Die Zeichnungen im Dresdner Kupferstich-Kabinett* (Dresden, 1991).

Leighten, Patricia, 'Picasso's Collages and the Threat of War, 1912–13', *The Art Bulletin*, December 1985.
———, *Re-ordering the Universe. Picasso and Anarchism 1897–1914* (Princeton, 1989).

Lemaire, Gérard-Georges, *et al.*, *Pour un Temps/ Wyndham Lewis* (Paris, 1982).

Leniashin, Vladimir (ed.), *Soviet Art 1920s–1930s* (Moscow, New York, 1988).

Levin, Gail, *Edward Hopper. The Art and the Artist* (New York, 1980).

Levine, Frederick S., *The Apocalyptic Vision. The Art of Franz Marc as German Expressionism* (New York, 1979).

Levy, Mervyn, *Gaudier-Brzeska. Drawings and Sculpture* (London, 1965).

Lewis, Beth Irwin, *George Grosz. Art and Politics in the Weimar Republic* (Princeton, 1991).

Lewis, Wyndham, 'Rebel Art in Modern Life', *Daily News and Leader*, 7 April 1914.
———, 'Kill John Bull with Art', *The Outlook*, 18 July 1914.
———, (ed.), *Blast No. 1* (London, 1914).
———, 'Note', *First Exhibition of the Vorticist Group* (London, Doré Galleries, 1915).
———, (ed.), *Blast No. 2* (London, 1915).
———, 'The War Baby', *Art and Letters*, Winter 1918.
———, Foreword, *Guns by Wyndham Lewis* (London, Goupil Gallery, 1919).
———, 'The Men Who Will Paint Hell. Modern War as a Theme for the Artist', *Daily Express*, 10 February 1919.
———, 'Mr. Wadsworth's Exhibition of Woodcuts', *Art and Letters*, Spring 1919.
———, *Blasting and Bombardiering* (London, 1937).
———, *Wyndham Lewis the Artist, from 'Blast' to Burlington House* (London, 1939).
———, *Rude Assignment. A Narrative of My Career Up-to-Date* (London, 1950).
———, Introduction, *Wyndham Lewis and Vorticism* (London, Tate Gallery, 1956).
———, 'The Vorticists', *Vogue*, September 1956.
———, and Louis F. Fergusson, *Harold Gilman. An Appreciation* (London, 1919).

Lewison, Jeremy (ed.), *Käthe Kollwitz 1867–1945. The Graphic Works* (Cambridge, Kettle's Yard, 1981).
———, (ed.), *Henri Gaudier-Brzeska, Sculptor* (Cambridge, Kettle's Yard, 1983).
———, (ed.), *A Genius of Industrial England. Edward Wadsworth 1889–1949* (London and Bradford, 1990).

L'Expressionisme en Allemagne (Paris, Musée d'Art Moderne de la Ville de Paris, 1993).

Liddiard, Jean, *Isaac Rosenberg. The Half Used Life* (London, 1975).

Lieberman, William S., *Max Ernst* (New York, 1961).

Max Liebermann in Seiner Zeit (Berlin, Nationalgalerie, 1979).

Lilly, Marjorie, *Sickert. The Painter and His Circle* (London, 1971).

Lipke, William C., 'Vorticism and the Modern Movement', *The Arts Review*, 21 August–4 September 1965.
———, *David Bomberg. A Critical Study of his Life and Work* (London, 1967).
———, 'The New Constructive Geometric Art in London, 1910–1915', *The Avant-Garde*, ed. Thomas B. Hess and John Ashbery, *Art News Annual*, XXXIV (New York, 1968).

Lista, Giovanni, *Giacomo Balla* (Modena, 1982).

Lloyd, Jill, 'Otto Dix – War', *War. A Cycle of Etchings by Otto Dix* (London, Goethe-Institut, 1988).
———, *German Expressionism, Primitivism and Modernity* (New Haven and London, 1991).

Löffler, Fritz, 'Otto Dix – Der Krieg', *Otto Dix* (Albstadt, 1976).
———, *Otto Dix – Leben und Werk* (Dresden, 1977).
———, *Otto Dix. Werkverzeichnis der Gemälde* (Recklinghausen, 1981).

Ludington, Townsend, *Marsden Hartley. The Biography of an American Artist* (New York, 1992).

Ludwig, Richard M. (ed.), *The Letters of Ford Madox Ford* (Princeton, 1965).

MacCarthy, Fiona, *Eric Gill* (London, 1989).

MacColl, D.S., 'Uncommissioned Art', *The Burlington Magazine*, vol. 32, 1918.

August Macke und die Rheinischen Expressionisten (Hanover, Kestner Gesellschaft, 1978).

Macke, August, *Briefwechsel mit Franz Marc* (Cologne, 1964).

MacShane, Frank, *The Life and Work of Ford Madox Ford* (London, 1965).

Maffina, Gianfranco, *L'Opera grafica di Luigi Russolo* (Varese, 1977).

Malevich, Kasimir, *Essays on Art 1, 1915–1928*, ed. Troels Andersen (Copenhagen, 1968).

Mantura, Bruno, Patrizia Rosazza-Ferraris and Livia Velani (eds.), *Futurism in Flight. "Aeropittura" paintings and sculptures of Man's conquest of space* (London, 1990).

Marc, Franz, *Briefe, Aufzeichnungen und Aphorismen*, Vol. 1 (Berlin, 1920).

———, *Briefe aus dem Felde* (Berlin, 1940).

———, *Aufzeichnungen und Aphorismen* (Munich, 1946).

Marinetti, F.T., *Zang Tumb Tuuum, Adrianopoli Ottobre 1912, Parole in Libertà* (Milan, 1914).

———, *Selected Writings*, ed. R.W. Flint (London, 1972).

Marks, A., *Der Illustrator Alfred Kubin* (Munich, 1977).

Martin, J.-H., *et al. Paris – Moscou, 1900–1930* (Paris, Centre Pompidou, 1979).

Martin, Marianne W., *Futurist Art and Theory 1909–1915* (Oxford, 1968).

Marx, Roger, 'Les "Nymphéas" de M. Claude Monet', *Gazette des Beaux Arts*, 15 June 1909.

März, Roland, *Franz Marc* (Berlin, 1987).

Mason, Lauris, *The Lithographs of George Bellows* (New York, 1977).

Materer, Timothy (ed.), *Pound/Lewis. The Letters of Ezra Pound and Wyndham Lewis* (London, 1985).

Mayakovsky, Vladimir, 'The Civilian Shrapnel – To Those who lied with the brush', *Collected Works*, Vol. 1 (Moscow, 1955).

Mayakovsky: Twenty Years of Work, ed. David Elliott (Oxford, Museum of Modern Art, 1982).

Mayes, Alice, 'The Young Bomberg, 1914–1925', unpublished memoir 1972, Tate Gallery Archives, London.

McConkey, Kenneth, *Sir George Clausen, R.A. 1852–1944* (Bradford, 1980).

McGreevy, Linda F., *The Life and Works of Otto Dix. German Critical Realist* (Michigan, 1981).

Ludwig Meidner, an Expressionist Master (Ann Arbor, University of Michigan Museum of Art, 1978).

Meidner, Ludwig, 'An Introduction to Painting Big Cities', *Kunst and Künstler*, Vol. 12 (1914).

———, *Im Nacken das Sternemeer* (Leipzig, 1918).

———, 'Ein denkwürdiger Sommer', *Der Monat*, 16 (1964).

Meier-Grafe, Julius, Editorial, *Kriegszeit*, 31 August 1914.

Meseure, Anna, *August Macke 1887–1914* (Cologne, 1991).

Messum, David, *The Life and Work of Lucy Kemp-Welch*, ed. Laura Wortley (London, 1976).

Metzinger. Pre-Cubist and Cubist Works (Chicago, International Galleries, 1964).

Meyer, Franz, *Chagall* (London, 1964).

Meyers, Jeffrey, *The Enemy. A Biography of Wyndham Lewis* (London, 1980).

——— (ed.), *Wyndham Lewis: A Revaluation. New Essays* (London, 1980).

Michel, Walter, *Wyndham Lewis Paintings and Drawings*, introductory essay by Hugh Kenner (London, 1971).

——— and C.J. Fox (eds.), *Wyndham Lewis on Art. Collected Writings 1913–1956* (London, 1969).

Miller, Sanda, 'Brancusi's "Column of the Infinite"', *The Burlington Magazine*, July 1980.

Mitsch, Erwin, *The Art of Egon Schiele* (London, 1975).

Mizener, Arthur, *The Saddest Story. A Biography of Ford Madox Ford* (London, 1972).

Mohalov, Lev, *Kuzma Petrov-Vodkin* (Leningrad, 1980).

Montague, C.E. and John Salis, *British Artists at the Front*, Vol. 3 (London, 1918).

Henry Moore on Sculpture, ed. Philip James (London, 1966).

Henry Moore Wood Sculpture (London, 1983).

Morphet, Richard, *British Painting 1910–1945* (London, 1967).

Morris, Lynda (ed.), *Henry Tonks and the 'Art of Pure Drawing'* (Norwich, 1985).

Mortimer, Raymond, *Duncan Grant* (London, 1948).

Nagel, Otto, *Käthe Kollwitz*, trans. Stella Humphries (London, 1971).

Nairne, Sandy and Nicholas Serota (eds.), *British Sculpture in the 20th Century* (London, Whitechapel Art Gallery, 1981).

Nakov, Andrei, *Avant-Garde Russe* (London, 1986).

Nash, Paul, *Outline. An Autobiography and Other Writings* (London, 1949).

Paul Nash. Through The Fire: Paintings, drawings and graphic work from the First World War (London, Imperial War Museum, 1988).

Nergaard, Trygve, *et al.*, *Per Krohg 1889–1965. Bilder 1910–1930* (Oslo, 1989).

Neve, Christopher, *Unquiet Landscape. Places and Ideas in 20th-Century English Paintings* (London, 1990).

Nevinson, C.R.W., Interview, *Daily Express*, 25 February 1915.

———, 'Art and War', *Daily Graphic*, 11 March 1915.

———, Preface, *Exhibition of Pictures of War* (London, Leicester Galleries, 1918).

———, Interview, *Newcastle-on-Tyne Illustrated Chronicle*, 22 January 1919.

———, *Paint and Prejudice* (London, 1937).

Nevinson's Collection of Press Cuttings. Vol. I: 1910–1914; Vol. II: 1914–1918, Tate Gallery Archives, London.

C.R.W. Nevinson. The Great War and After (London, McLean Gallery, 1980).

Newman, Sasha M., *et al.*, *Félix Vallotton* (New York and New Haven, 1991).

Normand, Tom, *Wyndham Lewis The Artist. Holding the mirror up to politics* (Cambridge, 1992).

Novotny, Fritz and Johannes Dobai, *Gustav Klimt. With a Catalogue Raisonné of his Paintings* (London, 1968).

Oliver, W.T., 'Sadler as Art Collector', *Michael Sadler* (Leeds, 1989).

Olson, Stanley, *John Singer Sargent: His Portrait* (London, 1986).

Ormond, Richard, *John Singer Sargent. Paintings, drawings and watercolours* (London, 1970).

Orpen, William, *An Onlooker in France 1917–19* (London, 1921).

Pach, Walter, *Raymond Duchamp-Villon* (Paris, 1924).

Paige, D.D. (ed.), *The Letters of Ezra Pound, 1907–1941* (London, 1951).

Palmer, J. Wood, Introduction, *Harold Gilman 1876–1919* (London, Arts Council, 1954).

———, Introduction, *Spencer Frederick Gore 1878–1914* (London, Arts Council, 1955).

———, Introduction, *Henri Gaudier-Brzeska 1891–1915* (London, Arts Council, 1956).

Parigoris, Alexandra, 'Brancusi at Tirgu-Jiu: The Return of the "Prodigal Son",' *The Burlington Magazine*, February 1984.

Parkin, Michael, Introduction, *The Appalling Loss* (London, Parkin Gallery, 1973).

Parsons, Ian (ed.), *The Collected Works of Isaac Rosenberg* (London, 1984).

Parton, Anthony, *Mikhail Larionov and the Russian Avant-Garde* (London, 1993).

Partsch, Susanna, *Franz Marc 1880–1916* (Cologne, 1991).

Passuth, Krisztina, *et al.*, *L. Moholy-Nagy* (London, 1980).

———, *Moholy-Nagy* (London, 1985).

Peck, Glenn C. and Gordon K. Allison, *George Bellows and the War Series of 1918* (New York, 1983).

Penny, Nicholas, 'English Sculpture in the First World War', *Oxford Art Journal*, November 1981.

Penrose, Roland, Introduction, *Picasso. Sculpture Ceramics Graphic Work* (London, 1967).

———, *Picasso. His Life and Work* (Harmondsworth, 1971).

———, *Max Ernst's Celebes* (Newcastle upon Tyne, 1972).

———, *Man Ray* (London, 1975).

Perez-Tibi, Dora, *Dufy* (London, 1989).

Perloff, Marjorie, *The Futurist Moment. Avant-Garde, Avant Guerre and the Language of Rupture* (Chicago, 1986).

Petrova, Evgeniya, *et al.*, *Malevich. Artist and Theoretician* (Paris, 1990).

Phillips, Christopher and Patrick, *Nash and Nevinson in War and in Peace. The Graphic Work 1914–1920* (London, 1977).

Picasso: The Body on the Cross (Paris, Musée Picasso, 1992).

Picasso & les choses (Paris, Grand Palais, 1992).

Pickvance, Ronald, Introduction, *Sickert 1860–1942* (London, Arts Council, 1964).

Pople, Kenneth, *Stanley Spencer. A Biography* (London, 1991).

Pound, Ezra, 'Vorticism', *The Fortnightly Review*, 1 September 1914.

———, 'Affirmations. II. Vorticism', *The New Age*, 14 January 1915.

———, 'Affirmations. III. Jacob Epstein', *The New Age*, 21 January 1915.

———, 'Affirmations. V. Gaudier-Brzeska', *The New Age*, 4 February 1915.

———, *Gaudier-Brzeska. A Memoir* (London, 1916).

———, 'Prefatory Note', *A Memorial Exhibition of the Work of Henri Gaudier-Brzeska* (London, Leicester Galleries, 1918).

Powell, L.B., *Jacob Epstein* (London, 1932).

Prelinger, Elizabeth, *et al.*, *Käthe Kollwitz* (New Haven and London, 1992).

Quinn, Edward, *Max Ernst* (London, 1977).

John Quinn 1870–1925. Collection of Paintings, Water Colors, Drawings & Sculpture. Foreword by Forbes Watson (New York, 1926).

Paintings and Sculptures. The Renowned Collection of Modern and Ultra-Modern Art, Formed by the Late John Quinn. Sale Catalogue (New York, 1927).

Raabe, P., *Alfred Kubin. Leben, Werk, Wirkung* (Hamburg, 1957).

Ray, Man, *Self Portrait* (London, 1988).

Realismus 1919–1939, ed. Gérard Regnier (Munich, 1981).

Reid, B.L., *The Man from New York. John Quinn and His Friends* (Oxford, 1968).

Rewald, Sabine, *Paul Klee. The Berggruen Collection in the Metropolitan Museum of Art, New York and the Musée National d'Art Moderne, Paris* (London, 1989).

Rhyne, Brice, 'Henri Gaudier-Brzeska: The Process of Discovery', *Artforum*, May 1977.

Richter, Hans, *Dada. Art and Anti-Art* (New York, 1965).

Rigby, Ida Katherine, 'The Revival of Printmaking in Germany', *German Expressionist Prints and Drawings* (Los Angeles, 1989).

Roberts, Michael, *T.E. Hulme* (London, 1938).

Roberts, William, 'Wyndham Lewis, the Vorticist', *The Listener*, 21 March 1957.

———, *The Vortex Pamphlets 1956–1958* (London, 1958).

———, *Memories of the War to End War 1914–18* (London, 1974).

————, *Paintings and Drawings by William Roberts R.A.* (London, 1976).

Robinson, Duncan, *William Nicholson. Paintings, Drawings & Prints* (London, 1980).

————, *Stanley Spencer* (Oxford, 1990).

Robinson, S.B. *Giacomo Balla. Divisionism and Futurism, 1871–1912* (Ann Arbor, 1981).

Roethel, Hans K. and Jean K. Benjamin, *Kandinsky* (Oxford, 1979).

————, *Kandinsky-Catalogue raisonné of the Oil Paintings*, 2 Vols. (London, 1982–4).

Rodman, Selden, *Horace Pippin. A Negro Painter in America* (New York, 1947).

Rogoff, Irit (ed.), *The Divided Heritage. Themes and Problems in German Modernism* (Cambridge, 1991).

Rose, W.K. (ed.), *The Letters of Wyndham Lewis* (London, 1963).

Rosenblum, Robert, *Cubism and Twentieth-Century Art* (New York, 1976).

Rosenthal, Mark (ed.), *Franz Marc 1880–1916* (Berkeley, University of California, 1979–80).

Roskam, Albert, *Dazzle Painting* (Rotterdam, 1987).

Roters, Eberhard and Bernhard Schulz, *Ich und die Stadt. Mensch und Grosstadt in der deutschen Kunst des 20-Jahrhunderts* (Berlin, 1987).

Rothenstein, John, *British Artists and the War* (London, 1931).

————, *Augustus John* (London, 1944).

————, *Modern English Painters. Volume One. Sickert to Grant* (London, 1952).

————, *Modern English Painters. Volume Two. Innes to Moore* (London, 1956).

————, *British Art Since 1900. An Anthology* (London, 1962).

————, *John Nash* (London and Sydney, 1983).

————, *Modern English Painters. Volume Two. Nash to Bawden* (London, 1984).

Rothenstein, Michael, *Drawing Book. Drawings and Paintings Aged 4–9. 1912–1917* (London, 1986).

Rothenstein, William, *Men and Memories. Recollections of William Rothenstein 1900–1922* (London, 1932).

Rubenstein, Daryl R., *Max Weber. A Catalogue Raisonné of his Graphic Work*, Foreword by Alan Fern (Chicago, 1980).

Rubin, William, *Dada and Surrealist Art* (London, 1969).

———— (ed.), *Pablo Picasso. A Retrospective* (New York and London, 1980).

———— (ed.), *De Chirico* (New York, 1982).

————, *Picasso and Braque. Pioneering Cubism* (New York, 1989).

Rudenstine, A.Z. (ed.), *Russian Avant-garde Art. The George Costakis Collection* (New York, 1981).

Ruhrberg, Karl, *Twentieth Century Art. Painting and Sculpture in the Ludwig Museum* (London, 1986).

Rusakov, Yury and Nina Barabanova, *Kuzma Petrov-Vodkin 1878–1939* (Leningrad, 1986).

Russell, John, Introduction, *Rouault* (London, Tate Gallery, 1966).

————, 'Apollinaire as Art Critic', *Art and Artists*, November 1968.

————, *The Meanings of Modern Art* (London, 1981).

Russolo, Maria Zanovello, Ugo Nebbia and Paolo Buzzi, *Russolo: l'uomo, l'artista* (Milan, 1958).

Rutter, Frank, *Some Contemporary Artists* (London, 1922).

————, *Evolution in Modern Art. A Study of Modern Painting, 1870–1925* (London, 1926).

————, *The British Empire Panels Designed for the House of Lords by Frank Brangwyn, RA* (Essex, 1933).

Sabarsky, Serge, *Kokoschka: early drawings and watercolours* (London, 1985).

————, *Egon Schiele. 100 Dessins* (Paris, 1985).

Sadleir, Michael, *Michael Ernest Sadler. A Memoir by His Son* (London, 1949).

Sadler, Michael, 'Premonitions of the war in modern art', 1915. Unpublished ms., Brotherton Library, Leeds University.

Salaman, Malcolm C., 'The Art of C.R.W. Nevinson', *The Studio*, December 1919.

Salzmann, Siegfried, *Wilhelm Lehmbruck. Katalog der Sammlung des Wilhelm-Lehmbruck-Museums der Stadt Duisburg* (Recklinghausen, 1981).

————, *Hinweg mit den Knienden. Ein Betrag zur Geschichte des Kunstskandals* (Duisburg, Kunstverein, 1981).

Sarabianov, Dmitrii Vladimirovich, *Russian and Soviet Painting* (New York, 1977).

Särnstedt, Bo, *et al.*, *GAN. Gösta Adrian-Nilsson 1884–1965* (Stockholm, 1984).

Schlichter, Rudolf, *Das widerspenstige Fleisch* (Berlin, 1982).

Schmidt, Dieter, *Otto Dix im Selbstbildnis* (East Berlin, 1978).

Schmied, Wieland, *Neue Sachlichkeit and the German Realism of the Twenties* (London, Hayward Gallery, 1978).

————, *et al.*, *De Chirico. Leben und Werk* (Munich, 1980).

————, 'Points of Departure and Transformations in German Art 1905–1985', *German Art in the 20th Century* (London and Munich, 1985).

Schneede, Uwe M., *The Essential Max Ernst* (London, 1972).

————, *George Grosz. Der Künstler in seiner Gesellschaft* (Cologne, 1975).

————, *Käthe Kollwitz: Das zeichnerische Werk* (Munich, 1981).

Schneider, Pierre, *Matisse* (New York, 1984).

Schrader, Barbel and Jurgen Schebera, *The "Golden" Twenties. Art and Literature in the Weimar Republic* (New Haven and London, 1988).

Schrecken und Hoffnung. Catalogue (Hamburg, Munich, Moscow and Leningrad, 1987–88).

Schubert, Dietrich, *Max Beckmann. Auferstehung und Erscheinung der Toten* (Worms, 1985).

Schulz, Bernhard, *et al.*, *Expressionisme a Berlin 1910–1920* (Brussels, 1984).

Schulz, Katharina, *Oskar Kokoschka 1886–1980* (London, 1986).

Schröder, Klaus Albrecht and Harald Szeemann (eds.), *Egon Schiele and His Contemporaries* (Munich, 1989).

Schulz-Hoffmann, Carla and Judith C. Weiss (eds.), *Max Beckmann Retrospective* (Munich, 1984).

Schwieger, Werner Joseph, *Der junge Kokoschka – Leben und Werk 1904 bis 1914* (Vienna and Munich, 1983).

Scott, Gail R., *Marsden Hartley* (New York, 1988).

Secretain, Roger, *Un Sculpteur 'Maudit': Gaudier-Brzeska 1891–1915* (Paris, 1979).

Segonzac, André Dunoyer de, *Dessins 1900–1970* (Geneva, 1970).

Seligman, Germain, *Roger de La Fresnaye* (Greenwich, Ct., 1969).

Selz, Peter, *Max Beckmann* (New York, MOMA, 1964).

Gino Severini (Florence, Palazzo Pitti, 1983).

Shakespear Pound, Dorothy, *Etruscan Gate* (Exeter, 1971).

Shanes, Eric, *Constantin Brancusi* (New York, 1989).

Shewring, Walter (ed.), *Letters of Eric Gill* (London, 1947).

Shone, Richard, *Bloomsbury Portraits* (Oxford, 1976).

————, *A Century of Change. British Painting Since 1900* (Oxford, 1977).

————, *Walter Sickert* (Oxford, 1988).

Sickert, Walter, 'O Matre Pulchra', *The Burlington Magazine*, April 1916.

————, *A Free House! Or, The Artist as Craftsman (Being the Writings of Walter Richard Sickerts)*, ed. Osbert Sitwell (London, 1947).

Silber, Evelyn, *The Sculpture of Epstein* (Oxford, 1986).

Sillars, Stuart, *Art and Survival in First World War Britain* (Basingstoke and London, 1987).

Silver, Kenneth E., *Esprit de Corps. The Art of the Parisian Avant-Garde and the First World War, 1914–1925* (London, 1989).

Simpson, Ann, *et al.*, *James Pryde* (Edinburgh, 1992).

Sitwell, Osbert, *C.R.W. Nevinson* (London, 1925).

————, Introduction, *Memorial Exhibition of Pictures by C.R.W. Nevinson, 1889–1946* (London, Leicester Galleries, 1947).

————, *Great Morning. Being the Third Volume of Left Hand, Right Hand! An Autobiography* (London, 1948).

Skipwith, Peyton, Foreword, *The Art of War 1914–1918. Wyndham Lewis, Paul Nash, C.R.W. Nevinson, William Roberts* (London, The Morley Gallery, 1971).

————, 'Gilbert Ledward RA and the Guards' Division Memorial', *Apollo*, January 1988.

Soby, James Thrall, *The Prints of Paul Klee* (New York, 1947).

————, *Giorgio de Chirico* (New York, 1955).

Sotriffer, Kristian, *Albin Egger-Lienz 1868–1926* (Vienna, 1983).

Spalding, Frances, *Roger Fry. Art and Life* (London, 1980).

————, 'Mark Gertler – the early years', *Mark Gertler – the Early and Late years* (London, Ben Uri Art Gallery, 1982).

————, *British Art Since 1900* (London, 1986).

Spate, Virginia, *Orphism* (Oxford, 1979).

————, *The Colour of Time: Claude Monet* (London, 1992).

Speaight, Robert, *The Life of Eric Gill* (London, 1966).

Spies, Werner (ed.), *Max Ernst. Oeuvre Katalog: Das Graphische Werk* (Cologne, 1975).

———— (ed.), *Max Ernst. Retrospektive* (Munich, 1979).

————, *Max Ernst Collages* (London, 1991).

———— (ed.), *Max Ernst. A Retrospective* (London, 1991).

———— and Gunter and Sigrid Metken, *Max Ernst Werke 1906–1925* (Cologne, 1975).

St James, Ashley, *Vallotton: Graphics* (London, 1978).

Steegmuller, Francis, *Cocteau. A Biography* (Boston, 1970).

Stein, Gertrude, *The Autobiography of Alice B. Toklas* (London, 1933).

————, *Picasso* (London, 1938).

Stemmler, Dierk, *Die rheinischen Expressionisten: August Macke und seine Malerfreunde* (Recklinghausen, 1980).

Stern, J.P., *et al.*, *Expression & Engagement. German Painting from the Collection* (Liverpool, Tate Gallery, 1990).

Stevens, MaryAnne and Lawrence Gowing, *The Edwardians and After. The Royal Academy 1900–1950* (London, 1988).

Stock, Noel, *The Life of Ezra Pound* (London, 1969).

Stuckey, Charles F., *Monet Water Lilies* (New York, 1988).

Suarez, Georges, *La Vie Orgueilleuse de Clemenceau* (Paris, 1930).

Sutton, Denys, Introduction, *Duncan Grant* (London, Wildenstein's, 1964).

———— (intro. and ed.), *Letters of Roger Fry*, 2 Vols. (London, 1972).

Sylvester, David, Introduction, *David Bomberg 1890–1957* (London, Marlborough Fine Art, 1964).

————, 'The Discovering of a Structure', *David Bomberg 1890–1957* (London, Tate Gallery, 1967).

————, 'Selected Criticism', *Bomberg. Paintings, Drawings, Watercolours and Lithographs* (London, Fischer Fine Art, 1973).

Synge, John, Foreword, *James Pryde 1866–1941* (London, Redfern Gallery, 1988).

Taggett, Sherry Clayton and Ted Schwarz, *Paintbrushes and Pistols. How the Taos Artists Sold the West* (Santa Fe, 1990).

Taylor, Joshua C., *Futurism* (New York, 1961).

Thomson, Belinda, *Vuillard* (London, 1988).

Thomson, Richard, 'Gilman's Subjects: Some Observations', *Harold Gilman 1876–1919* (London, 1981).

Tippett, Maria, *Art at the Service of War. Canada, Art, and the Great War* (Toronto, 1984).

Tittle, Walter, 'My Memories of John Sargent', *Illustrated London News*, CLXVI, 1925.

Tobler, K., 'A New Model. Félix Vallotton's War Landscapes', *Kulturmagazin*, September 1984.

Tonks, Henry, 'Wander Year', *Artwork*, Winter 1929.

Tucker, Paul Hayes, 'Monet in the '90s. The Series Paintings' (Boston, New Haven and London, 1990).

Uhr, Horst, *Lovis Corinth* (Berkeley, Los Angeles and Oxford, 1990).

Usherwood, Paul and Jenny Spencer-Smith, *Lady Butler. Battle Artist 1846–1933* (London, 1987).

Valensi, Henry, 'Colour and Forms', *Montjoie!*, Nov.–Dec. 1913.

Vallotton, Félix, *Documents Pour Une Biographie et Pour L'Histoire d'une Oeuvre III. Journal 1914–1921* (Paris, 1975).

Vallotton, Maxime and Charles Goerg, *Félix Vallotton. Catalogue Raisonné of the Printed Graphic Work* (Geneva, 1972).

Varia, Radu, *Brancusi* (New York, 1986).

Varley, Christopher, *F.H. Varley: A Centennial Exhibition* (Edmonton, 1981).

Verdet, André, *Fernand Léger et le dynamism pictural* (Geneva, 1955).

Vergo, Peter, *Art in Vienna 1898–1918. Klimt, Kokoschka, Schiele and their contemporaries* (Oxford, 1975).

————, *The Blue Rider* (Oxford, 1977).

Viney, Nigel, *Images of Wartime. British Art and Artists of World War I* (London, 1991).

Vogt, Paul, *Christian Rohlfs* (Cologne, 1953).

————, *Erich Heckel. Monographie mit Werkverzeichnis* (Recklinghausen, 1965).

————, *Christian Rohlfs – Oeuvre der Ölgemälde* (Recklinghausen, 1978).

————, *et al.*, *Expressionism. A German Intuition 1905–1920* (New York, Guggenheim Museum, 1980).

Vriesen, Gustav, *August Macke*, 2nd enlarged edn. (Stuttgart, 1957).

Wadsworth, Barbara, *Edward Wadsworth. A Painter's Life* (Salisbury, 1989).

Wagner, Geoffrey, *Wyndham Lewis. A Portrait of the Artist as the Enemy* (London, 1957).

Waissenberger, R., *Wien, 1870–1930. Traum und Wirklichkeit* (Vienna, 1984).

Watkins, Nicholas, *Matisse* (Oxford, 1984).

Watney, Simon, *English Post-Impressionism* (London, 1980).

————, *The Art of Duncan Grant* (London, 1990).

Wees, William C., *Vorticism and the English Avant-Garde* (Toronto and Manchester, 1972).

Weight, Angela, 'The Kensingtons at Laventie – a twentieth-century icon', *Imperial War Museum Review No. 1*, 1986.

Wellington, Hubert, *Jacob Epstein* (London, 1925).

White, Gabriel, Introduction, *Notes and Sketches by Sickert from the Walker Art Gallery* (London, Arts Council, 1949).

————, Introduction, *Sickert Paintings and Drawings* (London, Arts Council, 1960).

Whitford, Frank, *Egon Schiele* (London, 1981).

————, *Oskar Kokoschka. A Life* (London, 1986).

————, *Expressionist Portraits* (London, 1987).

————, *Klimt* (London, 1990).

Whittick, Arnold, *War Memorials* (London, 1946).

Wiese, Stephan von, *Max Beckmanns zeichnerisches Werk 1903–1925* (Düsseldorf, 1978).

Wijngaert, Frank van den, *Jules de Bruycker* (Anvers, 1948).

Wildenstein, Daniel, *Claude Monet: Biographie et catalogue raisonné*, Vol. IV (Lausanne and Paris, 1985).

Wilhelm-Lehmbruck-Sammlung-Plastik-Malerei (Duisburg, 1964).

Wilkinson, Norman, 'The Dazzle Painting of Ships', 10 July 1919, *Camouflage* (Edinburgh and London, 1988).

Willett, John, *The Weimar Years. A Culture Cut Short* (London, 1984).

Wilmerding, John, *American Art* (Harmondsworth, 1976).

Wilson, Sarah, 'Raoul Dufy: Tradition, Innovation, Decoration, 1900–1925', *Raoul Dufy 1877–1953* (London, Arts Council, 1983).

Wingler, Hans Maria, *Oskar Kokoschka – Das Werk des Malers* (Salzburg, 1956).

———— and F. Welz, *Oskar Kokoschka – Das druckgraphische Werk*, 2 Vols. (Salzburg, 1975 and 1981).

Wodehouse, R.F., *A Check List of the War Collections of World War I, 1914–18 and World War II, 1939–1945* (Ottawa, National Gallery of Canada, n.d.).

————, 'The Canadian War Memorials Collection at Ottawa', *Studio International*, December 1968.

Woodeson, John, Introduction and Notes, *Mark Gertler 1891–1939* (Colchester, London, Oxford and Sheffield, 1971).

————, *Mark Gertler. Biography of a Painter 1891–1939* (London, 1972).

Woolf, Virgina, *Roger Fry. A Biography* (London, 1940).

Yablonskaya, M.N., *Women Artists of Russia's New Age 1900–1935* (London, 1990).

Yorke, Malcolm, *Eric Gill. Man of Flesh and Spirit* (London, 1981).

Zemina, Jaromír, Introduction, *Cubist Art from Czechoslovakia* (London, Tate Gallery, 1967).

Zhadova, Larissa A., *Malevich. Suprematism and Revolution in Russian Art 1910–1930* (London, 1982).

Zilczer, Judith, *"The Noble Buyer": John Quinn, Patron of the Avant-Garde* (Washington, 1978).

Zweig, Stefan, *The World of Yesterday. An Autobiography* (New York, 1943).

Zweite, Armin (ed.), *Kandinsky und München – Begegnungen und Wandlungen 1896–1914* (Munich, 1982).

PICTURE CREDITS

The author and the publishers would like to thank the owners of the pictures for providing, and/or permitting the use of, photographs used in this book; they are credited in the captions. Additional credits are listed here. Any uncredited images are from private collections. The numbers throughout refer to the plates.

1. Jörg P. Anders, Berlin. 2. Rudolf Wakonigg. 3. Jörg P. Anders, Berlin. 17. Martin Bühler, Basel. 18. Blauel/Gnamm - Artothek. 23. Martin Bühler, Basel. 28. Musée National d'Art Moderne, Paris. 32. Rheinisches Bildarchiv, Cologne. 37. Vincent Böckstiegel. 38. Stickelmann, Bremen. 45. Barbican Art Gallery, London. 51. Phillips Fine Art Auctioneers, London. 52. Malcolm Varon, New York. 59. Gian Sinigaglia, Milan. 68. Rheinisches Bildarchiv, Cologne. 70. Volker W. Feierabend. 82. © Estate of Edward Wadsworth 1994. All rights reserved DACS. 96. David Heald, New York. 130. Hans-Joachim Bartsch. 135. David Heald, New York. 143. Hans Cordes, Hamburg. 179. Rudolf Wakonigg. 180. Friedrich Rosenstiel. 183. Royal Academy of Arts, London. 219. David Rees, London. 224. Helene Toresdotter. 234. Barbican Art Gallery, London. 235. Leicestershire Museums, Art Galleries and Record Service. 241. Deutches Historisches Museum, Berlin. 243. Elke Walford. 253. Blake Praytor. 259. © Estate of Hart Benton/DACS. 260. Prudence Cuming Associates, London. 287. Mayor Gallery Archives. 292. Geoffrey Clements Photography, New York. 311. John Webb. 313. © Estate of Edward Wadsworth 1994. All rights reserved DACS. 320. © Succession H. Matisse/DACS 1994. 336. Vitra Design Museum, Weil-am-Rhein. 339. Royal Academy of Arts, London. 340. Bildarchiv Preussischer Kulturbesitz, Berlin. 343. Peter Grosz, Princeton. 344. Walter Klein, Düsseldorf. 345. Jörg P. Anders, Berlin. 348. Paul Hester. 353. Royal Academy of Arts, London. 376. Courtauld Institute of Art, London. 380. Jörg P. Anders, Berlin. 381. Jim Strong, New York. 392. Courtauld Institute of Art, London. 394. National Trust Photographic Library. 395. National Trust Photographic Library. 396. National Trust Photographic Library. 399. National Trust Photographic Library. 402. Sachsische Landesibliothek Dresden/Deutsche Fotothek. 403. Elke Walford. 404. Bildarchiv Preussischer Kulturbesitz, Berlin.

© ADAGP/SPADEM. 201, 223, 327, 348, 349, 350.

© Estate of Stanley Spencer 1994. All rights reserved DACS. 394, 395, 396, 397, 398, 399.

© DACS 1994. 11, 16, 21, 23, 26, 27, 36, 52, 53, 54, 55, 57, 58, 59, 62, 63, 67, 95, 96, 102, 109, 111, 112, 113, 114, 115, 116, 117, 118, 119, 120, 121, 122, 123, 124, 125, 126, 127, 128, 129, 136, 148, 149, 150, 151, 152, 180, 181, 190, 191, 195, 196, 197, 202, 203, 204, 205, 208, 215, 216, 225, 226, 228, 229, 230, 231, 232, 233, 235, 236, 237, 239, 240, 241, 242, 243, 244, 250, 251, 276, 277, 322, 323, 324, 325, 328, 339, 341, 342, 343, 344, 351, 352, 361, 362, 363, 364, 365, 366, 367, 368, 369, 370, 371, 372, 373, 374, 375, 379, 380, 381, 382, 383, 384, 385, 393, 402, 403, 404.

© ADAGP, Paris and DACS London 1994. 6, 7, 8, 9, 12, 20, 22, 28, 29, 30, 31, 41, 42, 43, 44, 69, 70, 71, 72, 101, 105, 144, 158, 159, 188, 206, 207, 222, 293, 318, 357, 358, 359, 360, 408, 409, 410.

INDEX

Numbers in italics refer to illustrations

Ablutions (Spencer) 1928 (Pl. 395), 297, *297*
Académie Matisse, Paris, 125
Adenauer, Dr Konrad, 273
AD MCMXIV (Man Ray) 1914 (Pl. 22), *33*, 34
Admiral Lord Fisher (Epstein) 1916 (Pl. 171), 133–4, *134*
Adrian-Nilsson, Gösta *see* GAN
Advanced Dressing Station on the Struma 1916 (Lamb) 1920 (Pl. 337), 250, *251*
After the Battle (Nash) 1918 (Pl. 268), 199, *199*
After the War (Küpper) 1919 (Pl. 321), 239, *239*
Against the War (Hauser) 1916 (Pl. 148), 116, *118*
Agnew's Gallery, London, 195
Air Attack (Grosz) 1915 (Pl. 128), 102, *102*
Aitken, Charles, 129
Aitken, Max *see* Beaverbrook, Lord
Die Aktion, literary journal, 10, 102
Albert-Birot, Pierre, *War* 1916 (Pl. 187), 146, *146*
Alexander the Great, 307
Alexandrescu, Ion, 310
Allied Flags, April 1917 (Hassam) 1917 (Pl. 193), 151, *152*, 191
Almanach des Lettres et des Arts, 160
Altdorfer, Albrecht, *The Battle of Alexander*, 305, 397
The Ambulance (Copley) 1918 (Pl. 260), 194, *194*
American Artists' Committee of One Hundred, 151
Angel of Victory (Bourdelle), 1924 (Pl. 333), 248, *248*
Angels and Aeroplanes (Goncharova) 1914 (Pl. 42), 50, *50*
The Answerable (Slevogt) 1917 (Pl. 232), 175, *175*
The Anzac Book, 139
Apocalyptic Landscape, Berlin (Meidner) c. 1913 (Pl. 1), *13* , *13*, 182
Apocalyptic Landscape, Münster (Meidner) 1913 (Pl. 2), *13*, 14
Apollinaire, Guillaume, 9, 59, 60, 74, 184; Picasso's portraits of, 59, *60*, 147, *148*, 184, 287; Picasso's proposed monument to, 287
The Archangel Michael Vision (Goncharova) 1914 (Pl. 41), *49*, 49–50
Arkus, Leon Anthony, 302
The Armistice (Fraye) 1918 (Pl. 293), 217, *218*
Armistice Night (Luks) 1918 (Pl. 292), 217, *218*
Armistice Night (Nicholson) 1918 (Pl. 294), 217, *219*
Armoured Train in Action (Severini) 1915 (Pl. 70), 70, *70*, 74
Armstrong, Colonel, 219
Arnot Gallery Exhibition, Schiele's poster 1914 (Pl. 97), 84, *84*
Arp, Jean, 125, 243
Arsenal for a Creation (Marc) 1915 (Pl. 140), 110, *110*
Art Nouveau, 214
Artillery (La Fresnaye) 1911 (Pl. 10), 20, *21*
Artillerymen in the Shower (Kirchner) 1915 (Pl. 135), 106–7, *107*, *108*
Asquith, Cynthia, 206
Asquith, Herbert, 57
Austrian Soldier with Pipe (Schiele) 1916 (Pl. 100), 85, *85*
The Avenger (Barlach) 1914 (Pl. 39), 47, *47*, 293

Baader, Johannes, *252*
Baargeld, Johannes, 243
Bacon, Francis, 75
Baer, Vico, 149
Balfour, Arthur, 133
Balla, Giacomo, 67, 68, 149; *Battleship + Widow + Wind* 1916 (Pl. 192), 10, 149, *149*; *Boccioni's Fist – Lines of Force* 1915 (Pl. 65), 67, *68*; *Flags at the Country's Altar* 1915 (Pl. 66), 67, *68*, 149; *Mutilated Trees* 1918 (Pl. 273), 203, *203*; *Patriotic Demonstration* 1914 (Pl. 64), 67, *67*, 149; *The Risks of 9 May – Risks of War*, 67; *Volume-forms of the Cry 'Viva l'Italia'*, 67
The Ballroom of the Piccadilly Hotel during an Air Raid (Nicholson) 1918 (Pl. 261), 194, *195*, 217
Bank of the Czechoslovak Legion (Banka Legii) façade, Prague, (Gočár, Stursa, Gutfreund) 1922 (Pl. 336), 249, *250*

The Banquet of the Starved (Ensor) 1915 (Pl. 122), 98, *99*
Barbed Wire (Vallotton) 1916 (Pl. 107), 88, *89*
Barbusse, Henri, 170, *279*; *Le Feu*, 279, *306*, 307
Barlach, Ernst, 10, 46–7, 48, 112, 145–6, 270, 271, 293–4; *The Avenger* 1914 (Pl. 39) 47, *47*, 293; *Dona Nobis Pacem!* 1916 (Pl. 186), 10, *145*, 146; *The Ecstatic One: The Desperate One*, 145; *From a Modern Dance of Death* 1916 (Pl. 185), *145*, 145–6, 177; *The Holy War* 1914 (Pl. 38), 10, 46–7, *47*, 112, 293; *Hunger*, 47; *Mass Grave* 1915 (Pl. 143), 112, *113*, 145, 174; *War Memorial*, Güstrow (Pl. 391), 293, *293*, 294; *War Memorial*, Magdeburg (Pl. 392), 293–4, *294*; *The Year of the Lord 1916 A.D.*, 145
Barnes, Julian, 11
The Barricade (Bellows) 1918 (Pl. 255), 191, *191*
The Battalion Runner on the Duckboard Track (Roberts) 1918 (Pl. 287), 211, *213*
Battenberg family, 183
A Battery Shelled (Lewis) 1919 (Pl. 305), 225–7, *226*
The Battle (Kokoschka) 1916 (Pl. 151), 118, 120, *120*
Battle of the Fish (Ernst) 1917 (Pl. 222), 170, *170*
Battlefield (Jaeckel) 1915 (Pl. 133), *105*, 105–6
Battlefield (Kubišta) 1918 (Pl. 248), 186, *187*
The Battlefield of Ypres (Cameron) 1919 (Pl. 299), 222, *222*
Battlefield with Dead Soldiers (Grosz) 1915 (Pl. 126), *101*, 101–2
Battleship + Widow + Wind (Balla) 1916 (Pl. 192), 10, 149, *149*
Bayes, Walter, *The Underworld* 1918 (Pl. 262), 194, *195*
Beaumetz, Etienne, 225
Beaverbrook, Lord, 206, 218
Beckmann, Max, 9, 10, 95–7, 140, 144, 154, 181–4, 185, 239–41, 244, 272; *Carrying the Wounded* 1914 (Pl. 116), 95, *95*; *Children Playing* 1918 (Pl. 243), 184, *184*; *Declaration of War* 1914 (Pl. 27), 37, *38*, 40; *The Descent from the Cross* 1917 (Pl. 241), 181, *182*, 260, 272; *Fallen Soldiers*, 95; *Going Home* 1919 (Pl. 322), 239, *239*, 252; *The Grenade* 1915 (Pl. 119), 97, *97*, 101, 239; *Hell*, lithograph series, 239; *The Morgue* 1915 (Pl. 118), 96, *96*, 98, 106, 181, 182, 227, 240; *Mustering* 1914 (Pl. 136), 107, *108*; *The Night* 1918–19 (Pl. 323), 96, 240–1, *240*, 257; *Operation* 1915 (Pl. 117), 96, *96*, 189, 241; *Portrait of my Wounded Brother-in-law Martin Tube*, 95; *Resurrection* 1909, 181–2, 183; *Resurrection* 1918 (Pl. 242), 181, 182–4, *183*; *Scene from the Destruction of Messina*, 37; *Self-Portrait as Medical Orderly* 1915 (Pl. 120), 97, *98*; *Self-Portrait with Red Scarf* 1917 (Pl. 240), 181, *182*; *The Sinking of the 'Titanic'*, 37; *Théâtre du Monde – Grand Spectacle de la Vie*, 95; *Two Officers of the Motor Corps*, 96; *Weeping Woman* 1914 (Pl. 26), 37, *38*, 43, 95
Beckmann, Peter, 184
Before Antwerp: Cover of Blast No. 2 (Lewis) 1915 (Pl. 83), 76, *77*
Behrend, Louie and Mary, 296–7
Bell, Clive, 73, 79
Bell, Vanessa, 79
Bell, Robert, 102
The Bellowing of Savage Soldiers (Ernst) 1919 (Pl. 327), *242*, 242–3
Bellows, George, 189–91, 192, 194, 195; *The Bacchanale*, 190; *The Barricade* 1918 (Pl. 255), 191, *191*; *Base Hospital*, 190; *Belgian Farmyard*, 190; *The Cigarette*, 190; *Edith Cavell* 1918 (Pl. 252), 91, 189, *189*; *The Germans Arrive* 1918 (Pl. 254), 190–1, *191*; *The Last Victim*, 190; *Massacre at Dinant* 1918 (Pl. 253), 91, 190; *Village Massacre*, 190
Bennett, Arnold, 133, 218
Benton, Thomas Hart, 193–4; *Impressions, Camouflage WWI* 1918 (Pl. 259), 193, *194*, 232
Berlin 'Dada Fair' 1920 (Pl. 340), 252, *252*
Berlin Dada Manifesto (1918), 257
Bernheim, Georges, 288
Biallowons, Hugo, 106, 140
Der Bildermann, publication, 120, 145, 146
Billet (Bomberg) 1915 (Pl. 91), 80, *81*
Binyon, Lawrence, 213
Blake, William, 196, 200–1

Blashfield's *Carry On*, 191
Blast magazine, 29, 43, 77–8; 'War Number' (1915), 76, *77*
Der Blaue Reiter, 17, 22, 23, 91, 110, 140
Blood and Iron (Butler) 1916 (Pl. 162), 127, *128*
Bloomsbury Group, 79
Blunden, Edmund, 139
Boccioni, Umberto, 62, 64–5, 67, 68, 69, 149, 203; *Charge of the Lancers* 1915 (Pl. 60), *63*, 64–5, 69
Boccioni's Fist – Lines of Force (Balla) 1915 (Pl. 65), 67, *68*
Böckstiegel, Pieter August, 46; *Departure of the Youngsters for War (study)* 1914 (Pl. 37), 46, *46*
Böhmer, Bernhard and Marga, 293
Bombardment of a City (Meidner) 1913 (Pl. 4), 14, *15*
Bomberg, David, 10, 80, 167–8, 229–30; *Billet* 1915 (Pl. 91), 80, *81*; *Field of Fire*, 168; *Figures Helping a Wounded Soldier* (recto) 1916–17 (Pl. 218), 167, *168*, 229; *Figures Helping a Wounded Soldier* (verso) 1916–17 (Pl. 219), 167–8, *168*, 229; *Gunner Loading Shell*, 229; *In the Hold*, 229; *The Mud Bath*, 229; *'Sappers at Work': A Canadian Tunnelling Company (Study for)* c. 1918 (Pl. 309), 229, *230* (First Version) 1918–19 (Pl. 311), 229, *231* (Second Version) 1919 (Pl. 310), 230, *230*; *Soldier Patrolling Tunnel*, 229
Bone, Muirhead, 139, 168, 218, 219, 244, 261, 263; *Tanks* 1916 (Pl. 177), 139, *139*, 194
Bonnard, Pierre, 156; *Village in Ruins near Ham* 1917 (Pl. 201), 156–7, *157*, 268
Bosch, Hieronymus, 144, 189
Boston Public Library, Sargent's murals, 220, 221
Bottomley, Gordon, 201
Bouquet for the 14 July (Flowers, 14 July) (Matisse) 1919 (Pl. 319), 237–8, *238*
Bourdelle, Cléopatre, 248
Bourdelle, Emile Antoine, 247; *Angel of Victory* 1924 (Pl. 333), 248, *248*; *France Supporting the Wounded Soldier* 1924–8 (Pl. 334), 248, *249*; *Monument to the Dead, in the War 1914–18, of Montceau-les-Mines* 1919–30 (Pl. 332), 247–8, *248*; *Monument to the Deputies who died for France*, maquette for, 247; *Saint Barbe*, 247, 249; *Virgin of the Offering* 1922 (Pl. 335), 248–9, *249*
Brancusi, Constantin, 11, 185, 310–13; *Bird in Space*, 313; *Column of the Kiss*, 311; *Endless Column* 1937 (Pl. 410), 11, *312*, 312–13; *Gate of the Kiss* 1938 (Pl. 409), 11, *311*, 311–12, 313; *The Kiss*, 311; *Study for Column of the Kiss*, 311; *Table of Silence* 1937 (Pl. 408), 11, 310–11, *311*; *Temple of Love* project, 311; Tirgu-Jiu Memorial complex, 310–13
Brangwyn, Frank, *The Call to Arms and the Departure for the Front*, 291; *The Gun*, 291; *Put Strength in the Final Blow: Buy War Bonds*, 291; Royal Gallery wall painting scheme, 291–3; *A Tank in Action* 1925–6 (Pl. 390), 291–2, *292*
Braque, Georges, 21, 59
Braunbehrens, Major von, 181
Briantspuddle Memorial *see The Cross*
Brice-Miller, Beatrix, *To the Vanguard*, 237
Brodzky, Horace, *Two Camouflaged Ships*, 232
Brooke, Rupert, 79, *79*
Brown, Milton, 189
Die Brücke group, 24, 106
Bruegel the Elder, Jan, 144, 189; *The Parable of the Blind*, 221
Bruycker, Jules de, 139–40, 267; *The Death Knell in Flanders* 1916 (Pl. 178), 139, *140*; *Kultur!*, 139
Bryce, Viscount (Bryce Report), 189, 190
Buchan, John, 81, 168, 194, 197, 203, 213
Burghclere, Sandham Memorial Chapel (Spencer), 11, 263, 269, 283, 296–300, 397, 312
Burliuk, David, 51
A Bursting Shell (Nevinson) 1915 (Pl. 78), 74, *75*, 307–8
Burton, Robert, *The Anatomy of Melancholy*, 158
Burying the Dead After a Battle (Roberts) 1919 (Pl. 304), 224, *225*
Bussy, Simon, 146
Butler, Charles, 127; *Blood and Iron* 1916 (Pl. 162), 127, *128*
Butler, Lady, 9, 72–3, 250–1; *Action Front!!*, 251; *In the Retreat*

from Mons: The Royal Horse Guards 1920 (Pl. 338), 251, *251*; *Patrick, Au Revoir!* 1914 (Pl. 75), 72, *73*, 250
Butler, Patrick, 72, *73*, 250

Cain (Corinth) 1917 (Pl. 239), 10, 20, 178–9, *179*
Callot, Jacques, 10, 274
Cambridgeshire soldiers *en route* to the station, October 1939 (Pl. 411), 313–14, *314*
Camden Town Group, 131
Cameron, Sir David Young, *The Battlefield of Ypres* 1919 (Pl. 299), 222, *222*
Camoin, Charles, 238
camouflage, 59–60, 86, 111, 171, 193, 230, 232; dazzle, 230, 232–4
A Canadian Gun Pit (Lewis) 1918 (Pl. 284), 209, *210*, 225, 226
Canadian War Memorial Fund/Building, 204, 208, 209, 211, 218, 229, 230, 235–6
The Canadians Opposite Lens (John) 1918 (Pl. 279), 206, *206* 209, 222
Cannon in Action (Severini) 1915 (Pl. 72), 69–70, *71*, 94, 211
Cannon-Brookes, Peter, 248–9
Canudo, Riccioto, 148
Capper, General Thompson, 72
Captured (Grosz) 1915 (Pl. 127), *101*, 101–2
The Card Game (Léger) 1917 (Pl. 214), 164–5, *165*, 254–5
The Card Players (Léger) 1915 (Pl. 104), 87, *87*, 164
Carline, Richard, 297
Carrà, Carlo, 62, 63, 69, 149; *Atmospheric Swirls. A Bursting Shell*, 63; *The Chase* 1914 (Pl. 59), *63*, 64, 69; *Interventionist Demonstration* 1914 (Pl. 58), *62*, 63, 69
Carrington, Dora, 137
Carrying the Wounded (Beckmann) 1914 (Pl. 116), 95, *95*
Cartoon for War Triptych (Dix) 1932 (Pl. 403), 304, *305*
Cassirer, Bruno, 186
Cassirer, Paul, 46, 65, 120, 145
Celebes (Ernst) 1921 (Pl. 350), 258, *259*, 260
Cenotaph, London, 237
Cenotaph for the War Dead, Paris (Jaulmes, Mare and Süe) 1919 (Pl. 318), 237, *237*
The Centurion's Servant (Spencer) 1914 (Pl. 35), 44, *45*
Cézanne, Paul, 59, 149, 164
Chagall, Marc, 9, 18, 20, 37–41, 46, 51–2; *Leave-taking Soldiers* 1914 (Pl. 30), 40, *40*, 42–3; *Man on Stretcher*, 41; *The Newspaper Vendor* 1914 (Pl. 28), 38, *39*; *The Salute*, 40; *The Smolensk Newspaper*, 38; 40; *The Soldier Drinks*, 18; *Soldiers* 1912 (Pl. 9), 20, *20*; *War*, 40; *Woman Crying* 1914–15 (Pl. 31), 41, *41*; *Wounded Soldier* 1914 (Pl. 29), *40*, 40–1; *The Wounded Soldier*, 41
Chamisso, Adelbert von, *The Amazing Story of Peter Schlemihl*, 109
Charge of the Lancers (Boccioni) 1915 (Pl. 60), *63*, 64–5, 69
The Chase (Carrà), 1914 (Pl. 59), *63*, 64, 69
Chebnikov, poet, 81
Cheke, Colonel, 127–8
Children Playing (Beckmann) 1918 (Pl. 243), 184, *184*
Chirico, Giorgio de, 31, 44, 46; *The Anguish of Departure*, 31; *The Enigma of Fatality*, 31; *The Evil Genius of a King*, 46; *The Philosopher's Conquest* 1914 (Pl. 21), 31, *32*, 34; *The Sailors' Barracks* 1914 (Pl. 36), 44, 46, *46*
Church at Souain, ruins and rubble (Vallotton) 1917 (Pl. 200), 89, 156, *157*, 289
Churchill, Sir Winston, 57, 133
Clark, Sir Kenneth, 213
Claudel, Paul, *Tête d'Or*, 20
Clausen, George, 129–30; *Renaissance*, 129; *Returning to the Reconquered Land* 1919 (Pl. 315), *234*, 236; *Youth Mourning* (original version) 1916 (Pl. 165), 129–30, *130* (revised state) 1916–28 (Pl. 166), 130, *130*
Clear Morning with Willows (Monet) 1927 (Pls. 386 and 387), *289*, 290
Clemenceau, Georges, 161, 237, 287, 288, 289
Clio and the Children (Sims) 1913–15 (Pl. 164), 128–9, *129*
Cockburn, Claud, 169
Cocteau, Jean, 69, 68, 147; *Dante on our Side* 1915 (Pl. 67), 68, *69*; Picasso's portrait of, (Pl. 191) 147–8, *148*
collages, 21, 22, 59, 62, 63, 87, 123–4, 242, 243, 257
Combat (Roberts) 1915 (Pl. 81), 76, *77*, 210
Combat No. 2 (Lewis) 1914 (Pl. 34), 43, 44, *44*, 226
A Common Grave (Goncharova) 1913 (Pl. 44), 49, 50, *51*
Composition VI (Kandinsky) 1913 (Pl. 6) *17*, 17–18
Compton, Susan, 38
The Connoisseur, 129
Convoy of Wounded Men Filling Water-Bottles at a Stream (Spencer) 1932 (Pl. 396), 298, *298*
Convoy of Wounded Soldiers Arriving at Beaufort Hospital Gates (Spencer) 1927 (Pl. 394), *296*, 297
Conway, Sir Martin, 244
Cookham War Memorial, see Unveiling Cookham War Memorial
Copley, John *The Ambulance* 1918 (Pl. 260), 194, *194*; *Recruits*, 80
A Copse, Evening (Jackson) 1918 (Pl. 274), 203, *203*
Le Coq d'Or (Rimsky-Korsakov), Goncharova's designs for, 48, 49
Corinth, Lovis, 20, 91, 93, 181; *Black Hussar*, 179; *Cain* 1917 (Pl. 239), 10, 20, 178; *Portrait of Makabäus – Hermann Struck* 1915 (Pl. 111), 91, 93, *93*, 178–9, *179*
Cottington, David, 21
The Crashed Aeroplane (Léger) 1916 (Pl. 212), 164, *164*
The Cross, Briantspuddle (Gill) 1920 (Pl. 354), 264, *264*

The Crucifixion (Gies) 1921 (Pl. 351), *260*, 260–1
Crucifixion (Picasso) c. 1918 (Pl. 244), 184, *184*
Crucifixion (Spencer), 261, 263
The Cry (Dix) 1919 (Pl. 328), 243, *243*
Cubism, 9, 20, 21, 22, 24, 38, 59, 68, 79, 85, 120, 146, 147, 148, 160, 166, 217, 229, 230, 232, 283; Rococo, 59; Synthetic, 22, 91
Cubo-Futurism, 10, 125, 192, 223, 272
Curl, James Stevens, 281
Curzon, Lord, 282
Czechoslovak Legion bank façade, Prague (Gočár, Štursa, Gutfreund), 1922 (Pl. 336), 249, *250*

Dada, 10, 217, 243, 252, *252*, 257, 260, 272, 146
Dalou, Jules, *Monument to Labour*, 282
A Dance of Death (Kubin) 1918 (Pl. 249), 186–7, *187*
Dance of Death (Uzarski) 1916–17 (Pl. 238), 177, *178*
Dance of death 1917 (the dead man's mound) (Dix) 1924 (Pl. 375), 278–9, *279*
Dangel, Yvonne, 163
Daniel, Charles, 193
Dante on our Side (Cocteau) 1915 (Pl. 67), 68, *69*
Dardel, Nils, *The Trench* 1916 (Pl. 160), 125, *127*
Darras, Jacques, 115
Daumier, Honoré, 89, 189
David and Goliath (Weisgerber) 1914 (frontispiece), (Pl. 40), 47, *48*
Davringhausen, Hubertus Maria, 140–2; *The Dreamer*, 140; *The General*, 140; *The Madman* 1916 (Pl. 179), 140, *141*, 142, 255; *The Prisoner*, 255; *The Profiteer* 1920 (Pl. 344), 255, *255*, 257, 265; *The Sex Murderer*, 140
dazzle camouflage on ss *New York City* 1918 (Pl. 312) 232, *232*
Dazzle-Ships in Drydock at Liverpool (Wadsworth) 1919 (Pl. 313), 208, 232, *233*, 234
The Dead Arise, Infernal Resurrection (Masereel) 1917 (Pls. 236, 237), 177, *178*
Dead Germans in a Trench (Orpen) 1918 (Pl. 263), 169, 195, 196
Dead Soldier from *Missa Eroica* (Egger-Lienz) 1918 (Pl. 247), 185, *186*
A Death Among the Wounded in the Snow (Orpen) c. 1918 (Pl. 264), 195, *196*
Death and Life (Klimt) 1908–11, revised 1915–16 (Pl. 153), 10, 121, *121*
Death for an Idea (Klee) 1914 (Pl. 63), 65, *65*
The Death Knell in Flanders (Bruycker) 1916 (Pl. 178), 139, *140*
Death Sacrifice (Egger-Lienz) 1925 (Pl. 388), 290, 290–1
'decadent/degenerate' art, 106, 273, 285
Declaration of War (Beckmann) 1914 (Pl. 27), 37, *38*, 40
Dedicated to Oskar Panizza (Grosz) 1917 (Pl. 251), 187, *188*, 189, 283
Degas, Edgar, 55, 57; *L'Absinthe*, 108
Degenerate Art exhibition (Munich 1937), 273, 285
Delacroix, Eugène, 247; *Liberty Leading the People*, 14, 247
Delaunay, Robert, 51, 91, 140
Demon above the Ships (Klee) 1916 (Pl. 181) *143*, 143–4
Denis, Maurice, *Evening Calm at the Front Line*, 156
Departure of the Youngsters for War (study: Böckstiegel) 1914 (Pl. 37), 46, *46*
Derain, André, 9, 59, 60, 61
Derby, Lord, 169
The Descent from the Cross (Beckmann) 1917 (Pl. 241), 181, *182*, 260
Detaille, Edouard, 225
Deutsch, Ernst, 120
Diaghilev, Serge, 48, 177
Dieren, Bernard van, 243, 244
Dix, Otto, 10, 11, 93–5, 143, 158, 204, 211, 239, 243, 251–5, 272–8, 287, 291, 302–7; *Artillery Duel* 154; *Cartoon for War Triptych* 1932 (Pl. 403), 304, *305*; *The Cry* 1919 (Pl. 328), 243, *243*; *Dance of death*, 1917 (the dead man's mound) 1924 (Pl. 375), 278, *279*; *Destroyed Trenches*, 277; *Dug-out* 1924 (Pl. 374), 278, *278*, 305; *Dying Soldier*, 277; *The Dying Warrior*, 158; *Flanders (after Henri Barbusse 'Le Feu')* 1934–6 (Pl. 404), 11, *306*, 306–7; *Grave (Dead Soldier)*, 158; *Heavy Shell Fire*, 204; *House destroyed by bombs (Tournai)* 1924 (Pl. 372), 277, 278; *Lovers on Graves* 1917 (Pl. 205), 158, 160, 197; *Match Vendor*, 252; *Meal-time in the ditch* (Loretto heights), 278; *Men killed by gas*, 276; *Metropolis* 1928 (Pl. 383), *286*, 287; *Nocturnal Meeting with a Madman* 1924 (Pl. 373), 277, 278; *Prague Street* 1920 (Pl. 342), 254, 254–5; *Seen at the steep slope at Cléry-sur-Somme* 1924 (Pl. 369), *275*, 276; *Self-Portrait as a Soldier* 1914 (Pl. 112), 93, *93*, 204, 251; *Self-Portrait as Mars* 1915 (Pl. 114), 94, *94*; *Self-Portrait as Shooting Target* 1915 (Pl. 115), 95, *95*; *Self-Portrait with Artillery Helmet* 1914 (Pl. 113), 93–4, *94*; *Setting Sun (Ypres)* 1918 (Pl. 277), 204, *205*, 243; *Signal Flare* 1917 (Pl. 203), 158, *159*; *Shell Crater with Flowers*, 278; *Skat Players* 1920 (Pl. 342), 254, 254–5; *Skin Graft* 1924 (Pl. 371), *276*, 277–8; *Skull* 1924 (Pl. 370), *276*, 277; *Soldier with Pipe* 1918 (Pl. 276), 204, *204*; *Soldier's grave between the lines*, 273; *Souvenir of the Mirrored Halls in Brussels* 1920 (Pl. 339), 251, 252; *Sunrise* 1913 (Pl. 16), 26, *26*, 158; *This is How I Looked as a Soldier* (frontispiece), 273; *The Trench* 1920–3 (Pl. 366), 10, 272, 272–3, 274, 277, 279, 302, 303; *Trench Warfare*, 302; *Two Riflemen* 1917 (Pl. 204), 158, *160*; *Visit to Madame Germaine at Méricourt* 1924 (Pl. 368), 274, 276; *War Cripples*, at Berlin 'Dada' Fair 1920 (Pl. 340), 252, *252*, 273; *War series*, 10, 94, 103, 104, 273–9, 307; *War Triptych* 1932 (Pl. 402), 10, 278–302–6, *304*; *Wounded (Autumn 1916, Bapaume)*, 274;

Wounded man fleeing (Battle of the Somme, 1916) 1924 (Pl. 367), 274, *274*
Dobson, Frank, 224; *The Ration Party (In the Trenches)* 1919 (Pl. 303), 224, *225*
Dodd, Francis, 139, 168
Dodgson, Campbell, 197
Dona Nobis Pacem! (Barlach) 1916 (Pl. 186), 10, *145*, 146
The Doomed City (Goncharova) 1914 (Pl. 43), 50, *50*, 68, 257
The Drinker (Kirchner) 1915 (Pl. 137), 108, *108*
Duchamp, Marcel, 154
Duchamp-Villon, Raymond, 147, 185, 243; *Horse*, 147; *Portrait of Professor Gosset* 1918 (Pl. 245), 185, *185*; *Rooster (The Gallic Cock)* 1916 (Pl. 189), 147, *147*
Dufy, Raoul, 9, 60, 160, 146–7; *The Allies*, 60; *The End of the Great War* 1915 (Pl. 55), 9, 49, 60, *61*, 147; *The Four Aymon Sons* 1914 (Pl. 54), 60, *61*; *The Nations United for the Triumph of Right and Liberty*, 146
Dug-out (Dix) 1924 (Pl. 374), 278, *278*, 305
Dug-out or *Stand-to* (Spencer) 1928 (Pl. 398), 299, *299*
Duncan, Isadora, 247
Durand-Ruel's Gallery, Paris, 288, 289

Eberle, Matthias, 37, 96
Eclipse of the Sun (Grosz) 1926 (Pl. 381), 285, *285*, 286
Eddy, Arthur Jerome, 18
Edith Cavell (Bellows) 1918 (Pl. 252), 91, 189, *189*
Egger-Lienz, Albin, 115–16, 185–6, 290–1; *Attack*, 290; *Dead Soldier* from *Missa Eroica* 1918 (Pl. 247), 185, *186*, 257; *Death Sacrifice* 1925 (Pl. 388), *290*, 290–1; *Finale*, 185–6; *Missa Eroica* 1918 (Pl. 246), 185, 186, *186*, 195, 257, 290–1; *The Nameless Ones 1914* 1916 (Pl. 147), *114*, 115–16, *117*, 185, 290; *The Resurrection* 1925 (Pl. 389), 291, *291*; *War 1915–16* (Pl. 146), 115, *117*; *War Wives* 1918–22 (Pl. 347), 257, *257*
Eliot, T.S., 76, 189, 194
The End of the Great War (Dufy) 1915 (Pl. 55), 9, 49, 60, *61*, 147
The End of War: Starting Home (Pippin) c. 1931 (Pl. 400), 302, *302*
Endless Column (Brancusi) 1937 (Pl. 410), 11, *312*, 312–13
Ensor, James, *The Banquet of the Starved* 1915 (Pl. 122), 98–9, *99*
Epstein, Jacob, 133–5, 139, 219, 243; *Admiral Lord Fisher* 1916 (Pl. 171), 133–4, *134*; *Risen Christ* 1917–19 (Pl. 329), 243, *244*, 244–5, 247, 264; *Rock Drill* (original state) 1913–15 (Pl. 173), *134*, *135*; *Sergeant D.F. Hunter V.C.*, 134; *The Tin Hat* 1916 (Pl. 172), 133, *134*; *Torso in Metal from the 'Rock Drill'* 1913–16 (Pl. 174), 134–5, *135*, 244; *Wounded Soldier* 1918 (Pl. 330), 244, *245*, 291
Erfurth, Hugo, 274
Ernst, Carl, 170
Ernst, Max, 42, 170, 171, 257–60; *Battle of the Fish* 1917 (Pl. 222), 170, *170*; *The Bellowing of Savage Soldiers* 1919 (Pl. 327), 242, 242–3; *Celebes* 1921 (Pl. 350), 186, 258, *259*, 260; *Machine-Menace*, 170; *The Massacre of the Innocents* 1920 (Pl. 349), 257, *258*; *Untitled*, or *The Murderous Aeroplane* 1920 (Pl. 348), 257–8, *258*; *Victory of the Spindles*, 170
Etchells, Frederick, 232
Ewart, David, *These Shall Our Hearts Remember*, 292
The Exiles (Kokoschka) 1916–17 (Pl. 152), 120, 120–1
Explosion (Grosz) 1917 (Pl. 194), 151–2, *153*
Explosion (Nevinson) c. 1916 (Pl. 195), 151, 152, *152*, 308
Expression of the Dardanelles (Valensi) 1917 (Pl. 197), 154, *155*
Expressionism, 9, 10, 13, 14, 24, 42, 75, 98, 106, 120, 125, 211, 214, 242, 243, 257, 260, 261, 272
Ey, Johanna, art dealer, 242

Falkenhayn, General, 81
The Fallen Man (Lehmbruck) 1916 (Pl. 183), 10, 144, *144*, 145
Fallen Soldier (Scharl) 1932 (Pl. 401), 302, *303*
Fan for Alma Mahler (Kokoschka) 1914 (Pl. 95), 83, *83*
Farewell (Macke) 1914 (Pl. 32), *42*, 42–3
The Fate of the Animals (Marc) 1913 (Pl. 17), 26–7, *27*, 110, 111
Faure, Félix, 242
Fehr, Hans, 109
Felixmüller, Conrad, *Soldier in a Madhouse* 1918 (Pl. 290), 214, *214*
Férat, Serge, 287
Fergusson, J.D., 234–5; *Portsmouth Docks* 1918 (Pl. 314), *234*, 234–5
Field of Honour (Luce) 1915 (Pl. 109), 88, *89*
Fighting Forms (Marc) 1914 (Pl. 18), 27–8, *28*
Figures Helping a Wounded Soldier (Bomberg) 1916–17 (recto, Pl. 218) 167, 168, 229 (verso, Pl. 219) 167–8, *168*, 229
Filonov, Pavel, 82; *A Sermon-Chant about Universal Sprouting*, 82; *War with Germany* 1915 (Pl. 94), 82, *82*
Fine Arts Society Gallery, London, 139
The First German Gas Attack at Ypres (Roberts) 1918 (Pl. 286), 211, *212*, 212–13, 223
Fisher, Admiral Lord, 133–4, *134*
Flags at the Country's Altar (Balla) 1915 (Pl. 66), 67, *68*
Flanders (after Henri Barbusse 'Le Feu') (Dix) 1934–6 (Pl. 404), 306, 306–7
Flavell, M. Kay, 285
Flooded Trench on the Yser (Nevinson) 1915 (Pl. 76), 73, *74*, 198, 223
For What? (Varley) 1918 (Pl. 275), 204, *204*
Forain, Jean-Louis, *The Milestone—Verdun* 1916 (Pl. 216), *166*, 166–7
Ford, Ford Madox, 79; Lewis's Cover of *Antwerp* 1915 (Pl. 84), 76, *77*

Forestier, Albert, drawing of the Somme's 'big push' 1916 (Pl. 161), 125, *127*
The Forge, see Munitions Factory in Lyons
Forward the Guns! (Kemp-Welch) 1917 (Pl. 163), 128, *128*
The Four Aymon Sons (Dufy) 1914 (Pl. 54), 60, *61*
Frampton, Sir George, 244, 247; *Saint George* 1918 (Pl. 331), 247, *248*
France Supporting the Wounded Soldier (Bourdelle) 1924–8 (Pl. 334), 248, *249*
Francet d'Esperey, Marshal, 213–14
Fraye, André, *The Armistice* 1918 (Pl. 293), 217, *218*
The French Allies (Malevich) 1914 (Pl. 47), 54, *54*, 60, 82
Fresnaye, Roger de La *see* La Fresnaye
Freud, Sigmund 'Reflections upon War and Death', 226
Freyburg, Lieutenant Karl von, 91, 93, 99
Friedrich, Ernst, 274
Friesz, Othon, *The Horrors of War* 1915–16 (Pl. 144), 115, *116*
From a Modern Dance of Death (Barlach) 1916 (Pl. 185), *145*, 145–6, 177
Fry, Roger, 18, 79–80; *Bulldog*, 79; *German General Staff* 1915 (Pl. 89), 79–80, *80*; *Queen Victoria*, 79
Fussell, Paul, 314
Futurism, 10, 16–17, 22, 24, 42, 51, 61–5, 69, 70–2, 73–4, 77, 79, 82, 94, 123, 125, 132, 133, 148–9, 168, 173, 186, 203, 217
'The Futurist Synthesis of the War' declaration (1914), 62

Galerie Arnold, Dresden, 94
Galerie Boutet de Monvel, Paris, 148
Galerie Paul Guillaume, Paris, 49
Galtier-Boissière, Jean, *Procession of the Mutilated, 14 July 1919* 1919 (Pl. 320), 237–8, *238*, 239
The Game of Cards (Léger) 1916 (Pl. 213), 164
GAN (Gösta Adrian-Nilsson), 171–3; *Death of the Sailor*, 173; *Sailors' Dream of War* 1917 (Pl. 224), *172*, 173
The Gas Chamber (Roberts) 1918 (Pl. 285), 209–10, *211*
Gassed (Sargent) 1918–19 (Pl. 298), 10, 212, 220–2, *221*; *(Study for)* 1918–19 (Pl. 297), 221, *221*
Gassed and Wounded (Kennington) 1918 (Pl. 288), 213, *213*
Gate of the Kiss (Brancusi) 1938 (Pl. 409), 11, *311*, 311–12, 313
Gaudier-Brzeska, Henri, 9, 77–9, 87, 244; *The Martyrdom of St Sebastian* 1914 (Pl. 85), 77, *78*, 84; *A Mitrailleuse in Action* 1915 (Pl. 86), 78, *78*; *One of Our Shells Exploding* 1915 (Pl. 87), *78*, 78–9; 'VORTEX GAUDIER-BRZESKA (Written from the Trenches)', 77–8
Géricault, Théodore, 37, 59; *The Raft of the Medusa*, 11, 37; *Wounded Cuirassier*, 20
German General Staff (Fry) 1915 (Pl. 89), 79–80, *80*
The Germans Arrive (Bellows) 1918 (Pl. 254), 190–1, *191*, 192
Germany, a Winter's Tale (Grosz) 1917–19 (Pl. 324), *241*, 241–2, 252, *252*, 283, 285
Gertler, Mark, 135–8, 139; *Eve*, 138; *Merry-Go-Round* 1916 (Pl. 175), 51, 135, *136*, 137–8; *Swing Boats*, 135
Gies, Ludwig, 10; *The Crucifixion* 1921 (Pl. 351), 260, 260–1
Gill, Eric, 263–6; *The Cross*, Briantspuddle 1920 (Pl. 354), 264, *264*; LCC Monument project, 264–5; *Our Lord driving the Moneylenders out of the Temple* 1923 (Pl. 355), 245, 264–6, *265*, 309; *Stations of the Cross*, Westminster Cathedral, 263, 265, 308–9
Gillies, Sir Harold, 138; *Plastic Surgery of the Face*, 138
Gilman, Harold, 131, 207–8; *Halifax Harbour at Sunset* 1918 (Pl. 282), 207, *208*; *Tea in the Bed-Sitter* 1916 (Pl. 168), 131, *131*
Gimpel, René, 217, 288
Ginner, Charles, 206; *The Shell Filling Factory* 1918 (Pl. 280), 206–7, *207*, 209
Giolitti, Giovanni, 67
Giotto, 297
Glass and Bottle of Suze (Picasso) 1912 (Pl. 11), *21*, 21–2
Gleizes, Albert, 51, 85–6, 154; *Return* 1915 (Pl. 101), 60, 85, *86*
Gočár, Josef, façade of the Bank of the Czechoslovak Legion (Banka Legii), Prague, 1922 (Pl. 336), 249, *250*
Goethe, Johann Wolfgang von, 241
Going Home (Beckmann) 1919 (Pl. 322), 239, *239*, 322
Golding, John, 22
Goldring, Douglas, 28
Goncharova, Natalia, 10, 48–51; *Angels and Aeroplanes* 1914 (Pl. 42), 50, *50*; *The Archangel Michael Vision* 1914 (Pl. 41), *49*, 49–50; *The Christ Loving Host*, 50; *A Common Grave* 1913 (Pl. 44), 49, 50, *51*; *Le Coq d'Or* designs, 48, 49; *The Doomed City* 1914 (Pl. 43), 50, *50*, 68, 257; *Dynamo Machine*, 49; *The English Lion*, 49; *The French Cock*, 49; *The Harvest*, 50; *Mystical Images of War*, 10, 49–51, 123; *The Pale Horse*, 50; *St Alexander Nevsky*, 50–1; *St George Victorious*, 49; *St Michael* (cover of the *Knave of Diamonds*), *49*; *Vision*, 50; *The White Eagle*, 49
Gordon, Donald E., 13, 99
Gordon, Jan, 203
Goupil Gallery, London, 81, 197
Gouraud, General, 154
Goya, Francisco de, 10, 57, 103, 104, 166, 189, 274; *Disasters of War* cycle, 103, 104, 278; *Ravages of War*, 104, 278; *The Shooting of the Third of May, 1808*, 55, 103; *The Sleep of Reason Produces Monsters* (*Caprichos*), 173
Graf, Urs, 10, 274, 276
La Grande Illustrazione, magazine, 65
Grant, Duncan, 79; *In Memoriam: Rupert Brooke* 1915 (Pl. 88), 79, *79*
The Graphic, cover, Jan. 1915 (Pl. 182), *143*, 144
Graves, Robert, 55, 189, 277; *Goodbye to All That*, 170

Gray, Camilla, 22
The Great War by Artists, magazine, 88
Greco, El, 181, 184; *Christ Driving the Traders from the Temple*, 229
The Greedy Mouth (Marc) 1915 (Pl. 141), 111, *111*
Green, Christopher, 163
Greene, Graham, 169
The Grenade (Beckmann) 1915 (Pl. 119), 97, *97*, 101, 239
The Grenade (Krohg) 1916 (Pl. 158), *125*, *126*
Grey Day (Grosz) 1921 (Pl. 345), 255, *256*, 284
Gris, Juan, 59
Grochowiak, Thomas, 14
Gromaire, Marcel, 283; *The Banks of the Marne*, 283; *The War* 1925 (Pl. 379), 283, *284*
Grosz, George, 9, 10, 99–102, 109, 118, 140, 143, 151–4, 165, 170, 187, 211, 241, 244, *252*, 255, 283–6; *Air Attack* 1915 (Pl. 128), 102, *102*; *Battlefield with Dead Soldiers* 1915 (Pl. 126), *101*, 101–2; *Captured* 1915 (Pl. 127), *101*, 101–2; *Dedicated to Oskar Panizza* 1917 (Pl. 251), 187, *188*, 189; *Eclipse of the Sun*, 1926 (Pl. 381), 285, *285*, 286; *Explosion* 1917 (Pl. 194), 151–2, *153*; *Germany, a Winter's Tale* 1917–19 (Pl. 324), *241*, 241–2, 252, *252*, 283, 285 at Berlin 'Dada Fair' 1920 (Pl. 340), *252*; *Grey Day* 1921 (Pl. 345), 255, *256*, 284; *K.V. (Fit for active service)* 1916–17 (Pl. 196), 154, *154*; *Landscape with Dead Bodies*, 101; *Pandemonium* 1914 (Pl. 125), *100*, 100–1, 102; *Pillars of Society* 1926 (Pl. 380), 283–5, *284*; *The Rabble Rouser* 1928 (Pl. 382), 285–6, *286*; *Republican Automatons*, 255; *The Shell* 1915 (Pl. 124), *100*, 100, 101, 102; *Shell Crater*, 101; *Stick It Out!* c. 1915 (Pl. 129), 102, *102*, 140; *These war invalids are getting to be a positive pest!* (Pl. 343), *254*, 255, 265
Grünewald, Mathias, 9, 10, 181, 273, 277, 302, 305; *The Temptation of St Anthony*, 273
The Guardsman (Malevich) 1913 (Pl. 13), 22, *24*
Guillaume Apollinaire, Artilleryman (Picasso) 1914 (Pl. 53), 59, *60*, 147, 287
Gunn, Tom, 211
Güse, Ernst-Gerhard, 140
Güstrow Cathedral War Memorial (Barlach), 293, *293*, 294
Gutfreund, Otto, *The Return of the Legionaries*, frieze for the façade of the Bank of the Czechoslovak Legion, Prague, 1922 (Pl. 336), 249, *250*

Haig, Field-Marshal Earl, 139, 197, 220, 267
Halifax Harbour at Sunset (Gilman) 1918 (Pl. 282), 207, *208*
Hall of Remembrance, London, 218–19, 220, 222, 223, 225, 227, 236, 308
Hals, Frans, 217
Hamilton, Duchess of, 133
Hamilton, General Sir Iain, 133
Hamilton, Lady, 55
Hanfstängl, art dealer, 189
Hartley, Marsden, 22–3, 24, 91, 93; *Military* 23; *Painting No. 47, Berlin*, 91, 97; *Painting No. 48* 1913 (Pl. 15), 23, *24*; *Portrait of Berlin*, 23; *Portrait of a German Officer* 1914 (Pl. 110), 23, 91, *92*; 'Tribal Esthetics', essay, 91; *The Warriors*, 23
Hartmann, Georg, 181
The Harvest of Battle (Nevinson) 1919 (Pl. 300), 223, *223*
Hasenclever, Walter, 120
Hassall, John, *The Vision of St George over the Battlefield* 1915 (Pl. 80), 76, *76*
Hassam, Childe, 151, 191–2, 217; *Allied Flags, April 1917* 1917 (Pl. 193), 151, *152*, 191, 217; *Allies Day, May 1917*, 151; *Red Cross Drive, May 1918* 1918 (Pl. 256), 192, *192*, 217
Hauptmann, Gerhard, 13
Hauser, Carry, *Against the War* 1916 (Pl. 148), 116, *118*
Hausmann, Raoul, *252*
He Gained a Fortune But He Gave a Son (Nevinson) 1918 (Pl. 346), 257, *257*
Heartfield, John, *252*, 255
Heavy Artillery in Action (Kubišta) 1913 (Pl. 14), 24, *25*, 186
Heckel, Erich, 9, 24, 96, 97–9, 140, 142–3, 144, 181; *Cripple by the Ocean*, 143; *Demented Soldier*, 143; *Landscape in Thunderstorm*, 24, 26, 142; *The Madman*, 142; *Man on a Plain* 1917 (Pl. 235), 99, 177, *177*; *Ostend Madonna* 1915 (Pl. 123), 99, *100*; *Self-Portrait*, 98; *Two Wounded Soldiers* (first woodcut) 1914, 97–8; *Two Wounded Soldiers* 1915 (Pl. 121), 98, *98*, 143
Heckmanns, Friedrich, 279
Heine, Heinrich, 241
Heinrich von Neumann (Kokoschka) 1916 (Pl. 149), 116, 118, *119*, 185
Hell (Leroux) 1917–18 (Pl. 223), 171, *171*
Herzfelde, Wieland, 10, 102, 140, 170, 255, 284
Hesse, Herman, 247
Heym, George, 14, 140
Hills, Paul, 309
Hindenburg, President Paul von, 81, 285, 286
Hitler, Adolf, 285–6, 313
Hitzberger, Otto, 261
Höch, Hannah, *252*
Hoetger, Bernhard, *Peace Memorial: Lower Saxony Monument* 1915–22 (Pl. 352), 261, *261*
Hoffman, Malvina, 312
Hogarth, William, 189
Holbein the Elder, Hans, 181
Holden, Charles, 219
The Holy War (Barlach) 1914 (Pl. 38), 10, 46–7, *47*, 112, 293
Hopper, Edward, Study for poster *Smash the Hun* 1918 (Pl. 258), 192–3, *193*

The Horrors of War (Friesz) 1915–161 (Pl. 144), 115, *116*
Hospital Train (Severini) 1915 (Pl. 71), 70, *70*
House destroyed by bombs (Tournai) (Dix) 1924 (Pl. 372), *277*, 278
Hulme, T.E., 167, 244
Hutchinson, St John, 137
Hyde Park Corner *see Machine Gun Corps Memorial; Royal Artillery Memorial*
Hynes, Samuel, 9

The Illustrated London News, 232; Forestier's drawing of the Somme's 'big push', 1916 (Pl. 161), 125, *127*
image d'Epinal tradition, 9, 59, 60, 146
Images of the Decadence in Art exhibition (1933), 273
Impressionism, 57, 65, 106, 192, 203, 217, 287
Impressions, Camouflage WWI (Benton) 1918 (Pl. 259), 193, *194*, 232
Improvisation Gorge (Kandinsky) 1914 (Pl. 20), *30*, 31
Improvisation 30 (Cannons) (Kandinsky) 1913 (Pl. 7), 18, *19*
In Memoriam: Rupert Brooke (Grant) 1915 (Pl. 88), 79, *79*
In Parenthesis (Jones) 307–9, 310 *Frontispiece* 1937 (Pl. 406), *308*, 309; *Tailpiece: The Victim* 1937 (Pl. 407), 309, *309*
In the Darkness (Vallotton) 1916 (Pl. 108), 88–9, *89*
In the Retreat from Mons: The Royal Horse Guards (Butler) 1920 (Pl. 338), 251, *251*
Ingres, Jean-Auguste Dominique, 147
The Integrity of Belgium (Sickert) 1914 (Pl. 51), 57, *58*
Interrogation of the Prisoner (Vuillard) 1917 (Pl. 208), 161, *161*
Interventionist Demonstration (Carrà) 1914 (Pl. 58), *62*, 63, 69
Iribe, Paul, 68
Irish Troops in the Judaean Hills Surprised by a Turkish Bombardment (Lamb) 1919 (Pl. 306), 227, *227*
Italian Pride (Futurist manifesto), 149
Iveagh, Lord, 291, 292

Jack, Richard, *The Second Battle of Ypres 22 April to 25 May 1915* 1918 (Pl. 278), 204, *206*, 209
Jackson, A.Y., 203–4; *A Copse, Evening* 1917 (Pl. 274), 203, *203*
Jacob, Max, 147
Jaeckel, Willy, 10, 103–6, 278; *Battlefield* 1915 (Pl. 133), *105*, 105–6; *Memento* (series of lithographs) 1914–15 (Pls. 130–2), 103–5, *103–5*, 106, 278
Jagger, Charles Sargeant, 236, 281–3; *The First Battle of Ypres*, 236, 237; *Hoylake Memorial*, 281; *Humanity*, 281; *No Man's Land* 1919–20 (Pl. 317), 236, 237, 281; *Recumbent Figure, Royal Artillery Memorial*, 1921–5 (Pl. 378), 283, *283*; *Royal Artillery Memorial* (west side) 1921–5 (Pl. 377), 237, 281–3, *283*, 290, 297
Janthur, Richard, 14
Jaulmes, Gustave, *Cenotaph for the War Dead*, Paris 1919 (Pl. 318), 237, *237*
Jellicoe, Admiral, 133
Jesus Mocked (Jones) 1922–3 (Pl. 405), 308, *308*
Joffre, Marshal, 64, 81
John, Augustus, 204, 206, 209, 219; 'A "Fag" after a Fight', 219; *The Canadians Opposite Lens* 1918 (Pl. 279), 206, *206*, 209, 222
John, Gwen, *Soldier at a Bar* c. 1914–18 (Pl. 56), 61, *62*
Johnson, Riddle & Co. Ltd., London, recruiting poster 1914 (Pl. 73), 72, *72*
Jones, Adrian, Cavalry Memorial, Hyde Park, 281
Jones, David, *In Parenthesis* 1937, 307–9, 310; *Frontispiece* (Pl. 406), *308*, 309; *Tailpiece: The Victim* (Pl. 407), 309, *309*; *Jesus Mocked* 1922–3 (Pl. 405), 308, *308*
Julian of Norwich, 264
'The just man, like sandalwood, perfumes the blade that cuts him down' (Rouault) (Pl. 359), 268–9, *269*, 270

Kaesbach, Walter, 97, 98
Kahnweiler, dealer, 59
Kaiser with Von Moltke and General Staff officers 1914 (Pl. 90), 80, *80*
Kandinsky, Wassily, 9, 17–18, 22, 23, 31, 110, 111, 230, 265; *Composition VI* 1913 (Pl. 6), *17*, 17–18; *Compositions and Improvisations*, 17; *Concerning the Spiritual in Art* (book), 18; *The Deluge*, 17; *Improvisation Deluge*, 18; *Improvisation Gorge* 1914 (Pl. 20), *30*, 31; *Improvisation Sea Battle*, 18; *Improvisation 30 (Cannons)* 1913 (Pl. 7), 18, *19*; *War in the Air*, 18
Kashin, V.N., 49
Kaulbach, Friedrich August von, *Peace*, 112
Kemp-Welch, Lucy, 127–8; *Forward the Guns!* 1917 (Pl. 163), 128, *128*, 251
Kennington, Eric *Blinded Soldier*, 213; *The Conquerors*, 235; *Gassed and Wounded* 1918 (Pl. 288), 213, *213*; *The Kensingtons at Laventie* 1915 (Pl. 92), 80–1, *81*, 213, 235
The Kensingtons at Laventie (Kennington) 1915 (Pl. 92), 80–1, *81*, 213, 235
Khlebnikov, poet, 22; *Battles of 1915–17*, 123
Kirchner, Ernst Ludwig, 9, 24, 43, 46, 106–10, 118, 140, 154, 244; *Artillerymen in the Shower* 1915 (Pl. 135), 106–7, *107*, 108; *Conflict*, 109; *The Drinker, Self-Portrait* 1915 (Pl. 137), 108, *108*; *In the Barracks Yard: Two Artillerymen Riding*, 106; *The Madman*, illustration for Heym's poem, 140; *Memorial Woodcut to Hugo Biallowons*, 140; *Peter Schlemihl* cycle of woodcuts, 109; *Sailor Saying Goodbye* 1915 (Pl. 33), 43, *43*; *Schlemihl's Encounter with the Shadow* 1915 (Pl. 139), 109, *110*; *Self-Portrait as a Soldier* 1915 (Pl. 138), 108–9, *109*
Kitchener, Field-Marshal Lord, 75, 81, 125, 133, 170
Klee, Felix, 143
Klee, Paul, 9, 26–7, 42, 112, 143–4, 243, 255, 287; *Death for an Idea* 1914 (Pl. 63), 65, *65*; *Demon above the Ships* 1916 (Pl.

181), *143*, 143–4; *Destruction and Hope*, 143; *Statuette of a One-Armed Officer*, 287; *Statuettes of Disabled War Heroes* 1927 (Pl. 284), 287, *287*
Klimt, Gustav, *Death and life* 1908–11, revised 1915–16 (Pl. 153), 10, 121, *121*
Knave of Diamonds Album, 49
Knight Errant (Kokoschka) 1915 (Pl. 96), 83, *83*, 120
Knoedler Galleries, New York, 191
Koklova, Olga (Mme Picasso), 184
Kokoschka, Oskar, 10, 34–5, 82–4, 115, 116, 118–21, 185; *The Agony in the Garden*, *120*; *The Battle* 1916 (Pl. 151), 118, 120 *120*; *The Exiles* 1916–17 (Pl. 152), *120*, 120–1; *Fan for Alma Mahler* 1914 (Pl. 95), 83, *83*; *Heinrich von Neumann* 1916 (Pl. 149), 116, 118, *119*, 185; *Knight Errant* 1915 (Pl. 96), 83, *83*, 120; *The Passion*, *120*; *The Tempest* 1914 (Pl. 23), *33*, 34–5, 83; *Tom di Tolmino* 1916 (Pl. 150), 118, *120*
Kollwitz, Käthe, 10, 270–2, 294–6; *Memorial Sheet for Karl Liebknecht*, 270; *Memorial to the Fallen*, installed 1932 (Pl. 393), 271, 294–6, *295*; *'No More War!'*, 272; *The Parents* 1922–3 (Pl. 363), *270*, 271–2, 296; *The People* 1922–3 (Pl. 365), *271*; *The Victim* 1922–3 (Pl. 361), *270*, 271; *The Volunteers* 1922–3 (Pl. 362), *270*, 271; *War* cycle (woodcuts), 271–2, 396; *The Widow (II)* 1922–3 (Pl. 364), *271*, 272, 278, 294
Kollwitz, Karl, 294, 295
Kollwitz, Peter, 270, 294, 295
Konody, P.G., 204, 206, 208, 209, 229–30
Kornfeld, Paul, 120
Kramer, Jacob, *Types of the Russian Army*, 76
Der Krieg (Weber) 1918 (Pl. 257), 192, *193*
Krieg dem Kriege, publications, 274
Kriegszeit, weekly, 46, 65, 106
Krohg, Per, 125; *The Cannon Edith Cavell*, 125; *The Grenade* 1916 (Pl. 158), 125, *126*; *Wounded Horse in the Vosges* 1916 (Pl. 159), 125, *127*
Kruchenykh, Aleksey, 22, 123; *The Universal War*, 123; *The War*, 123
Kubin, Alfred, 65, 267; *The Abandoned City*, 115; *A Dance of Death* 1918 (Pl. 249), 186–7, *187*; *Torch of War* 1914 (Pl. 62), *64*, 65, 187
Kubišta, Bohumil, 23–4, 186; *Battlefield* 1918 (Pl. 248), 186, *187*; *The Bombing of Pulju*, 75, 186; *Heavy Artillery in Action* 1913 (Pl. 14), 24, *25*, 186
Kupka, Frantisek, 29, 79
Küpper, Will, *After the War* 1919 (Pl. 321), 239, *239*
K.V. (Fit for active service) (Grosz) 1916–17 (Pl. 196), 154, *154*

La Fresnaye, Roger de, 20; *Artillery* 1911 (Pl. 10), 20, *21*; *The Cuirassier*, 20
Laboureur, Jean-Emile, 158, 160; *Small Images of the War on the British Front*, 158; *Spring in Artois* 1916 (Pl. 206), 158, *160*
Lacerba, Futurist magazine, 62, 63
Lacroix, Donna, 34
Lamb, Henry, 249, 263, 297; *Advanced Dressing Station on the Struma 1916* 1920 (Pl. 337), 250, *251*; *Irish Troops in the Judaean Hills Surprised by a Turkish Bombardment* 1919 (Pl. 306), 227, *227*; *Succouring the Wounded in a Wood on the Dorian Front*, 250
Land of Terror (Steinlen) 1916 (Pl. 217), 167, *167*
Landscape with Barbed Wire (Moholy-Nagy) 1917 (Pl. 202), 157–8, *158*
Lavery, John, 55, 195; *The Cemetery, Etaples*, 195
Lawniczakowa, Agnieszka, 122
Lawrence, D.H., 137
Lazare-Lévy, M., 175
Leave-taking Soldiers (Chagall) 1914 (Pl. 30), 40, *40*, 42–3
Larionov, Mikhail, 18, 20, 41, 48, 49, 51; *Soldier on a Horse* c. 1912 (Pl. 8), 18, *20*, 41, 49; *The Soldiers*, 18
The Last Day (Meidner) 1916 (Pl. 145), 115, *116*
Le Fauconnier, 51
Lee, Major, late Colonel, 168, 169, 195, 203
Lee, Major, late Colonel, 168, 169, 195, 203
Leeds University War Memorial *see Our Lord Driving the Moneylenders out of the Temple*
Lefevre, Camille, 289
Léger, Fernand, 9, 10, 51, 82, 86–7, 96, 163–6; *The Card Game* 1917 (Pl. 214), 164–5, *165*; *The Card Players* 1916 (Pl. 104), 87, *87*, 164; *The Crashed Aeroplane* 1916 (Pl. 212), 164, *164*; *The Game of Cards* 1916 (Pl. 213), 164; *Horses in the Cantonment*, 87; *Mobile Kitchen* 1915 (Pl. 103), 86, *87*; *On the Fleury Road, two killed* 1916 (Pl. 210), 163, *163*; photograph at Argonne of, 86; *Soldier Smoking* 1916 (Pl. 209), *162*, 163, 164; *Soldiers in a Shelter*, 86–7; *Study for the Card Game*, 166; *Study for Three Portraits* or *The Wedding*, 82; *Trench-digger* studies, 164; *The Wounded Soldier*, 164
Lehmbruck, Wilhelm, 144–5; *The Fallen Man* 1916 (Pl. 183), 10, 144, *144*, 145; *Seated Youth* 1916 (Pl. 184), 144–5, *145*; *Siegfried*, 144; *Violent Man*, 144; *'Who Is Still Here?'*, poem, 145
Leicester Galleries, London, 131, 133, 168, 169, 197, 200
Leighton, Patricia, 21
Lenin, V.I., 176
Lentulov, Aristarck Vasilyevitch, 9, 51, 177, 219; *Allegory of the Patriotic War of 1812*, 51; *Peace, Celebration, Liberation* 1917 (Pl. 234), *176*; *A Victorious Battle* 1914 (Pl. 45), 51, *52*, 54, 177
Léon, Paul, 289
Leonardo da Vinci, 189
Leroux, Georges, 171; *Hell* 1917–18 (Pl. 223), 171, *171*
Lewin, Colonel, 282
Lewis, Wyndham, 19, 29–31, 35, 43–4, 63, 68, 72, 74, 76–7,

78–9, 98, 208–9, 213, 225–7, 230, *267*; *A Battery Shelled* 1919 (Pl. 305), 225–7, *226*; *Before Antwerp: Cover of Blast No. 2* 1915 (Pl. 83), 76, *77*; *A Canadian Gun Pit* 1918 (Pl. 284), 209, *210*, 225, 226; *Combat No. 2* 1914 (Pl. 34), 43, 44, *44*, 226; *Combat No. 3*, 44; *Cover of Antwerp* 1915 (Pl. 84), 76, *77*; *Drawing of Great War No. 2*, 209; *'The New Egos'*, essay, 43–4; *Officer and Signallers* 1918 (Pl. 283), 208, *209*; *Plan of War* 1914 (Pl. 19), 29, *29*, 30, 31; *Signalling*, 29; *Slow Attack*, 29–30
Lhote, André, *Portrait of Someone who is about to Die* 1917 (Pl. 207), 160, *161*
Liebermann, Max, 65, 273; *March, March, Hurrah!*, 65; *'Now we will thresh you!'* 1914 (Pl. 61), *64*, 65, 106, 273
Liebknecht, Karl, 240
Lienz War Memorial Chapel murals (Egger-Lienz), 290–1
Lima, Sir Bertram, 204
Lincolnshire, Lord, 291
Lissy, Jan, *121*, 121–2
Lloyd George, David, 198, 219, 237
London Group, 72, 78, 134, 137–8
Lönnberg, 125
Loos, Adolf, 83, 118
Loring, Frances, *Noon Hour in a Munitions Plant* 1918 (Pl. 281), 207, *208*
Lovers on Graves (Dix) 1917 (Pl. 205), 158, *160*, 197
Luce, Maximilien, 89; *Field of Honour* 1915 (Pl. 109), 89, *89*
Ludendorff, General Erich von, 55, 181, 184, 187, 213
Luks, George, *Armistice Night* 1918 (Pl. 292), 217, *218*
Lutyens, Edwin, 237, 282
Luxemburg, Rosa, 240

Macbeth Gallery, New York, 151
McBey, James, 194
MacColl, D.S., 138
McConkey, Kenneth, 129
MacDonald, Ramsay, 133
Machine Gun Corps Memorial (Wood) (Pl. 376), 281, *282*
Macke, August, 17, 41, 46, 110, 111; *Farewell* 1914 (Pl. 32), *42*, 42–3; *Farewell* (small version), 42
The Madman (Davringhausen) 1916 (Pl. 179), 140, *141*, 142, 255
Magdeburg Cathedral War Memorial (Barlach), 293–4, *294*
Mahler, Alma, 34, 82, 83, *83*, 118
Malczewski, Jacek, *Portrait of Jan Lissy* 1916 (Pl. 154), *121*, 121–2
Malesskircher, Gabriel, 181
Malevich, Kasimir, 9, 24, 51–4, 70, 82, 123; *The Carousel of Wilhelm*, 54; *Death of the Cavalry General*, 54; *The French Allies* 1914 (Pl. 47), 54, *54*, 60, 82; *The Guardsman* 1913 (Pl. 13), 22, 24; *'Look, Oh Look, Near the Vistula . . . '*, 54; *1914–Private of the First Division* 1914 (Pl. 46), 51, *53*, 54; *Suprematist Painting*, 22; *'What a Boom! What a Blast!'* 1914 (Pl. 48), 54, *54*, 60, 82
Man on a Plain (Heckel) 1917 (Pl. 235), 99, 177, *177*
Manet, Edouard, 55, 57; *The Dead Toreador*, 272; *The Execution of the Emperor Maximilian*, 55, 57
Mann, Thomas, 270
Manners, Lady Diana, 133
Mantegna, Andrea, *Dead Christ*, 181
The March into the Unknown (Slevogt) 1917 (Pl. 225), 173, *173*
Marching Soldiers (Villon) 1913 (Pl. 12), 22, *23*
Marcoussis, Louis, 168
Marc, André, 86, 237; *Cenotaph for the War Dead*, Paris 1919 (Pl. 238), 237, *237*
Marinetti, Filippo Tommaso, 16–17, 22, 24, 292, 51, 61, 62–3, 68, 70–1, 72, 74, 77, 123, 148, 149; *'Initial Manifesto of Futurism'* 1909, 16, 149; *'Kill the Moonlight'* 1912, 16; *Parole in libertà (Bombardamento)*, 63; *Parole in libertà (Irredentismo)* 1914–15 (Pl. 57), 62, *62*; *'The Siege of Adrianople'*, poem, 24
Martini, Alberto, *Avanti Italia!*, 68
The Martyrdom of St Sebastian (Gaudier-Brzeska) 1914 (Pl. 85), 77, *78*, 84
Marwick, Arthur, 134
Mascreel, Frans, 10, 88; *The Dead Arise, Infernal Resurrection* 1917 (Pls. 236 and 237), 177, *178*, 269; *Mass Grave* (Barlach) 1915 (Pl. 143), 112, *113*, 145, 174; *Massacre at Dinant* (Bellows) 1918 (Pl. 253), 91, 190; *The Massacre of the Innocents* (Ernst) 1920 (Pl. 349), 257, *258*
Masterman, C.F., 139, 168, 169, 213
Matisse, Henri, 60–1; *Bathers by a River*, 238; *Bouquet for the 14 July (Flowers, 14 July)* 1919 (Pl. 319), 237–8, *238*; *Harmony in Red*, 238; *The Moroccans*, 238
Matyushin, Mikhail, 51
May, Mabel, *Women Making Shells*, 206–7
Mayakovsky, Vladimir, 51; *Come, Germans, Come . . .*, 54
Meidner, Ludwig, 9, 13–16, 17, 18, 26, 35, 37, 96, 101, 115; *Apocalyptic Landscape* c. 1913 (Pl. 1), Berlin, 13, *14*, 115, 182; *Apocalyptic Landscape* 1913 (Pl. 2), Münster, 14, *15*; *Apocalyptic Landscape*, Saarbrücken, 13; *Bombardment of a City* 1913 (Pl. 4), 14, *15*; *The Burning City*, 13; *Im Nacken das Sternemeer*, prose poem, 13, 14; *The Last Day* 1916 (Pl. 145), 115, *116*; *On*

the *Eve of War* 1914 (Pl. 25), 35, *35*, 101; *Revolution* 1913 (Pl. 3), 14, *15*, 16; *Self-Portrait as a Prophet (Self-Portrait with Prayer Shawl)*, frontispiece; *Soldier Karl Stein*, 160–1
Meier-Graefe, Julius, 46, 272
Memento series of lithographs (Jaeckel) 1914–15, 103–5, 106; *Memento* (1) (Pl. 130), 103, *103*; *Memento* (3) (Pl. 131), 104, *104*; *Memento* (10) (Pl. 132), 105, *105*
Memorial to the Fallen (Kollwitz) installed 1932 (Pl. 393), 271, 294–6, *295*
Men Marching at Night (Nash) 1918 (Pl. 267), 198–9, *199*
The Menin Road (Nash) 1919 (Pl. 301), *222*, 222–3, 236
Meninsky, Bernard, 75
Merry-Go-Round (Gertler) 1916 (Pl. 175), 51, 135, *136*, 137–8
Metropolis (Dix) 1928 (Pl. 383), *286*, 287
Metzinger, Jean, 51; *Nurse* c. 1914–16 (Pl. 188), 146, *146*
The Milestone – Verdun (Forain) 1916 (Pl. 216), 166, 166–7
Military Cemetery at Châlons-sur-Marne (Vallotton) 1917 (Pl. 199), 89, 155–6, *156*
Le Miroir, cover 1916 (Pl. 211), 163, *163*
Missa Eroica (Egger-Lienz) 1918 (Pl. 246), 185, 186, *186*, 195, 290–1; *Dead Soldier* from (Pl. 247), 185, *186*
La Mitrailleuse (Nevinson) 1915 (Pl. 77), 73, 74, *74*, 78, 132, 223
A Mitrailleuse in Action (Gaudier-Brzeska) 1915 (Pl. 86), 78, *78*
Mobile Kitchen (Léger) 1915 (Pl. 103), 86, *87*
Moholy-Nagy, Laszlo, 157–8; *Landscape with Barbed Wire* 1917 (Pl. 202), 57–8, *158*
Moilliet, Louis, 42
Moltke, General-Oberst Helmut von, *80*
Mond, Sir Alfred, 260
Mond, Lieutenant Francis, 247, *248*
Mondrian, Piet, 9; *Pier and Ocean* series, 155
Monet, Claude, 217, 287–90; *Clear Morning with Willows* 1927 (Pls. 386 and 387), *289*, *290*; *The Grandes Décorations*, Musée de l'Orangerie, 1927 (Pls. 386 and 387), 287–90, *289*, *290*; *Reflections of Trees* 1927 (Pl. 386), *289*; *Rouen Cathedral* series, 287; *The Rue Montorgueil, Festival of June 30, 1878*, 192; *The Two Willows* 1927 (Pl. 387), *290*
Monet, Michel, 288
Monro, Harold, 73, 76
The Monster of War (Zatkova) 1918 (Pl. 250), 186, *187*
The Monument (Pryde) c. 1916–17 (Pl. 167), *130*, 130–1
Monument to the Dead, in the War 1914–18, of Montceau-les-Mines (Bourdelle) 1919–30 (Pl. 332), 247–8, *248*
Moore, Henry, 170, 194, 268; *Private H.S. Moore* (frontispiece), 170; *Roll of Honour* 1917 (Pl. 221), *169*, 170; *Warrior with Shield*, 170
Mopp, Maximilian, 146; *The World War*, 146
The Morgue (Beckmann) 1915 (Pl. 118), 96, *96*, 98, 106, 181, 182, 227, 240
Morrell, Lady Ottoline, 137
Le Mot, magazine, 60, 68, 85–6
The Mothers (Slevogt) 1917 (Pl. 230), 174–5, *175*
The Mule Track (Nash) 1918 (Pl. 270), 199–200, *200*, 201
Munch, Edvard, 89; *The Scream*, 177
Munitions Factory in Lyons. The Forge (Vuillard) 1917 (Pl. 233), 176, *176*
The Murderous Aeroplane (Ernst) 1920 (Pl. 348), 257–8, *258*
Musée de l'Orangerie, Paris, Monet's *Grandes Décorations* in, 287–90
Musée Marmottan, Paris, 290
Mussolini, Benito, 61
Mustering (Beckmann) 1914 (Pl. 136), 107, *108*
Mutilated Trees (Balla) 1918 (Pl. 273), 203, *203*

Nagel, Otto, 295
The Nameless Ones 1914 (Egger-Lienz) 1916 (Pl. 147), *114*, 115–16, 117, 185, 290
Napoleon III, Emperor, 55
Nash, John, 223; *Over the Top* 1918 (Pl. 265), 195–6, *197*, 223
Nash, Paul, 8, 196–204, 208, 209, 222–3, 260, 307; *After the Battle* 1918 (Pl. 268), 199, *199*; *Chaos Decoratif*, 8, 197–8; *The Landscape – Hill 60*, 199; *Men Marching at Night* 1918 (Pl. 267), 198–9, *199*; *The Menin Road* 1919 (Pl. 301), *222*, 222–3, 236; *The Mule Track* 1918 (Pl. 270), 199–200, *200*, 201; *A Night Bombardment* 1918–19 (Pl. 316), *235*, 236; *Rain: Lake Zillebeke* 1918 (Pl. 266), *198*, 198; *Sunrise: Inverness Copse*, 201–2, 203; *'Tiriel'* designs, 200–1; *Void* 1918 (Pl. 271), 200, *201*, 201, 236; *Void of War* exhibition (1918), 200, 203, 204; *We are Making a New World* 1918 (Pl. 272), *202*, 201–2, 223, 313; *Wire* 1918 (Pl. 269), 199–200, *200*; *Wytschaete Woods*, 197
Natanson, Thadée, 176
The Nation, journal, 131, 191
Neopathetic Cabaret, 14
Neo-Realism, 206, 207
Neuberger, Dr Fritz, *120*, 120–1
Die Neue Jugend, periodical, 10, 102, 140
Neue Sachlichkeit (New Objectivity), 255, 257, 272
Neumann, Heinrich von, Kokoschka's portrait of, 116, 118, *119*, 185
Never again war! exhibition, 273
Nevinson, Christopher, 10, 70–2, 73–5, 80, 95, 131–3, 139, 144, 151, 168–9, 197, 198; appointed official war artist (1917), 169; *A Bursting Shell* 1915 (Pl. 78), 74, 75, 131; *Automobilist or Machine Slave*, 73; *Column on the March*, 199; *Explosion* c. 1916 (Pl. 195), 151, 152, *152*, 307–8; *Flooded Trench on the Yser* 1915 (Pl. 76), 73, *74*, 131, 198, 223; *A Group of Soldiers*, 168–9; *The Harvest of Battle* 1919 (Pl. 300), 223, *223*; *He Gained a Fortune But He Gave a Son* 1918 (Pl. 346),

257, *257*; *In the Observation Ward*, 133; *La Mitrailleuse* 1915 (Pl. 77), 73, 74, *74*, 78, 132, 223; *Motor Lorries*, 133; *My Arrival at Dunkirk*, 71–2; *Paths of Glory* 1917 (Pl. 220), 169, *169*, 195; *La Patrie* 1916 (Pl. 169), 131, 132, *132*, 133; *Pursuing a Taube*, 133; *Returning to the Trenches* 1914–15 (Pl. 74), 72, *72*, 73; *Searchlights*, 75, *133*; *Troops Resting* 1916 (Pl. 170), 132, *133*
Nevinson, H.W., 73
Nierendorf, Karl, art dealer, 273
New English Art Club exhibitions, 57, 80
The Newspaper Vendor (Chagall) 1914 (Pl. 28), 38, *39*
Nicholas, Grand Duke, 49
Nicholas II, Tsar, 51, 82
Nicholson, William, 217, 237; *Armistice Night* 1918 (Pl. 294), 217, *219*; *The Ballroom of the Piccadilly Hotel during an Air Raid* 1918 (Pl. 261), 194, *195*, 217
Nietzsche, Friedrich, 24–6, 37, 77, 93, 94, 111, 140, 158; *Thus Spoke Zarathustra*, 24–6, 26, 94
The Night (Beckmann) 1918–19 (Pl. 323), 96, 240–1, *240*, 257
A Night Bombardment (Nash) 1918–19 (Pl. 316), 235, 236
1914 . . . Landscape with Scorched Ruins (Vallotton) 1915 (Pl. 106), 88, *88*, 90
1914–Private of the First Division (Malevich) 1914 (Pl. 46), 51, 53, 54
No Man's Land (Jagger) 1919–20 (Pl. 317), *236*, 237, 281
Nocturnal meeting with a madman (Dix) 1924 (Pl. 373), 277, 278
Nolde, Emil, 196, 109
Noon Hour in a Munitions Plant (Loring) 1918 (Pl. 281), 207, *208*
Northcliffe, Lord, 217
'Now we will thresh you!' (Liebermann) 1914 (Pl. 61), *64*, 65, 106
Nurse (Metzinger) c. 1914–16 (Pl. 188), 146, *146*

Oakley, Mercia, 236
'Obedient unto death, even the death of the cross' (Rouault) (Pl. 360), 267, *267*, 270
Officer and Signallers (Lewis) 1918 (Pl. 283), 208, *209*
On the Eve of War (Meidner) 1914 (Pl. 25), 35, *35*, 101
On the Firing Line (Petrov-Vodkin), 1915–16 (Pl. 155), *122*, 122–3
On the Fleury Road, two killed (Léger) 1916 (Pl. 210), 163, *163*
One of our Shells Exploding (Gaudier-Brzeska) 1915 (Pl. 87) *78*, 78–9
Operation (Beckmann) 1915 (Pl. 117), 96, *96*, 189, 241
Orley, Barnaert (Bernard) van, 9; *Altarpiece of the Visions of Job*, 97
Orpen, William, 194–6, 222, 266; *Blown-Up – Mad*, 266; *Dead Germans in a Trench* 1918 (Pl. 263), 169, 195, *196*; *A Death Among the Wounded in the Snow* c. 1918 (Pl. 264), 195, *196*; *The Mad Woman of Douai*, 195–6; *The Signing of the Peace in the Hall of Mirrors, Versailles*, 266; *Thiepval*, 195; *To the Unknown British Soldier in France* (first version) 1922 (Pl. 356), 266–7, *267*
Ostend Madonna (Heckel) 1915 (Pl. 123), 99, *100*
Osthaus, Karl Ernst, 109
Our Lord Driving the Moneylenders out of the Temple (Gill) 1923 (Pl. 355), 245, 264–6, *265*, 309
Over the Top (John Nash) 1918 (Pl. 265), 195–6, *197*, 223
Owen, Wilfred, 139; *'Exposure'*, 132; *Strange Meeting*, 245
Ozenfant, Amédée, 86; *Brow and Necklace of Victory*, 86

Pach, Walter, 147
Painting No. 48 (Hartley) 1913 (Pl. 15), 23, *24*
Palmer, Samuel, 196
Pandemonium (Grosz) 1914 (Pl. 125), *100*, 100–1, 102
Panizza, Oskar, Grosz's painting of, 187, *188*, 189
papiers collés, 21, 22, 59, 79
The Parents (Kollwitz) 1922–3 (Pl. 363), *270*, 271–2, 296
Parole in libertà (Irredentismo) (Marinetti) 1914–15 (Pl. 57), 62, *62*
Paroxysm of Destruction (Slevogt) 1916 (Pl. 229), 174, *175*
Die Pathetiker group exhibition (1912), 14
Paths of Glory (Nevinson) 1917 (Pl. 220), 169, *169*, 195
Patrick, Au Revoir! (Lady Butler) 1914 (Pl. 75), 72, *73*, 250
La Patrie (Nevinson) 1916 (Pl. 169), 131, 132, *132*, 133
Patriotic Demonstration (Balla) 1914 (Pl. 64), 67, *67*
Peace, Celebration, Liberation (Lentulov) 1917 (Pl. 234), *176*, 177
Peace Memorial: Lower Saxony Monument (Hoetger) 1915–22 (Pl. 352), 261, *261*
Pearson, Lionel, 282, 297
Pechstein, Max, 10; *Somme–8* 1918 (Pl. 325), *241*, 242
Pegasus Forced into Military Service (Slevogt) 1917 (Pl. 228), 174, *174*
Les Peintres de la Guerre au Camouflage, 60
Pennell, Joseph, 189
Penrose, Roland, 59, 258
The People (Kollwitz), 1922–3 (Pl. 365), *271*
Petrascu, Militza, 310
Petrov-Vodkin, Kuzma *Bathing the Red Horse*, 122; *On the Firing Line* 1915–16 (Pl. 155), *122*, 122–3
The Philosopher's Conquest (Chirico) 1914 (Pl. 21), 31, *32*, 34
Piatti, Ercole, 62
Picabia, Francis, 154, 243
Picasso, Pablo, 9, 21–2, 59–60, 62, 125, 147–8, 149, 184, 185, 232, 287; *Crucifixion* c. 1918 (Pl. 244), 184, *184*; *Glass and Bottle of Suze* 1914 (Pl. 11), *21*, 21–2; *Guillaume Apollinaire, Artilleryman (Guillaume de Kostrowitzky, Artilleur)* 1914 (Pl. 53), 59, *60*, 147, 287; *Guitar, Sheet-Music and Glass*, 21; *Metamorphosis*, 287; *Portrait of Jean Cocteau in Uniform* 1916 (Pl. 191), 147–8, *148*; portrait of Riccioto Canudo, 148; *Still*

Life with Cards, Glasses and Bottle of Rum 1914–15 (Pl. 52), 59, *59*; *Table with Bottle*, 22; *Table with Bottle, Wineglass and Newspaper*, 22; *Violin*, 21; *Wire Construction* 1928 (Pl. 385), 287, *288*; *The Wounded Apollinaire* 1916 (Pl. 190), 147, *148*, 184
Piero della Francesca, San Sepolcro fresco, 291
Pierre, Gustave, *Soldiers Marching Off*, 160
Pillars of Society (Grosz) 1926 (Pl. 380), 283–5, *284*
Piper, Reinhard, 145
Pippin, Horace, 300, 302; *The End of War: Starting Home* c. 1931 (Pl. 400), 302, *302*
Plan of War (Lewis) 1914 (Pl. 19), 29, *29*, 30, 31
Plastic Synthesis of the Idea 'War' (Severini) 1915 (Pl. 69), 69, *70*
Poincaré, Raymond, 20
Poiret, Paul, 60
Pople, Kenneth, 44
Portrait of a German Officer (Hartley) 1914 (Pl. 110), 23, 91, *92*
Portrait of Jan Lissy (Malczewski) 1916 (Pl. 154), *121*, 121–2
Portrait of Jean Cocteau in Uniform (Picasso) 1916 (Pl. 191), 147–8, *148*
Portrait of Makabäus – Hermann Struck (Corinth) 1915 (Pl. 111), 91, 93, *93*, 178
Portrait of Professor Gosset (Duchamp-Villon) 1918 (Pl. 245), 185, *185*
Portrait of Someone who is about to Die (Lhote) 1917 (Pl. 207), 160, *161*
Portsmouth Docks (Fergusson) 1918 (Pl. 314), *234*, 234–5
Post-Impressionism, 283
Pound, Ezra, 8, 35, 79, 208–9
Prague Street (Dix) 1920 (Pl. 341), 252, *253*
Preparation of the Artillery, Section Hors-Bois, Lorraine, January 1915 (Segonzac) 1915 (Pl. 102), 86, *86*
The Prisoner (Rohlfs) 1918 (Pl. 289), 214, *214*
Procession of the Mutilated, 14 July 1919 (Galtier-Boissière) 1919 (Pl. 320), 237–8, *238*, 239
The Profiteer (Davringhausen) 1920 (Pl. 344), 255, *255*, 257
Pryde, James *The Monument* c. 1916–17 (Pl. 167), *130*, 130–1; *The Red Ruin*, 130
Purrmann, Hans, 60

Quinn, John, 244

The Rabble Rouser (Grosz) 1928 (Pl. 382), 285–6, *286*
Rachewsky, Tatiana, 311
Rain: Lake Zillebeke (Nash) 1918 (Pl. 266), *198*, 198
Raphael, *Deliverance of St Peter from Prison*, 189
The Ration Party (In the Trenches) (Dobson) 1919 (Pl. 303), 224, *225*
Ray, Man, 9, 34, 219; *AD MCMXIV* 1914 (Pl. 22), *33*, 34, 51
Recruiting poster published by the Parliamentary Recruiting Committee (Pl. 73), 72, *72*
Red Cross Drive, May 1918 (Hassam) 1918 (Pl. 256), 192, *192*
Reflections of Trees (Monet) 1927 (Pl. 386), *289*
Remarque, Erich Maria *All Quiet on the Western Front*, 171, 279; *The Black Obelisk*, 251, 293
Resurrection (Beckmann) 1918 (Pl. 242), 181, 182–4, *183*
The Resurrection (Egger-Lienz) 1925 (Pl. 389), 291, *291*
The Resurrection, Cookham (Spencer), 263, 297
The Resurrection of the Soldiers (Spencer) 1928–9 (Pl. 399), 263, 297, 299–300, *301*, 302
Return (Gleizes) 1915 (Pl. 101), 60, 85, *86*
The Return of the Legionaries (Gutfreund) 1922 (Pl. 336), 249, *250*
Returning to the Reconquered Land (Clausen) 1919 (Pl. 315), *234*, 236
Returning to the Trenches (Nevinson) 1914–15 (Pl. 74), 72, *72*, 73
Reveille (Spencer) 1929 (Pl. 397), 298–9, *299*
Revolt (Russolo) 1911 (Pl. 5), 16, *16*, 17, 217
Revolution (Meidner) 1913 (Pl. 3), 14, *15*, 16
Rewald, Sabine, 287
Richter, Käthe, *120*, 120–1
Rickards, E.A., 204
Rippl-Rónai, József, 118
Risen Christ (Epstein) 1917–19 (Pl. 329), 243, *244*, 244–5, 247, 264
Roberts, Sarah, 212
Roberts, William, 75–6, 209–13, 223–5, 229, 230, 265; *The Battalion Runner on the Duckboard Track* 1918 (Pl. 287), 211, *213*; *Burying the Dead After a Battle* 1919 (Pl. 304), 224, *225*; *Combat* 1915 (Pl. 81), 76, 77, 210; *The First German Gas Attack at Ypres* 1918 (Pl. 286), 211, *212*, 212–13, 223, 229; *The Gas Chamber* 1918 (Pl. 285), 209–10, *211*; *Machine Gunners*, 76, 210; *Memories of the War to End War* (pamphlet), 211; *St George and the Dragon* 1915 (Pl. 79), *75*, 75–6; *A Shell Dump, France* 1918–19 (Pl. 302), *224*, 224–5; *War Celebrations* 1918 (Pl. 295), 218, *219*
Rock Drill (Epstein) 1913–15; original state (Pl. 173), 134, *135*
Rodin, Auguste, 147, 288, 311
Roethel, Hans K., 31
Roggevelde cemetery, Kollwitz *Memorial to the Fallen* at, 271, 294–6
Rohlfs, Christian, 214; *The Prisoner* 1918 (Pl. 289), 214, *214*; *War* c. 1915 (Pl. 134), 106, *106*, 214
Roll of Honour (Moore) 1917 (Pl. 221), *169*, 170
Rolland, Romain, 271
Ronnebeck, Arnold, 91
Rooster (Duchamp-Villon) 1916 (Pl. 189), 147, *147*
Rosenberg, Isaac, 229; *Self-Portrait in a Steel Helmet* c. 1916 (Pl.

308), 229, *229*
Rosenberg, Léonce, 148
Rosenblum, Robert, 20
Ross, Robert, 218
Rossetti, Dante Gabriel, 196
Rothenstein, William, 135
Rothermere, Lord, 204
Rouault, Georges, 88, 267–70; *'Arise, you dead!'*, 269; *'The just man, like sandalwood, perfumes the blade that cuts him down'* (Pl. 359), 268–9, *269*, 270; *'Man is wolf to man'*, 267, 268; *My sweet country, where are you?*, 268; *'Obedient unto death, even the death of the cross'* (Pl. 360), 267, *267*, 270; *This will be the last time, dear father!* (Pl. 357), 267, 268; *Von X* 1915 (Pl. 105), 88; *'War, hated by mothers'* (Pl. 358), 267–8, *268*, 269, 271; *War cycle*, 267–70
Rousseau, Henri 'Le Douanier', 23
Royal Academy, 128, 129, 194, 222, 232, 266, 267; War Relief exhibition (1915), 57
Royal Artillery Memorial (west side), Hyde Park (Jagger) 1921–5 (Pl. 377), 237, 281–3, *283*, 290, 297; *Recumbent Figure* 1921–5 (Pl. 378), 282, *283*
Royal Gallery, Westminster, Brangwyn wall-painting scheme for, 291–3
Rozanova, Olga *Battle of Mars with Scorpio*, 123; *Explosion of a Trunk*, 123; *Germany Arrogant*, 123; *Germany Lying in Dust*, 123; *Heavy Gun*, 123; *Military State*, 112; *Prayer for Victory*, 123; *Universal War* 1916 (Pl. 157), 123, 125, *125*; *The War* 1916 (Pl. 156), 123, *124*
Rubens, Peter Paul, 181
Ruined Cathedral, Arras (Sargent) 1918 (Pl. 296), 220, *220*
Runge, Philipp Otto, 9; *Morning*, 99
Russell, Bertrand, 189
Russell, John, 92
Russian Officer (Schiele) 1915 (Pl. 98), *84*, 85
Russolo, Luigi, 62, 68; *Revolt* 1911 (Pl. 5), 16, *16*, 17, 217
Rutter, Frank, 29, 30, 293

Sadler, Sir Michael, 18, 133, 263, 265, 266
Sailor Saying Goodbye (Kirchner) 1914 (Pl. 33), 43, *43*
The Sailors' Barracks (Chirico) 1914 (Pl. 36), 44, 46, *46*
Sailors' Dream of War (GAN) 1917 (Pl. 224), *172*, 173
Saint George (Frampton) 1918 (Pl. 331) 247, *248*
St George and the Dragon (Roberts) 1915 (Pl. 79), *75*, 75–6
Salmon, André, 59
Salon d'Automne, Paris, 125
Salon des Indépendants, 283
Sandham, Lieutenant Henry, 296
Sandham Memorial Chapel *see* Burghclere
Sant'Elia, Antonio, 68, 149
'Sappers at Work': A Canadian Tunnelling Company (Bomberg), *Study for* c. 1918 (Pl. 309), 229, *230*; (First Version) 1918–19 (Pl. 311), 229, *231*; (Second Version) 1919 (Pl. 310), 230, *230*
Sargent, John Singer, 212–13, 219–22; Boston Public Library murals, 220, 221; *Gassed* 1918–19 (Pl. 298), 10, 212, 220–2, *221*; *Ruined Cathedral, Arras* 1918 (Pl. 296), 220, *220*; *Some General Officers of the Great War*, 222; *Study for Gassed* 1918–19 (Pl. 297), 221, *221*; Widener Memorial Library wall decorations, 222
Sassoon, Siegfried, 167
Scharl, Josef, 10, 302; *Fallen Soldier* 1932 (Pl. 401), 302, *303*
Scheer, Admiral von, 133
Schelling, Felix, 79
Schiele, Egon, 10, 84–5, 115; *Austrian Soldier with Pipe* 1916 (Pl. 100), 85, *86*; Poster for Arnot Gallery Exhibition 1914 (Pl. 97), 84, *84*; *Russian Officer* 1915 (Pl. 98), *84*, 85; *Self-Portrait in Uniform* 1917 (frontispiece); *Sick Russian Soldier* 1915 (Pl. 99), 85, *85*
Schilling, Erna, 108
Schlemihl's Encounter with the Shadow (Kirchner) 1915 (Pl. 139), 109, *110*
Schlichter, Rudolf, 239, 284
Schmalhausen, Otto, 189, 284
Schmidt-Rottluff, Karl, *Has Christ Not Appeared to You?*, 184–5
Schmied, Wieland, 14, 142
Schreber, Dr Daniel, *Memoirs of My Nervous Illness*, 13
Schubert, Otto, 10, 174; *Under Shell Fire (from The Suffering of Horses in the War)* c. 1917 (Pl. 227), 174, *174*
Seated Youth (Lehmbruck) 1916 (Pl. 184), 144–5, *145*
The Second Battle of Ypres (Jack) 1918 (Pl. 278), 204, *206*, 209
Seen at the steep slope at Cléry-sur-Somme (Dix) 1924 (Pl. 369), *275*, 276
Segonzac, André Dunoyer de, 86, 111; *At the Bistro*, 161; *Preparation of the Artillery, Section Hors-Bois, Lorraine, January 1915* (Pl. 102), 86, *86*, 111
Self-Portrait as a Soldier (Dix) 1914 (Pl. 112), 93, *93*, 204
Self-Portrait as a Soldier (Kirchner) 1915 (Pl. 138), 108–9, *109*
Self-Portrait as Mars (Dix) 1915 (Pl. 114), 94, *94*
Self-Portrait as Medical Orderly (Beckmann) 1915 (Pl. 120), 97, *98*
Self-Portrait as a Prophet (Self-Portrait with Prayer Shawl) (Meidner) 1918 (frontispiece)
Self-Portrait as Shooting Target (Dix) 1917 (Pl. 115), 95, *95*
Self-Portrait in a Steel Helmet (Rosenberg) c. 1916 (Pl. 308), 229, *229*
Self-Portrait in Uniform (Schiele) 1917 (frontispiece)
Self-Portrait with Artillery Helmet (Dix) 1914 (Pl. 113), 93–4, *94*
Self-Portrait with Red Scarf (Beckmann) 1917 (Pl. 240), 181, *182*
Seligman, Germain, 20

Setting Sun (Ypres) (Dix) 1918 (Pl. 277), 204, 205
The Seven Vials of Wrath (Vogeler) 1918 (Pl. 291), 214, 215
Severini, Gino, 10, 68–70, 74, 125, 148–9, 154; Armoured Train in Action 1915 (Pl. 70) 70, 70, 74; Cannon in Action 1915 (Pl. 72), 69–70, 71, 94, 211; First Futurist Exhibition of the Plastic Art of War, 148; The Hospital Train 1915 (Pl. 71), 70, 70; Italian Lancers at a Gallop, 69; Maternité, 70; Motherhood, 148–9; Nord-Sud, 70; Plastic Synthesis of the Idea 'War' 1915 (Pl. 69), 69, 70; Red Cross Train Passing a Village, 70; War, 69, 148
Shakespear, Dorothy, 35; War Scare, July 1914 (Pl. 24), 34, 35
The Shell (Grosz) 1915 (Pl. 124), 100, 101, 102
A Shell Dump, France (Roberts) 1918–19 (Pl. 302), 224, 224–5
The Shell Filling Factory (Ginner) 1918 (Pl. 280), 206–7, 207, 208
Sick Russian Soldier (Schiele) 1915 (Pl. 99), 85, 85
Sickert, Walter Richard, 54–7, 74, 76, 79–80, 131; The Baby Grand, 55; Chopin, 55; The Integrity of Belgium 1914 (Pl. 51), 57, 58; The Soldiers of King Albert the Ready 1914 (Pl. 50), 55, 56, 57, 74, 80, 131; Suspense, 131; Tipperary 1914 (Pl. 49), 54–5, 55
Signal Flare (Dix) 1917 (Pl. 203), 158, 159
Sillars, Stuart, 125
Silver, Kenneth, 9–10, 59, 149
Sims, Charles, 128–9, 222; Clio and the Children 1913–15 (Pl. 164), 128–9, 129
Sinjakowa, Maria, Study for the 'War' Cycle 1914–15 (Pl. 93), 81, 82, 118
Sironi, Mario, Yellow Aeroplane with Urban Landscape 1915 (Pl. 68), 68, 69, 168
Skat Players (Dix) 1920 (Pl. 342), 254, 254–5
Skin Graft (Dix) 1924 (Pl. 371), 276, 277–8
Skull (Dix) 1924 (Pl. 370), 276, 277
Smash the Hun (Hopper), study for poster 1918 (Pl. 258), 192–3, 193
Snowden, Philip, 133
Soby, James Thrall, 143
Slevogt, Max, 10, 145, 173–5, 177, 178; The Answerable 1917 (Pl. 232), 175, 175; The Aviator, 175; The Call to Arms, 174; The Forgotten, 175; The March into the Unknown 1917 (Pl. 225), 173, 173; The Mothers 1917 (Pl. 230), 174–5, 175; Paroxysm of Destruction 1916 (Pl. 229), 174, 175; Pegasus Forced into Military Service 1917 (Pl. 228), 174, 174; Shellfire, 174; The Suicide-Machine 1917 (Pl. 231), 175, 175; The Supreme Command, 174; The Utopia of Peace, 174; The Victor's Dream 1917 (Pl. 226), 173, 174; Visions, 10, 173–5
Soldier at a Bar (John) c. 1914–18 (Pl. 56), 61, 62
Soldier in a Madhouse (Felixmüller) 1918 (Pl. 290), 214, 214
Soldier on a Horse (Larionov) c. 1912 (Pl. 8), 18, 20, 41, 49
Soldier Smoking (Léger) 1916 (Pl. 209), 162, 163, 164
Soldier with Pipe (Dix) 1918 (Pl. 276), 204, 204
Soldiers (Chagall) 1912 (Pl. 9), 20, 20
The Soldiers of King Albert the Ready (Sickert) 1914 (Pl. 50), 55, 56, 57, 74, 80, 131
Somme-8 (Pechstein) 1918 (Pl. 325), 241, 242
Souvenir of the Mirrored Halls in Brussels (Dix) 1920 (Pl. 339), 251, 252
Spencer, Florence, 298
Spencer, Gilbert, 44; The Crucifixion, 44
Spencer, Hilda, 296, 297
Spencer, Stanley, 11, 44, 70, 227–9, 261–3, 269, 282, 303, 307; Ablutions 1928 (Pl. 395), 297, 297; Burghclere: Sandham Memorial Chapel (Pls. 394–9), 11, 263, 269, 282, 296, 296–300, 307, 312; The Centurion's Servant 1914 (Pl. 35), 44, 45; Christ Overturning the Money Changers' Tables, 265; Convoy of Wounded Men Filling Water-Bottles at a Stream 1932 (Pl. 396), 298, 298; Convoy of Wounded Soldiers Arriving at Beaufort Hospital Gates 1927 (Pl. 394), 296, 297; Crucifixion, 261, 263; Dug-Out or Stand-to 1928 (Pl. 398), 299, 299; Kit Inspection, 297–8; Map Reading, 298; The Resurrection, Cookham, 263, 297; The Resurrection of the Soldiers 1928–9 (Pl. 399), 263, 297, 299–300, 301, 302; Reveille 1929 (Pl. 397), 298–9, 299; Scrubbing the Floor, 297; Travoys Arriving with Wounded at a Dressing-Station at Smol, Macedonia 1919 (Pl. 307), 70, 227–8, 228, 250, 261, 294; Unveiling Cookham War Memorial 1922 (Pl. 353), 262, 263
Spies, Werner, 257
Spring in Artois (Laboureur) 1916 (Pl. 206), 158, 160
Springtime in Flanders (Heckel) 1916 (Pl. 180), 99, 140, 142, 142, 177
ss New York City, with dazzle camouflage 1918 (Pl. 312), 232, 232
Statuettes of Disabled War Heroes (Klee) 1927 (Pl. 384), 287, 287
Steep Memorial Hall project, Spencer's, 297
Steichen, Edward, 312–13
Stein, Gertrude, 22, 59, 60, 232; The Autobiography of Alice B. Toklas, 59
Steinhardt, Jakob, 14
Steinlen, Théophile-Alexandre, 88; Land of Terror 1917 (Pl. 217), 167, 167; Souvenir of Mobilization, 88; The Two Friends, 167
Stick It Out! (Grosz) c. 1915 (Pl. 129), 102, 102
Still Life with Cards, Glasses and Bottle of Rum (Picasso) 1914–15 (Pl. 52), 59, 59
Stopford, Francis, 203
Strachey, Lytton, 137

Strauss, Louise, 257
Struck, Hermann, 91, 93, 93, 178
Stuckey, Charles F., 288
Study for Gassed (Sargent) 1918–19 (Pl. 297), 221, 221
Study of Facial Wounds (Tonks) 1916 (Pl. 176), 138, 138
Study for the 'War' Cycle (Sinjakowa) 1914–15 (Pl. 93), 81, 82, 118
Der Sturm gallery, Berlin, 14, 16, 170
Der Sturm, magazine, 16, 83
Štursa, Jan, limestone consoles for the façade of the Bank of the Czechoslovak Legion, Prague, 1922–3 (Pl. 336), 249, 250
Süe, Louis, Cenotaph for the War Dead, Paris 1919 (Pl. 318), 237, 237
The Suicide-Machine (Slevogt) 1917 (Pl. 231), 175, 175
Sunrise (Dix) 1913 (Pl. 16), 26, 26
Suprematism, 9, 22, 54, 123
Surrealism, 260
Synthetic Cubism, 22, 91
Table of Silence (Brancusi) 1937–8 (Pl. 408), 11, 310–11, 311
A Tank in Action (Brangwyn) 1925–6 (Pl. 390), 291–2, 292
Tanks (Bone) 1916 (Pl. 177), 139, 139, 168
Tatarascu, Aretia, 310, 311, 313
Taylor, A.J.P., 29, 81
Tea in the Bed-Sitter (Gilman) 1916 (Pl. 168), 131, 131
The Tempest (Kokoschka) 1914 (Pl. 23), 33, 34–5, 83
Temple of Hathor, 312
Teuscher, Dr, 120
These war invalids are getting to be a positive pest! (Grosz) (Pl. 343), 254, 255
Third London Group show (1915), 74
This is How I Looked as a Soldier (Dix) 1924 (frontispiece)
This will be the last time, dear father! (Rouault) (Pl. 357), 267, 268
Thomas, W. Beach, 169
The Tin Hat (Epstein) 1916 (Pl. 172), 133, 134
Tipperary (Sickert) 1914 (Pl. 49), 54–5, 55
Tirgu-Jiu Memorial complex (Brancusi), 310–13
Titian, The Flaying of Marsyas, 191
To the Unknown British Soldier in France (first version) (Orpen) 1922 (Pl. 356), 266–7, 267
Tom di Tolmino (Kokoschka) 1916 (Pl. 150), 118, 120
Tonks, Henry, 138, 220; Studies of Facial Wounds 1916 (Pl. 176), 138, 138, 277–8
Torch of War (Kubin) 1914 (Pl. 62), 64, 65, 187
Torso in Metal from the 'Rock Drill' (Epstein) 1913–16 (Pl. 174), 134–5, 135, 244
Trakl, Georg, 65
Travoys arriving with Wounded at a Dressing-Station at Smol, Macedonia (Spencer) 1919 (Pl. 307), 70, 227–8, 228, 250, 261, 294
The Trench (Dardel) 1916 (Pl. 160), 125, 127
The Trench (Dix) 1920–3 (Pl. 366), 272, 272–3, 274, 277, 279, 302, 303
Troops Resting (Nevinson) 1916 (Pl. 170), 132, 133, 268
Tube, Frau, 182, 183
Tube, Martin, 37, 95
Tucker, Paul Hayes, 287
Two Riflemen (Dix) 1917 (Pl. 204), 158, 160
The Two Willows (Monet) 1927 (Pl. 387), 290
Two Wounded Soldiers (Heckel) 1915 (Pl. 121), 98, 98, 143
Uccello, Paolo, 9, 34, 225; Battle of San Romano, 51, 218–19, 225
Under Shell Fire (Schubert) c. 1917 (Pl. 227), 174, 174
The Underworld (Bayes) 1918 (Pl. 262), 194, 195
Universal War (Rozanova) 1916 (Pl. 157), 123, 125, 125
Unveiling Cookham War Memorial (Spencer) 1922 (Pl. 353), 262, 263, 265
Uzarski, Adolf, 10, 267; Dance of Death 1916–17 (Pl. 238), 177–8, 178; Hunger, 177
Valensi, Henri, 154; Expression of the Dardanelles 1917 (Pl. 197), 10, 154, 155
Vallotton, Félix, 88–9, 154–6, 222, 289; Barbed Wire 1916 (Pl. 107), 88, 89; Church at Souain, ruins and rubble 1917 (Pl. 200), 89, 156, 157, 289; In the Darkness 1916 (Pl. 108), 88–9, 89; Military Cemetery at Châlons-sur-Marne 1917 (Pl. 199), 89, 155–6, 156, 289; 1914 ... Landscape with Scorched Ruins 1915 (Pl. 106), 88, 88, 90; Plateau de Bolante, 155; This is War, series of woodcuts, 88–9; Verdun, an interpreted picture of war 1917 (Pl. 198), 89, 154–5, 155, 289; The Yser, 155, 222
Van Gogh, Vincent, 26, 179; The Painter on his Way to Work, 109
Varia, Radu, 312
Vaughan, Father Bernard, 245
Varley, F.H., 203–4; For What? 1918 (Pl. 275), 204, 204
Velázquez, Diego, 272; The Surrender of Breda, 218
Verdun, an interpreted picture of war (Vallotton) 1917 (Pl. 198), 89, 1154–5, 155
Verism, 272
The Victim (Kollwitz) 1922–3 (Pl. 361), 270, 271
A Victorious Battle (Lentulov) 1914 (Pl. 45), 51, 52, 54, 177
The Victor's Dream (Slevogt) 1917 (Pl. 226), 173, 174
Village in Ruins near Ham (Bonnard) 1917 (Pl. 201), 156–7, 157, 268
Villon, Jacques, 24, 59, 86, 111, 243; In Memoriam, 243; Marching Soldiers 1913 (Pl. 12), 22, 23; Seated Woman, 243
Virgin of the Offering (Bourdelle) 1922 (Pl. 335), 248–9, 249
The Vision of St George over the Battlefield (Hassall) 1915 (Pl. 80),

76, 76
Visit to Madame Germaine at Méricourt (Dix) 1924 (Pl. 368), 274, 276
Vogeler, Heinrich, The Seven Vials of Wrath 1918 (Pl. 291), 214, 215
Vogt, Leon, 248
Void (Nash) 1918 (Pl. 271), 200, 201, 201, 204, 236
Vollard, art dealer, 55, 147
Volunteer Cyclists' Battalion, 68
The Volunteers (Kollwitz) 1922–3 (Pl. 362), 270, 271
Von X 1915 (Pl. 105), 88
Vorticism, 28–9, 35, 43–4, 75–6, 79, 132, 134, 197, 204, 209, 210, 224, 225, 226, 230, 232
Vuillard, Edouard, 162, 175–6; Interrogation of the Prisoner 1917 (Pl. 208), 161, 161; Munitions Factory in Lyons. The Forge 1917 (Pl. 233), 176, 176
Wadsworth, Edward, 76, 226, 230; Dazzle-Ships in Drydock at Liverpool 1919 (Pl. 313), 208, 232, 233, 234; Disruption, 230; Drydocked for Scaling and Painting, 232; Liverpool Shipping, 232; War Engine c. 1915 (Pl. 82), 76, 77
Walden, Herwarth, 23, 83, 118, 120
Wallraf-Richartz Museum, Cologne, 273
war artists, official, 10, 80, 81, 134, 139, 168, 173, 194, 195, 196, 198, 204, 206, 208, 209, 244, 247
War (Albert-Birot) 1916 (Pl. 187), 146, 146
War, series of etchings (Dix) (Pls. 367–75), 10, 94, 103, 104, 272, 273–9, 307
War (Egger-Lienz) 1915–16 (Pl. 146), 115, 117
The War (Gromaire) 1925 (Pl. 379), 283, 284
War, series of woodcuts (Kollwitz), 270–1, 396
War (Rohlfs) c. 1915 (Pl. 134), 106, 106, 214
War, series of prints (Rouault), 267–70
The War (Rozanova) 1916 (Pl. 156), 123, 124
War Celebrations (Roberts) 1918 (Pl. 295), 218, 219
War Cripples (Dix) 1920 (Pl. 340), 252, 252, 273
War-Engine (Wadsworth) c. 1915 (Pl. 82), 76, 77
'War, hated by mothers' (Rouault) (Pl. 358), 267–8, 268, 269, 271
War Memorial, Güstrow Cathedral (Barlach) (Pl. 391), 293, 293, 294
War Memorial, Magdeburg Cathedral (Barlach) (Pl. 292), 293–4, 294
War Scare, July 1914 (Shakespeare) (Pl. 24), 34, 35
War Series, lithographs (Bellows), 189–91
War Triptych (Dix) (Pl. 402), 10, 278, 302–6, 304; Cartoon for 1932 (Pl. 403), 304, 305
War with Germany (Filonov) 1915 (Pl. 94), 82, 82
War Wives (Egger-Lienz) 1918–22 (Pl. 347), 257, 257
'Waterloo Centenary Exhibition' (1915), 72
We are making a New World (Nash) 1918 (Pl. 272), 201–2, 202, 223, 313
Weber, Max, 192, 194; Der Krieg 1918 (Pl. 257), 192, 193
Weeping Woman (Beckmann) 1914 (Pl. 26), 37, 38, 43, 95
Weight, Angela, 81
Weisgerber, Albert, 47–8; David and Goliath 1914 (Pl. 40), 47, 48, 84
Westheim, Paul, 144
Weyden, Rogier van der, 9, 96; Lamentation of Christ, 96, 181
'What a Boom! What a Blast!' (Malevich) 1914 (Pl. 48), 54, 54, 60, 82
Whitford, Frank, 118
The Widow II (Kollwitz) 1922–3 (Pl. 364), 271, 272, 294
Wiese, Stephan von, 182
Wilhelm II, Kaiser, 217
Wilkinson, Lieutenant-Commander Norman, 230, 232
Wilson, President Woodrow, 185, 192
Wire (Nash) 1918 (Pl. 269), 199–200, 200
Wire Construction (Picasso) 1928 (Pl. 385), 287, 288
Wolff, Kurt, publisher, 82
Wolff, S.J., 191
Wollheim, Gert, 243, 272; The Wounded Man 1919 (Pl. 326), 242, 242, 272, 302
Woman Crying (Chagall) 1914–15 (Pl. 31), 41, 41
Wood, Frederick Derwent, 282; Machine Gun Corps Memorial (Pl. 376), 281, 282
The Wounded Apollinaire (Picasso) 1916 (Pl. 190), 147, 148, 184
Wounded Horse in the Vosges (Krohg) 1916 (Pl. 159), 125, 127
The Wounded Man (Wollheim) 1919 (Pl. 326), 242, 242, 272, 302
Wounded man fleeing (Battle of the Somme, 1916) (Dix) 1924 (Pl. 367), 274, 274
Wounded Soldier (Chagall) 1914 (Pl. 29), 40, 40–1
Wounded Soldier (Epstein) 1918 (Pl. 330), 244, 245, 291
Wounded Soldier (Zadkine) 1917 (Pl. 215), 166, 166
Yeats, W.B., 'The Second Coming', 260
Yellow Aeroplane with Urban Landscape (Sironi) 1915 (Pl. 68), 68, 69
Youth Mourning (Clausen), original version 1916 (Pl. 165), 129–30, 130; revised state 1916–28 (Pl. 166), 130, 130
Zadkine, Ossip, 166; Red Cross Stretchers and Vans, 166; Wounded Soldier 1917 (Pl. 215), 166, 166
Zatkova, Larissa, 51
Zatkova, Ruzhena, 186; The Monster of War 1918 (Pl. 250), 186, 187
Zweig, Stefan, 14, 16